Unseen by the naked eye

HEAVEN

With an introduction by David Malin

& EARTH

Φ

For many of us, our experience of the world is limited to the amount we can see with our own eyes and with our feet planted firmly on the ground. We see dew drops, insects, plants, fields, lakes, mountains, rainbows, planets and stars. However, if the range of matter that exists in the universe could be measured, only a very small percentage would be visible to us. It may be too small, too distant or too fast, or only visible with ultraviolet light, x-rays or heat detectors. We are in fact blind to all but the thinnest slice of the universe in which we live.

This book attempts to forge a path through the intriguing complexities of nature and introduce a world that is normally hidden from view. The most powerful microscopes and telescopes reveal to us many of the fundamental workings of the universe. Organized in sequence according to magnification, size and distance, the book takes us on a journey from the smallest elements on the Earth's surface to the vast galaxies light years away.

To some, the world of science may conjure up images of fact, logic, objectivity and experimentation. We hope that this book will go some way to showing that it is much more than this. The visual world of science stimulates the imagination with views of nature that can be stirring in their beauty, composition and texture. There are few things more inspiring than the knowledge that our bodies are made up of millions of complex cells, or that when we look at the night sky we are looking at history – not just a distant memory of the past but a record of how the heavens looked hundreds of thousands of years ago.

Science is a method of unveiling the beauty of facts as well as a confirmation of our extraordinary capability and intellectual power, our unnerving desire to learn and our ability to comprehend that we, on this tiny planet, are minute particles in an infinite universe.

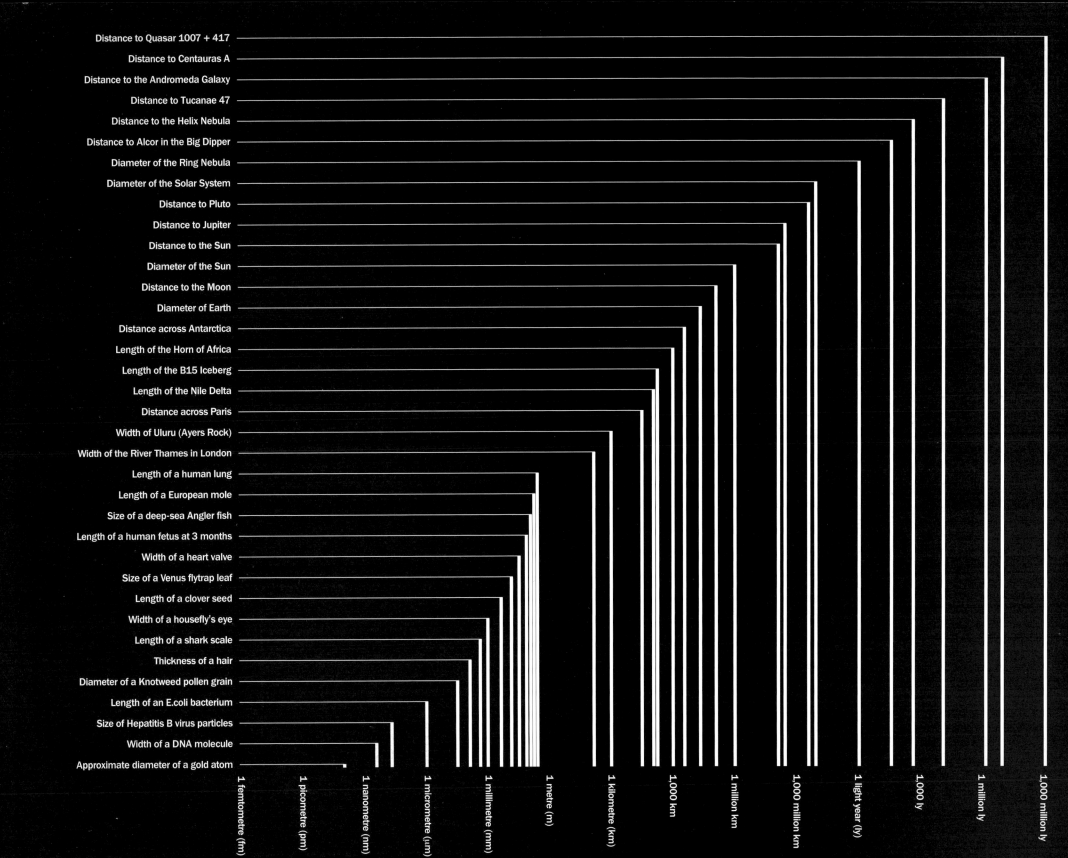

Contents

Introduction

Human beings have evolved to be aware of the world around them, indeed such awareness is essential for the survival of the human species – or any species for that matter. The five senses of sight, sound, smell, taste and touch were long thought to be sufficient to deal with the external world. However, if we accept that the evolution of the senses is the result of the struggle for survival, there is an essential sixth sense, pain, which tells us about our internal environment. Indeed, there may yet be another sense, a feeling for the passage of time. It has always been there in the background, reminding us of our mortality, but nowadays seems to have assumed a daily presence. In this book time is relevant to many of the ideas we encounter, since unaided we are unable to appreciate the importance (and beauty) of actions that occur on very short and very long timescales.

Most humans have the full set of senses, and the organs concerned with sight and sound are located high on the body, enabling us to see and hear far and wide. Our eyes and ears are in pairs so that we have three-dimensional vision and directional hearing, together refining our minute-by-minute knowledge of place and space and enabling us to respond to the environment which surrounds us. Though our senses are no more acute than in other creatures, they have the advantage of being connected to a more elaborate signal-processing system, the brain. In humans, this organ is not solely concerned with the essentials of life and it is here that self-awareness and consciousness are mysteriously created from the signals that our senses provide. This enormous processing power can apply itself to incoming information in ways that are only remotely connected to survival, such as an appreciation of beauty. The same brain enables us to create art, and science.

Art and beauty underlie the images in this book and are a recurrent theme throughout, but many of the pictures here are of places and things that are, for one reason or another, beyond our ability to appreciate directly. Some pictures are of things that are too small or occur too quickly for us to notice, while others are unimaginably large and distant and happen on timescales that are as long as time itself. The only reason for exploring them at all is human curiosity, which is formalized in the processes of science, but the images that result from this quest for knowledge are often remarkably beautiful as well as informative.

Though all the senses are fully integrated into the human experience, it is through our eyes that the richest and most varied impressions reach the mind. The visual image is just that, a picture, an instantaneous snapshot that is refreshed many times per second as the eye flits from scene to scene. Vision provides a vast quantity of information quickly. Our eyes tell us of colour, size, shape, texture, brightness and much else that contributes to the visual sensations that we experience and which may have aesthetic qualities as well as practical uses. The eye can prompt the brain to recognize a familiar face across a crowded room in an instant. The same glance may also capture mood and context while simultaneously transmitting a welcome or a warning.

Beyond its emotive power, the eye is a superb detector of light, allowing us (just) to see the surface of the Earth by the light of the stars alone. However, we can move around freely under the brighter light of the full moon, which provides almost a million times less illumination than the midday sun. Unaided, our eyes can pick out the Andromeda galaxy, which is as big as our own galaxy, the Milky Way, and two million light years distant. The same eyes, in almost the same instant, can see hairs

on the back of the hand that are a fiftieth of a millimetre wide.

This marvellous versatility has its limits, however. Like the other senses, the eye has evolved in response to our everyday environment, the apparently unique, fragile layer of air and water around a rocky planet near a modest, yellowish star. Our lives are illuminated by light from this star, the Sun. It is thus no accident that the eye is most sensitive to the green-yellow light that filtered to the forest floor where our early ancestors lived. The eye is also least sensitive to the blue part of the spectrum. There are few blue hazards in nature and little survival advantage in admiring the hue of the sky, but careful discrimination of green and yellow foods, and the shocking power of blood red are clearly vital signals. Similarly, there is no pressing evolutionary need to see the subtle colours of the stars, or anything much smaller than a flea, and we cannot. Nature is sparing with her most precious gifts.

We can see the range of colours found in the rainbow; no more, sometimes less. These colours complete a range from the shortest visible wavelengths (blue-violet) to the longest (red). All the colours of the rainbow, including red and violet, come from white light and can be recombined to reproduce white light. This was one of the major discoveries of the English mathematician and physicist Sir Isaac Newton (1642–1727). By 1666, Newton had uncovered the nature of colour and shown the way to explain the colour of nature.

The wavelengths referred to here are waves of electromagnetic radiation, of which Newton knew nothing. Light is but a very small part of the electromagnetic spectrum; in musical terminology the wavelength of visible light covers less than one octave. In the middle of this range is a wavelength of 550 nanometres, corresponding to greenish-yellow light, the visual equivalent of middle C. A nanometre is small, a billionth (10^{-9}) of a metre, but the full extent of the electromagnetic spectrum – from short wavelength gamma rays to long wavelength radio waves – covers an astonishing range, almost 75 octaves. These various waves of energy share the same physical nature, and all travel at the speed of light, but they have very different properties. Almost all of them are invisible to the eye, and some are harmful to life. In this book we extend our narrow human vision to include at least part of this invisible sea of radiation by using photography and other, less direct and more recent imaging techniques.

While much of the natural world is hidden from us because we cannot see heat, ultraviolet light, radio waves or x-rays directly, much more of it is beyond our immediate comprehension because it is too small, too short-lived, too faint or too distant, or even too big to be detected by the naked eye. This invisible universe is filled with intrigue and interest on all kinds of scales, but should we care about these hidden worlds? For our basic day-to-day survival perhaps not. For thousands of generations we have prospered knowing nothing of the stars or the galaxies beyond. Even the Sun and the Moon were mysterious until the invention of the telescope. Now we know of the existence of billions of galaxies, each containing myriads of Sun-like stars. None of this knowledge directly affects our daily lives, but we would be immeasurably poorer without it.

Only in the last century, with the construction of ever more powerful microscopes and other ways of exploring the very small, have we learned how a butterfly colours its wings and appreciated the existence of bacteria and viruses, the nature of crystals and the structure of the atom. Technologies from pharmaceuticals, computer chips and nuclear weapons based on these discoveries have profoundly altered the way we live, for good and ill. This knowledge of the smallest – and largest – entities that we can contemplate helps us to define where we fit into the scheme of things. Rather surprisingly, we find that humans are about halfway between the very smallest and the largest things we know.

A firm realization that the Earth (and by inference, its inhabitants) was not at the centre of creation finally arrived with the work of the fifteenth-century astronomer Nicholas Copernicus (1473–1543) and was confirmed by the telescopic observations of the Italian astronomer Galileo Galilei (1564–1642) in the early seventeenth century. These powerful ideas helped shape the Renaissance and led to the profound shift in perception that pointed the way to modern science.

Scientific advancement has helped us experience the enormous range of size that exists in the natural world, but it is our 'seventh sense' that stirs our awareness of that vast river of time of which we are a part. Time on this scale is almost imperceptible, but we are aware of its passage, day by day, year by year. On the grander scale our species is much less than a million years old, but we live on a planet that has circled the Sun for more than 4,000 million years in a universe three times older than that. We have much still to learn, and perhaps enough time in which to learn it.

Many of the images in this book have been made with devices that were made specifically to extend the power of the human eye and thus stretch the human mind. Foremost among them are microscopes and telescopes. Although the magnifying and diminishing power of curved pieces of glass has been known since ancient times, instruments combining several lenses first appeared 400 years ago. They were made by trial and error and their images were imperfect, but so powerful was their influence that this early optical technology can be credited with making modern science possible.

An optical microscope collects light from a small, nearby and usually strongly illuminated scene and enlarges it to fill the retina of the eye or some other light-sensitive detector. The first optical microscopes were of limited power; the best optical instruments of today can magnify about 1,500 times. The magnification is not restricted by technology, but by the wavelength of the light they use. The optical telescope appeared at about the same time as the microscope in the early seventeenth century and uses similar principles, but it is able to collect light from large, sometimes very faint scenes at a distance and makes a reduced image of it that can be seen or recorded. Though both instruments greatly extended the range of human vision, it was their later alliance with photography that spread the message that there was more to the world than meets the eye. If microscopes and telescopes combine science and technology, the invention of photography in the 1840s introduced the possibility of art. It is the interplay of this sturdy trio of forces that we explore in these pages.

Seventy years ago the underlying potential of the microscope was extended by using a beam of electrons rather than light to create images. This advance is generally credited to the German scientist Ernst Ruska (1906–88). Electron beams effectively have a much shorter wavelength than light and such microscopes can be tuned to see small molecules, even individual atoms. These developments

in the magnetic lenses of electron optics also allowed the design of the scanning electron microscope, later to be a spectacularly productive picture-making machine, ideal for examining surfaces in exquisite detail. The scanning microscope principle has since led to optical derivatives using scanned beams of laser light, and other, more exotic optical and electron hybrids. In skilled hands many of these modern instruments are capable of producing splendidly detailed photographs. If the microscopist has an eye for a picture, some of these images, enabled by technology and motivated by science, may also be works of art.

A similar branching trail can be discerned for the evolution of the telescope, but the motives and machinery involved are quite different. The terrestrial uses of telescopes and binoculars are obvious, and the telescope was first valued for the military and maritime advantages it gave to its owner. But it is in the field of astronomy that the telescope has become indispensable and, as with the microscope, the instrumentation has changed beyond recognition since an early example was first turned to the skies by Galileo in 1609. While most astronomical telescopes can make images, in professional astronomy imaging is not their primary purpose. Astronomers think of the telescope more as a light-gathering device than as a camera, and the bigger the telescope, the greater the amount of light that can be collected for analysis. Long ago it was found that big mirrors were easier to make than big lenses, so most telescopes are reflectors. This includes radio telescopes, for use at wavelengths where lenses, or even ordinary imaging, are not a practical proposition at all.

The biggest telescope of all is provided by nature herself. Almost a hundred years ago, the theoretical physicist Albert Einstein (1879–1955) predicted that the invisible power of gravity could bend light. This improbable idea has been shown to be valid many times, but never more dramatically than when, in 1979, it was found that unexpected, arc-like structures in a relatively nearby galaxy cluster were the distorted images of much more distant galaxies in the same line of sight whose light had been 'amplified' by the focusing effect of gravity.

Unlike microscopists, astronomers are generally unable to interact with the things they study, even if they wanted to. Instead, they depend on the messages encoded in the radiation they receive for their understanding of a universe that is quite unlike the biosphere in which we live. From the depths of space, images of astonishing beauty can be collected – cosmic landscapes that reveal the chemistry and physics of places so distant that they may no longer exist.

Apart from the various types of microscopes and telescopes there are many other ways of exploring the hidden world, often by using unseen electromagnetic radiation. In x-ray diffraction, an imaging technique developed by the German physicist Max von Laue (1879–1960) in 1912, a fine beam of x-rays is fired through a crystal to produce a pattern that reveals the molecular dimensions of the crystal with a precision that no microscope can. The same technique uncovered the double helical structure of DNA, the 'molecule of life'. A conventional x-ray photograph is a simple shadowgram, differentiating the different opacities that flesh and bone have to x-rays, while more sophisticated techniques such as computer axial tomography (CAT scanning) reveal the internal structures of human bodies and other opaque structures in astonishing detail and in three dimensions. Other imaging techniques, such as magnetic resonance imaging (MRI), use powerful magnets to excite atoms

in the body in order to release radio waves that are then imaged, again uncovering subtle structures hidden beneath layers of skin, fat and muscle.

In an entirely different frequency range, a beam of ultrasound can penetrate the body to show the living fetus in the womb; while on a much larger scale seismic sound waves passing through the Earth are able to expose the deep structure of the planet beneath our feet. From above, the Earth is regularly imaged at many wavelengths in order to monitor the ever-changing circulation of air and water vapour that affects our weather, while other satellites at other wavelengths, seen and unseen, monitor crops, light pollution and urban sprawl and search for the geological signatures of minerals. The data from these orbiting eyes is returned to Earth digitally, and the pictures we see have never been captured photographically in the normal sense. This does not diminish their interest, beauty or utility; rather it expands our ability to explore far beyond the Earth, to other planets, other worlds.

If we carry our detectors into space and point them away from the Earth, pictures can be made of distant objects in the infrared and ultraviolet parts of the spectrum that never reach the ground. This is the realm of the Hubble Space Telescope (HST), whose 2-metre diameter mirror is puny compared with its earth-bound cousins, but whose light is unaffected by the turbulence of the air. Since its launch in 1990, the HST has cost a fortune but has yielded a scientific dividend unimagined by those who nursed it through its early troubles. All of its output is public, but much of it is unseen, appearing only as tables of data and the wiggly lines of spectra in scientific literature. The pictures from the HST that are featured in these pages have done more than any other telescope or institution to make science, and especially astronomy, widely accessible.

Satellites like the HST do not have to stay tethered to the Earth, however, and a succession of interplanetary probes has provided vistas of distant planets where no human eye has roved. Unlike terrestrial telescopes, much (but by no means all) of the useful data is in the form of images of one kind or another. Seen from afar in space, Earth takes on a striking new personna, that of a fragile planet orbiting a nearby star, carrying with it the daily lives of everyone we have ever known and all of life as we know it. With increasing distance, the less significant our planet appears among the stars and the more our sense of scale is stretched.

These images of natural forms seen from unexpected viewpoints or in unusual ways are surprisingly revealing, a remark that can be applied to many of the images in this book. Of course they have been carefully selected for their visual impact, and not all can be described as aesthetically pleasing, but in the end, it is their astonishing variety that intrigues and stimulates.

Despite this variety, at the opposite extremes of scale explored here the images begin to have a blurry sameness which is itself remarkably revealing. At the sub-atomic scale there is simply not enough information to produce clear pictures, and on the largest scales what information there is about the beginning of time and space is tenuous, literally stretched out by the expansion of the universe itself, blurring the beginning. In between there lies a world of fascinating and endless detail that will delight the eye and the mind of anyone with an interest in the universe that is around and within us.

David Malin

Everything in the world around us is built from a huge diversity of material. Surprisingly, this wide variety is made up of relatively few kinds of individual particles. All matter known to man is constructed from 92 naturally occurring elements, for example oxygen, carbon and hydrogen. These minute building blocks are held together by fundamental physical forces and interact with one another to form liquids, gases and solids. Normally invisible to the naked eye, we can see them and the traces that they leave magnified many millions of times thanks to the use of enormously powerful instruments that have been developed and honed over the last century.

Although optical microscopes have been in use for many hundreds of years it was only during the twentieth century that instruments not limited by the powers of optical lenses and light were invented. Instead of the light rays used in optical microscopes, electron microscopes use streams of electrons controlled by electric or magnetic fields to give even greater magnification and depth of focus. The scanning electron microscope (SEM), introduced in 1966, gave us greater resolution and perspective images, while the scanning tunnelling electron microscope (STEM), invented in 1982, is capable of recording the individual atoms themselves.

Collections of atoms make up molecules, which in turn make up the fundamental building blocks of life, such as chromosomes that carry the genetic code of every individual being. Together these are contained within the nucleus of a cell, which is the most basic structural unit of life, and the basis of nearly all living things. Some organisms, such as amoebae, are made up of a single cell, whereas human beings contain around 50,000 billion cells of many different types specialized to perform a multitude of roles.

Our journey begins with the smallest things on the Earth's surface, and passes through a range of material that we encounter on a daily basis – from crystals, through butterfly wings, bacteria, viruses, vitamins, acids, membranes, insects, to a follicle of hair on the back of a hand. Sequenced in the order of their magnification and all recorded by use of highly specialized instruments, some artificially coloured to enhance their readability, these images reveal the beauty and intricacy of a normally invisible world.

Beneath the surface

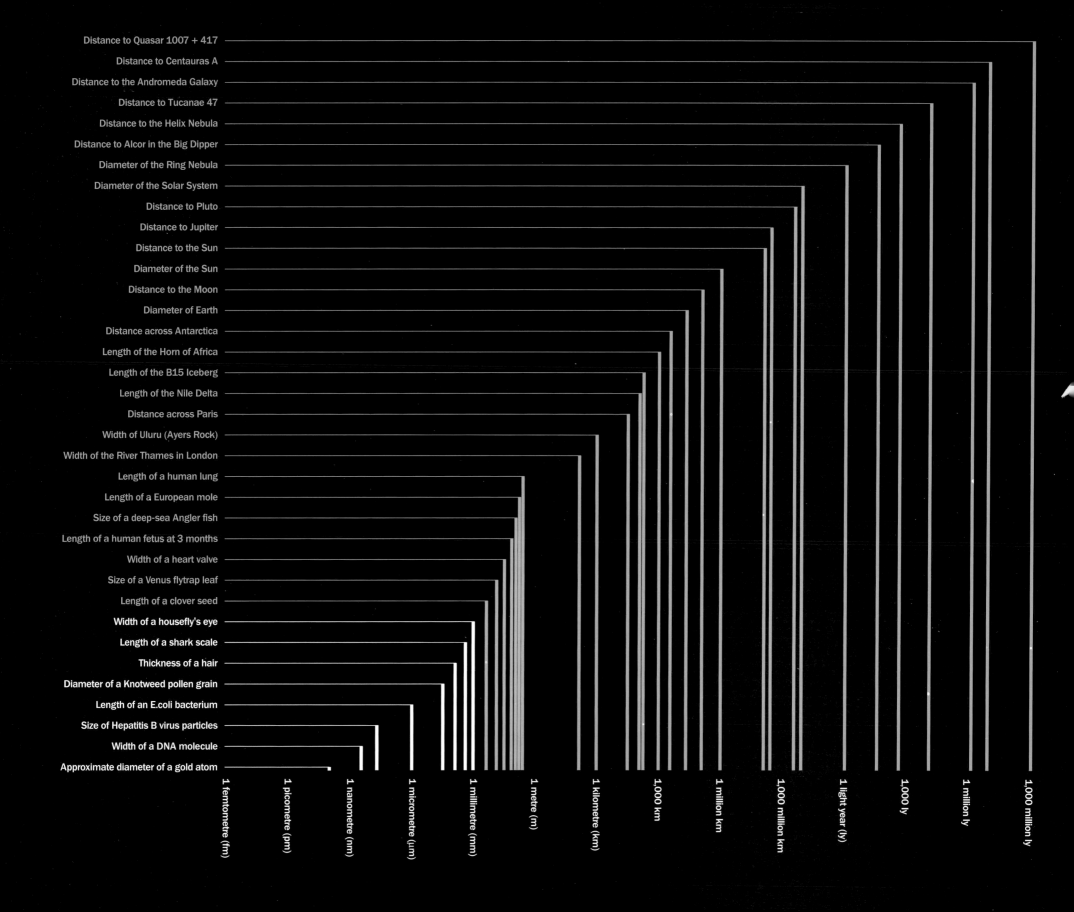

Distance to Quasar 1007 + 417

Distance to Centauras A

Distance to the Andromeda Galaxy

Distance to Tucanae 47

Distance to the Helix Nebula

Distance to Alcor in the Big Dipper

Diameter of the Ring Nebula

Diameter of the Solar System

Distance to Pluto

Distance to Jupiter

Distance to the Sun

Diameter of the Sun

Distance to the Moon

Diameter of Earth

Distance across Antarctica

Length of the Horn of Africa

Length of the B15 Iceberg

Length of the Nile Delta

Distance across Paris

Width of Uluru (Ayers Rock)

Width of the River Thames in London

Length of a human lung

Length of a European mole

Size of a deep-sea Angler fish

Length of a human fetus at 3 months

Width of a heart valve

Size of a Venus flytrap leaf

Length of a clover seed

Width of a housefly's eye

Length of a shark scale

Thickness of a hair

Diameter of a Knotweed pollen grain

Length of an E.coli bacterium

Size of Hepatitis B virus particles

Width of a DNA molecule

Approximate diameter of a gold atom

1 femtometre (fm)

1 picometre (pm)

1 nanometre (nm)

1 micrometre (μm)

1 millimetre (mm)

1 metre (m)

1 kilometre (km)

1,000 km

1 million km

1,000 million km

1 light year (ly)

1,000 ly

1 million ly

1,000 million ly

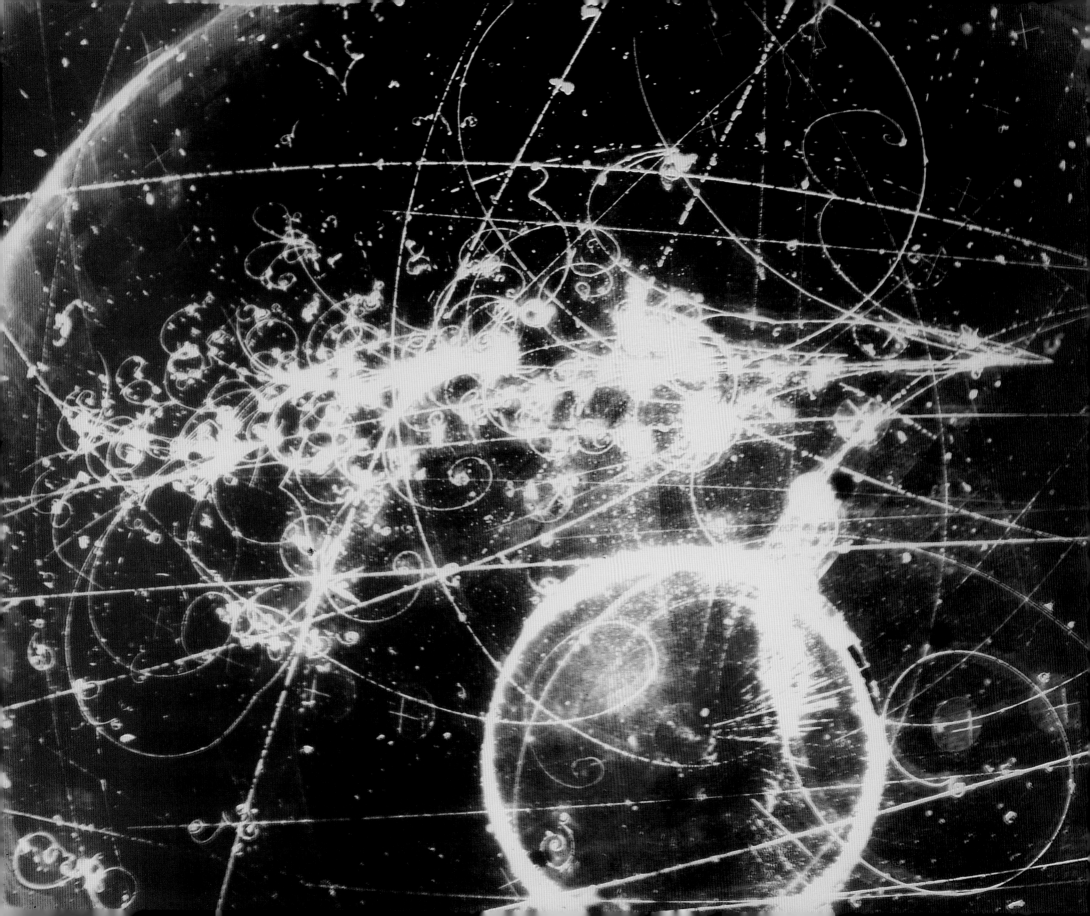

left
Bubble chamber trails
Bubble chambers are used
to detect the tiny components
that make up the constituent
parts (protons, neutrons,
electrons) of atoms. These
elusive, short-lived particles are
impossible to see directly; here
they make traces as they travel
through a super-cooled chamber
filled with liquefied gas.
The particles arrive in a beam
from a particle accelerator,
on the right of this coloured
photograph. The spray of
spiralling tracks is caused by
collisions between the
sub-atomic particles and other
particles in the chamber, which
create charged particles.
Powerful magnetic fields are
applied, causing the charged
particles to spiral left or right
according to their electric
charge. The degree of curvature
reveals important information
about their charge, mass
and speed.

Gold atom
A single atom of gold has been
magnified 260 million times in
this micrograph, taken using a
scanning electron microscope.
An atom is the smallest unit
of an element, made up of a
nucleus of protons and neutrons,
surrounded by clouds of
electrons. It is also the smallest
thing we are able to view using
current microscopes. Even the
ultra-short wavelengths of the
electron beams used to make
this image are too long to
resolve the gold atom perfectly,
so the effect is a fuzzy cloud.

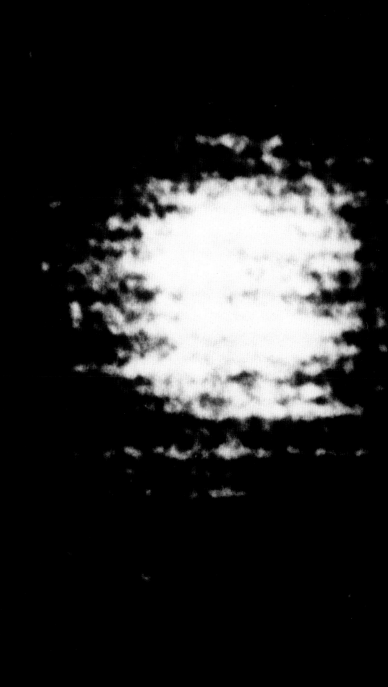

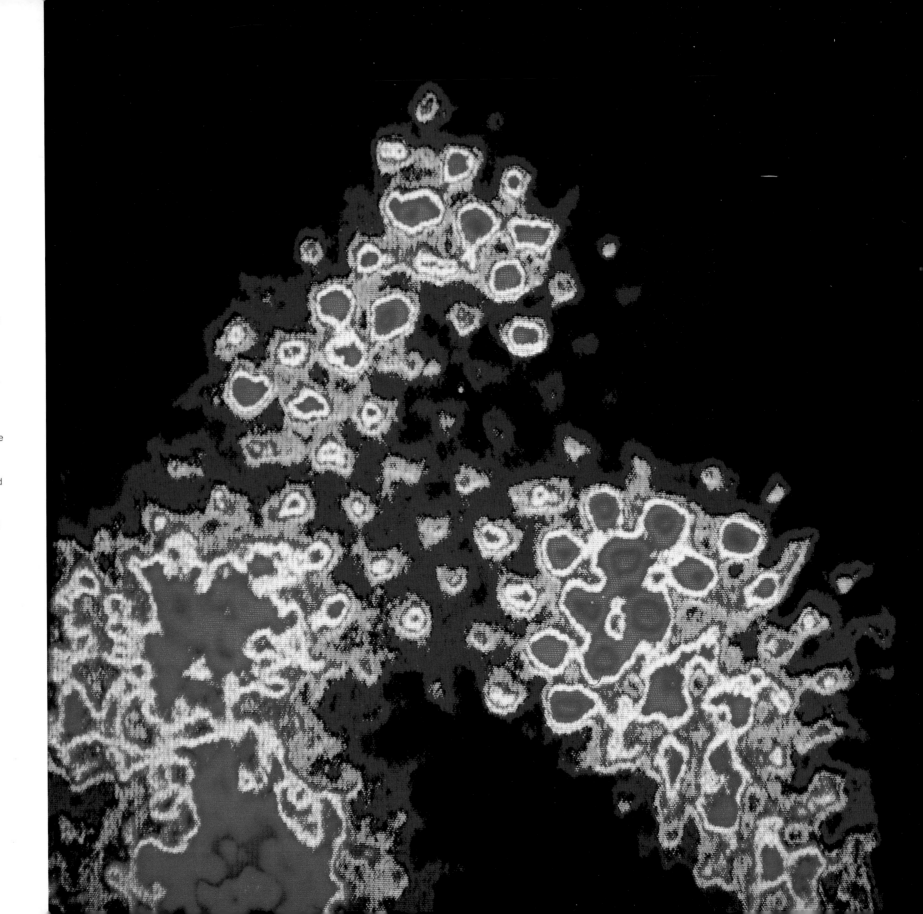

Uranyl acetate microcrystals
This image of the atomic structure of uranyl acetate crystals was made using a scanning electron microscope. Each bright spot represents a single uranium atom within the crystal lattice, magnified 50 million times. Uranyl acetate is a soluble compound of the element uranium. It is one of the most important stains used in transmission electron microscopy to study biological specimens. A coating of uranyl acetate improves the contrast and visibility of a specimen by increasing the scattering of electrons.

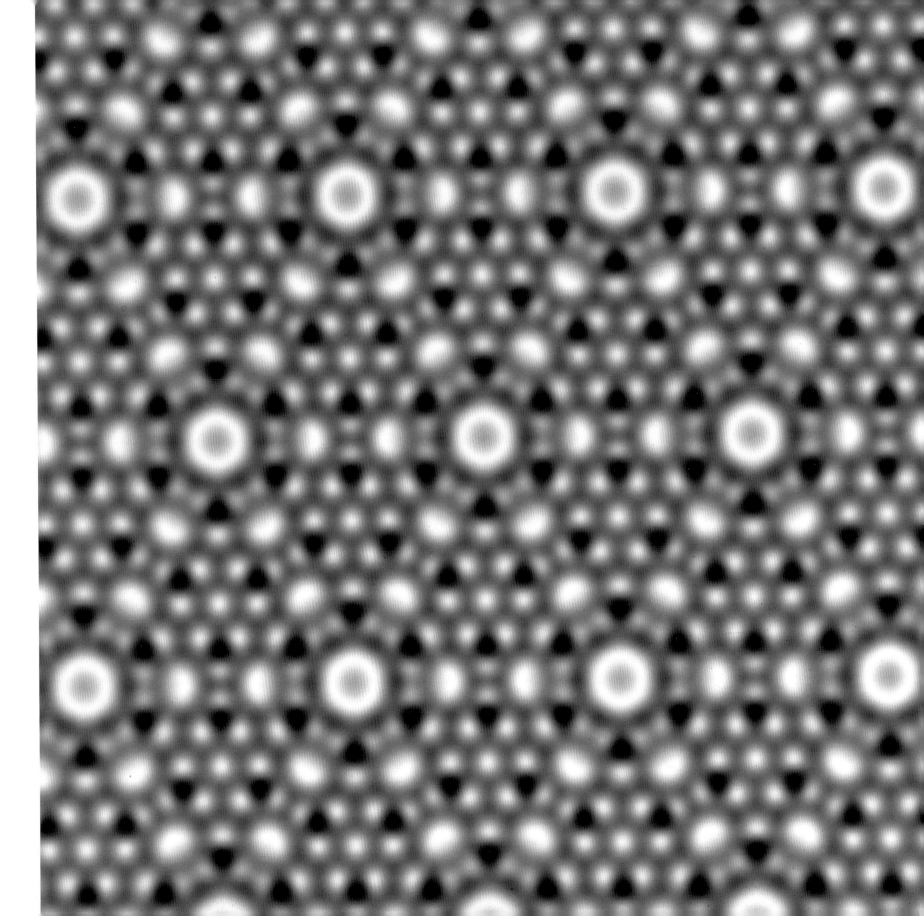

Silicon crystal

This high resolution scanning electron micrograph is the clearest ever image of the atomic structure of a pure silicon crystal. It is magnified 25 million times. The atoms form a pattern of repeating units, seen here at the crystal's surface. Patterns of this kind are typical of crystalline materials and give many crystals, such as diamond, their characteristic properties. Although silicon is the second most common element on Earth, it does not exist in nature in its pure form. It is usually found in mineral compounds containing oxygen, such as silicon oxides or silicates. These silicon-bearing minerals, which include quartz and feldspar, make up 95 per cent of the Earth's crust.

DNA

This scanning tunnelling electron micrograph shows part of a DNA (deoxyribonucleic acid) molecule magnified 17 million times. DNA is the main component of chromosomes and bears the genes that determine the individual characteristics of all organisms. Its structure is a 'double helix', like a twisted rope-ladder – you can make out three twists of the molecule here, each 10 nanometres long. When James Watson (1928–) and Francis Crick (1916–) worked out DNA's structure in 1953, it led to an understanding of how this molecule could encode genetic information and how this information could be copied and passed on from one generation to the next.

far right
X-ray diffraction image of DNA
X-ray diffraction, also known as x-ray crystallography, is a technique for working out the structure of molecules. When a crystal of any molecule is bombarded with x-rays, its regular structure scatters the x-rays to produce a characteristic pattern, which can be recorded on a photographic plate. This pattern was produced from a crystal of DNA. Watson and Crick used the x-ray diffraction data of Rosalind Franklin (1920–58) and Maurice Wilkins (1916–) – including images like this – to deduce DNA's helical structure, long before scanning tunnelling electron microscopy gave us more direct images.

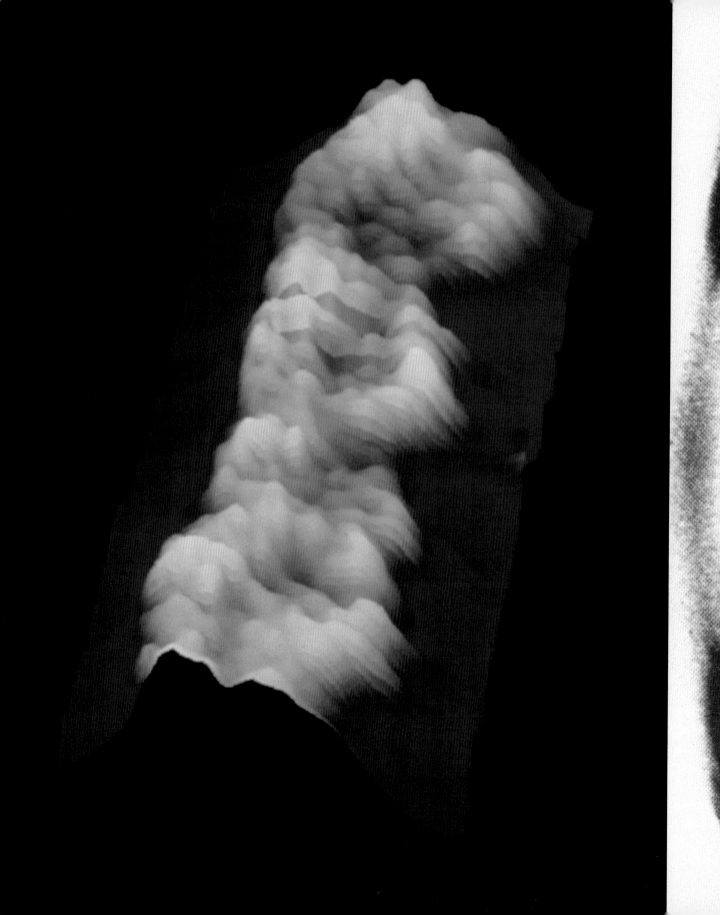

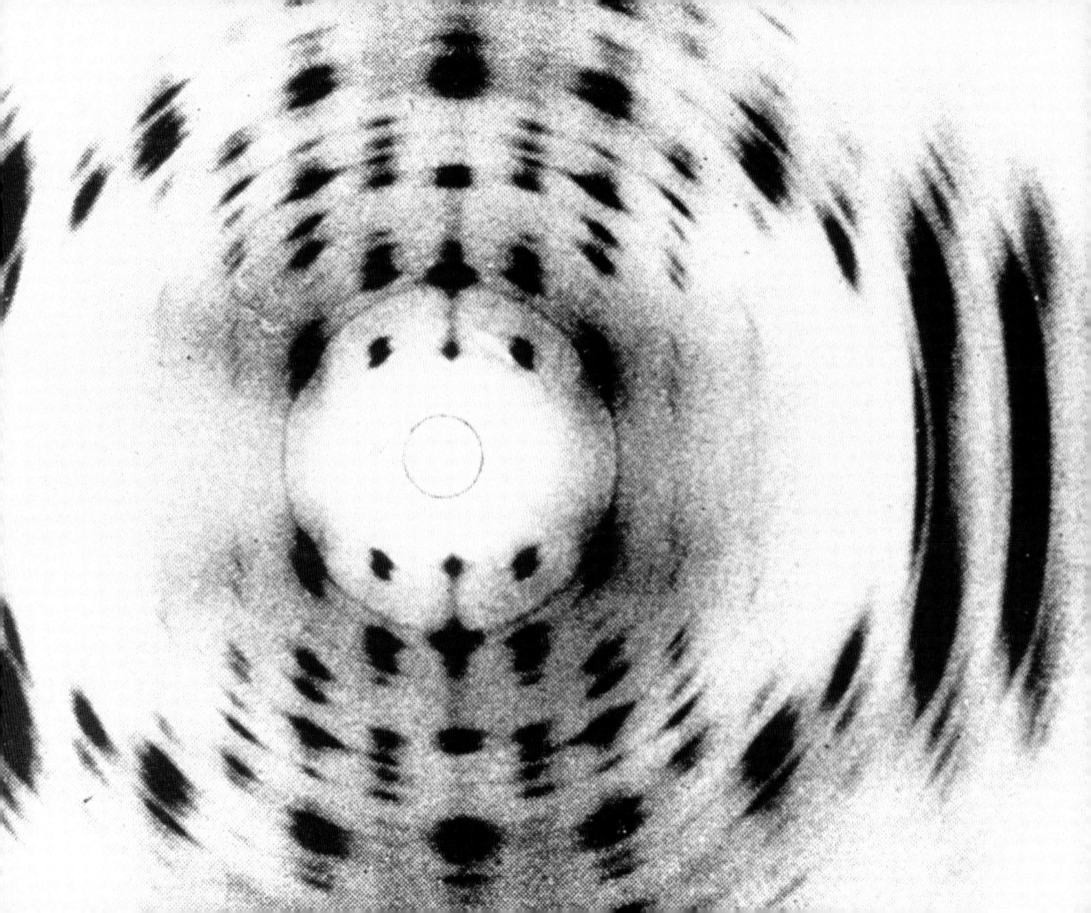

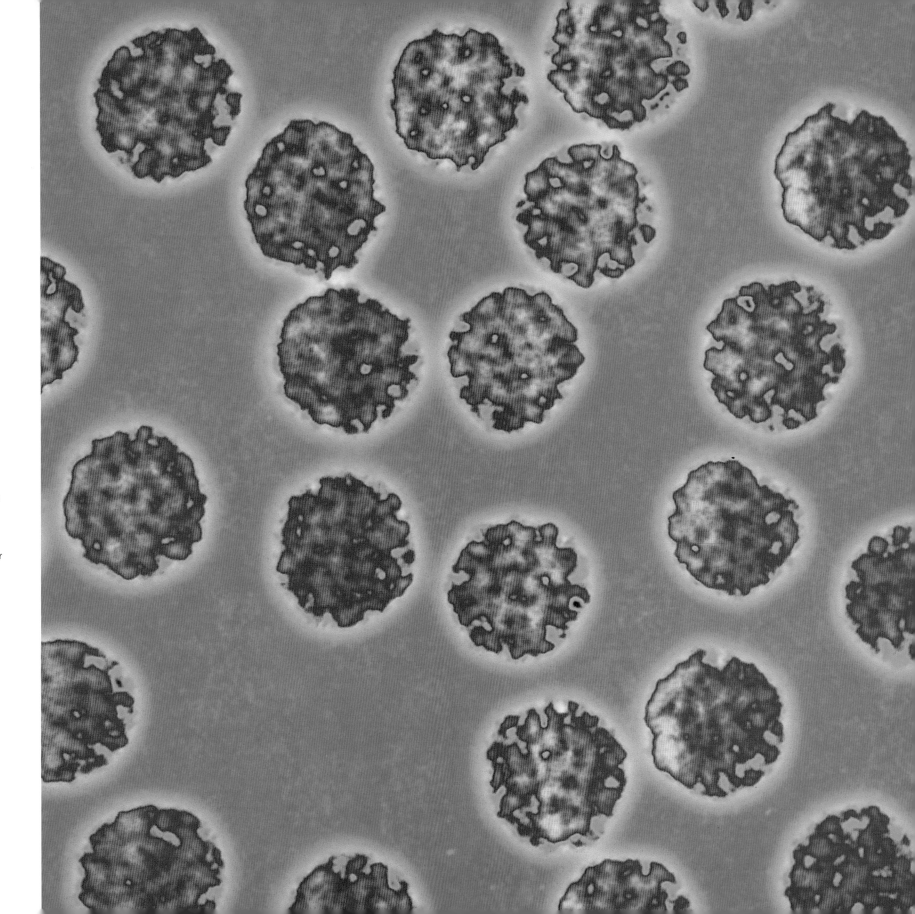

Hepatitis B virus particles
This transmission electron micrograph shows hepatitis B virus particles magnified one million times. In reality each particle is only 30 nanometres across, 20 times smaller than the wavelength of light. Viruses are very simple entities – they have a core, containing the genetic material (coloured red here), and an outer protein coat (coloured blue-green). Hepatitis B viruses are incredibly tough. It takes at least 30 minutes of boiling to kill them, so the disease can be spread wherever needles are shared and sterilization practices are poor.

Skeletal muscle
This is a transverse section through a muscle 'myofibril' magnified 800,000 times with a transmission electron microscope. Skeletal muscles, those that we contract to produce movement or tension in the body, are made up of bundles of long muscle fibres, which in turn are made up of many myofibrils. This micrograph shows in section the even finer protein filaments that these myofibrils are composed of. The large circles are filaments of the protein myosin and the small circles are filaments of the protein actin. They are tightly bundled in a neat geometrical arrangement, essential for coordinated contraction.

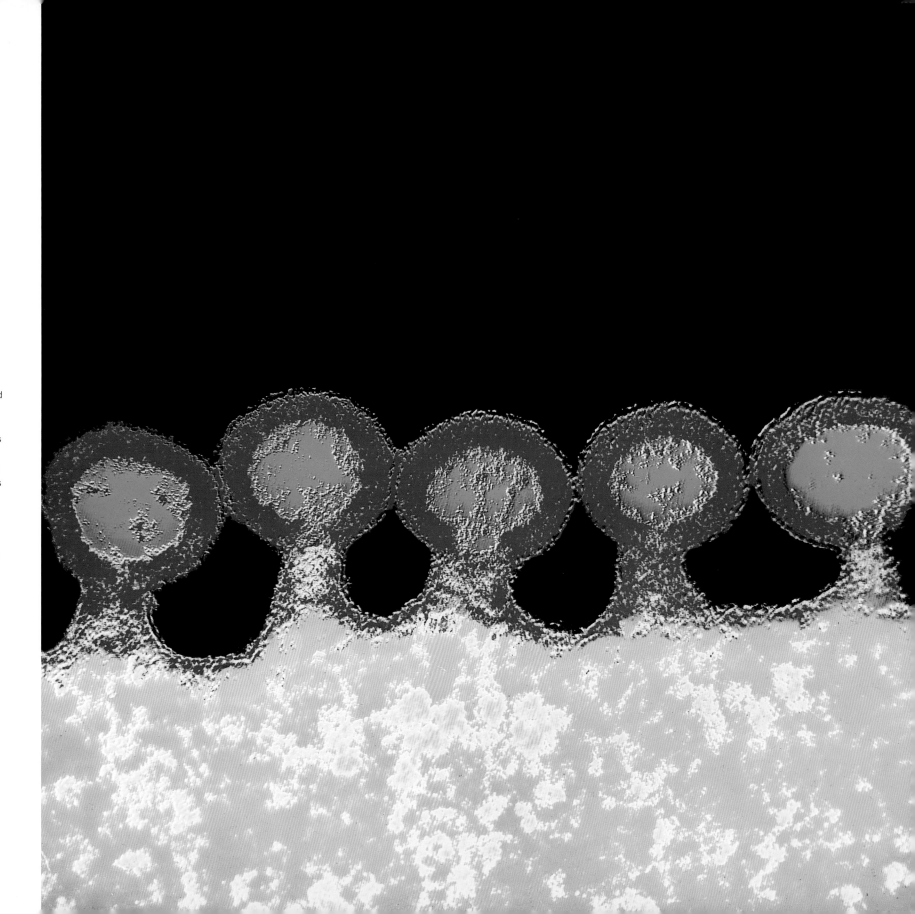

HIV virus particles

This transmission electron micrograph shows HIV (Human Immunodeficiency Virus) particles in the act of budding from the surface of a host white blood cell (coloured orange-yellow). Discovered in 1983 by Robert Gallo and Luc Montagnier, HIV reproduces by inserting its own genetic material into the DNA of its host cell. The cell produces new virus particles, which then escape by budding out of the cell membrane. The process eventually leads to the death of the host cell. This picture has been coloured to reveal the various structures, and is magnified 360,000 times.

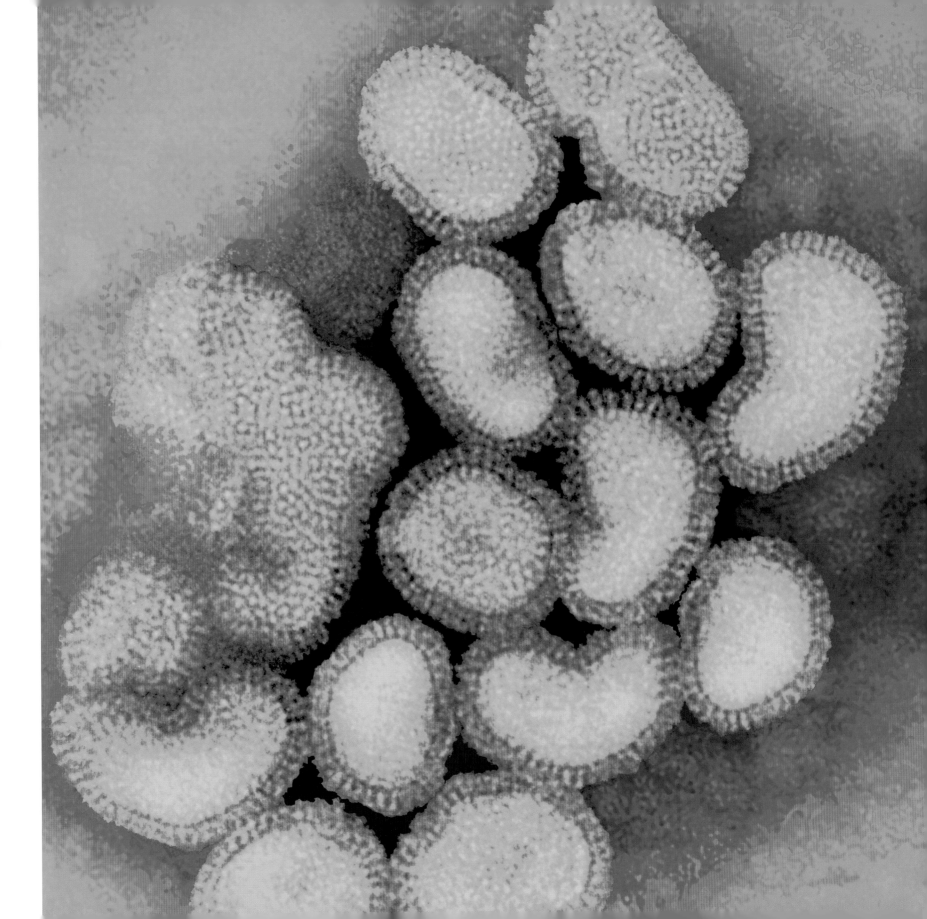

Influenza virus particles
This coloured image of influenza (flu) virus particles was taken with a transmission electron microscope. Each particle is roughly spherical and about 200 nanometres in diameter. The outer protein coat or capsid (coloured dark green here) bears a fringe of rigid spines. These allow the virus to attach to its host cell before invading it, and it is this proteinaceous coat that mutates to produce new strains of flu. The core (pale green) is made up of the virus's genetic material, ribonucleic acid (RNA).

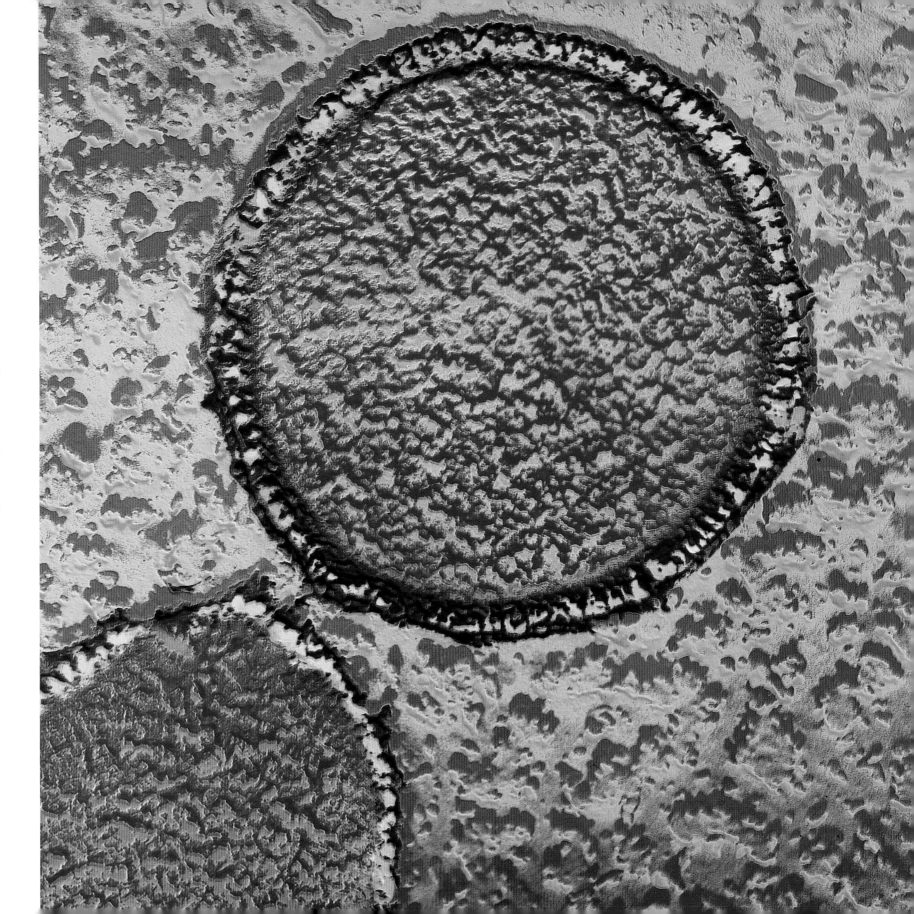

Heat-loving bacteria
This section through the bacterium *Staphylothermus marinus,* magnified 135,000 times, has been coloured to show its cell wall (green) and cell contents (pink). Bacteria are a diverse group of single-celled organisms abundant in the bodies of all living things and in all environments on Earth, even some of the most extreme. This is one of several kinds of newly discovered 'extremophile' bacteria which colonize volcanic springs on the deep ocean floor. They thrive in the hot, sulphur-rich waters that are found there, tolerating temperatures as high as 90 degrees Celsius.
The abundant supplies of sulphur allow them to generate the chemical energy they need to survive.

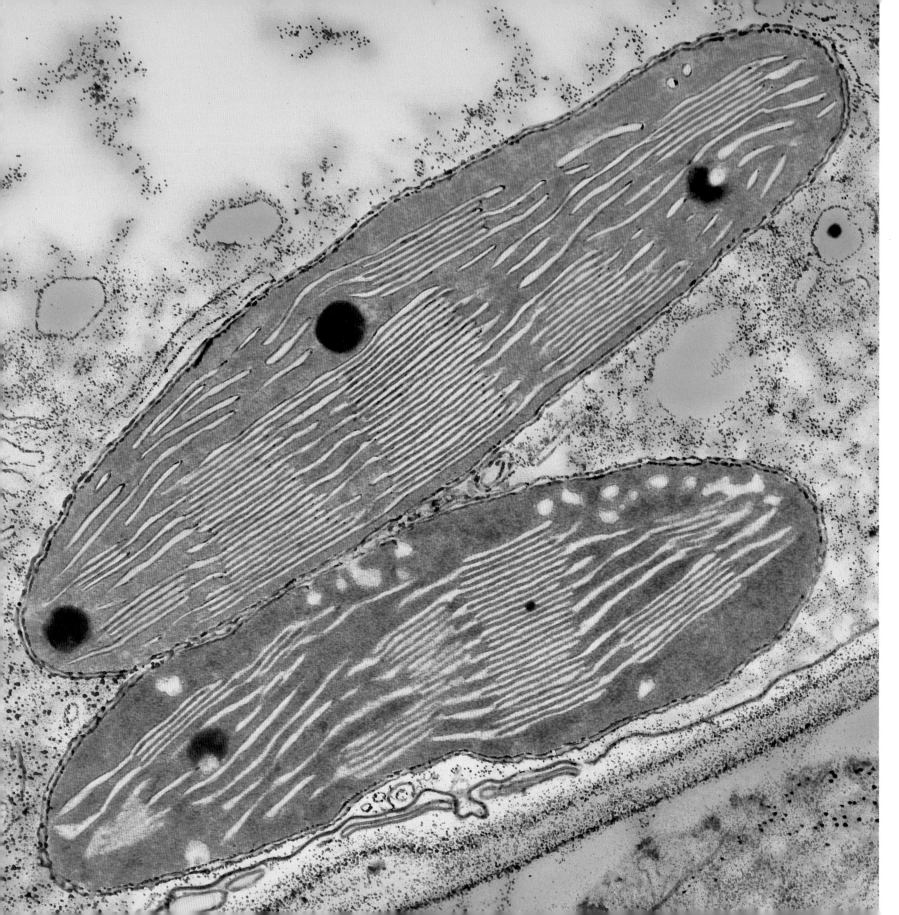

Pea leaf chloroplasts
Magnified 70,000 times,
this coloured transmission
electron micrograph shows a
section through two chloroplasts
in a cell from a pea plant leaf
(*Pisum sativum*). Chloroplasts
are a plant's food factories.
Their stacks of membranes
(grana) contain chlorophyll,
the green pigment that gives
plants their green colour and
captures the energy from
sunlight; plants use this energy
to make carbohydrates by
combining water and carbon
dioxide – a process called
photosynthesis. Granules
of carbohydrate can be seen
as dark circles.

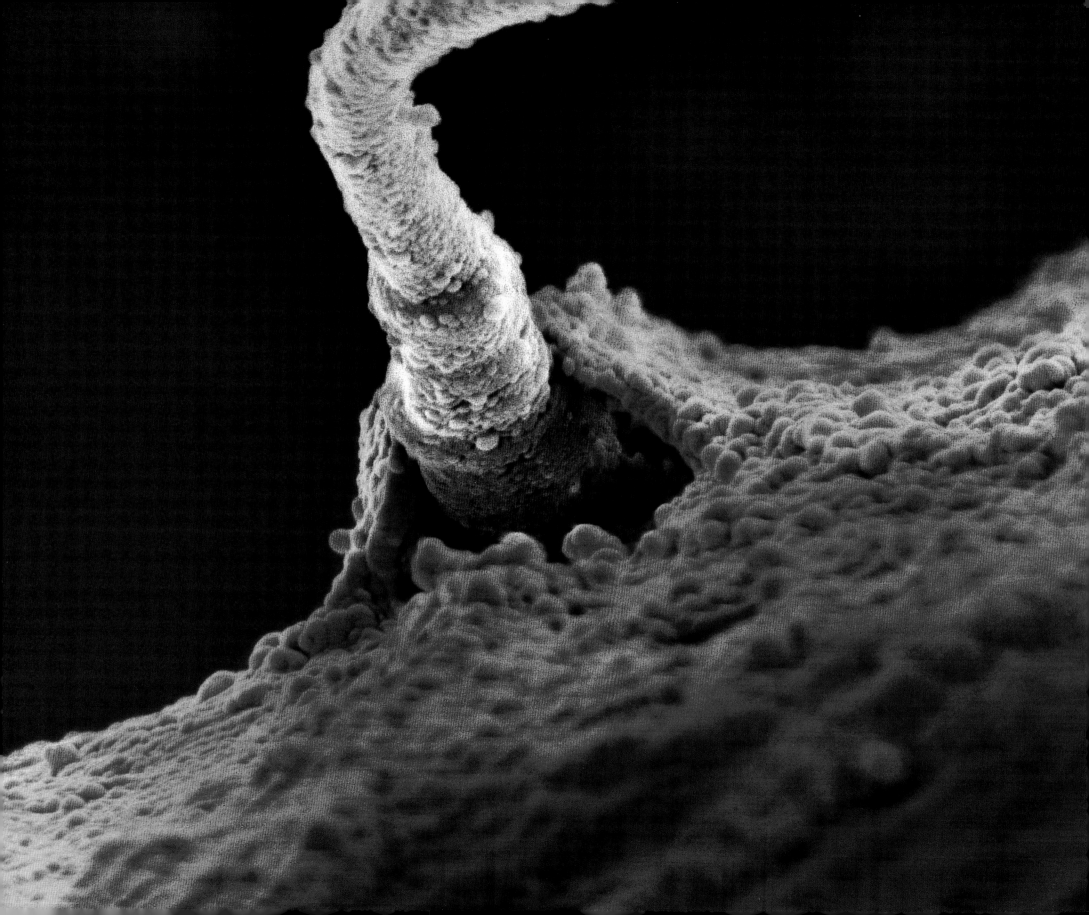

left
Sperm at conception
This scanning electron micrograph shows a single human sperm penetrating an egg cell, at a magnification of 48,000 times. As soon as the sperm is safely inside, the egg cell's outer membrane changes to become an impenetrable barrier to further sperm. The successful sperm fragments inside the egg, releasing the male's genetic material, which then combines with that of the female.

E.coli
Discovered in the human colon in 1885 by German bacteriologist Theodor Escherich (1857–1911), the bacterium *Escherichia coli*, *E.coli* for short, is magnified 30,000 times in this transmission electron micrograph. The small, fine hairs help it to stick to the cells of the intestine, while its long whip-like flagella propel it along in search of food. Most strains of *Escherichia coli* are harmless – millions live naturally in our digestive system where they synthesize vitamins, suppress more harmful bacteria and aid digestion. Some strains, however, can cause urinary infections and food poisoning, which can be fatal.

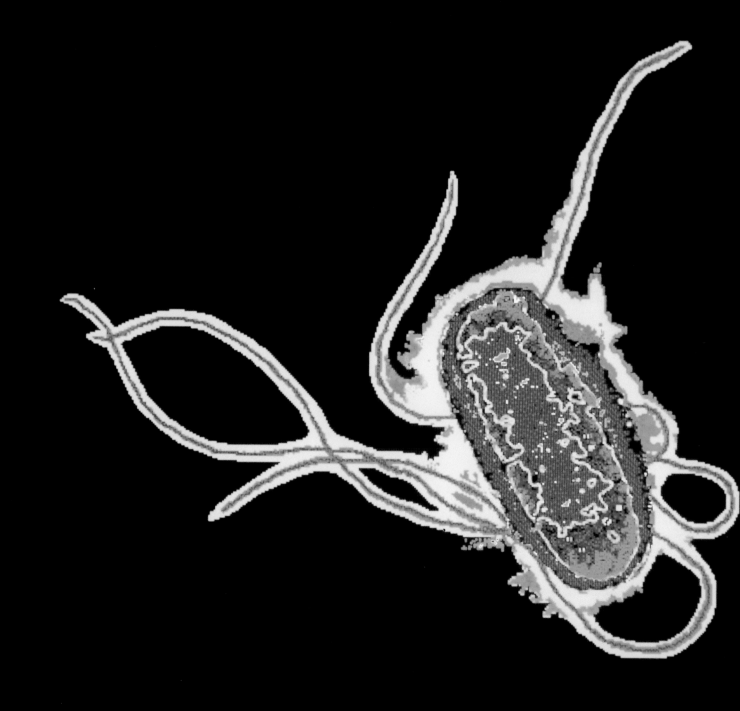

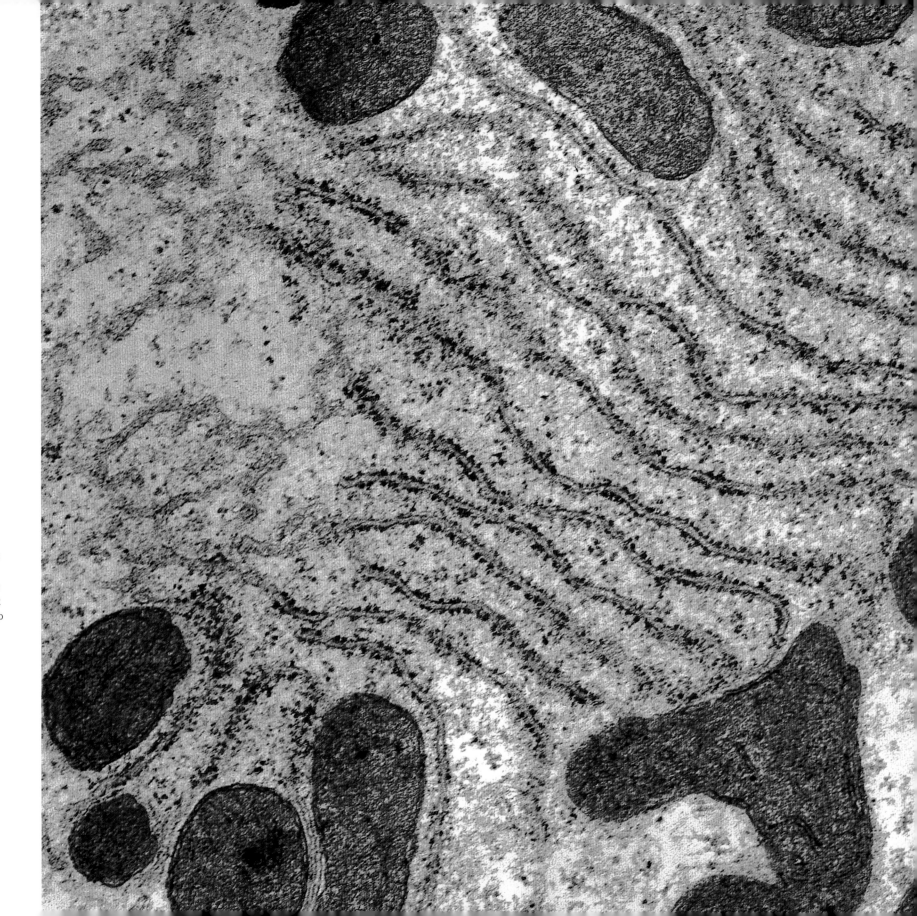

Liver cell

A mammalian liver cell is magnified 30,000 times showing three different structures. Mitochondria (red) are the 'power houses', generating energy for the cell. The tiny ribosomes (dark blue specks) are where the cell makes proteins from building blocks called amino acids, following instructions from its DNA. Some of these are attached to the endoplasmic reticulum (bright blue). This has a range of tasks, one of which is to fold and modify the protein chains to complete the production process.

far right
Eye lens

This scanning electron micrograph shows the cells which form the crystalline part of the lens of the eye, magnified 25,000 times. The crystalline lens is transparent and, with the curved cornea, it bends the light passing through to focus a sharp image on the back of the eye, the retina. Muscles in the eye expand and contract to alter the shape of the lens, changing its focal length. This allows the eye to focus on objects at different distances.

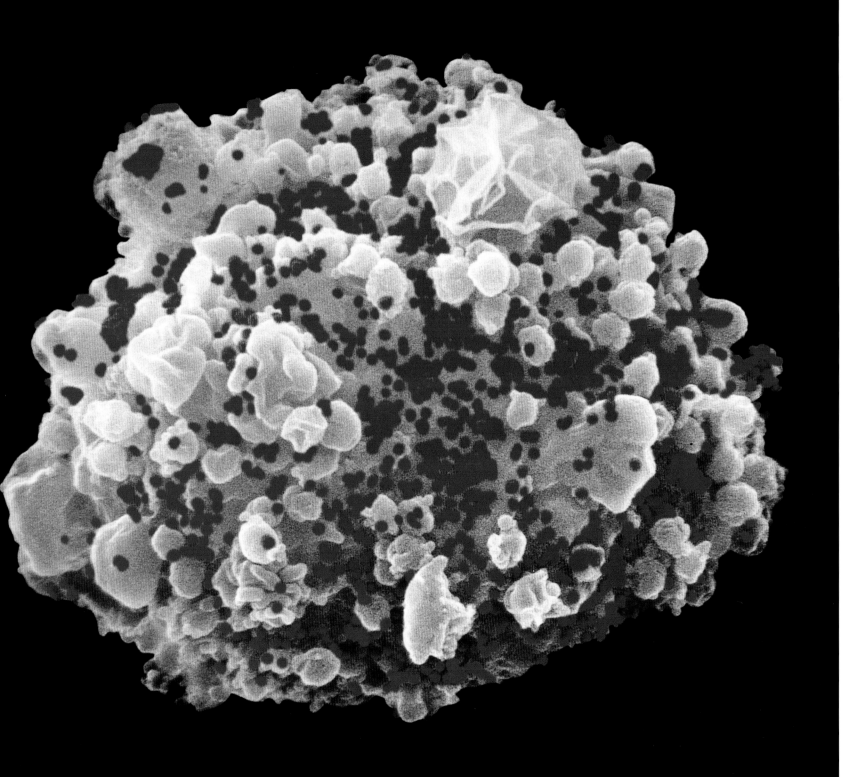

HIV-infected cell
This coloured scanning electron micrograph, magnified 24,000 times, shows a single white blood cell, called a T-lymphocyte, infected with HIV (Human Immunodeficiency Virus). The virus particles (shown as red dots) are budding from the cell membrane. T-lymphocytes are important immune system cells. They hunt through the bloodstream for infected cells, which they identify as 'foreign' and destroy. By attacking the T-cells, HIV reduces the efficiency of the whole immune system. Infection may eventually lead to full-blown AIDS (Acquired Immunodeficiency Syndrome).

right
Coccolithophore
This is the skeleton of a tiny planktonic organism, *Discosphaera tubifera*. It has been magnified 16,000 times, using a scanning electron microscope. Coccolithopores are a group of single-celled creatures that live within a spherical skeleton, a coccosphere, of disc-shaped calcareous plates called coccoliths. In this species each coccolith is ornamented with an elongated trumpet. When the coccolithophores die, the skeletons break up and the coccoliths fall to the ocean floor. Between 140 and 65 million years ago, billions of them lived and died in the seas that covered southern Britain. Their skeletons rained down to create the chalk which now forms the White Cliffs of Dover.

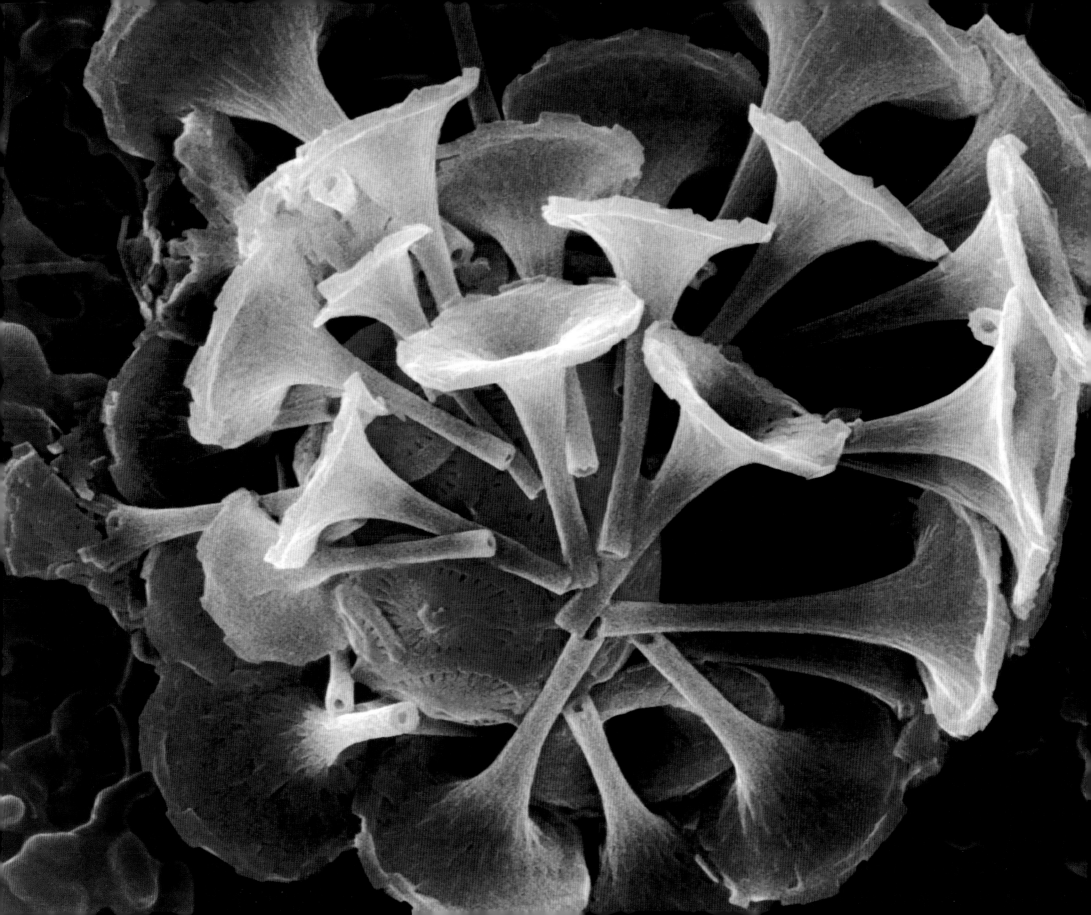

Carbon dioxide crystals

Crystals of frozen carbon dioxide, otherwise known as dry ice, are magnified 16,000 times using a low-temperature scanning electron microscope. The crystals are each about one micrometre across, and most are octahedral in shape. Crystals like these might exist on Mars, since remote sensing has revealed that the planet's icecaps are composed of both water and carbon dioxide ice. This is possible because temperatures there fall below minus 78 degrees Celsius, the freezing point of carbon dioxide. On Earth carbon dioxide exists as a colourless, odourless gas that makes up 0.04 per cent of the atmosphere. It is produced by respiration and consumed by plants for photosynthesis.

far right
Swedish ivy pollen

Taken using a scanning electron microscope, this is one of many thousands of pollen grains produced by a flower of *Plectracanthus*, the Swedish ivy. Here the 40-micrometre pollen grain is magnified 8,000 times to reveal the intricate patterns that decorate its surface. The elegant structure of the coat is unique to each plant species and is very tough. It must protect the genetic material inside the grain as it is carried by wind, insects or other creatures, from male to female flower parts.

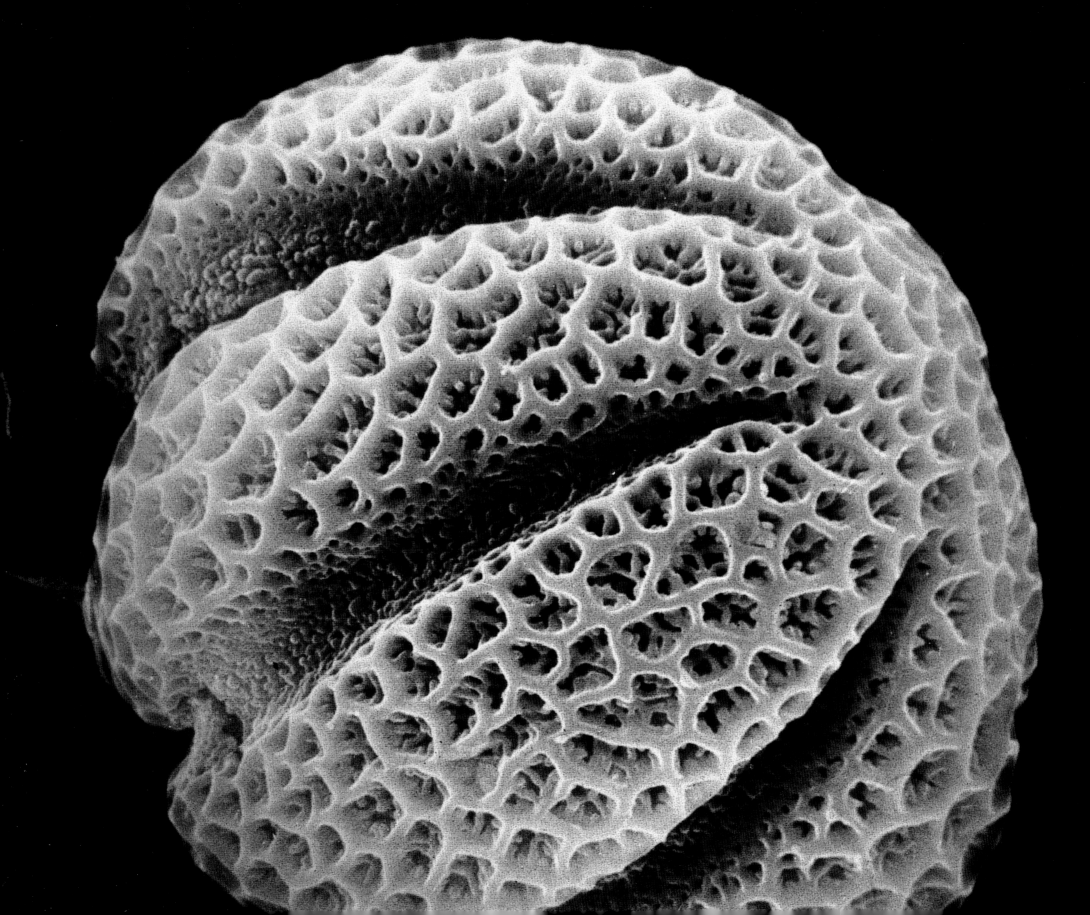

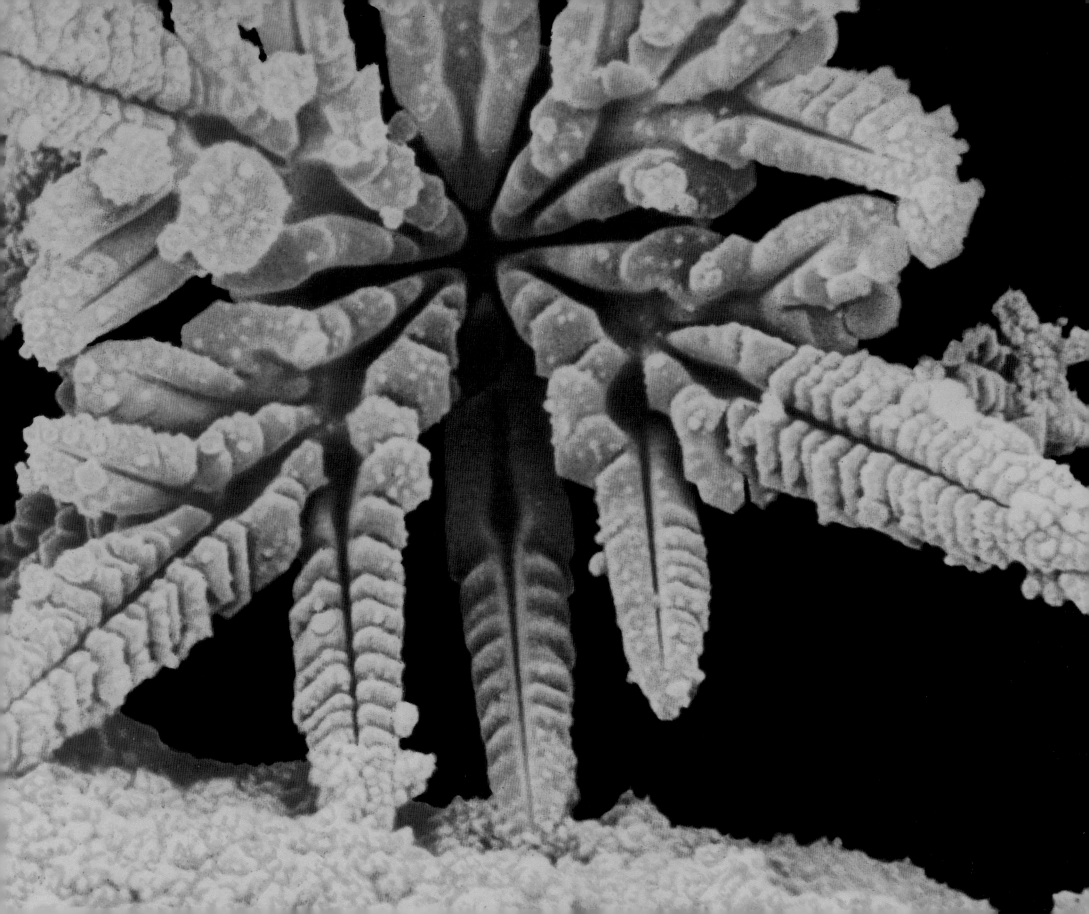

left

Snowflake crystal

This coloured scanning electron micrograph of a snow crystal magnified 6,500 times reveals the intricate branching shape of the ice crystals that make up snow. The detail of every snow crystal is determined by the temperature and moisture conditions of the cloud within which it formed. Crystals are always hexagonal, however, reflecting the atomic forces at work in the water molecules from which they are made. Snowflakes consist of many of these tiny crystals, frozen together into clumps.

Moss protoplast

A geneticist has chemically removed this moss cell's tough outer wall, creating a 'protoplast' so that genetic material can be injected directly into the cell. The fibres covering the protoplast, coloured yellow to make them stand out, are the beginnings of a new cellulose cell wall. This must re-grow if the cell is to survive the process of genetic engineering. This scanning electron micrograph shows the protoplast magnified 6,200 times.

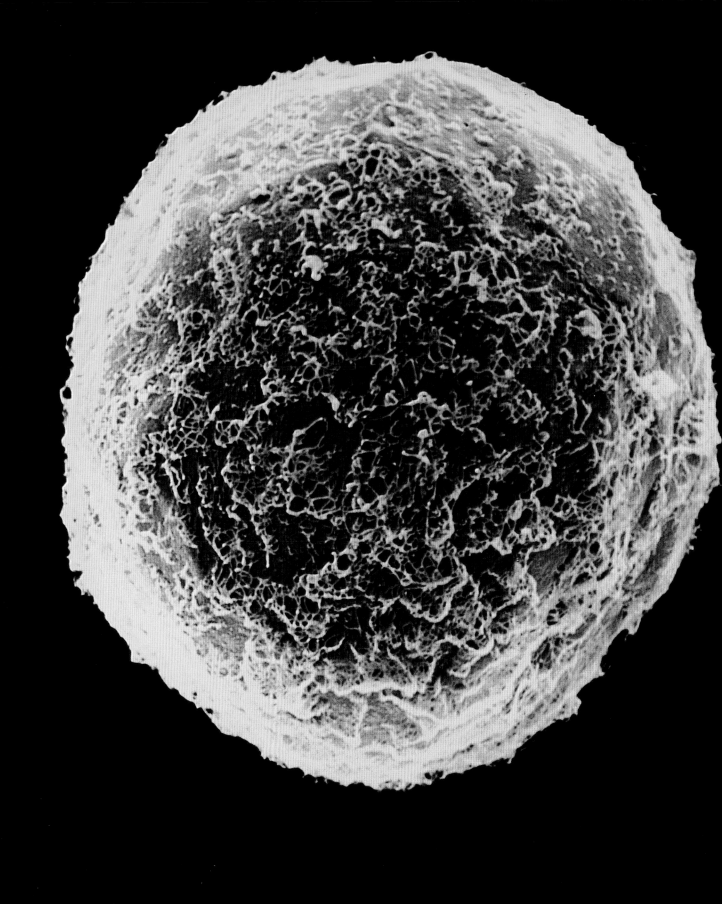

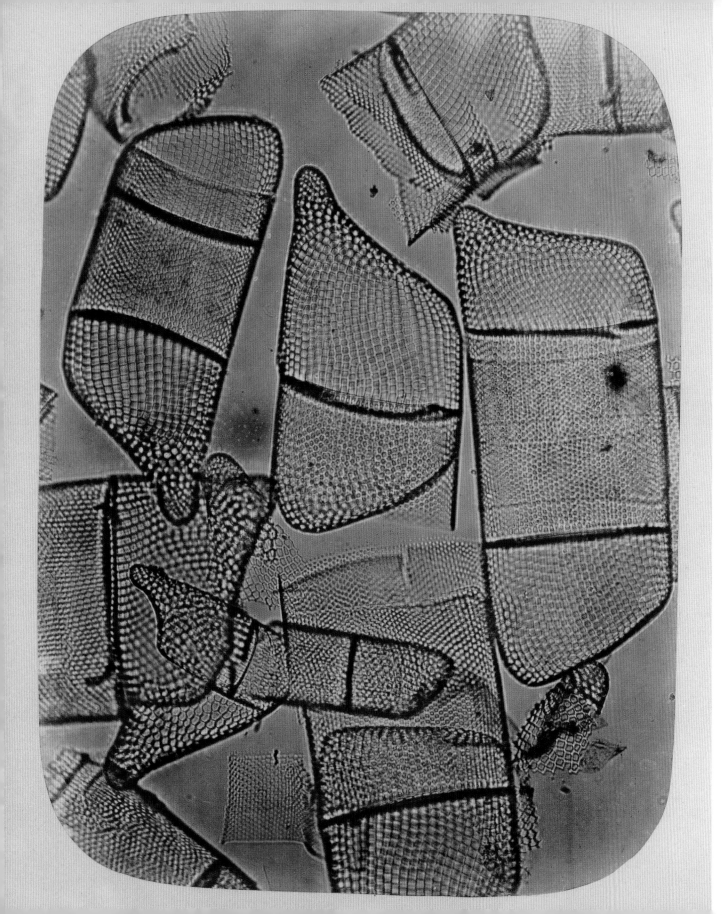

Diatom skeletons
This photograph of a collection of diatom skeletons (frustules) was taken in 1869, using a light microscope. Diatoms are an extremely diverse group of single-celled algae, with about 10,000 species occupying ecological niches that range from ponds, lakes, rivers and soil to salt marshes, lagoons, shelf seas and oceans. However, they always live near the surface where there is enough light to photosynthesize.

right
Diatom
A scanning electron micrograph reveals the geometric wall structure of a different species of diatom, *Diploneis smithii*, magnified 5,000 times. The wall enclosing the living cell is made of silica and is called a frustule. It has two halves which fit together like the lid and the bottom of a box. The frustule bears rows of slits and a central groove, which secretes mucus that helps the diatom to glide across surfaces. This example was collected from the slightly salty waters of the Hudson River, 50 kilometres north of New York City.

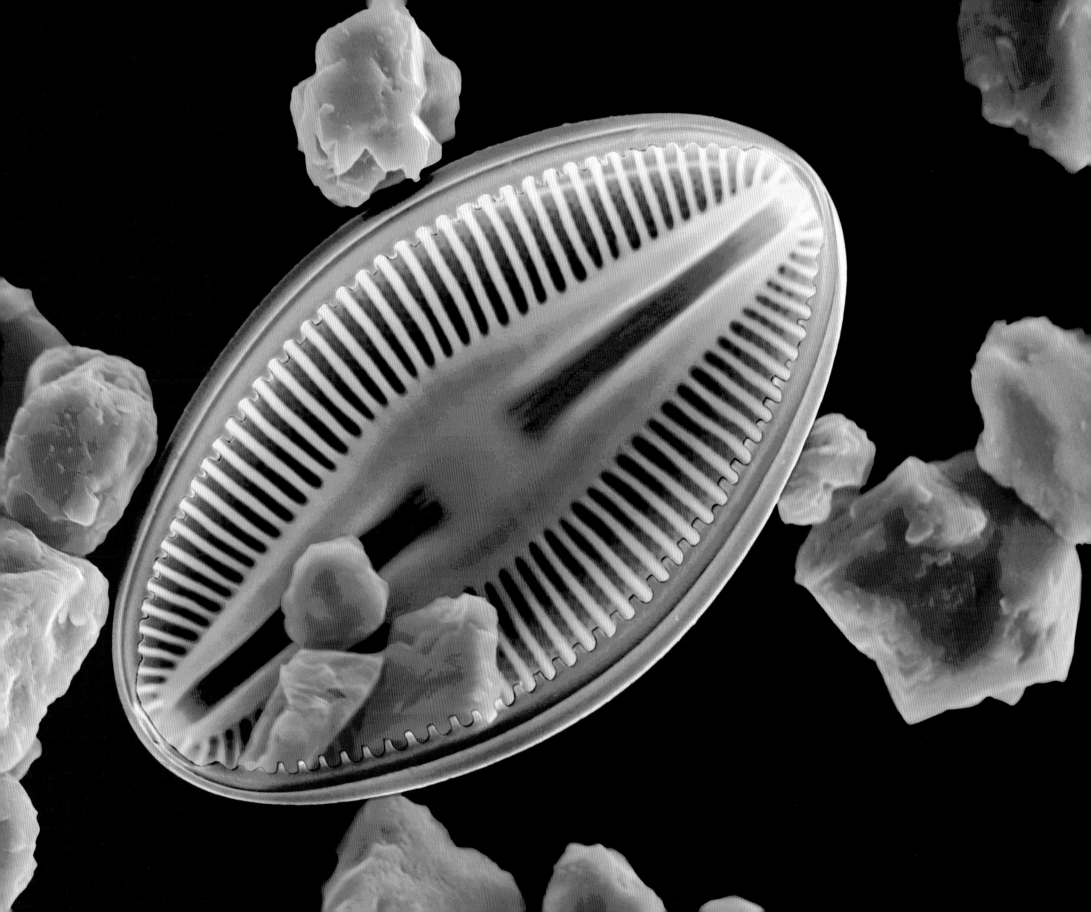

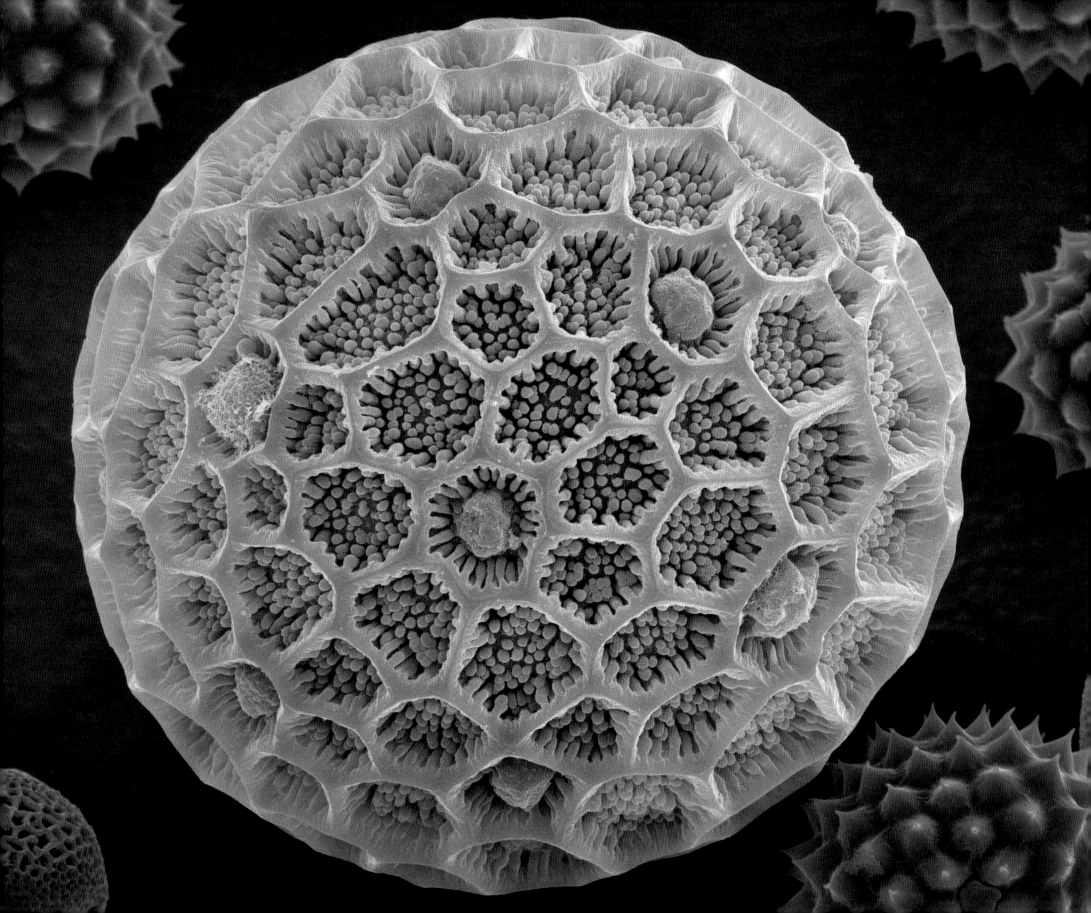

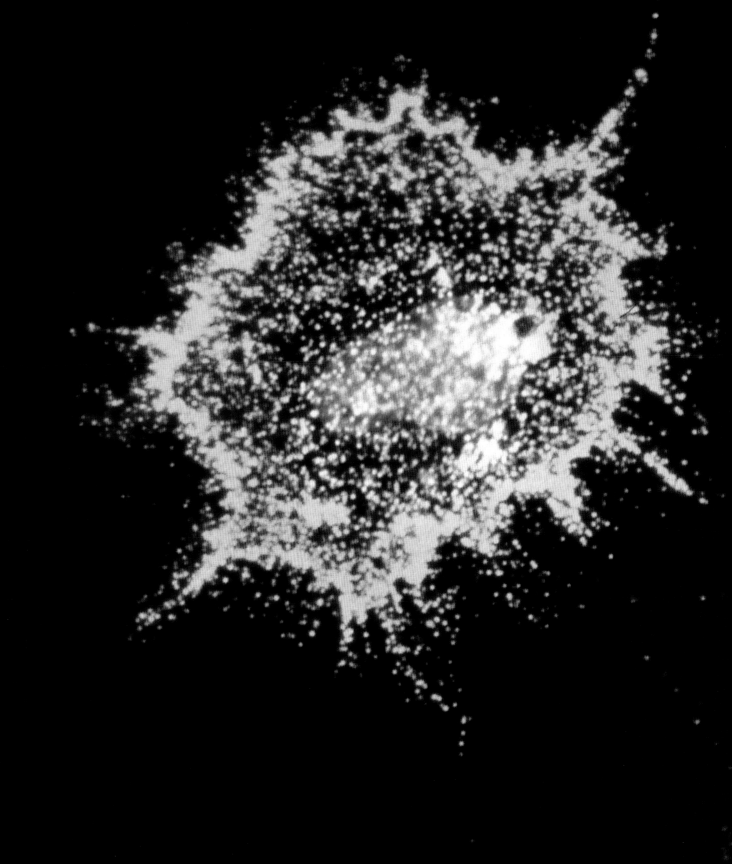

left

Knotweed pollen

This coloured scanning electron micrograph of knotweed (*Polygonum*) pollen, which is about 50 micrometres in diameter, clearly shows the striking three-dimensional sculpturing of the grain. Its surface is made up of short columns called 'baculae'. Some are fused at the top to form an irregular mesh of walls or 'muri'. Others stand free and are visible here as wart-like protrusions. The resulting rough surface probably helps the pollen grains to stick to insects.

Prion proteins

This light micrograph shows prions (gold), picked out by fluorescent antibodies, on the surface of a cell magnified 4,000 times. Prions are thought to be infectious agents, responsible for diseases such as scrapie and BSE (Bovine Spongiform Encephalopathy), and the related CJD (Creutzfeldt-Jakob Disease) in humans. But prion proteins are also found in healthy cells as in this image. In infection they change shape and this somehow leads to disease. No one yet knows how, and some scientists remain sceptical that they cause these diseases.

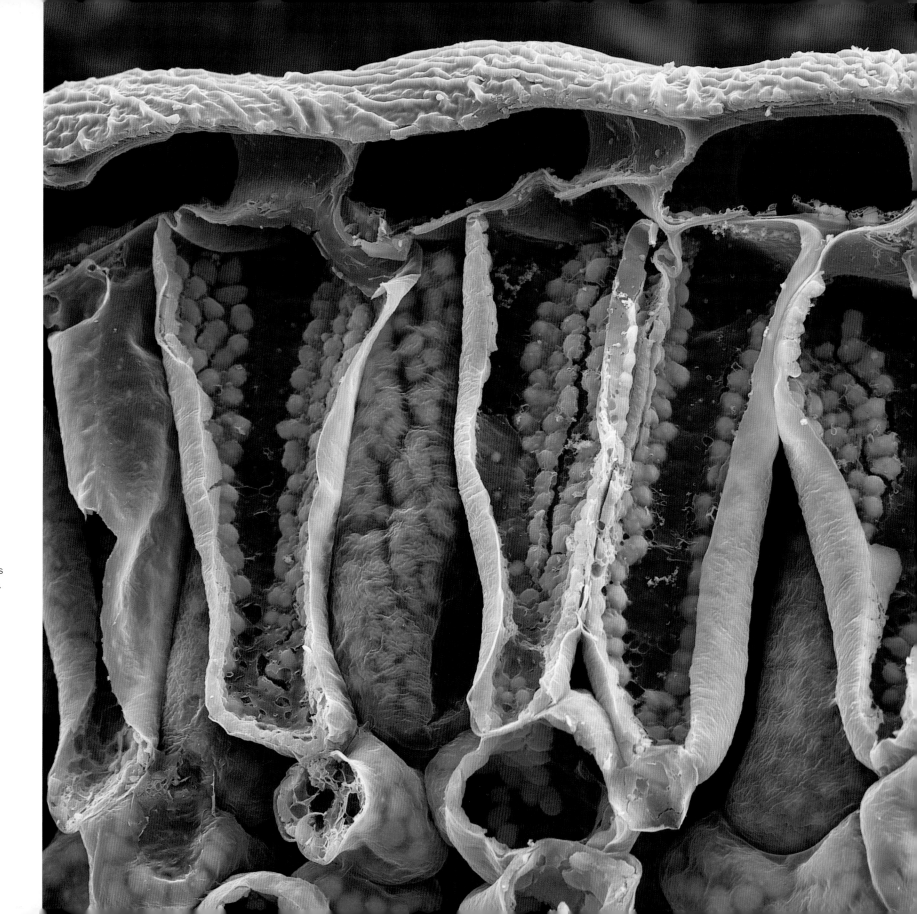

Christmas rose leaf

A section through a leaf of the
Christmas rose, *Helleborus
niger*, viewed using a scanning
electron microscope. The leaf's
upper surface is at the top.
Below are the flat, rectangular
cells of the epidermis, with the
long vertical pallisade cells
beneath them. Pallisade cells
contain round chloroplasts
(coloured green here). These
are the site of photosynthesis,
a complex set of reactions
that use the energy of the sun
to combine carbon dioxide and
water to make carbohydrates
such as sugar and cellulose. This
image is magnified 4,000 times.

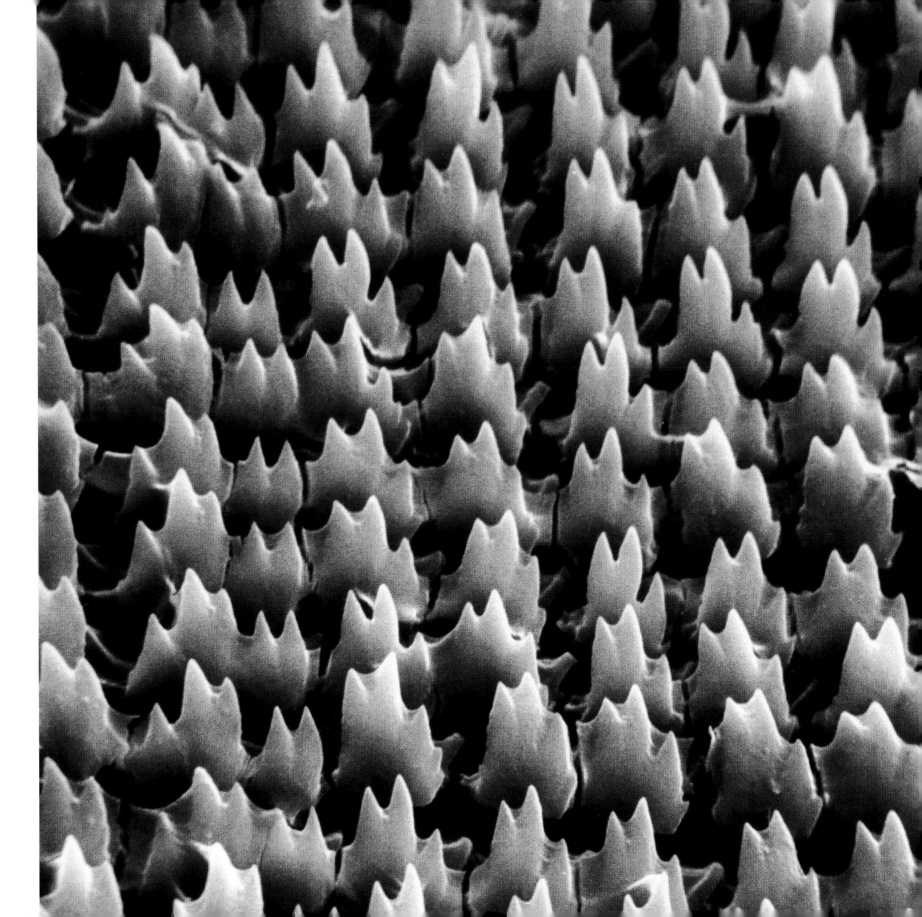

Snail's teeth

This image shows part of a snail's rasping tongue, the 'radula', magnified 4,000 times using a scanning electron microscope. The radula consists of a membrane stretched over a cartilage base and covered with hundreds of tiny, sharp teeth made of chitin, a remarkable natural polymer. Snails use it to feed by scraping, rasping and brushing surfaces with a licking motion. The radula grows continuously to replace teeth worn out by the scraping.

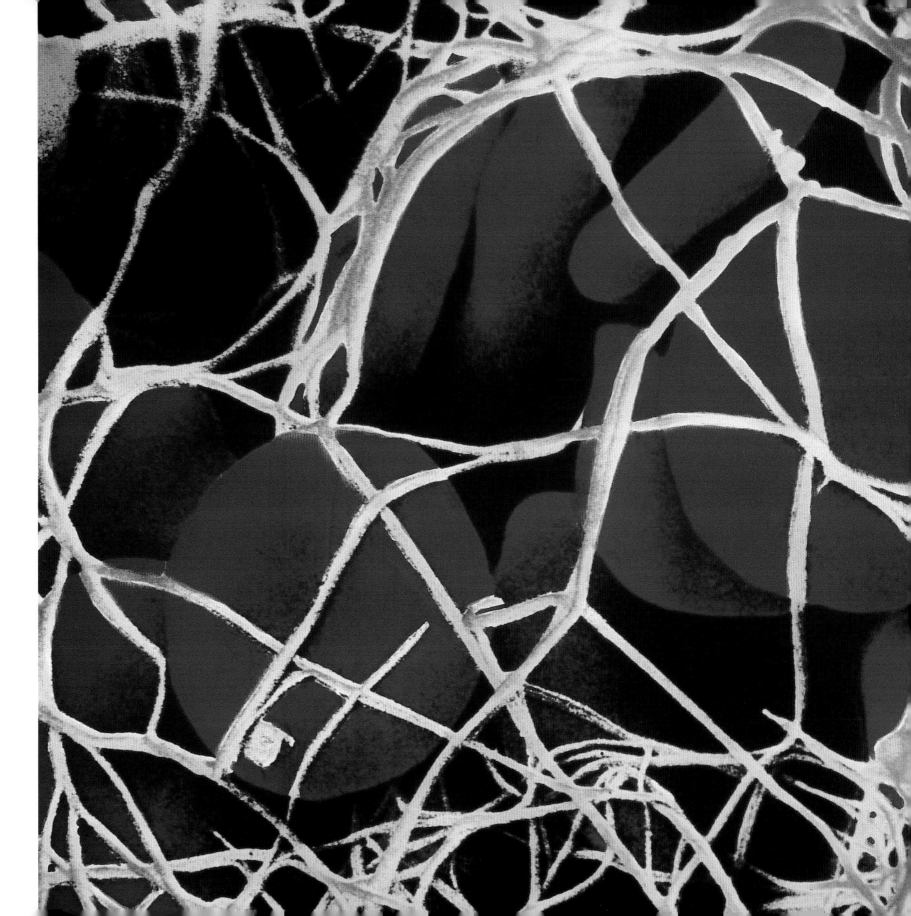

Blood clot
This scanning electron micrograph shows the fibrous material that makes a blood clot, magnified 4,000 times. It has been coloured to show the disc-shaped red blood cells and the meshwork of the protein fibrin more clearly. When tissue is damaged, a reaction in the blood converts a soluble protein called fibrinogen into insoluble fibrin. A fibrin mesh grows and traps blood cells, forming a blood clot which seals off broken blood vessels and stops further blood loss.

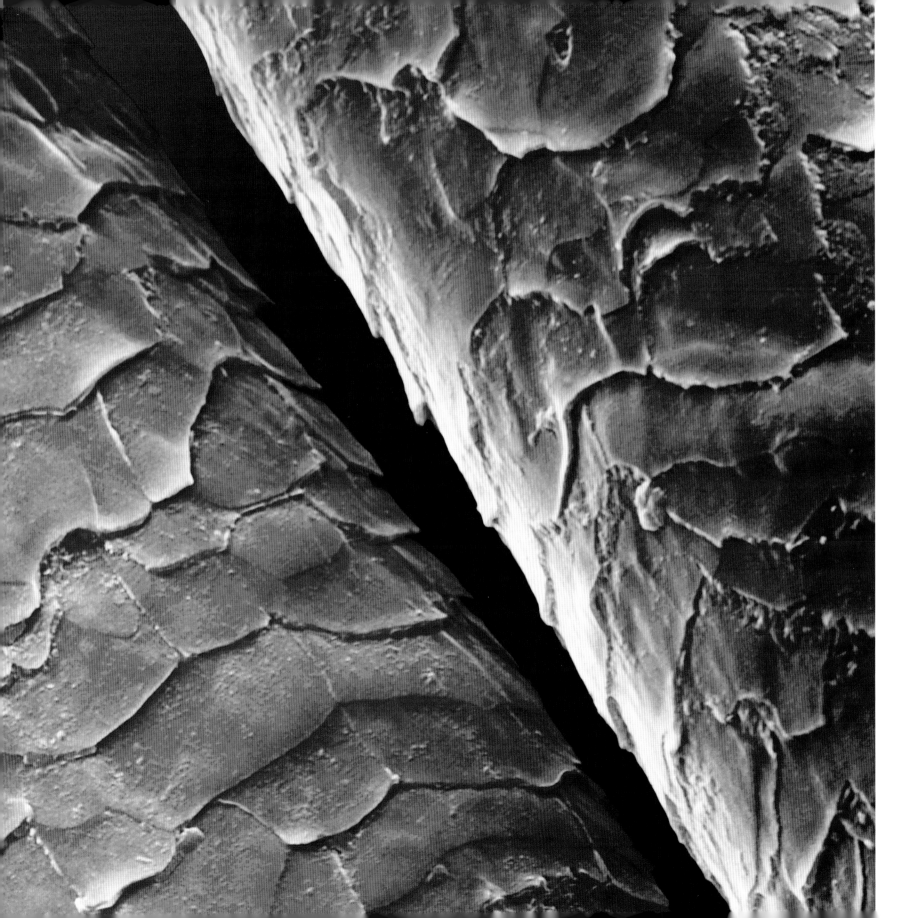

Human hair

These two hairs have been magnified 3,500 times using a scanning electron microscope. Each is protected by a tough, scaly cuticle. Beneath is a cortex strengthened with the protein keratin, and a spongy core or medulla. Damage to the cuticle leads to brittle hair and split ends, while the direction of the scales allows hair to be combed easily in only one direction. Pigments in the cortex give hair its colour. With age, this colouring disappears, turning individual hairs white. 'Grey' hair is a mixture of white hairs and hairs which still contain their pigment.

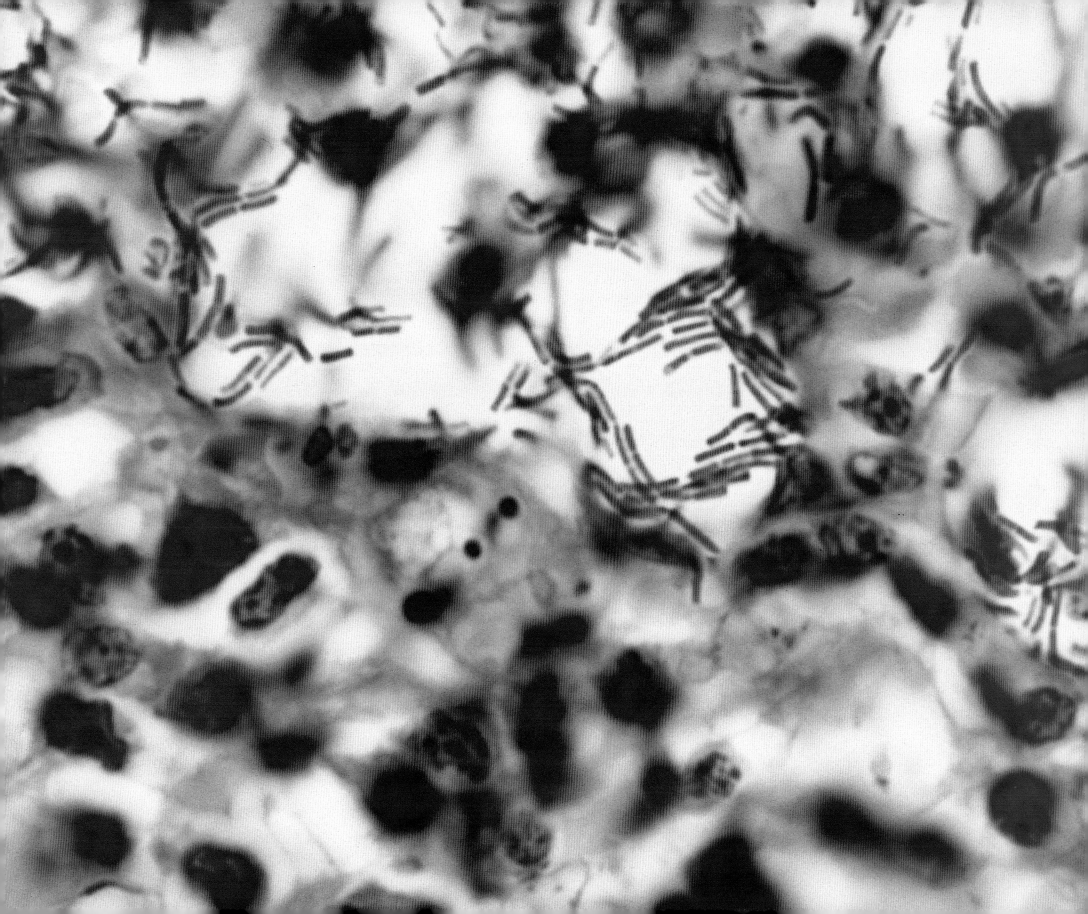

left

Anthrax bacteria

This section through tissue
infected with anthrax
(*Bacillus anthracis*) is magnified
3,500 times. The tissue has
been stained to pick out its
various features: the small
anthrax bacteria (red rods)
are clearly visible within the
mass of cells (blue), which have
rounded or oval nuclei (red).
Anthrax is a naturally occurring
disease that normally affects
livestock. Its spores can remain
dormant in soil for years.
If detected promptly, most
cases of anthrax in humans
respond quickly to treatment
with antibiotics.

Conifer wood

This longitudinal cross section
through conifer wood
is magnified 2,000 times with
a scanning electron microscope.
The long strips running vertically
are tube-like tracheid cells.
These dead cells form the bulk
of the xylem, the part of wood
responsible for carrying water
and nutrients up from the soil
and throughout the tree.
The cells are reinforced with
lignin, a compound which makes
the tree woody and more rigid.
The round pits that line the
tracheid cell walls allow fluid
to move between adjacent cells.

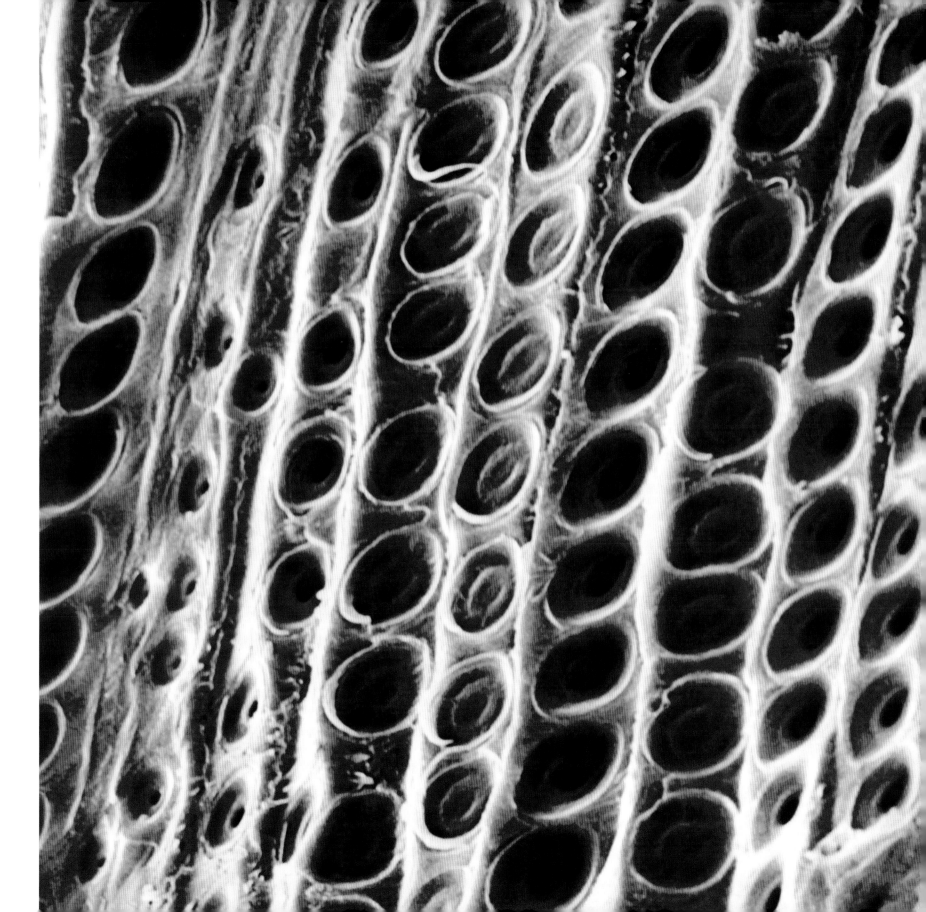

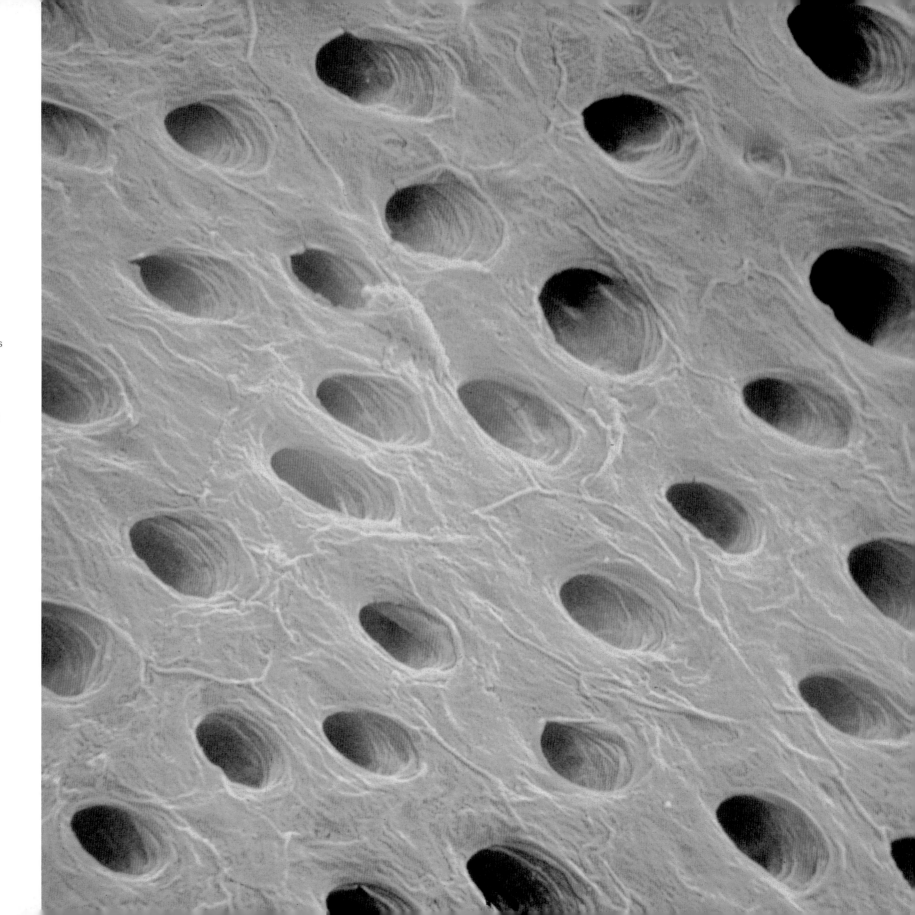

Dentine

Dentine is the tissue that makes up the bulk of a tooth. It forms a thick shell around the central pulp cavity and is capped with enamel. Dentine is a tough tissue, mineralized with calcium phosphate. It is permeated by a network of tunnels, whose entrances you can see here. These carry extensions of the dentine-producing cells as well as blood vessels and nerve endings sensitive to touch and extremes of temperature. The dentine in this scanning electron micrograph image is magnified 2,500 times.

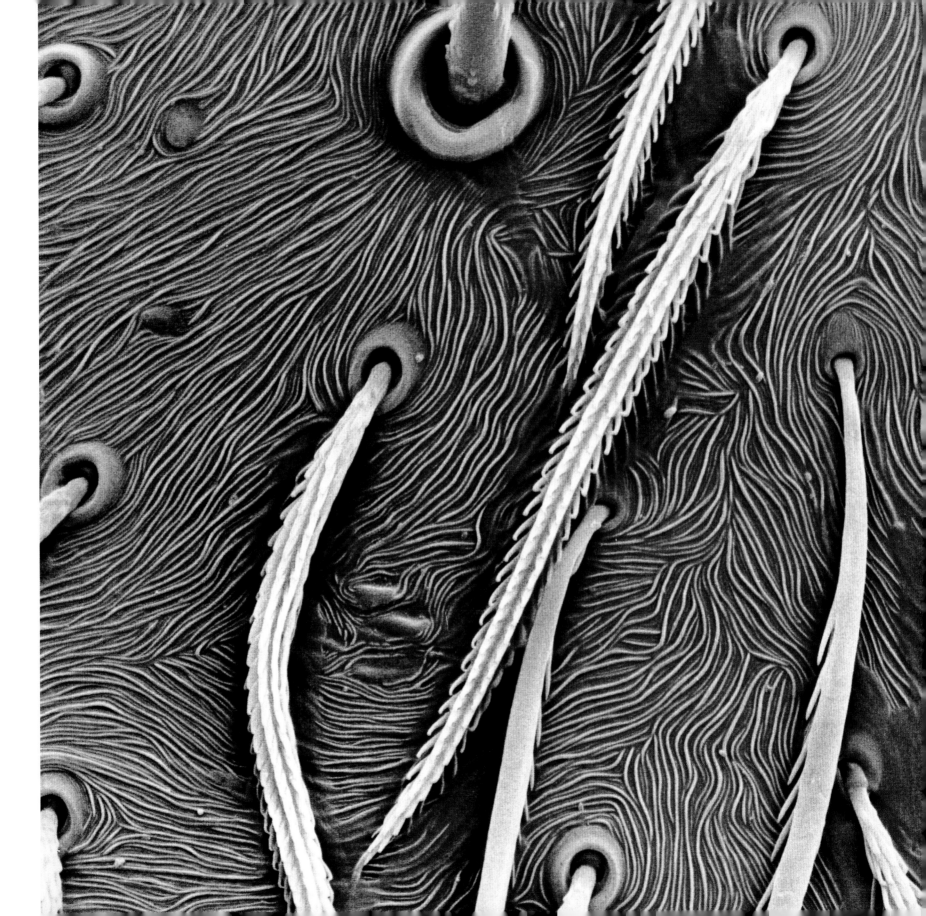

Spider exoskeleton
This scanning electron micrograph shows an area of a spider's abdomen, magnified 2,500 times. The spider's structural and protective outer casing, its exoskeleton, is covered with a thin layer of waterproof wax to protect the spider both from drying out and from getting wet. Sensory hairs, each one covered with rows of spines, emerge from pores in the exoskeleton. The hairs can detect movement – of prey on the web for example. They are just one of many sensory structures that spiders use to pick up signals from their environment.

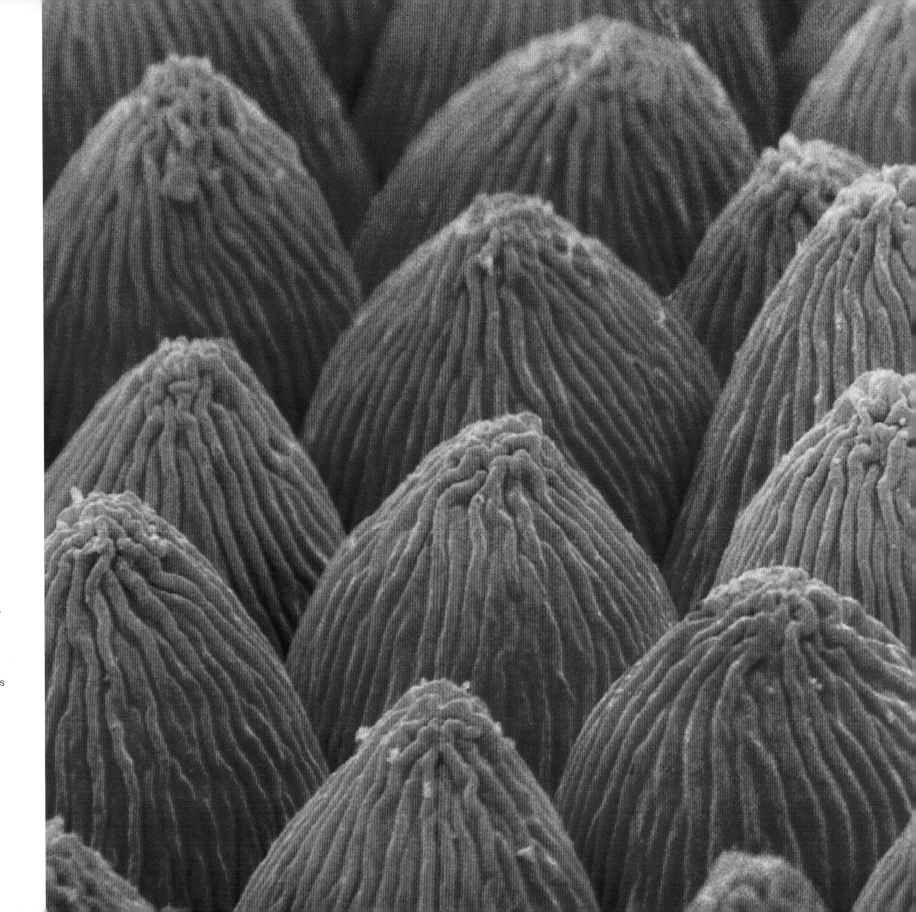

Rose petal

The seemingly smooth surface of a rose petal, when magnified 2,300 times using a scanning electron microscope, is actually covered with tiny humps called 'papillae'. These projections from the petal's surface cells are often swollen and covered with wax to help reduce water loss from the flower. The colour here is cosmetic, added later to make the image look more like a rose petal.

far right
Brewer's yeast

This light micrograph of brewer's yeast was taken by the French physicist Léon Foucault (1819–68) in the mid-nineteenth century. The oval yeast cells are about 75 micrometres in diameter. A few of those shown here are reproducing asexually by budding: outgrowths of the parent cell detach to form new genetically identical individuals. Brewer's yeast is a strain of the fungus *Saccharomyces cerevisiae*. It is added in beer-making to cause fermentation, the process by which yeast cells feed on sugars and produce alcohol and carbon dioxide.

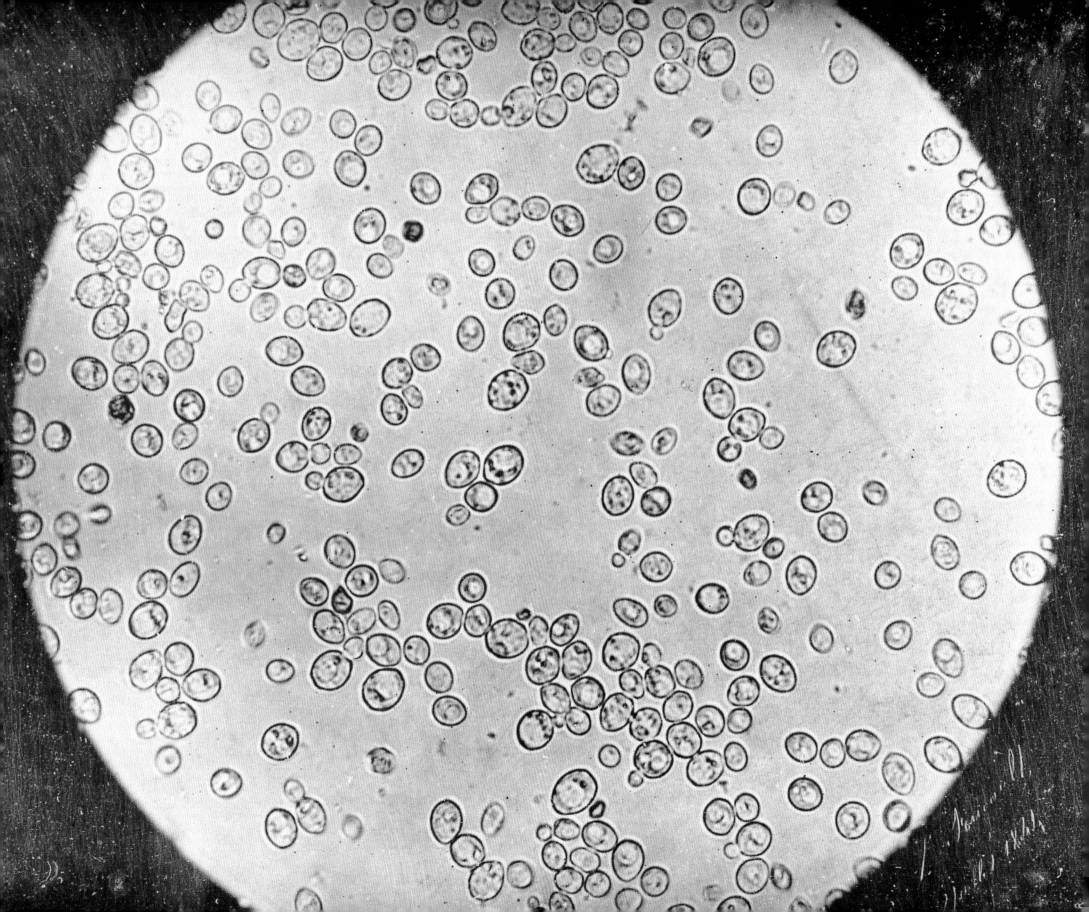

Melanoma
Normally, skin cells called melanocytes produce the brown pigment melanin, which protects the skin from exposure to harmful ultraviolet light. However, too much sunlight can damage the melanocytes, causing them to grow and reproduce chaotically to form cancers called melanomas. The extremely varied shapes of the cell nuclei (stained purple) in this image are typical of cancerous growth. Melanomas are almost always survivable if detected and treated promptly. This light micrograph is at a magnification of 2,100 times.

Chromosomes
The DNA that carries the genetic code in cell nuclei is arranged into tightly coiled threads called chromosomes. Here fluorescent green markers pick out the X chromosomes in a human cell. These chromosomes define the sex of an individual: women have two X chromosomes, while men have one X and one Y chromosome. The red fluorescent markers pick out the gene associated with Duchenne muscular dystrophy, an inherited wasting disease carried on the X chromosome. The magnification is about 2,000 times.

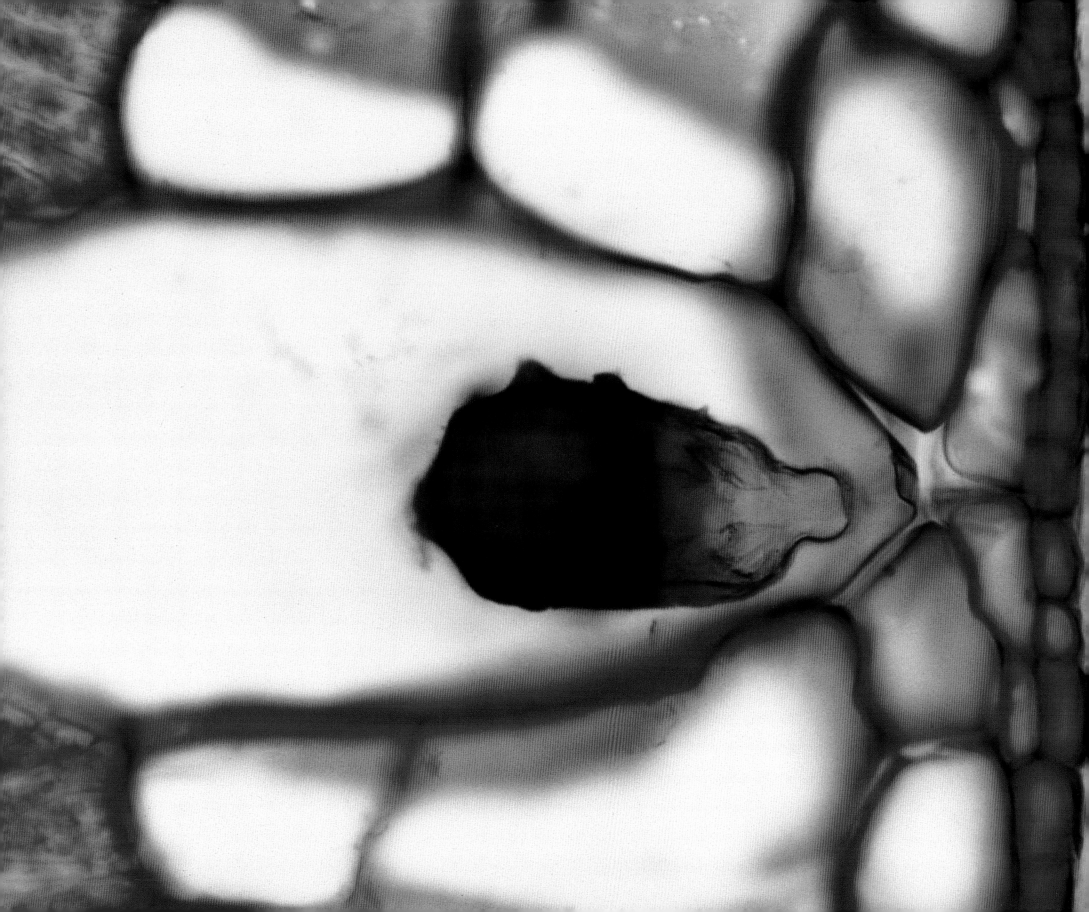

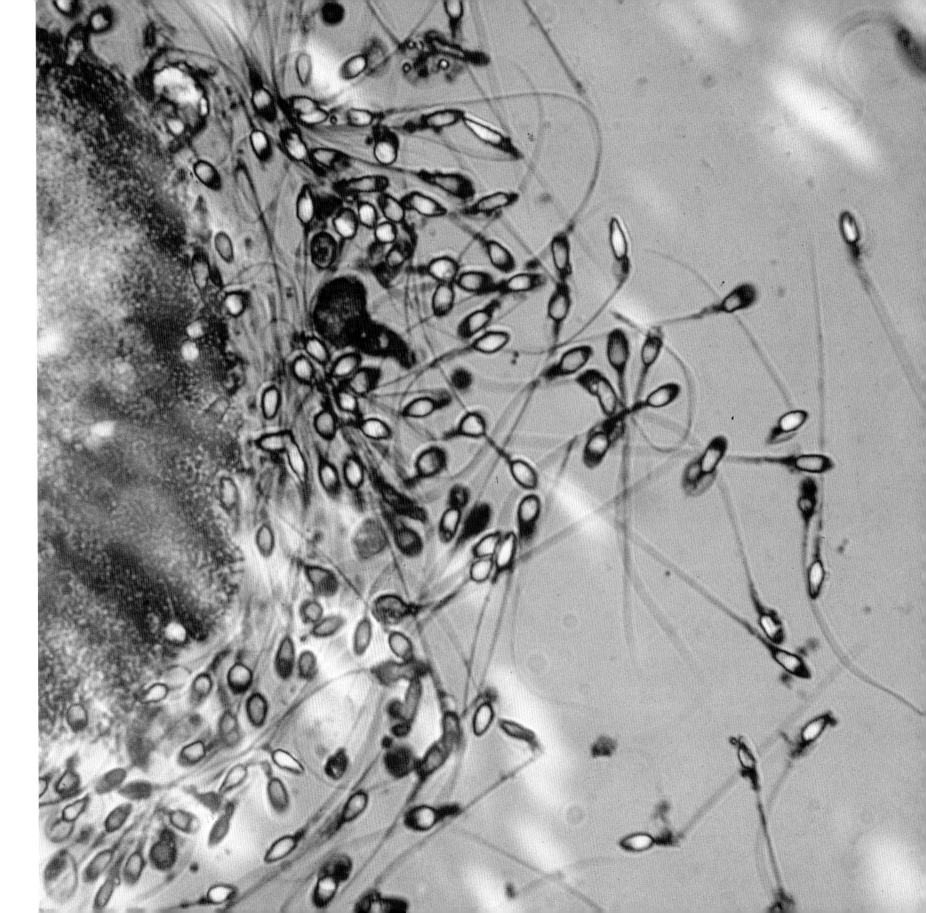

left

'Stone cell' in leaf

In this light micrograph, cells in the upper layer of a *Ficus* leaf are magnified 1,700 times to reveal a specialized cell called a lithocyst (literally 'stone cell'). The cell is enlarged and contains a concretion of calcium carbonate – the dark, drop-shaped object in the picture. These specialized cells occur in only a few species, the best known of which is the rubber plant *Ficus elastica*. Botanists are uncertain of the function of these cells, but they probably act as storage for some of the plant's waste products.

Human sperm

These human sperm, or spermatozoa, have been magnified 1,500 times under a light microscope. The testes produce spermatozoa in vast numbers – an average ejaculation of about 3 millilitres of semen contains up to 600 million of them. Only one is needed for fertilization, but the journey to the egg is long and hazardous, and production of such enormous numbers increases the chance of fertilization. As each spermatozoan has a unique genetic make-up, it also increases the opportunity for genetic mix and match.

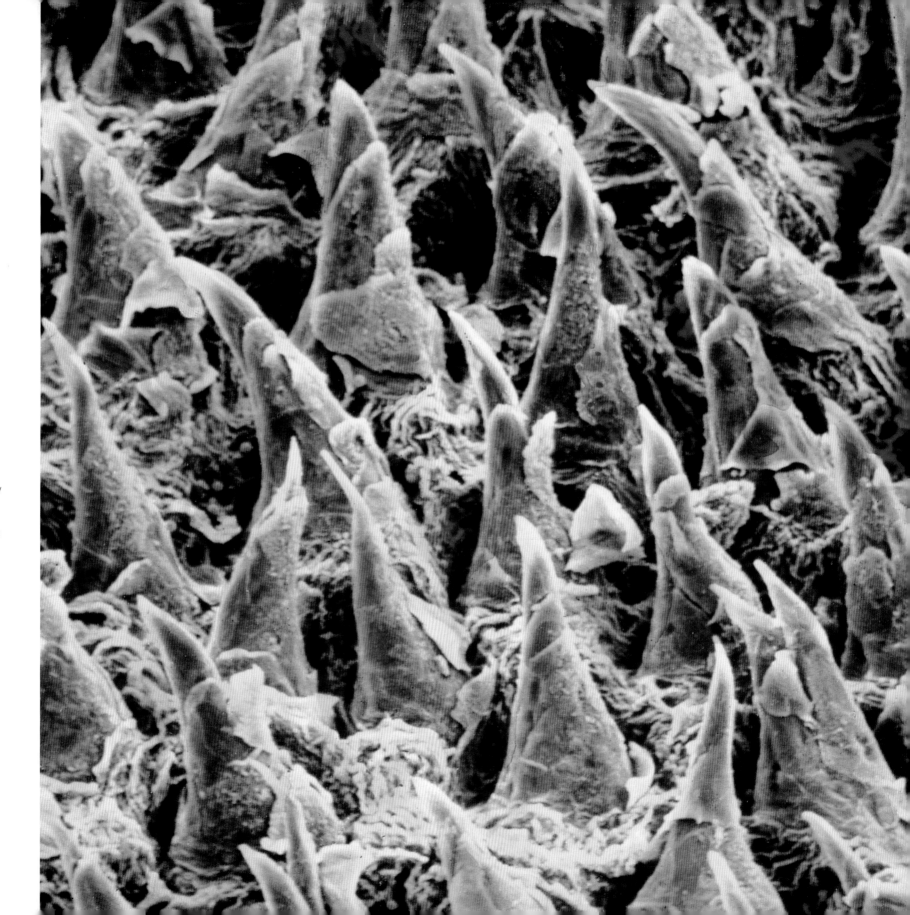

Tongue surface
This scanning electron micrograph shows the surface of a human tongue magnified 1,500 times and coloured. Thin conical structures, called papillae, run in parallel rows along the tongue. These make the tongue slightly rough, allowing you to lick ice cream off a cone. The tongue has many types of papillae on its surface. This particular type does not have taste buds, but is sensitive to touch and temperature – even more so than fingertips.

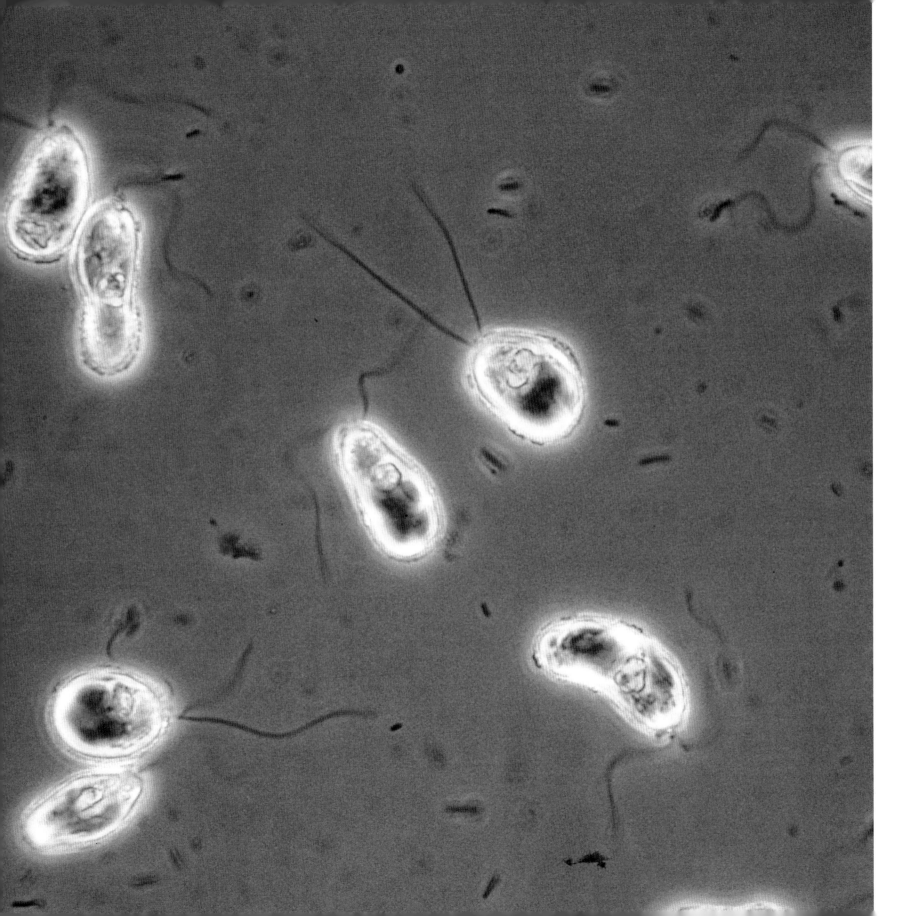

Living coccolithophores
These tiny single-celled phytoplankton belong to the genus *Coccolithophora*. They and their relatives live in huge numbers close to the surface of the world's oceans, where there is plenty of light for photosynthesis. They use their two long thin flagella to move through the water. These individuals have been magnified 1,300 times, using a light microscope. This picture does not show the intricate skeleton that typically surrounds such organisms – a sphere of ornamented calcareous plates called coccoliths.

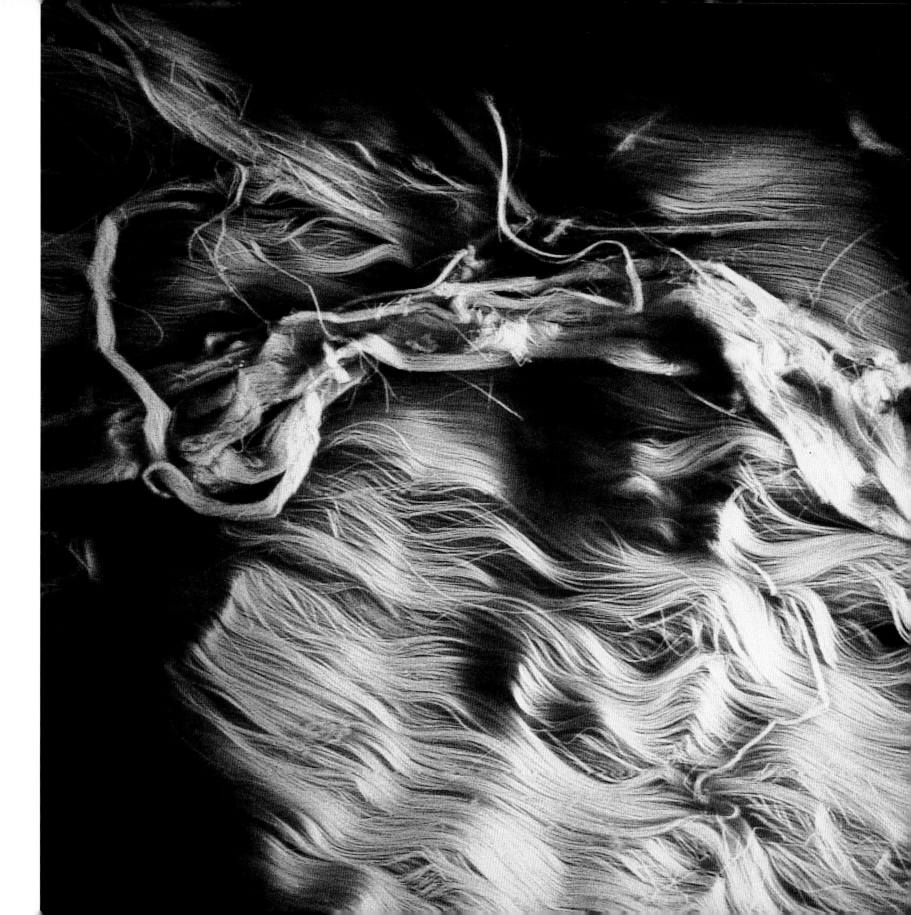

Collagen fibres
This image shows the damaged collagen fibres in a ruptured tendon, magnified 1,300 times. Tendons are the fibrous cords that join a muscle to a bone. They are made of bundles of tough collagen fibres, lying parallel to the lines of stress in the tendon. Each strand of collagen is like a rope, made up of three chains of the protein tropocollagen plaited together. Collagen fibres give the tendon very high tensile strength – in a violent muscle jerk, the bone is as likely to break as the tendon is to rupture.

Blastocyst

A blastocyst is a hollow ball of cells, formed as a fertilized egg divides again and again on its way to the uterus. This human blastocyst, magnified 1,200 times, is starting to embed itself into uterine wall tissue during a laboratory experiment set up to study the process of implantation. In life, this implantation takes place about six days after fertilization. Then, embedded in the uterine wall, cell division and differentiation continues and the blastocyst develops into an embryo.

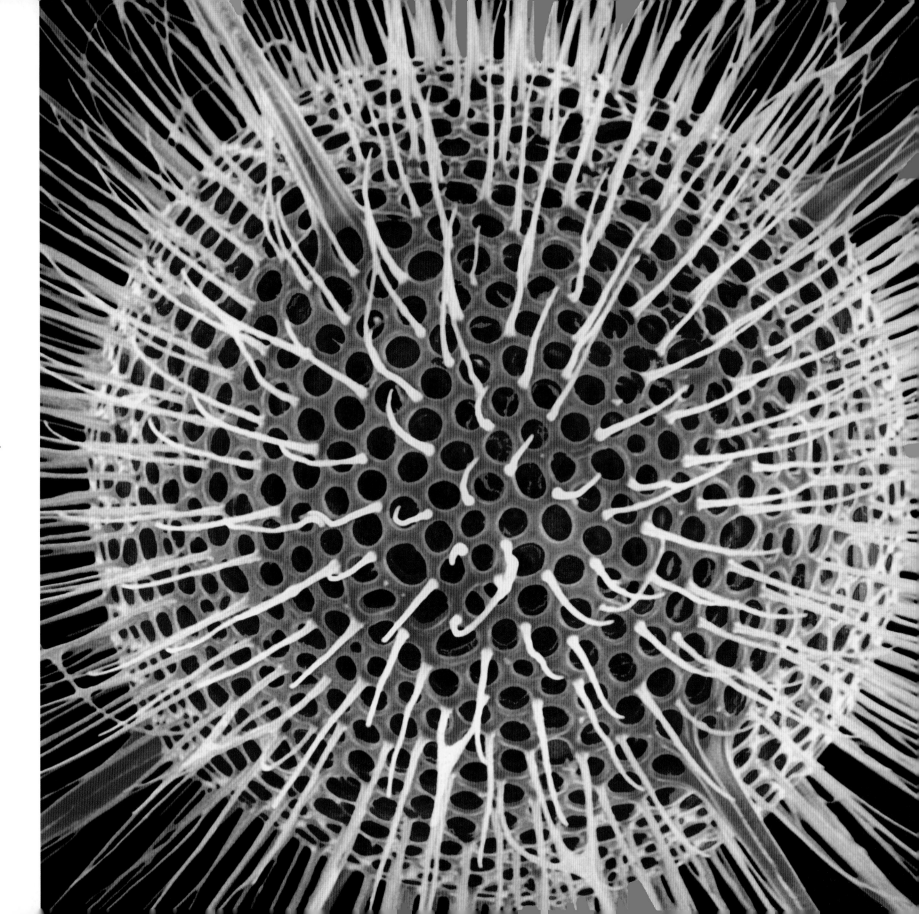

Radiolarian skeleton

Radiolaria are single-celled animals (amoeboid protozoa) that inhabit the surface waters of the oceans – this example comes from the Caribbean. Only its skeleton remains here, magnified 1,000 times with a scanning electron microscope. The skeleton is composed of glass-like opaline silica. In life it is surrounded by cytoplasm and a cell wall. The spines reinforce leg-like extensions of the cell called pseudopodia, which the radiolarian uses to feed and move along.

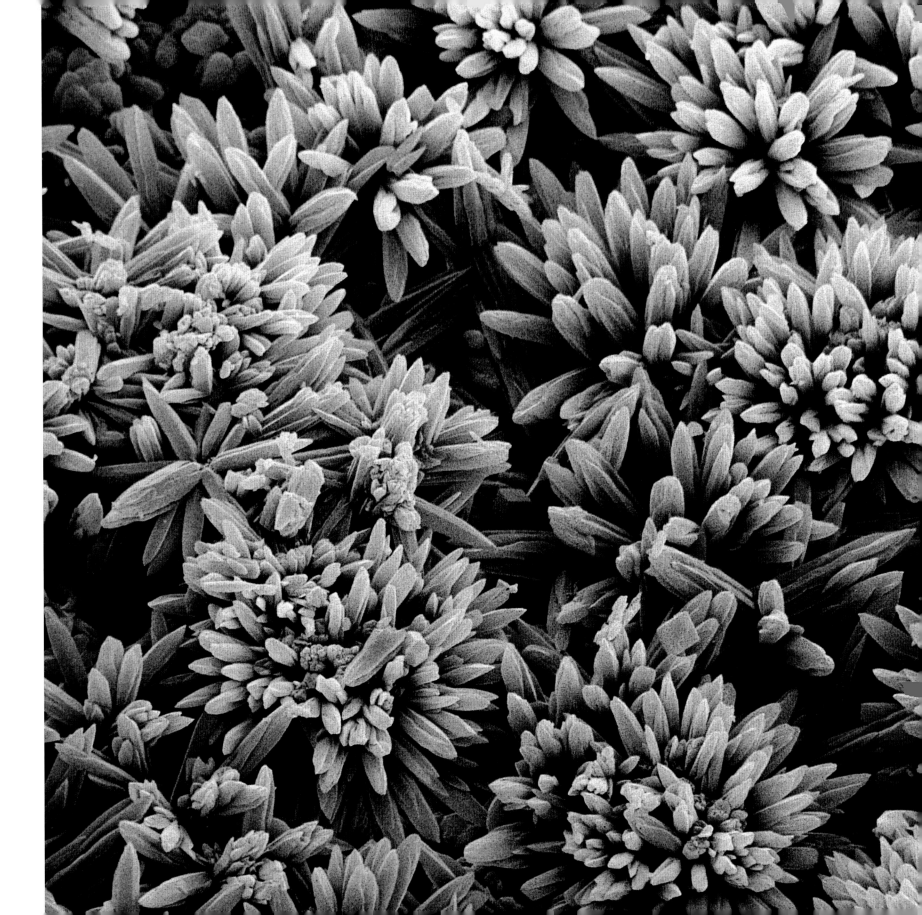

Kettle limescale
This scanning electron micrograph of fur from a domestic kettle shows calcium sulphate crystals growing in flower-like clumps, magnified 1,000 times. With regular boiling and evaporation, minerals like calcium sulphate and calcium carbonate precipitate out of the water and grow crystals on the inside surface of a kettle. This is most noticeable in limestone areas where tap water is very 'hard', containing high concentrations of calcium minerals.

Foraminiferan

This scanning electron micrograph shows the planktonic foraminiferan *Globorotalia scitula*, magnified 900 times. It belongs to a group of single-celled organisms, similar to amoebae, which secrete a hard shell of calcium carbonate. The shell of this species, which lives in sub-polar and temperate oceans, is coiled and has a number of chambers. Fossil foraminifera preserved in layers of deep ocean sediment have provided an invaluable record of changing oceanic temperatures during the ice ages.

far right
Butterfly wing

This light micrograph reveals the scales that give the butterfly *Urania madagascariensis* its iridescent colours. It is magnified 860 times. In life each scale is about 20 micrometres across. The bright colours are not due to pigment. The spacing of the scales' surface texture causes optical interference (like a thin film of oil in water), creating the vivid colours that we see here.

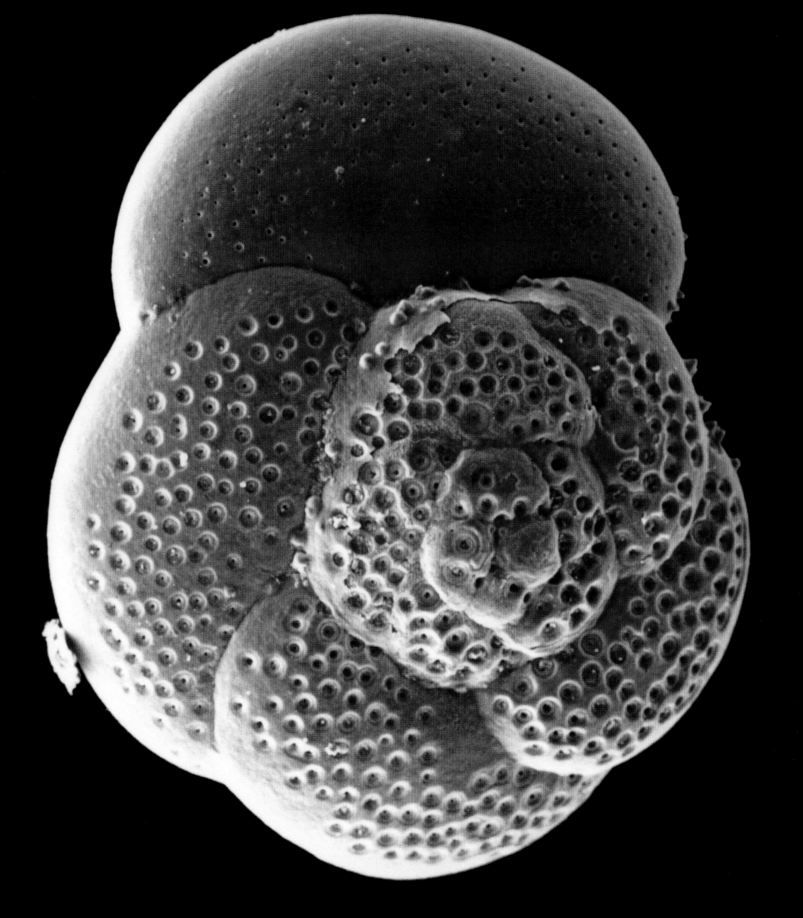

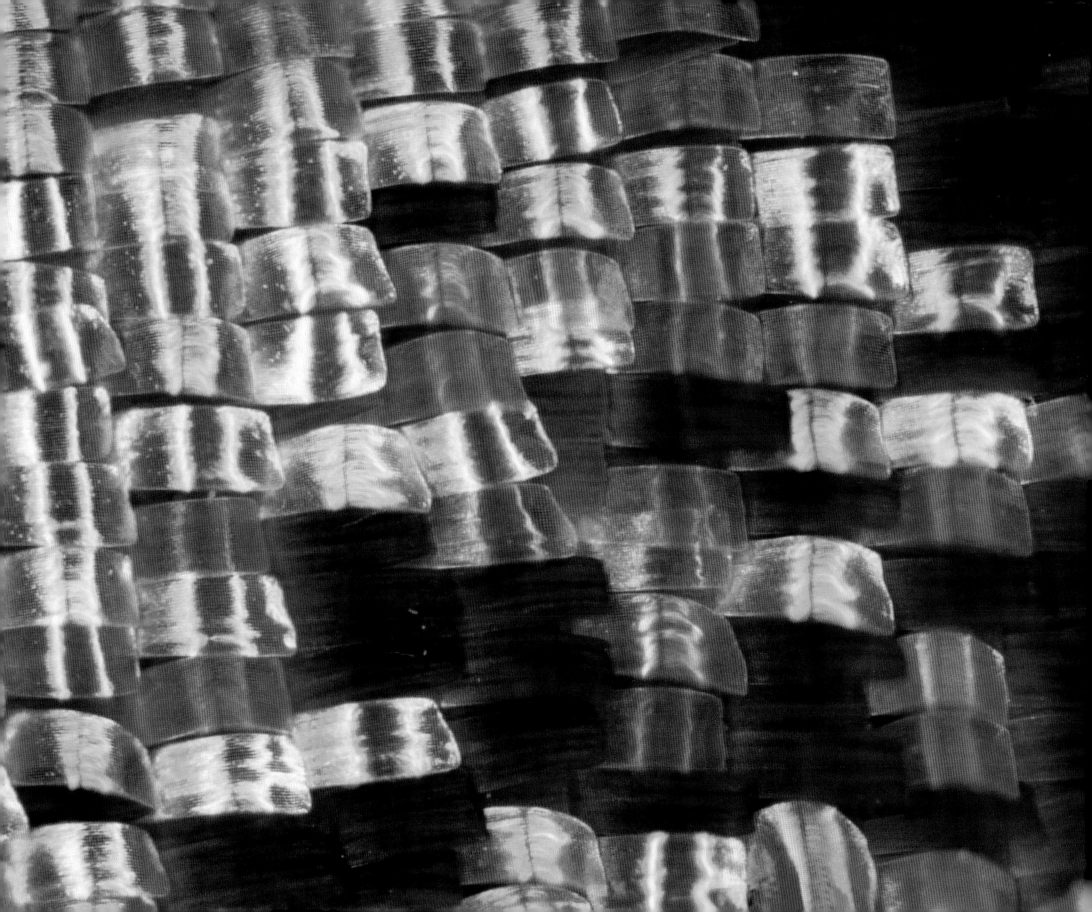

Heliozoan amoeba

This is a light micrograph of *Actinophora*, a single-celled amoeba, magnified 860 times. The long thin projections, or axopodia, that radiate from the main cell body, give this class its name 'heliozoa' – sun animal. The cell nucleus is visible in the centre as a dark circle. The cell body surrounding it has a frothy texture, full of bubbles called vacuoles within which the amoeba digests its prey. The *Actinophora* lives in fresh water, lurking amongst reeds and algae. It traps its prey with its axopodia before engulfing it.

Beetle exoskeleton

This scanning electron micrograph shows part of a weevil's tough exoskeleton magnified 800 times. There are about 40,000 species of weevil, including a number of agricultural pests such as the grain weevil. This example is a cow pea weevil, *Callosobruchus maculates*. It has a covering of tiny, ridged, leaf-shaped scales.

The exoskeletons of many weevil species are covered with such scales, which cause optical interference to give bright colours and patterns, in a similar way to the scales on a butterfly wing.

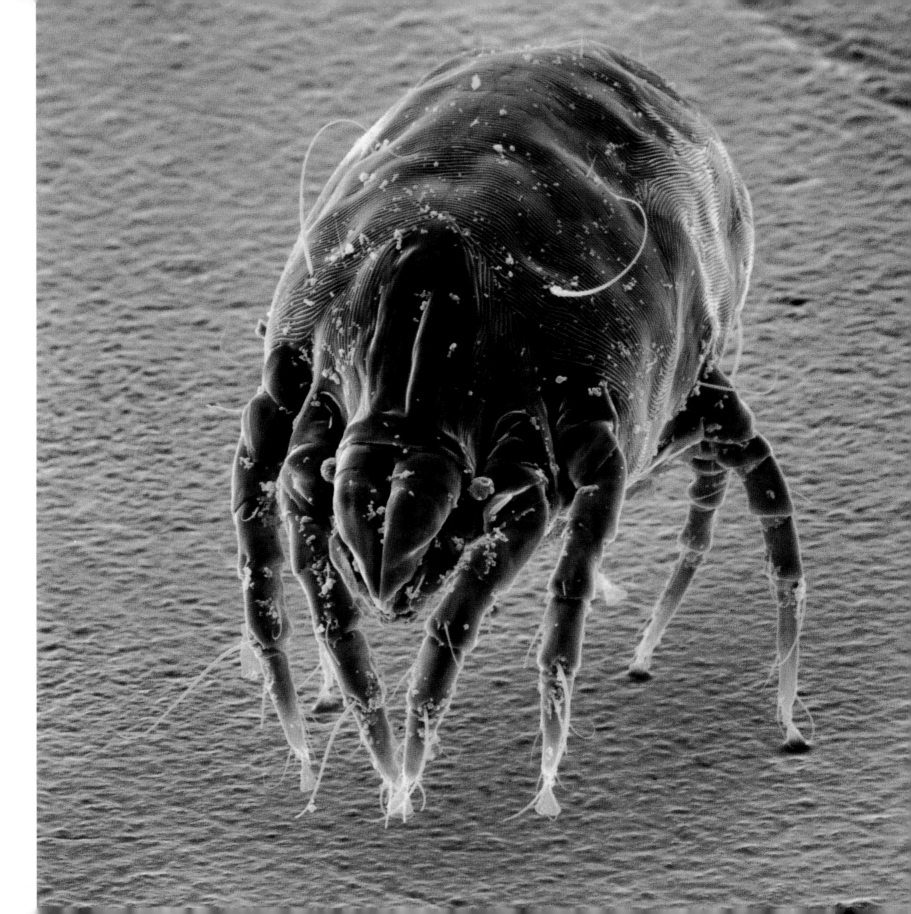

Dust mite

The dust mite, *Dermatophagoides pteronissinus*, here magnified 760 times using a scanning electron microscope, is about a third of a millimetre long and barely visible with the naked eye. Dust mites are scavengers, feeding on the flakes of skin we shed every day. They thrive in warm, dry conditions wherever dead skin accumulates, such as the folds of a mattress. Many people are allergic to dust mites and can suffer sneezing fits when sleeping in or making a bed.

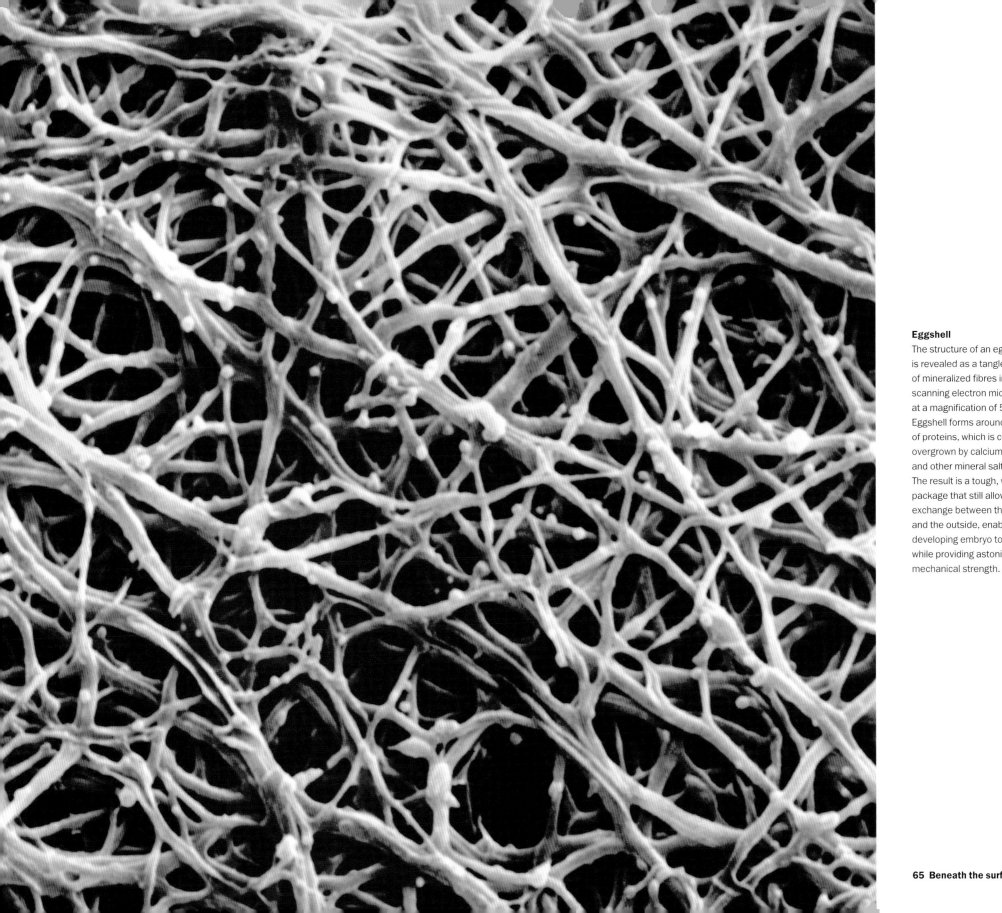

Eggshell

The structure of an eggshell is revealed as a tangled network of mineralized fibres in this scanning electron micrograph at a magnification of 500 times. Eggshell forms around a mat of proteins, which is coated and overgrown by calcium carbonate and other mineral salts.

The result is a tough, waterproof package that still allows gas exchange between the inside and the outside, enabling the developing embryo to 'breathe', while providing astonishing mechanical strength.

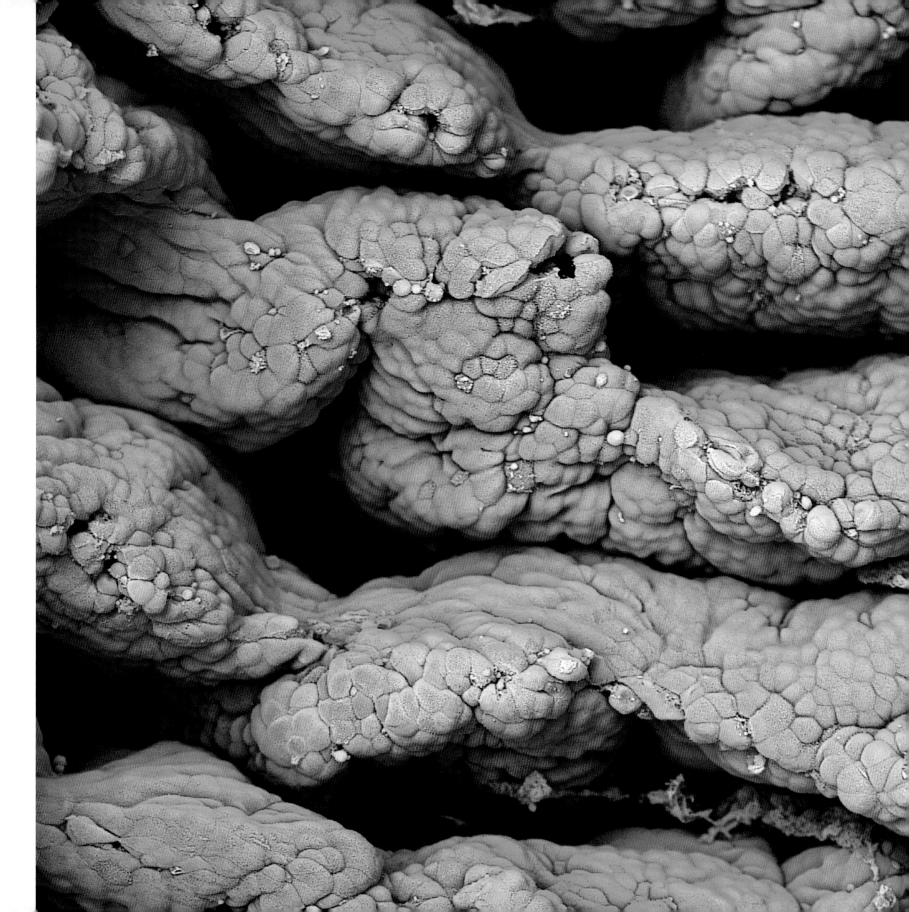

Small intestine

The highly folded mucous membrane lining the small intestine is magnified 650 times in this scanning electron micrograph. The folds are covered with a forest of narrow, finger-like projections called villi, which are specially adapted for absorbing digested food. The villi are crowded so close together that they make the mucous membrane look velvety at this scale. The folds and the villi combine to provide the gut with an enormous surface area of 250 square metres for digestion and absorption.

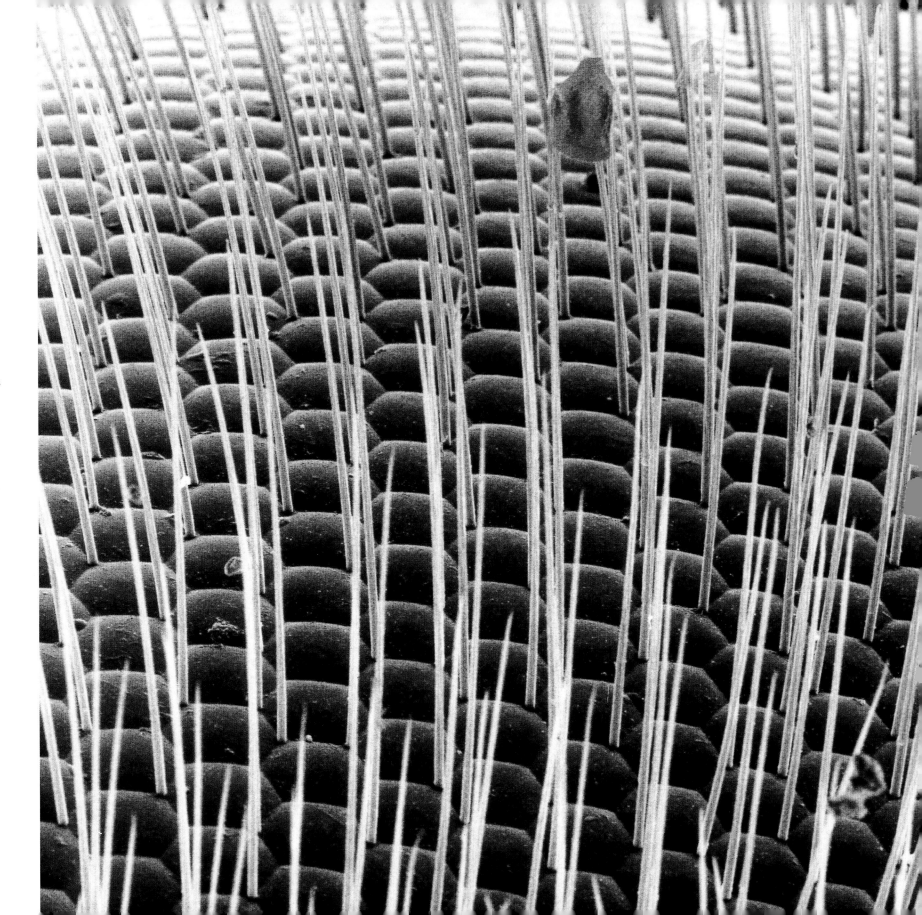

Bee's eye
This scanning electron micrograph of a honey bee's eye magnified 650 times reveals the tiny hexagonal lenses that make up the compound eye, half hidden by a forest of bristles. Each lens focuses light from a small part of the bee's field of vision onto its own set of light-sensitive cells. The bee's brain creates a picture of the whole visual field by combining these images provided by each lens. The bristles probably have a sensory function.

Pine charcoal

Wood is turned into charcoal when it burns in the absence of oxygen, for example in the lower layers of the forest floor during a fire. Charcoalification removes the volatile plant constituents, leaving a skeleton of pure carbon. This preserves the structures of woody tissues and makes them resistant to rotting and compression. This piece of pine wood charcoal clearly shows the large tubes of the tree's vascular system, which carried water and nutrients from the soil. It is magnified 650 times with a scanning electron microscope.

far right
Hair follicle

This scanning electron micrograph shows an empty hair follicle and surrounding skin, magnified 600 times. Except for the palms of the hands and the soles of the feet, all areas of the human skin contain such tube-like follicles, from which hairs grow. Individual hairs last for up to seven years before being shed and replaced by a new hair growing from the same follicle. Just below the surface of the follicle is the sebaceous gland, which produces sebum, an oily substance that keeps the hair and skin supple.

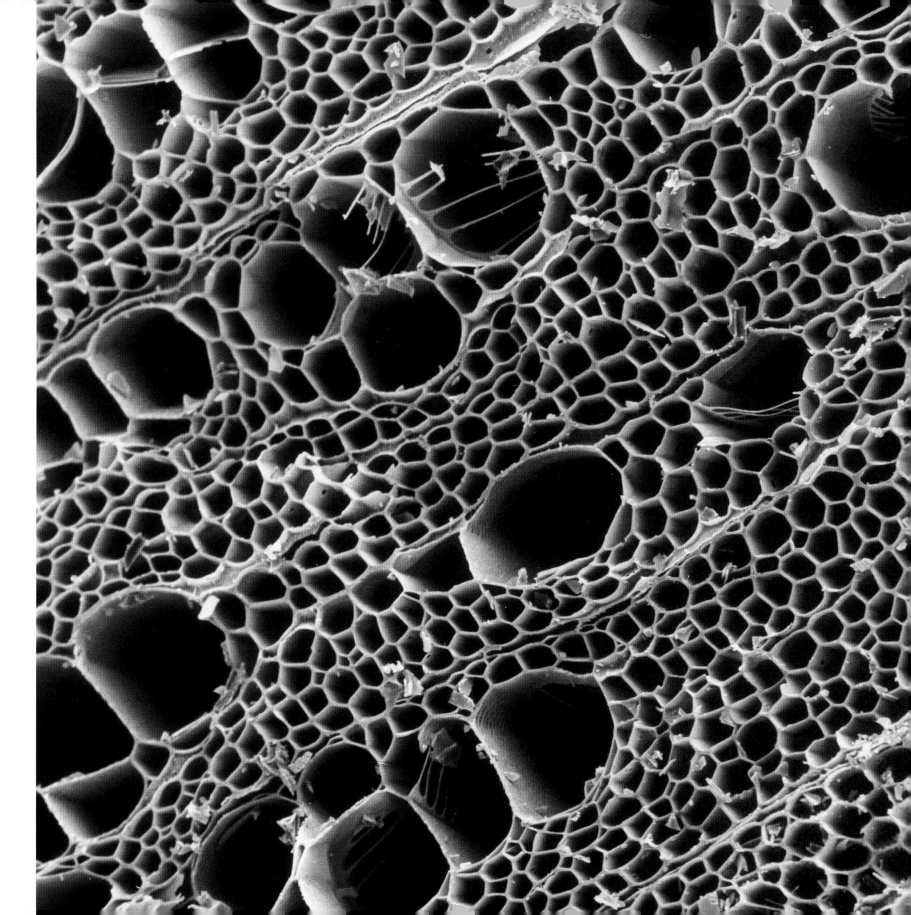

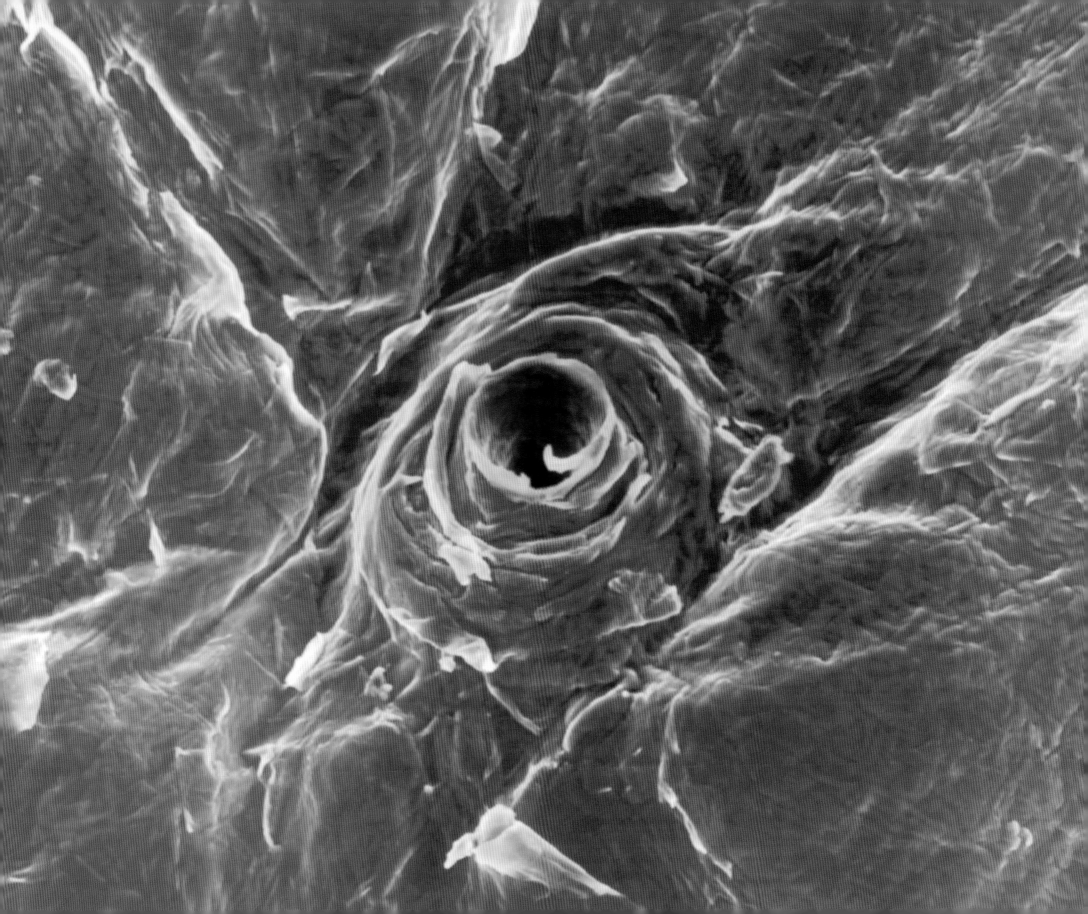

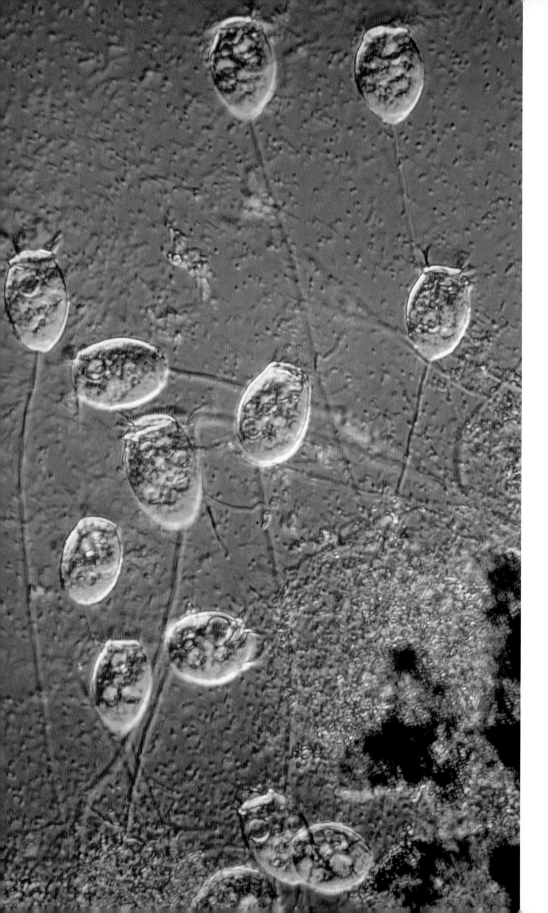

Vorticella

This image shows a group of *Vorticella*, single-celled animals that live attached to twigs, leaves and other debris at the bottom of ponds. Each animal has a goblet-shaped body attached to a long retractable stalk. The top of the goblet bears a ring of hair-like cilia that beat to waft food particles into the mouth at the centre. Bacteria are the main food supply of *Vorticella*, and are visible as specks in the water. This light micrograph is magnified 600 times.

right
Goose feather

This scanning electron micrograph shows part of a goose feather, magnified 570 times. The feather has a central shaft or rachis (green), with many slender barbs branching from it (also green), and dozens of smaller barbules branching from each barb (orange). The barbules interlock to form a more-or-less continuous surface, creating a structure that is strong yet light and flexible. Feathers are largely made of the same protein – keratin – that is found in hair.

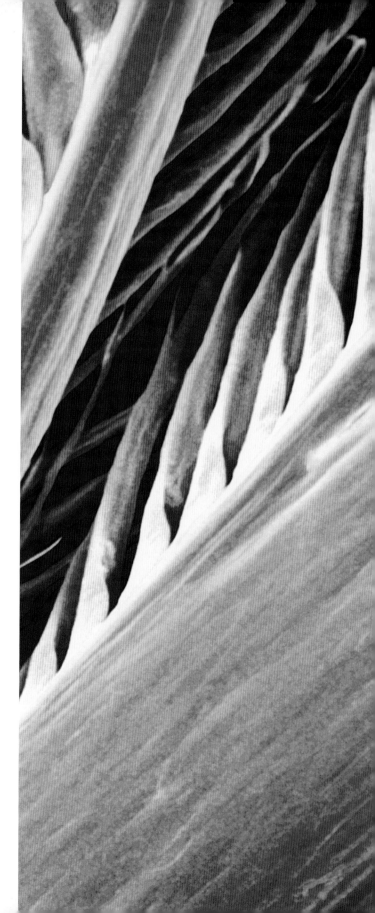

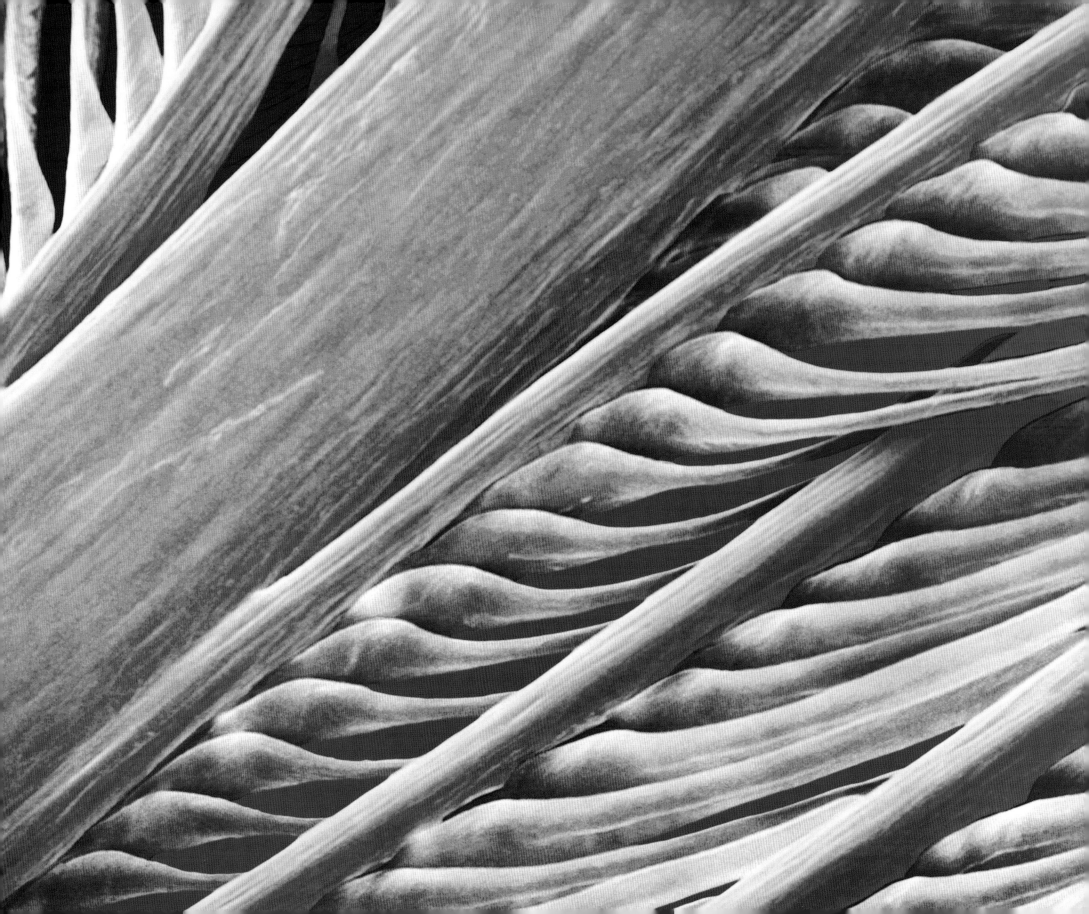

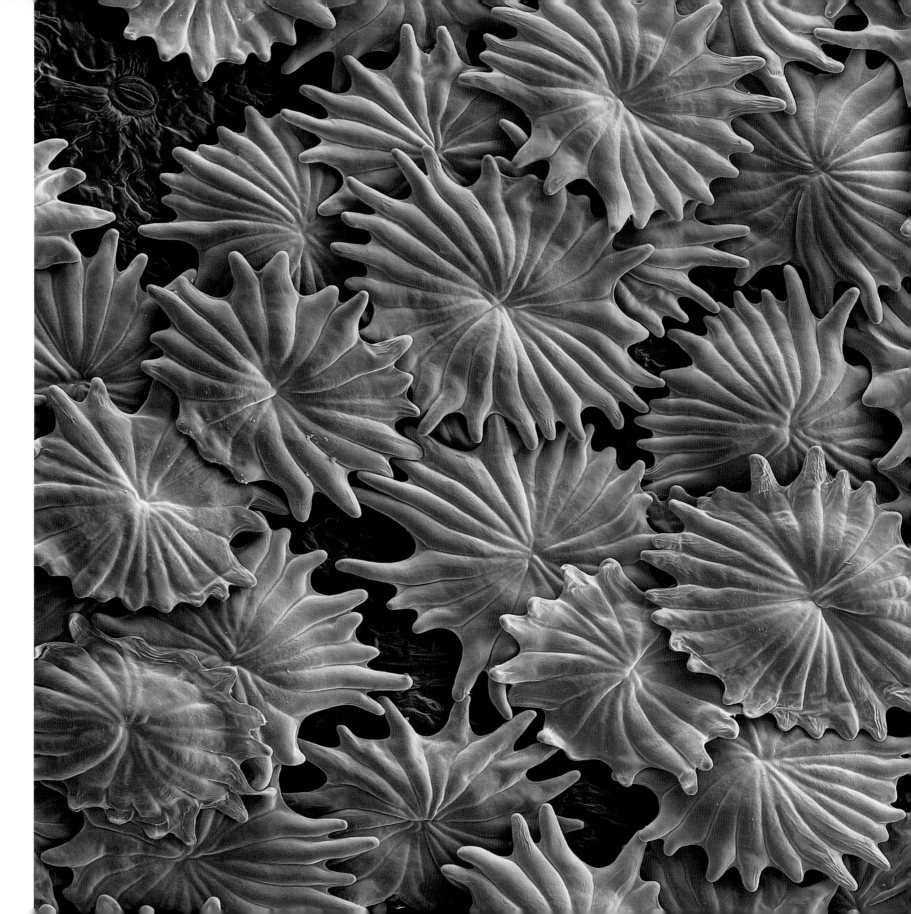

Olive leaf scales

The umbrella-like scales on the
surface of an olive tree leaf are
magnified 560 times in this
coloured scanning electron
micrograph. Olive trees flourish
in semi-arid conditions that other
trees cannot tolerate, in part
because of these scales.
They trap still, moist air close
to the leaf's surface, slowing
the rate of water loss. The leaf
contains pores called stomata
(one can be seen upper left)
that allow the leaf to breathe.

Fucus conceptacle

A light micrograph of a cross section through a male conceptacle of *Fucus*, the seaweed commonly known as bladder wrack. At certain times of the year swellings develop at the ends of its fronds, bearing many small cavities called conceptacles which house reproductive cells. The male reproductive cells develop inside them, at the ends of the branching structures visible in this picture. When mature, they are released through the hole at the top and swim off to fertilize egg cells released by female conceptacles. The conceptacle is magnified 200 times.

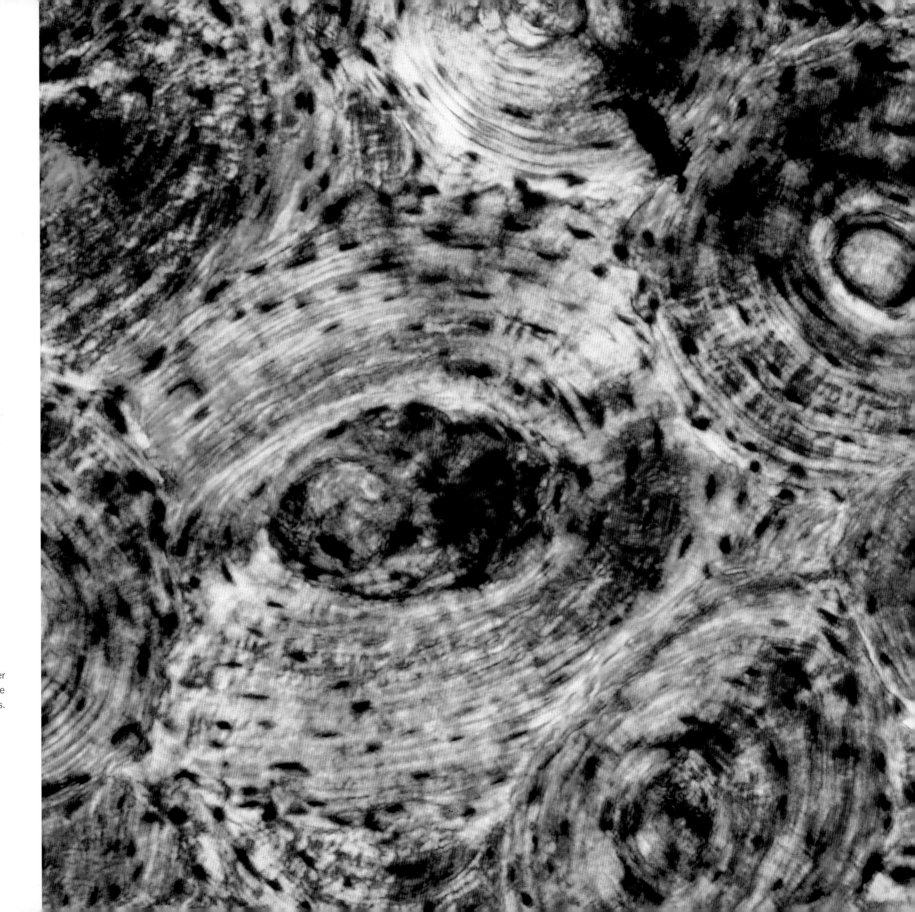

Bone tissue
This light micrograph shows a cross section of compact bone, magnified 540 times. This type of bone is dense and hard. It makes up the walls of the skeleton's long bones – the thigh bone, or femur, for example. Compact bone consists of numerous cylinders, each composed of concentric layers of bone around a central canal, which carries blood vessels, lymph vessels and nerves. The cross section also reveals black spots, which are spaces containing the cells that maintain the bony matrix.

far right
Root hairs
This light micrograph of the young root of a beetroot plant, magnified 500 times, reveals numerous tiny hairs. Each root hair is a tubular extension of a single cell of the root's outer cell layer. This increases the surface area of the root in contact with the soil, which greatly enhances the plant's ability to absorb water and minerals. When a plant wilts after being transplanted it is often due to a loss of its delicate root hairs.

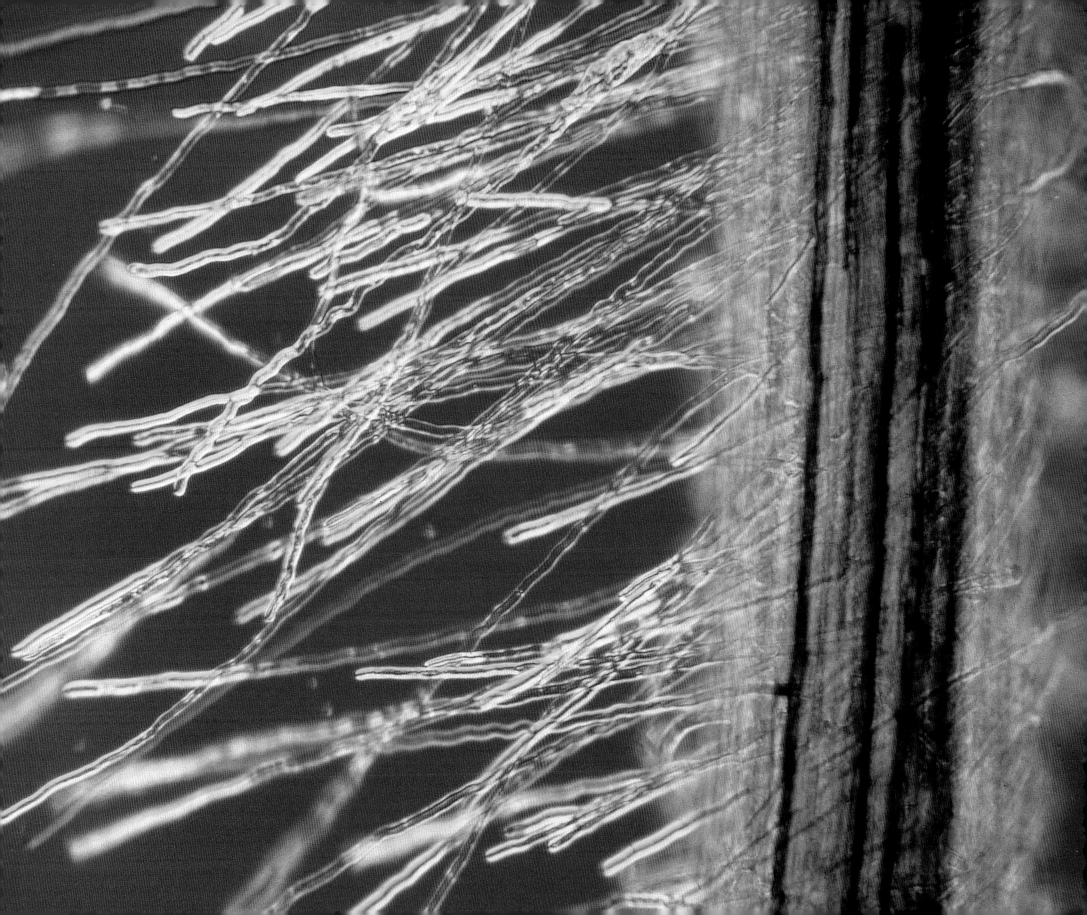

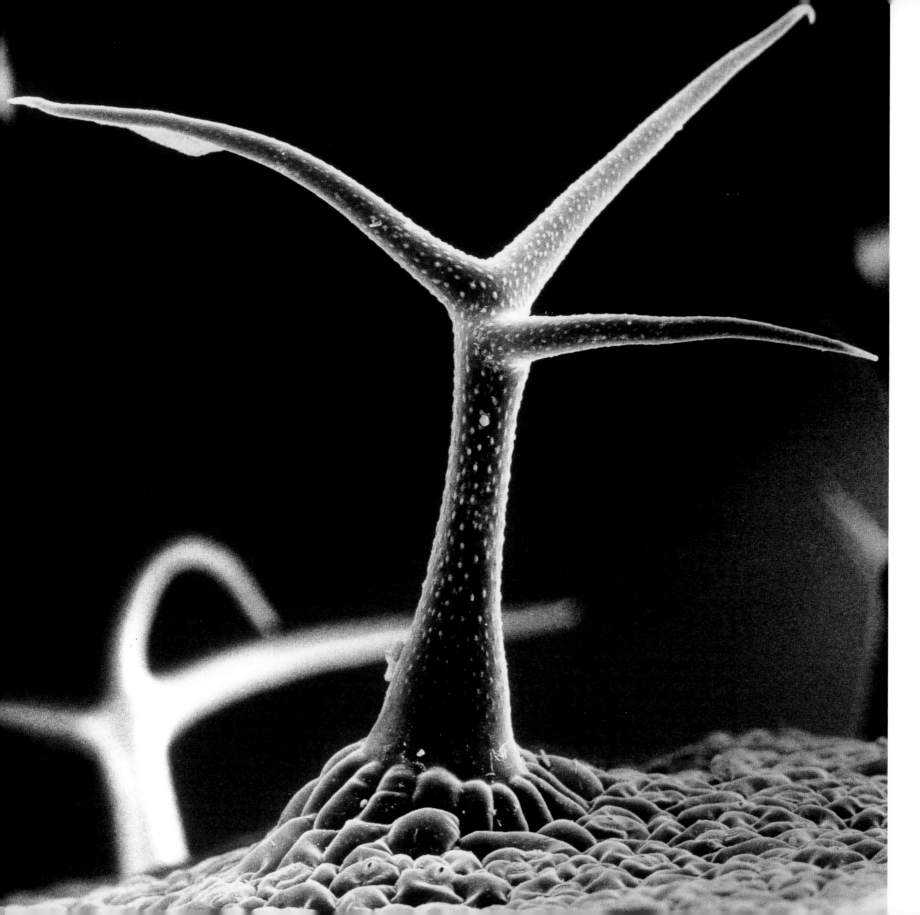

Leaf hair
This spiky hair, called a trichome, is growing out of a leaf of thale cress (*Arabidopsis thaliana*). Thrichomes exhibit an enormous diversity of form and function. This plant is covered with small hairs that help to protect plant tissues from attack by insects, and reduce air flow and thus water loss from the leaves. Other plants feature more specialized hair types such as the stinging hairs of nettles, which defend them against browsing animals. The hair in this scanning electron micrograph is magnified 500 times.

right
Mahogany wood
This transverse section through a piece of mahogany wood is magnified 400 times using a light microscope. It shows the bundles of tubular cells which make up the tree's vascular system, responsible for carrying water and nutrients from the soil. The slice of wood was taken from a living – or at least recently living – tree, and the double walls of the cells which make up the tubes are visible.

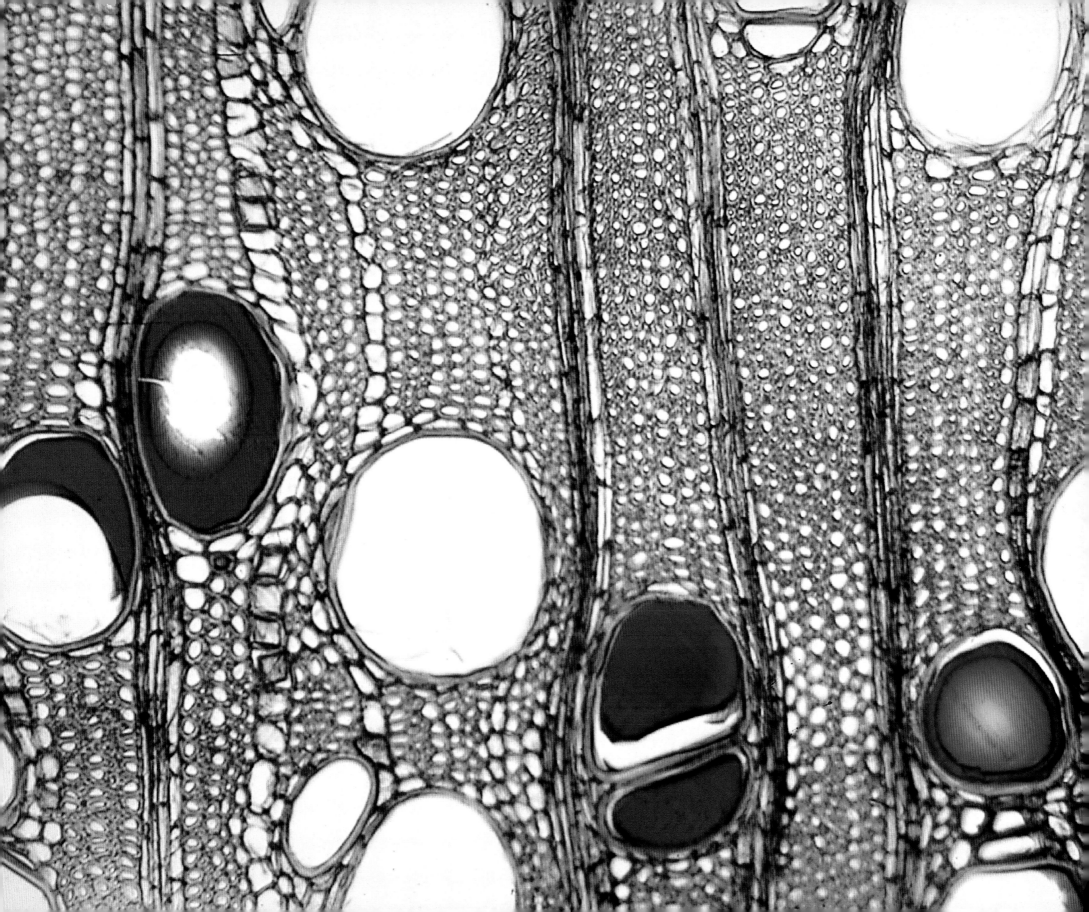

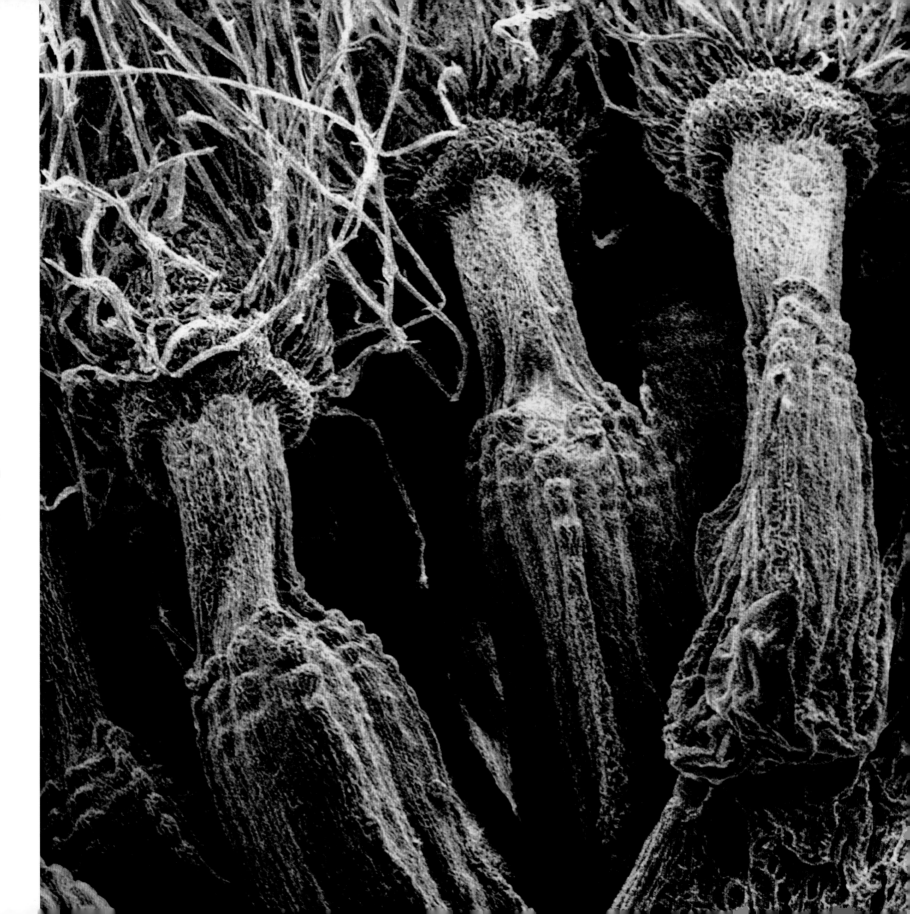

Dandelion seeds

This image shows dandelion (*Taraxacum*) seeds developing within the flower head.

The seeds develop from female sexual organs called ovules once fertilized. Each seed contains an embryonic plant, and the 'life-support system' it needs to survive and develop. A store of starch provides a food source, a tough skin protects it against drying out and biological attack, and a feathery canopy provides its means of dispersal. In this scanning electron micrograph the seeds are magnified 380 times.

Skin

This scanning electron micrograph of human skin magnified 370 times shows the creases which are both the cause and effect of our skin's flexibility. Skin cells are constantly being formed at the base of the epidermis and shed from the outermost layer. They move upwards towards the surface as they develop, becoming increasingly flattened and rich in keratin. In the outermost layer they are dead, flat and firmly attached to one another, forming a tough, pliant, waterproof covering.

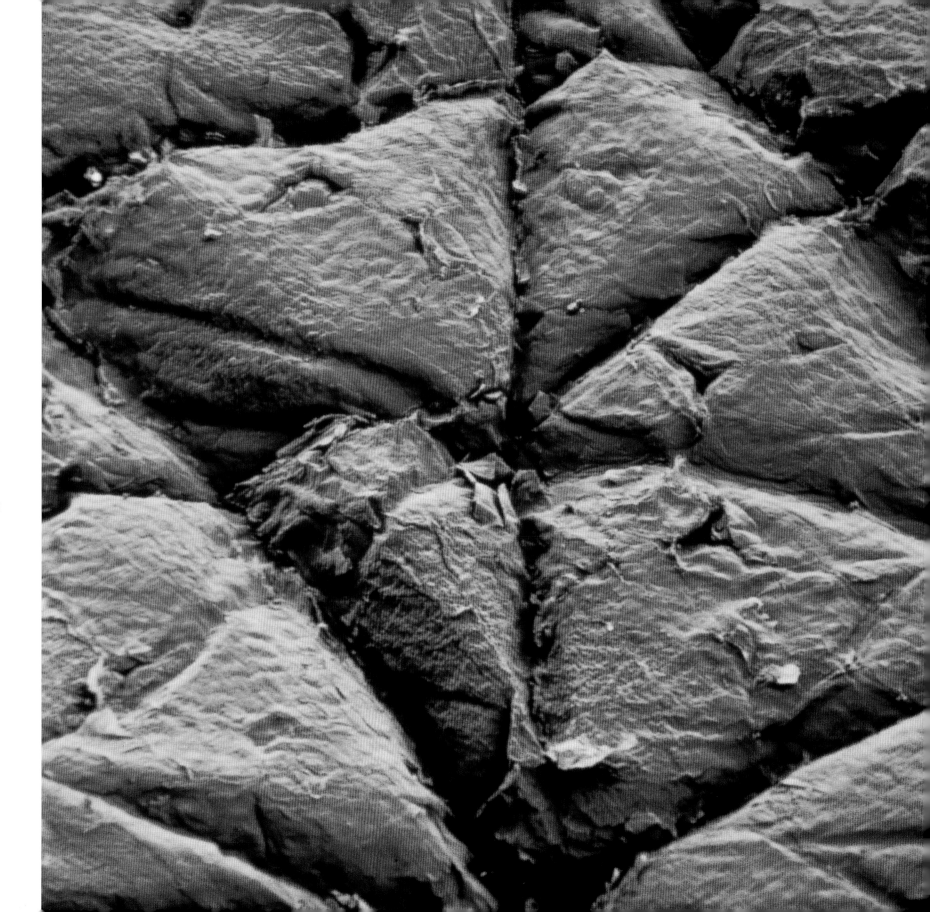

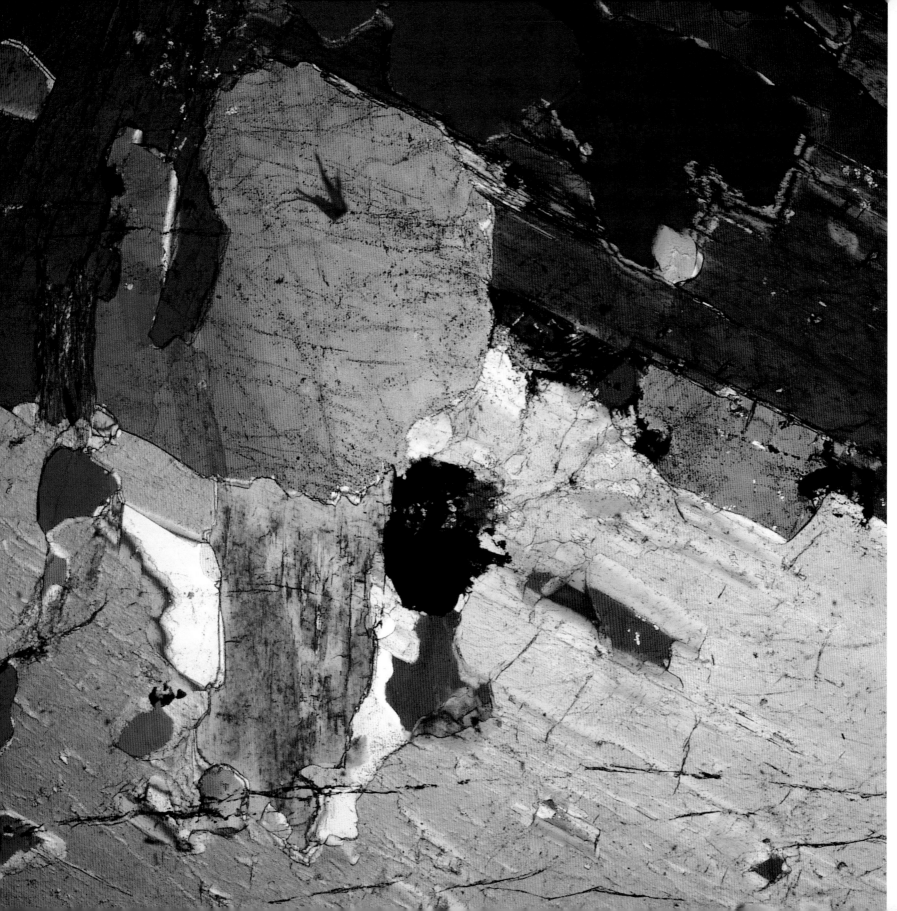

Hornblende

This light micrograph of the mineral hornblende is taken through crossed polarizing filters, at a magnification of approximately 300 times. To the naked eye, hornblende looks greenish-brown to black. The vivid colours seen here under the microscope are the result of a phenomenon known as birefringence, where crystals rotate the plane of vibration of light as it passes through them. This technique helps geologists to discriminate between different minerals under the microscope. Hornblende is a very common silicate mineral found in rocks such as granite, basalt and gneiss.

right

Tartaric acid crystals

Crystals of tartaric acid are viewed here through a stereomicroscope in cross-polarized light and magnified 250 times. Tartaric acid is an organic chemical that occurs naturally in grapes and other fruits, and forms the sediment in aged wines. Most commercial tartaric acid is obtained from the by-products of wine-making. It has a wide range of industrial uses including carbonated drink and jam production, metal polishing, wool dying, and photographic development and printing processes.

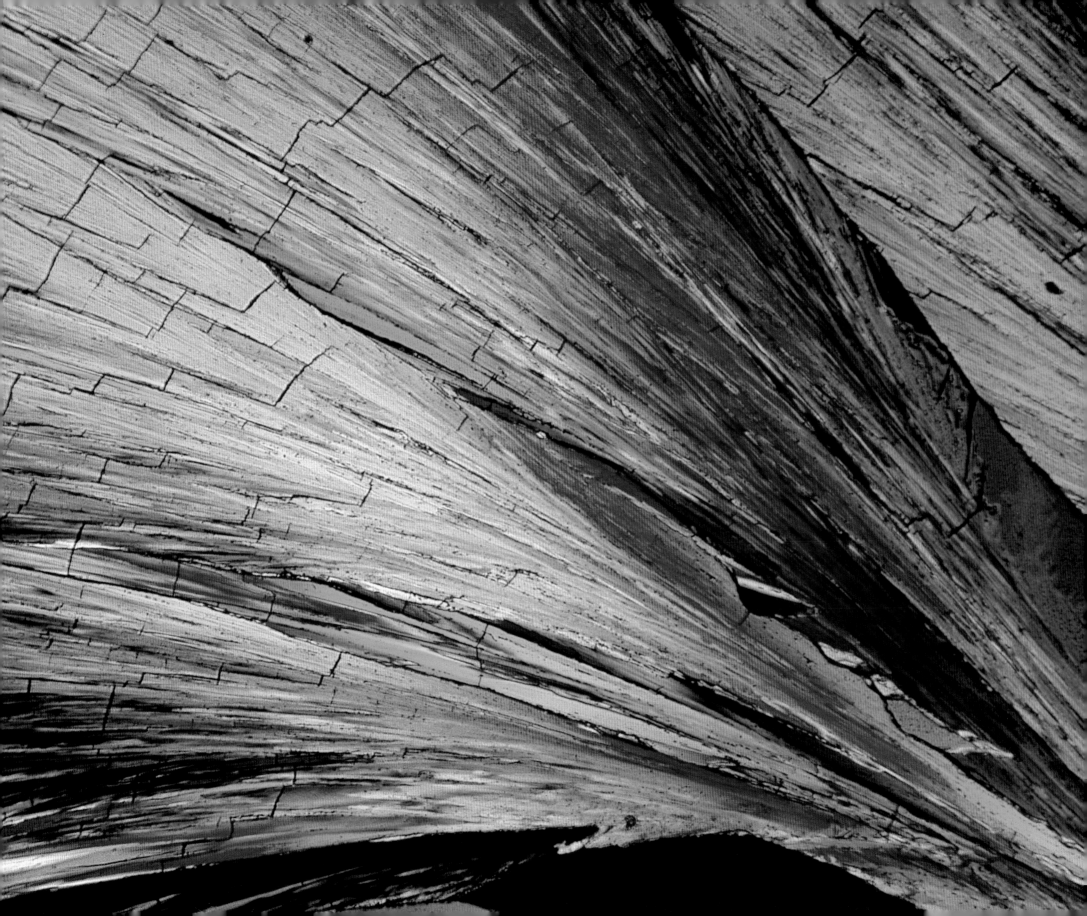

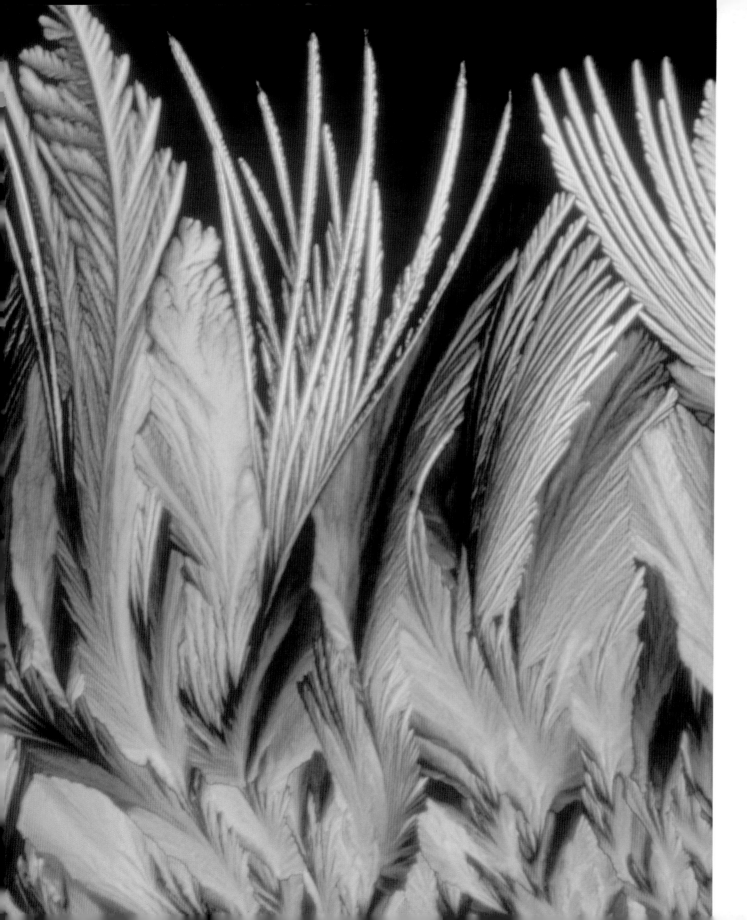

Vitamin C

This light micrograph at a magnification of about 250 times reveals the feathery patterns made by vitamin C as it crystallizes out of solution. In normal light the crystals are colourless but here, in polarized light, they appear in colours that reveal their thickness and orientation. Vitamin C has many important functions in the body. It is essential for growth and the maintenance of the body's structural materials such as teeth and bones, helps protect DNA from damage and stimulates the immune system against infection.

right

Meteorite

The Allende meteorite fell to the ground in Mexico in 1969. This cross-polarized light micrograph of a section through it, at a magnification of 200 times, shows that it is composed of small spherical mineral grains known as chondrules. This is typical of the most common group of meteorites, the chondrites or stony meteorites. The chondrules probably existed as independent particles in space before clumping together to form the meteorite.

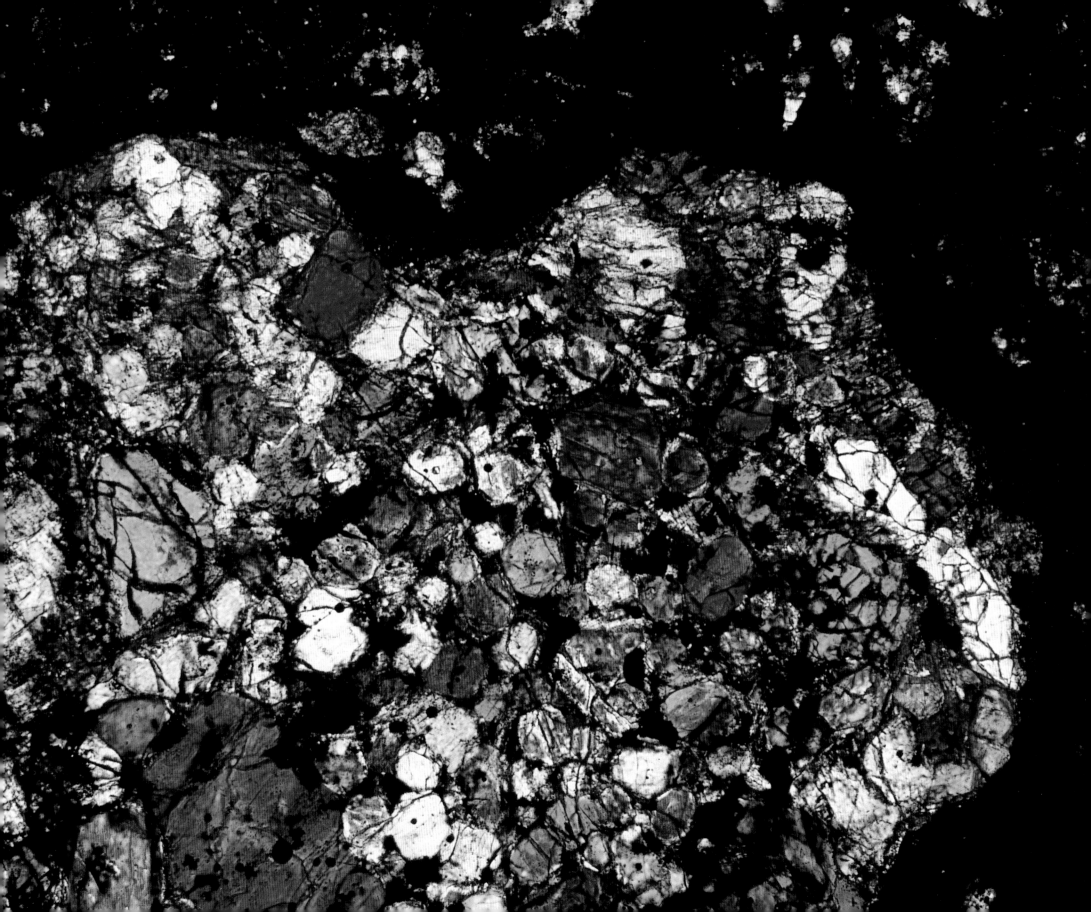

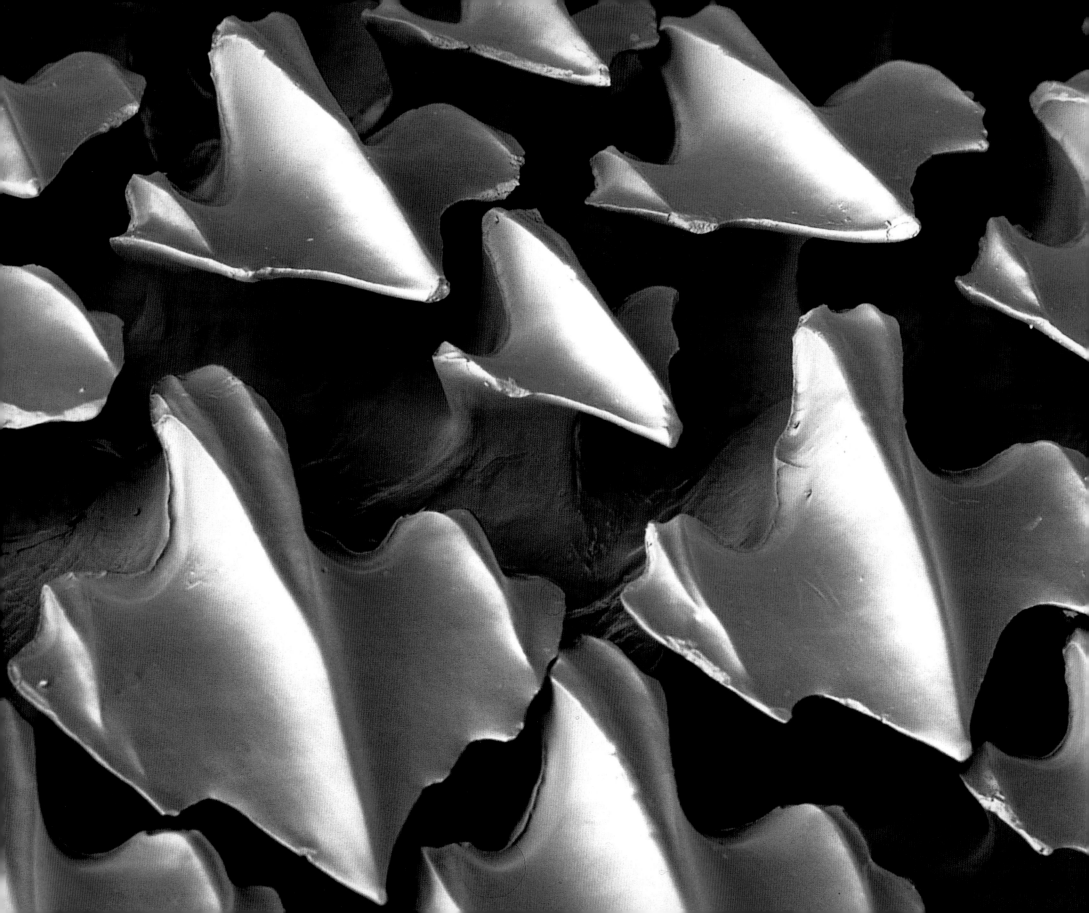

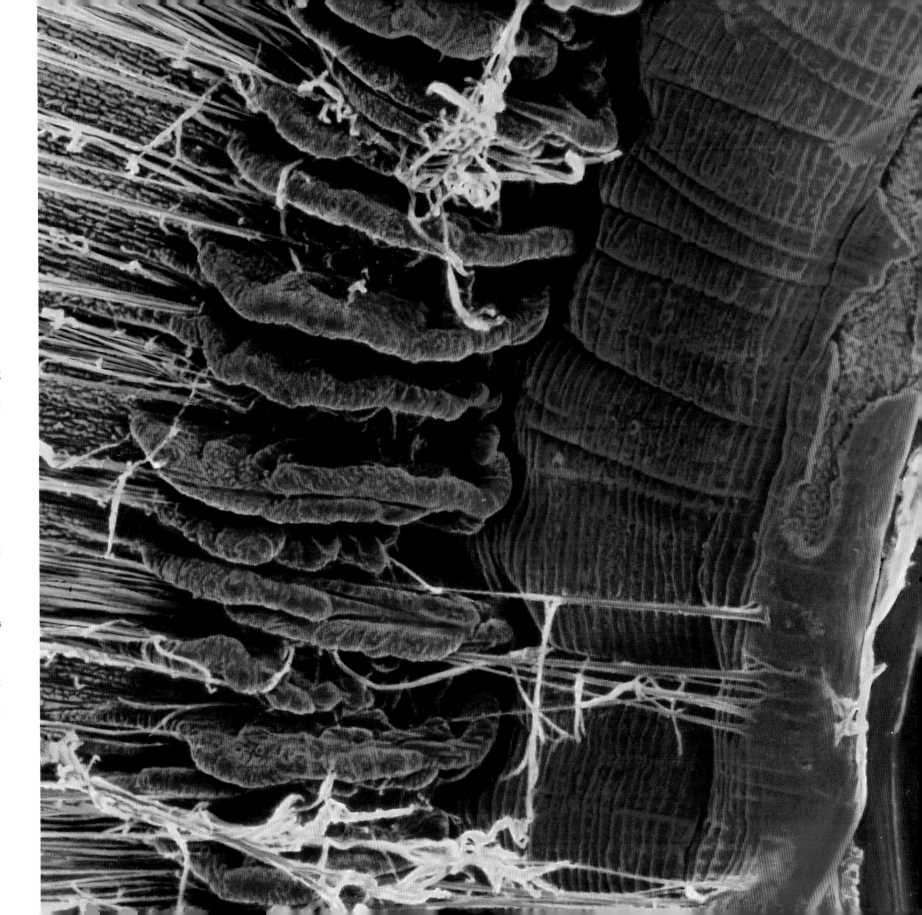

left

Shark scales

This scanning electron micrograph reveals the rows of minute scales that cover the skin of sharks, magnified 200 times. These scales are also known as dermal teeth (skin teeth) because they share their structure and evolutionary origin with the rows of sharp teeth in a shark's mouth. Rooted in the lower layer of skin and forming a backward-pointing spine, each scale has a central pulp cavity surrounded by a thick layer of dentine, and an outer coating of enamel.

Iris of an eye

This scanning electron micrograph showing part of the iris, the area of the eye around the central pupil, is magnified 170 times and has been coloured to reveal the structures more clearly. The iris is made of smooth muscle. It controls the size of the pupil (far right, blue), and therefore how much light enters the eye. The band of folds (red) around the inner edge is where the filaments (yellow and green) that suspend the lens are attached. If you look closely at your eye in the mirror, you will see the radiating pattern that is shown in detail here.

85 Beneath the surface

Snowflake crystal

Individual snow crystals vary considerably in size. This example, magnified 170 times, was large enough to be photographed using a macro lens rather than a microscope. Snow crystals sometimes fall singly, particularly when the air temperature is well below freezing, producing very fine powder snow. At temperatures close to freezing the ice crystals often clump and freeze together to form large, aggregate snowflakes that can grow to be several centimetres across.

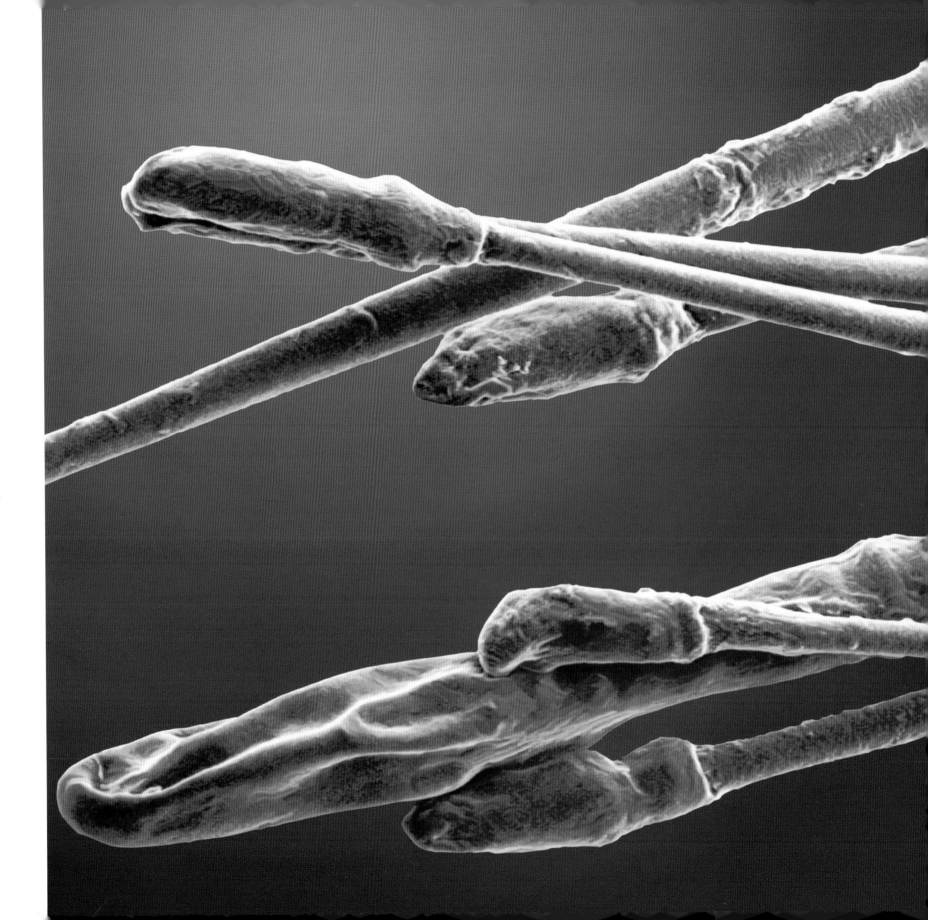

Eyelashes
This is a view of human eyelashes seen at a magnification of 200 times. Eyelashes help keep dust and debris away from the delicate eyes. They are among the slowest-growing hairs on the body, growing at just 0.16 millimetres per day. As they grow, new hair cells are added to the base of the hair, while the cells above die. The enlarged bulb seen here at the root of each eyelash contains the matrix of dividing cells.

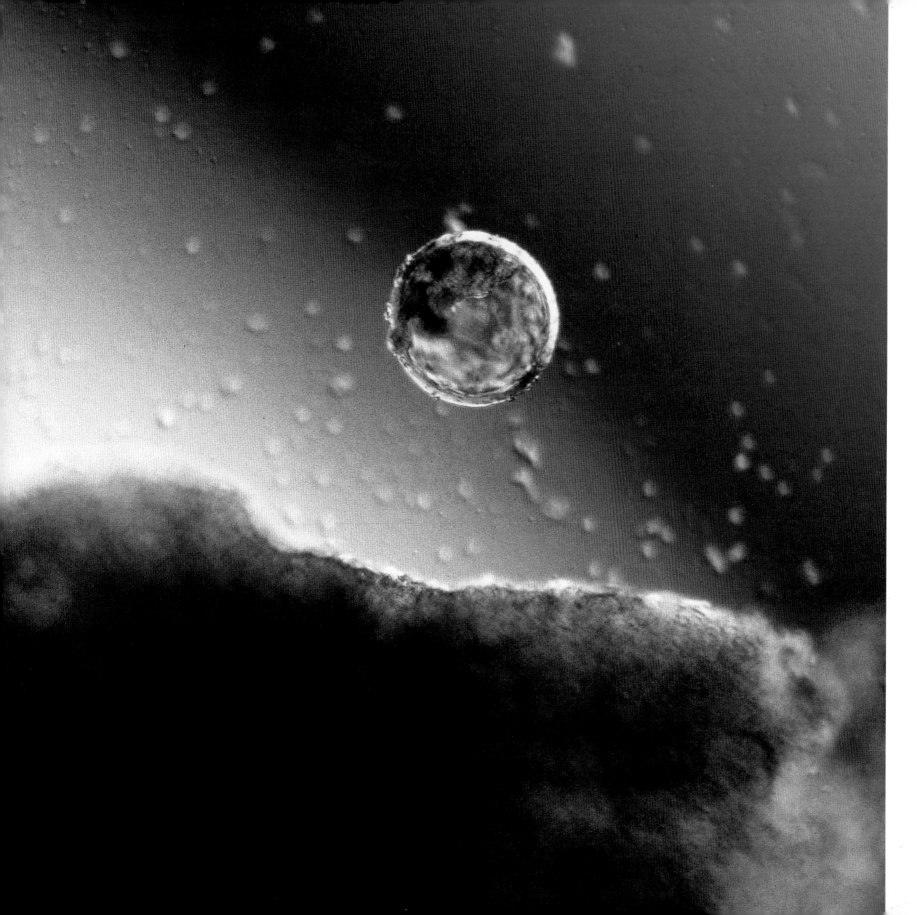

An egg in the Fallopian tube
In life, after its release from the ovary, the mammalian egg is swept into the entrance of the Fallopian tube. It is moved slowly along the tube by the wafting of millions of hairs, and muscular contractions of the tube walls. If the egg is fertilized here, it divides and grows into a bundle of cells (a blastocyst) that after about six days finds its way to the uterus where it implants in the uterine wall and develops into a fetus. This light micrograph shows the egg at a magnification of 430 times.

right
Gecko foot pads
Geckos (family Gekkonidae) are night-hunting lizards found in a wide variety of habitats. This coloured scanning electron micrograph, taken at a magnification of 130 times, shows the complex pattern of ridges and minute hairs that covers the gecko's foot. These tiny structures give geckos an amazing ability to climb, enabling them to walk up and across ceilings and even cling to glass, finding footholds in the microscopic imperfections of the smoothest surfaces.

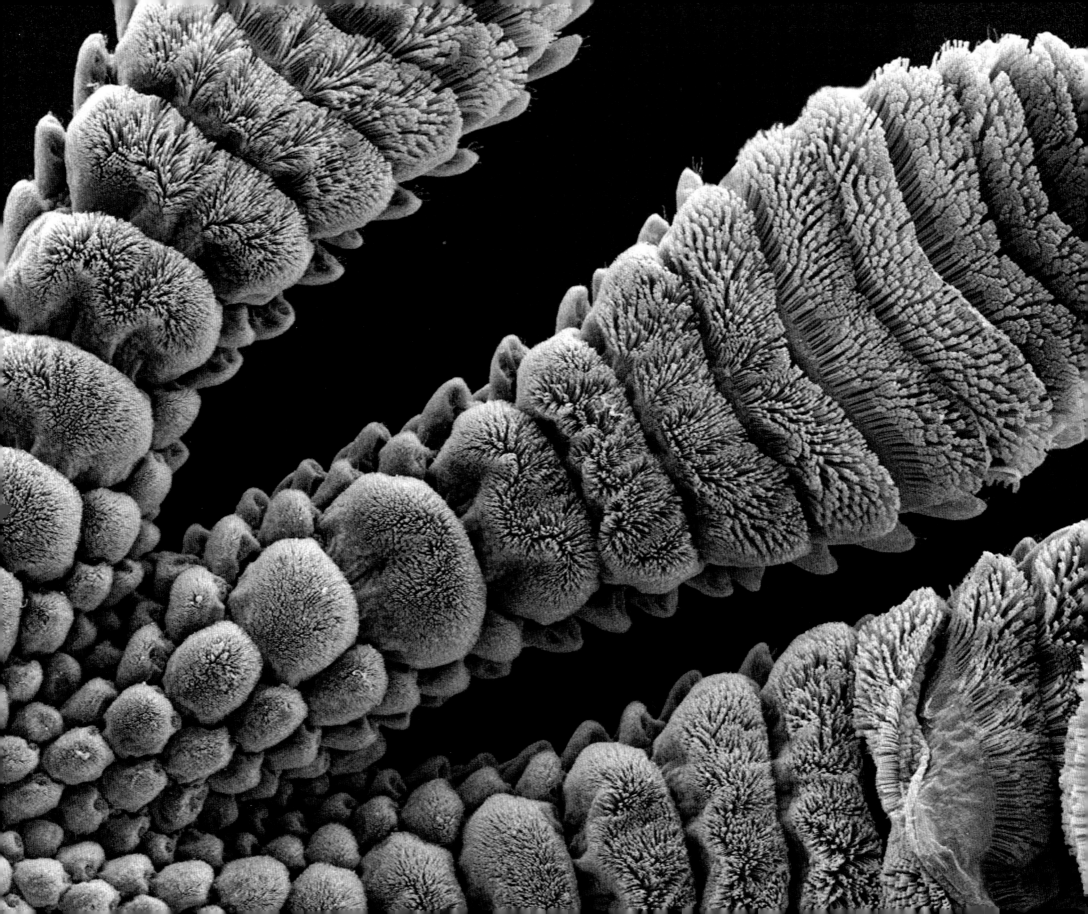

Blood vessels

This is a resin cast of blood vessels viewed with a scanning electron microscope at a magnification of 130 times. The cast was made by injecting resin into the vessels and removing the surrounding tissues once hardened. The smallest vessels, capillaries, branch off the main vessels, forming networks that carry blood into the tissues. Oxygen and nutrients pass through their permeable walls and into the tissues. Waste products, including carbon dioxide, pass back to be carried away.

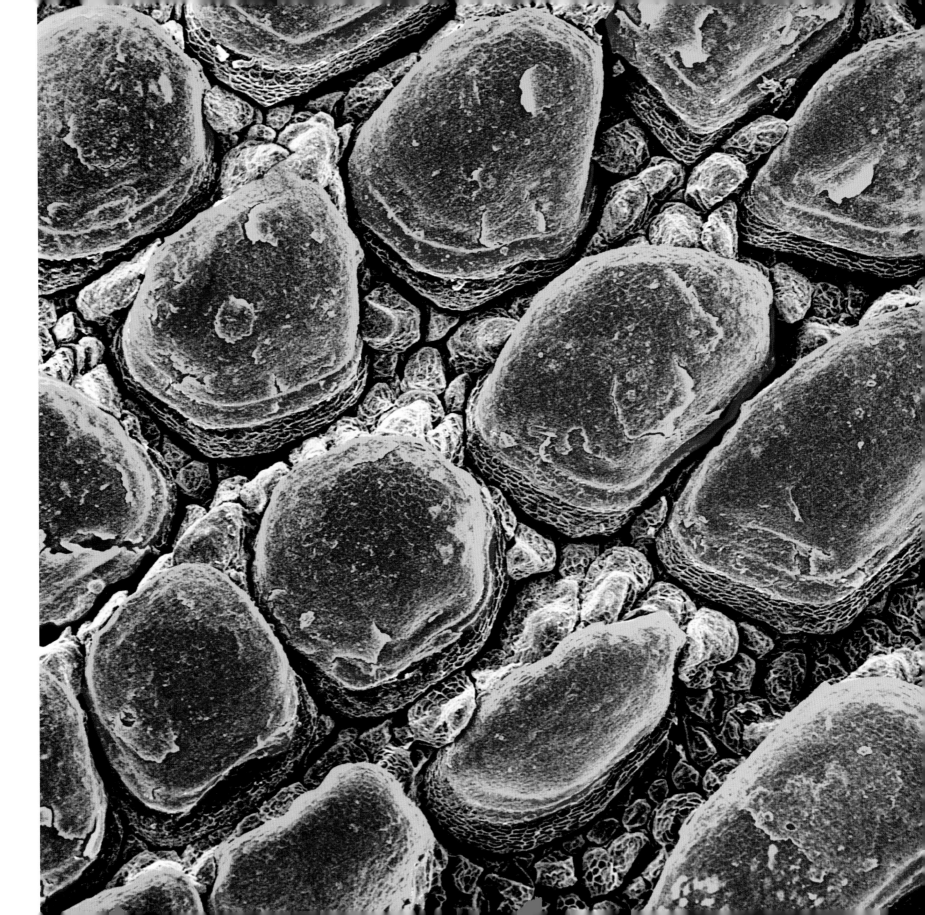

Iguana skin
The shed skin of an iguana
shows its raised scales.
These scales, typical of reptile
skin, are actually folds of skin
hardened with keratin,
the protein also found in hair
and fingernails. They form a hard
yet flexible surface that protects
the iguana from predators.
The scales also help prevent
water loss, allowing reptiles to
live in much drier environments
than the amphibians from which
they evolved. This scanning
electron micrograph shows
the scales magnified 100 times.

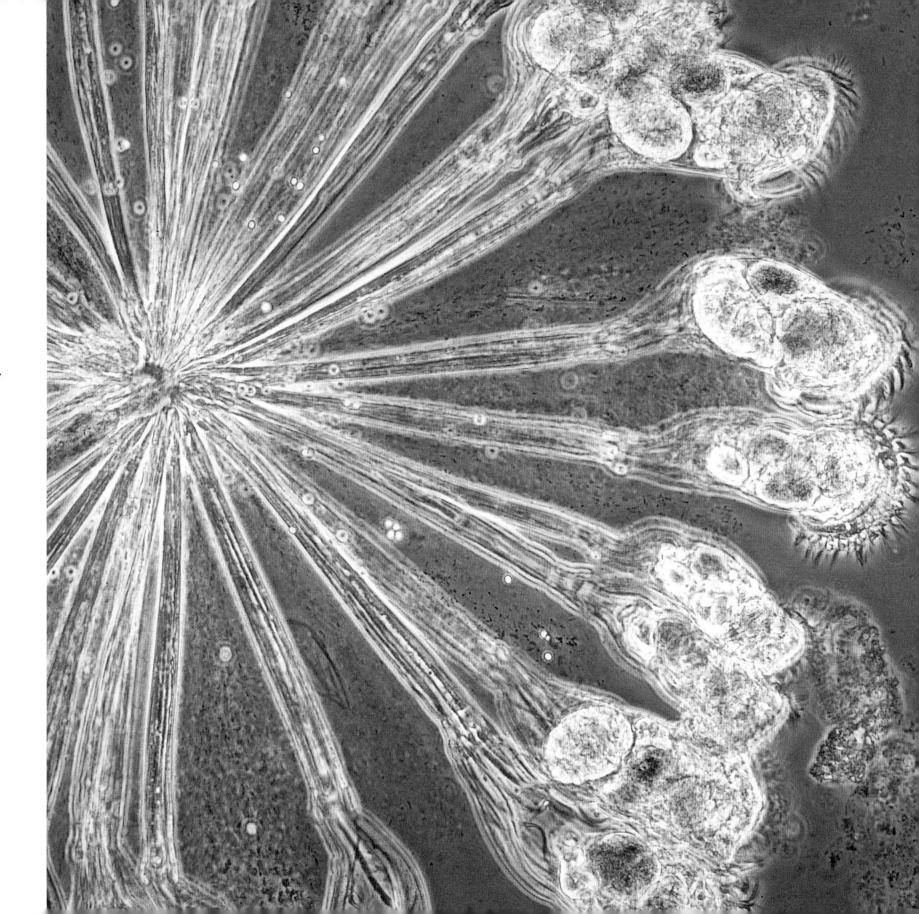

Rotifer colony

A colony of rotifers belonging
to the common pond-dwelling
species *Conochilus hippocrepi,*
is magnified 100 times under
a light microscope. The colony
is composed of between
50 and 100 individual
multicellular animals attached
to a central point, with their
bodies radiating outwards.
A ring of beating hair-like cilia
around the flattened top
of each animal draws food
particles in towards its mouth.
The colony swims through
the water by coordinating
the beating of these cilia.

House fly
This is a scanning electron micrograph of a house fly's head magnified 100 times. Its large compound eyes are made up of many hexagonal lenses. Behind each of these is a long cylindrical unit, containing the equipment needed for light detection, called an ommatidium. The insect's brain creates an image by compiling the signals received from each ommatidium. In some ways this is analogous to how the picture on a television screen is created from spots of light.

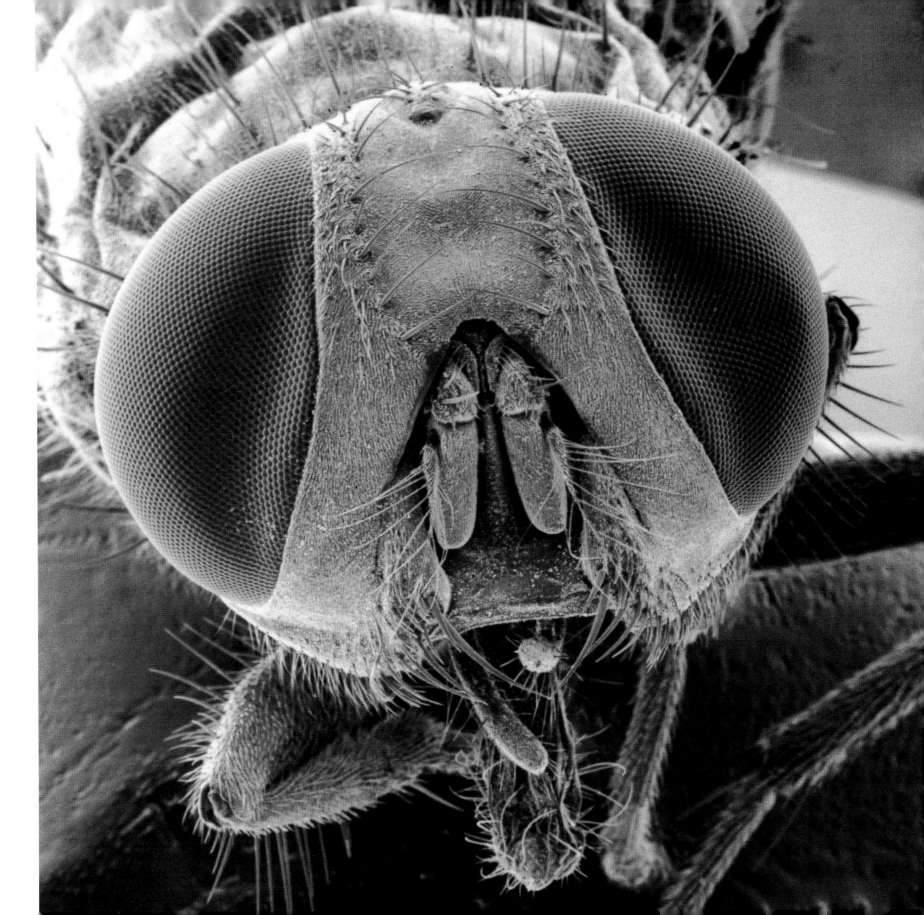

Pigment cells

These three light micrographs
show skin pigment cells,
or melanocytes, from three
ethnic groups, Black, Asian and
Caucasian, magnified 85 times.
These are artificially grown
cultures, but the cells are
identical to those found
naturally in skin. Melanocytes
are concentrated in the outer
layer of skin, the epidermis.
They produce the pigment
melanin, which gives skin its
colour. Melanin darkens the skin
to protect the layers beneath
from the harmful effects of the
sun's ultraviolet radiation. The
amount of melanin produced is
determined by both genetic
factors and exposure to sunlight.

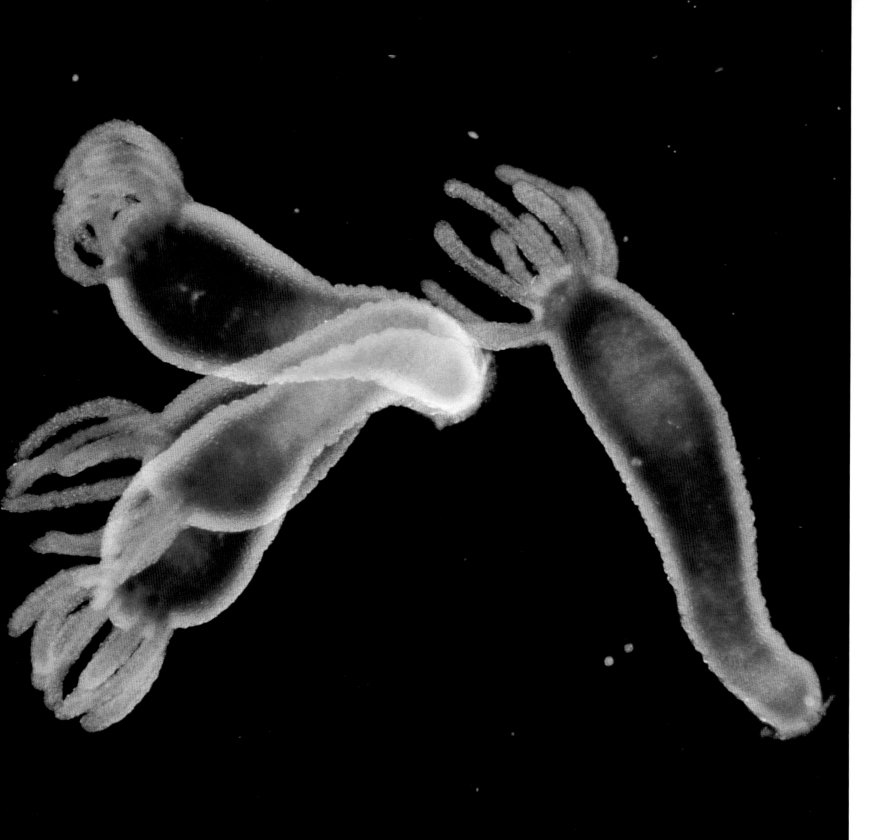

left
Hydra

This photograph was created
by taking several exposures
through a microscope at a
magnification of 85 times,
to show how the organism *Hydra*
moves along. *Hydras* are simple
multicellular creatures that live
at the bottom of lakes, ponds
and streams, anchored by their
base. At the other end their
mouth is surrounded by
tentacles with which they catch
prey. *Hydras* move around
by floating or somersaulting
to a new location. This one is
bending its body and tentacles
and starting to somersault.

Marram grass

This light micrograph of
a marram grass leaf in cross
section, magnified 85 times,
reveals a number of adaptations
that reduce the rate of water
loss by the plant. The leaf is
rolled up along its length, and its
inner surface is convoluted and
covered with hairs to trap humid
air. The outer surface of the
rolled leaf has a thick waxy
coating and no pores. These
attributes help marram grass
to survive in dry environments
such as sand dunes.

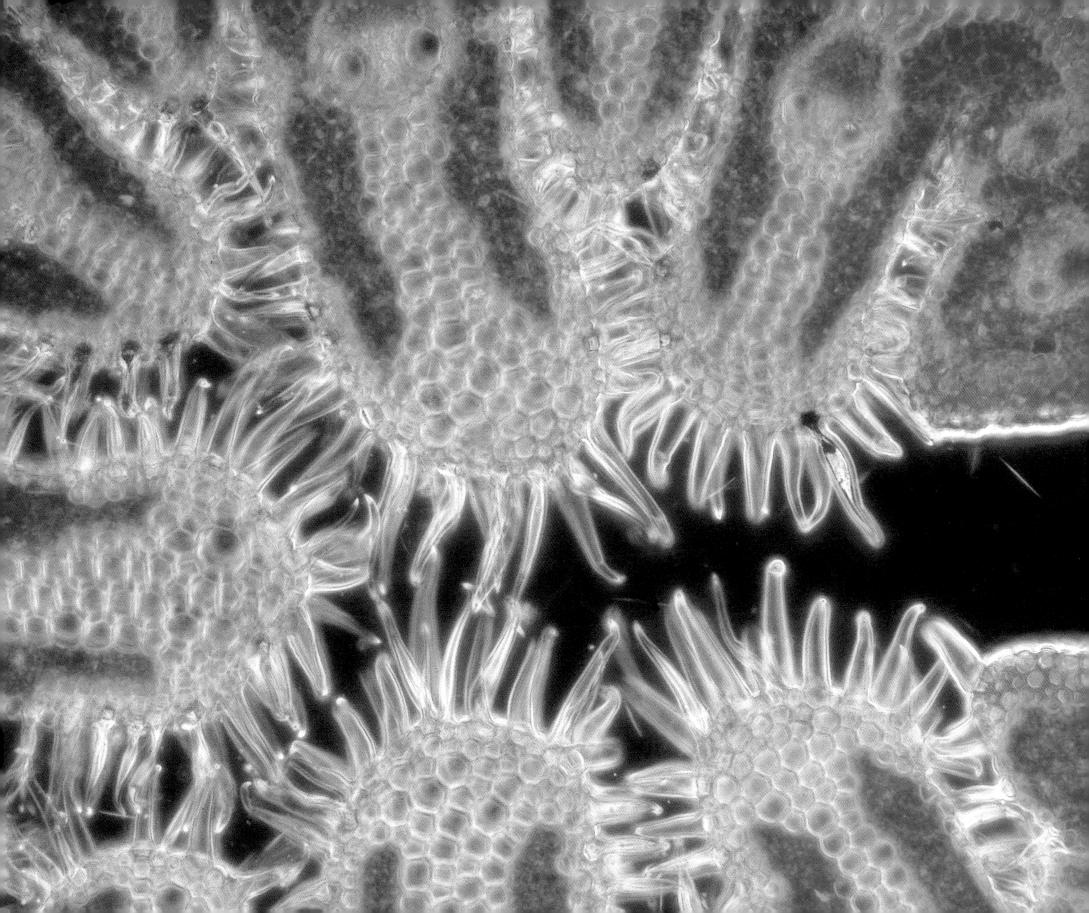

Volvox colonies

The elegant spherical colonies of the single-celled organism *Volvox* are seen here magnified 85 times under a light microscope. Each colony is composed of hundreds of individuals. Each organism has two whip-like flagella for locomotion – a characteristic of animals – but also possesses chloroplasts for photosynthesis, like plants. The colonies live near the surface of lakes and ponds where there is enough light for photosynthesis. The cells divide to form genetically identical daughter cells, which collect into new colonies – visible as spheres within the spheres.

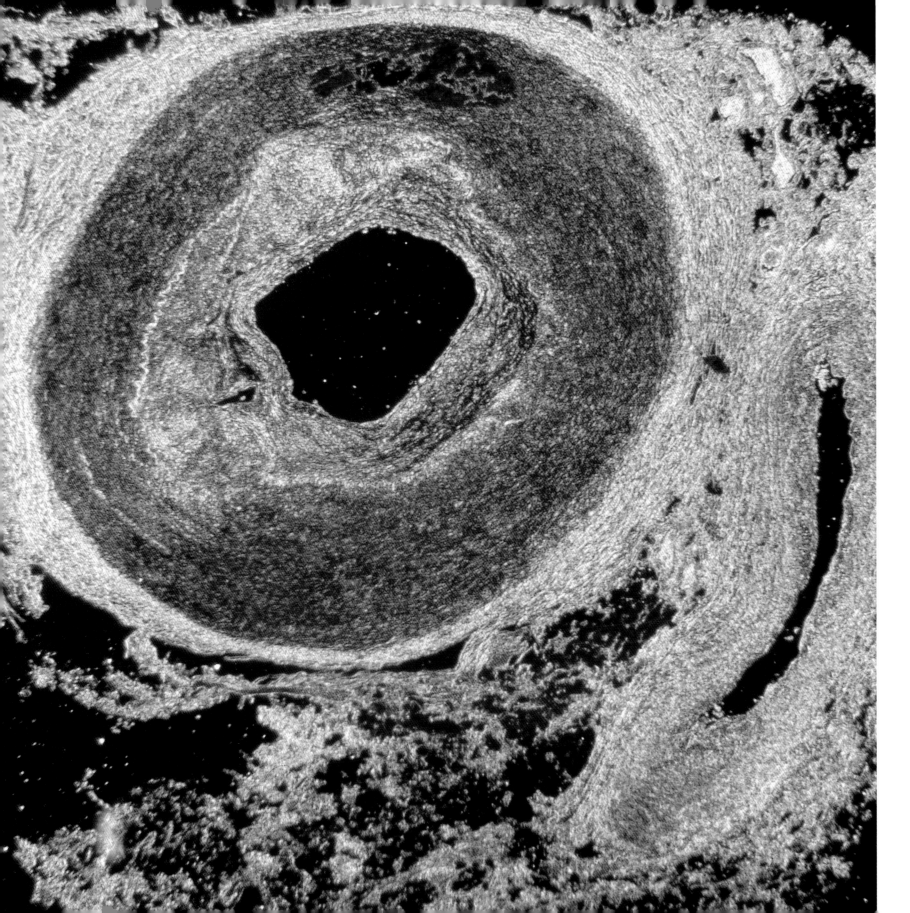

Narrowed artery

This is a cross section through a human artery, magnified 64 times using a light microscope. The central lumen of the artery (black), where blood flows, has been narrowed by layers of fibrous, fatty deposits around the inside of the muscular walls. This appears as a ring of grainy and irregular material. Narrowed arteries are mainly caused by a diet high in saturated fats, but are also a natural consequence of ageing. The impaired circulation can lead to thrombosis, high blood pressure, angina and heart attack.

In this chapter the objects begin to look familiar, although some are still substantially magnified. They are things we can normally see without the aid of instruments, but here, due to the way they are photographed, they appear very different. The human eye contains millions of rod and cone cells, which convert light into electrical signals that are sent to the brain via the optic nerve. An extraordinarily complex and sophisticated instrument, the eye's powers are, however, massively restricted. First we require light to see. Light is a small slice of energy contained in an infinite spectrum of electromagnetic waves that constantly vibrate around us. Heat, ultraviolet and x-rays also form part of the spectrum and are used to create images that are just as real as those we see with a naked eye.

Unlike a house fly or a bee, we cannot see in ultraviolet. Without the use of sophisticated instruments, we cannot see the bone structure of a living mole, inside the workings of the human body, the energy contained in a fingertip, or the facets that make up the eye of a dragonfly.

With the use of x-rays – which, unlike light, pass through matter – we can diagnose broken bones and varicose veins. With the use of computerized axial tomography, or CAT scans, we can record images of internal anatomy from different angles. This method of imaging has revolutionized medicine, especially neurology, by facilitating the diagnosis of brain and spinal cord disorders. With the use of infrared imaging we can see how the temperature of an ice cube changes as it melts; with ultraviolet we can visualize how a fly might see a spider in its web; while ultrasound enables us to study the development of a fetus in the womb.

Arranged in order of magnification and captured through a range of different techniques, *Just out of reach* shows us images of things we see everyday, but in a totally different light.

Just out of reach

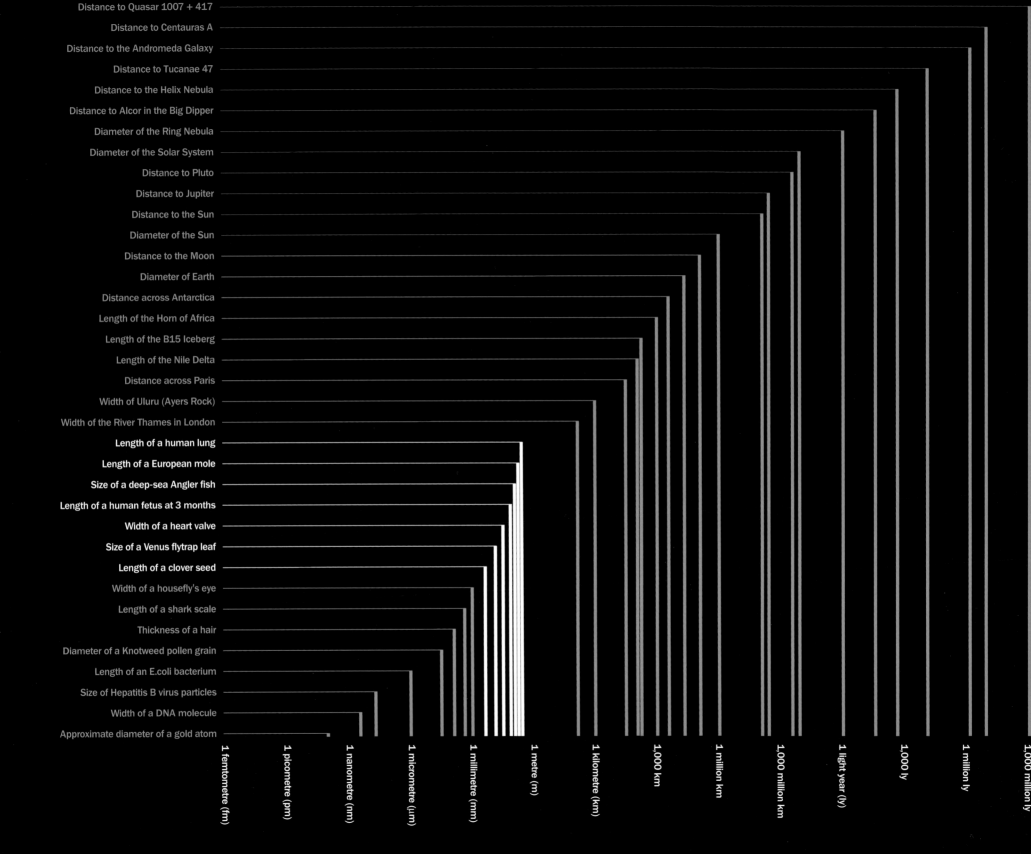

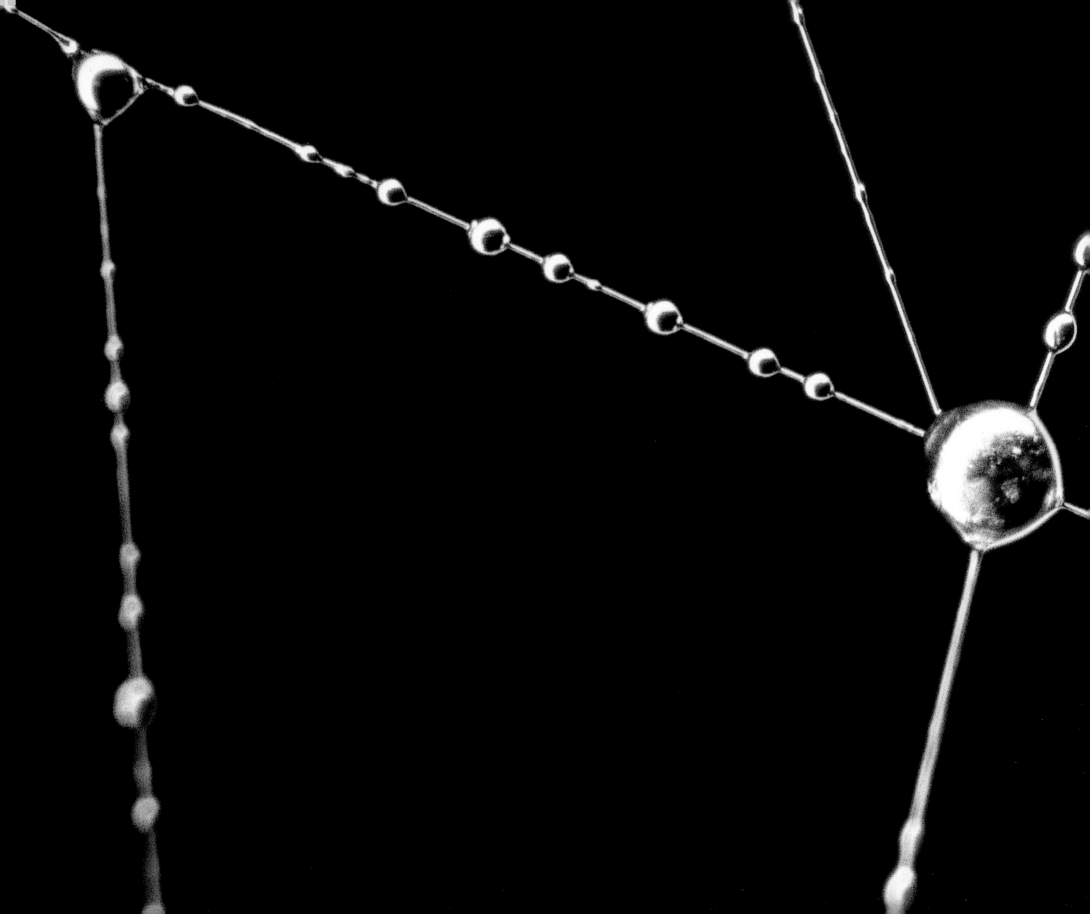

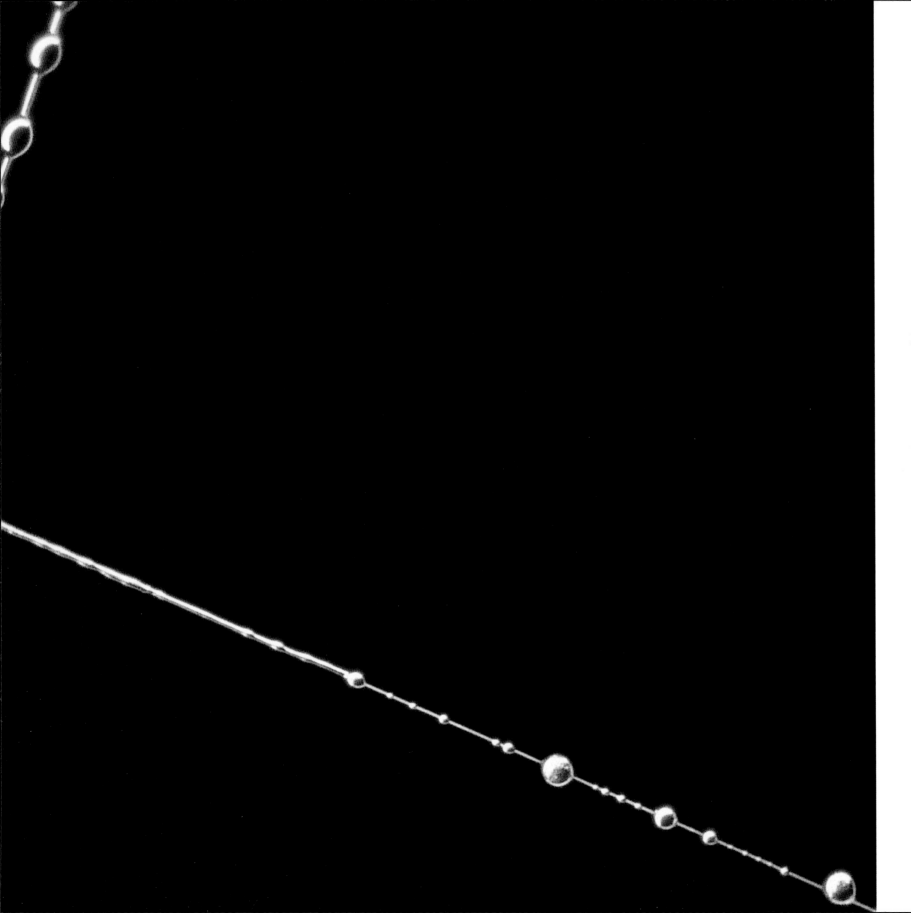

Spider silk
This light micrograph shows silk lines spun by an orb web spider, magnified 53 times. The silk is secreted as a liquid from glands in the spider's abdomen, and hardens as it is drawn out through the spinnerets. A single thread is composed of several proteinaceous fibres, giving it strength and elasticity. Each thread has a sticky outer coating, which helps trap prey. The round beads seen here are made of a gum that helps to keep the silk sticky by slowing down drying.

Fingerprint

This macrophotograph shows the ridges of skin, whose unique pattern makes up a person's identifying fingerprint and gives the fingers grip. Magnified about 50 times, the tiny depressions visible on the ridges are sweat glands which go down into the lower layers of the skin, the dermis. They secrete sweat, a solution of salt and urea, which serves to cool the skin by evaporation and to get rid of waste substances.

Martian meteorite

Meteorite ALH84001 is a Martian meteorite that fell to Earth in Antarctica 13,000 years ago. Researchers caused a storm of controversy in 1996 when they announced the discovery of structures in the meteorite that looked like fossil bacteria – the strongest evidence yet for the existence of life on Mars. The orange stains in this macrophotograph, 100–200 micrometres across, are carbonate minerals that precipitated out of water some 3.6 billion years ago, when Mars was a geologically active planet with a thick atmosphere and abundant surface water. It is these carbonates that contain the bacteria-like structures.

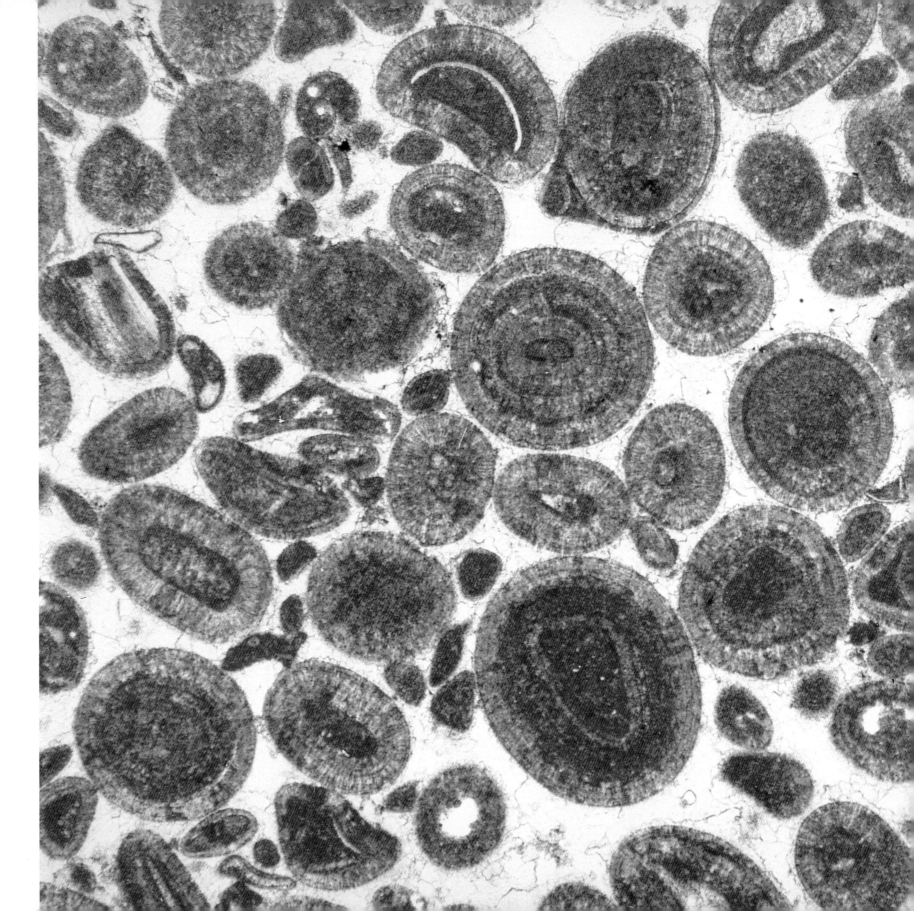

Oolitic limestone

This light micrograph shows a section through an oolitic limestone, magnified 50 times. This type of limestone is made up of spherical structures called ooliths, which formed millions of years ago in shallow tropical seas. Sedimentary particles (such as grains of sand) were repeatedly rolled by wave action through warm, carbonate-rich waters. Concentric layers of calcium carbonate precipitated around the grains. The ooliths are embedded in carbonate mud and this deposit gradually turned into rock.

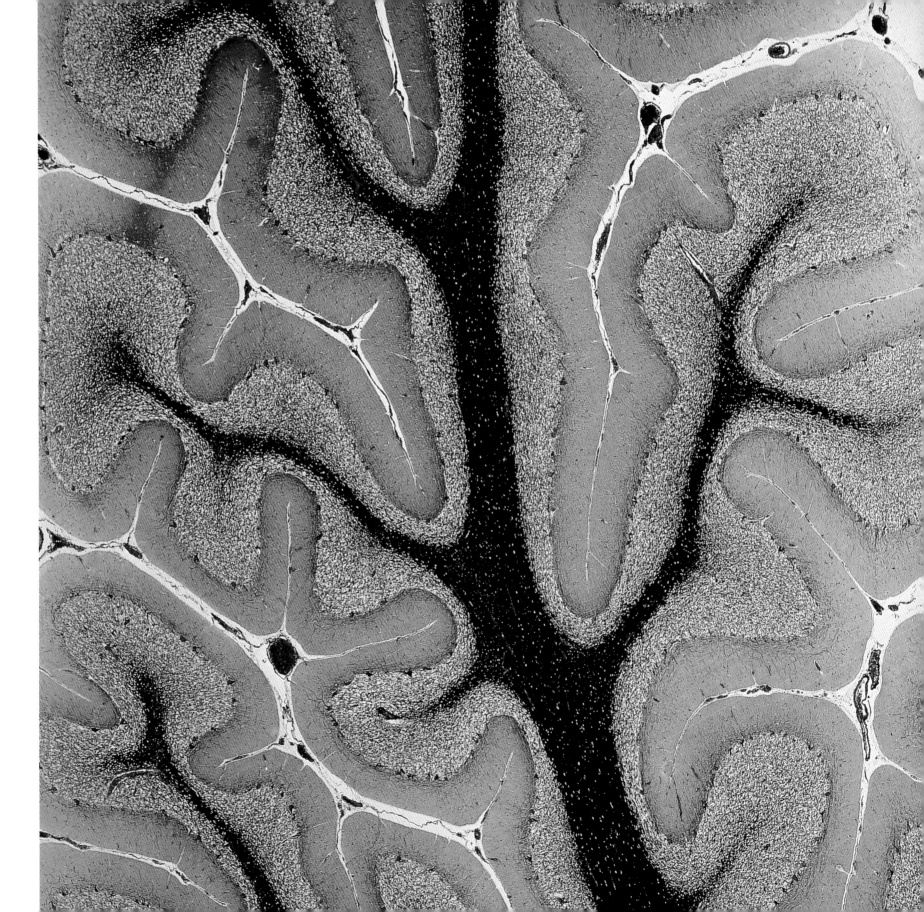

Human cerebellum
This light micrograph shows a stained section of healthy human cerebellum, magnified 40 times. Responsible for controlling movement and balance, this part of the brain has a deeply folded surface and sits towards the back of the head beneath the cerebrum, the two main hemispheres of the brain. The cortex, or outer layer, of the cerebellum is divided into an outer region (pale orange, grainy stain) containing nerve fibres, and an inner layer (smooth orange stain) of nerve cells. The branching pale tissue consists of bundles of nerve fibres.

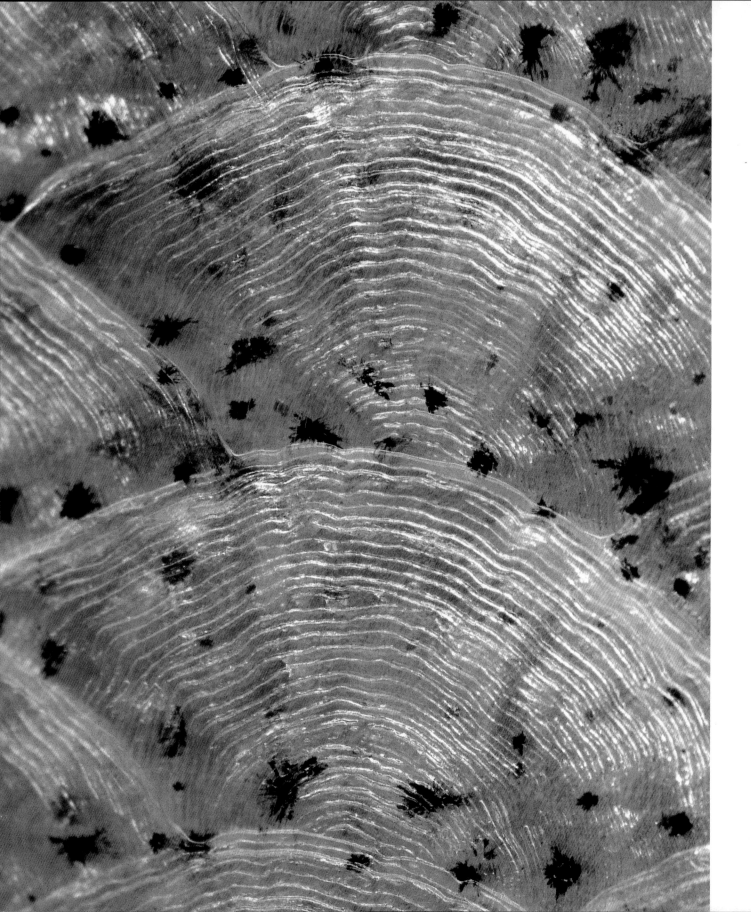

Fish scales

The overlapping scales of the cisco or lake herring (*Coregonus alba*), a freshwater fish from North America, are magnified 35 times in this photograph. The scales grow throughout the fish's life, increasing in size with the fish. As each scale grows it forms a concentric pattern of ridges. The ridges are close together during winter when growth is slow, and more widely spaced in summer when growth is faster. The number of winter growth ring sets gives the fish's age, just as the growth rings in a tree trunk give a tree's age.

right
Mosquito biting

This scanning electron micrograph shows a female *Aedes* mosquito in the act of plunging her piercing mouthparts into human skin. Razor-sharp blades at the end of the mosquito's tube-shaped mouthparts pierce the skin and blood passes up the tube, while brush-like organs secrete saliva into the wound. The saliva contains anti-coagulants to prevent the blood from clotting while the mosquito is feeding. Only female mosquitoes bite; their eggs need proteins from blood to develop. A mosquito can suck up its own weight in blood – about five milligrams – and still fly off with ease. The mosquito is magnified 35 times.

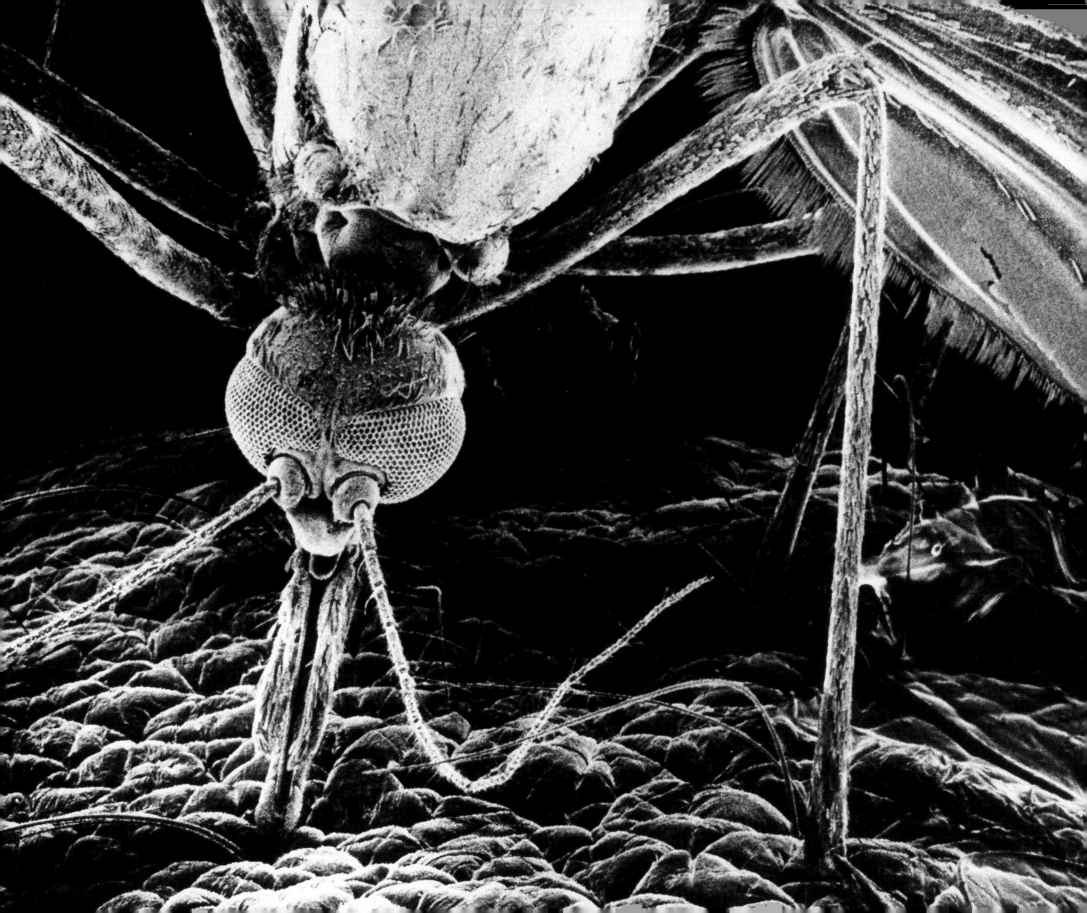

Leaf veins

Part of a leaf of lady's mantle (*Alchemilla vulgaris*) is photographed here, showing the network of veins. Veins are often encased in layers of tough, lignin-reinforced cells, which provide a stiff framework to support the broad, flat leaf surface. They also carry water and minerals to the photosynthesizing cells in the leaf, and remove the food sugars produced. The veins branch repeatedly, ensuring that no photosynthesizing cell is more than two cells away from a vein. The leaf is shown at about 30 times life size.

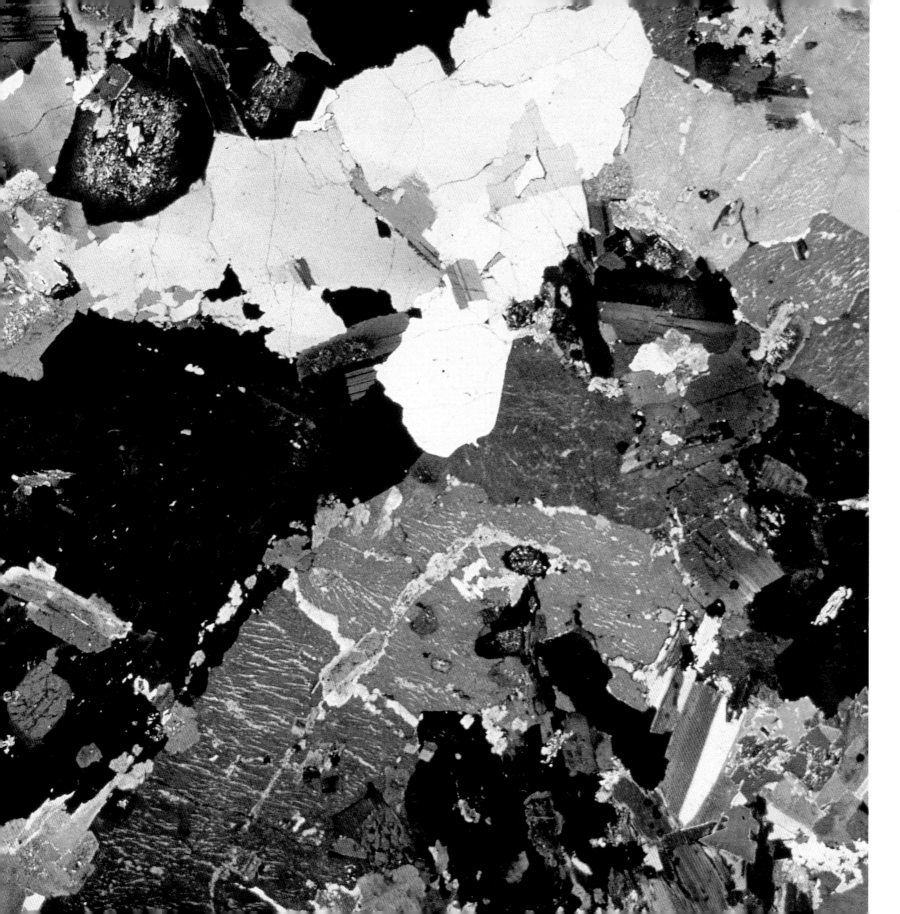

Cornish granite

A thin section of granite from Cornwall is viewed under a microscope in cross-polarized light, and is magnified 20 times. Thin section microscopy allows geologists to identify the mineral crystals that make up rocks, by revealing their distinctive properties of colour, pattern and shape. The crystals here in black, white and grey are quartz, the mid-grey crystals with veins of white are feldspars, and the crystals showing the bright colours of red, green, blue and yellow are mica.

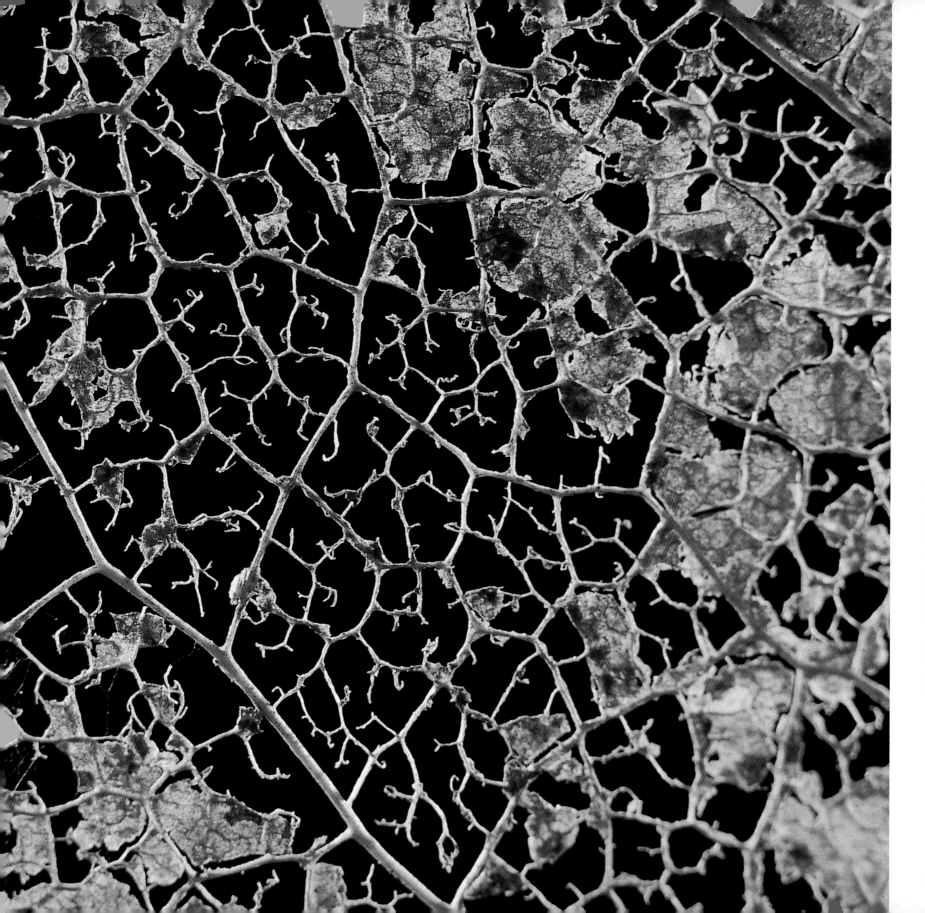

Leaf skeleton

This image is of a dead magnolia leaf, magnified 20 times. Bacteria and feeding insects have broken down the leaf tissue to leave an intricate latticework of veins – the leaf skeleton. The veins are more resistant to decay than the tissues in between as they are stiffened with lignin-reinforced cells. Each vein contains bundles of tubes which carried water and food to the cells of the living leaf.

right
Dragonfly eyes

This dragonfly belongs to the genus *Aeschna*, which includes some of the largest and most beautiful species of dragonfly known. Its most striking feature when photographed head-on is its large compound eyes. Each eye is made up of 30,000 facets. Each facet acts as a lens, focusing a point of light on receptors at the back of the eye. Although the resulting images are crude, the dragonfly eye is sensitive to rapid movement, enabling it to hunt fast-moving insects while flying.

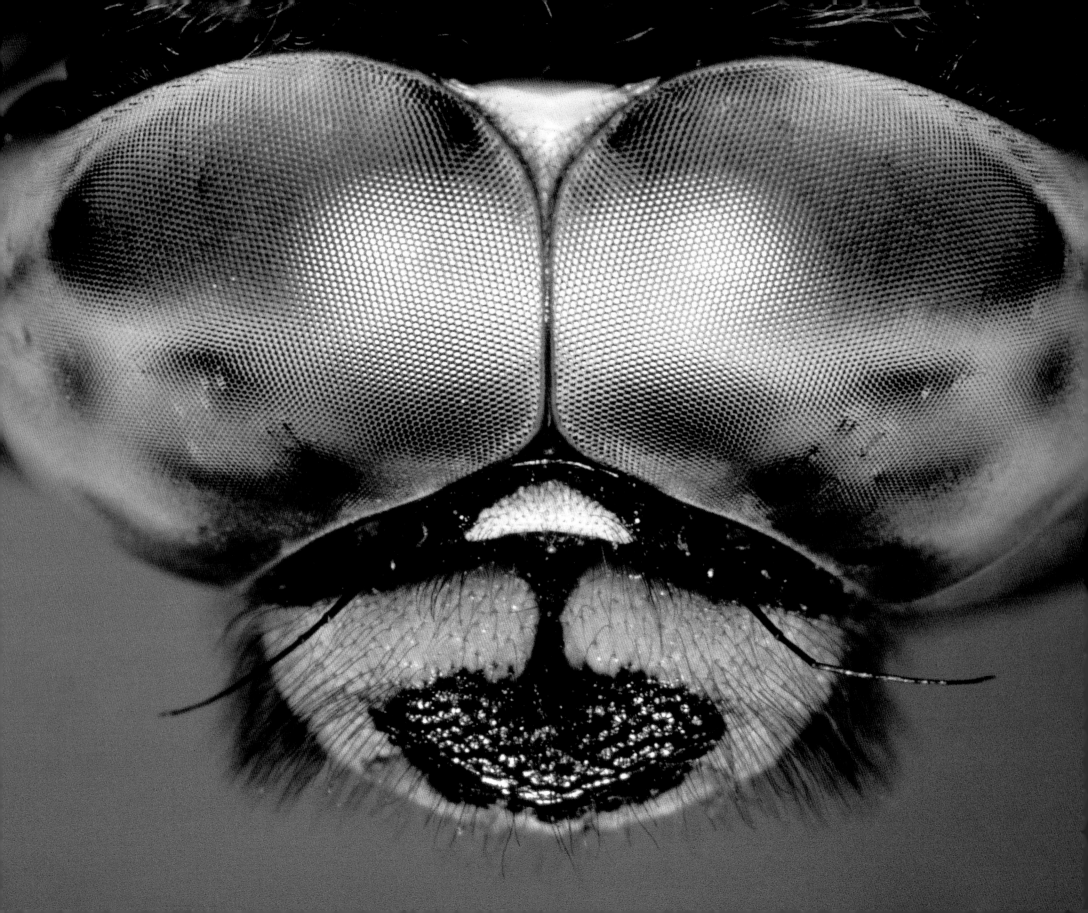

Wasp's nest

This photograph shows one of the regular hexagonal cells that make up the nest of a paper wasp (*Polistes gallicus*). The queen has laid a round, white egg inside. To make the paper cells, the wasps scrape wood from trees, fences and garden furniture with their strong jaws. They chew it up, mix it with saliva and spread it out. The queen is the only member of the colony to survive the winter. She builds a new nest in the spring, with up to 100 cells.

Hydromedusae

These tiny creatures are called hydromedusae, and are shown here about 17 times larger than life-size. Hydromedusae are among the simplest multicellular organisms. These examples live in the surface waters of the Atlantic, off northwest Africa (they were collected using a net towed along at the water's surface). They propel themselves through the water with rhythmic contractions of the swimming muscles in their umbrella-shaped body, controlled by a ring of nerve fibres around the body rim.

Clover seeds

These seeds, shown at about 17 times life-size, were photographed using dark field illumination. They belong to the hare's-foot trefoil (*Trifolium arvense*), a type of clover that grows to about 40 centimetres tall. The feathery appendages help the seeds to be carried on the wind, away from the parent plant. Germinating at a distance means that the young plants do not compete with their parent for resources, giving both a greater chance of survival. Like other species with wind-dispersed seeds, such as the dandelion and thistle, hare's-foot can spread quickly across large areas.

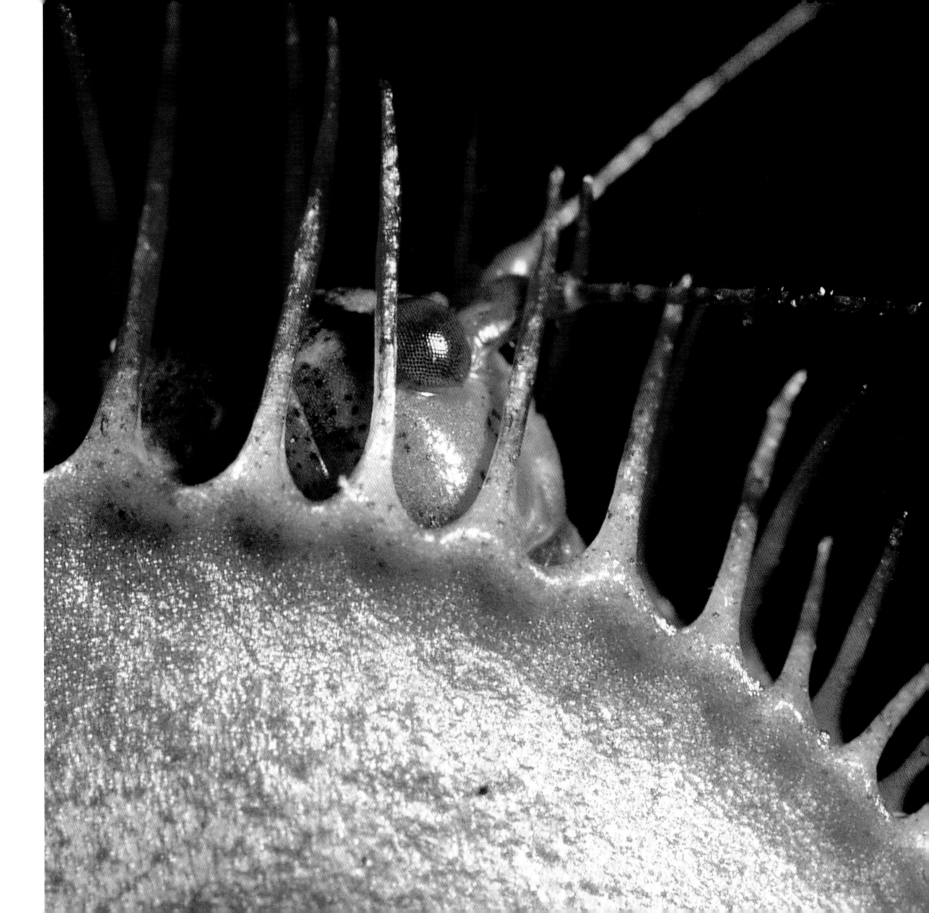

Venus flytrap
The head of an unfortunate bush cricket appears through the cage-like spines of a Venus flytrap (*Dionaea muscipula*), magnified 17 times. Flytraps and other carnivorous plants grow on extremely poor soils. They feed on insects as a way of gathering essential nitrogen and other missing nutrients. The flytrap's leaves spring shut in an instant when an unwary insect triggers touch-sensitive hairs inside the leaf. Enzymes digest the insect's soft parts, releasing nutrients to be absorbed by the plant.

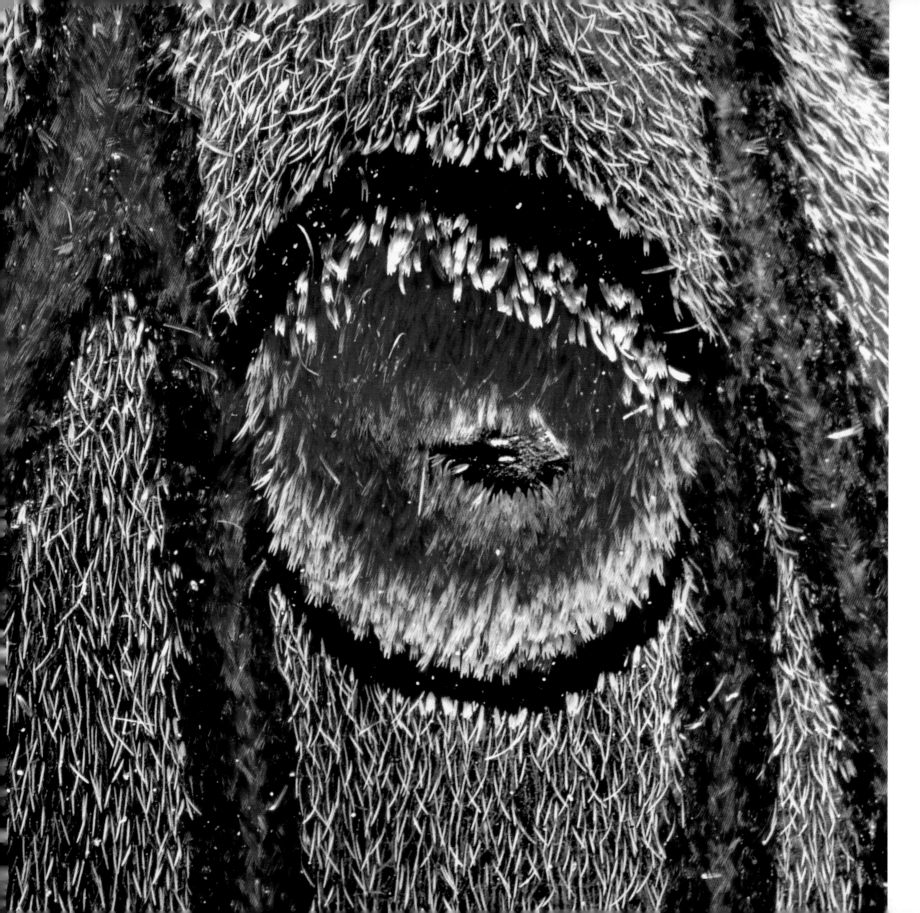

Moth wing

The wings of the Spanish Moon moth (*Graellsia isabellae*) bear patterns that look strikingly like eyes. This rare and protected moth, found in Spain and the French Alps, normally rests with its wings folded. When alarmed it spreads its wings, revealing a single 5 millimetre wide eyespot on each wing and startling any attacker by its apparent transformation from a moth to the head of a much larger creature. Eyespots are a common defensive device throughout the animal kingdom.

right
Frog spawn

This light micrograph shows the frog spawn of the European edible frog *Rana temporaria*, magnified 13 times. The male fertilizes the eggs externally as the female lays them in the pond. The eggs float in a tapioca-like mass at the surface. Their gelatinous coating protects the developing embryos from shock and drying out, and makes attack by predators more difficult. Tadpoles hatch from the eggs to live and grow in the water, gradually metamorphosing into amphibious adults.

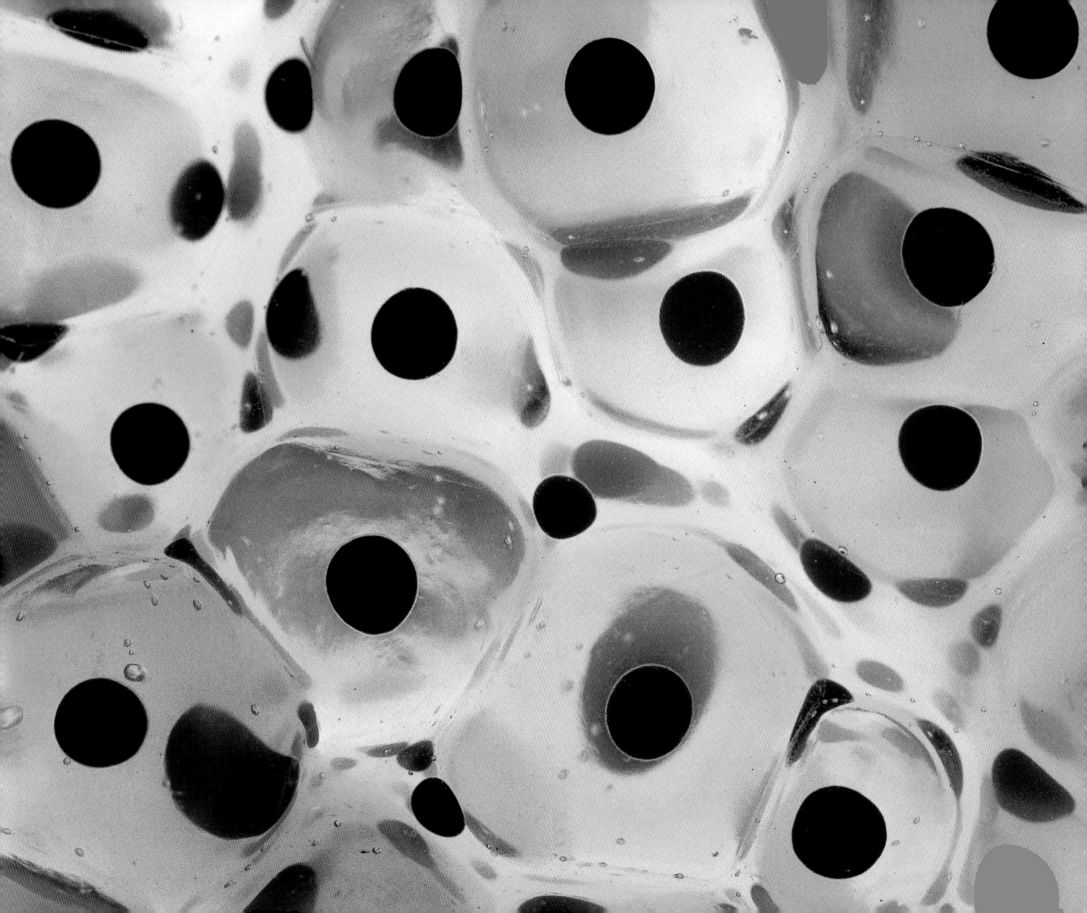

Dandelion seed head

This close-up view shows a dandelion (*Taraxacum*) seed head magnified eight times. Like other members of the daisy family, dandelion flowers consist of a large number of florets packed tightly in spirals on the flower head. When fertilized, each floret develops a fruit (an encased seed) with a feathery, umbrella-like canopy. Caught and carried by the wind, the seeds can travel long distances to colonize new territory. This is one reason why these plants spread and grow quickly on bare ground.

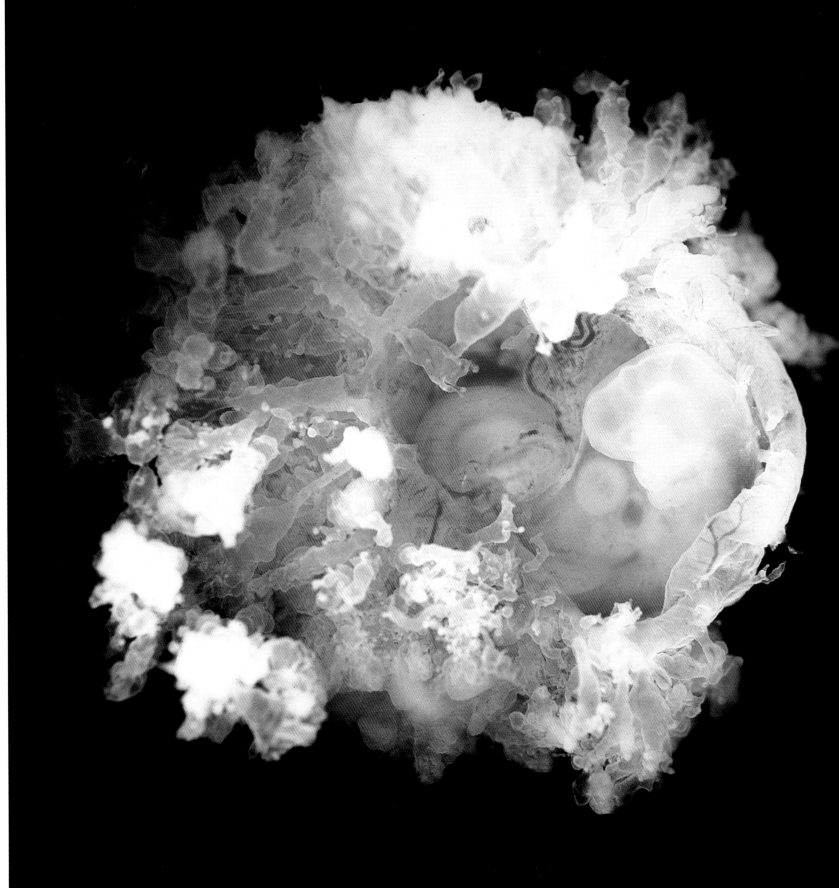

Human embryo

A tiny human embryo, four to five weeks old, is surrounded by the protective amniotic sac and shaggy outer membrane, the chorion. The early embryo absorbs nutrients from its mother directly through these membranes. Here the amnion and chorion have been opened to show the embryo inside which, at this stage of development, is 7–8 millimetres long. The beginnings of the fetus form are just visible on the right.

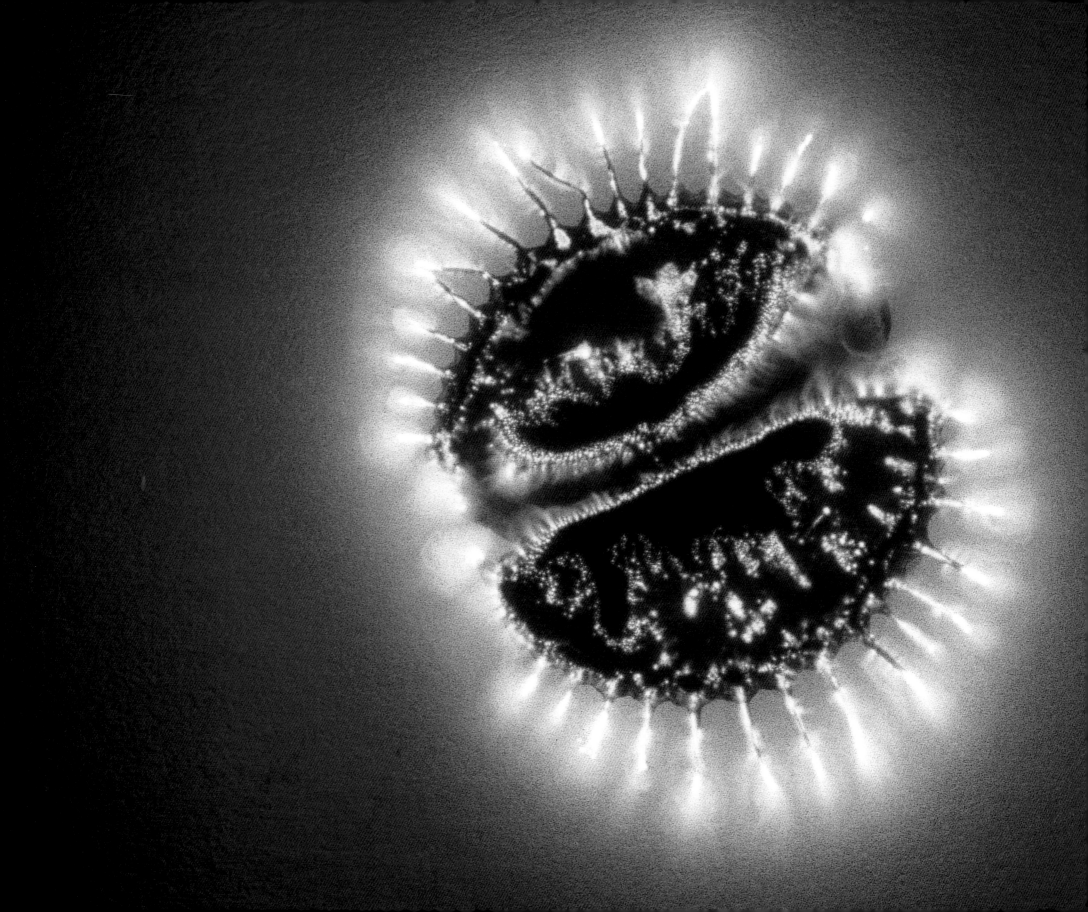

Venus flytrap

This photograph shows the paired leaf of the Venus flytrap (*Dionaea muscipula*). The paired leaf has hinged leaves that snap shut when a fly lands on them. The glowing corona effect is achieved by photographing the plant in the presence of an electric field, a technique known as Kirlian photography. Electric discharges from the object are captured on film, giving the appearance of a corona of light. The discharges are affected by temperature, pressure, moisture and, some believe, the subject's level of health.

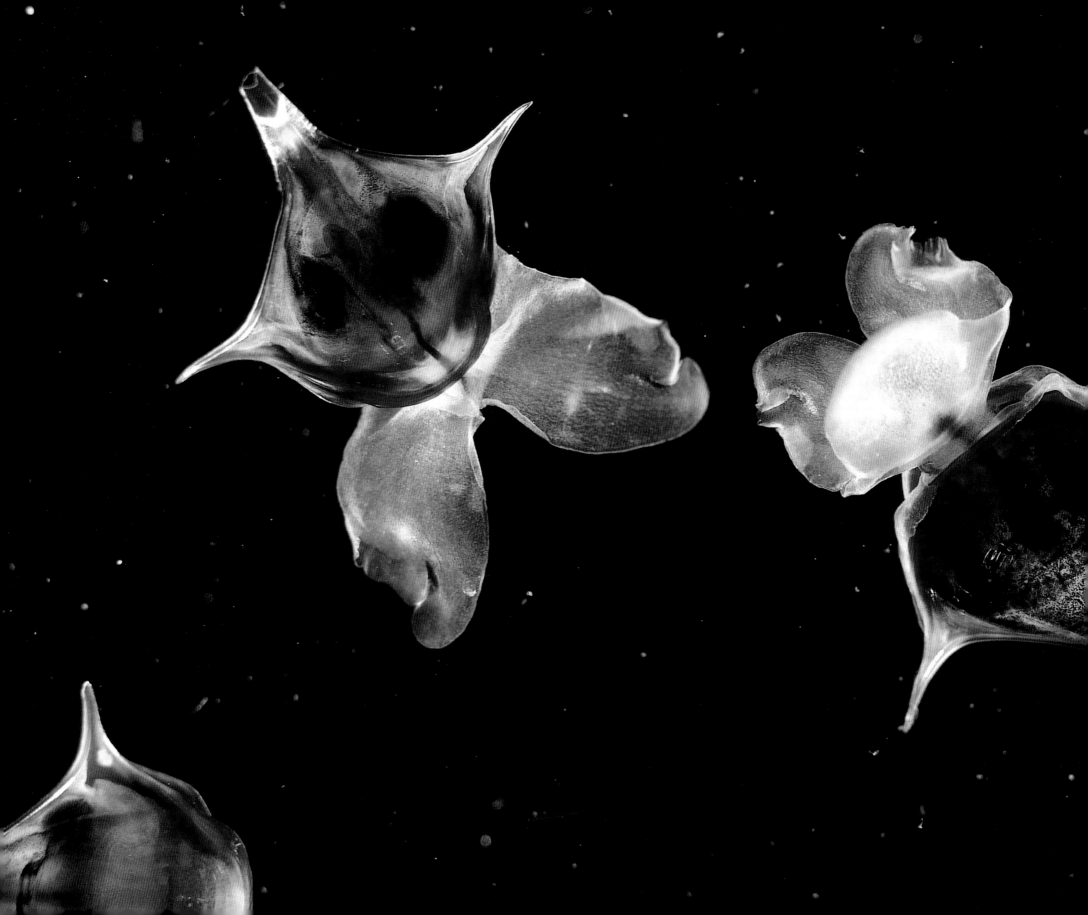

left

Sea butterflies

These two sea butterflies, or pteropods, from the North Atlantic are photographed swimming in a petri dish of sea water using dark field illumination. In life they are 5–10 millimetres long. Pteropods belong to the group that includes common garden slugs and snails. Their muscular foot is adapted to form two fins, which they use as oars to swim in the surface waters of the ocean.

Spongy bone

This macrophotograph shows the spongy bone from a human thigh bone (the femur), magnified approximately eight times. Spongy bone is found at the expanded ends of long bones, such as the bones of the arms, legs, fingers and toes. It also makes up the bulk of irregular bones like the skull and vertebrae. The open mineral structure seen here, composed of interconnected trabeculae, is surrounded in life by blood vessels and bone marrow. The spongy structure is both light and strong, and is especially resistant to bending and stretching.

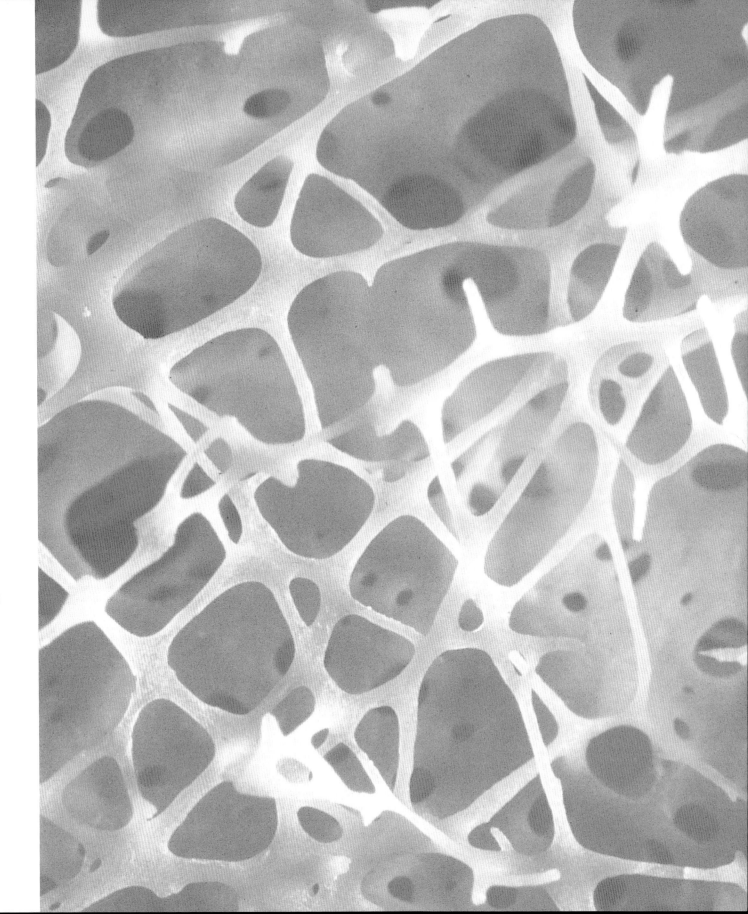

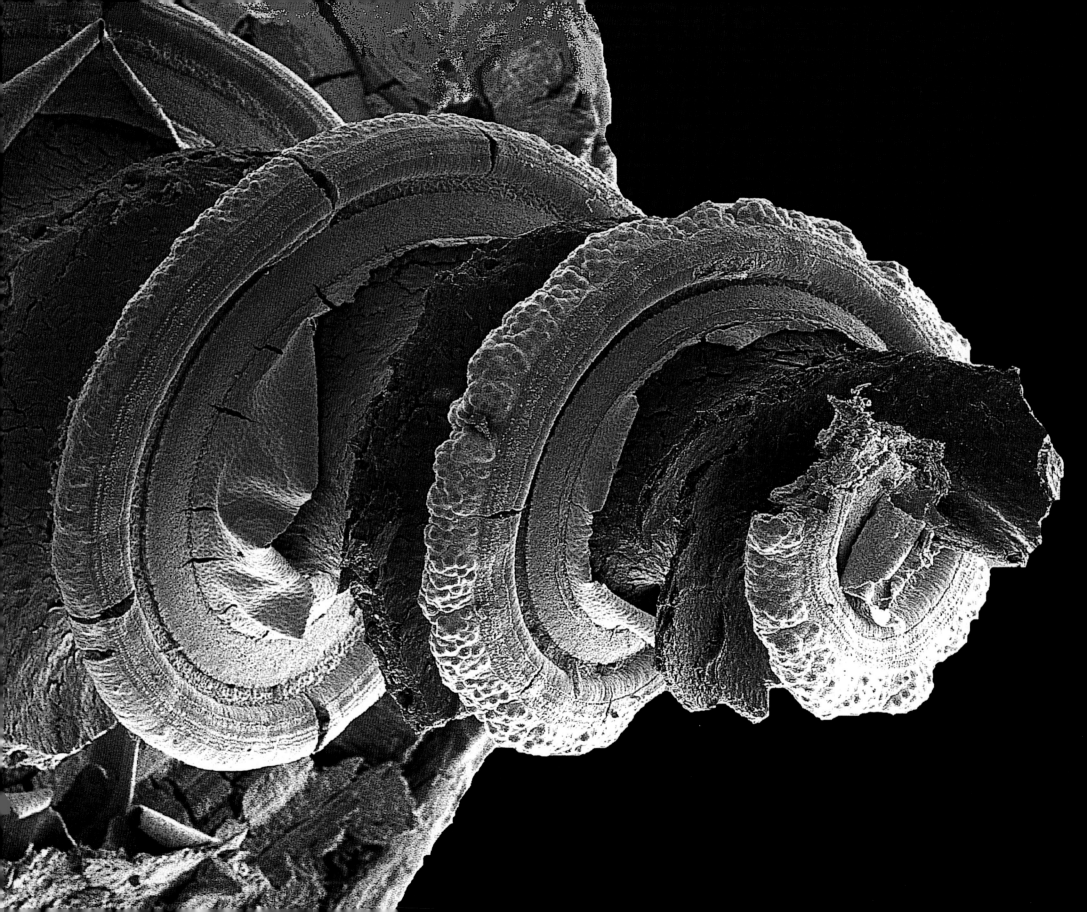

left

Inner ear

This scanning electron micrograph of the human inner ear shows the cochlea, the organ responsible for hearing. The cochlea is a spiral, fluid-filled canal 35 millimetres long. It is coiled like a snail shell and contains the organ of Corti. Here, sound vibrations are converted into nerve impulses that are transmitted to the brain. The brain identifies sounds of different pitches (vibrations of different wavelengths) from the distance they travel along the organ of Corti. The cochlea is magnified seven times in this image.

Bromeliad seeds

Seeds of *Puya raimondi*, a member of the pineapple family (Bromeliaceae), are shown here at about seven times their true size. These little seeds were produced by an enormous plant. *Puya raimondi* can reach more than 10 metres in height and bear leaf rosettes 2 metres in diameter. It takes between 50 and 70 years to reach reproductive maturity, before it produces a flower spike four metres tall. The seeds are released from capsules, which split open once mature, and are shaken loose by the wind. Dark field illumination reveals the dark embryo in each seed to be surrounded by a translucent extension which protects it and acts as a sail, helping the seeds to travel away from the parent plant before reaching the ground.

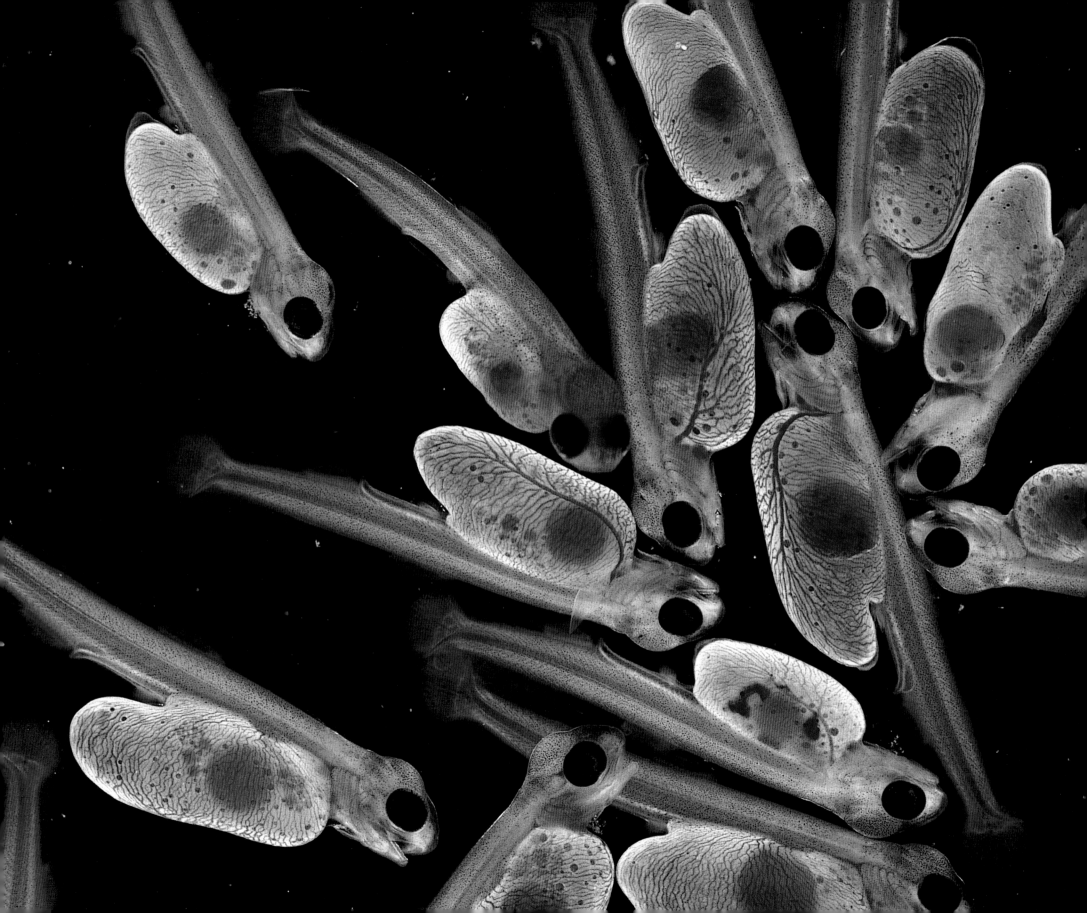

left

Trout hatchlings

This photograph shows a group of newly hatched young trout, called alevins, each about 16 millimetres in length. Once hatched, the alevins remain within the river gravel and attached to their yolk sacs which provide them with food, via a rich network of blood vessels, for the first three to four weeks of life. Once the contents of the yolk sac have been completely absorbed and the young fish have developed fins and other adult features, they are known as fry and swim up from the gravel to begin catching small live prey.

Heart valve

This photograph of a human heart valve, the mitral or bicuspid valve, shows the thin strands called chordae tendinae that attach the underside of the valve to the wall of the chamber below. The strands slacken to allow the valve to open and blood flow into the chamber. Then, when the chamber contracts to pump blood out of the heart via a different valve, the pressure pushes the mitral valve closed. The taut chords prevent it opening the other way, and thus stopping blood from leaking out the way it came in.

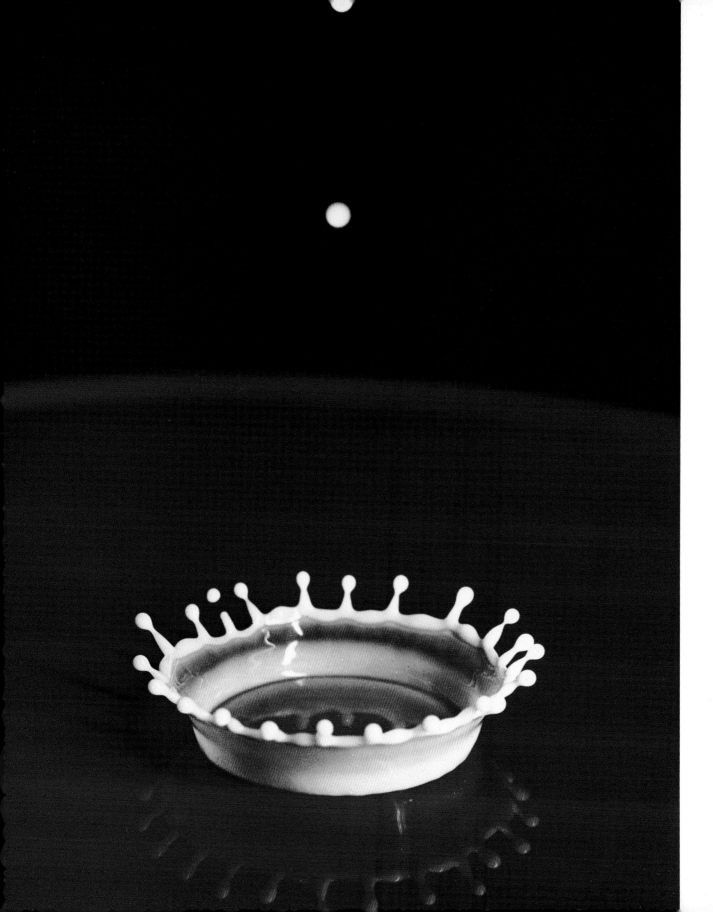

Milk drop coronet

The splash made by a drop of milk as it lands onto a thin layer of milk on a plate is captured here using stroboscopic or 'stop-action' photography. The almost symmetrical coronet shape forms fleetingly as the drop flies apart on impact. The event passes too quickly to be seen with the naked eye, but it can be captured on film using an extremely short exposure time. This was achieved by using a stroboscope, an instrument which lights up the scene in a series of bright flashes of one millionth of a second, each flash giving the appearance of the drop being still. The image was taken by the inventor of stroboscopic photography, Harold E Edgerton (1903–90), in 1957.

right
Carotid artery

This view along a human carotid artery was obtained using a helical scanner. This non-invasive imaging technique uses x-rays to create pictures of 'slices' of a part of the body. A computer then uses these images to reconstruct a complete three-dimensional image. The resulting images are so lifelike that the technique has been called 'virtual endoscopy'. This 5 millimetre wide artery carries oxygenated blood from the heart to the head and neck. At the far end, the image shows the point where the artery divides into two.

Young deep-sea lobster

This photograph shows the larval form of the deep-sea lobster *Eryoneicus* about four times larger than life size. Adult *Eryoneicus* live on the floor of the northeast Atlantic Ocean at a depth of 4,000 metres. Like other decapod crustaceans (such as shrimps, crabs and true lobsters), young *Eryoneicus* individuals hatch as free-swimming larvae, which look quite unlike their clawed parents. The young live at a depth of about 1,000 metres and pass through several distinct larval stages, gaining more adult features with each moult.

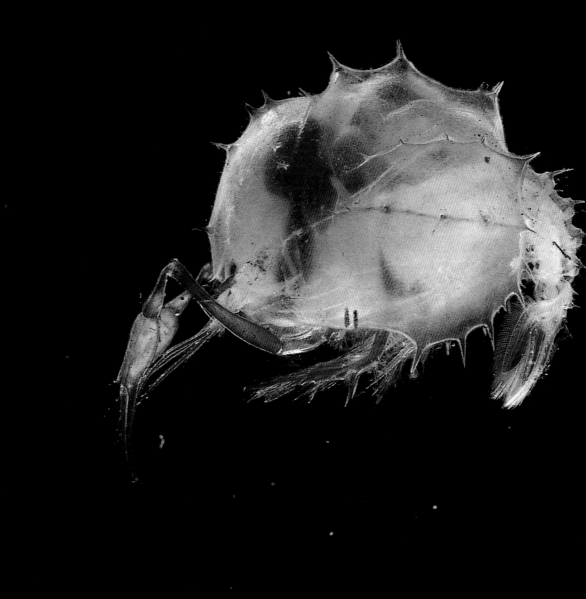

Rainbow trout eggs
This photograph shows a clutch of perfectly packed rainbow trout eggs. Each egg is actually about 4 millimetres across. The developing embryo is visible in each one, most clearly distinguishable by a black dot, which is its eye. The female trout lays up to 5,000 eggs in a nest on the gravelly riverbed. The eggs hatch after 100 to 150 days, depending on the temperature. This 'eyed-egg' stage represents a late stage in development before hatching.

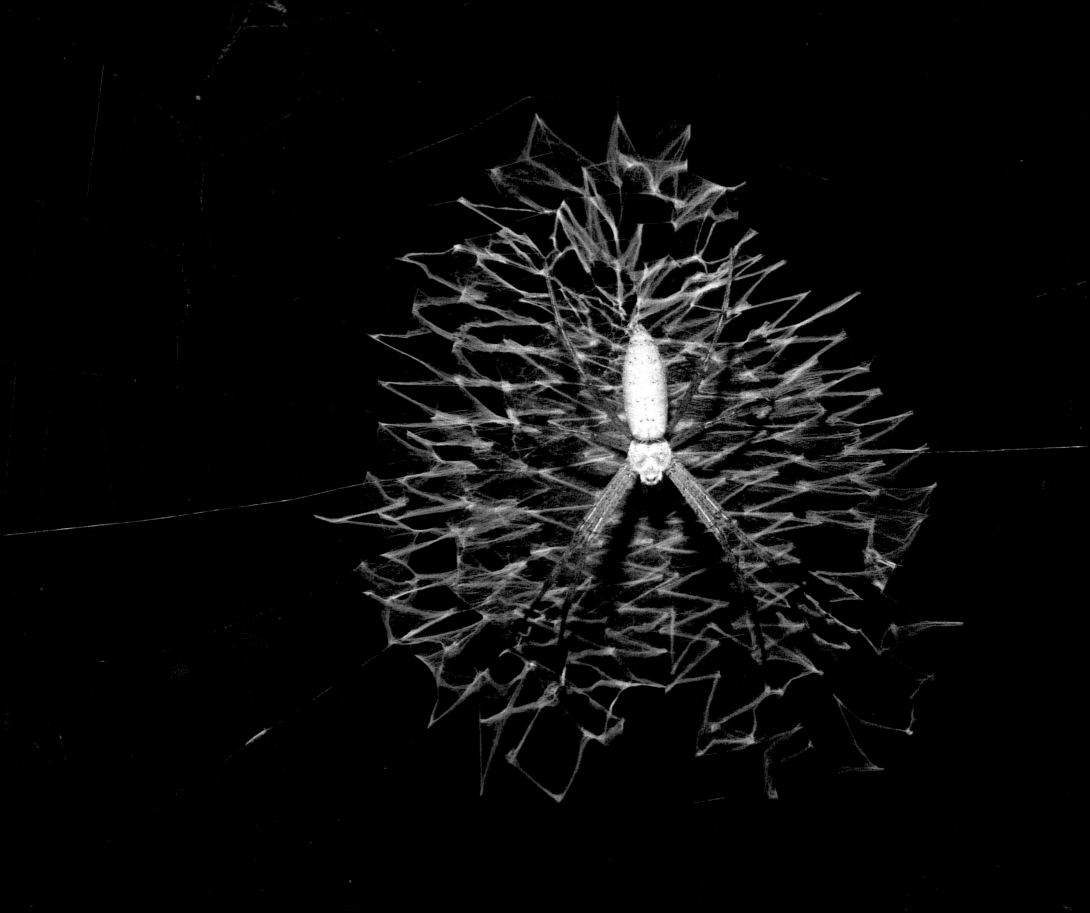

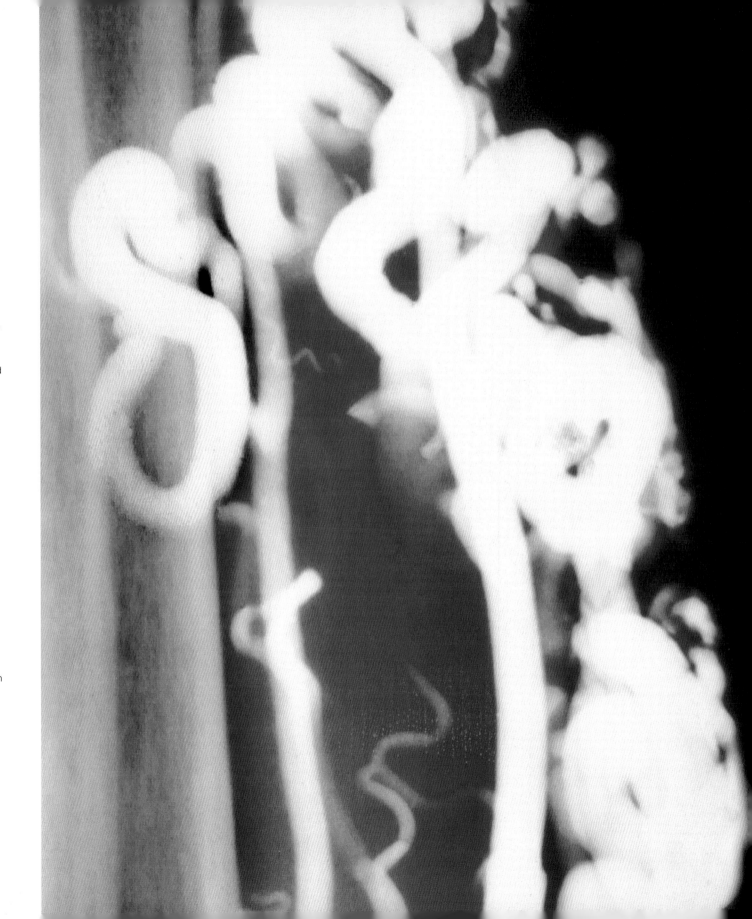

left

Spider and web
This spider has been
photographed on its web using
ultraviolet light; special filters
on the camera eliminate visible
wavelengths. The spider has
woven a conspicuous zig-zag
pattern of silk, called
a stabilimentum, in the centre
of its web. There are several
theories as to why spiders make
these structures. One is that
they make the web more visible
and so less likely to be damaged
by birds and large insects flying
into it inadvertently. The spider
belongs to the genus *Argiope*,
a member of the garden spider
family, which lives in warm
temperate regions. The actual
length of the spider's body
is about 8 millimetres.

Varicose veins
This angiogram of a leg with
varicose veins was produced
by injecting a radio-opaque
substance into the blood
vessels, then taking an x-ray.
In the resulting picture the veins
are coloured yellow and the
bone green to show them more
clearly. Varicose veins form
when valves, whose job is to
prevent blood from flowing down
to the feet under gravity, stop
working. This causes the blood
to pool in places, especially
in the legs, causing the veins
to swell and lengthen.

Kangaroo vine

This is a Kirlian photograph of a leaf from a kangaroo vine (*Cissus antartica*). In 1939, the Soviet scientist Semyan Kirlian accidentally discovered that if a high voltage electrical field is applied to an object resting on a photographic plate, the resulting image shows a pattern of electrical discharge from the object to the atmosphere. This process of 'coronal discharge' is responsible for natural phenomena such as lightning and St Elmo's Fire. Similar static discharges from the human body can sometimes be seen in a darkened room as tiny blue sparks.

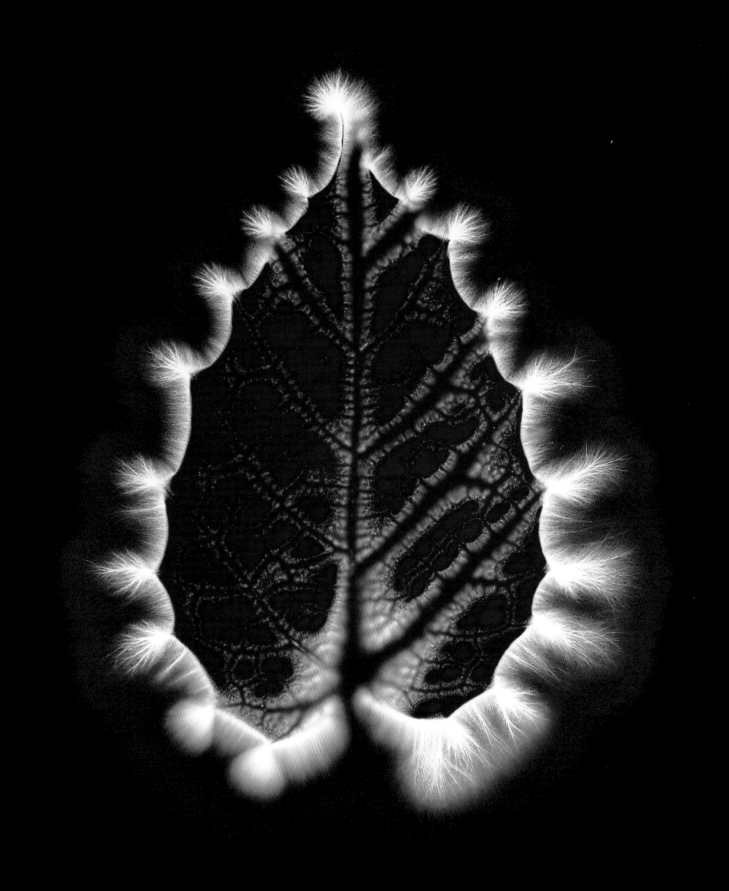

Fingertip

The discovery of Kirlian photography caused great excitement when it reached the West in the 1970s. Some people claimed that these pictures showed the 'aura' or life force present in all living things – in this instance a person's fingertip. Kirlian photography has even been touted as a diagnostic medical tool. However, scientists have shown that changes in a person's aura are entirely attributable to the amount of perspiration on the subject's skin.

Small intestine
This is an endoscopic image of the interior of a human small intestine. In adults, the small intestine has a total length of 6 metres. Here, enzymes break down food into small molecules, which are then absorbed through the gut wall into the blood vessels. The folds of the intestine wall vastly increase the area of contact between the enzyme-bearing mucus lining and the partially digested food that passes through. The folds also help to mix the contents of the small intestine, further aiding digestion.

far right
Human kidney
This false-colour arteriogram picks out the blood vessels of a human kidney. The kidneys remove nitrogenous waste materials, such as urea, from the blood and regulate its salinity, acidity and fluid balance. Thick branches of the renal artery deliver blood to increasingly fine capillaries in the outer part of the kidney, where the filtering processes take place. The treated blood is then drawn away through veins (not seen) and waste products are converted into urine.

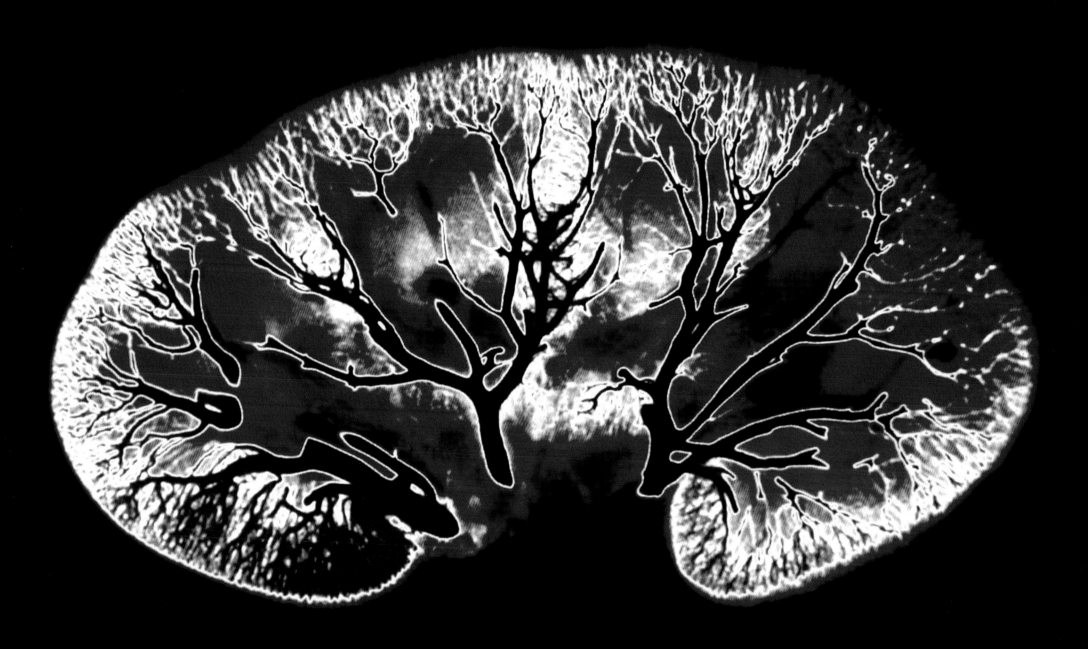

European mole

This x-ray image shows the skeletal structure of a 14 centimetre long European mole (*Talpa europaea*). Moles live mostly underground in tunnels, eating earthworms, insects and other small invertebrates. Their bodies are well adapted to this way of life. They have powerful shoulders and broad front feet with large claws for digging. Their skulls bear small sharp teeth, typical of an insectivore. Moles also have a well-developed sense of smell and touch for finding their way in the dark.

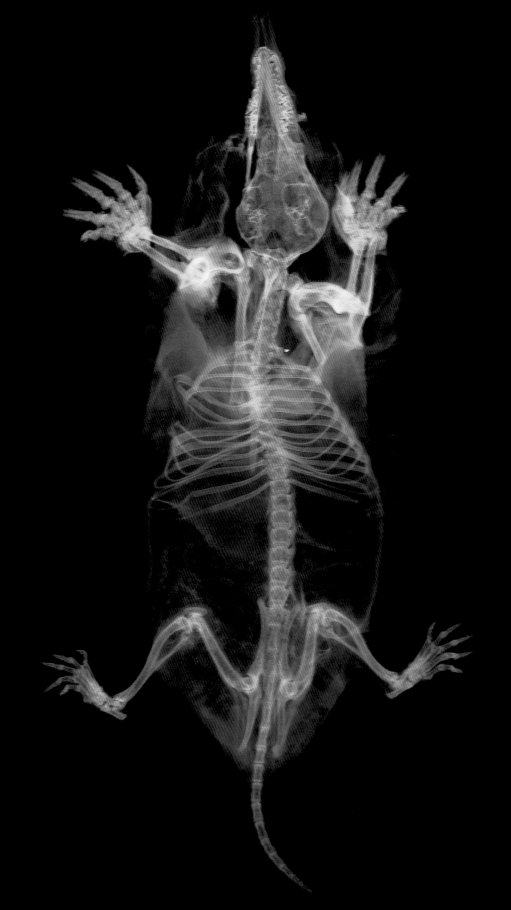

Screw shell

This is the distinctive long spiral
shell of the tropical marine
gastropod *Turritella*, or screw
shell. Gastropods are a class
of mollusc that includes land
and freshwater snails, as well as
marine forms. This x-ray image
reveals the internal structure
of the shell, with whorls of shell
around a central rigid spine
called the columella. As the
animal grows in the end whorl,
it continues to secrete calcium
carbonate along the outer rim
so that the shell lengthens
over time.

Musk mallow

This photograph of a musk mallow flower was taken using ultraviolet (UV) photography, in which special filters are used to eliminate visible light. It reveals fine stripes on the petals from pigment that strongly reflects UV, normally invisible to the human eye. We have to rely on photographic film to convert the ultraviolet light into colours we can see. Insects, however, can detect ultraviolet light and so would see this flower much as it appears here. The stripes on the petals guide insects to the flower's nectar in the centre; the insects pick up pollen on their way.

Angler fish

This female deep-sea angler fish, *Haplophryne schmidti*, is 7 centimetres long. Two diminutive males are fused to her body – an evolutionary adaptation to the problem of finding a partner in the pitch black ocean depths. The males provide a reliable source of sperm, which is coordinated with egg release by hormones in their shared circulatory system. This fish was photographed in an aquarium immediately after being brought up from a depth of 1,000 metres by an oceanographic research vessel.

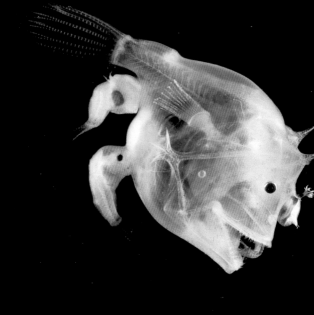

Hand

This is the first x-ray photograph. It was taken by the German physicist Wilhelm Conrad Röntgen (1845–1923), who discovered x-rays in 1895. He noticed that certain minerals glowed when placed near a cathode tube, and concluded that the tube must be emitting some form of invisible radiation. When he placed his hand in front of the cathode tube, the radiation penetrated the soft tissues and cast a shadow of the bones inside. He named this mysterious radiation 'x-ray' and only one month later succeeded in capturing radiographs on film, starting with this picture of his wife's hand and her wedding ring.

right
Melting ice cube

The thermal gradient around a melting ice cube is revealed in this infrared picture. All objects, even ice cubes, emit infrared radiation which can be seen using an infrared detector. This image has been coloured to show the variation in the intensity of infrared radiation picked up by the detector. Purple represents the lowest temperatures, red the highest. The rings of colour show the increase in temperature of the water as it melts and flows away from the cube.

Lumbar vertebrae
The lumbar region towards the base of the human spine takes the brunt of the range of forces involved in moving the body. Consequently, the lumbar vertebrae are the largest and strongest of the 33 in the human spine. This coloured x-ray, seen from the front, shows their broadly cylindrical shape. The sideways extensions (grey) serve as muscle attachment points. Between the vertebrae lie softer discs made of cartilage (pink), while the spinal cord – the trunk route of the nervous system – lies in a canal that runs through the vertebrae.

Fetus at three months

In this photograph, the chorion (the shaggy outer membrane surrounding a fetus) is folded back to reveal the human fetus through the thin amniotic membrane. At around 12 weeks the fetus is about 5 centimetres long. The head, arms and legs, and even fingers and toes, are clearly visible. It is also possible to make out the ears, eyes and ribs. At this stage, the first bone tissue is developing, replacing the initial cartilage skeleton.

Brain scan

This false-colour magnetic resonance imaging (MRI) scan shows a transverse section through a human head. The eyeballs (black) are each connected to the brain by a thick optic nerve (red). Between the eyes is the nasal cavity, containing thin scroll-like bones called conchae. The two halves of the highly convoluted cerebrum, the largest region of the brain, are coloured yellow. They sit either side of the mid-brain (centre) with part of the cerebellum just visible below.

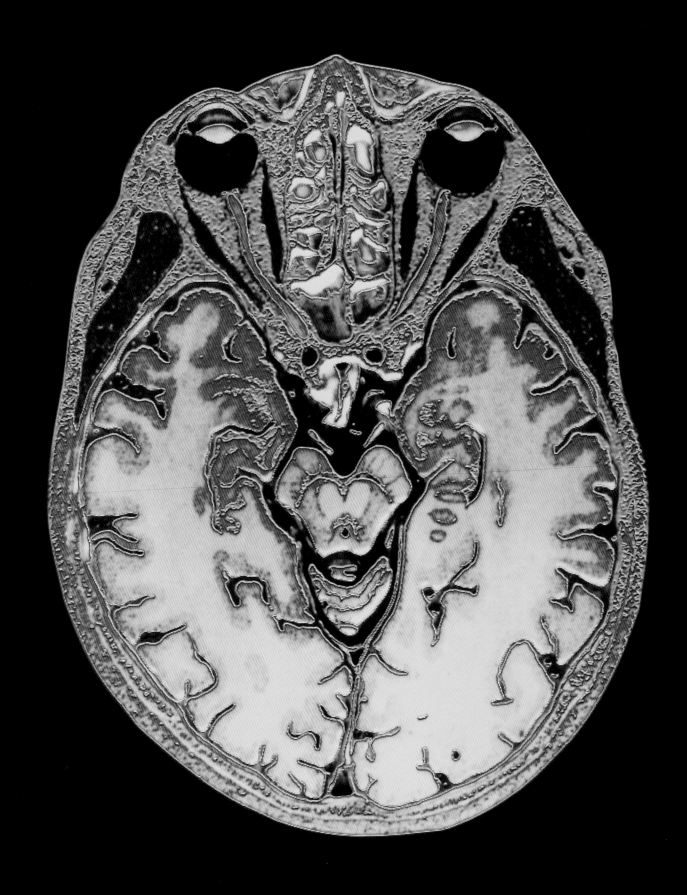

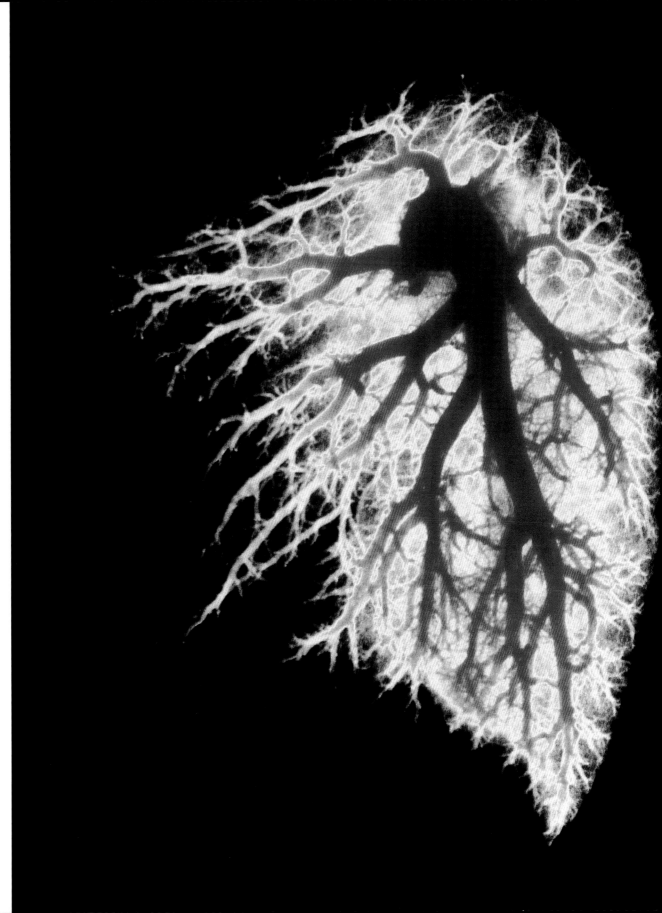

Pulmonary arteries
This is a false-colour arteriogram of the pulmonary arteries in a healthy human lung. The main pulmonary artery divides into thick left and right branches, one to each lung, carrying large quantities of blood. Inside the lungs the arteries divide repeatedly to form a network of fine capillaries, maximizing the area of surface contact (an astonishing 70 square metres) between the blood and lung tissues for the exchange of gases. Oxygen from inhaled air enters the bloodstream, while waste carbon dioxide is released and exhaled.

Tun shell

This false-colour x-ray image
shows the complex coiled shell
of a tun (*Tonna galea*), a marine
gastropod that can grow up
to 25 centimetres in length.
The shell's spiral form allows
it to grow without building
an excessively long shell,
which could slow down its
movement. It is a carnivore,
which kills or paralyses its prey
by injecting it with acid through
its jaw plates. This species lives
in warm shallow waters off
the coasts of the Atlantic
and Pacific oceans, and the
Mediterranean Sea.

far right
Fetal twins at 20 weeks

This ultrasound scan reveals
fetal twins in the womb at about
20 weeks. Both heads are in the
upper part of the image and we
see them both in profile.
The baby on the left is in a sitting
position. The other baby is facing
downwards, its body horizontal
and some vertebrae are visible
in its spine. One in every
80 pregnancies naturally results
in twins. Identical twins come
from a single fertilized egg that
splits to form two embryos.
Non-identical twins develop
from two different eggs, each
fertilized by a different sperm.

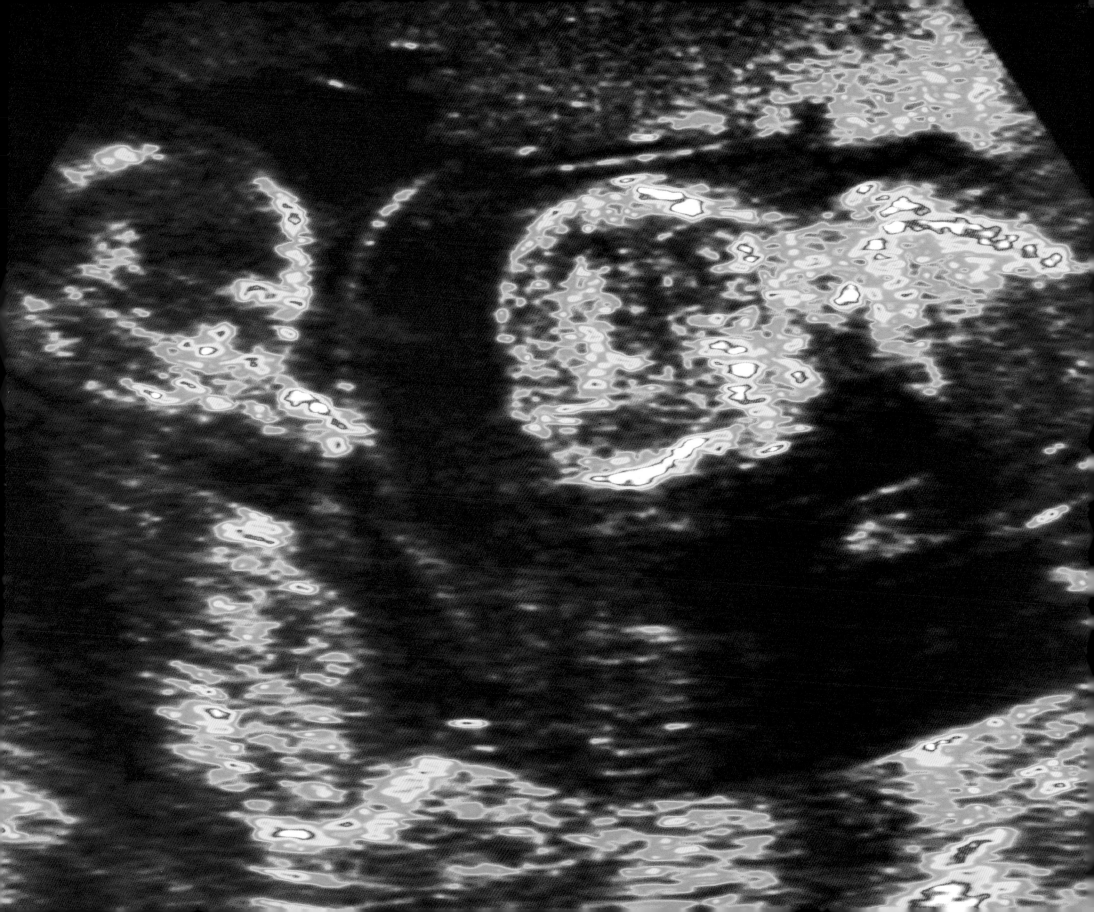

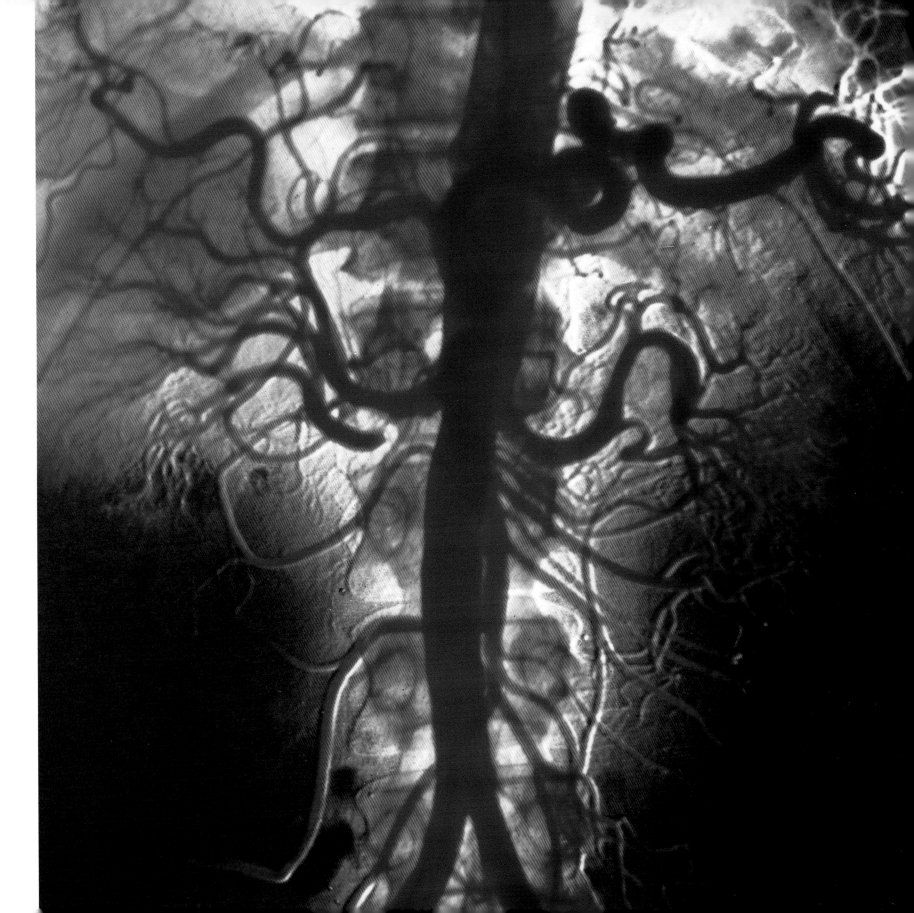

Abdominal artery
This false-colour arteriogram
taken of a healthy person shows
the arteries that supply blood
to the kidneys, spleen and liver.
The large vessel running
vertically is the abdominal aorta;
the backbone is visible behind it.
Offshoots supply the kidneys
(middle). Above and to the right
the splenic artery connects
to the spleen. At top left,
the hepatic artery feeds the liver.
At the bottom of the picture
the abdominal aorta splits into
two lower branches, the left
and right common iliac arteries,
which supply the legs.

Argonaut shell

The delicate shell of the female paper nautilus, *Argonauta argo*, is shown in this x-ray. The paper nautilus is a cephalopod, a type of mollusc related to the octopus and squid, and lives in warm tropical seas. The male of the species is dwarfed, typically 1 or 2 centimetres long. The female, by contrast, can exceed 30 centimetres. Only she secretes the thin, papery shell that gives the species its name. The shell protects her developing embryos, of which there may be 50,000 at any one time.

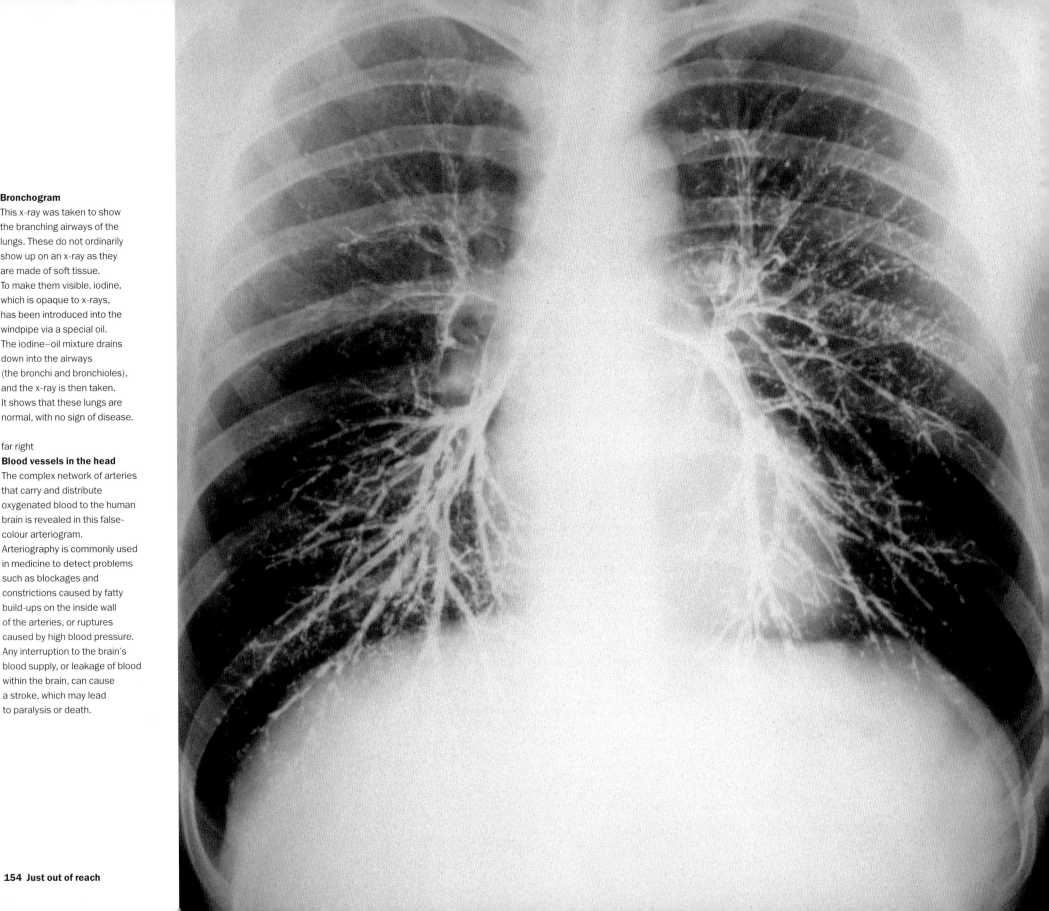

Bronchogram
This x-ray was taken to show the branching airways of the lungs. These do not ordinarily show up on an x-ray as they are made of soft tissue.
To make them visible, iodine, which is opaque to x-rays, has been introduced into the windpipe via a special oil.
The iodine–oil mixture drains down into the airways (the bronchi and bronchioles), and the x-ray is then taken.
It shows that these lungs are normal, with no sign of disease.

far right
Blood vessels in the head
The complex network of arteries that carry and distribute oxygenated blood to the human brain is revealed in this false-colour arteriogram.
Arteriography is commonly used in medicine to detect problems such as blockages and constrictions caused by fatty build-ups on the inside wall of the arteries, or ruptures caused by high blood pressure. Any interruption to the brain's blood supply, or leakage of blood within the brain, can cause a stroke, which may lead to paralysis or death.

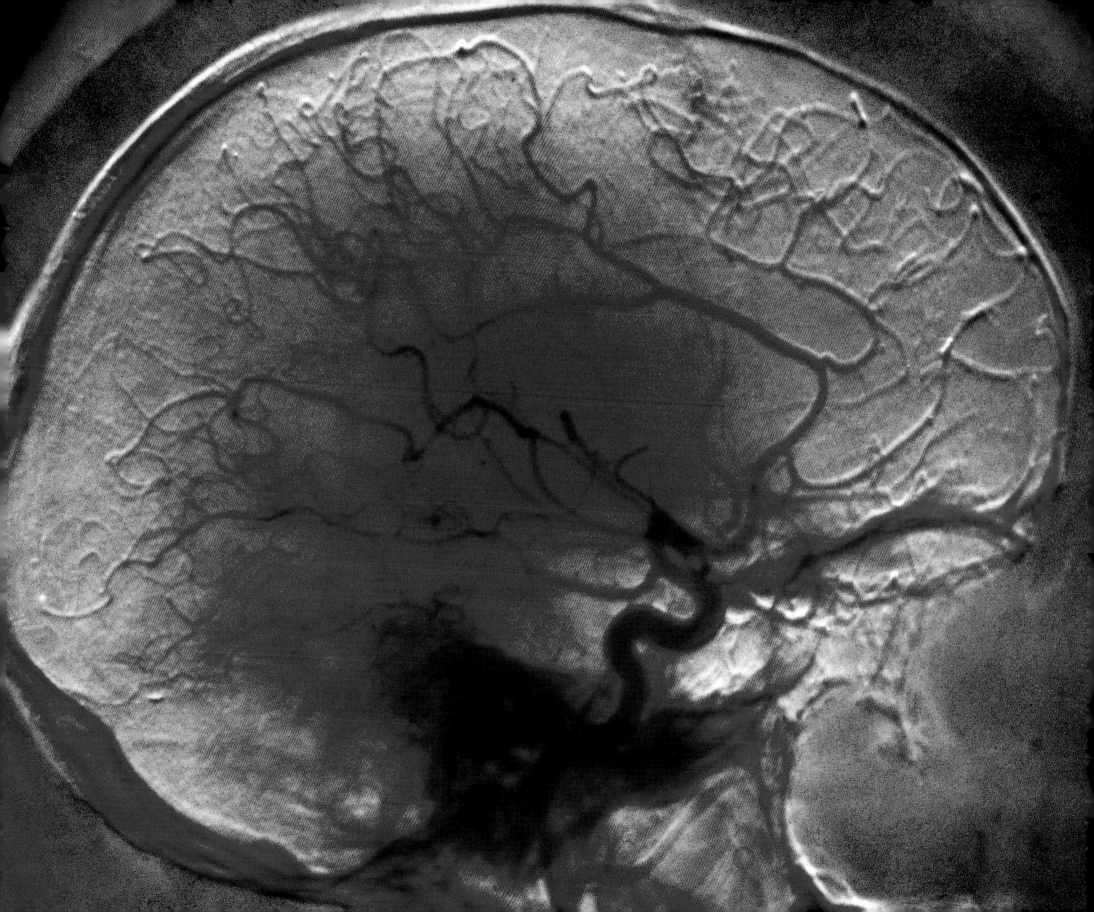

Leaving the surface of the Earth, we float up into the atmosphere and look back at our planet. In this chapter we see areas of its surface in ascending order of size and distance – areas that include dune fields, craters, rivers and volcanoes.

Thought to be 4.5 to 5 billion years old, the Earth has been moulded by gravitational forces into an imperfect sphere, being slightly flattened at the poles and bulging at the equator. The Earth rotates from west to east and a complete rotation takes one day. The distribution of heat across the globe and over the year is caused by the Earth's tilt in relation to the Sun. When the northern end of the Earth's axis tilts towards the Sun, the most direct rays of sunlight fall in the northern hemisphere, causing the summer season. The poles never directly face the Sun and are, therefore, under snow cover all year round.

The Earth today is composed of six large distinct landmasses, which traditionally are divided into seven continents: Africa, Antarctica, Australia, Asia, Europe, North America, South America. It is believed that between 275 and 175 million years ago all the continents formed a single landmass and that over time they have split, moved and drifted to their present positions. These landmasses, or plates, are still moving, sometimes causing earthquakes and volcanic activity.

The Earth's core is encased in an outer shell, or crust, which is thickest beneath the mountains and thinnest beneath the ocean. Seventy-one per cent of the Earth's surface is covered in water. Liquid water is essential for life and is also responsible for most of the erosion and weathering of the Earth's surface. With photographs taken from satellites and spacecraft we learn about the Earth's surface and its environment. Infrared imaging detects heat and enables us to measure and monitor the Earth's surface and atmosphere, and identify phenomena such as deforestation, urbanization or movement along geological fault lines.

From the sand dunes of the Al Kidan desert to storm clouds over the eastern seaboard of the United States, *Planet Earth* travels in an ever ascending journey through weather formations and spectacular displays of light, high up into and above the atmosphere.

Planet Earth

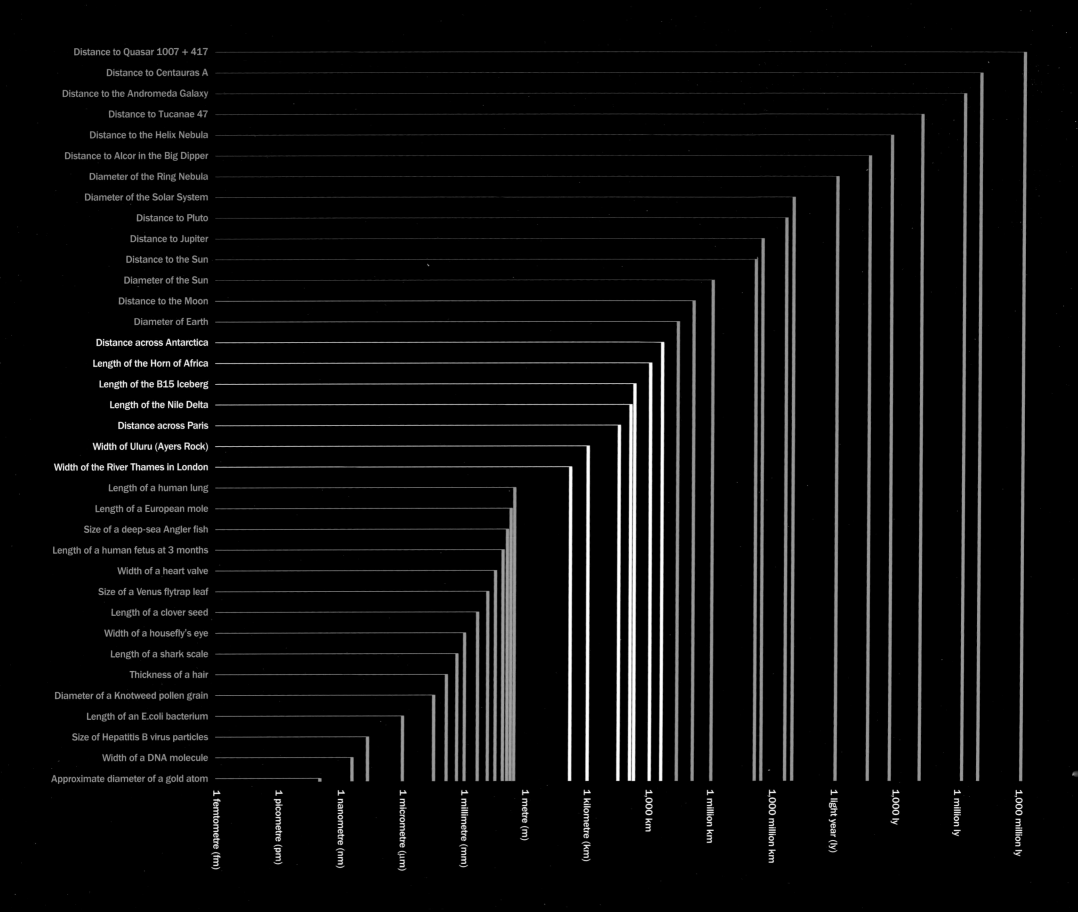

Distance to Quasar 1007 + 417
Distance to Centauras A
Distance to the Andromeda Galaxy
Distance to Tucanae 47
Distance to the Helix Nebula
Distance to Alcor in the Big Dipper
Diameter of the Ring Nebula
Diameter of the Solar System
Distance to Pluto
Distance to Jupiter
Distance to the Sun
Diameter of the Sun
Distance to the Moon
Diameter of Earth
Distance across Antarctica
Length of the Horn of Africa
Length of the B15 Iceberg
Length of the Nile Delta
Distance across Paris
Width of Uluru (Ayers Rock)
Width of the River Thames in London
Length of a human lung
Length of a European mole
Size of a deep-sea Angler fish
Length of a human fetus at 3 months
Width of a heart valve
Size of a Venus flytrap leaf
Length of a clover seed
Width of a housefly's eye
Length of a shark scale
Thickness of a hair
Diameter of a Knotweed pollen grain
Length of an E.coli bacterium
Size of Hepatitis B virus particles
Width of a DNA molecule
Approximate diameter of a gold atom

1 femtometre (fm)
1 picometre (pm)
1 nanometre (nm)
1 micrometre (μm)
1 millimetre (mm)
1 metre (m)
1 kilometre (km)
1,000 km
1 million km
1,000 million km
1 light year (ly)
1,000 ly
1 million ly
1,000 million ly

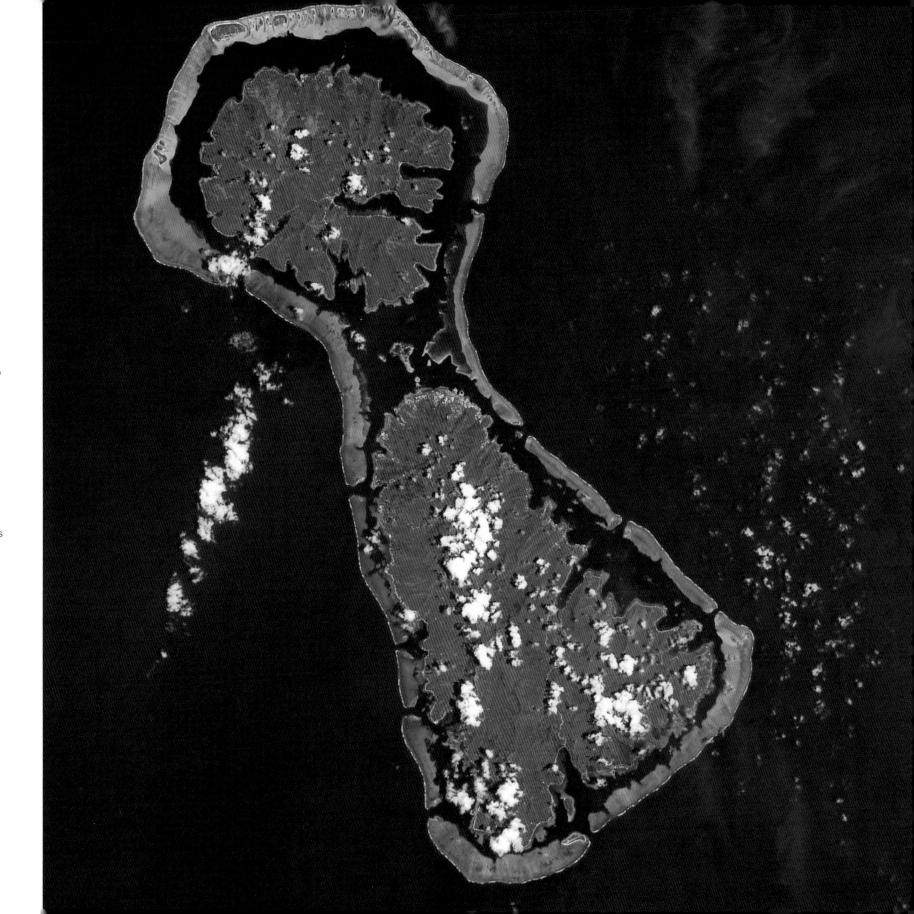

Pacific island reef
The islands of Tahaa (above) and Raiatea (below), part of the Society Islands in the South Pacific, are fringed by a coral reef. This infrared image, taken by a SPOT satellite, shows deep water in black, shallow water in blue and vegetation in red; white clouds drift above.
The living coral reef, which has grown on the flanks of these oceanic volcanoes since they were last active, encloses a shallow lagoon, protected from the waves which pound the reef's outer slopes.
Fine carbonate sands and muds eroded from the outer slopes accumulate in the tranquil lagoon, and where these sediments break the water's surface, they have become colonized by plants.

Mand River, Iran

The Mand River, one of the few
to drain into the Persian Gulf,
meanders around the base
of a mountain in the lower right
of this satellite image showing
southwest Iran, with the
Persian Gulf at bottom left.
At 685 kilometres long,
the Mand is one of Iran's largest
rivers. The mountain slopes,
with their unusual oval outline,
show evidence of gully erosion.
Gullies form when occasional
heavy rainfall causes large
quantities of soil to be washed
downhill. This is characteristic
of arid climates where sparse
vegetation makes the soil
unstable and vulnerable
to erosion.

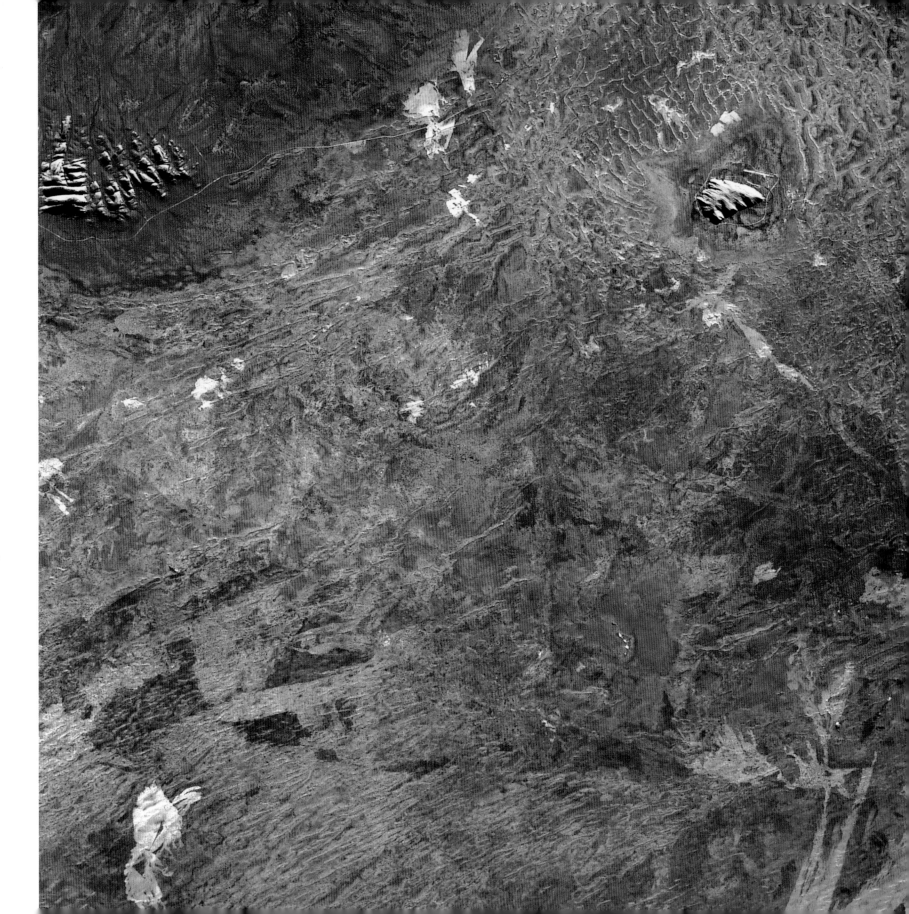

Uluru (Ayers Rock), Australia
Uluru appears in grey at the top right of this infrared SPOT satellite image, which shows an area 50 kilometres across, in Australia's Northern Territory. Standing proud of the surrounding plain of softer bedrock, at 335 metres high and 3.6 kilometres long, Uluru is the largest monolith on Earth. Further isolated masses of weathered rock are visible to the top left, but none approaches its vast dimensions.

Valley glaciers, Chile
This photograph, taken from the International Space Station, shows part of a large glaciated region near the Chilean coast, at a latitude of 47 degrees south. Glaciers consist of moving masses of ice that flow from high altitudes, where snow and ice accumulate, towards lower altitudes, where the ice melts. These glaciers are slowly flowing along deep valleys between the mountains. Like the tributaries of a river, confluent valley glaciers flow towards the main glacier and join its flow. The dark stripes are caused by sediment carried in the ice, which becomes smeared out into long bands by the glacier's gradual downhill movement.

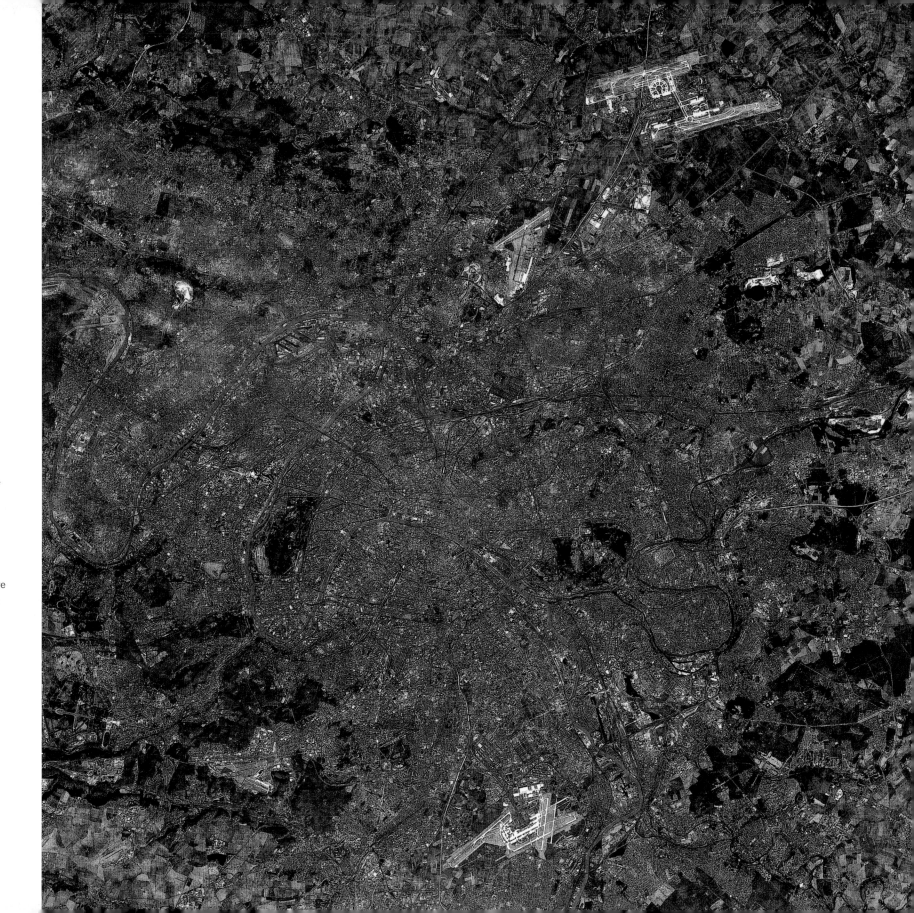

Paris, France

The River Seine flows through the French capital in long, meandering loops. In this false-colour photograph, taken by a French SPOT satellite, water is blue, urban areas are blue and white, and vegetation is red. Paris was founded on an island in the Seine more than two thousand years ago by a Gallic tribe known as the Parisii. The runways of three airports are visible (white-red): to the north De Gaulle (top) and Le Bourget (upper centre), and to the south Orly (lower centre). To the southwest (lower left corner), the blue cross shape is a large decorative pool at the palace of Versailles.

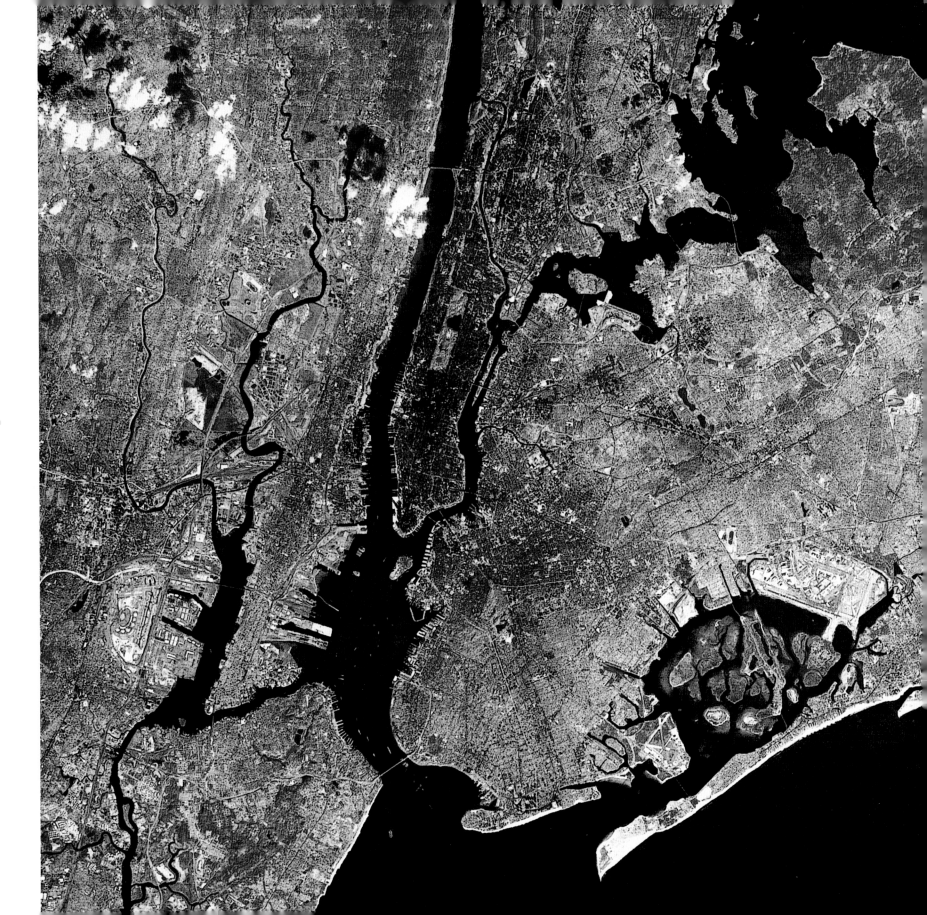

New York, USA
In this Landsat infrared image of New York, the Hudson River (black) flows straight down the picture into the Atlantic. Long Island Sound is the wide inlet at top right, connecting with the Hudson via the East River. The finger-like protrusion of Manhattan island sits between the Hudson and the East River; Central Park is clearly visible as a vegetated (red) rectangle. The huge urban sprawl of New York is seen here as light blue and grey patches, spreading out in all directions around the city.

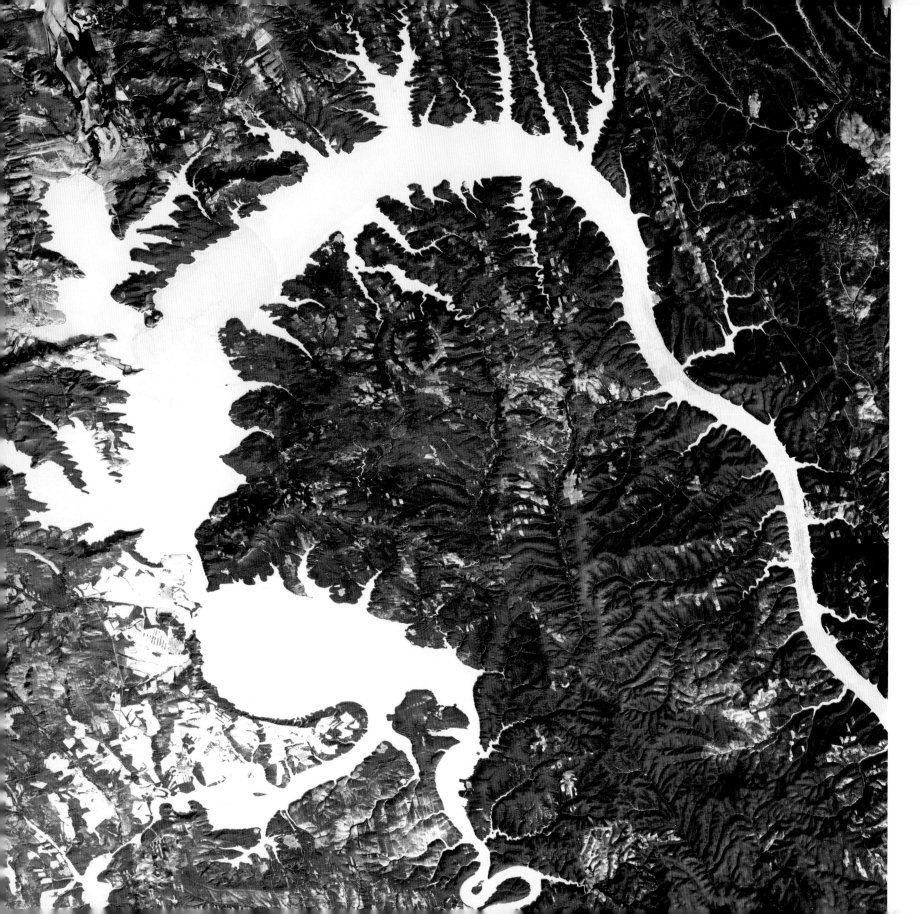

Bratskove Reservoir, Siberia
The striking shape of the Bratskove Reservoir in southern Siberia has led to it being given the nickname 'Dragon Lake'. The reservoir was built on the Angara River, near the city of Bratsk, which lies just northeast of the reservoir on the Trans-Siberian railway. This satellite photograph was taken in winter when the lake had frozen over. Its covering of ice makes it stand out in strong contrast against the surrounding dark highlands.

right
Vesuvius, Italy
Mount Vesuvius, a volcano that last erupted in 1944, stands out clearly in this infrared image showing the Bay of Naples. The city of Naples is on the coast to the left of centre. Red indicates vegetation and blue-green an absence of vegetation (both urban areas and bare rock). Note the rich vegetation growing on the fertile lower slopes of Vesuvius in a ring around the central cone. Vesuvius is famous for the catastrophic eruption in 79 AD that buried the Roman towns of Herculaneum (to the east of modern Naples) and Pompeii (on the plain to the southeast of the volcano) under ash and debris flows up to 23 metres thick.

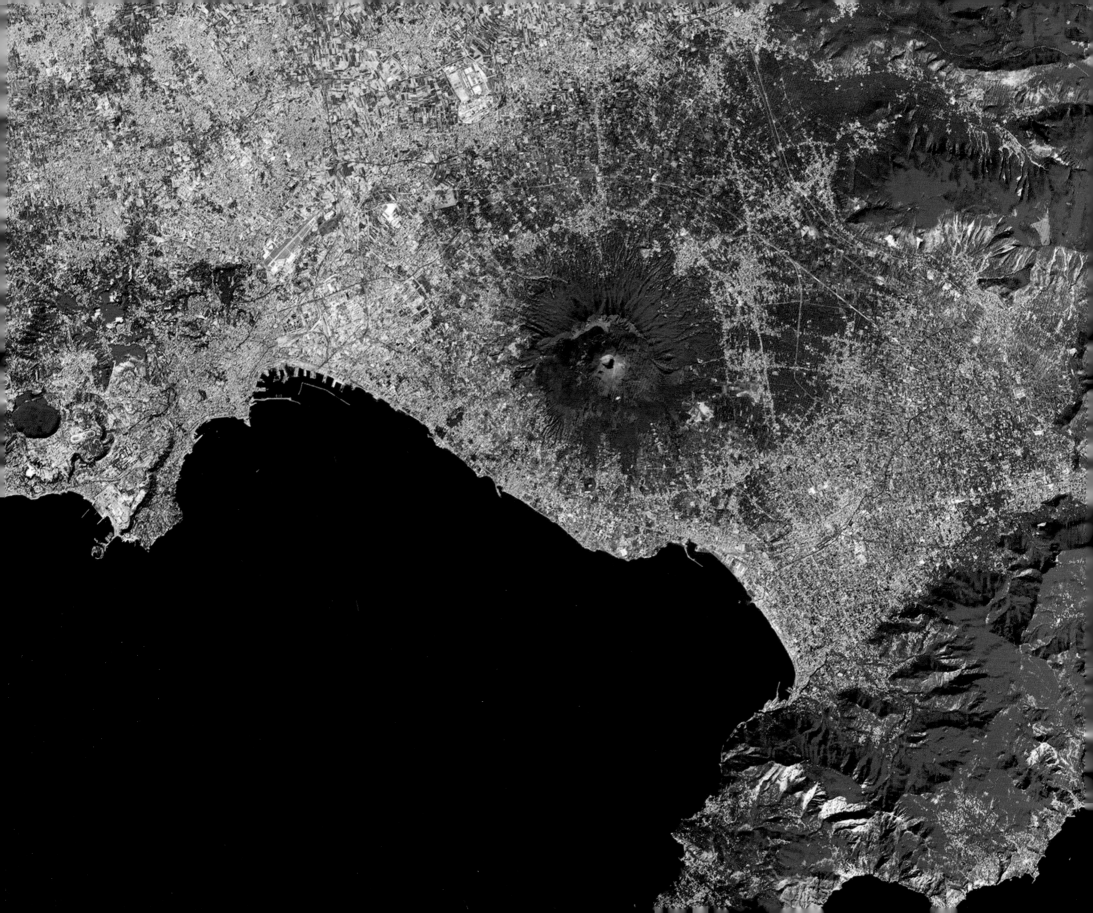

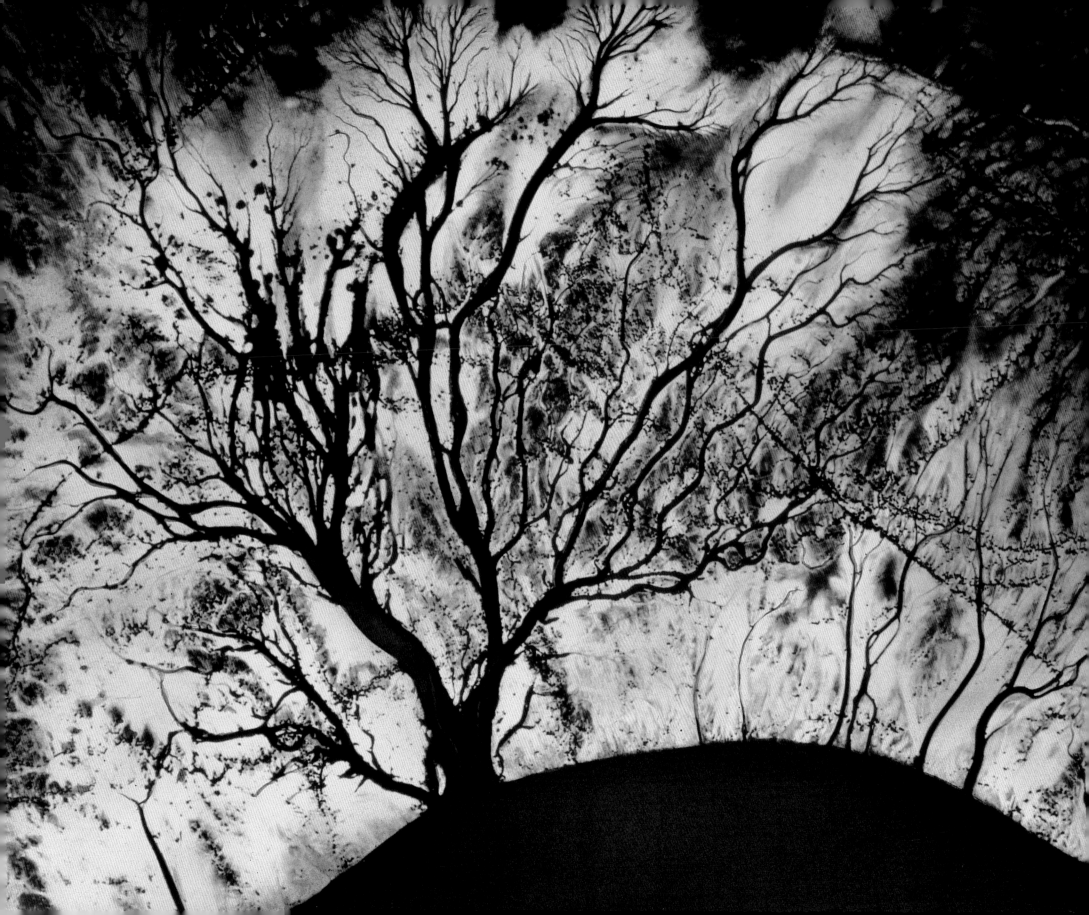

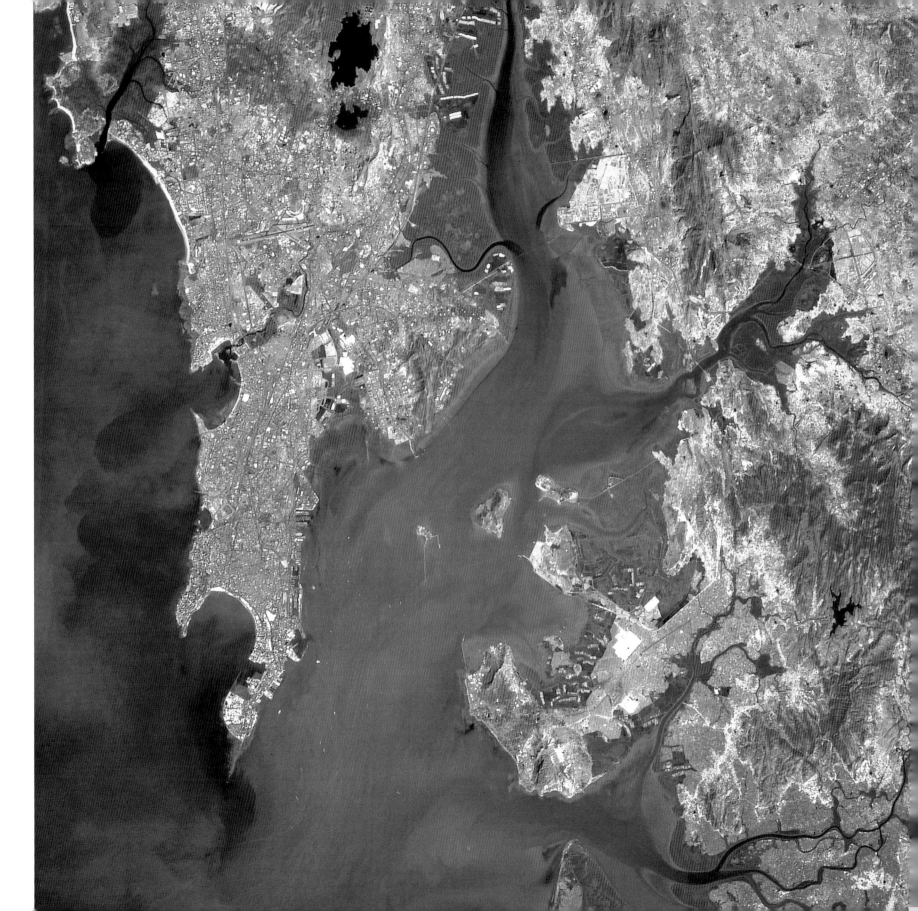

left

Colorado River Delta, USA
The dark hemispherical shape at the bottom of this aerial photograph is the main channel of the Colorado River. Above, distributary channels guide water from the river across the delta's sandbars, made of sediment, towards the Gulf of California. The low gradient and loose substrate encourage the formation of the branching, tree-like patterns seen here, which are typical of deltaic systems.

Mumbai (Bombay), India
This coloured SPOT satellite image shows the city of Mumbai, built on a group of islands just off the west coast of the Indian mainland. Vegetation is coloured red; note the racecourse on the western side of the city. On the east side of the main island are the rectangular shapes of the harbour. River sediments appear brown-grey, while the white and grey patches (upper left of centre) are salt pans. With industrial and commercial development, Mumbai has become one of the most densely populated cities in the world.

Monterrey, Mexico
This image from the Space Shuttle Atlantis shows the concentric ridges which form the Sierra Madre Oriental in northeast Mexico (left). The image spans an area 46 kilometres across, with the city of Monterrey, the third largest in Mexico, visible at bottom right. The population of this industrial city expanded by a factor of 100 to 3 million during the course of the twentieth century.

Polders in the Netherlands

This reclaimed land, known as 'polder' in Dutch, is located at the southern end of Ijssel Meer in the Netherlands. The land was reclaimed by building a dam, completed in 1932, across the seaward entrance to the Ijssel Meer lagoon, and then pumping out water to lower the level, bringing into use previously submerged areas. This infrared SPOT satellite image shows the resulting vast, flat and fertile plains, which are now farmed intensively. With no natural topographic obstacles, the land is divided into fields along straight lines, imposing a strongly geometric pattern on the landscape.

Parana River Delta, Argentina
This coloured satellite image shows a small section of the vast Parana River Delta. Multiple channels are visible (lower right) flowing east into the Rio de la Plata, an inlet on Argentina's Atlantic coast lying north of Buenos Aires. The Parana River flows 4,850 kilometres southwards from its source in the Brazilian highlands through Paraguay and Argentina. The delta's apex, where the river begins to branch, is 300 kilometres north of where the channels now meet the sea. The delta is advancing steadily, with 165 million tonnes of alluvial sediment deposited each year.

**Desert irrigation
in Saudi Arabia**

The brown and red discs
scattered throughout this
coloured SPOT-1 satellite image
are irrigated fields in the desert
of Saudi Arabia. The fields,
typically 600 metres across,
are irrigated using a centre-pivot
system, where water drawn
from a well in the centre of each
field is applied to the crops by
a sprinkler system rotating about
the well. Such irrigation schemes
have enabled Saudi Arabia
to become a net exporter of
many crops, particularly wheat,
although there are worries about
the long term viability of the
aquifers which feed the wells.

Richat Structure, Mauritania
The Richat Structure – often referred to as the Bull's Eye after its shape – is one of the most striking landmarks in the Sahara to have been photographed from space (in this case from the Space Shuttle Columbia). The 39 kilometre wide structure resembles a meteorite crater but is actually a dome of rock, probably pushed up from beneath by volcanic activity, whose top has been eroded. Hard bands of quartzite are left exposed as upstanding circular ridges 100 metres high. In the lower part of the picture, a sea of sand can be seen encroaching on the Bull's Eye.

Lena Delta, Russia

This satellite image shows the intricate network of channels of the Lena Delta in northeastern Russia. The Lena River flows from Lake Baykal in southern Siberia for 4,400 kilometres before draining into the Laptev Sea far north of the Arctic Circle. The delta, formed by sediment deposited by the river as it reaches the sea, has developed its lace-like network as a result of regular flooding of the delta channels; with each major flood, channel banks are breached and new channels form. The delta is an extensive protected wilderness area which is an important refuge and breeding ground for many species of Siberian wildlife.

River Senegal

Shown here in a false-colour SPOT satellite image, a section of the River Senegal forms a natural border between the desert sands of Mauritania (upper right) and the savannah of Senegal (lower left). The Mauritanian desert is largely bare rock (grey) and sand dunes (yellow) but some sparse vegetation (red) does manage to grow along shallow, linear depressions. South of the river are mixed scrub and grassland (a richer red colour), characteristic of savannah vegetation. The main river channel (dark green) meanders along a wide alluvial flood plain (grey), with numerous minor channels and lakes (blue and green) which form when the river bursts its banks.

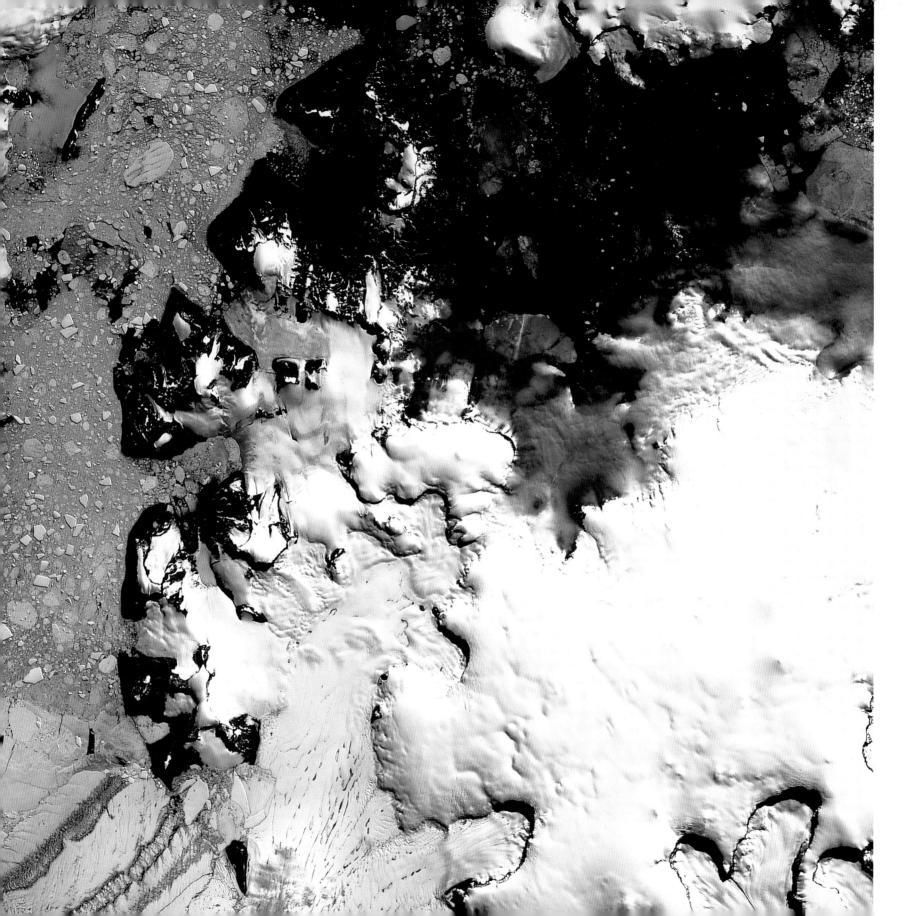

Graham Land, Antarctica

Graham Land (also known as the Antarctic Peninsula) is the northernmost part of continental Antarctica. This infrared SPOT-1 satellite image shows the eastern coast near the tip of Graham Land. Snowfields (white) dominate the lower right of the image, while a string of bare rock (black) runs along the coast from lower left to top centre. This image was taken in the southern summer, when air temperatures at the coast are often above freezing: broken, scattered pack ice (blue-green) floats on the Weddel Sea on the left, with open water (also black) at top right. The field of view is about 60 kilometres across.

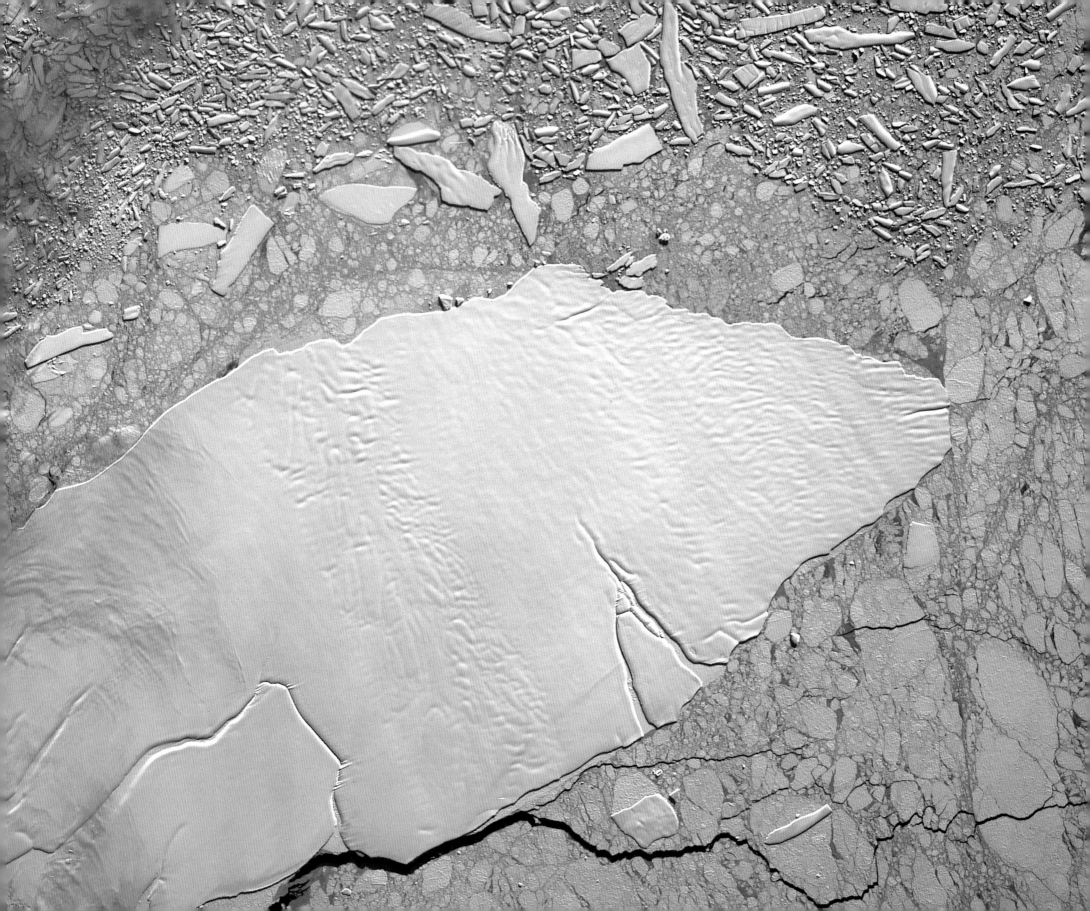

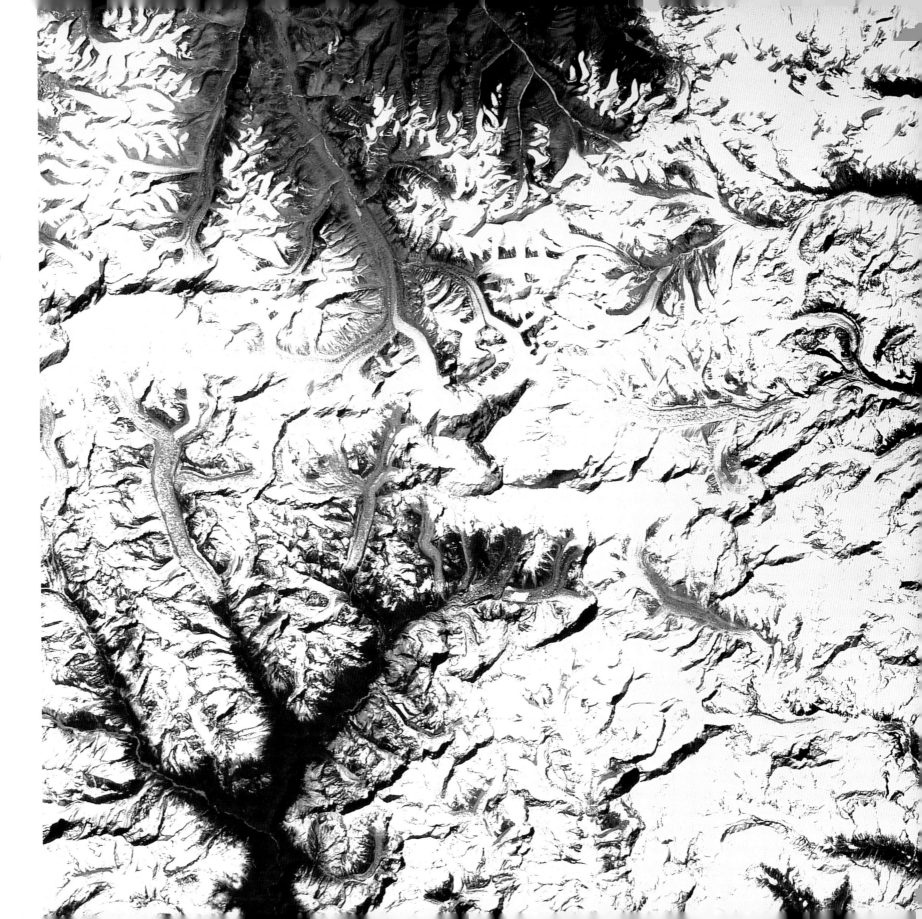

left

Iceberg near Antarctica

This SPOT-3 satellite photograph shows a large iceberg in the sea near Antarctica. It was taken during the southern autumn when pack ice, which has fragmented during the summer, is beginning to refreeze into solid sheets of ice. The water surrounding the iceberg, full of pack ice fragments, is in the process of refreezing as temperatures fall with the coming of winter.

Mount Everest

Mount Everest rises at the centre of this infrared SPOT-1 satellite image. On the border between Nepal and Tibet, Everest, at 8,850 metres, is the highest peak on Earth. The Himalaya range results from the buckling of the Earth's crust as the Indian and Asian tectonic plates collide, which takes place at a rate of about 10 centimetres each year. Satellite positioning surveys have shown that Everest is still slowly growing, as well as moving slightly northeast.

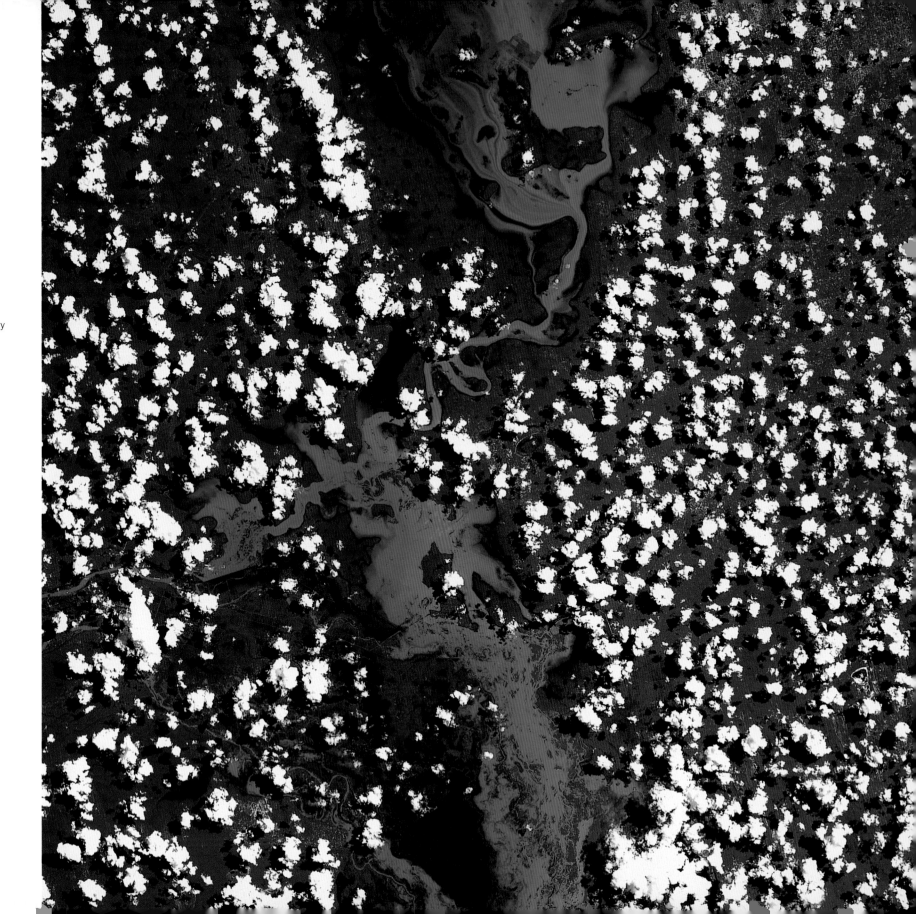

Flooding in Mozambique
A combination of weeks of heavy rain, followed by the arrival of Cyclone Eline on 22 February 2000, caused catastrophic flooding of the Limpopo River in southern Mozambique. The severe flooding lasted for three weeks, with flood waters rising 8 metres above the normal river level, and nearly a million people were affected. This infrared image, taken by the SPOT-2 satellite, vividly shows the green floodwaters, heavy with silt, mingling with the red infrared signature of vegetation. Fluffy white cumulus clouds have formed over the land.

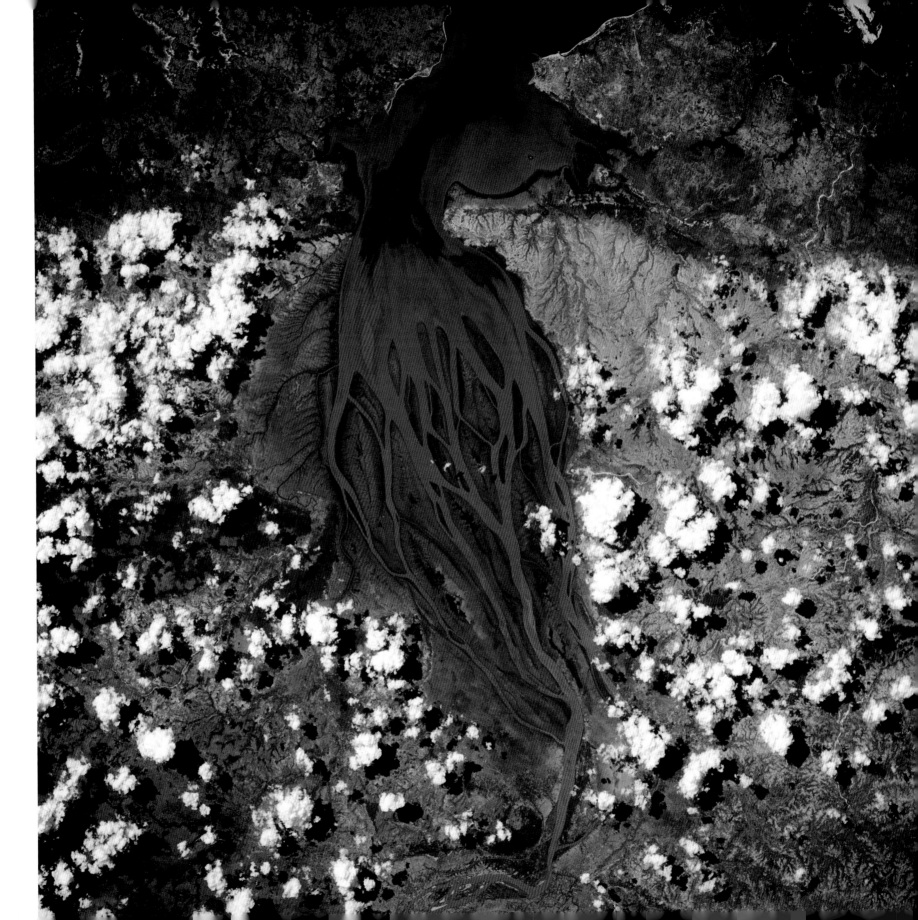

Betsiboka River, Madagascar
Over the course of the twentieth century forest cover on the island of Madagascar decreased from about 90 per cent to just 10 per cent, due to agricultural expansion and timber extraction. The resulting eroded soil shows up in red in this shuttle photograph of the Betsiboka River. Satellite mapping has enabled scientists to trace the growth of silt bars in the estuary of the Betsiboka; some are now sufficiently permanent to support woodland.

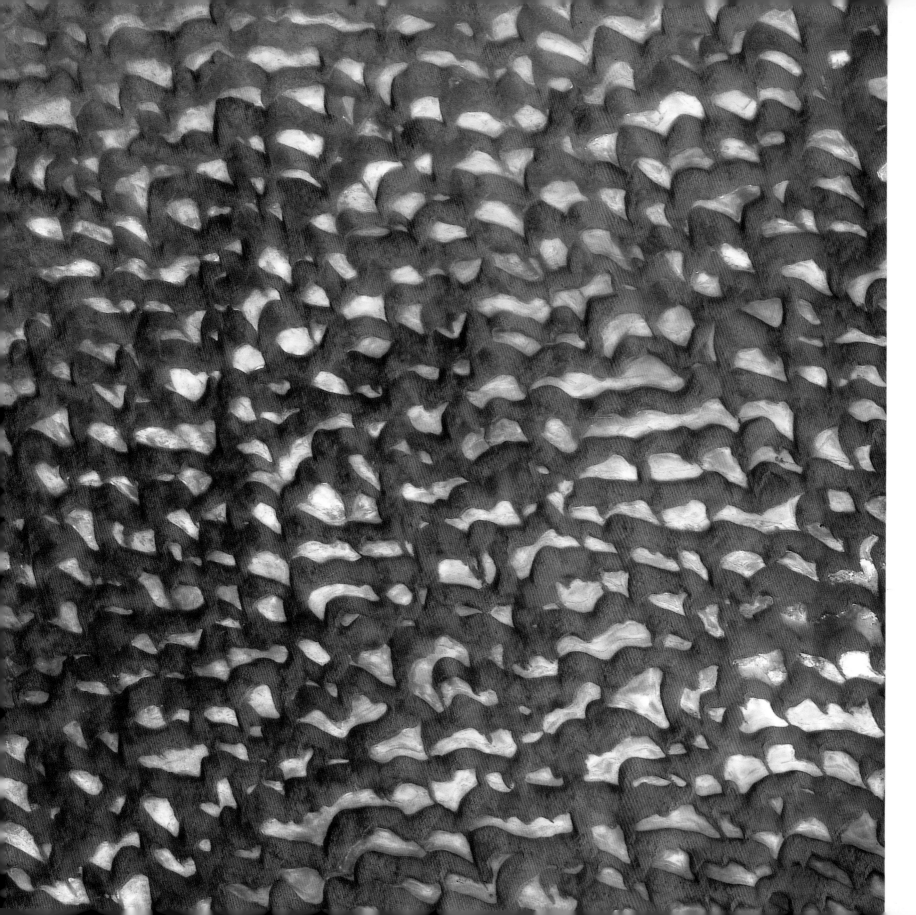

**Al Kidan plain,
Arabian Peninsula**

The Al Kidan plain, situated in the
northern part of the Rub al Khali,
or 'Empty Quarter', of the
Arabian Peninsula, is a hyper-
arid region with an average
of only 20–50 millimetres of rain
per year. This infrared image
taken from the SPOT-2 satellite
shows the barchanoid (slightly
crescent-shaped) dunes that
dominate this region. The dunes
are typically 3–4 kilometres
across; the asymmetry of the
crescent shapes shows that they
were formed by winds blowing
from the north. Between the
dunes lie depressions where
brine has evaporated following
occasional rain storms, leaving
behind salt deposits (pale blue).

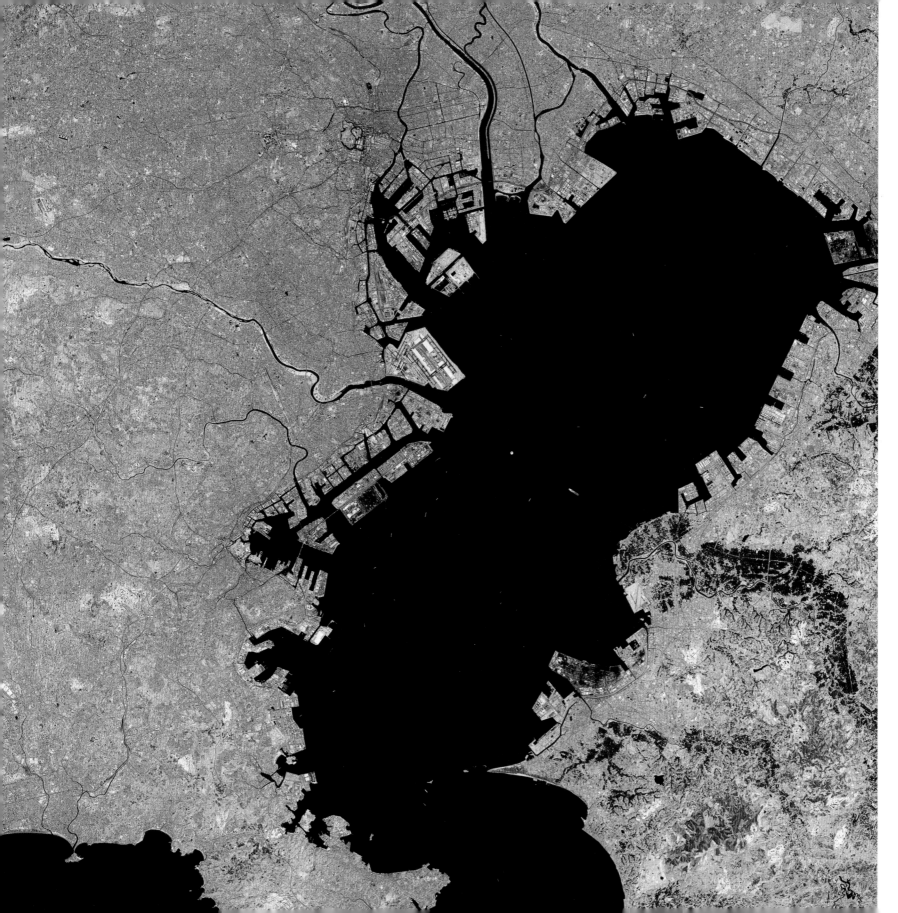

Tokyo Bay, Japan
This SPOT satellite image of Tokyo Bay, Japan, has been coloured to reveal areas of different land use more clearly. The vast and sprawling urban areas are blue, ever-decreasing areas of vegetation are orange, while water is black. Tokyo city is at the north of the west coast of the bay (top centre) and Yokohama port is to its south (centre). They were once separate cities but urban expansion has joined the two to form a huge, densely populated metropolis that is the largest city in the world, with the most expensive land prices.

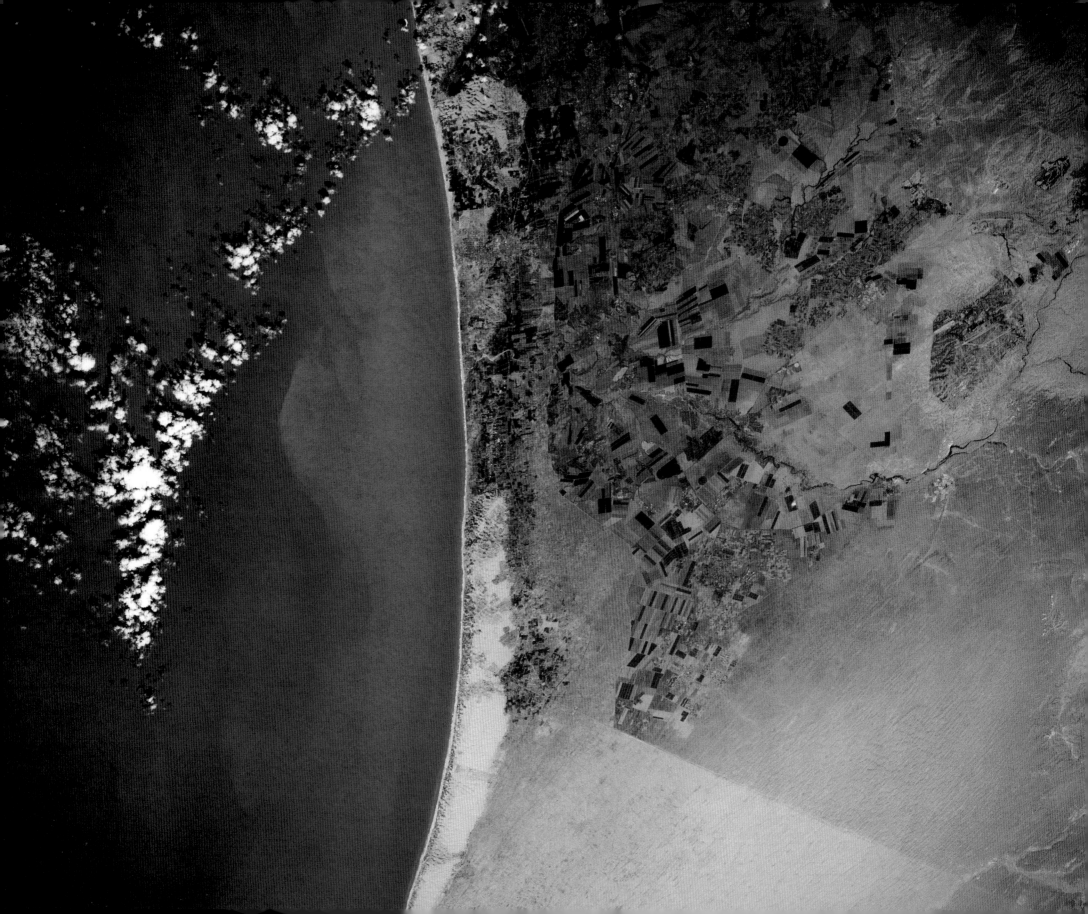

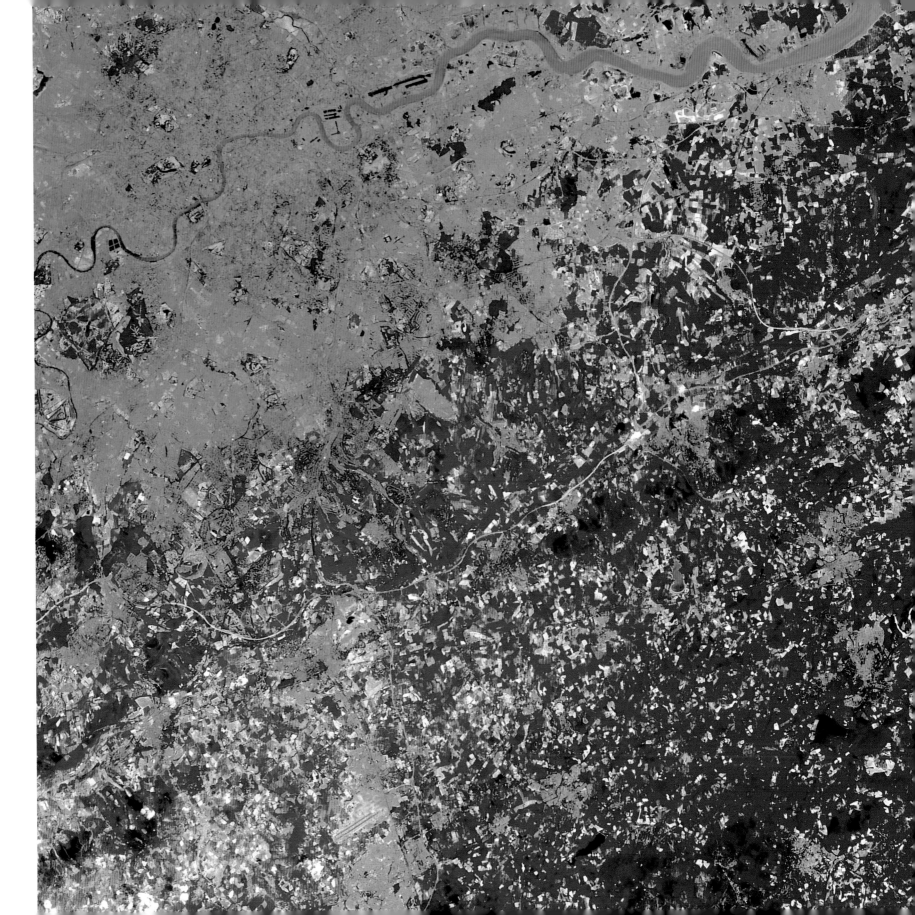

left

Egyptian–Israeli border
This photograph from the
Space Shuttle Challenger shows
the extent to which the peculiarly
human passion for straight lines
is reshaping the Earth's surface.
The straight line through this
picture divides the uncultivated,
arid Sinai Desert of Egypt
in the south, from the darker,
irrigated land of Israel to the
north. Individual Israeli fields,
fed by water from the
Jordan River, appear almost
black. The pale coloured strip
of land crossing the border along
the coast is a heavily grazed
area. This image covers
70 square kilometres across.

London and environs, UK
The urban area of London
is shown as blue and green at
the top of this infrared SPOT-1
image. London grew up along
the River Thames, expanding
rapidly during the nineteenth
and early twentieth centuries,
to be halted by the imposition
of the Green Belt in 1938.
Ironically, this helped to make
the surrounding counties less
rural in character as their towns
became dormitories for workers
commuting to London.
This image shows some of the
enlarged commuter towns
(also blue and green) that vie
for space among fields (red)
and woodland (brown).

Meteorite impact craters, Quebec

This view of the Clearwater Lakes in Quebec, Canada, taken from the Space Shuttle Challenger, shows that these circular lakes are in fact water-filled impact craters from a meteorite strike, which occurred some 290 million years ago. It is thought that a single meteorite broke up during its entry into the atmosphere, producing two side-by-side craters measuring 22 and 32 kilometres across respectively. The ring of islands in the larger lake marks a central uplifted area; the islands are covered in rocks melted in the impact.

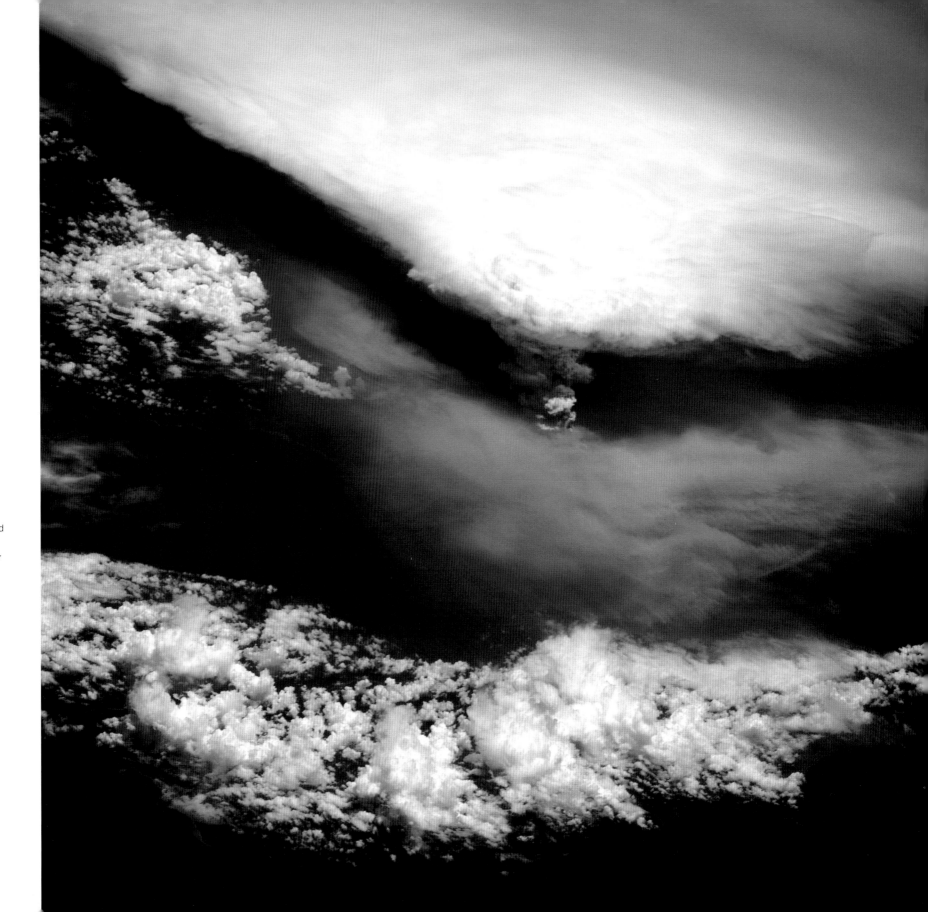

**Rabaul Volcano,
Papua New Guinea**
Astronauts aboard Space
Shuttle Discovery captured this
oblique photograph of Rabaul
Volcano in Papua New Guinea
as it erupted on the morning of
19 September 1994. At the top
of the picture, a white plume
of smoke, steam and fine ash
extends to an altitude of
18 kilometres. The brown layer
between the smoke plume and
the clouds, towards the bottom
of the photograph, consists
of heavier ash fallout suspended
in the lower atmosphere.
This ash cloud deposited a layer
20–25 centimetres thick over
the town of Rabaul, causing
many roofs to collapse.

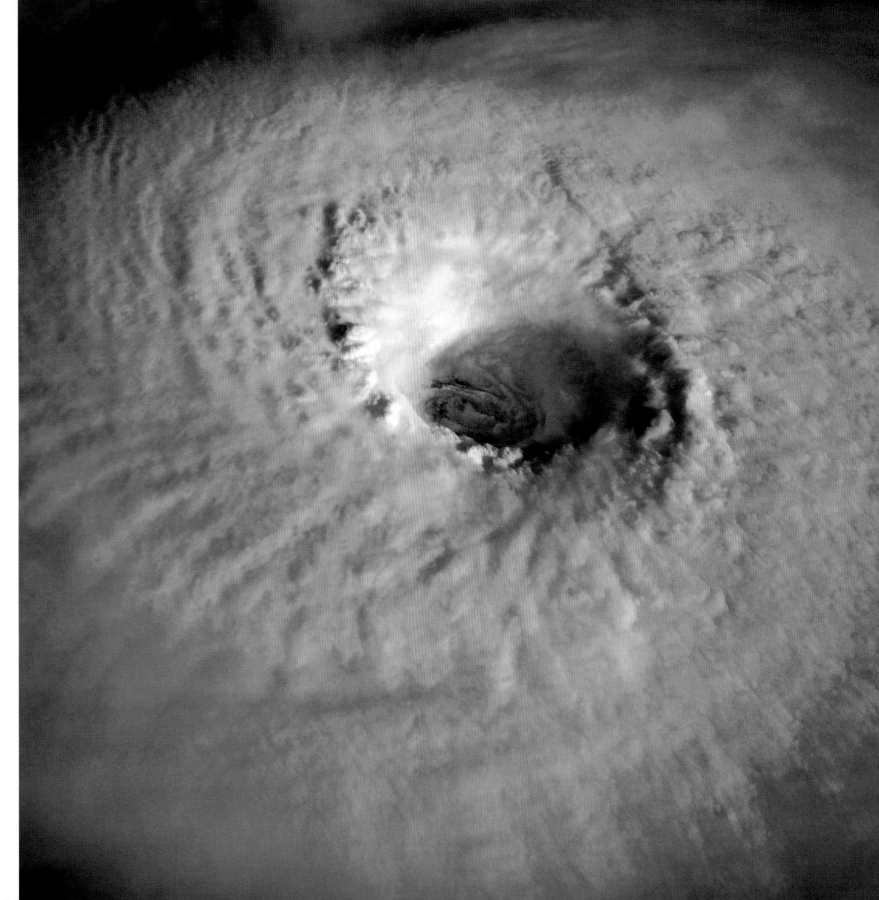

Typhoon Odessa

The most striking weather features to be viewed from space are perhaps tropical cyclones. The crew of the Space Shuttle Discovery took this photograph of Typhoon Odessa in the western Pacific in August 1985 from an altitude of 373 kilometres. Tropical cyclones form when moist air over the ocean is forced to rise. As the moist air rises, it expands and cools, generating the spiralling cloud formations that are visible from space. The eye of the storm, which here is 27 kilometres across, is formed as dry air from above rushes into the low pressure area at the centre of the storm and plunges downwards, leaving a cloud-free circle surrounded by a cylindrical wall of thunder clouds.

Hurricane Bonnie

This satellite image shows Hurricane Bonnie approaching the eastern seaboard of the United States on 25 August 1998. The following day, the hurricane arrived at North Carolina's southern coastline, its strong winds and flooding rain damaging buildings, tearing down trees and cutting off power to nearly half a million people. Hurricane Bonnie formed a towering mass of spiralling cloud twice as tall as Mount Everest, unusually high for an Atlantic storm. This image was taken by the GOES-8 satellite which monitors weather patterns and other environmental variables on a continuous basis.

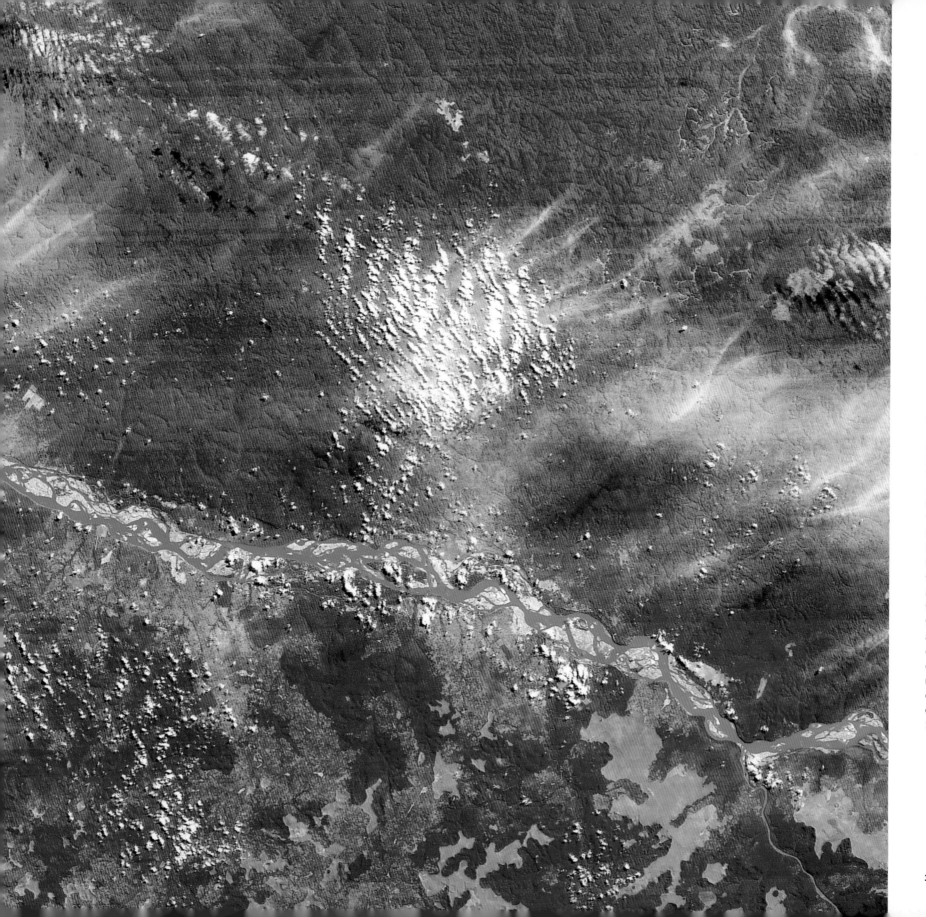

Rainforest in central Africa
This false-colour infrared image, obtained by a Landsat satellite, shows the southern boundary of rainforest vegetation in the Bandundu Province, in the west of the Democratic Republic of Congo. The wide River Kasai flows east to west (right to left) across the picture. The strong red colour north of the river represents healthy, dense rainforest cover (with a few white clouds above). The paler reds and greens to the south represent less densely forested areas and grassland.

right
Huang Ho (Yellow River), China
The Huang Ho, or Yellow River, 5,500 kilometres in length, is China's second longest river. The Yellow River takes its name from the colour of its sediment-laden waters. Its course passes from the highlands of Tibet through a hilly region known as the Loess Plateau, named for its soft, yellow-brown, wind-deposited silts known as loess. Heavy summer rainfall erodes the loess deposits and carries the sediment into the river. Downstream, the sediment contributes to the fertile soils of flood plains that feed 120 million people.

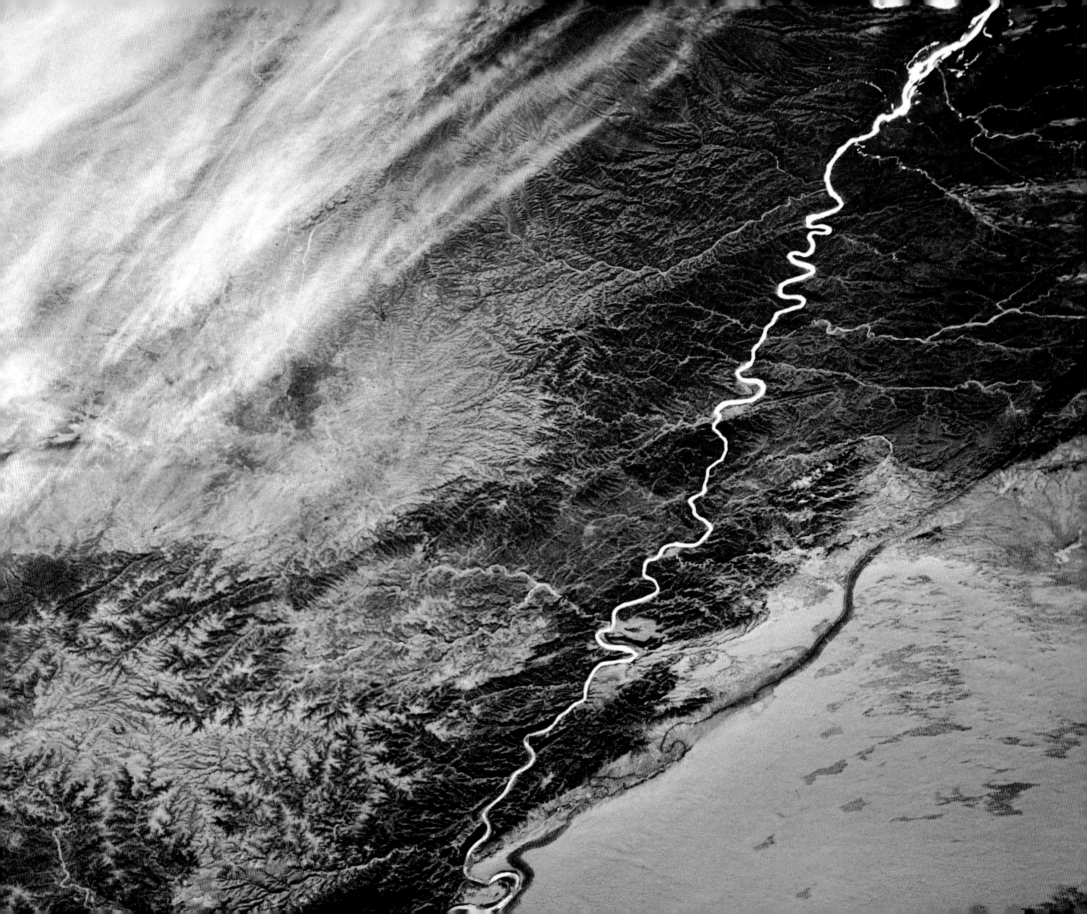

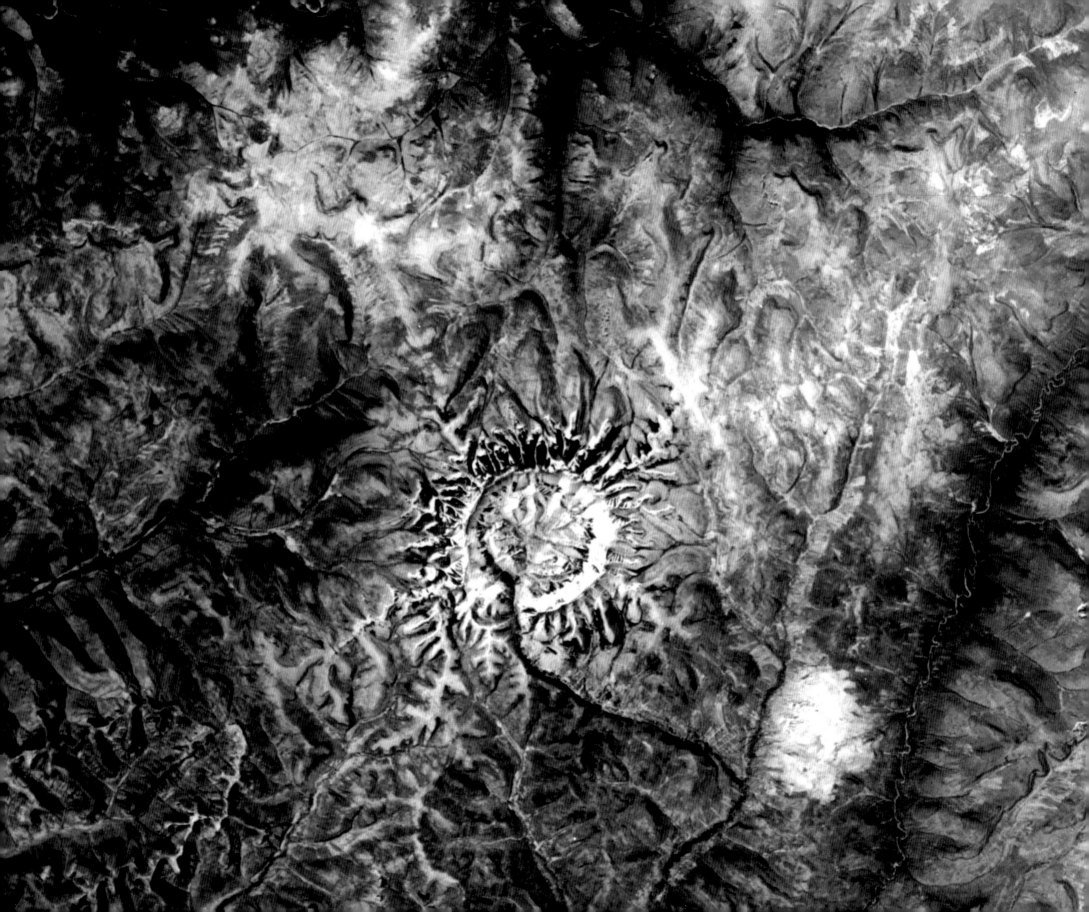

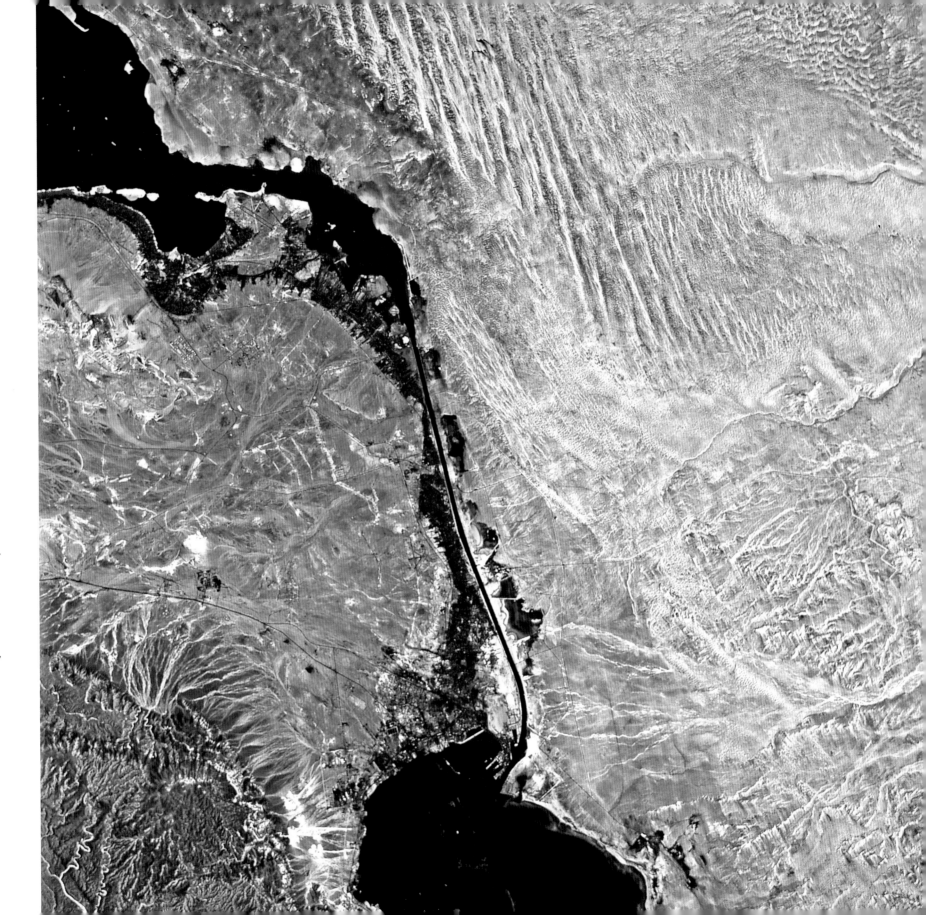

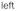

Gora Konder Crater, Siberia

This photograph, taken from the Space Shuttle Discovery, shows the circular outline of the Gora Konder Crater, Republic of Yakutsk, Siberia. This crater, 12 kilometres across, is either the extinct caldera of an ancient volcano, or the result of impact by a meteorite. The two kinds of landform appear similar from above, and only detailed work on the geology of the feature can ascertain its true nature. This region, one of the Earth's great wildernesses, is so remote that no ground survey work has yet been undertaken.

Suez Canal, Egypt

The Suez Canal, 167 kilometres long, was constructed between 1859 and 1869 to link the Mediterranean with the Red Sea. It has been widened twice, and now carries over 50 ships each day. This infrared SPOT satellite image shows the southern part of the canal, between the Red Sea (bottom) and Little Bitter Lake and Great Bitter Lake (top), surrounded by the Egyptian desert. The town of Suez, which lies on the northern shore of the Red Sea, is not visible.

Ganges River Delta
A few of the Ganges River Delta's many channels meet the sea in this satellite image. The delta apex lies 300 kilometres north of the coast, where the Ganges splits into many smaller channels, which flow south through Bangladesh into the Bay of Bengal. The delta has been formed over thousands of years from sediment transported from the river's vast catchment and deposited as the river slows on meeting the sea. The fertile alluvial soils of the delta support a dense population, despite the risk of flooding; cultivated fields are visible in the upper left corner. To the south a vast tract of forest and salt water swamp (dark blue) provides one of the last preserves of the Bengal tiger.

Kure Atoll, Hawaii
Just 10 kilometres across,
Kure Atoll lies at the extreme
end of the Hawaiian Island chain
in the north-central Pacific.
The atoll began life as a coral
reef growing in the shallow
waters around a volcanic island.
As the volcano began to subside,
the coral reef continued to grow,
building upwards to keep pace
with the sinking volcano so that
its top remained in shallow
water. Eventually the volcano
disappeared beneath the waves,
leaving only the fringing reef
and a shallow central lagoon
which together form a sanctuary
for birds.

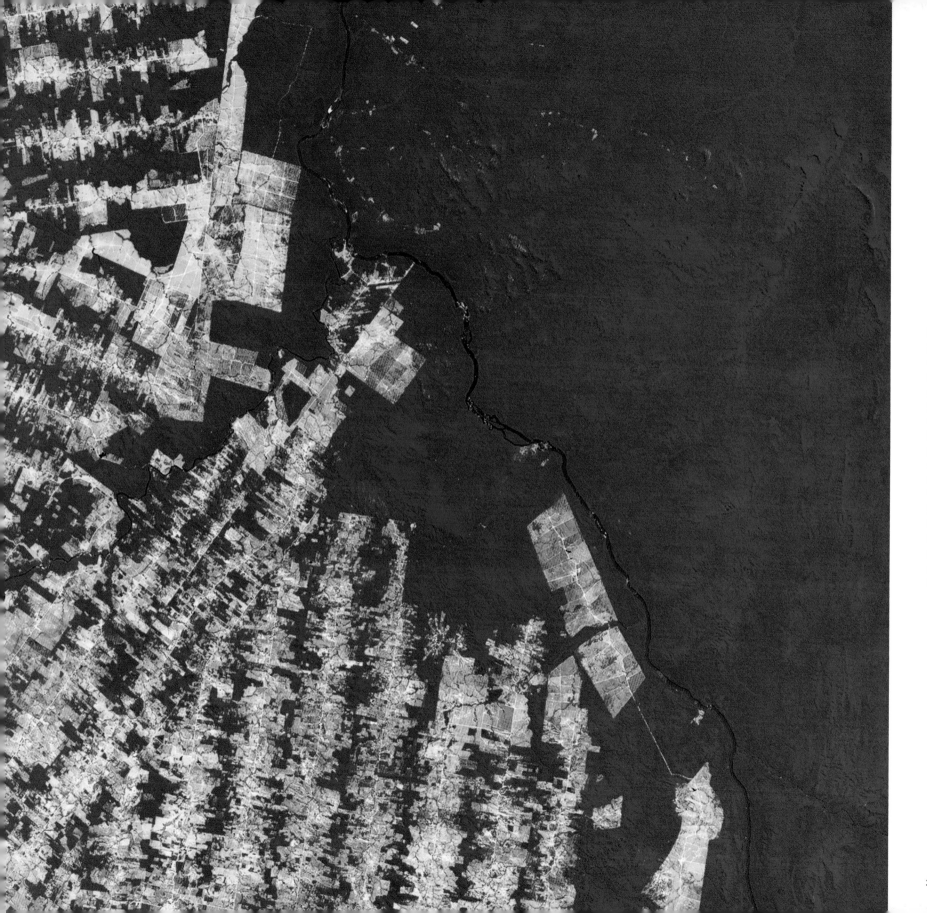

Deforestation in Brazil
Dense vegetation, the remnants
of the rainforest, show up red in
this infrared satellite image of
deforested areas in the Amazon
basin of Brazil. The geometrical
shapes are areas of cleared
land. In 1970, about 99 per cent
of the Amazon rainforest was
still standing; 30 years later,
only 85 per cent remained.
The main cause of deforestation
here is slash-and-burn clearance
for agriculture. Rainforest soils
are usually poor in nutrients
and can only be farmed for a few
years before more clearance
is necessary.

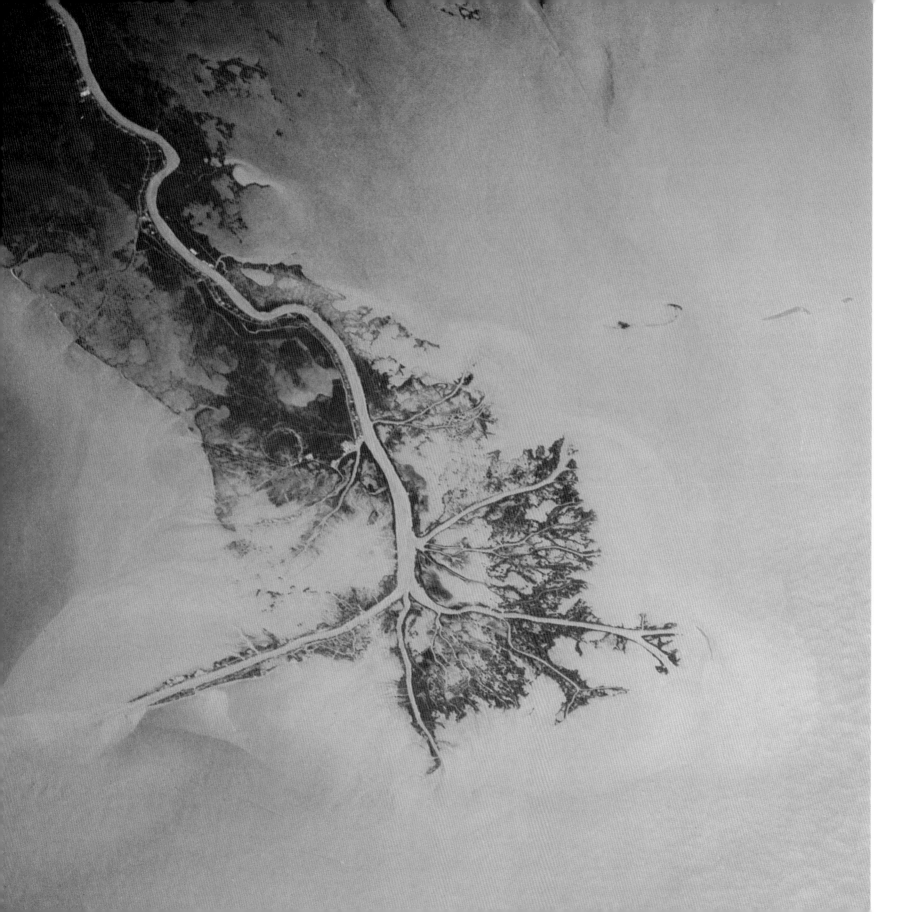

Mississippi Delta, USA
The Mississippi Delta is a textbook example of a bird's-foot delta, the form that many river estuaries take as their coastal mud flats enlarge and extend away from the coast into open water. The mud flats have built up highest around the main trunk of the river, with smaller streams called distributaries spilling off in all directions. Plumes of fine-grained river sediment, dispersed by wind-driven surface water currents, can be seen on the left of this satellite photograph. The distance from the point where the river enters the image to the far end of the delta is about 60 kilometres.

Desert, United Arab Emirates
This aerial view of desert terrain in the United Arab Emirates' Bu Hasa oil field shows an area of sand dunes (lower right) and the smoke plume from a burning oil well flare (top centre). Flares are lit deliberately to burn off gases, associated with oil deposits, that are not commercially viable to collect. Oil is a fossil fuel, derived from the buried remains of ancient plants and animals, which turn into oil under particular geological conditions over millions of years. As such oil is a non-renewable resource like coal and natural gas. Oil reserves in Abu Dhabi Emirate, which contains one tenth of the world's total, are expected to last until the end of the twenty-first century.

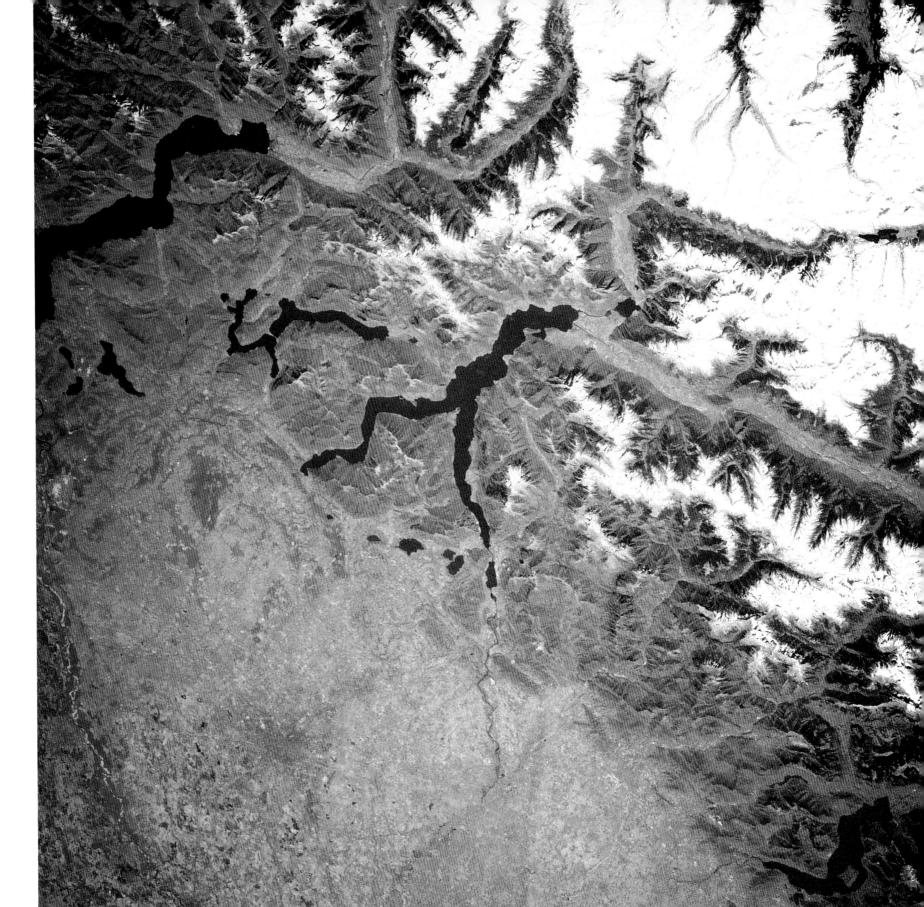

Alps, Switzerland and Italy
The snow-capped Alps of Switzerland occupy the upper right half of this infrared satellite image, taken in the spring of 1997. Glaciated valleys wend their way through the mountains from the highest in the northeast down towards the lower slopes in the southwest. Until 12,000 years ago glaciers extended to much lower altitudes than they do today, carving out the valleys that are now filled by lakes, the four largest of which are Maggiore, Lugano, Como and d'Iseo (from northwest to southeast). Further south, beyond the alpine foothills, is the patchwork of fields that covers the flat plains of the industrialized and agriculturally productive Po River valley.

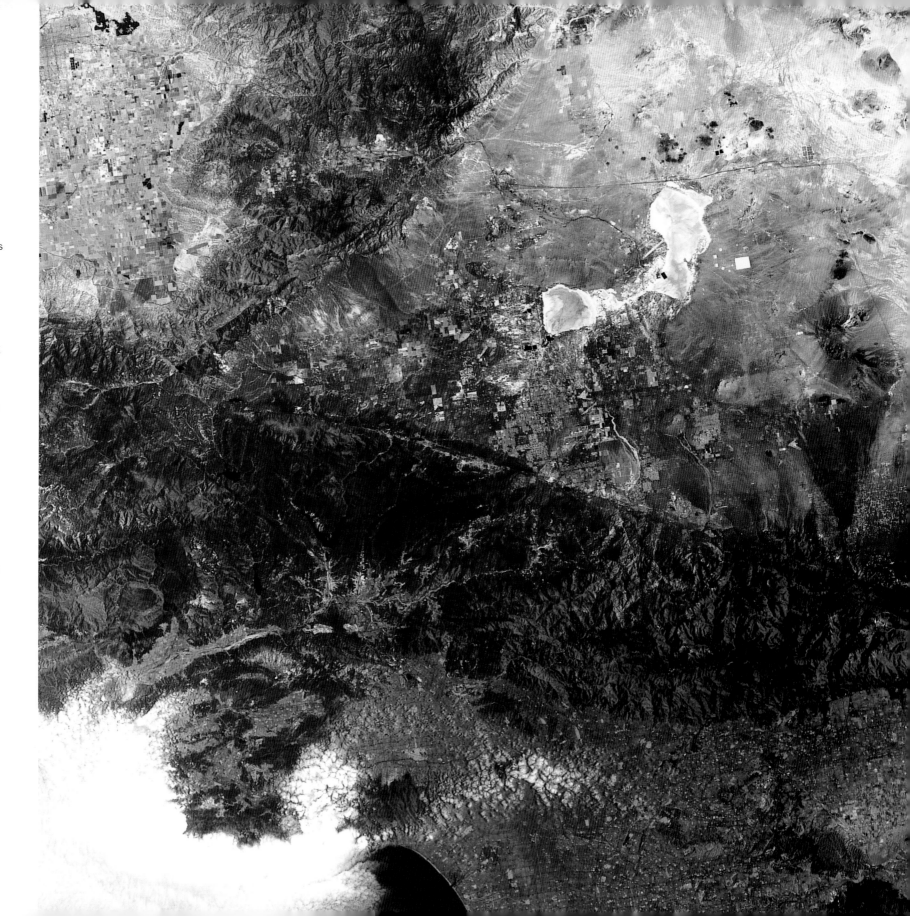

San Andreas Fault, California

This colour satellite image shows part of the San Andreas Fault in California, on the west coast of the United States. The fault, which represents the boundary between the Pacific and North American tectonic plates, is clearly visible as a line running southeast to northwest across the picture. To the north above the fault, brown indicates arid, grassy plains, while to the south green areas indicate wetter, forested mountains, different because of the distinct geological and climatic conditions encountered either side of the fault. A second fault, the Garlock Fault, meets the San Andreas Fault left of centre, and shows the same landscape contrast to either side.

The Pacific plate, which includes part of the California coast, is moving northwest past the North American plate at a rate of several centimetres per year. At this rate, in 10 million years' time, Los Angeles (blue, lower right) will come to be opposite San Francisco.

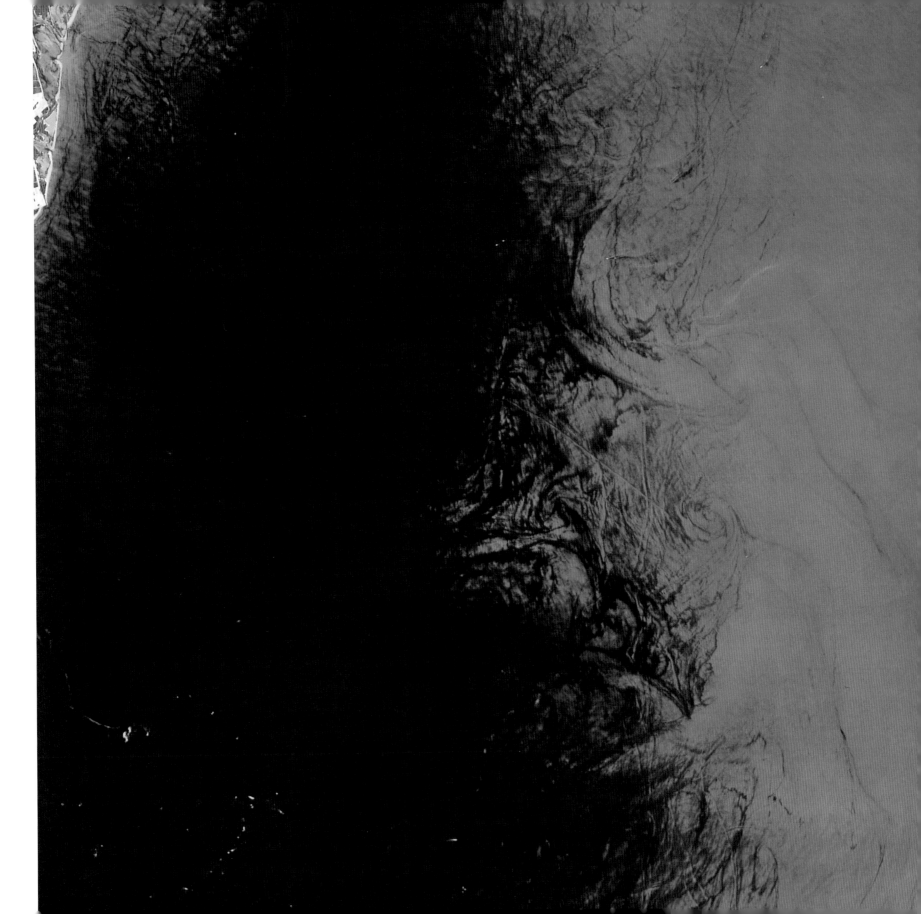

Algal blooms in the Adriatic
In this infrared image of the
Adriatic Sea, off the coast of
northern Italy, dense clouds of
planktonic algae, known as algal
blooms, show up blue against
the black of clear water.
Vegetation on land appears red
(top left). Algal blooms are
particularly common in the
Adriatic because it is surrounded
on three sides by land; rivers
flowing off the land carry
nutrients which encourage algal
growth. Slow circulation of water
within the Adriatic means that
nutrient levels build up in the
surface waters, leading to large
algal blooms. This image was
taken by the SPOT-2 satellite
in July 1991.

Guatemala City

Guatemala City (blue, right of centre) occupies a valley in Guatemala's central highlands, surrounded by the peaks of the Sierra Madre. Forest clearance, to make way for agricultural and urban development (also blue), has also spread to the surrounding valleys. North of the city is the east–west running Motagua Fault, movement along which has caused many major earthquakes in the last 200 years. A line of volcanoes south of the city further attests to the violent geological activity that affects this area. This satellite image shows a region 150 kilometres across.

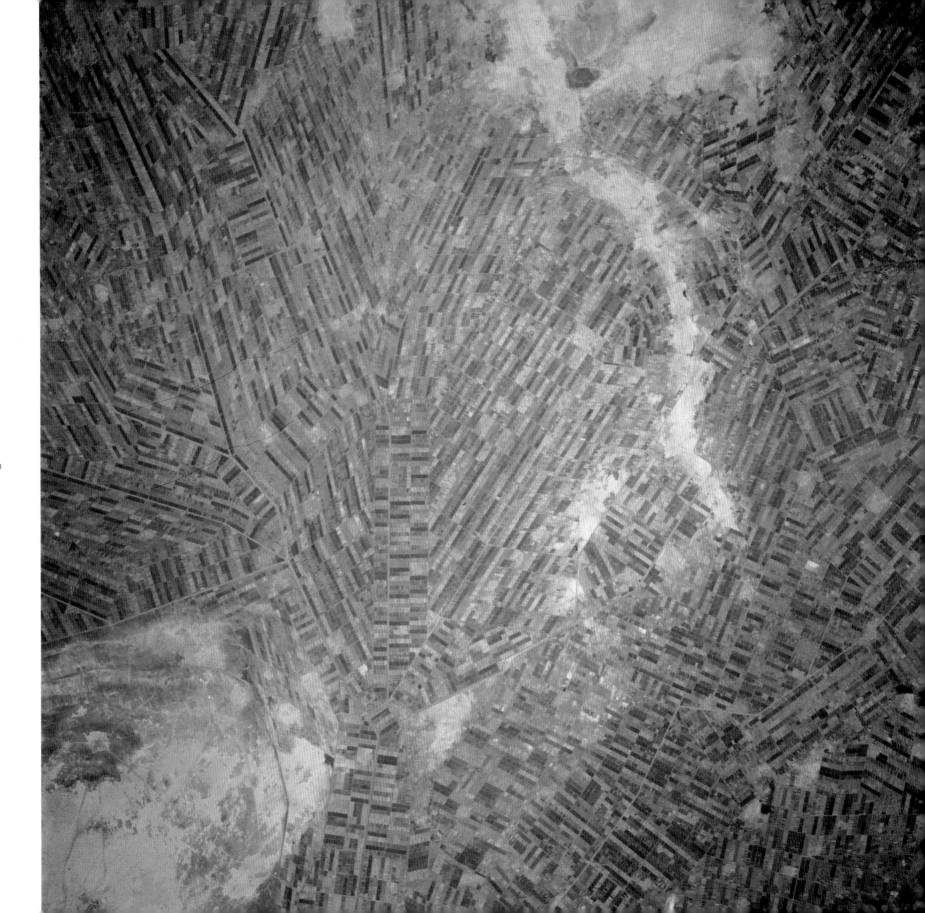

Sudan's irrigated fields
This view of one of the world's largest irrigation schemes, located southeast of Khartoum, Sudan, was taken by the Space Shuttle Columbia. Begun in 1925, the Gezira scheme is based on a network of 4,300 kilometres of canals and ditches that irrigate a million hectares of semi-arid land lying between the Blue and White Niles. The crops produced by the Gezira scheme, of which the most important is cotton, underpin the Sudanese economy. The field of view here is about 170 kilometres across.

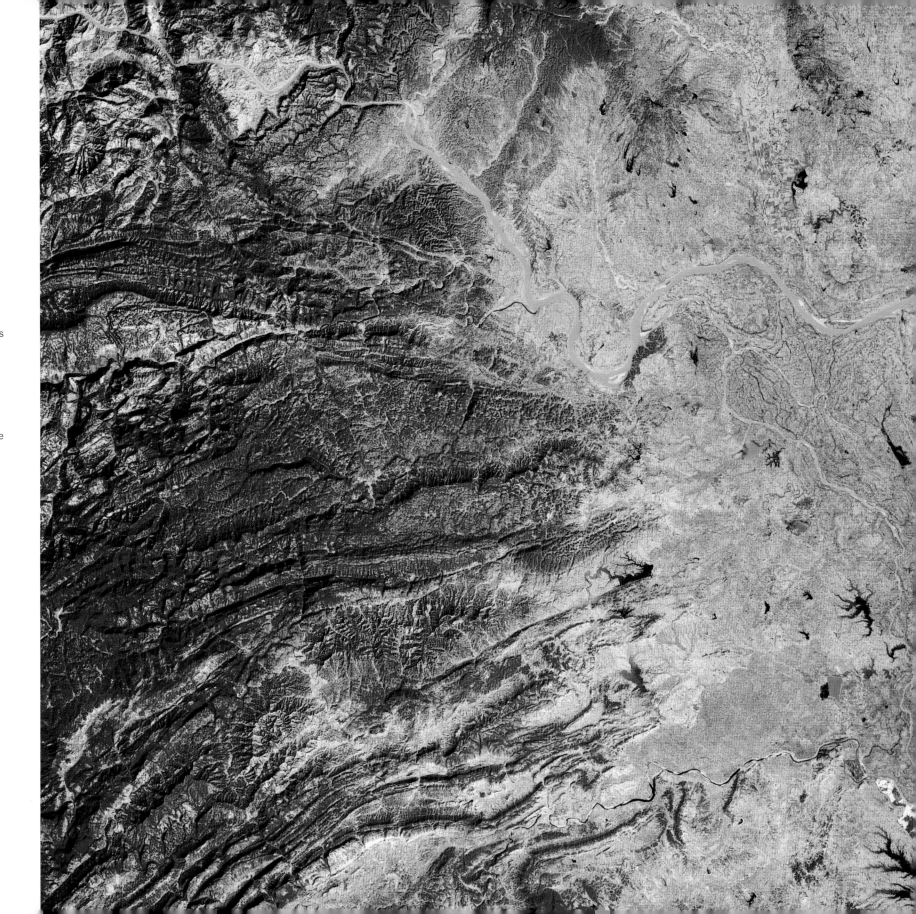

Chang Jiang (Yangtze River), China

This Landsat image shows a 180-kilometre section of China's longest river, the Chang Jiang or Yangtze River, as it flows from the high mountains of western China (upper left corner) into the plains of the east. In the mountains the Yangtze flows through limestone gorges up to 600 metres deep. Since this picture was taken in 1988, a dam has been built and the rapids of Xilin Gorge have been submerged by a reservoir. The Yangtze slows as it reaches the East China Plain, which it crosses in broad, meandering loops. This is a fertile region, providing half of China's agricultural output, and is home to one third of China's population.

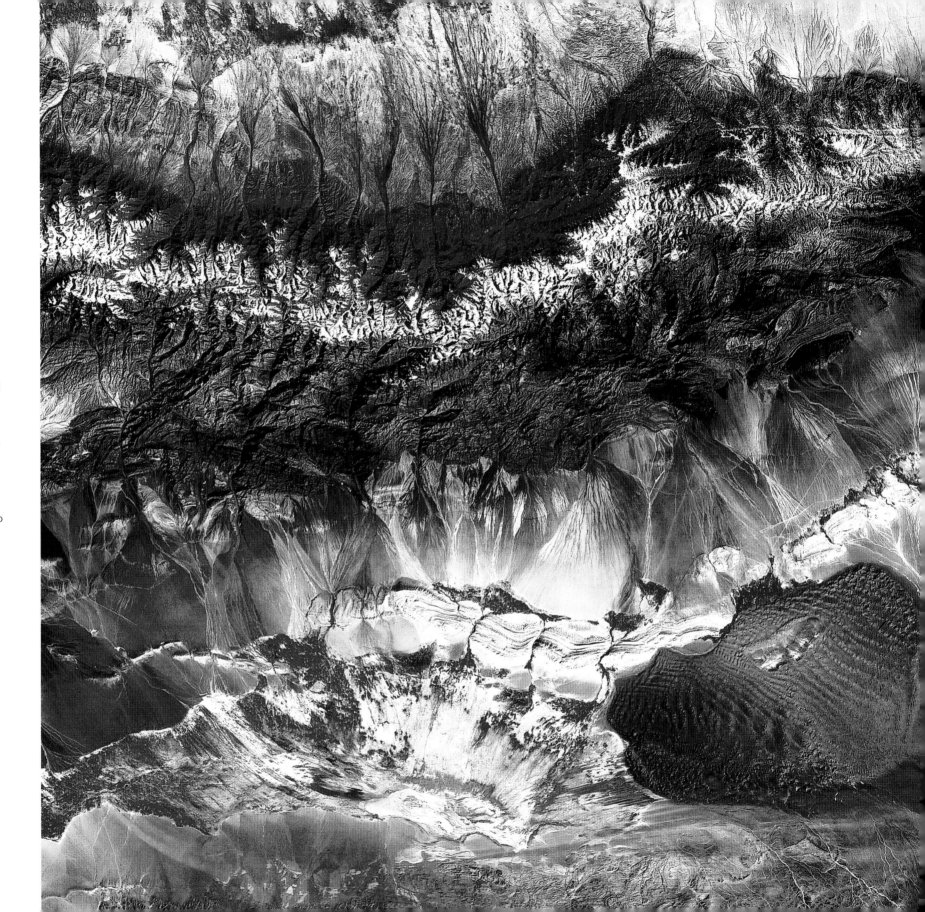

Turfan Depression, China
This false-colour satellite image shows the northern edge of the Turfan Depression, a low lying basin in northwestern China, close to the border with Kyrgyzstan. The snow-capped Tien Shan (Heavenly Mountains) run across the upper half of the picture and form the northern rim of the depression. While the wet northern slopes are densely forested (red), trees on the arid southern slopes only grow in deep, shady valleys (dark red). Temporary streams (off-white) on the southern slopes flow onto a gravel plain (brown-green) where the water seeps in, supplying springs along the plain's lower margin which support cultivation (red).
To the east, an area of sand dunes is a reminder of the proximity of desert.

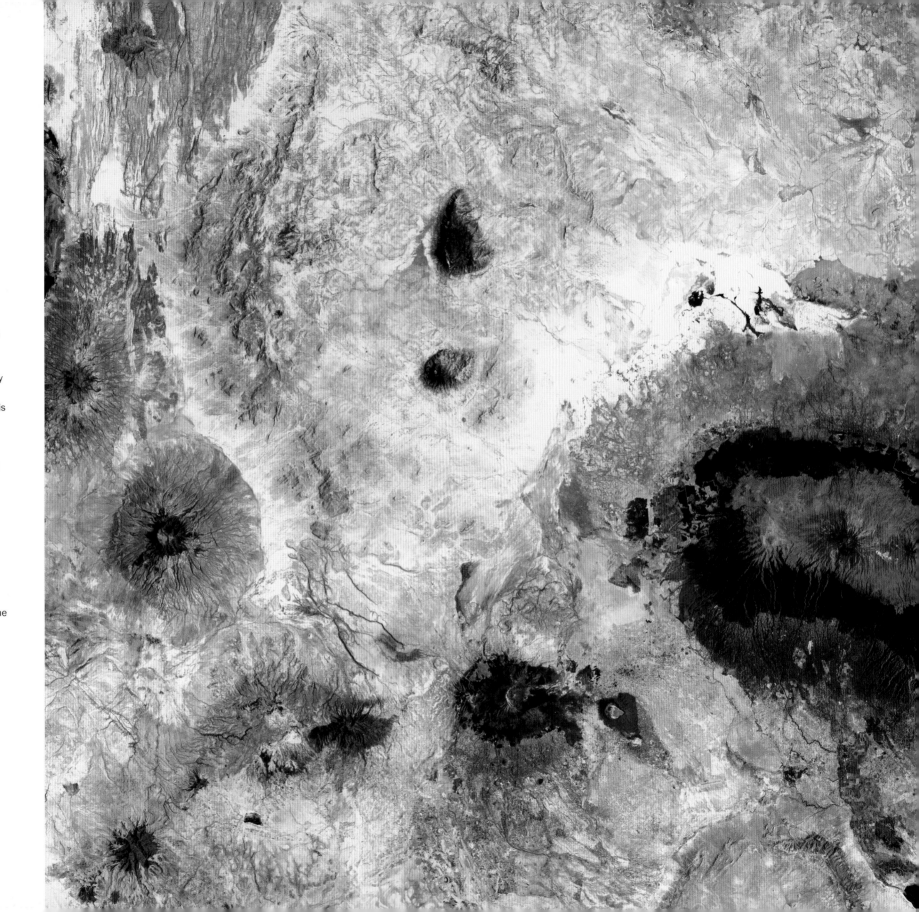

Mount Kilimanjaro, Tanzania
Mount Kilimanjaro is on the far right of this coloured satellite image. This 80 kilometre long volcanic massif in northeastern Tanzania consists of a number of dormant volcanoes and is associated with the geologically active East African Rift System running along the left side of this image. Mount Kilimanjaro's central cone, Kibo, is the youngest and the highest; at 5,960 metres it is the tallest peak in Africa. A number of smaller, conical volcanoes are also visible in this picture; they are Meru (lower centre), Longido (centre left) and Gelai (far left). The artificial colours show the altitudinal changes of vegetation, from semi-arid scrub in the lowlands, through cultivated lower slopes, to alpine desert close to the permanent icecap at the summit.

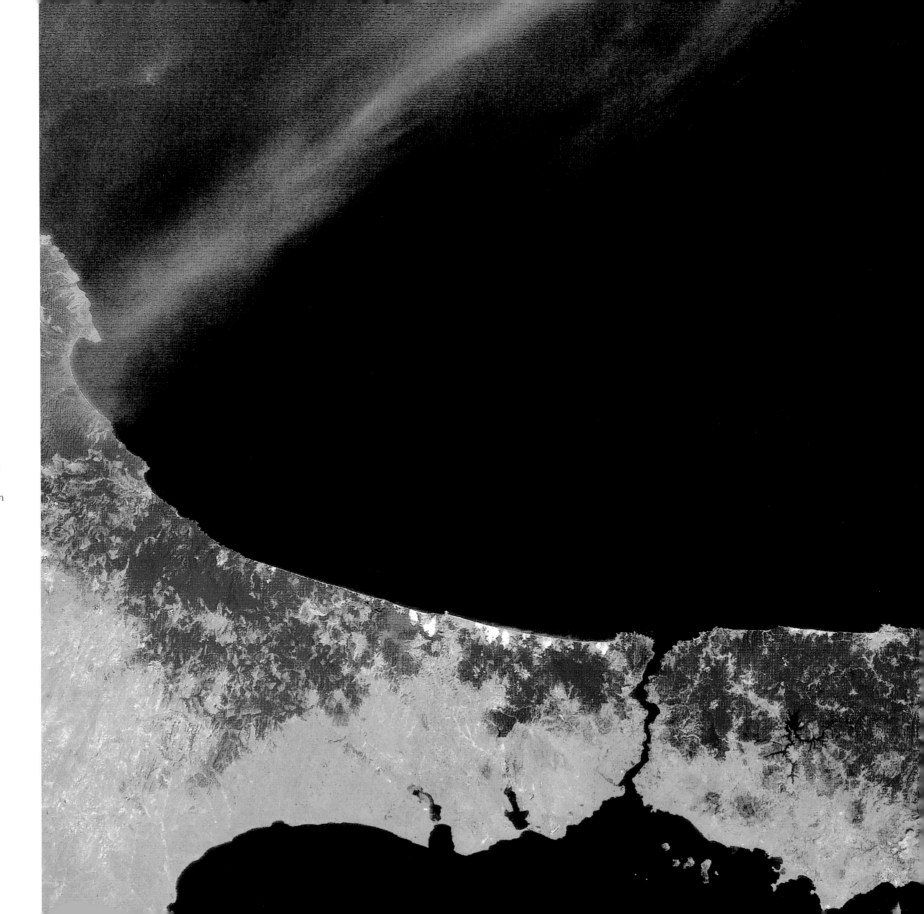

Istanbul and the Bosphorus, Turkey

This false-colour Landsat image of part of Turkey shows the Bosphorus, a narrow strait connecting the Black Sea, to the north, with the Sea of Marmara, to the south. Turkey's capital city, Istanbul, which straddles the strait, was founded in ancient times as a major trading centre known as Constantinople. Occupying this narrow neck of land between the landmasses of Europe and Asia, Constantinople was considered the gateway between the two continents. Red areas are highlands, part of the Yildiz Daglari Mountain Range. Blue represents sparse vegetation on the lowlands.

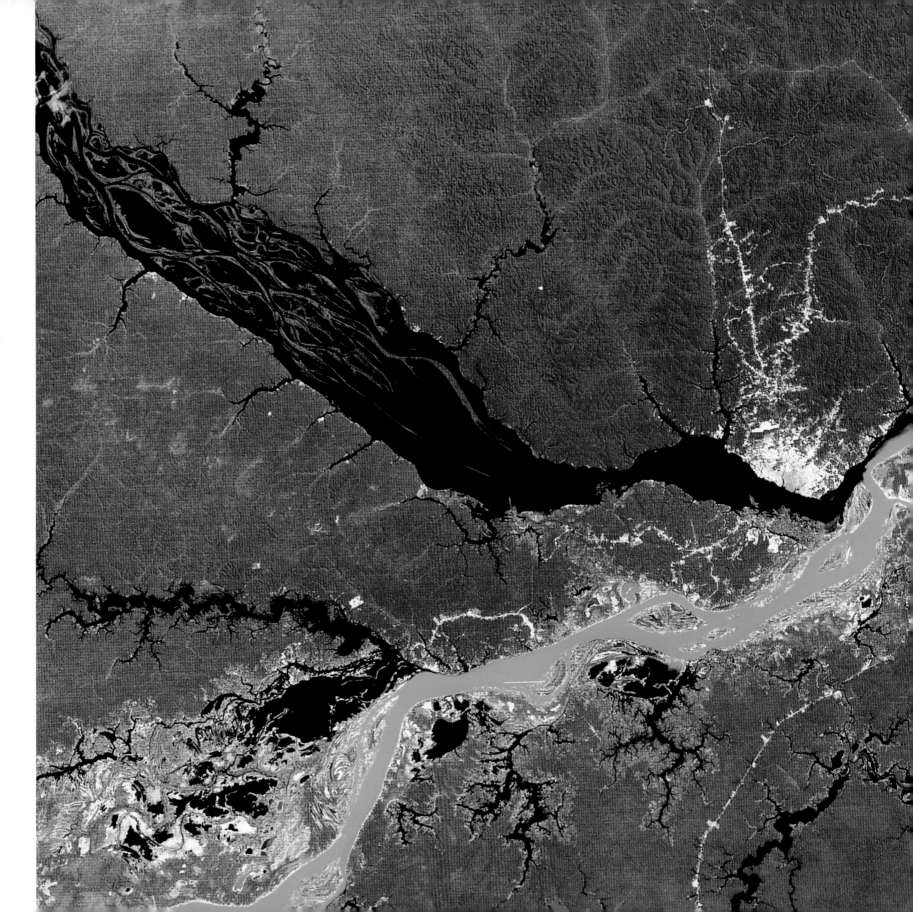

Confluence of the Amazon and Negro rivers
This coloured Landsat image, covering an area 200 kilometres across, shows the junction, or confluence, of the Amazon River (lower) and the Rio Negro (upper), downstream of the city of Manaus (blue-white) in Brazil. Close to the confluence, the silt-laden waters of the Amazon (which appear blue here) remain separate from the clearer waters of the Rio Negro, creating a striking colour boundary.
The rest of the frame is filled by the dense vegetation of the Amazon rainforest (red), broken only by river tributaries (blue and black) and roads (white).

far right
Nile Delta, Egypt
This infrared Landsat image makes it easy to see how deltas get their name – after the triangular shape of the capital Greek letter delta. When rivers meet the sea, the sediment they carry is deposited, forming mud flats, which over time generally extend further and further out to sea, becoming wider and wider – forming the classic triangular shape of the delta.
In this picture, the well-watered, vegetated delta (red) is clearly distinguished from the desert beyond. It is 170 kilometres from the apex of the delta to the coast.

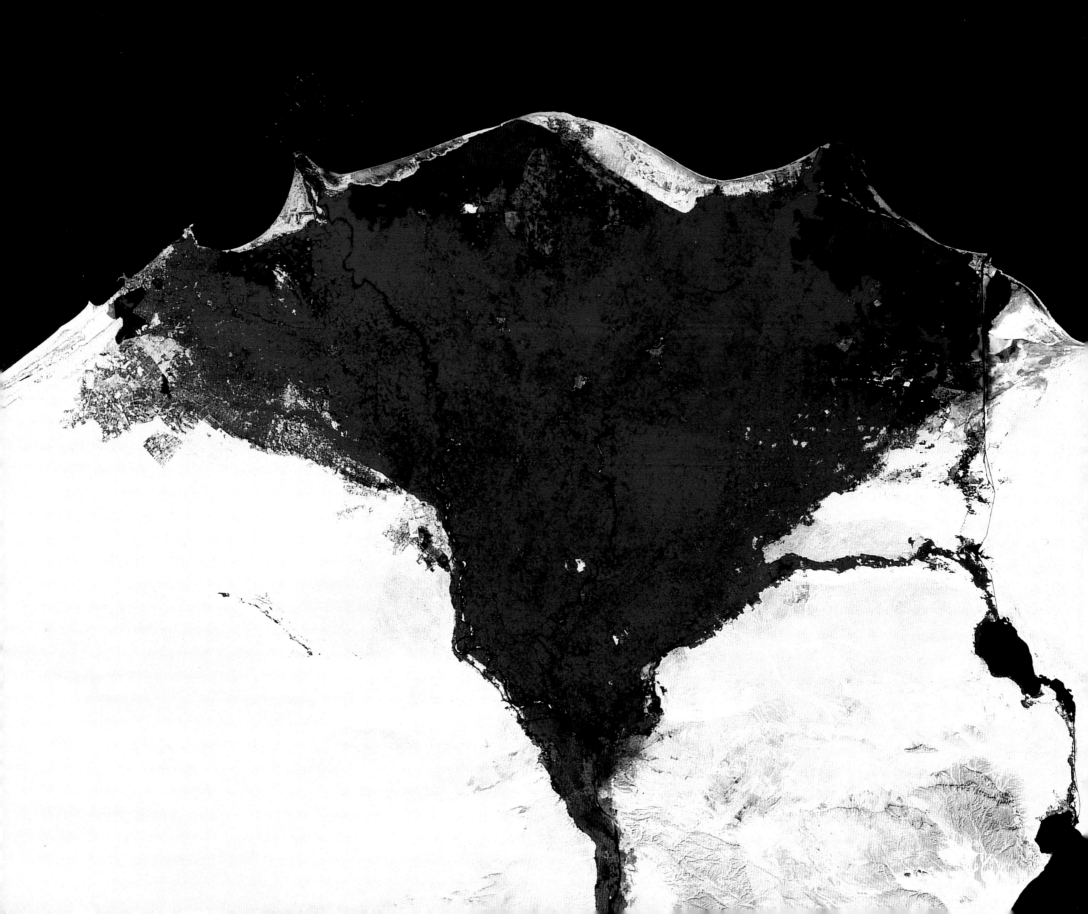

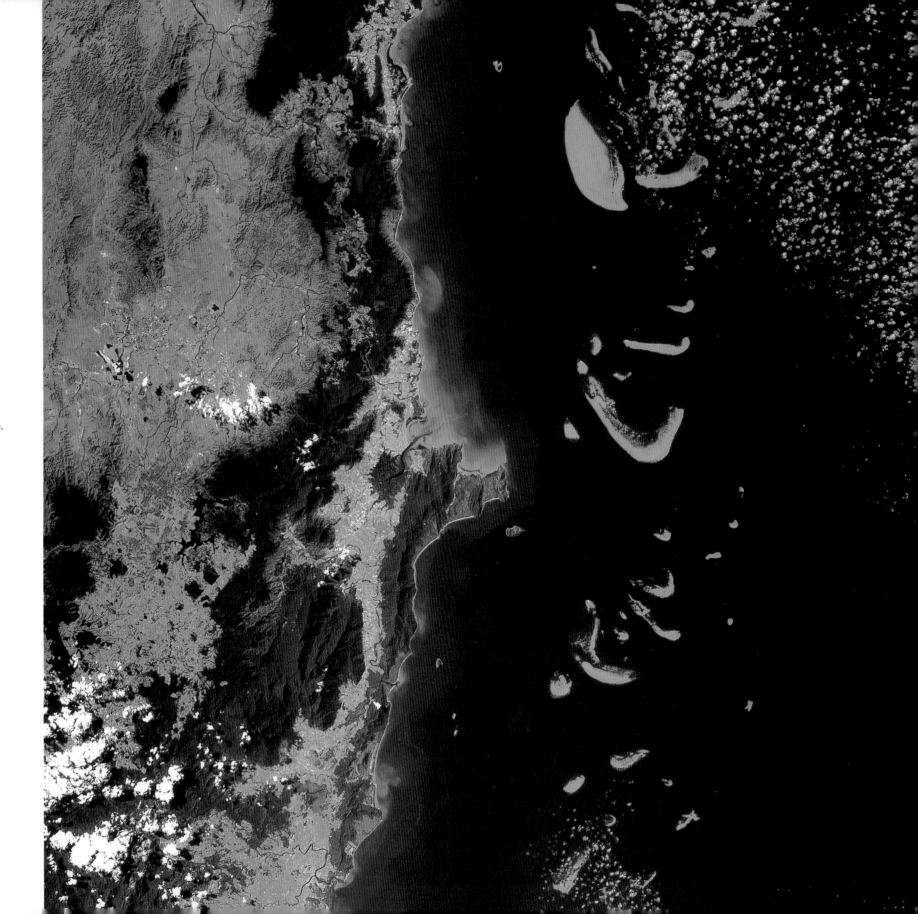

Great Barrier Reef, Australia
The Great Barrier Reef
is a ribbon of coral reefs
that stretches for over
1,600 kilometres along the
coast of Queensland in
northeastern Australia.
This satellite image shows
the town of Cairns at the centre,
with the Great Barrier Reef
about 50 kilometres off the
coast. The clear, warm waters
at the edge of the continental
shelf provide ideal growing
conditions for corals.
The Great Barrier Reef
has been developing since
the sea rose to its current level
(from the low levels of the
preceding ice age) some
9,000 years ago.

**Eastern Grand Canyon
and Lake Powell, USA**
A winter view of the eastern
Grand Canyon and the man-
made reservoir of Lake Powell
(dark blue, in the upper right
of the image). This natural-colour
photograph, taken from the
Skylab Space Station, shows
snow dusting the higher
elevations. The dark, snow-free
floor of the winding Canyon
(left), far below and considerably
warmer than the general land
surface, stands out in stark
contrast – a colourful indication
of the three-dimensional nature
of the land surface that would
otherwise be hard to deduce
from a vertical shot such as this.

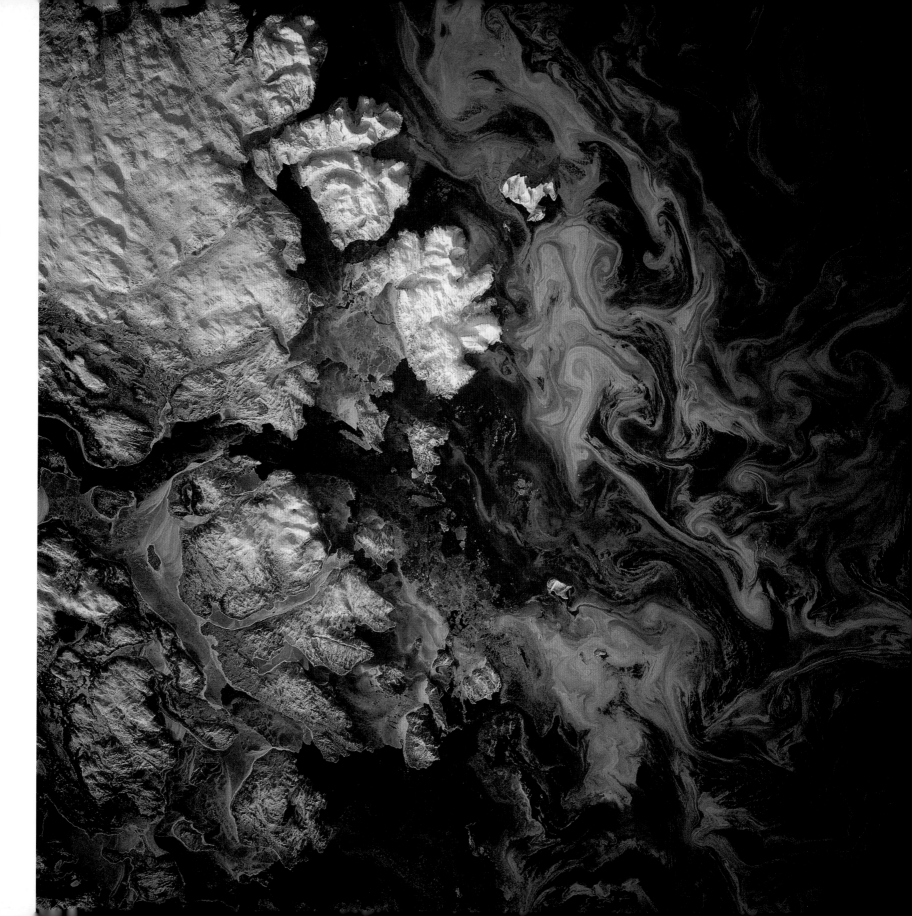

Labrador coast, Canada
The rugged coast of Labrador, northeast Canada, owes much of its topography to glaciation during the last ice age, which peaked some 20,000 years ago. The numerous fjords and inlets visible here were hollowed out by ice. The excavated, ground up rock was deposited as a loose gravelly sediment called till. Modern streams and rivers erode the soft till, washing into the sea great plumes of sediment. The right half of this shuttle photograph shows the sediment stirred by strong coastal currents. The image covers an area 420 kilometres across.

far right
Iceberg calving, Antarctica
This satellite image shows the huge iceberg named B-15 as it broke away, or calved, from Antarctica's Ross Ice Shelf in March 2000. At nearly 300 kilometres in length and 40 kilometres in width, it was one of the largest icebergs ever seen. Iceberg calving is a common phenomenon and is part of the natural dynamics of an ice shelf. Ice shelves grow out to sea as snow accumulates inland at the Antarctic margin. Eventually pieces break off the outside edge and the ice margin is moved back towards the continent, but since the snow continues to accumulate, the cycle of ice shelf advance and calving can begin again.

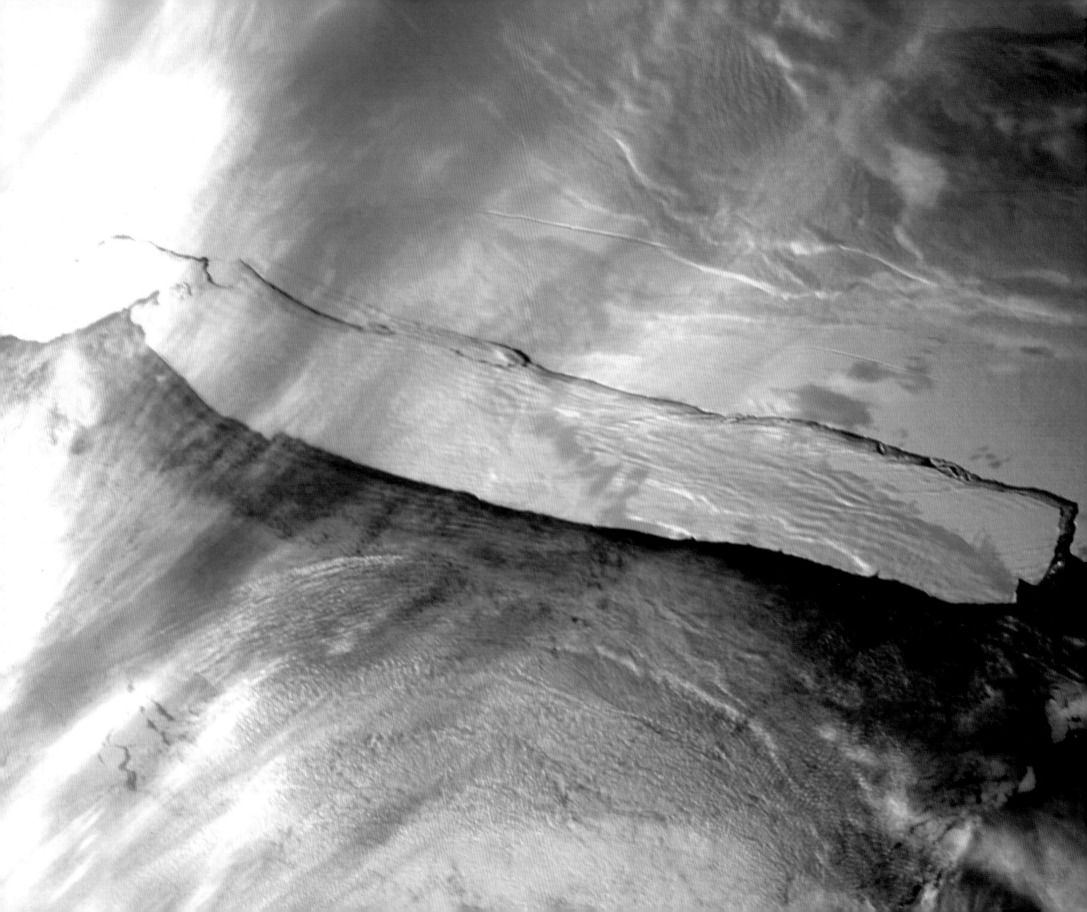

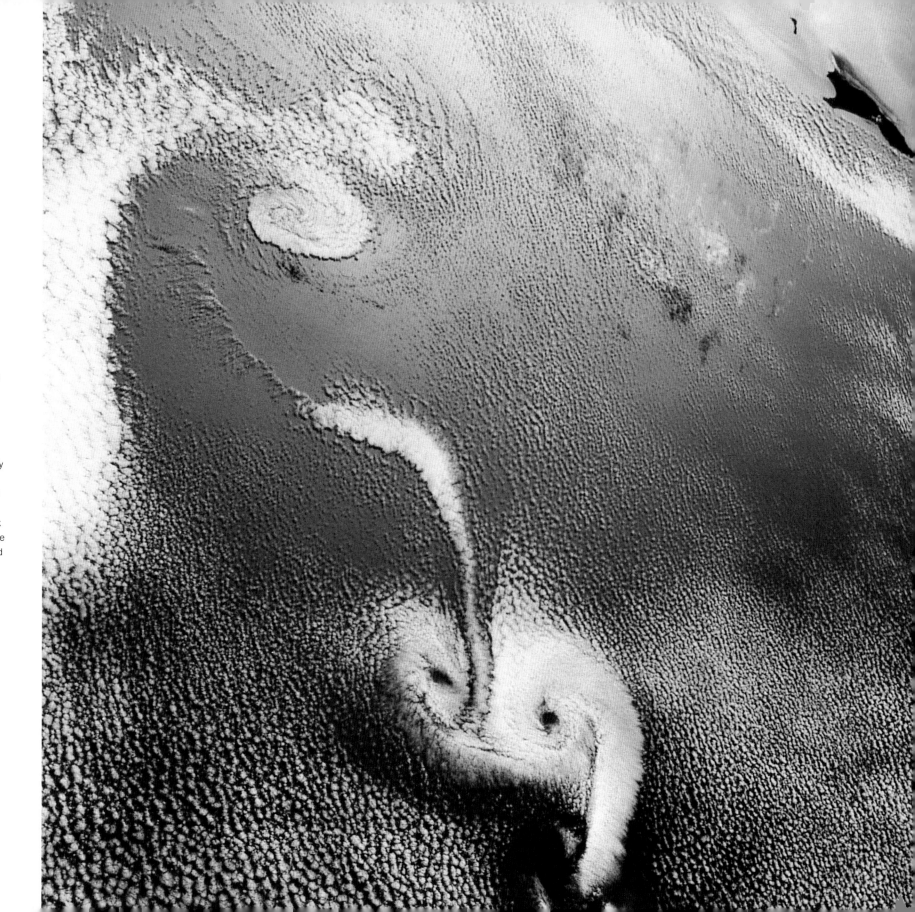

Von Karman vortices, Caribbean

This space shuttle photograph, taken near the island of Guadeloupe in the Caribbean Sea, shows the swirling cloud formations of an atmospheric phenomenon known as a von Karman vortex street. This long line of eddies, or vortices, which rotate alternately clockwise and anticlockwise, is caused by obstacles, such as islands, disturbing the air flow as it passes. Von Karman vortex streets are often seen in satellite images of the cloud layer behind an island, since clouds follow the spiral shape of the eddies.

Lake Eyre, Australia

Lake Eyre is the lowest point
in Australia, 15.2 metres below
sea level, and the centre
of an immense drainage basin
encompassing one seventh
of the continent's land surface.
However, central Australia is
so arid that Lake Eyre is usually
dry. Salt crusts, formed through
evaporation of the lake waters,
are clearly visible in this shuttle
photograph (light pink);
the red colour of the water
is due to the presence of brine-
tolerant algae. The ancient
desert floor around the lake
is stained red-brown due to the
presence of a residue of iron
oxides following millions of years
of weathering and erosion.

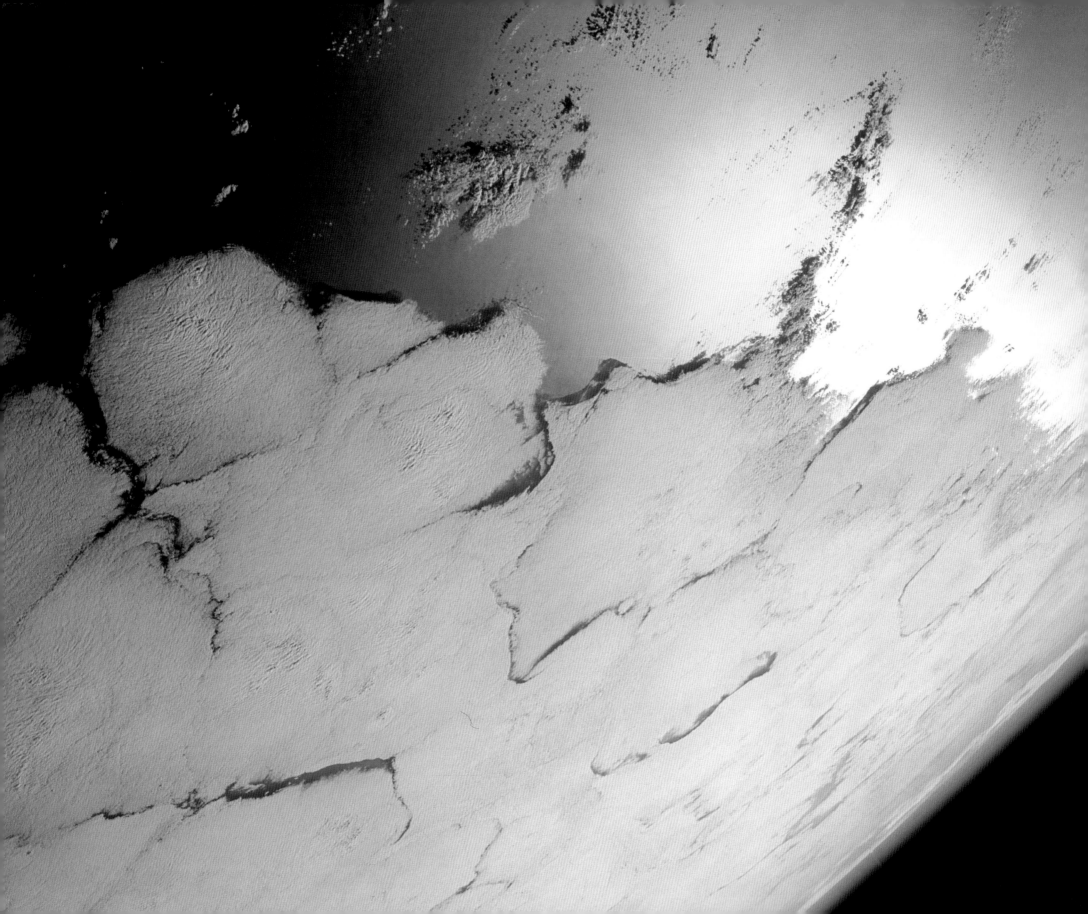

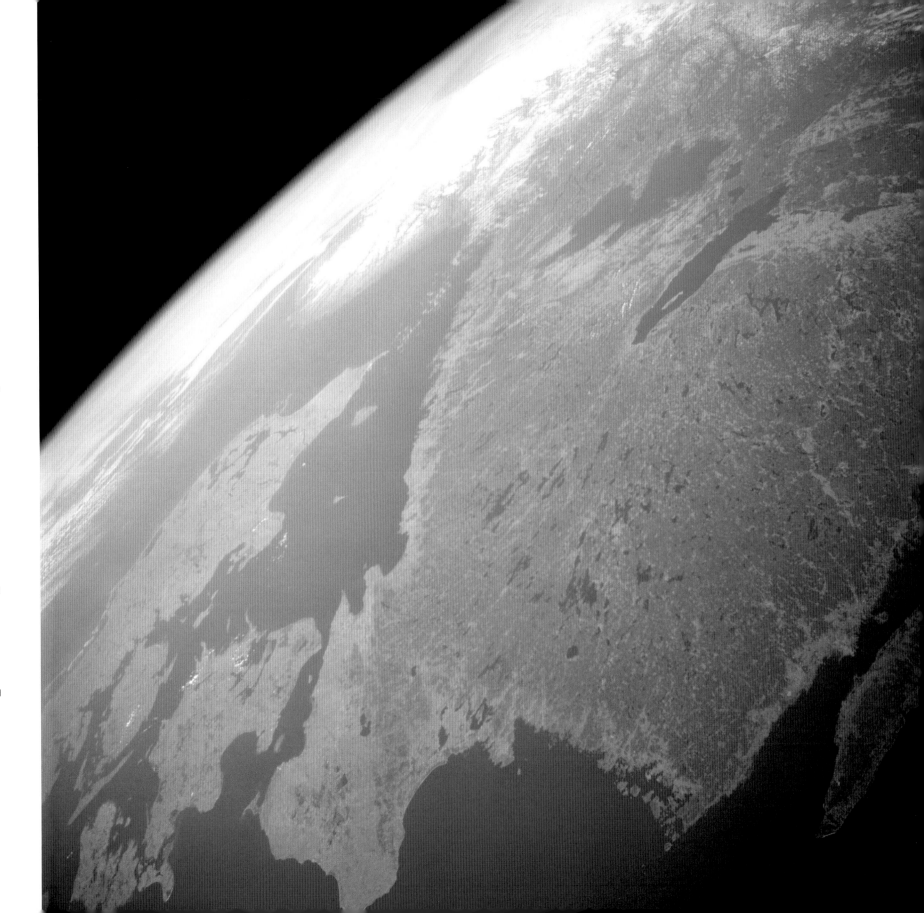

left

Stratocumulus clouds
This photograph was taken
from the Apollo 17 spacecraft
at an altitude of 250 kilometres
in December 1972. It shows
a layer of stratocumulus clouds
lying about 1,000 metres above
the ocean, off which the sun
is reflecting. Clouds form when
water vapour rises through
the atmosphere and cools with
increasing altitude, causing it
to condense into water droplets
or ice crystals. Accumulations
of these droplets or crystals
are clouds. Stratocumulus form
a distinct layer of low level cloud,
and are a common cloud
formation over oceans.
The oblique angle of this shot
also allows us to see the
atmosphere edge on, which
appears as a thin band of blue
encircling the Earth.

Southern Sweden
This photograph looks west
across southern Sweden,
with Denmark and Norway still
further west. The multitude
of lakes in Sweden were created
during the last glacial stage,
at its peak about 20,000 years
ago, when a vast continental
ice sheet covered the region.
Movement of the ice scoured
the ground beneath to leave
countless depressions that filled
with water as the ice retreated.
The lakes radiate out from
the location of the ancient ice
sheet's summit (top right).

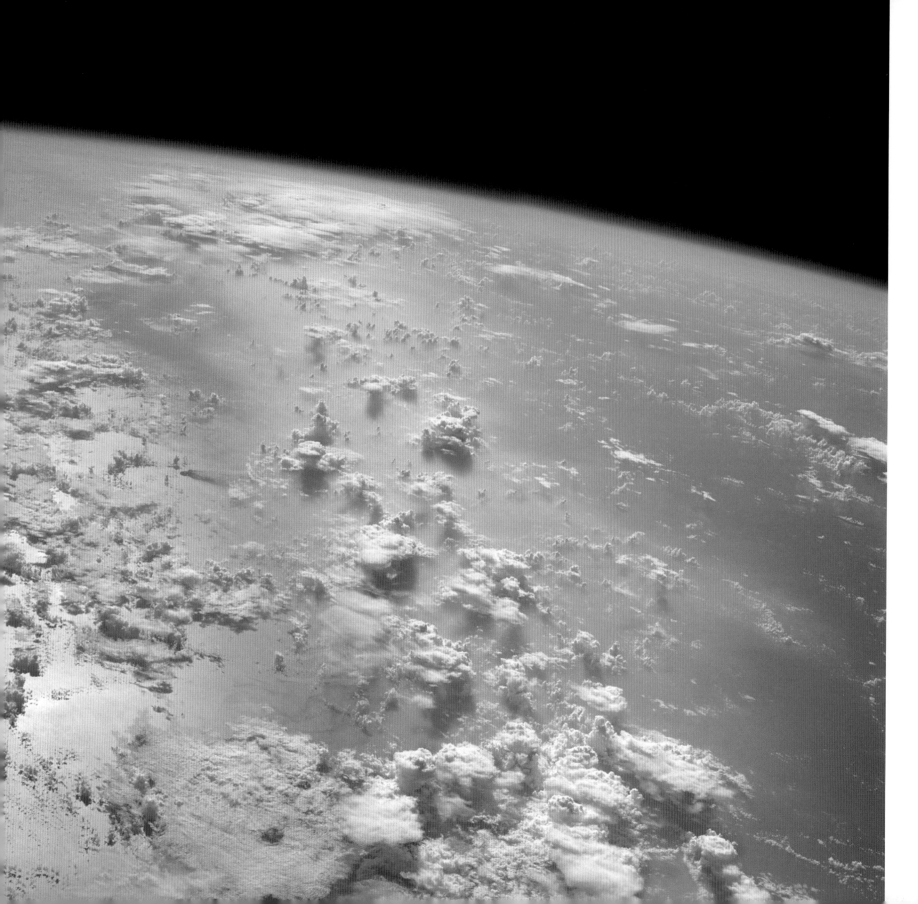

Clouds and volcanic smoke over the Pacific Ocean
The crew of the Space Shuttle Discovery took this photograph when they were 1,600 kilometres east of Manila. Looking east across the Pacific, it shows smoke from the volcano Pagan in the far distance. In the foreground, clouds are forming as warm, moist air rises above the multitude of volcanic islands that dot the Pacific. Below the volcanic smoke and far below the water on the sea floor is the Mariana Trench, which is the lowest point on Earth, reaching a depth of 11,000 metres below sea level.

right
Storm clouds over Argentina
Looking west across northern Argentina, this view from the Space Shuttle Endeavour shows a line of thunder clouds developing between the Parana River basin (foreground) and the Andes Mountains (background). The clouds' flattened anvil shape is characteristic of mature clouds that have been developing for several hours, and indicates that storm activity is imminent.

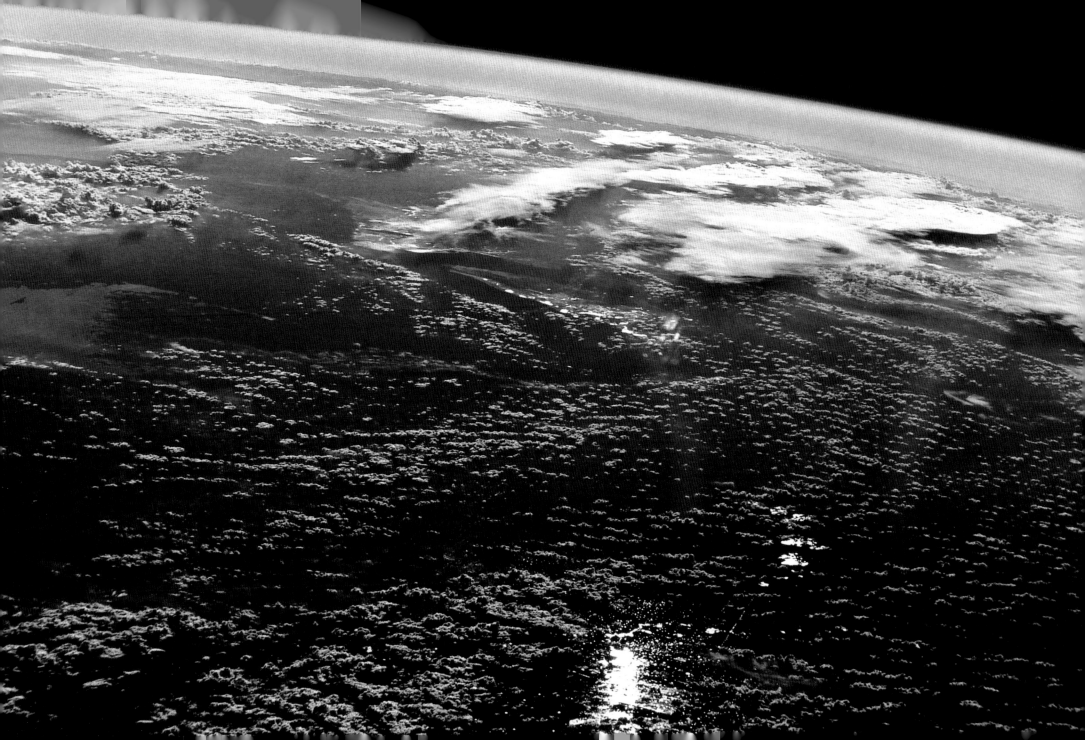

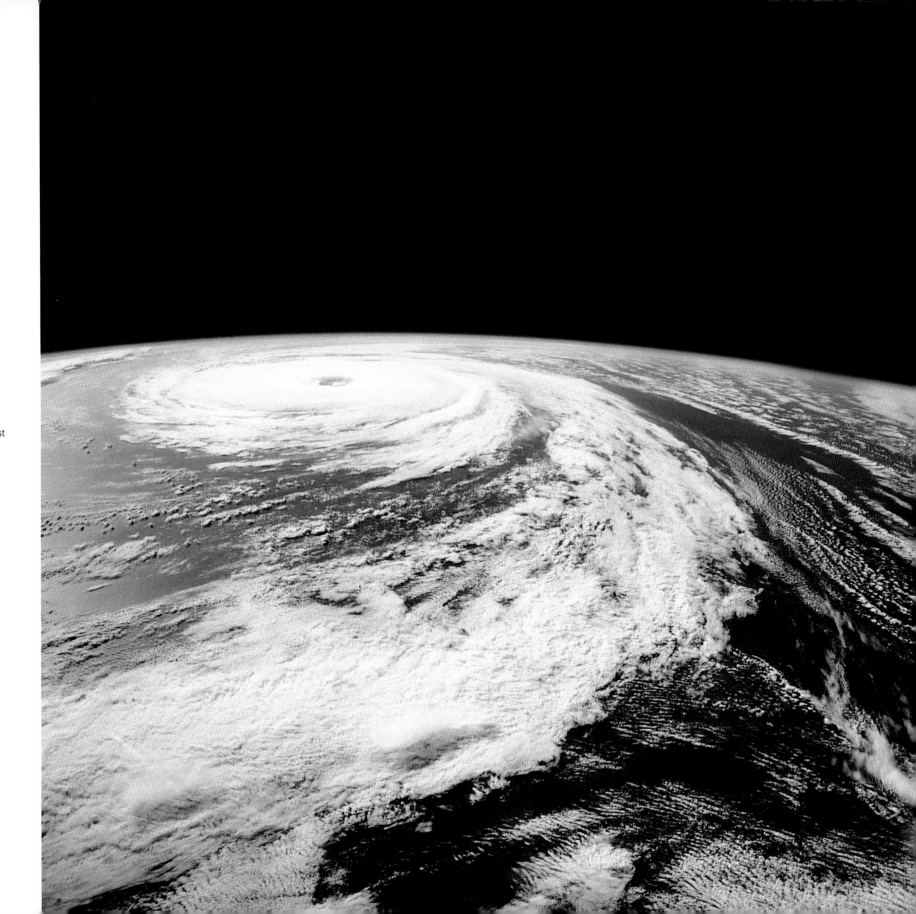

Hurricane Florence

The spiralling cloud formations of Hurricane Florence over the Atlantic were photographed from the Space Shuttle Atlantis on 14 November 1994, when the hurricane was just east of Bermuda. The spiral shape formed by the storm clouds in a tropical cyclone is caused by the Coriolis effect, a consequence of the Earth's rotation. This effect is reversed in the southern hemisphere, where tropical cyclones revolve in the opposite direction.

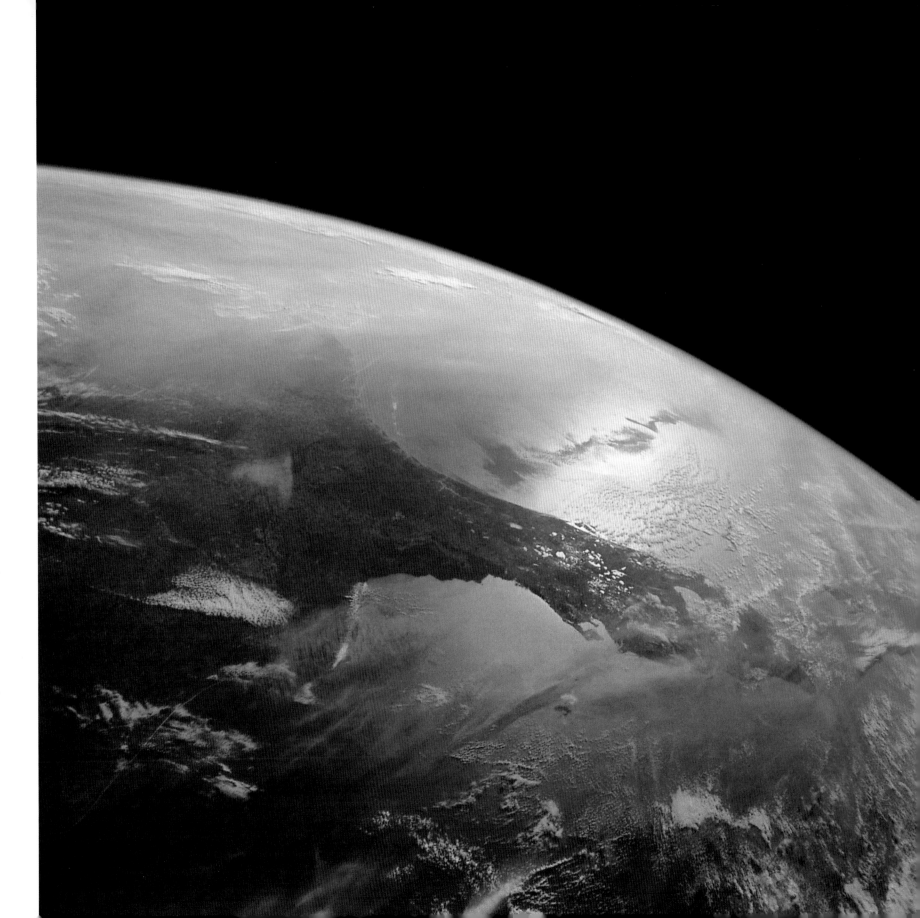

Florida peninsula, USA
Looking east across the Florida peninsula from a space shuttle, the field of vision reaches from Georgia and South Carolina in the north (left) to the shallow waters of the Great Bahama Bank, visible as a light blue patch, to the south (right). A narrow band of cloud casts a shadow across the water and also highlights patterns in the surface waters off Florida's east coast. These are related to the Gulf Stream ocean current, which flows northwards past here.

Cape Cod and Long Island, USA
This oblique photograph, taken from the Space Shuttle Endeavour over the Atlantic, shows the coastline of New England from the west. With the sun reflecting off the sea, landmasses appear dark in colour. The curve of Cape Cod, Nantucket Island and Martha's Vineyard can be seen in the foreground; in the distance is Long Island, stretching towards New York.

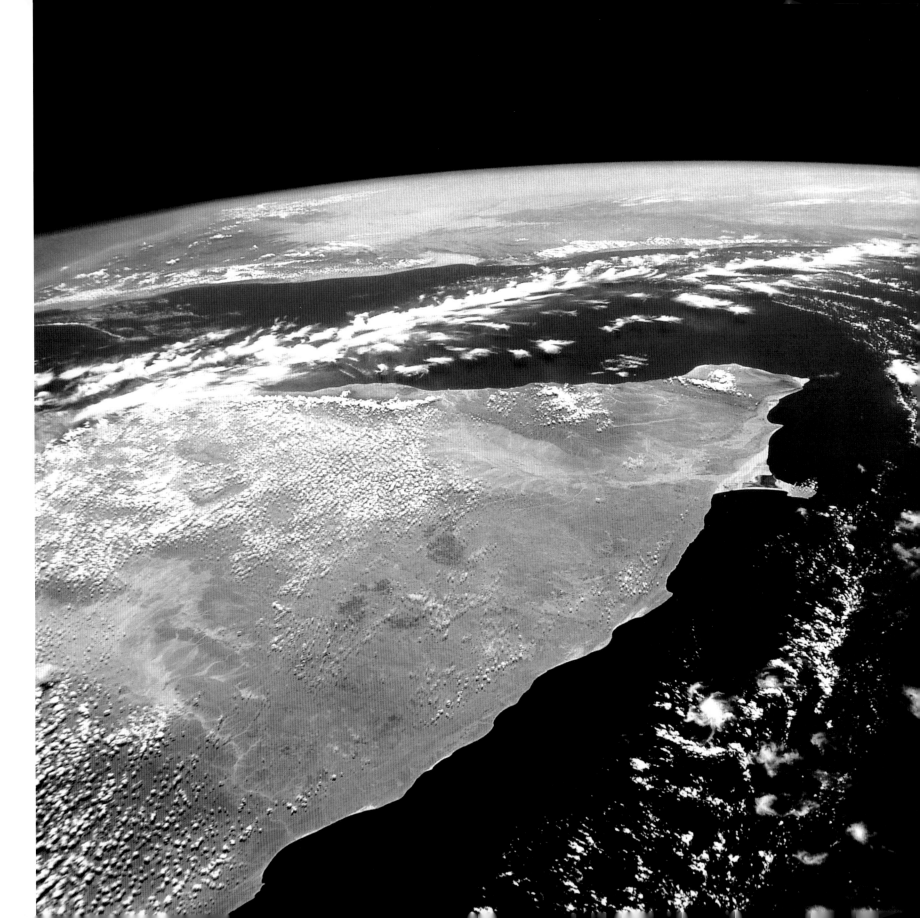

Horn of Africa
Taken by the crew of the Space
Shuttle Columbia in 1993,
this oblique shot looking towards
the north shows Somalia jutting
out into the Indian Ocean
to form the Horn of Africa.
At the tip of Somalia is Cape
Guardafui, and to its south is the
small peninsula of Raas Xaafuun,
which forms the easternmost
point of the African continent.
To the north, across the
300 kilometre wide Gulf of Aden,
are the pale deserts and dark
mountains of Yemen.

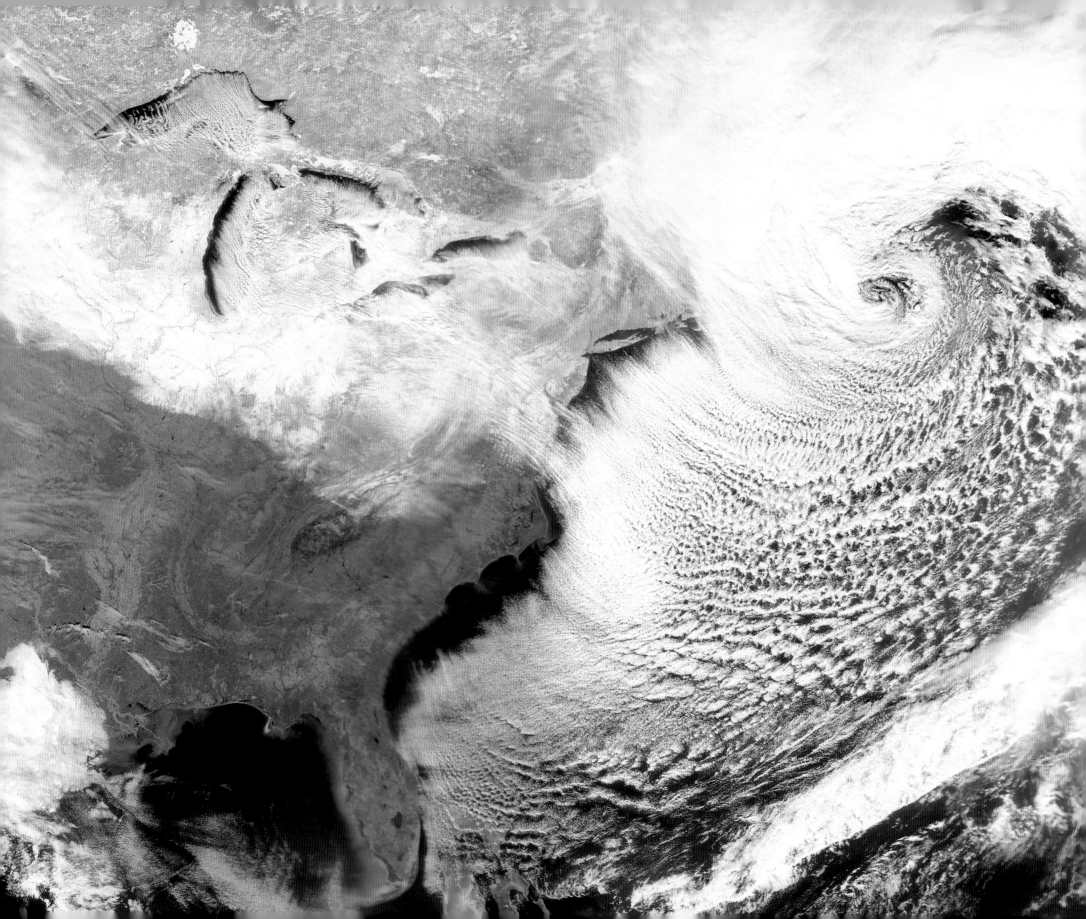

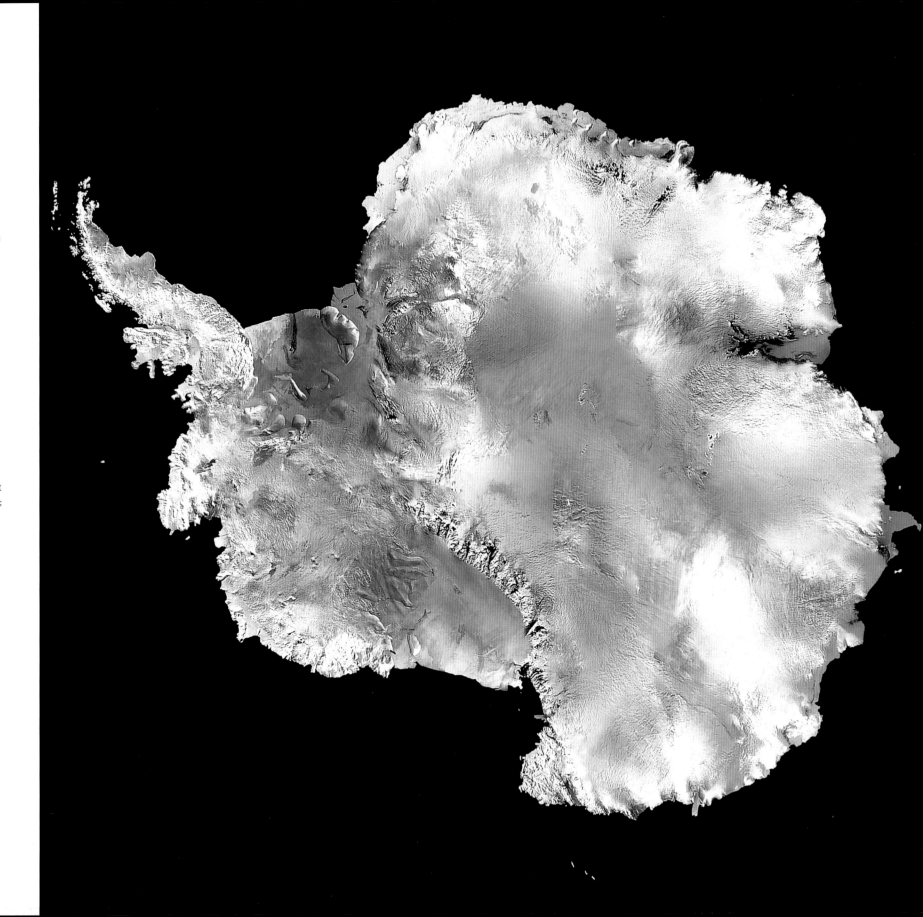

left
Snow storm, North America
This satellite image shows a storm off the east coast of North America, and the band of snow lying in its wake. Considerable cloud cover obscures the northern part of the continent, but the Great Lakes and areas of snow-covered ground can be seen through the gaps. The north–south gradient in temperature across the continent is vividly reflected in the absence of snow cover to the south.

Antarctica
The continent of Antarctica is viewed in infrared. Snowfall in Antarctica is so infrequent that the continent qualifies as desert; nonetheless, the gradual accumulation of snow has built an icecap up to 4 kilometres thick containing 70 per cent of the Earth's fresh water. The Transantarctic Mountain Range (black) projects above the icecap at lower centre. In places, the icecap extends beyond the edge of the continent to form floating ice shelves. In winter, the area of the continent is more than doubled when the surrounding ocean freezes.

left
Earth's atmosphere seen at sunset

The crew of the Space Shuttle Endeavour took this photograph of the atmosphere at sunset while in orbit around the Earth in September 1992. The air at different altitudes scatters sunlight to different degrees; at low altitude, the dense, dusty air appears red while the thinner, dust–free air higher up appears blue. Enormous cumulonimbus clouds are silhouetted against the Sun. Their flattened anvil tops indicate the top of the troposphere, the thin atmospheric layer stretching from the ground to between 5 and 15 kilometres up. This atmospheric layer supports life and contains most of our weather systems.

Aurora australis

The aurora australis, the southern equivalent of the aurora borealis, was photographed from the flight deck of Space Shuttle Discovery in 1991, while it orbited at 250 kilometres above the Earth. The aurora are spectacular displays of light in the Earth's upper atmosphere, visible from high latitudes. When the stream of charged particles emanating from the Sun (the solar wind) meets the Earth's magnetic field, it is swept down towards the poles. Here the charged particles strike gases in the Earth's upper atmosphere and cause them to glow in the same way that electrons passing through gases in a tube cause a neon sign to light up.

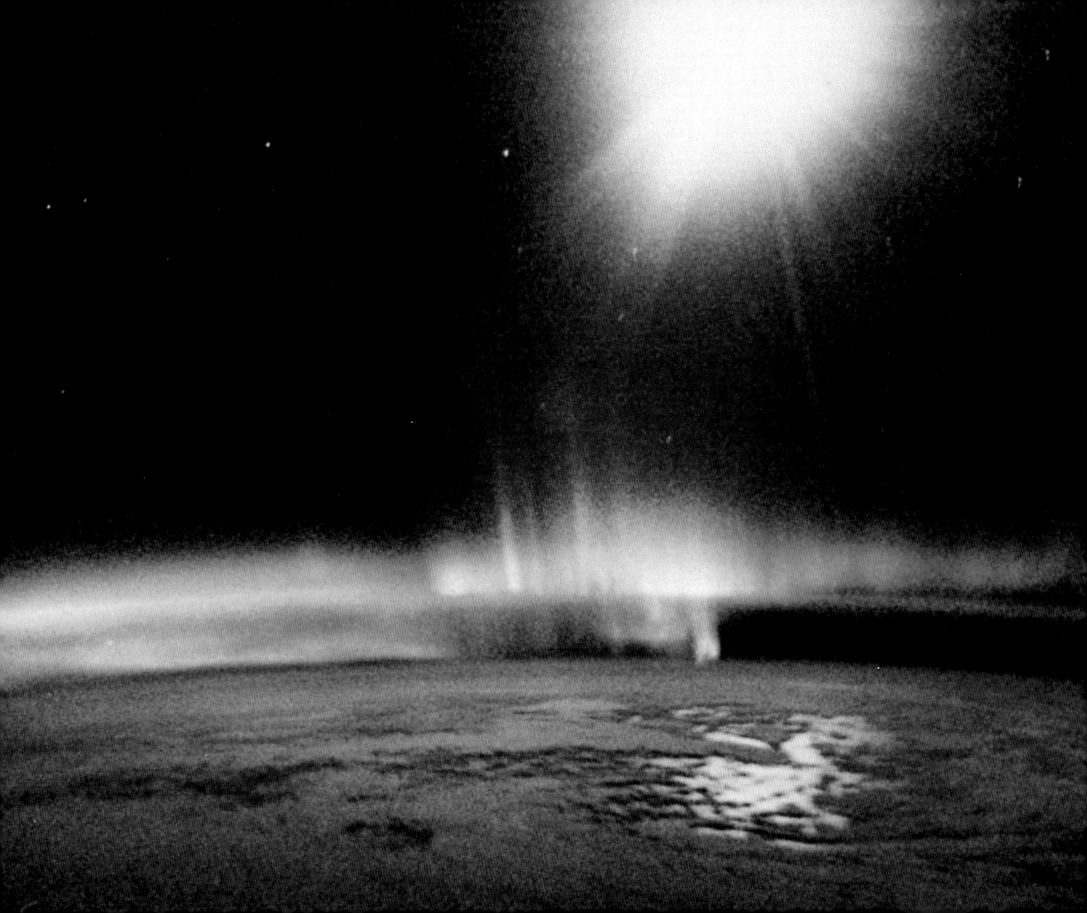

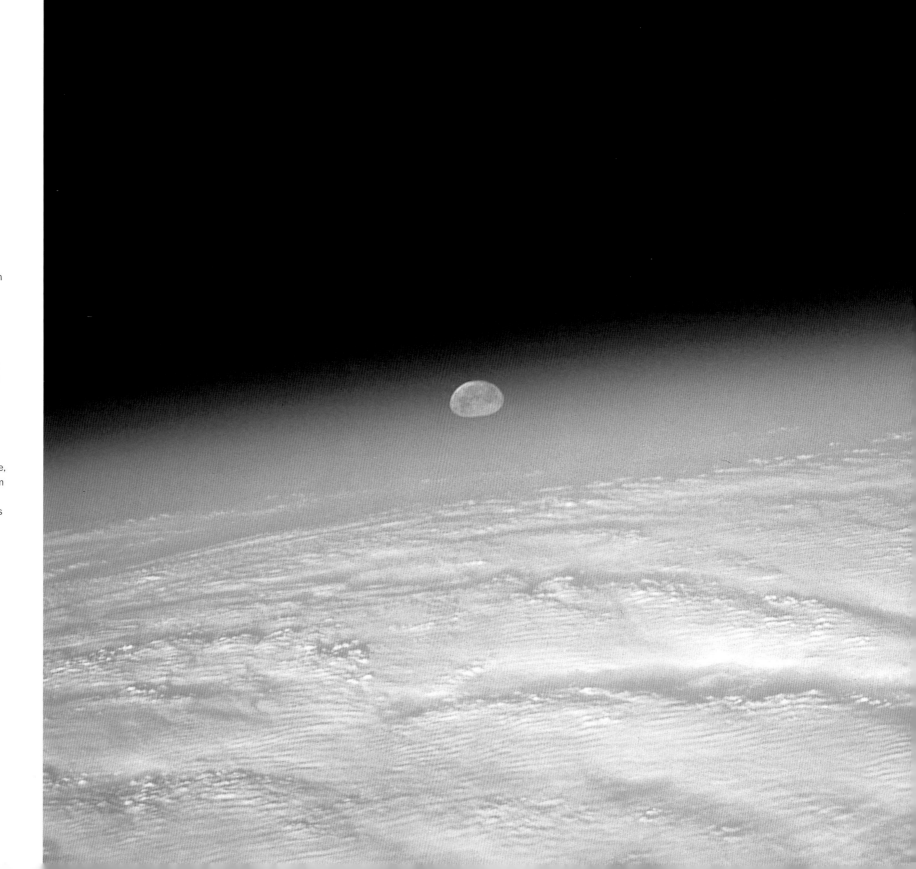

Moon setting

The Moon sets behind the Earth in this photograph taken from a space shuttle. The distortion of the Moon's shape is due to diffraction, or the bending of light, caused by the Earth's atmosphere. Diffraction occurs as light passes between media of differing optical densities. A common example is the apparent bending of a straw placed in a glass of water. Here the same phenomenon operates on a much larger scale, as light passes from the vacuum of space through the Earth's atmosphere. The cloud patterns in the foreground of the photograph indicate that a storm system is developing.

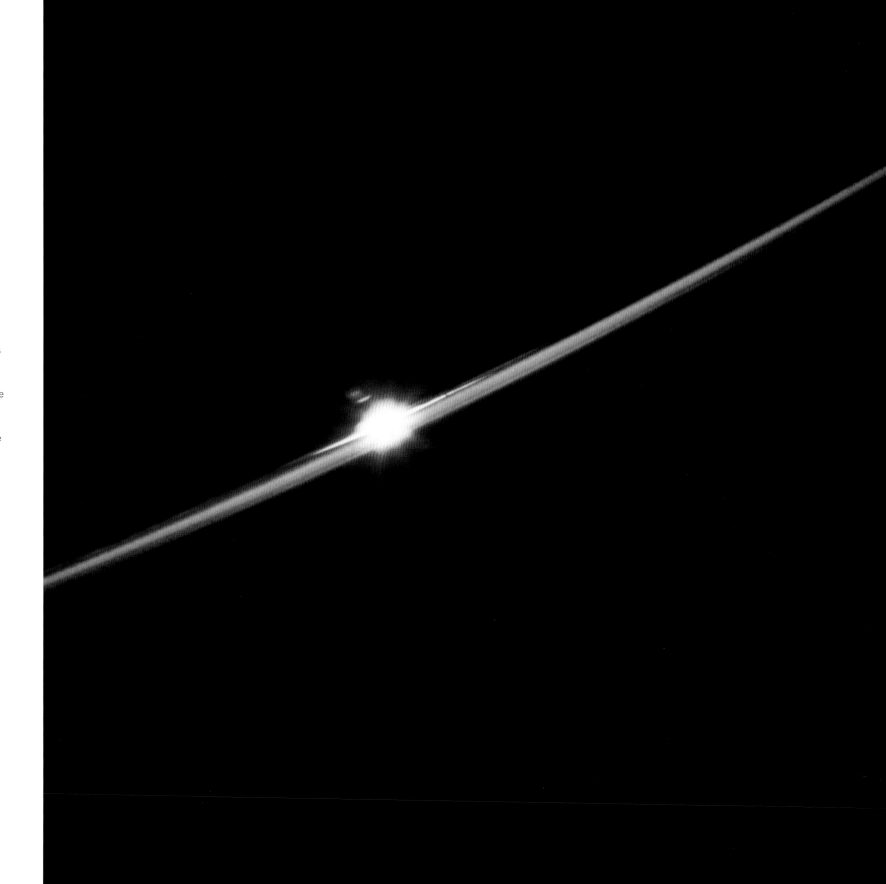

Sunrise from Skylab

Taken with a hand-held camera from the Skylab Space Station in 1973, this photograph shows the Sun rising over the Earth. Skylab's rapid orbit of the Earth allowed its crew to see a sunrise every 90 minutes. The bands of colour emerging as the sun appears over the curved outline of the planet are caused by the interaction of sunlight with the atmosphere. The lower layers of the atmosphere refract light at the red end of the spectrum, while blue light is refracted by less dense air at the top of the atmosphere.

Once we leave planet Earth and look towards the heavens our perception of size and space begins to change. Distances and dimensions expand dramatically. The Moon, our satellite and nearest neighbour in space, is 384,000 kilometres away while Pluto, the most distant planet in our corner of the universe, is almost six billion kilometres distant.

The planets have been tracked for thousands of years. Astronomers of the pre-Christian era identified spots of light that seemed to drift across the sky and named them after mythological deities: Jupiter – king of the gods, Mars – god of war, Mercury – messenger of the gods, Venus – god of love and beauty, and Saturn – god of agriculture.

As with everything in this book, we are unable to see these objects in detail without the use of highly sophisticated instruments. Most of the images illustrated in this chapter are viewed through telescopes. Constructed and developed in the early seventeenth century, the basic telescope is a system of mirrors or lenses, or both, that gather light from distant objects. The first telescope was constructed in Holland in 1608, and developed a year later by the Italian astronomer Galileo into the first astronomical telescope, similar to those used by observatories today. Since the invention of the telescope, three more planets have been discovered: Uranus – father and son of Gaea, Neptune – god of the sea, and Pluto – god of the underworld.

Ancient astronomers believed that the Earth was the centre of the universe and that the Sun and all the other stars revolved around it. It wasn't until the sixteenth century that the Polish astronomer, Nicholas Copernicus, proved that the Earth and the other planets actually orbit the Sun, hence these are now known as the solar system.

Continuing our journey from the surface of the Earth to the most distant objects in the sky, we take one last look at our planet and then move on to the Moon. Next we travel to the Sun – the dominating force of the solar system and whose strong gravitational pull maintains the orbits of its satellites. We then move to Mercury, the closest planet to the Sun, and further outwards to Venus, Mars, Jupiter, Saturn, Uranus, Neptune and finally to the most distant planet of the solar system, Pluto. In addition to the planets themselves we also investigate the space between them, which is populated with dust, gas, radiation and over one hundred moons, comets and asteroids.

Into the heavens

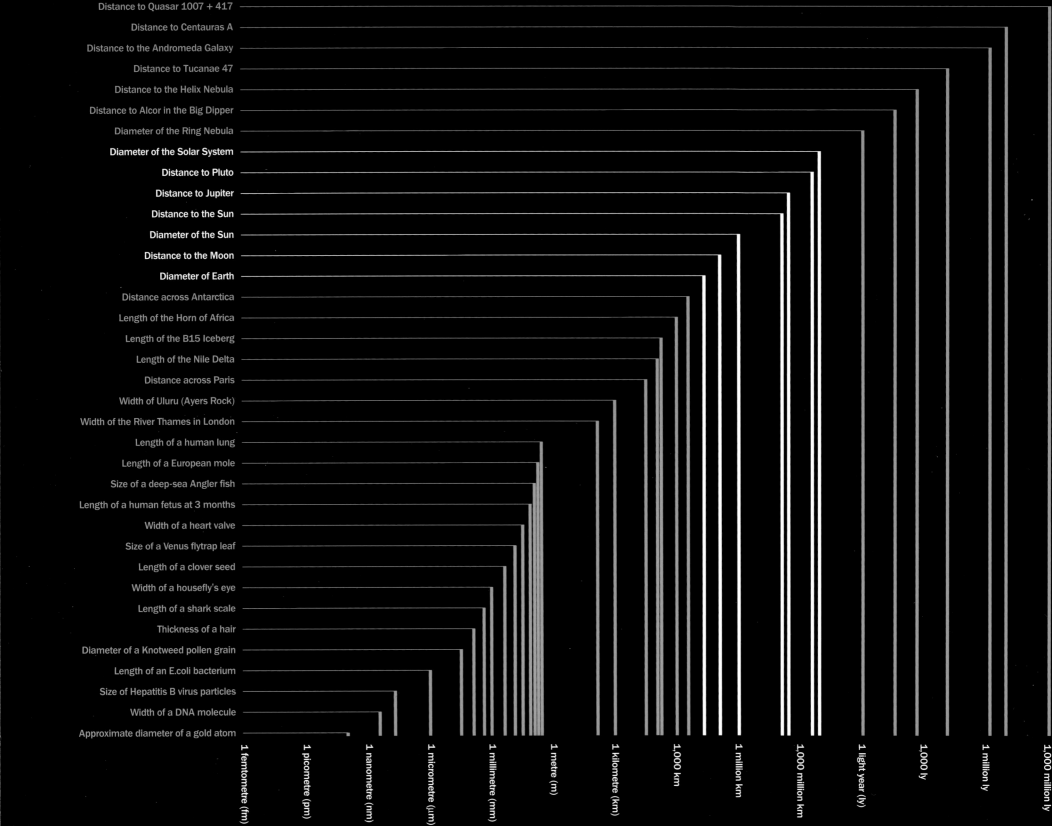

Distance to Quasar 1007 + 417

Distance to Centauras A

Distance to the Andromeda Galaxy

Distance to Tucanae 47

Distance to the Helix Nebula

Distance to Alcor in the Big Dipper

Diameter of the Ring Nebula

Diameter of the Solar System

Distance to Pluto

Distance to Jupiter

Distance to the Sun

Diameter of the Sun

Distance to the Moon

Diameter of Earth

Distance across Antarctica

Length of the Horn of Africa

Length of the B15 Iceberg

Length of the Nile Delta

Distance across Paris

Width of Uluru (Ayers Rock)

Width of the River Thames in London

Length of a human lung

Length of a European mole

Size of a deep-sea Angler fish

Length of a human fetus at 3 months

Width of a heart valve

Size of a Venus flytrap leaf

Length of a clover seed

Width of a housefly's eye

Length of a shark scale

Thickness of a hair

Diameter of a Knotweed pollen grain

Length of an E.coli bacterium

Size of Hepatitis B virus particles

Width of a DNA molecule

Approximate diameter of a gold atom

1 femtometre (fm)

1 picometre (pm)

1 nanometre (nm)

1 micrometre (μm)

1 millimetre (mm)

1 metre (m)

1 kilometre (km)

1,000 km

1 million km

1,000 million km

1 light year (ly)

1,000 ly

1 million ly

1,000 million ly

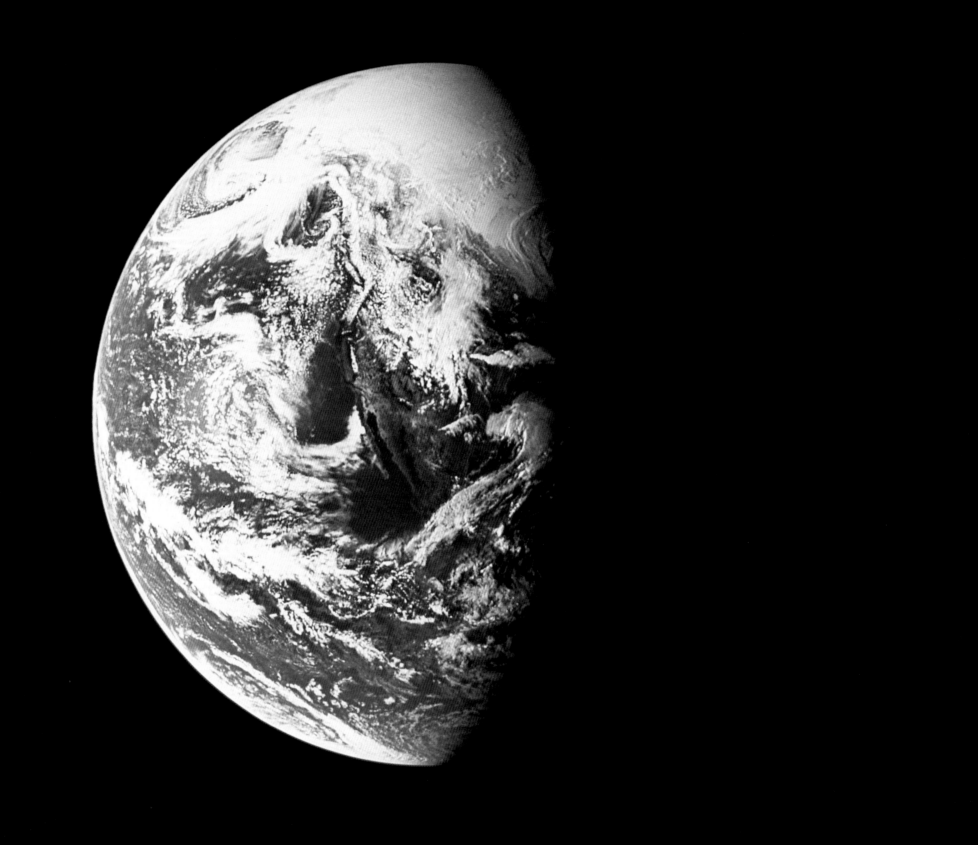

left
Earth from Apollo 13
The crew of the aborted Apollo
13 Moon mission took this
photograph on 14 April 1971
from a height of 125,000
kilometres, two days before their
damaged spacecraft re-entered
the Earth's atmosphere. Part of
southwestern USA and northern
Mexico (with the long finger
of the Baja Peninsula) can just
be seen through clouds swirling
over the Pacific Ocean.

**Earth showing Europe
and Africa**
The lack of cloud cover in this
view of Europe and North Africa
reveals the colours of different
climate zones – the green
of temperate Europe, the beige
of arid desert and the dark green
of tropical Africa. The thin band
of cloud along the southern
Mediterranean marks the
meeting place of the Trade
Winds which blow from the
northeast and the southeast.
Composed of photographs from
several satellites, this true-
colour image is centred on a
point on the Greenwich Meridian
approximately 30 degrees north
of the equator.

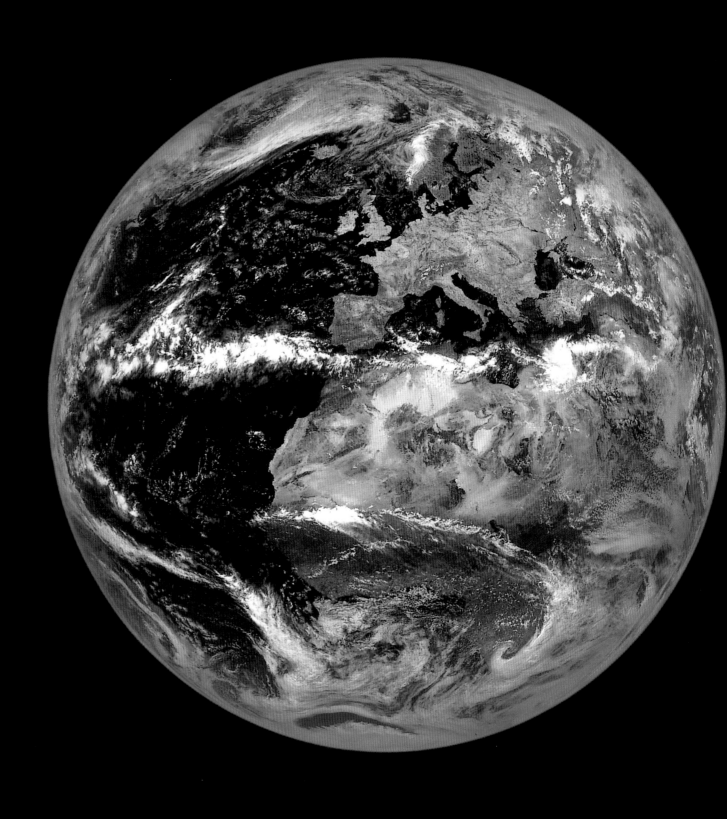

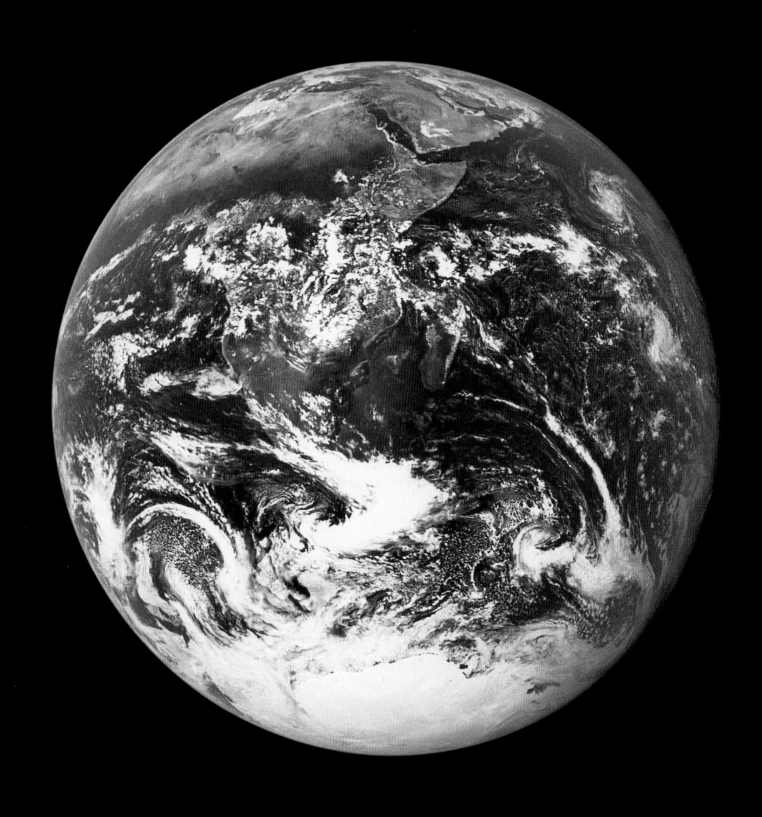

Earth from Apollo 17
In this view of the Arabian Peninsula, Africa and the island of Madagascar taken from Apollo 17's command module, belts of desert lie under cloudless skies north and south of the vegetated, cloudy equatorial zone. The ring of clouds surrounding the Antarctic continent marks the edge of the circumpolar vortex, a high pressure region that isolates the atmosphere over Antarctica from weather systems to the north.

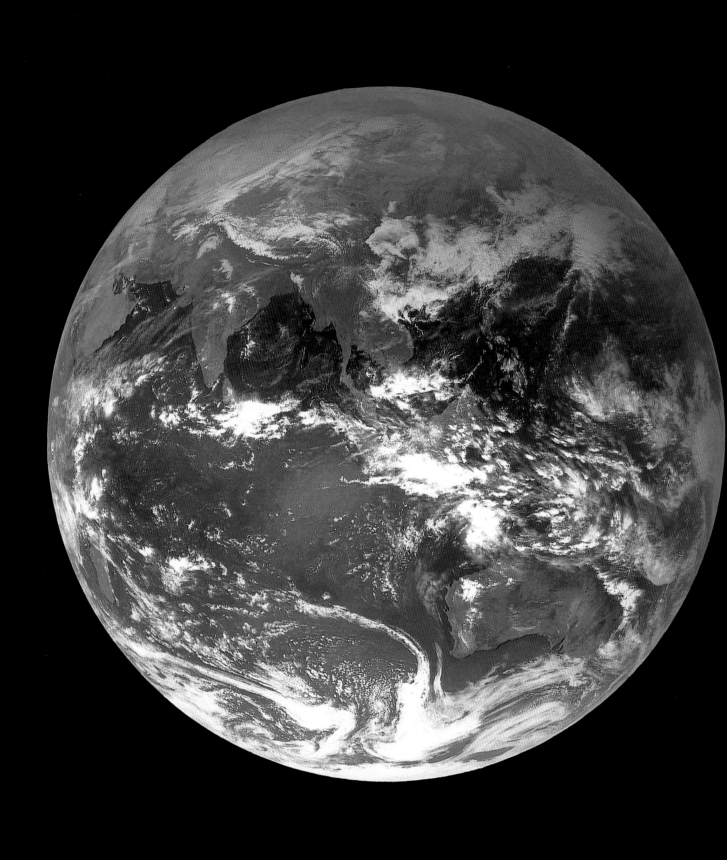

Earth showing Southeast Asia and Australia

The continents appear much greener than they really are in this picture, which combines visible and infrared images. Parts of the Arabian Peninsula, India and Southeast Asia are visible to the left, with Australia on the lower right, while China is obscured by cloud.

The image comes from the Chinese FY-2 satellite, launched in 1997 to track the movements of major weather systems from a geostationary orbit 36,000 kilometres above the southern Indian Ocean.

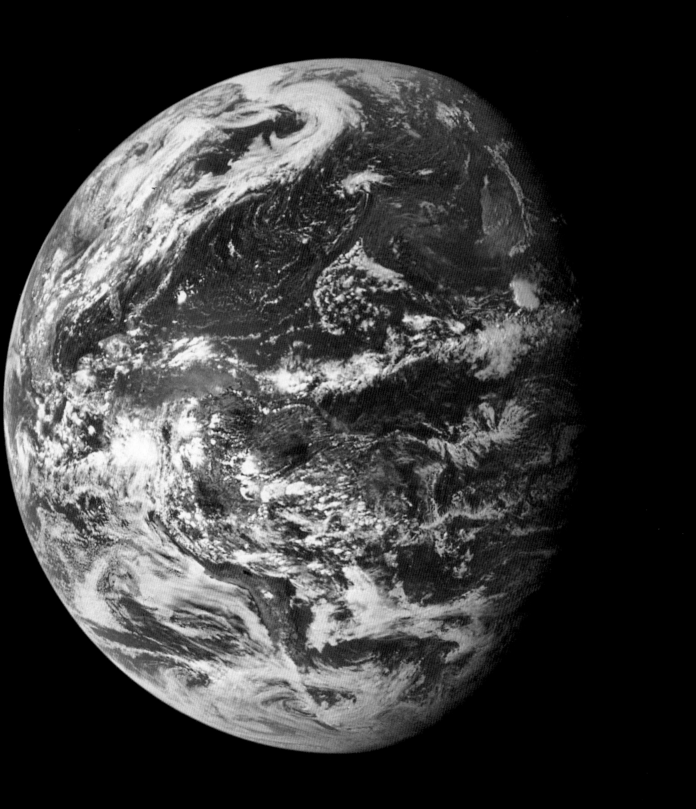

South America from Apollo 15
This view was taken from
50,000 kilometres above
the Earth as Apollo 15 headed
for the Moon on 26 July 1971.
The image shows the marked
contrast in the vegetation
of South America between
the brown scar of the Andes
in the southwest and the lush
green rainforests of the
northeast. Although cloud
obscures most of North America,
Central America is just visible
on the left and Spain and
northwest Africa on the top right.

right
Earthrise
Earth is rising 384,000
kilometres from the Moon's
barren, cratered terrain. Its vast
oceans and thick atmosphere
make the Earth appear
predominantly blue from space.
Situated 150 million kilometres
from the Sun, the Earth is the
only planet in the solar system
where conditions allow liquid
water to exist at the surface.
As a result life has thrived,
continually modifying the Earth's
environment for over three
quarters of its 4.6 billion-year
history. This photograph was
taken during the Apollo 8
mission in December 1968.

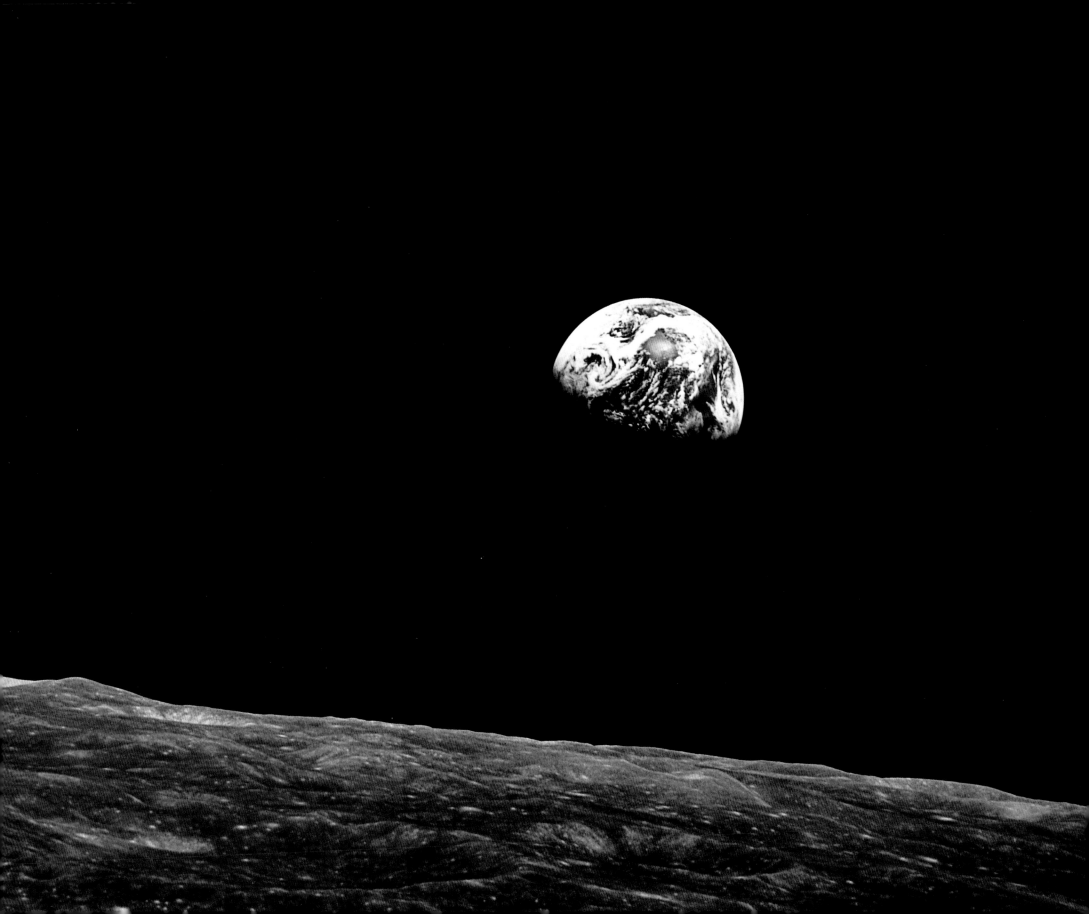

left

Leonid Meteors

A major display of Leonid Meteors occurs every 33 years when Comet Tempel-Tuttle returns to the inner solar system. The Earth happens to be heading towards the constellation of Leo at this time and so the meteors seem to originate in that part of the sky, hence the name. These meteors, seen here centre and right, are particles of debris shed by the comet as it crosses Earth's orbit. The last major Leonid Meteor shower was in 1999, but every November Earth's orbit takes us through the narrow band of debris left behind. Some particles hurtle into Earth's upper atmosphere at up to 70 kilometres per second, becoming visible as they burn up. This photograph was taken from Mount Fuji in Japan on 18 November 2001, using an eight-minute exposure.

Full Moon

Here the full Moon is seen from Earth. The Moon is 3,476 kilometres in diameter and 384,000 kilometres from Earth. The large dark, smooth areas are called maria ('sea' in Latin), as early observers thought they looked like seas. They formed early in the Moon's history when meteorites crashed into the surface and gouged out gigantic craters; these filled with molten rock pushing up from beneath the crust. The maria are not as densely cratered as the rest of the Moon because they formed after the period of most intense meteorite bombardment. One of the most famous maria is the Sea of Tranquillity, which was the site of the first manned Moon landing, Apollo 11, in 1969.

Lewis M Rutherfurd
New York Janry 8 1865

Moon
This photograph of the Moon's
surface was taken by the
American physicist Lewis Morris
Rutherfurd (1816–92) in 1865.
The two large craters with bright
rays of impact debris extending
out from them are called Tycho
(upper right) and Copernicus
(centre right) after the
Renaissance astronomers
Tycho Brahe (1546–1601)
and Nicholas Copernicus
(1473–1543). The rays formed
when debris was hurled
hundreds of kilometres out
from the impact site before
falling to the ground because
of the Moon's low gravity. Their
brightness indicates that this
occurred quite recently, as they
have not yet been obscured
by subsequent impacts.

right
Surface of the Moon
This 1898 photograph shows
the northeast quadrant of the
side of the Moon that faces
Earth. The pair of meteorite
craters near the centre of the
photograph are named Hercules
and Atlas, and they are each
about 70 kilometres in diameter.
In 1651, long before the advent
of photography, the Jesuit
astronomer Giovanni Battisti
Riccioli (1598–1671) drew
a map of the Moon naming
many of the main craters after
characters from Greek
mythology, as well as scientists
and philosophers.

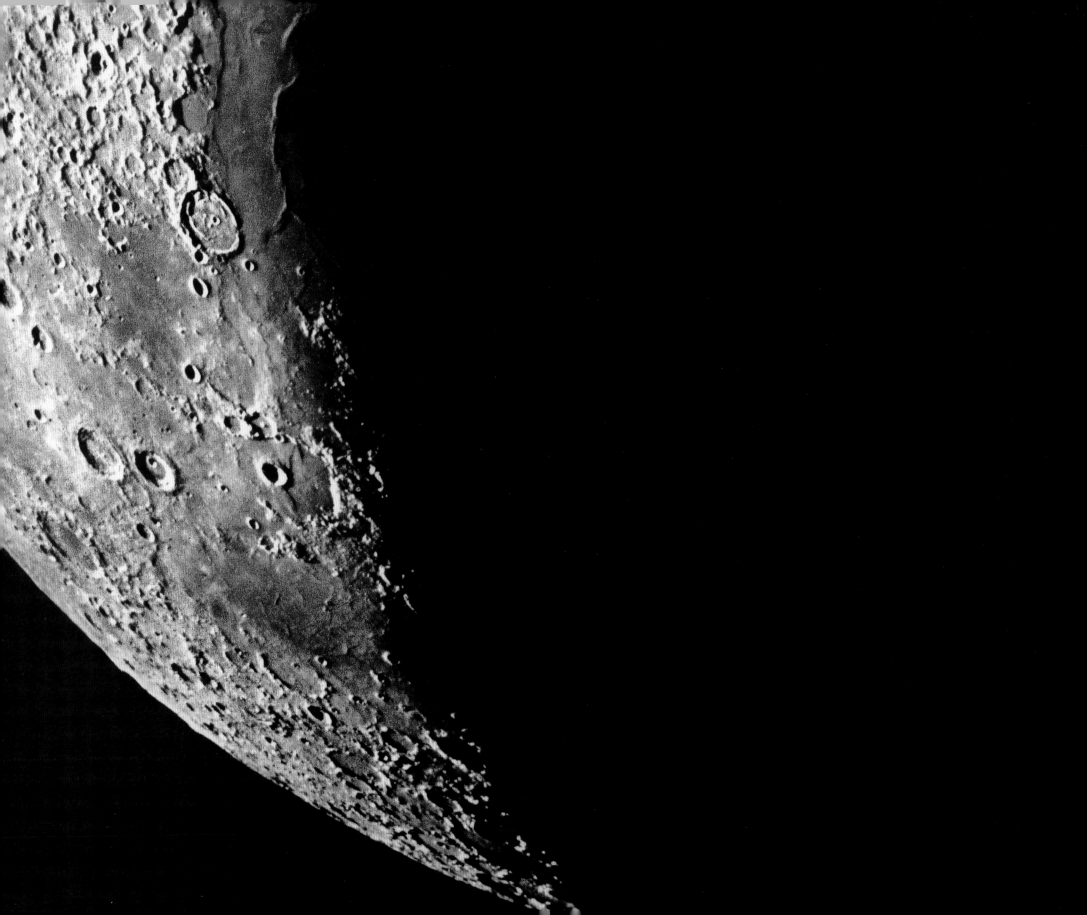

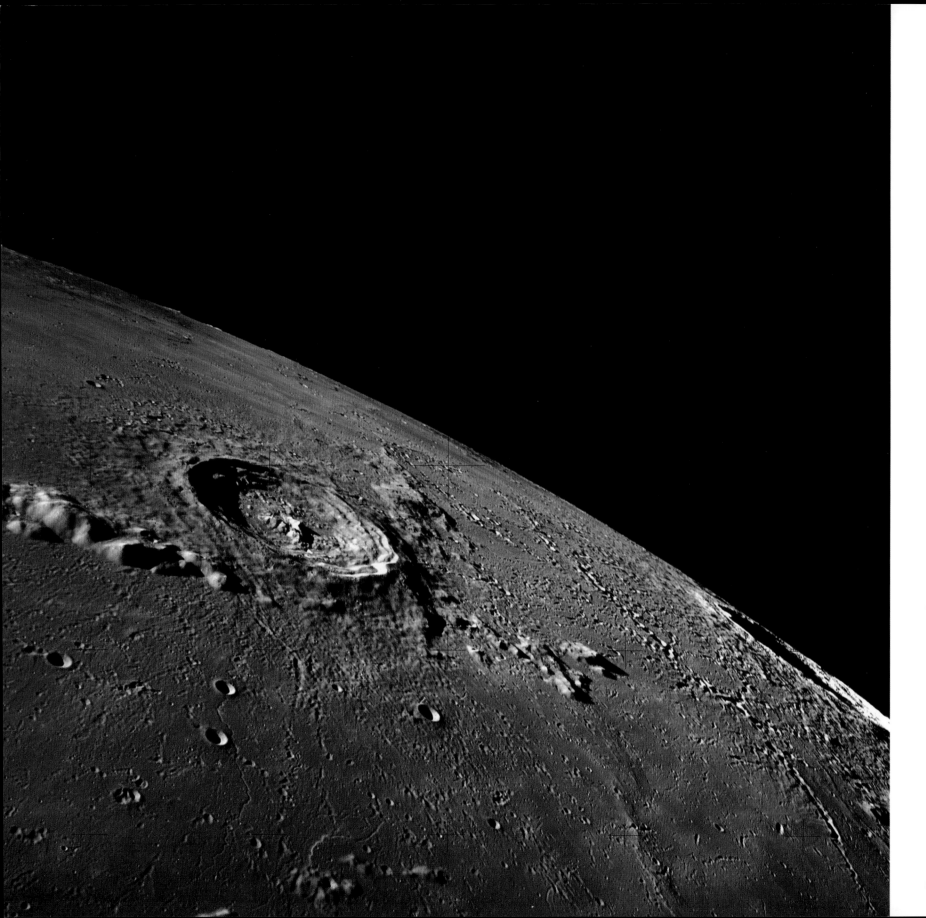

Lunar crater
The Moon has no air and water, and it has witnessed little recent geological activity. Nothing slows the arrival of even the smallest asteroid, and even these create distinctive craters. Erosion is so slow that pockmarks survive largely unchanged for many hundreds of millions of years. Scientists can therefore estimate the age of features on the Moon's surface by measuring the density of meteorite craters: the more craters, the older the surface. On Earth, by contrast, craters left by the few large asteroids that reach the surface are obliterated relatively quickly by wind and rain erosion or by tectonic activity.

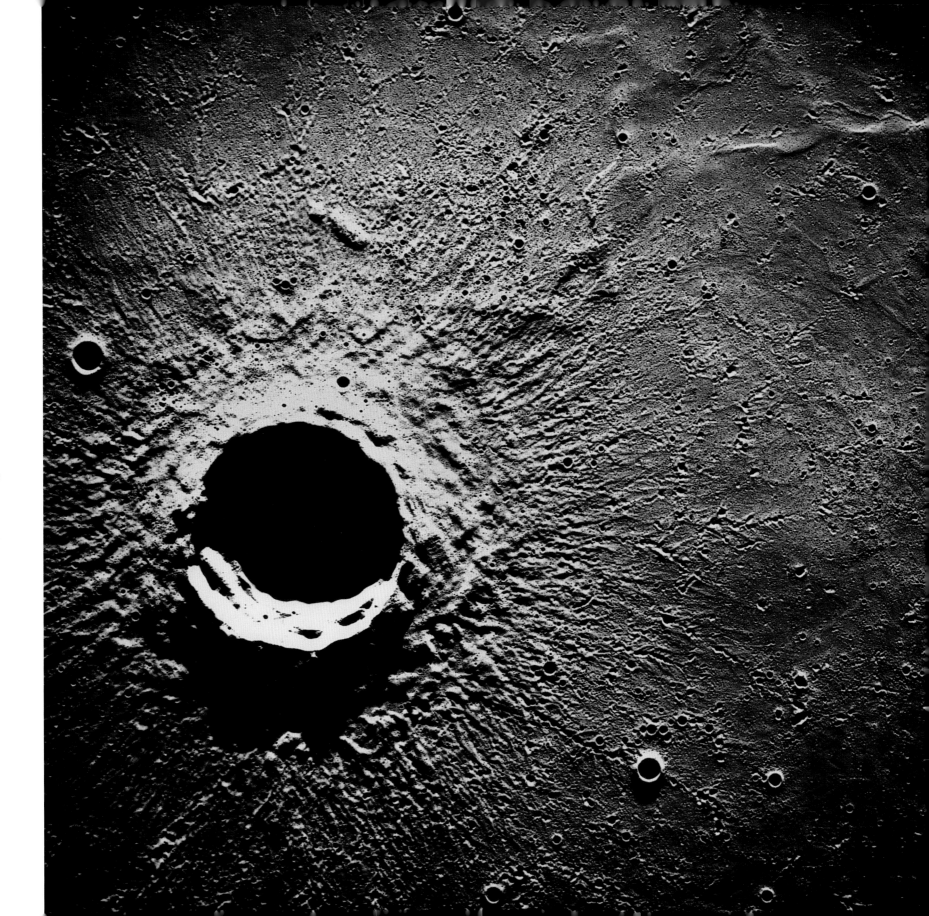

Crater Timocharis

The crater Timocharis punctures the smooth lava flood of the Moon's Mare Imbrium. The crater is about 35 kilometres in diameter. Its sharp edge indicates that it is relatively young, since the dust, micrometeorites, solar wind particles and cosmic rays that slowly erode and rework the Moon's surface have not had time to smooth the crater's edges. The orbiting Apollo 15 spacecraft took this photograph in 1971 from a height of 100 kilometres.

Far side of the Moon
The far side of the Moon was *terra incognita* until 1959 when the Soviet space probe Lunik 3 orbited the Moon and took the first pictures. The same half of the Moon always faces the Earth, as the Moon rotates on its axis in synchrony with its orbit of the Earth. This image reveals part of the far side of the Moon, taken from the Apollo 16 spacecraft on its return to Earth after landing on the Moon in April 1972.

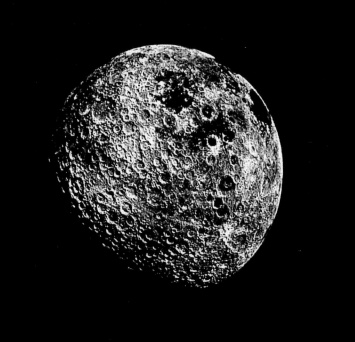

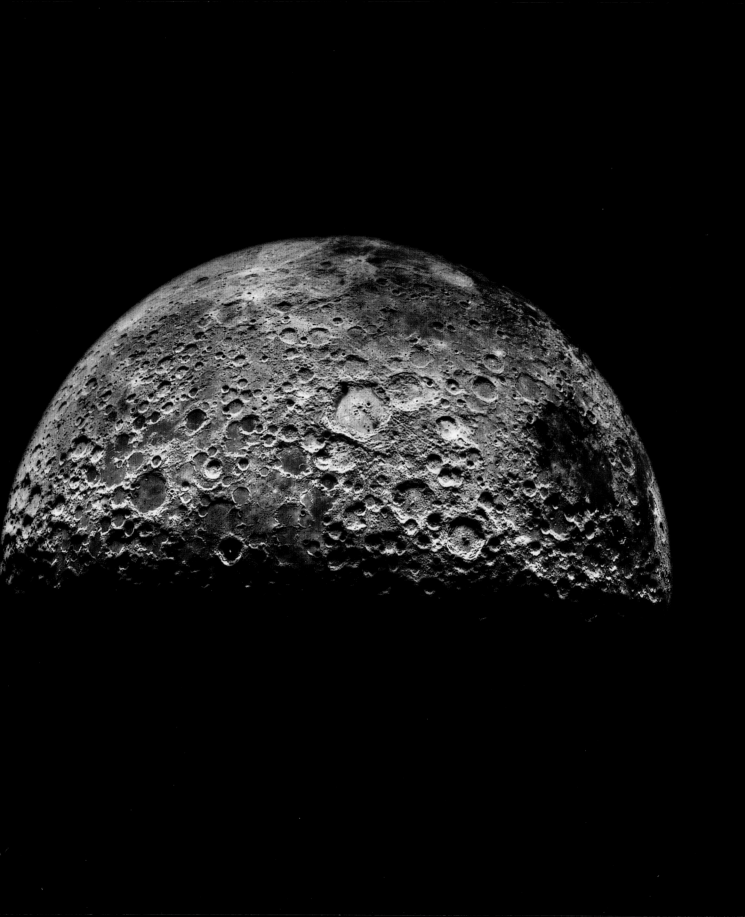

Southern hemisphere of the Moon

This image of the Moon's southern hemisphere was taken from the departing Apollo 15 spacecraft in August 1971, following a successful Moon landing. The far side of the Moon, on the centre and left in this view, is much more densely cratered than the familiar near side, seen on the right and top centre. The lack of wide smooth 'seas' (maria) of ancient lava came as a surprise to scientists mapping the Moon's far side. It has since been suggested that the crust on this side is thicker and so less likely to fracture and pour forth the lava lakes that became the maria.

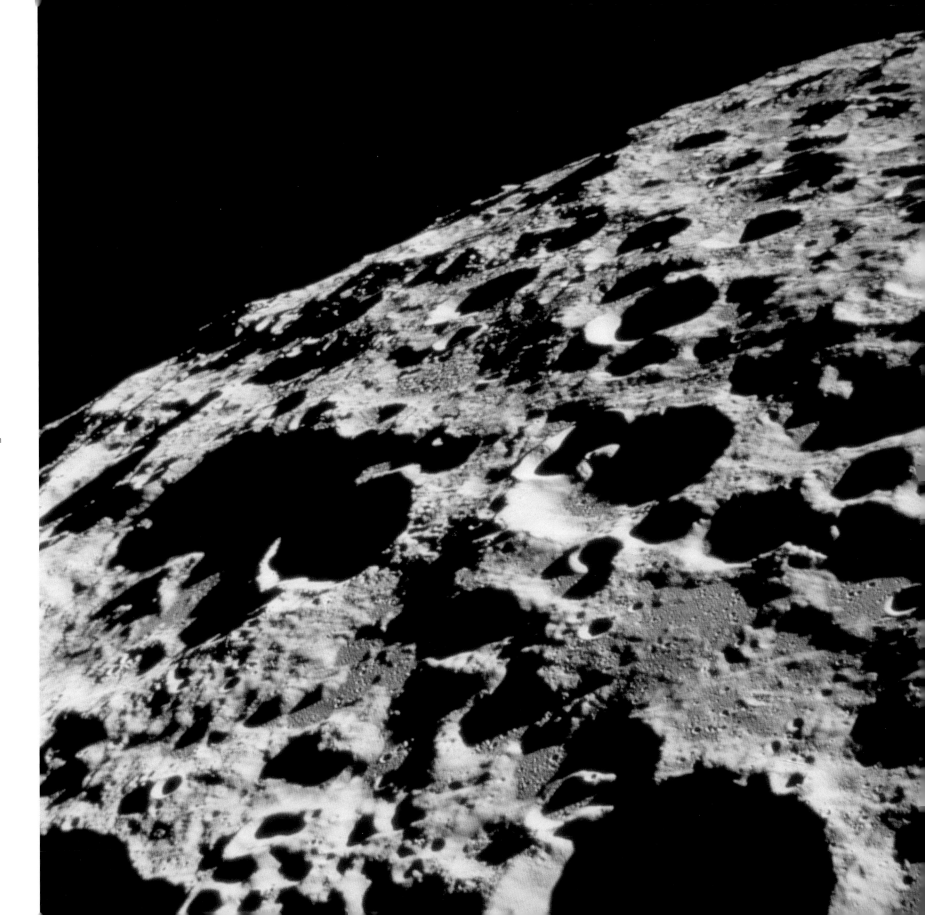

Surface of the Moon's far side
Until the Space Age, no one knew what lay on the far side of the Moon. One nineteenth-century astronomer suggested that there would be water, an atmosphere and even lush green vegetation. This out-of-sight world has now been mapped in great detail by a succession of orbiting satellites and, though unlike the near side, it is mysterious no longer. This picture was taken from Apollo 11, the mission that put the first man on the Moon in 1969.

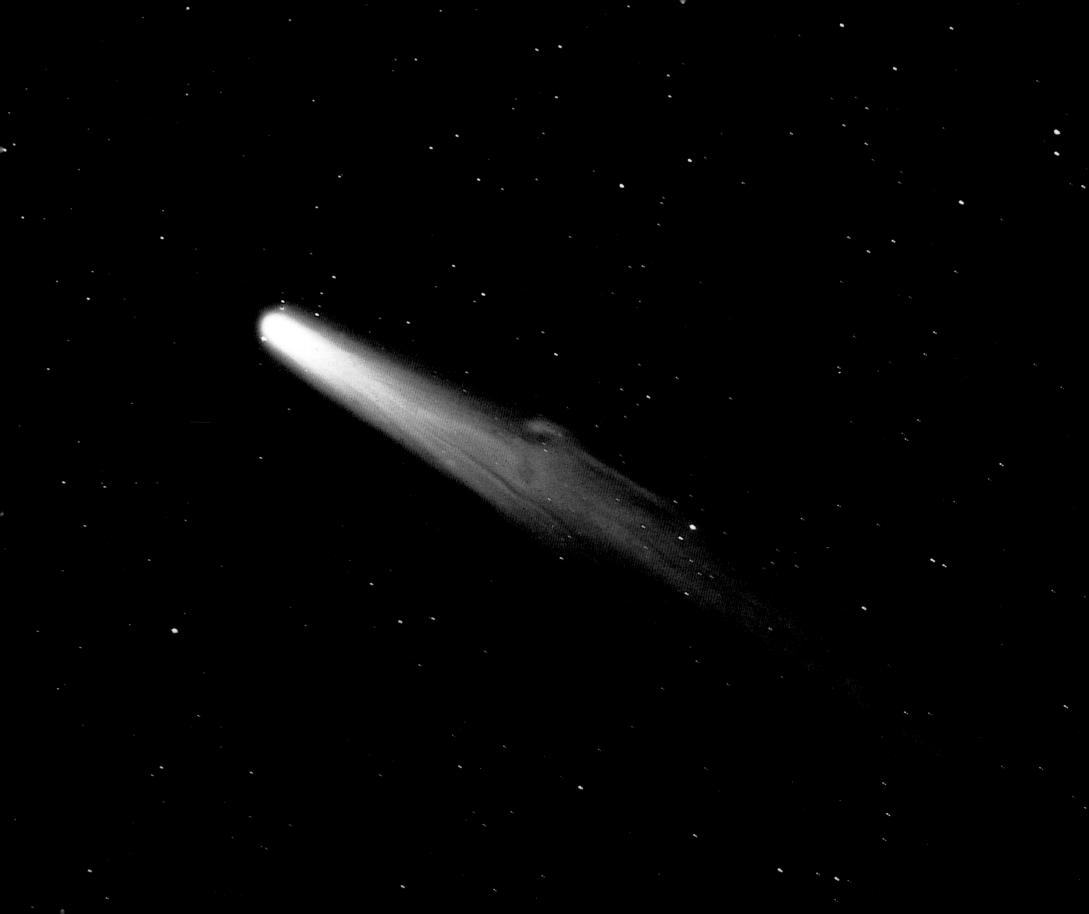

left
Halley's Comet

Halley's Comet travels through the solar system in a highly elliptical orbit, looping around the Sun at one end, which is where we see it from Earth, and Neptune at the other. Observing the comet in 1682 and studying records of previous sightings, the English astronomer and mathematician Edmond Halley (1656–1742) calculated that the comet took about 76 years to complete an orbit, and successfully predicted its return in 1758. This photograph was taken from Arequipa, Peru, using a 30-minute exposure on blue-sensitive film.

Nucleus of Halley's Comet

This image of the dark nucleus of Halley's Comet shows jets of gas vaporized by the heat of the Sun. The nucleus is a 15 kilometre long, peanut-shaped aggregate of water-ice, frozen gases and rubble. Its dark outer coating bears scars of meteorite impact craters from its long journey as well as cracks caused by recent solar heating. This image was taken by the Giotto spacecraft, one of several probes that were sent to intercept Halley's Comet in 1986 when it passed at 63 million kilometres from Earth.

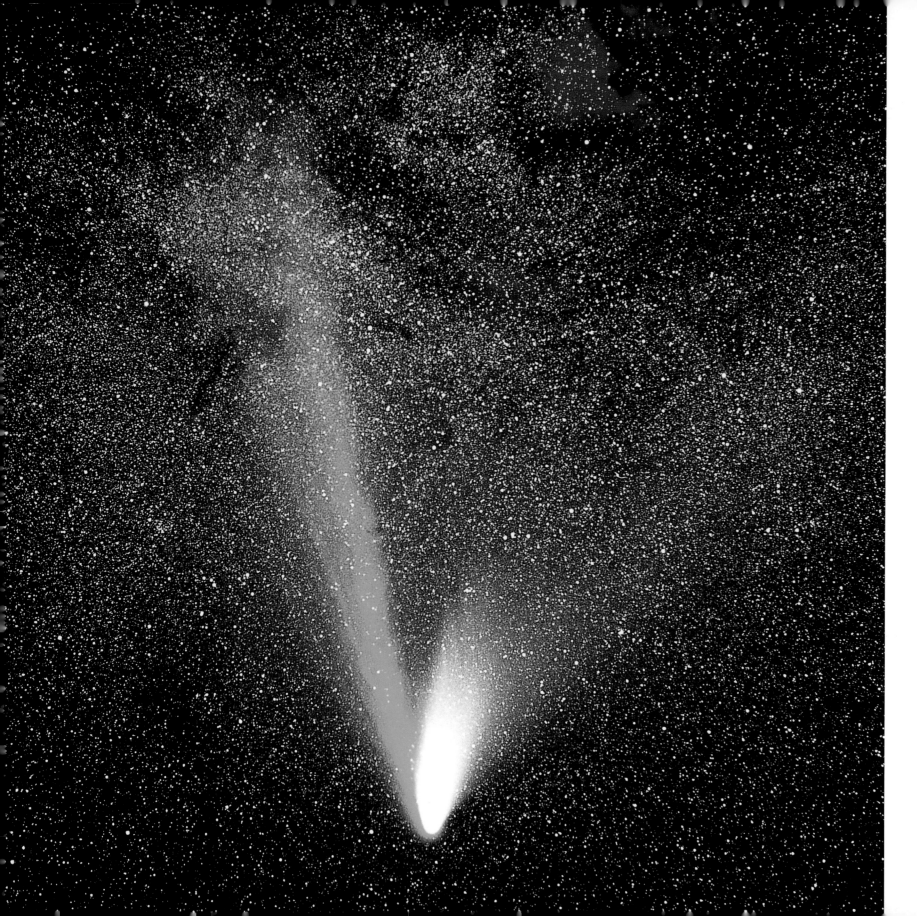

Comet Hale-Bopp

Comet Hale-Bopp was one of the brightest comets of the twentieth century, and has two characteristic tails of gas and dust. It was discovered in July 1995 by two US astronomers, Alan Hale (1958–) and Thomas Joel Bopp (1949–). As a comet approaches the Sun it warms, vaporizing water-ice and frozen gases and releasing dusty grains to form a coma – a huge envelope of gas and dust around the solid nucleus – which is swept away by the solar wind into a tail. The tail seen here glows blue in the Sun's ultraviolet radiation and is 150 kilometres long. The white tail consists of tiny dust particles, pushed away from the coma by radiation pressure from the Sun. Hale-Bopp will return to the vicinity of Earth in 2,400 years.

right
Morehouse Comet

The Morehouse Comet was first observed and recorded in 1908. It made its closest approach to the Sun on Christmas Day in 1908, and was named after the US astronomer Daniel Walter Morehouse (1876–1941), who discovered it. Astronomers began to capture comets on film successfully from the start of the 1880s, when new photographic techniques enabled them to record these faint objects. Of all the comets observed during the early days of comet photography, the Morehouse Comet was the most frequently photographed and the one that yielded the most spectacular pictures. This photograph was taken by the German astronomer Maximilian Wolf (1863–1932) on 16 November 1908.

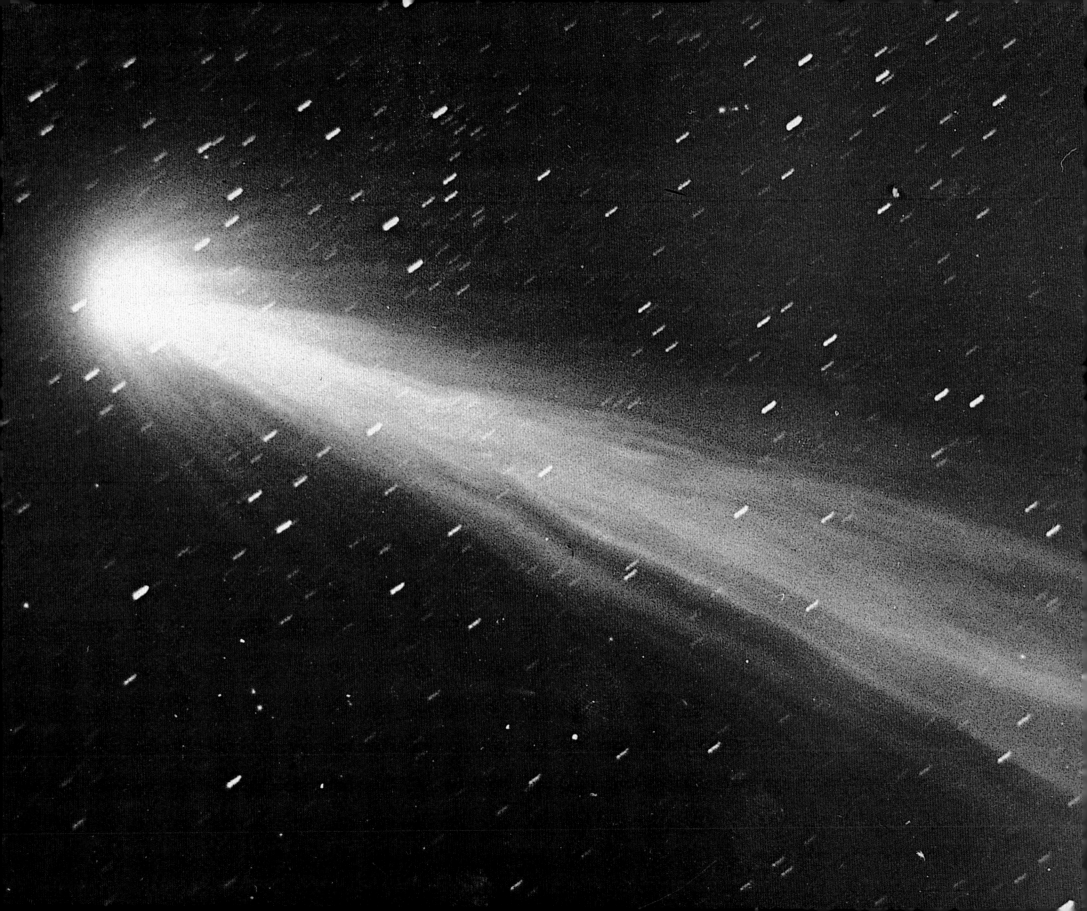

The Sun's corona

The Sun lies at the centre of the solar system and is the nearest star to Earth, lying 150 million kilometres away. It provides essential light and warmth, enabling life to thrive on Earth. Although we normally only see the bright disk, the Sun has an extensive faint atmosphere called the corona, which extends millions of kilometres into space. This is visible from Earth during a total eclipse, when the Moon obscures the Sun's bright surface. The corona is the hottest part of the Sun, reaching several million kelvin. This picture was made during the total eclipse experienced in India in 1980. The unexpected colours are the result of using a special gradient filter.

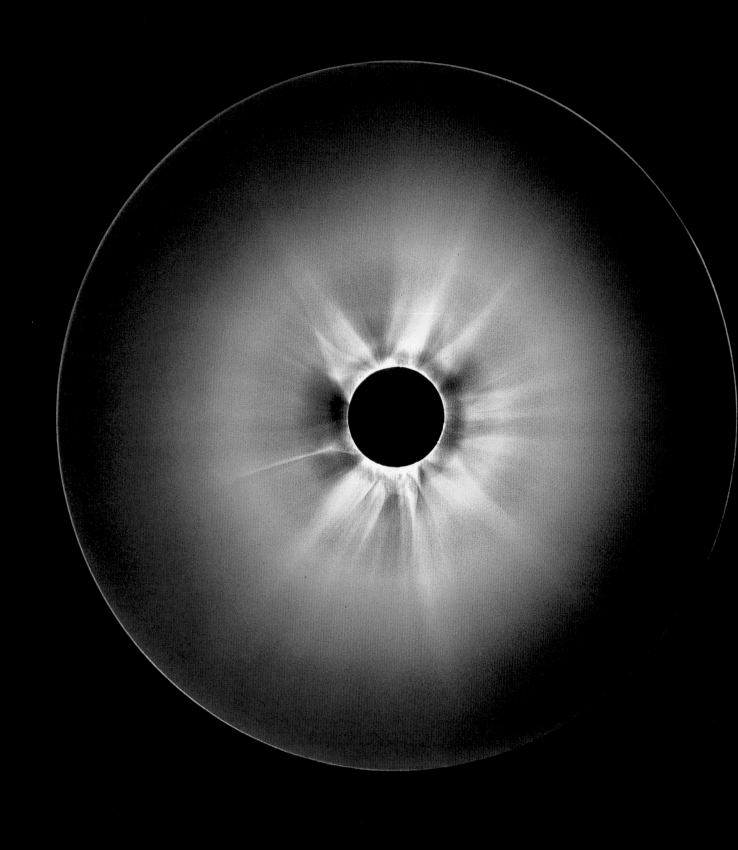

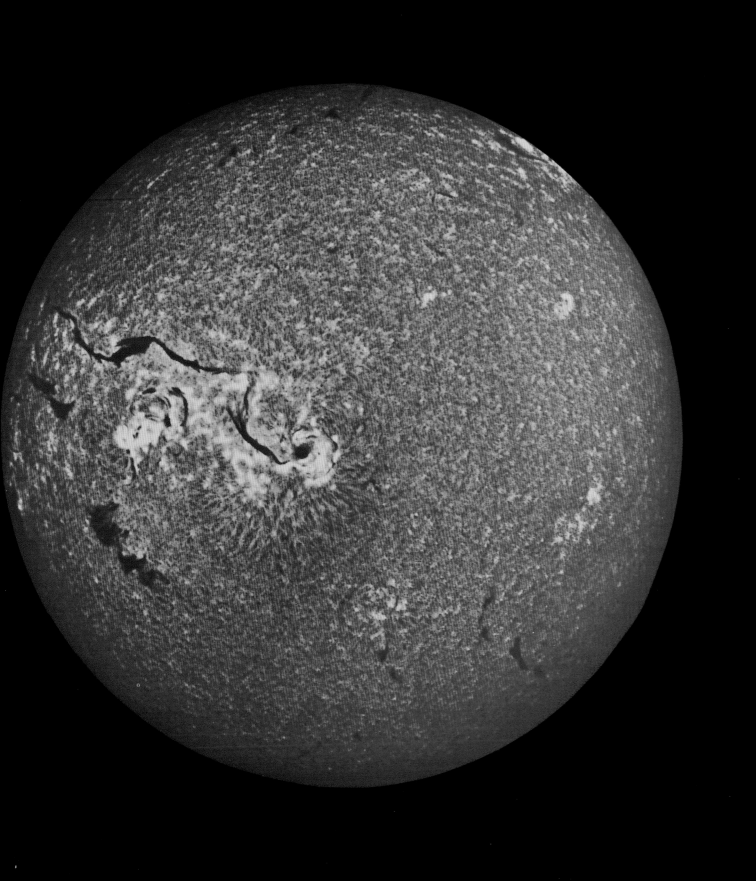

The Sun and its sunspots
This image of the Sun was made using film sensitive to the red light emitted by hydrogen, the Sun's main constituent and fuel. The dark red areas are sunspots, which can last from a few hours to several months. These pockets of cool, dark gas develop where the Sun's magnetic field lines rise through its surface, or photosphere. The number of sunspots, and other indicators of solar activity like prominences and flares, varies on an 11-year cycle, which reflects cyclic variation in the Sun's magnetic field.

X-ray image of the Sun
The corona is the Sun's hottest part. Here, temperatures reach several million kelvin, whereas the visible surface of the Sun is only around 5,770 kelvin. These extremely high temperatures mean that the Sun's outer atmosphere emits a significant proportion of its radiation as x-rays. This image was taken by an x-ray telescope in orbit above the Earth's atmosphere. Such a picture would be impossible to obtain from the ground because the Earth's atmosphere is opaque to x-rays.

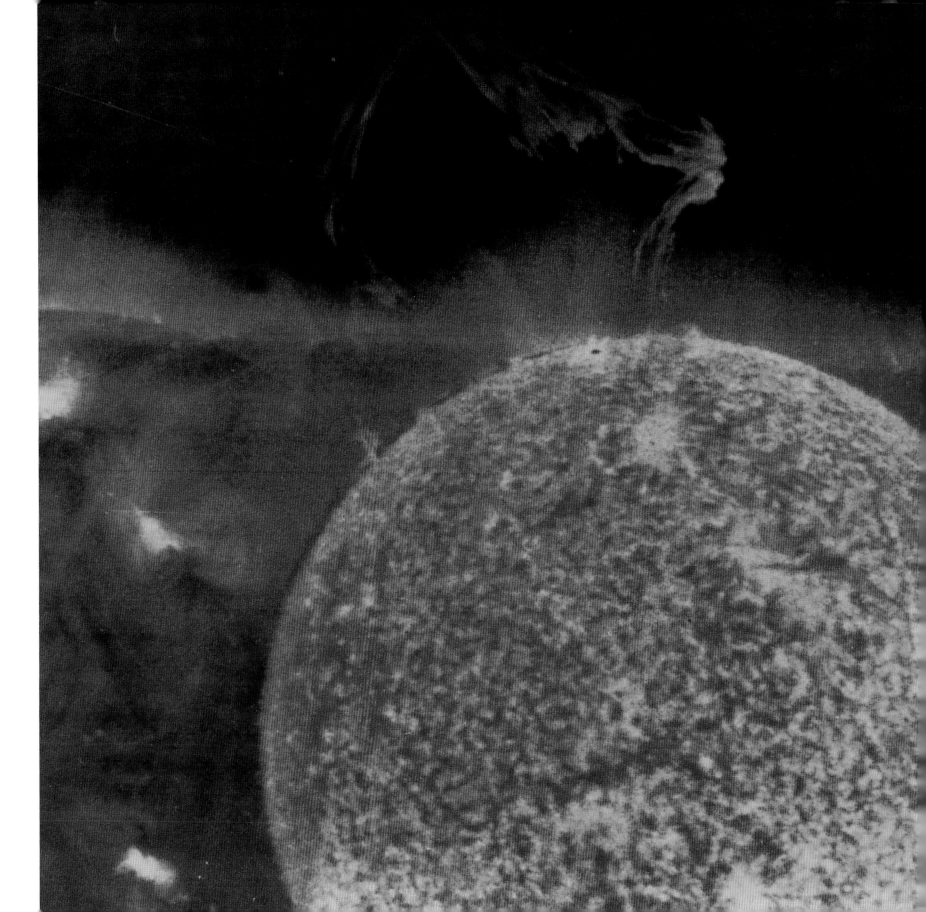

Solar prominence

The 'elbow' shape at the top of this picture is a solar prominence, made up of huge clouds of glowing, incandescent gas at a temperature of 10–20,000 kelvin. Also appearing as loops, jets and arches, these hot clouds are blasted from the Sun's lower atmosphere by magnetic fields. Eruptive prominences like this one usually last for less than a day before shrinking back. Prominences show up well in this extreme ultraviolet image from the Skylab Space Station because the Sun's surface does not appear particularly bright at these wavelengths.

Surface of the Sun

Most of the Sun's light comes from its mottled surface, the photosphere, whose temperature is about 5,770 kelvin. Surrounded by darker, slightly cooler areas, the light areas are called granules. This granular pattern is caused by convection cells of solar plasma, each about 1,000 kilometres across. The cells transport energy from the Sun's interior to the surface. Then, as the energy radiates away, the plasma cools and sinks, and the cycle continues. The bright granules represent zones of hot, rising gas and the dark zones, cooler, descending gas. An early pioneer in the use of photography in solar physics, the French astronomer Jules Janssen (1824–1907) took this photograph in 1887.

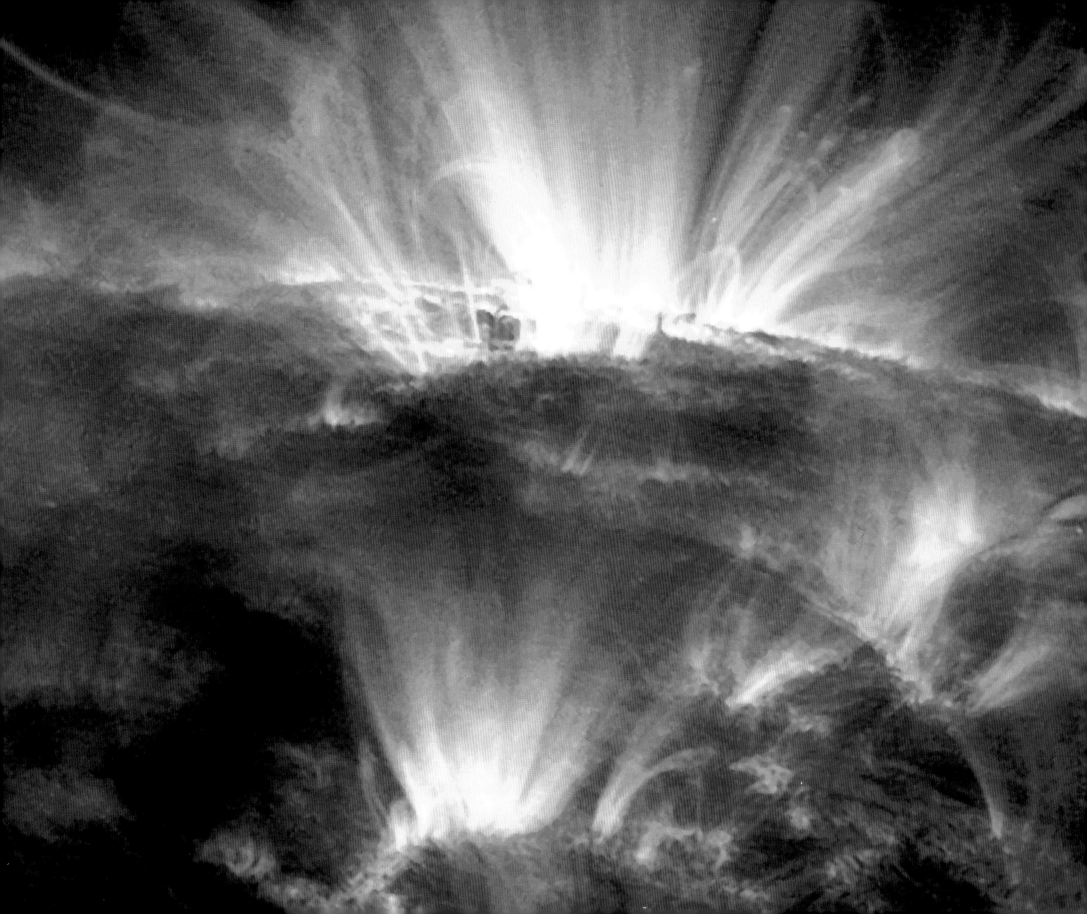

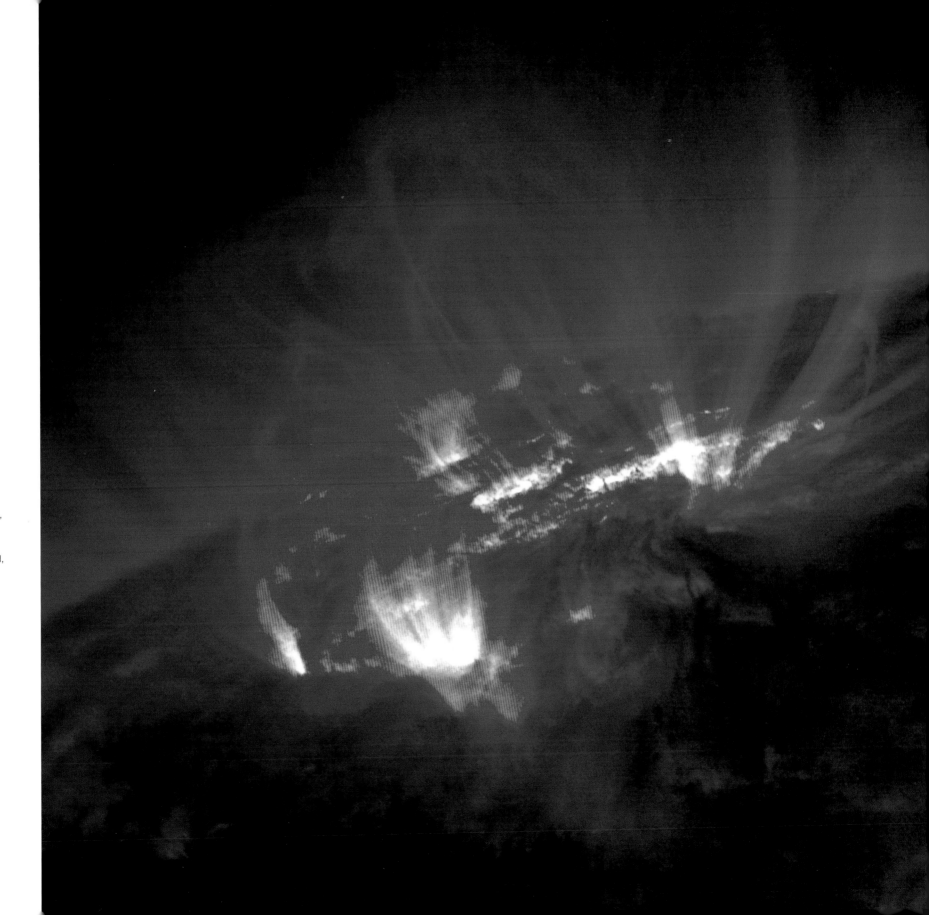

left and right
Coronal loops
Beneath the fiery surface
of the Sun, solar plasma
(highly ionized gas) churns
constantly, generating strong
magnetic fields that extend far
into the million-degree solar
corona. Along the field lines,
enormous erupting loops and
jets of plasma are channelled
several million kilometres into
the corona. They emerge from
hotspots on the Sun that are
many times the size of the Earth,
eventually plunging back into
the Sun, driven by magnetic
forces. These are false-coloured,
ultraviolet TRACE (Transition
Region and Coronal Explorer)
satellite images.

Mercury

Mercury, the innermost planet of the solar system, has only been visited by one space probe, Mariner 10, which returned this image in 1974. Mercury's elliptical orbit brings it to within 47 million kilometres of the Sun, sending daytime temperatures up to 460 degrees Celsius. However, the absence of an atmosphere means that night-time temperatures can plummet to minus 180 degrees Celsius. One day (from one sunrise to the next) on Mercury is equivalent to 176 Earth days. With a diameter of 4,900 kilometres, Mercury is the second smallest planet in the solar system.

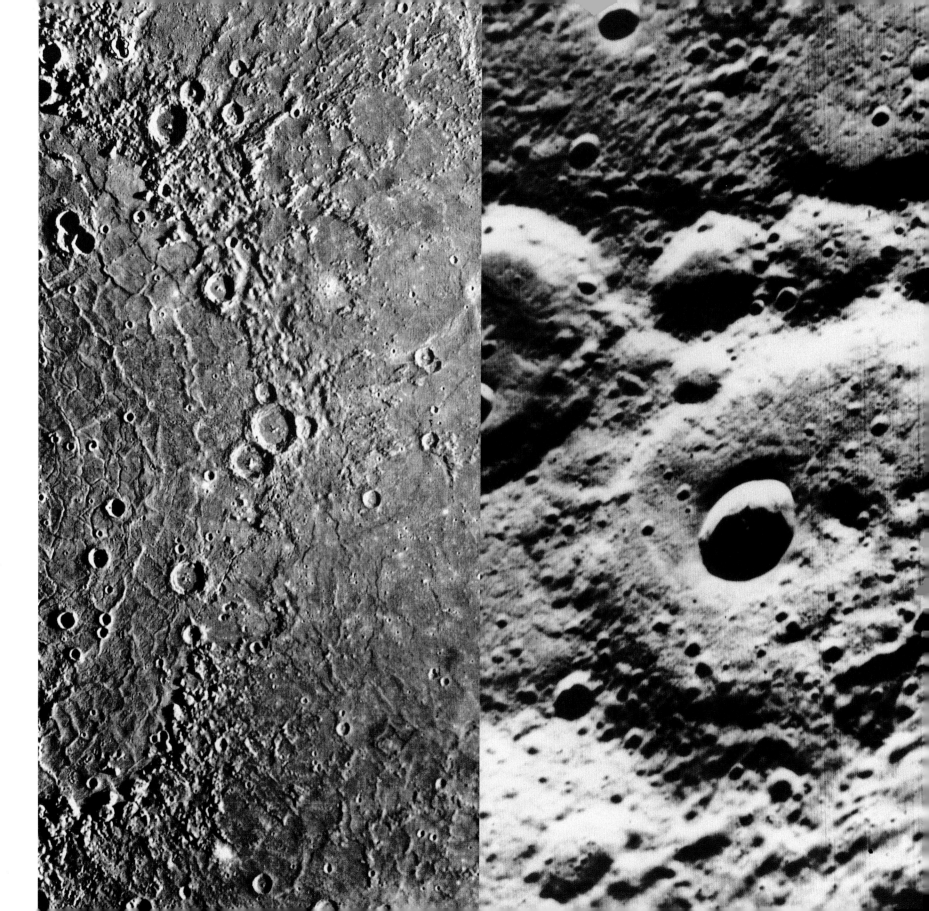

right
Surface of Mercury
On the left of this view
of the surface of Mercury
is a semicircle of mountains
surrounding a smoother,
low-lying basin. This is part
of the Caloris Planitia, a huge
basin gouged out by what was
probably the biggest meteorite
to collide with the planet in its
4.6 billion year history.
The basin would have flooded
with molten rock as the impact
explosion breached the crust,
in the process throwing up
a surrounding ring of mountains
measuring 1,300 kilometres
across and 2 kilometres high.

far right
Craters on Mercury
Mercury's battered surface
bears the scars of four billion
years of meteorite strikes.
With little gravitational field
and extremely high daytime
temperatures, atmospheric
gases are rapidly lost into space.
What little atmosphere there
is consists mostly of atoms,
continually blasted off the
surface by the solar wind.
With so little protection, even
the smallest meteorites reach
Mercury's surface, leaving
a heavily cratered landscape
similar to that found on the
Moon. This image is viewed from
the space probe Mariner 10
and covers an area about
170 kilometres across.

Venus

This radar image shows the
western hemisphere of Venus,
constructed from data gathered
by the Magellan spacecraft
during its first cycle
of observations in 1991.
Venus is the second planet from
the Sun, in orbit at an average
of 108 million kilometres. Venus
is similar in size to the Earth
but its surface temperature
is extremely hot, with an average
of 460 degrees Celsius.
This is due to its close proximity
to the Sun and the fact that its
atmosphere is rich in carbon
dioxide, causing a strong
'greenhouse effect'. This searing
hot surface is covered by dense
swirling clouds of sulphuric acid,
making it impossible to
photograph the surface from
orbit. However, radar can
penetrate this thick cloud cover,
providing data about the planet's
topography. The coloured dark
areas represent smooth and
low-lying regions, while the bright
areas represent rough surfaces
and highlands.

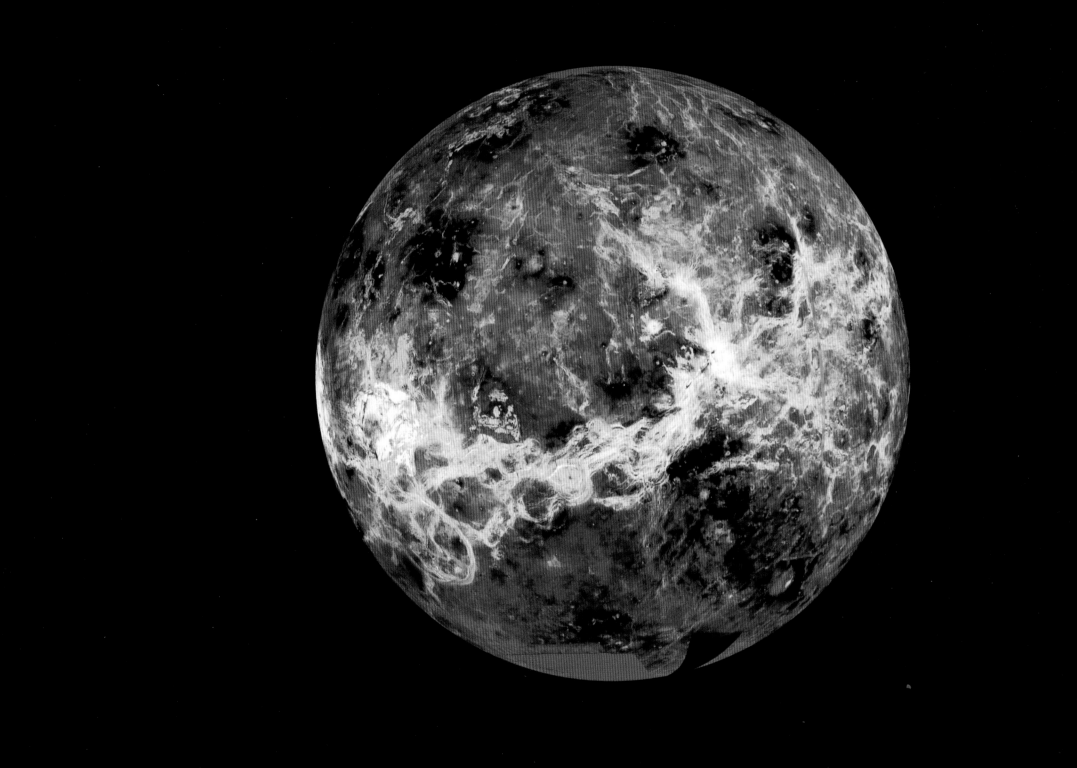

**Volcanoes on Venus
(Alpha Regio)**
These volcanic domes on Venus
are unique in the solar system.
Each dome is about
25 kilometres across and up
to 1 kilometre high. The domes
appear to be made of thick
volcanic lavas which would have
erupted from beneath the
surface into pancake shapes
and then cracked to form
concentric and radial patterns
as they cooled. This mosaic
image was made using data from
the US Magellan radar-mapping
spacecraft during successive
orbits of the planet in 1990.

Devana Chasma on Venus
This image shows a complex of parallel geological faults called the Devana Chasma, which lies on Venus's equator. The region is about 180 kilometres across, and the individual faults are about 5 kilometres apart.
The complex may be the result of tectonic stretching, a process similar to the movements of the Earth's crust that produced rift valleys. However, Venus's thick crust and lack of water prevent plate tectonics from operating as they do on Earth. The Magellan radar mapper made 30 orbits to complete this false-colour mosaic image.

Sif Mons on Venus

Sif Mons is one of the largest volcanoes on Venus. Like the island of Hawaii on Earth, it is a shield volcano with broad gentle slopes. Formed from runny lava, the volcano is 200 kilometres across at its base but only 2 kilometres tall. Constructed from Magellan radar data, this false-colour perspective view has been given a vertical exaggeration of about 20 times. The radar imagery picks out lava flows of different ages, the roughest, least eroded and most recent flow being the brightest.

far right
Craters on Venus

The surface of Venus is scarred with craters. In the foreground of this image is the Howe Crater (37.3 kilometres across), on the left, the Danilova Crater (47.6 kilometres across) and on the right, the Aglaonice Crater (62.7 kilometres across). The radar-bright area around each crater shows that the surface is rough and strewn with impact debris. This perspective view has been calculated, enhanced and coloured using radar data from Magellan and information from the few colour photographs that have been taken on the surface of Venus.

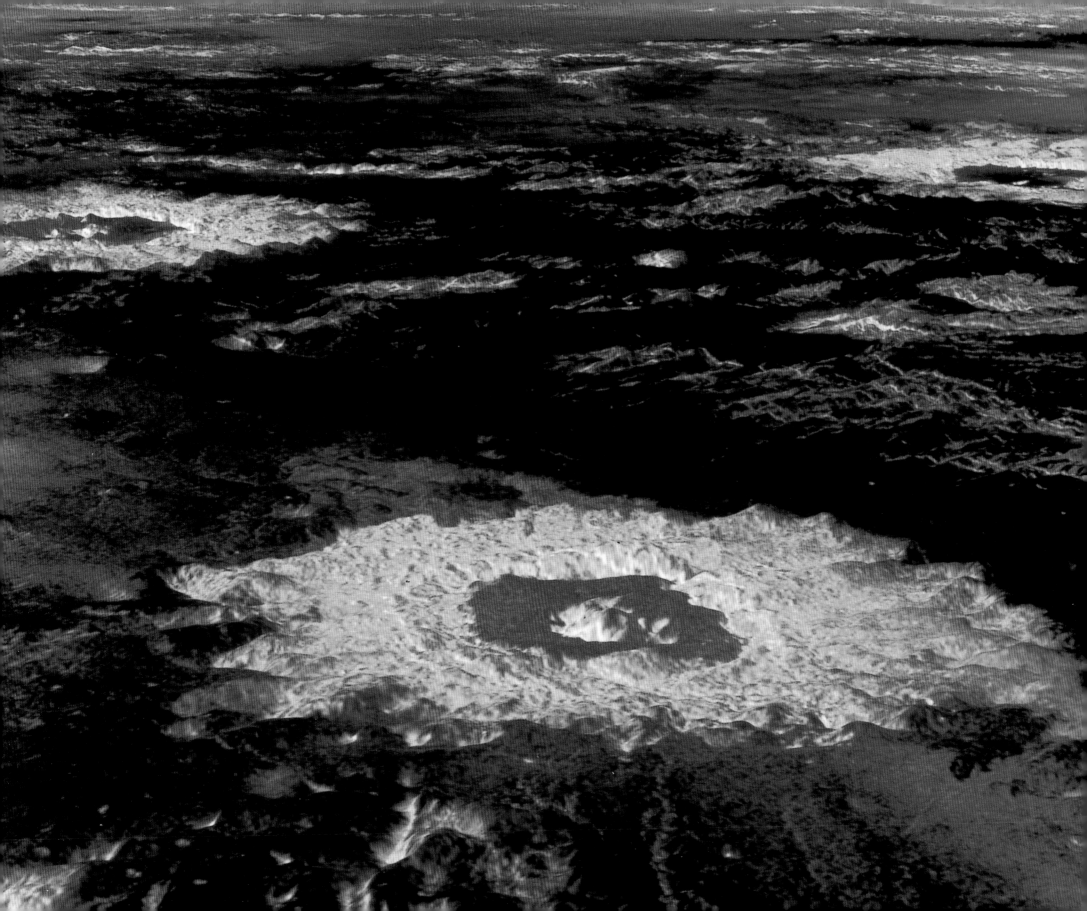

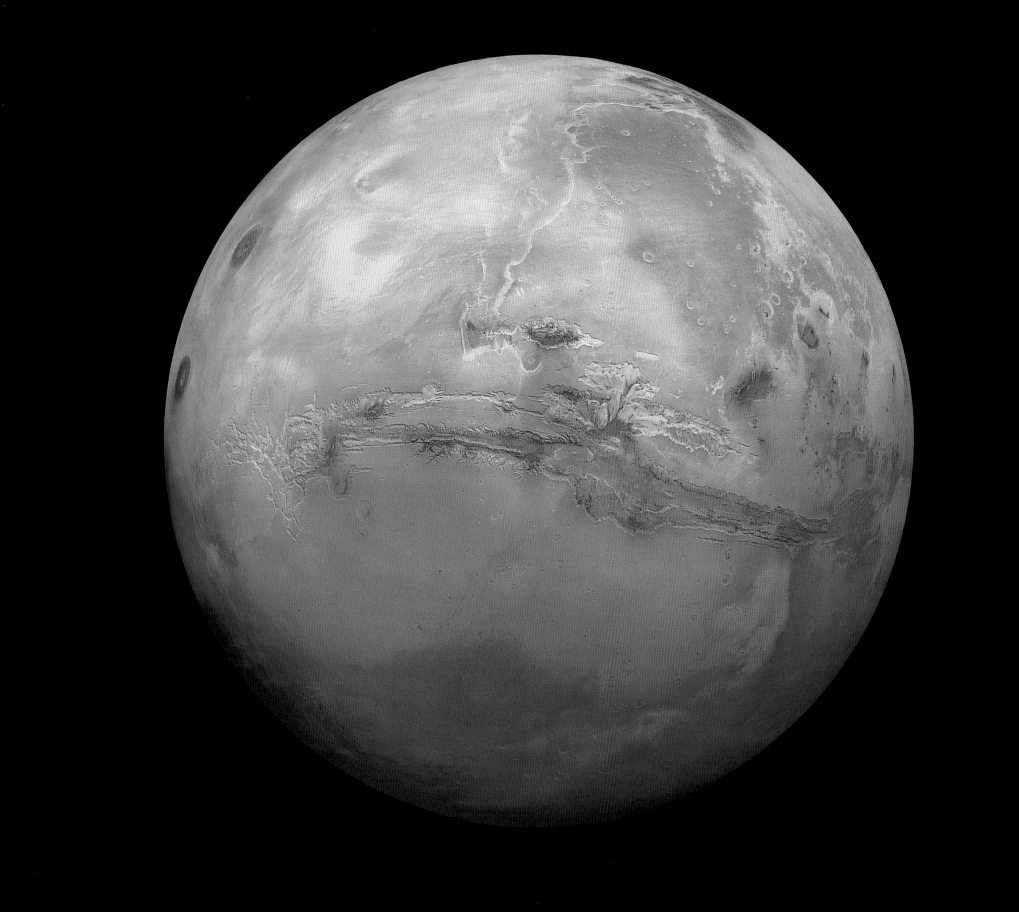

Mars

Further from the Sun than Earth
and too small to maintain much
of an atmosphere, Mars is
a cold planet and any water
on its surface is frozen solid.
The dark streak across the
centre seen here is the Valles
Marineris canyon system.
This is not an image of a whole
hemisphere of Mars but a fish-
eye view, a simulation of the
view from a spacecraft about
2,500 kilometres above the
surface taken through a very
wide-angle lens. The field of view
is about 60 degrees of latitude
and longitude. The image was
made using data from the
Viking Orbiter probe.

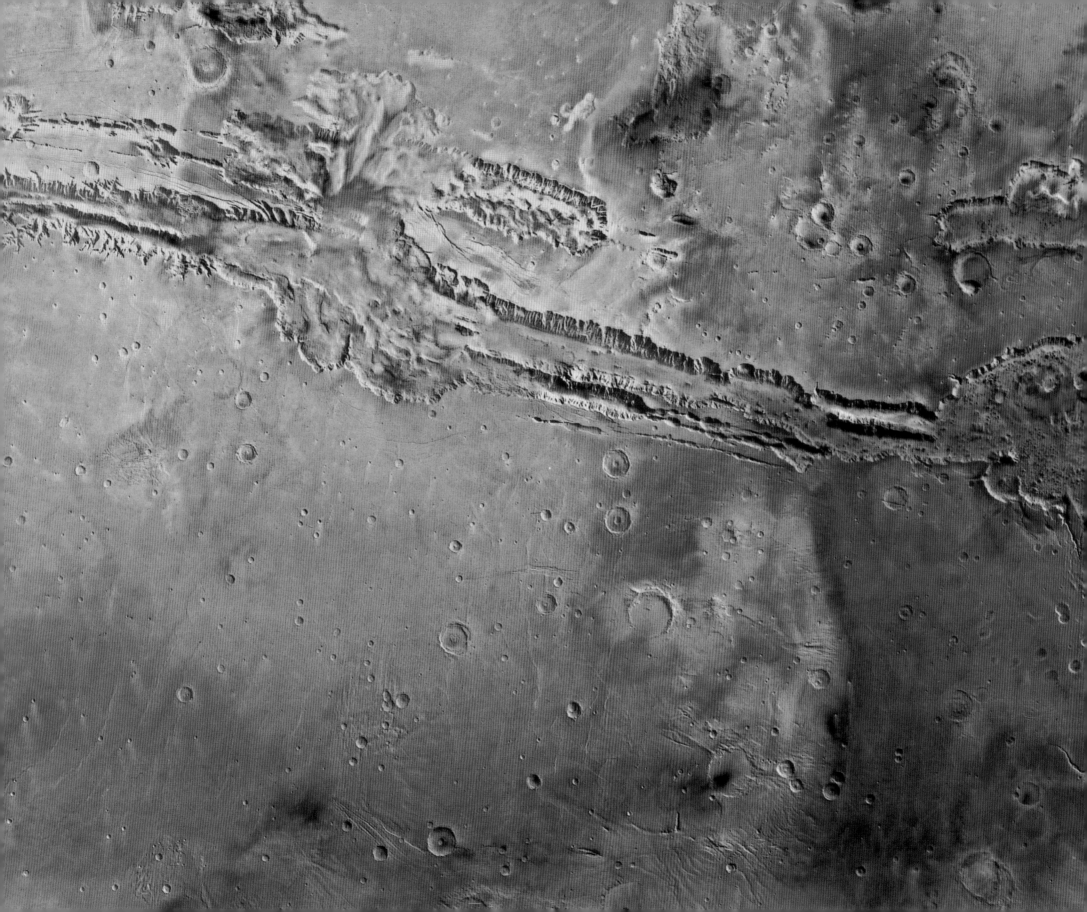

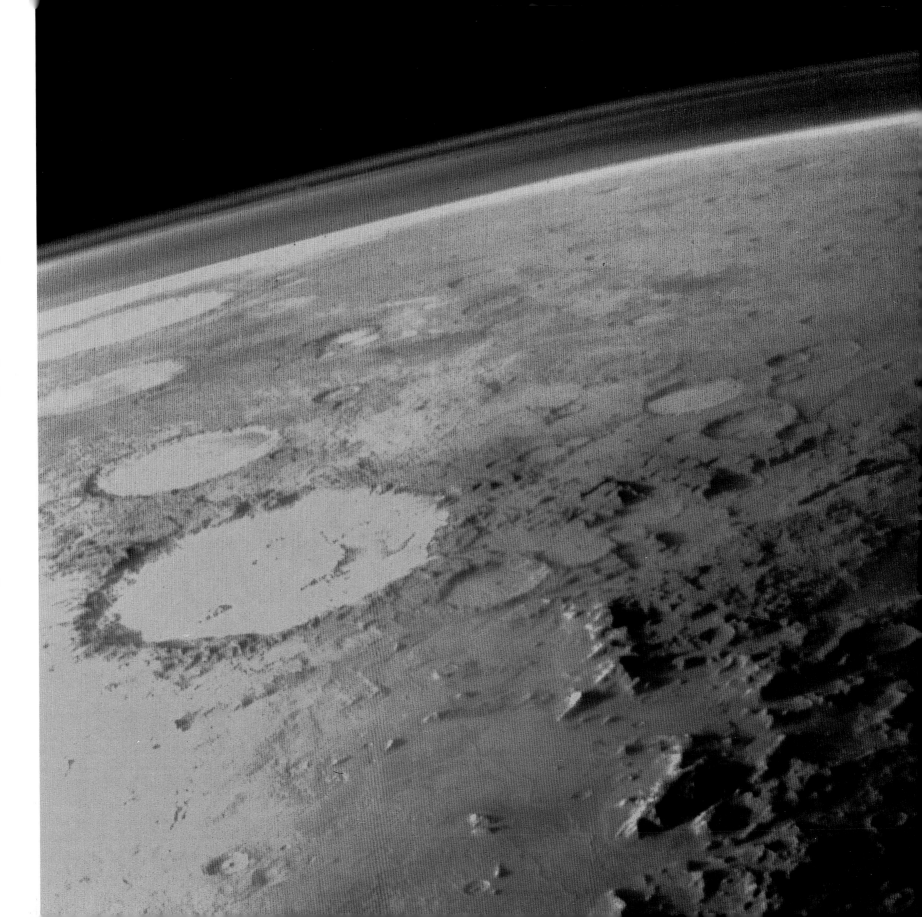

left

Valles Marineris, Mars

This shows part of the Valles
Marineris, a 4,000 kilometre
long system of canyons just
south of the Martian equator.
The canyons are typically several
hundred kilometres across,
and range in depth from
2 to 7 kilometres. The round
chasm at upper left, where
several canyons merge,
is 600 kilometres wide.
The canyons are thought to have
been formed through tectonic
faulting and then shaped by wind
and water erosion. This mosaic
of images comes from the
Viking I and II probes.

Argyre Basin, Mars

This is an oblique view of part
of the Argyre Basin on Mars.
This huge and ancient impact
crater (870 kilometres across)
has been heavily eroded by
water, ice and wind. It is thought
that the basin once held a
partially frozen lake, and sinuous
sediment features on the lake
bed were probably formed by
rivers flowing beneath the ice.
Several more recent impact
craters dot the basin floor.
The thin Martian atmosphere,
composed mainly of carbon
dioxide with small amounts
of nitrogen and other gases,
is visible above the limb.

Olympus Mons, Mars
The Martian Olympus Mons
is the solar system's largest
volcanic mountain.
At 27 kilometres it is three
times as high as Mount Everest,
and the central crater is
80 kilometres across. Its base
is 620 kilometres wide.
Its gentle slopes define it
as a shield volcano, less steep
than the more familiar Vesuvius
or Mount Fuji on Earth.
Olympus Mons was probably
still active at some point
during the last billion years,
making it a youngster among
Martian volcanoes.

'Face' on Mars
Intended as a light-hearted
release, this image from the
Viking Orbiter probe quickly
gained notoriety as so-called
evidence for alien intelligence
on Mars. In fact, the face-like
appearance of the 1.5 kilometre
wide feature is due to nothing
more than a combination
of unusual lighting conditions,
chance symmetry of topography
and defects in the image
which have created the black
dots. Other unusual Martian
features include hills whose
shape suggests Egyptian
and Inca pyramids.

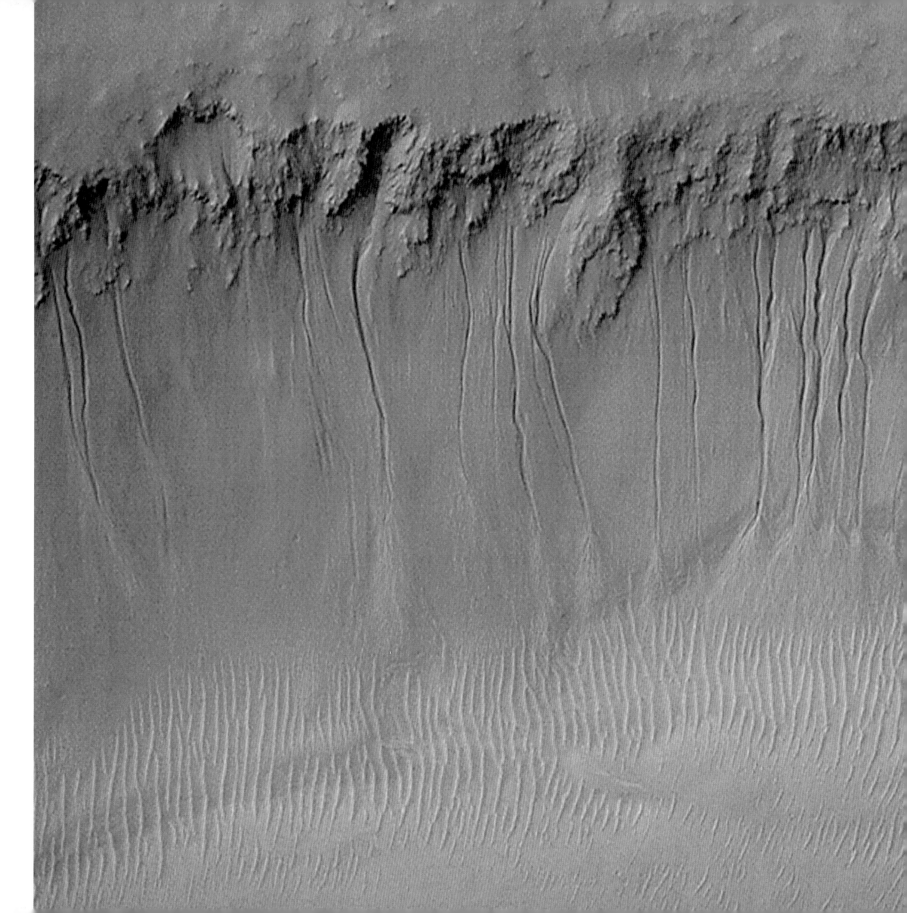

Water gullies on Mars

This photograph of the Nirgal Vallis presents strong evidence that running water has existed on Mars at some period in its history. At least 14 channels, each about a kilometre long, run down the south-facing slope of the valley. They end in fan-shaped aprons of sediment covering existing dune fields, shown in the lower half of the picture. A flowing liquid – quite possibly water – may have formed these channels, which resemble river channels on Earth. This photo was taken by the Mars Orbital Camera aboard the Mars Global Surveyor spacecraft and shows an area of roughly three kilometres square.

Martian crater

A meteorite impact crater has been gouged out in Elysium Planitia, a smooth, low lying plain on Mars. A ring of rocky material thrown up by the impact explosion surrounds the 2.7 kilometre wide crater, clearly visible against the surrounding smooth plain. The ejecta appears thicker than usual and has unusual radial grooves, hinting at the presence of water when the crater was formed. This photograph was taken by the Mars Global Surveyor, a satellite in orbit around Mars that has been observing and mapping the planet since 1998.

Asteroid 243 Ida

Asteroid Ida must be very old as its surface is covered with craters. Although only about 50 kilometres long and 20 kilometres wide, Ida has its own satellite, Dactyl, measuring only a kilometre across, which orbits 100 kilometres away. Together they circle the Sun as part of the main asteroid belt between the orbital paths of Mars and Jupiter. The Galileo spacecraft obtained this image of Ida in 1993 as it passed through the belt en route to Jupiter.

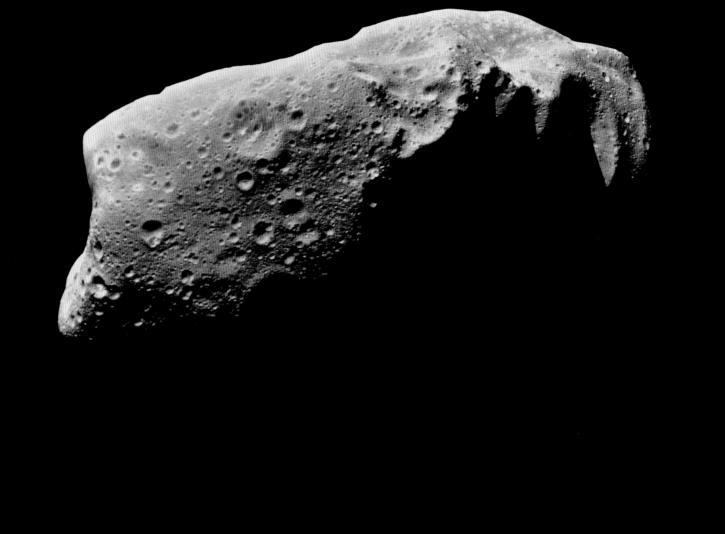

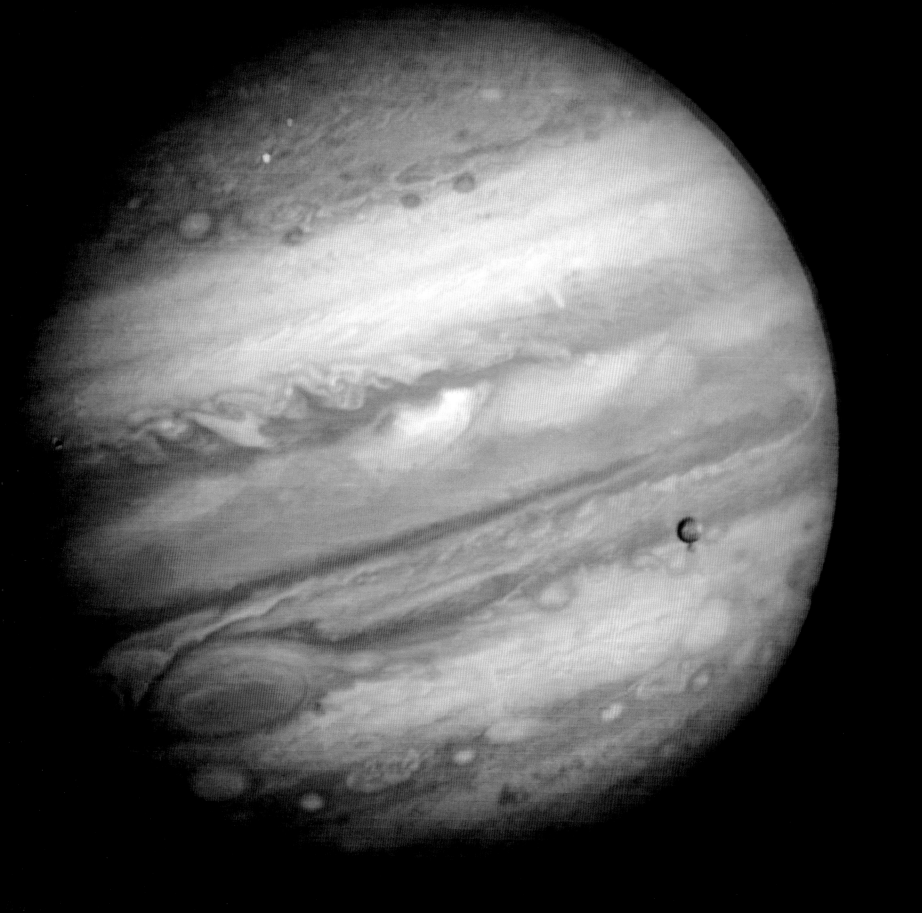

Jupiter, Io and Europa

Lying 700 million kilometres
from the Sun, Jupiter is by far
the biggest planet in the solar
system. It is 144,000 kilometres
across, greater than all the other
planets combined. Its thick
atmosphere is composed of
hydrogen and helium, with small
amounts of other compounds
lending the clouds their colours.
The striped cloud formations
are caused by winds travelling
at over 180 kilometres per hour,
whipped up by the planet's
extremely rapid rotation
(a Jovian day lasts only
10 hours) and stirred by heat
from within. Jupiter has 16
orbiting satellites, the brightest
of which are the four Galilean
moons – Io, Europa, Ganymede
and Callisto – which were
discovered by the Italian
astronomer Galileo Galilei
(1564–1642) in 1610.
This 1979 Voyager 1 image
shows the Great Red Spot
(lower left), a storm system
several times larger than Earth,
and Jupiter's nearest moons,
Io (centre) and Europa (far right).

Comet Shoemaker-Levy 9 impact on Jupiter
The bright spots on this infrared image are the still-hot impact sites of comet Shoemaker-Levy 9. Over six days in July 1994, 20 fragments of the comet hurtled through Jupiter's atmosphere at a rate of 60 kilometres per second. Plunging through the atmosphere, each fragment exploded into a huge fireball, leaving a rising column of hot gases and debris in its wake. The columns formed plumes rising 3,500 kilometres above the top of the clouds, before splashing back down to each cover an area the size of the Earth.

right
Aurorae on Jupiter
This is the Jovian equivalent of the Earth's Aurora Borealis and Aurora Australis. Aurorae occur when charged particles of the solar wind enter the upper atmosphere, making it glow. As on Earth, Jupiter's aurorae peak every 11 years at times of greatest solar activity and strongest solar winds.
Aurorae occur around the poles because the stream of charged particles is attracted here by the planet's magnetic field. This false-coloured ultraviolet image is from the Hubble Space Telescope.

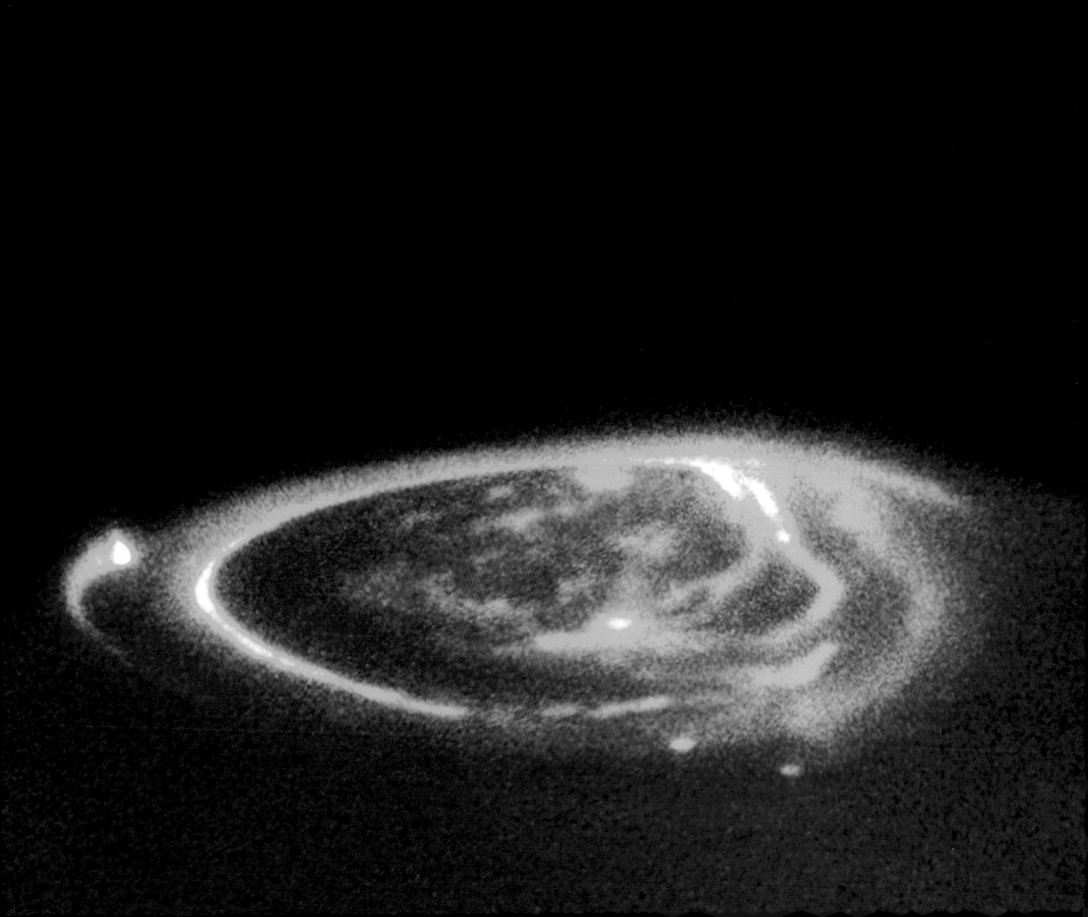

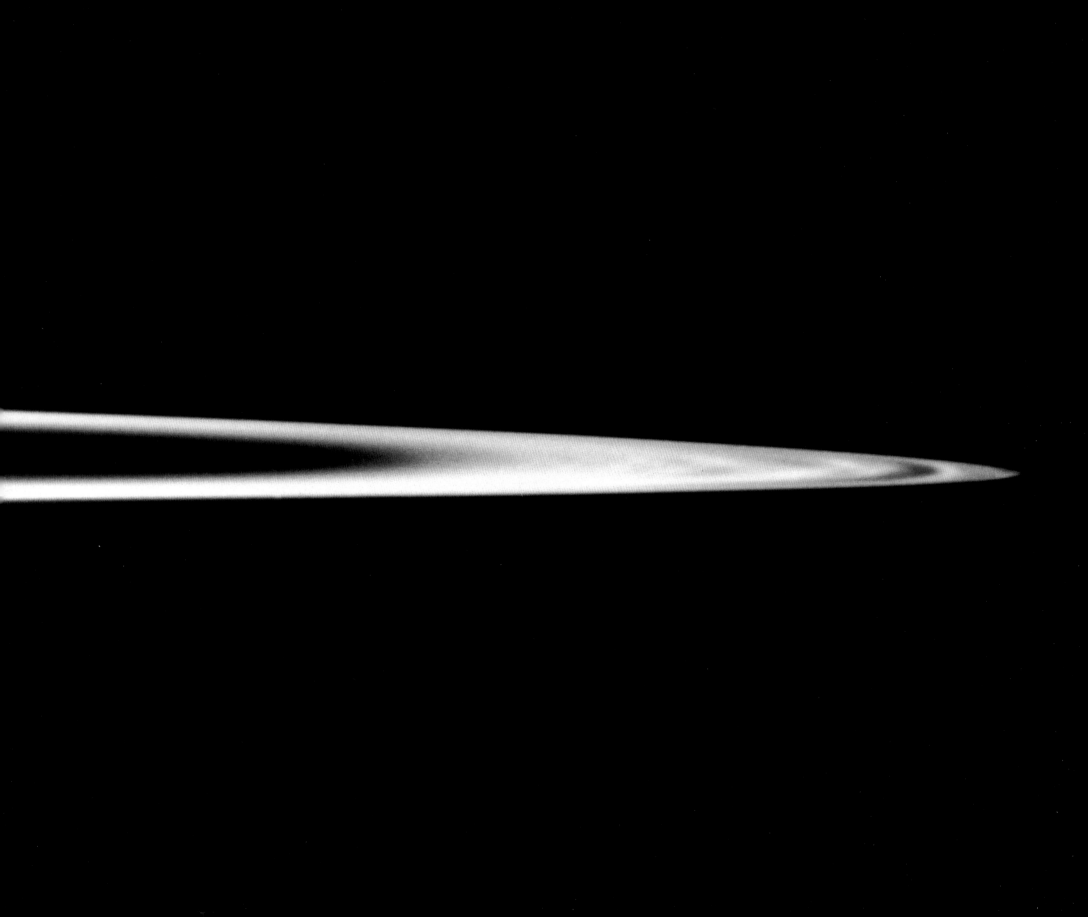

left
Jupiter's rings
In 1979, Voyager probes
discovered a ring of dust-sized
particles around Jupiter,
so faint and thin as to be
invisible from Earth. The ring
forms a 30 kilometre thick disk,
about 300,000 kilometres in
diameter, whizzing around the
planet at roughly 200,000
kilometres per hour. This 1996
Galileo spacecraft image shows
dark, dust-free rings alternating
with bright rings of dust.
The orbiting particles fall towards
the planet over time but are
constantly replenished by dust
created by impacts on Jupiter's
many moons.

Volcano on Io, Jupiter's moon
Io is about the size of the Earth's
moon but geologically very
different. It is one of the solar
system's most active bodies,
with over 300 volcanoes and
fissures. Io's proximity to Jupiter
and its eccentric orbit combine
to exert gravitational stresses
on its molten interior, making
it extremely active volcanically.
Io's surface appears yellow
because it is covered by
sulphurous volcanic deposits
and lava flows. Here, a large
volcanic plume is erupting,
its blue hues the result
of sulphur dioxide condensing
as it cools. The picture was
taken by the Galileo space
probe from a distance of about
a million kilometres.

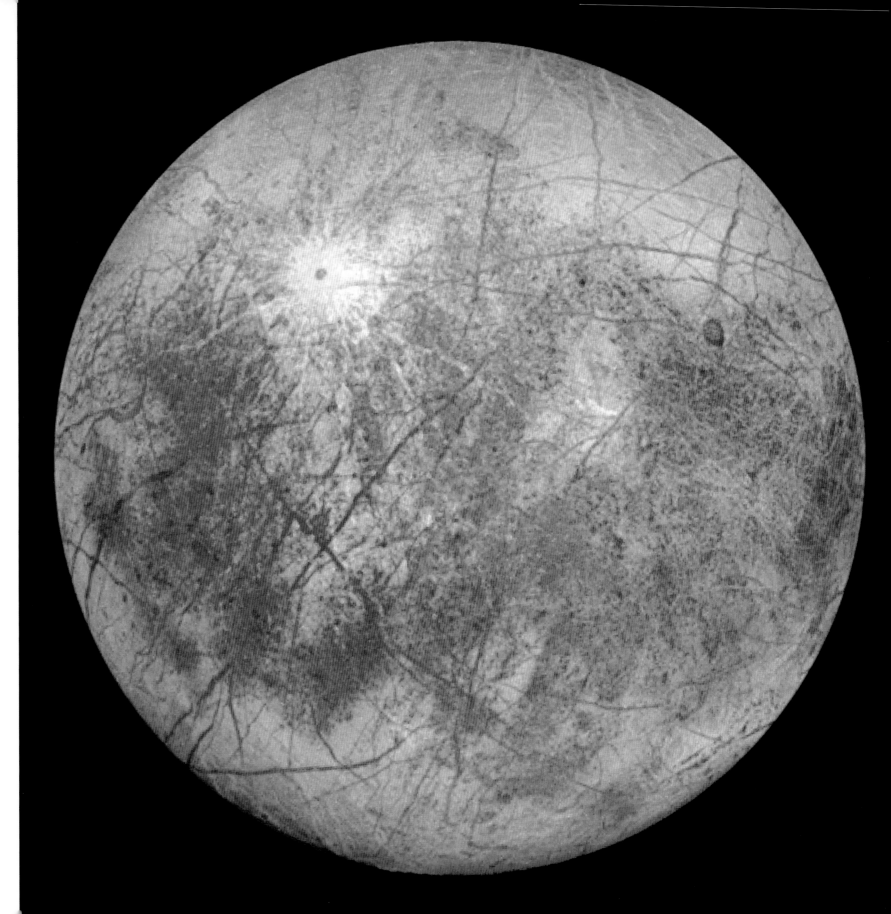

Europa, Jupiter's moon

Europa is Jupiter's second
moon. In contrast to Io, it shows
little geological activity, probably
due to its greater distance from
Jupiter and its more circular
orbit. Radical astronomers
suggest that bacteria trapped
in Europa's surface ice might
account for its reddish hue.
Although even extremophile
bacteria could not live on the
surface, it is just possible that
they could survive in the ocean
believed to exist under the ice
crust. When water with its cargo
of bacteria erupts through
cracks in the ice, it would
instantly freeze. This image
is from the Galileo spacecraft.

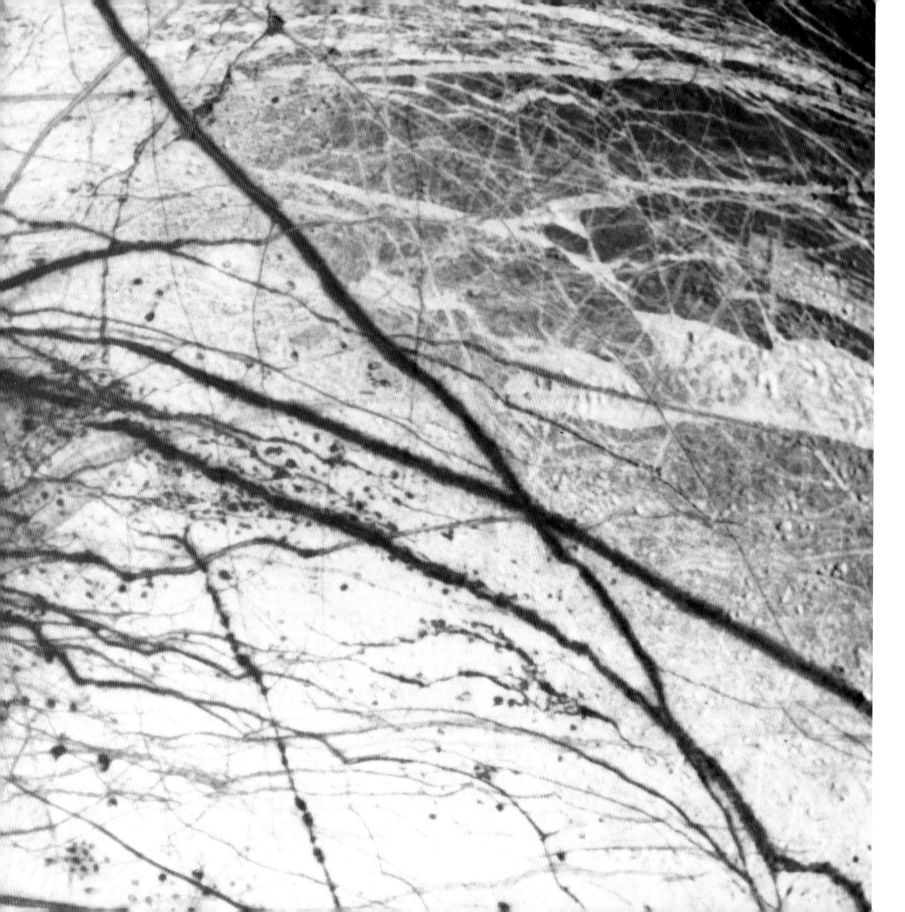

Europa's surface
Cracks up to 3,000 kilometres long and 30 kilometres wide streak across Europa's icy surface. They appear to have been filled by muddy, icy material from beneath the crust. This Galileo spacecraft image has been processed to enhance the surface's colour differences. Reddish brown indicates ice contaminated with mud and possibly bacteria. The blues indicate uncontaminated water-ice: light blue for areas of fine-grained ice and dark blue for coarse-grained ice.

Callisto, Jupiter's moon

Callisto is Jupiter's most distant Galilean moon. It is the second largest of the four satellites discovered by Galileo Galilei in 1610. Its surface bears the scars of 4.6 billion years of meteoritic bombardment, at its heaviest during the first billion years of solar system history. Judging by the lack of smooth lava flows, Callisto has been geologically inactive in more recent times. It appears to be made of rock and ice with probably a layer of liquid water beneath the frozen ice-rock crust. The Voyager 1 spacecraft took this image in 1979 from a distance of 202,000 kilometres.

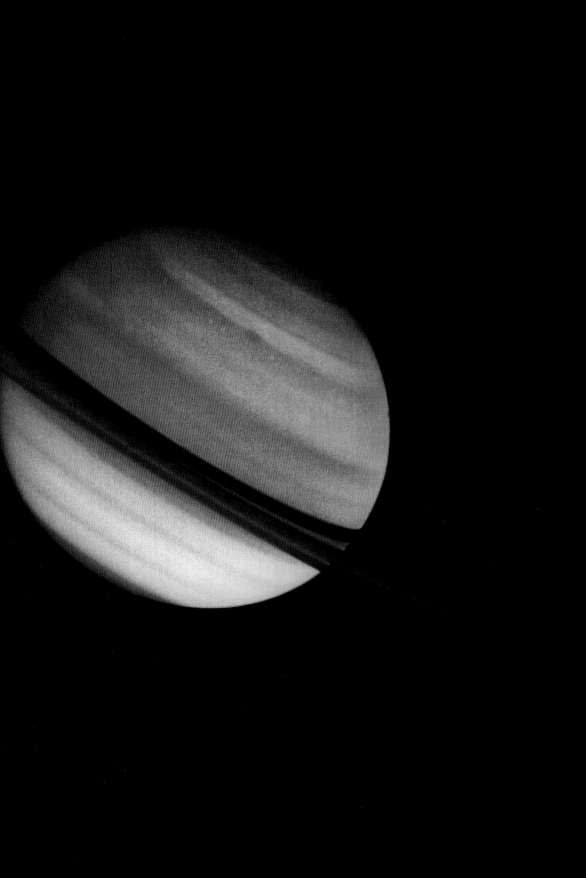

Saturn

At 120,000 kilometres
in diameter, Saturn is the solar
system's second largest planet.
Like Jupiter it is a gas giant made
up chiefly of hydrogen around
a small rocky core. It has at least
30 moons, more than any other
planet. Cloud formations are
less complex and striking than
on Jupiter, although wind speeds
are much greater. First observed
by Galileo in 1610, Saturn's
ring system is the largest, most
complex and best studied of all
the gas giants. The Voyager 1
spacecraft took this photograph
in 1980 and it has been
colour enhanced.

right
Saturn's rings

Saturn's ring system starts
about 7,000 kilometres above
its clouds. Despite extending
for almost a million kilometres,
it is only about 200 metres thick,
hence the knife-edge
appearance when viewed edge-
on. Although they look like solid
disks, the rings are in fact made
of water-ice particles, which
range in size from tiny specks
of dust to boulders measuring
10 metres in diameter.
The Voyager 2 spacecraft
captured this image, which has
been colour enhanced.
In reality the rings are reddish
brown, cream and tan due to
impurities in the ice, such as
iron oxide (rust), and to ice
crystal damage from the
Sun's ultraviolet radiation.

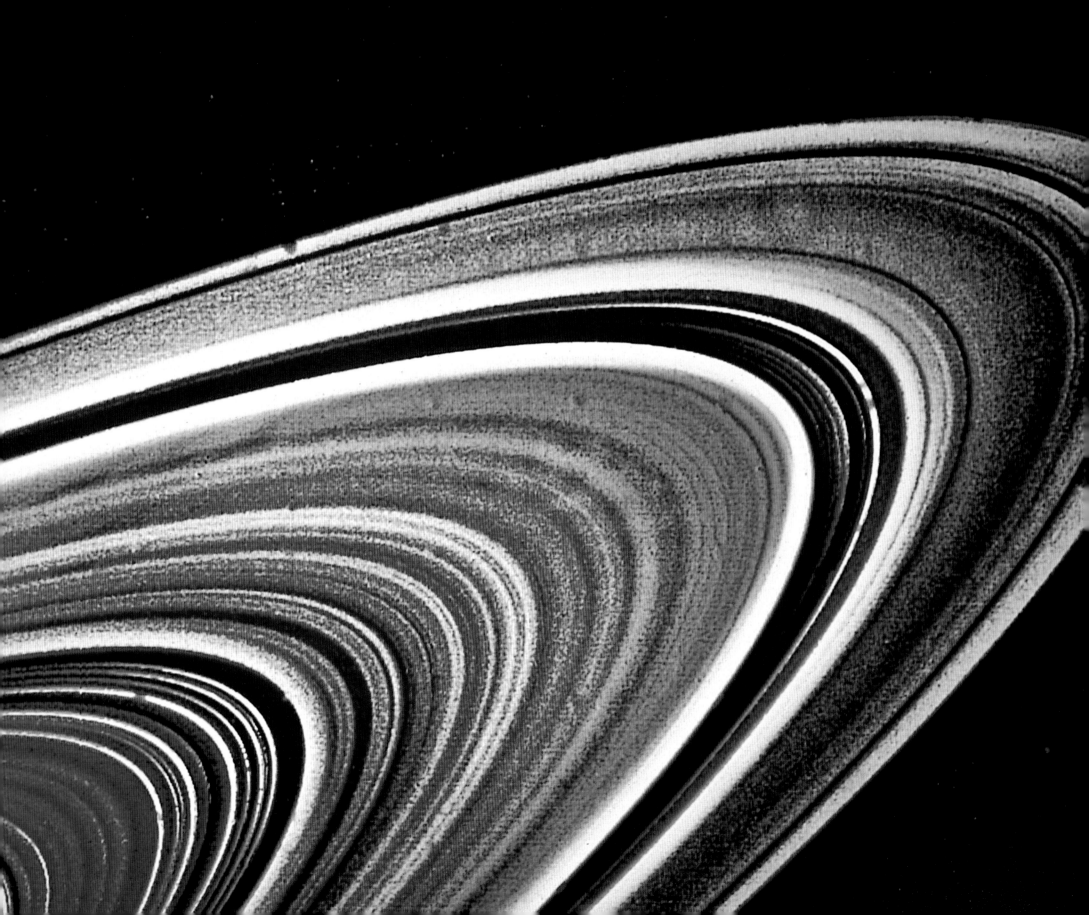

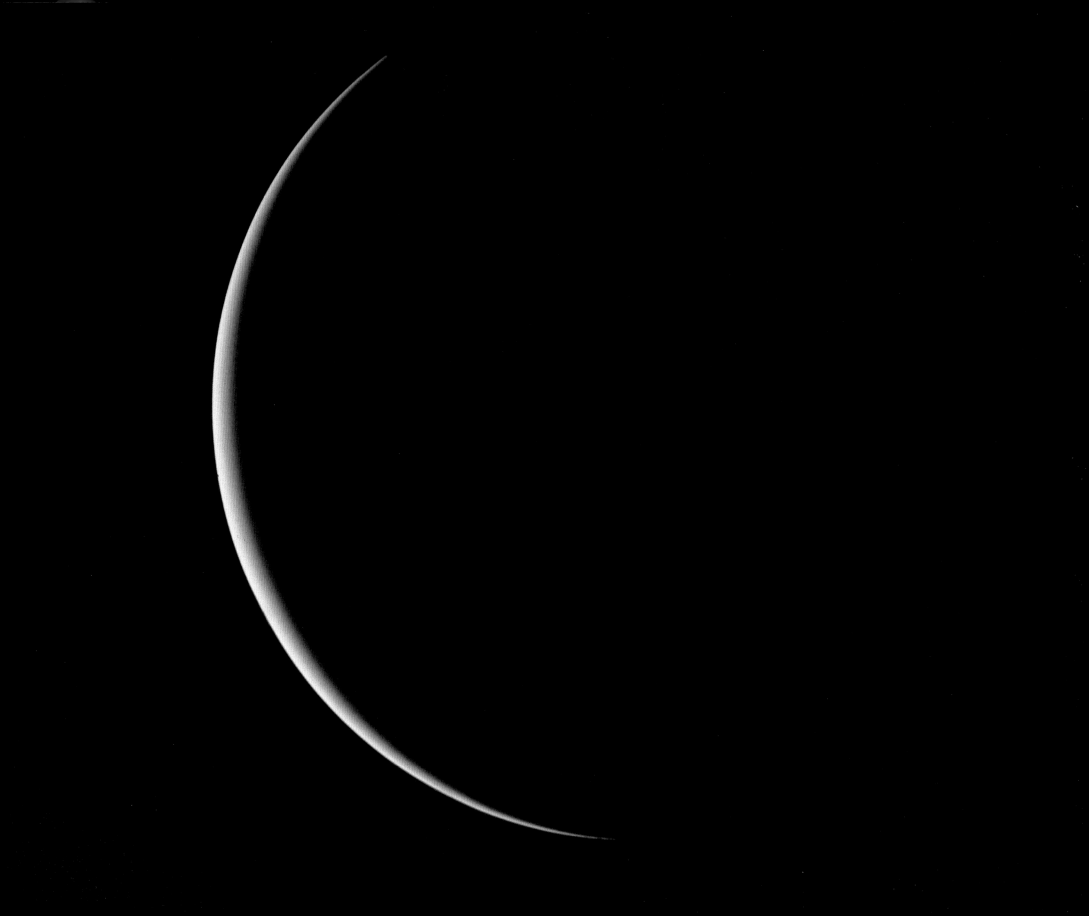

Uranus

A thin crescent of Uranus is lit by
the Sun in this Voyager 2 image,
taken as the spacecraft left
the planet behind and set forth
on its journey to Neptune. Three
times the diameter of Earth,
Uranus lies two and a half billion
kilometres beyond Saturn.
Its atmosphere is made up
of mainly hydrogen and helium
together with smaller amounts
of gases such as methane,
which gives the planet its blue-
green colour; methane absorbs
red light, allowing blue light
to be reflected. The atmosphere
of Uranus seems featureless,
although computer-enhanced
images reveal faint bands of
colour encircling the planet.

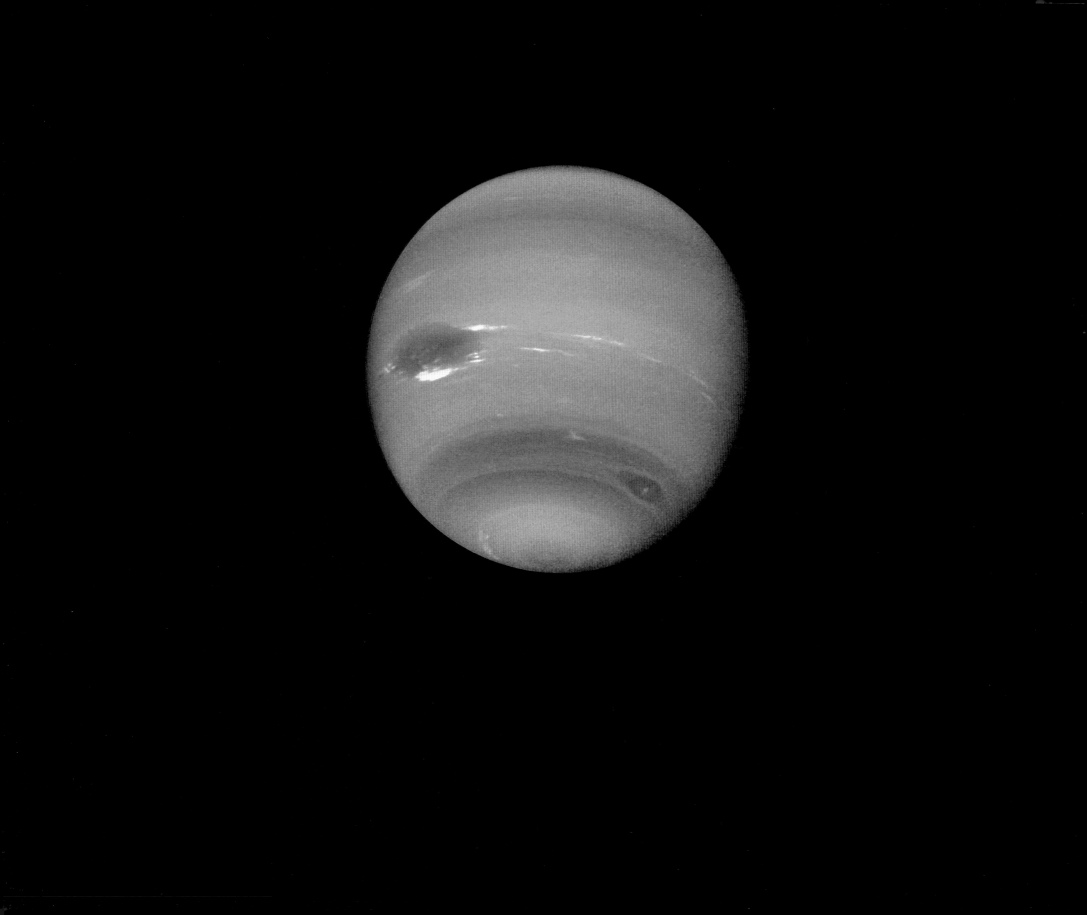

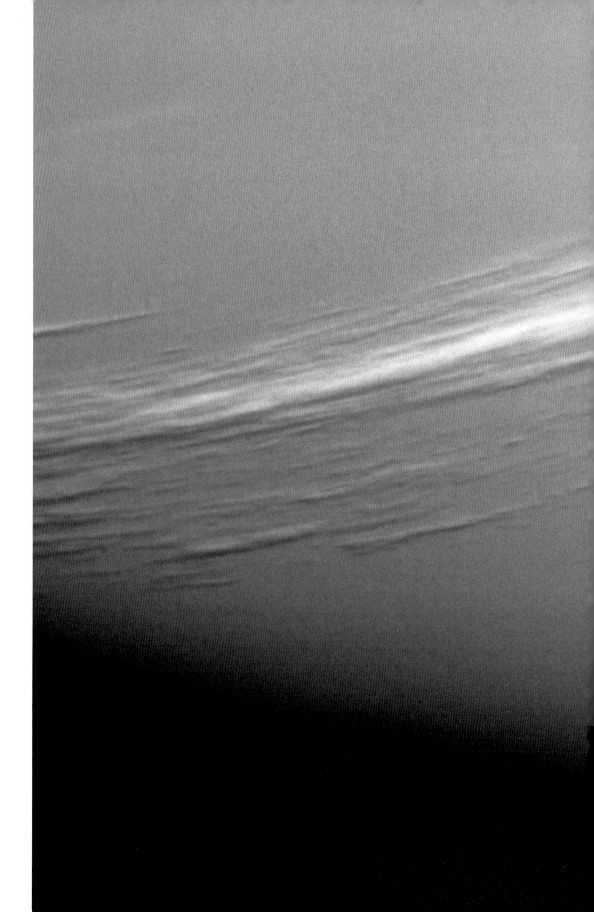

left
Neptune

Like other outer planets in the
solar system, Neptune is a gas
giant, about three times the
diameter of the Earth with a thick
hydrogen atmosphere
surrounding a small rocky core.
Small amounts of methane in the
atmosphere make the planet
appear blue as it absorbs red
light. Although not as prominent
as on Jupiter and Saturn,
Neptune has active weather
systems with strong winds and
storms. This virtually true-colour
image, taken by the Voyager 2
spacecraft in 1989, shows the
Great Dark Spot (left), a giant
storm system which has since
disappeared.

Neptune's clouds

This image shows wispy streaks
of cloud high in the atmosphere
above Neptune's southern
hemisphere. It was taken just
before Voyager 2's closest
approach to Neptune, in August
1989. These linear white clouds
are similar in shape to the cirrus
clouds that form at high altitudes
in the Earth's atmosphere,
but they are made of methane
rather than condensed water
vapour. The methane clouds are
between 50 and 200 kilometres
wide and lie 50 to 100
kilometres above Neptune's
main cloud tops, onto which they
cast shadows as seen here.

Neptune and Triton
The Voyager 2 spacecraft takes
a parting look back at partially
lit Neptune and its moon Triton
(in the foreground). Neptune
has seven other moons, six
of them unknown until the
Voyager mission and all smaller
than 500 kilometres in diameter.
The Neptune system also has
four rings of fine debris, some
of which is as small as smoke
particles. Since this encounter
between Voyager 2 and
Neptune, both Voyager probes
have continued to send back
data as they leave the solar
system at speeds of around
15 kilometres per second.
They are expected to function
until 2020.

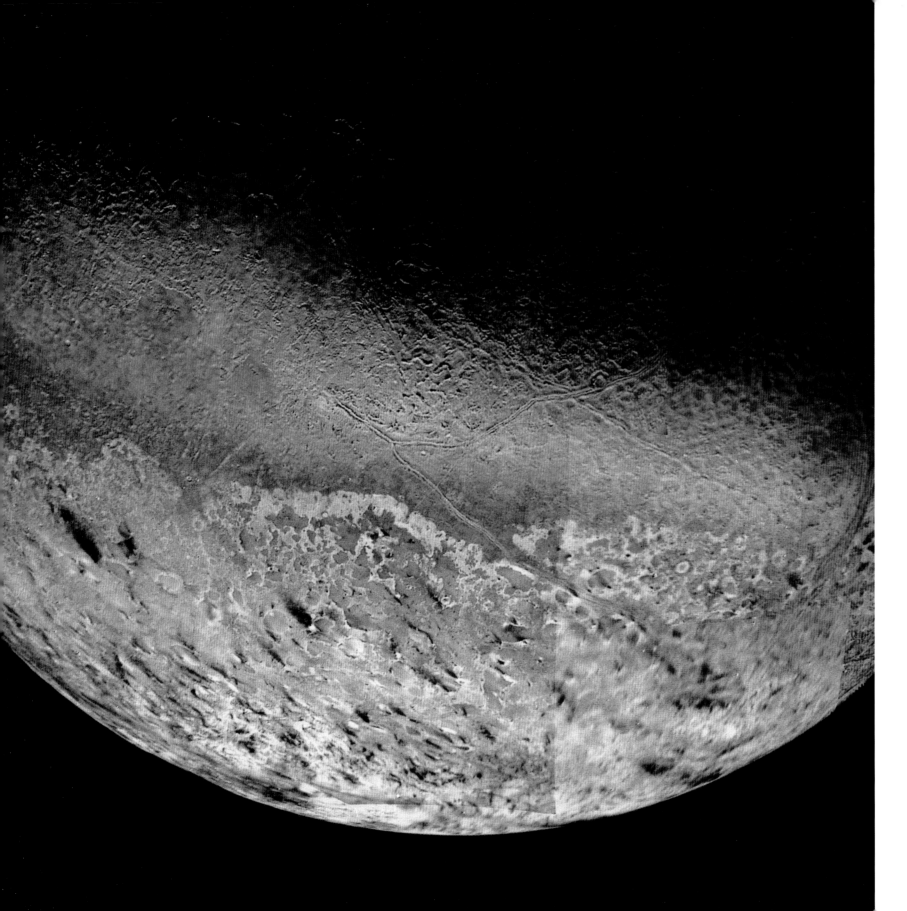

Triton, Neptune's moon
Triton is Neptune's largest moon and has many unique features. About the same size as the Earth's moon, it has a retrograde orbit (that is, it travels in the opposite direction to the rotation of Neptune). Triton also has a large rocky core, active volcanoes and a nitrogen atmosphere. With a surface temperature of minus 235 degrees Celsius, most of the nitrogen on Triton is in the form of ice, which makes up the bulk of its cracked surface. In this false-colour image, dark streaks may represent erupted carbonaceous dust. The greenish, fissured area towards the centre left is called the 'Canteloupe terrain', because of its resemblance to the surface of a melon.

Pluto and Charon

Four and a half billion kilometres from Earth, close to the edge of the solar system, are rocky Pluto and its icy moon, Charon. With a diameter of 2,302 kilometres, Pluto is smaller than the Earth's moon. Half the size of Pluto, Charon is locked in a synchronous orbit: for an observer standing on the surface of Pluto, it would appear to hang motionless in the sky all day and night. This 1994 image, taken by the Hubble Space Telescope, shows Pluto on the left and Charon on the right.

The solar system is one of many star systems that lie within our galaxy, the Milky Way. In fact, the Milky Way contains at least two hundred billion stars, some of which may be over 50,000 light years away. Looking into space means looking back in time. When we look at a star that is 50,000 light years away we are seeing it as it was 50,000 years ago. Looking at the sky is like reading the history of the universe.

Although we do not fully understand what causes stars to be born, we do know that they are created in nebulae (dark clouds of dust and gas), that they can be seen in clusters, and that when they die some explode as supernovae, in the most dramatic cosmic climax.

It is believed that the number of galaxies in the universe amounts to billions, but we know very little about them. How are they born? How do they develop? Why are there different kinds? We do know that they are assemblies of stars, gas and dust that are so massive that their contents are held together by their own gravity. We know that they exist in an enormous range of sizes – the smallest may contain a million stars whereas the largest may be made up of one thousand billion. It is generally thought that there are two kinds – spiral, like Andromeda or our own Milky Way, and elliptical, like Messier 87.

Our knowledge and understanding of the universe is relatively new and increases almost daily. One of the most important observations made in the twentieth century was by the astronomer Edwin Powell Hubble (1889–1953), who stated that the distances between galaxies or clusters of galaxies are continuously increasing, and that the universe is therefore expanding. The speed with which it is expanding is thought to determine the age of the universe itself, and is strongly debated.

Photographs taken with the use of manned ground-based telescopes and satellites that travel through space and send back images to Earth, continue our journey through time and space. We travel past stars, deep into nebulae and towards clusters of galaxies that we can only glimpse at 300 million light years away.

And beyond

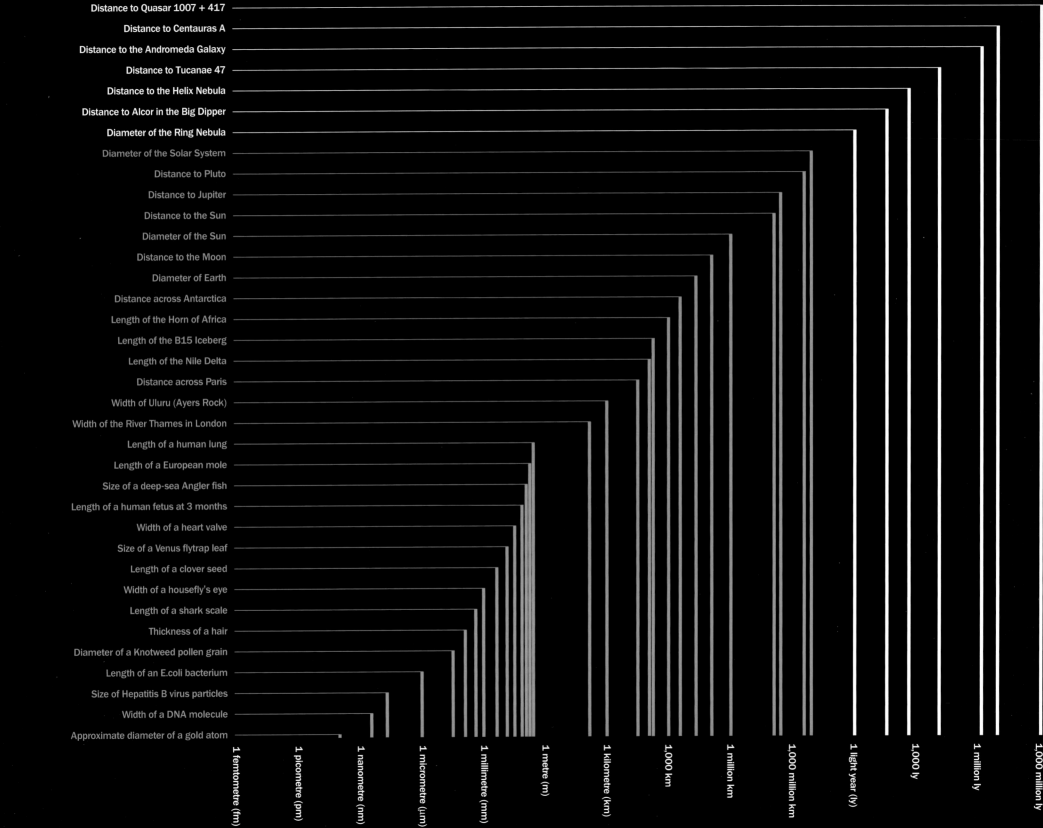

Distance to Quasar 1007 + 417
Distance to Centauras A
Distance to the Andromeda Galaxy
Distance to Tucanae 47
Distance to the Helix Nebula
Distance to Alcor in the Big Dipper
Diameter of the Ring Nebula
Diameter of the Solar System
Distance to Pluto
Distance to Jupiter
Distance to the Sun
Diameter of the Sun
Distance to the Moon
Diameter of Earth
Distance across Antarctica
Length of the Horn of Africa
Length of the B15 Iceberg
Length of the Nile Delta
Distance across Paris
Width of Uluru (Ayers Rock)
Width of the River Thames in London
Length of a human lung
Length of a European mole
Size of a deep-sea Angler fish
Length of a human fetus at 3 months
Width of a heart valve
Size of a Venus flytrap leaf
Length of a clover seed
Width of a housefly's eye
Length of a shark scale
Thickness of a hair
Diameter of a Knotweed pollen grain
Length of an E.coli bacterium
Size of Hepatitis B virus particles
Width of a DNA molecule
Approximate diameter of a gold atom

1 femtometre (fm)
1 picometre (pm)
1 nanometre (nm)
1 micrometre (μm)
1 millimetre (mm)
1 metre (m)
1 kilometre (km)
1,000 km
1 million km
1,000 million km
1 light year (ly)
1,000 ly
1 million ly
1,000 million ly

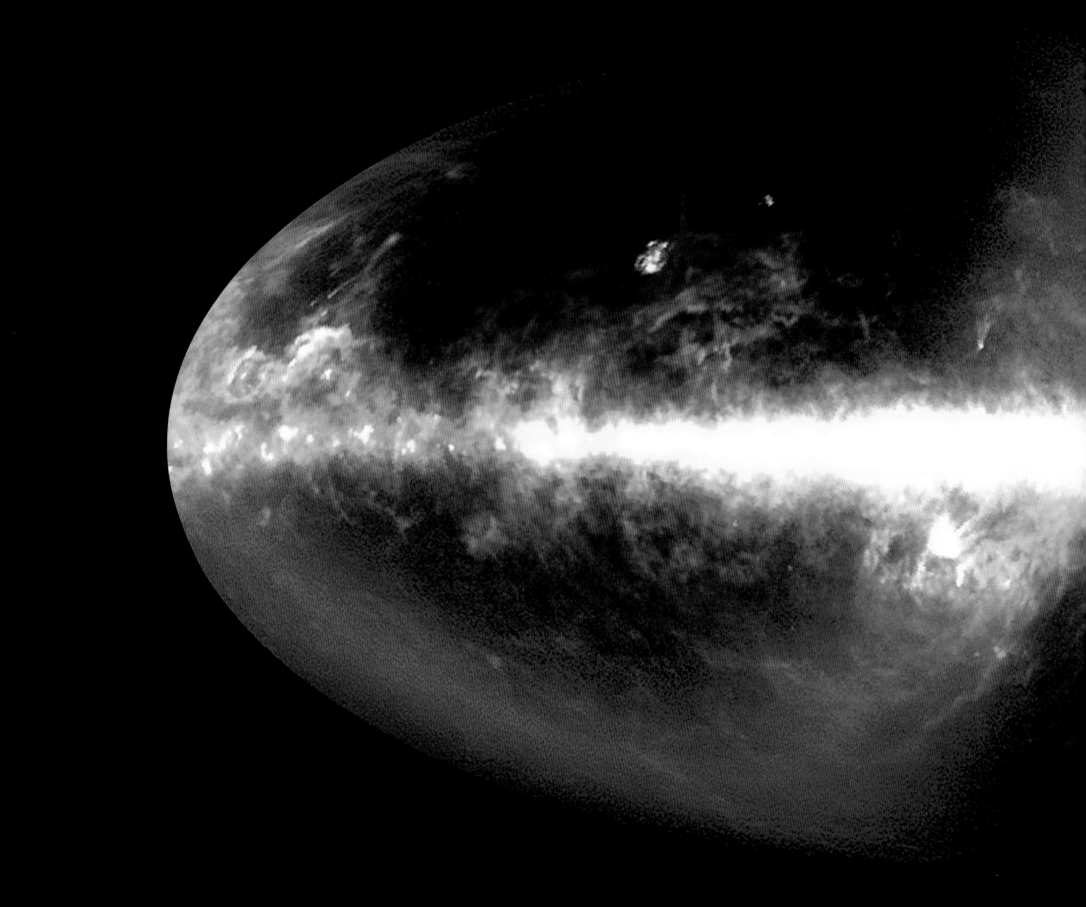

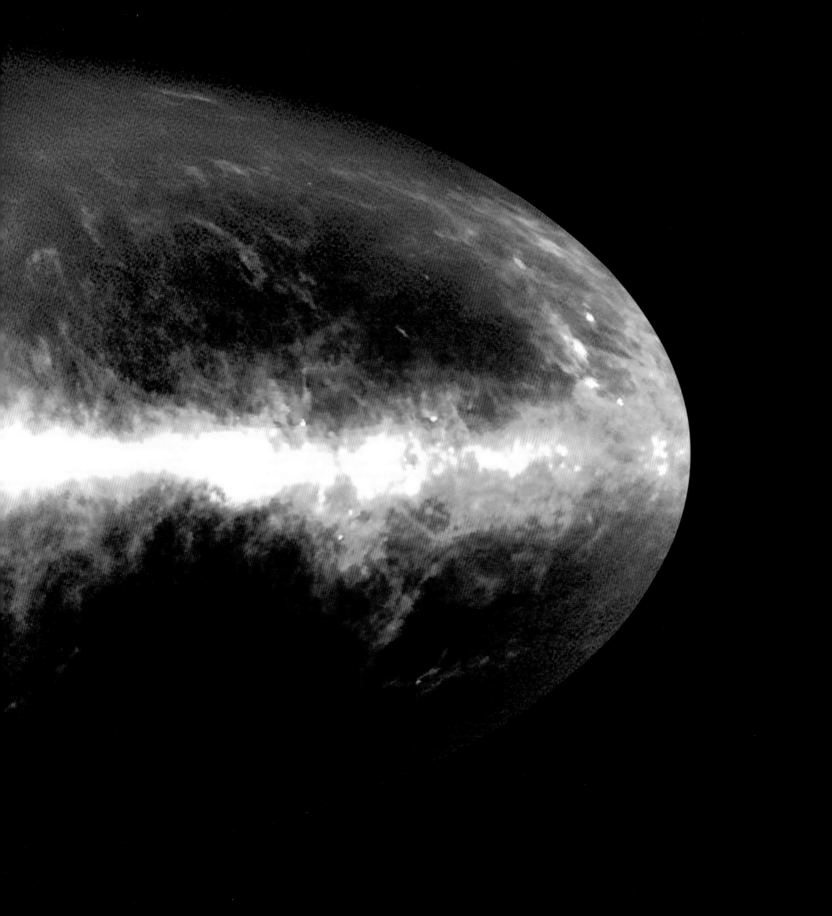

The Milky Way

The Milky Way is Earth's own galaxy. It appears as a band of faint light across the sky, visible to the naked eye on moonless nights, and consists of stars, dust and gas. This picture of the whole sky reveals how the Milky Way looks at infrared wavelengths. The bright yellow band is the infrared radiation from warm interstellar dust in the galactic plane. The bulge in the middle is the centre of the galaxy. The reddish wisps are star-forming regions and dust ejected from the plane by hot stars. The blue S-shaped swirl is caused by the dusty remains of recent comets within the solar system.

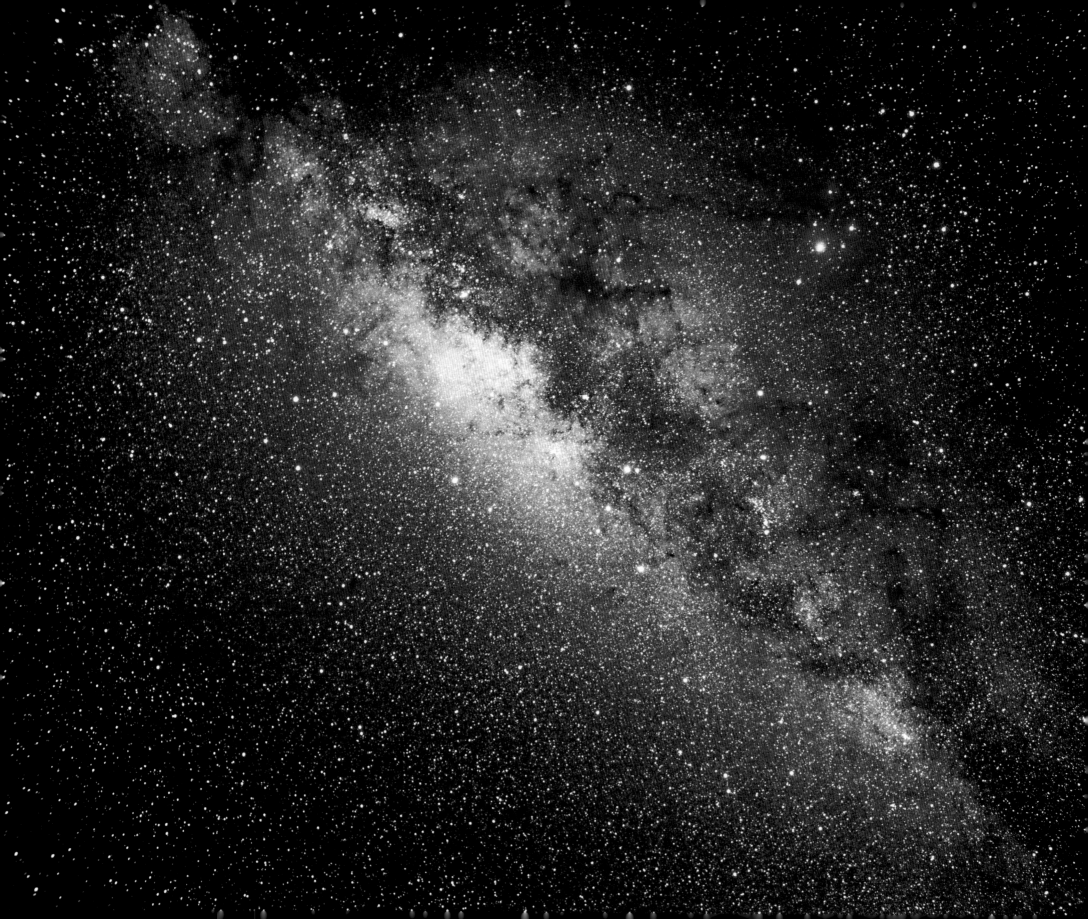

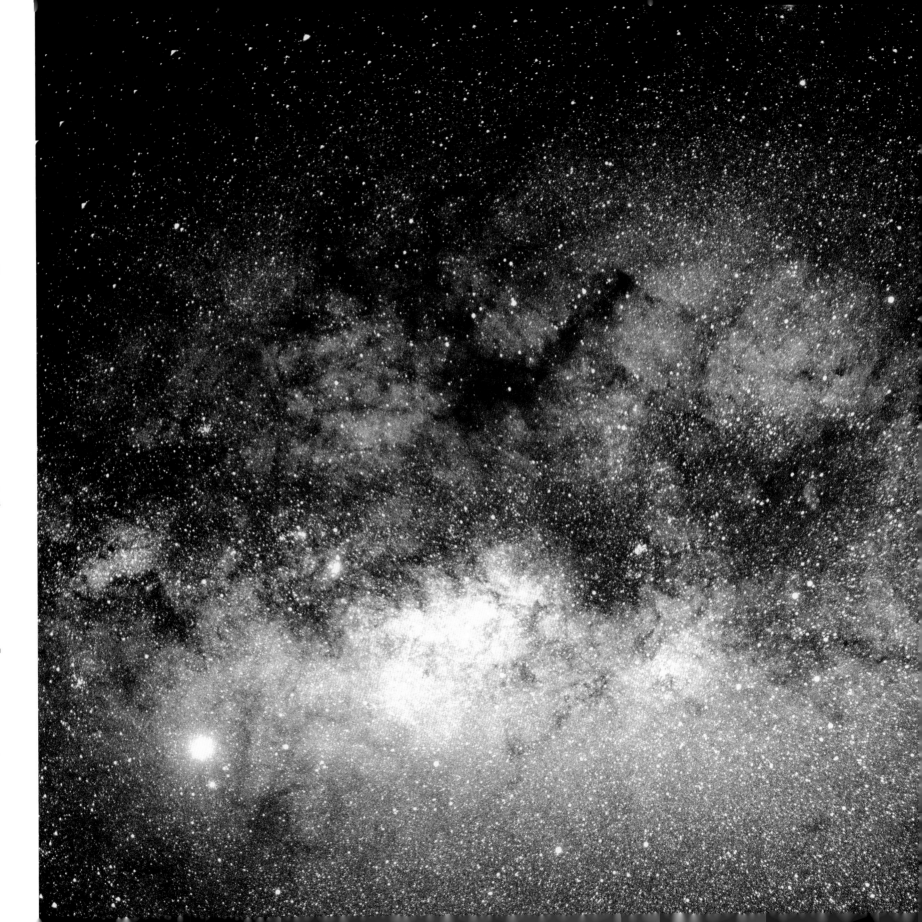

left
Southern hemisphere view of the Milky Way

The Milky Way is a spiral galaxy, made up of multitudes of stars and clouds of dusty gas. This optical telescope image shows the view towards the centre as seen from Earth, which is located in one of the galaxy's outer spiral arms. The central bulge is seen in the direction of the constellation Sagittarius; it appears to be divided into two bands by a line of opaque dust blocking out the light from the stars behind. This photograph of the Milky Way, as seen from the southern hemisphere, was made using a conventional camera.

Galactic centre, the Milky Way

This view of the Milky Way shows the central galactic bulge, with its concentration of stars, in more detail. Dust makes up a tiny fraction of the mass of the Milky Way but profoundly affects our view of it. Behind the darkest clouds is the galactic centre, named Sagittarius A, 25,000 light years away and dominated by a black hole. Embedded in the dust are numerous reddish star-forming regions, including the Lagoon Nebula (M8) to the centre left of this image. With the rest of the galaxy's spiral arms, the solar system orbits around the galactic centre once every 220 million years at about 250 kilometres per second.

from left to right

Jupiter and Saturn move into Taurus

The distant stars in our galaxy create their own light and appear fixed in the sky, but among them are the nearby planets of the solar system, reflecting sunlight. The brightest object here in the constellation Taurus is Jupiter, about 800 million kilometres away and apparently close to the Hyades star cluster whose brightest star, the golden Aldebaran, is 68 light years away. The next brightest object is Saturn (right), twice as far away as Jupiter, and seemingly close to the Pleiades star cluster whose stars are almost 400 light years away.

Pleiades

This optical photograph shows the Pleiades star cluster. Its faint stars would be inconspicuous were they not gathered into a compact and distinctive cluster. Visible in the constellation Taurus, seven individual stars can be seen with the naked eye, hence their popular name, the Seven Sisters. In reality they are the brightest of a cluster of several hundred stars that formed about 80 million years ago. Halley's Comet shines brightly at the bottom of the picture.

The Big Dipper and Polaris

The Big Dipper, or Plough, is part of the constellation Ursa Major (the Great Bear). The second star from the left is called Mizar and just above it is Alcor. A thousand years ago, the Arabs used the ability to see Alcor with the naked eye as proof of good eyesight. At the top of the picture is Polaris, the Pole Star, which marks the north celestial pole. Early navigators measured the altitude of the Pole Star above the horizon to calculate their latitude and its direction to find true north.

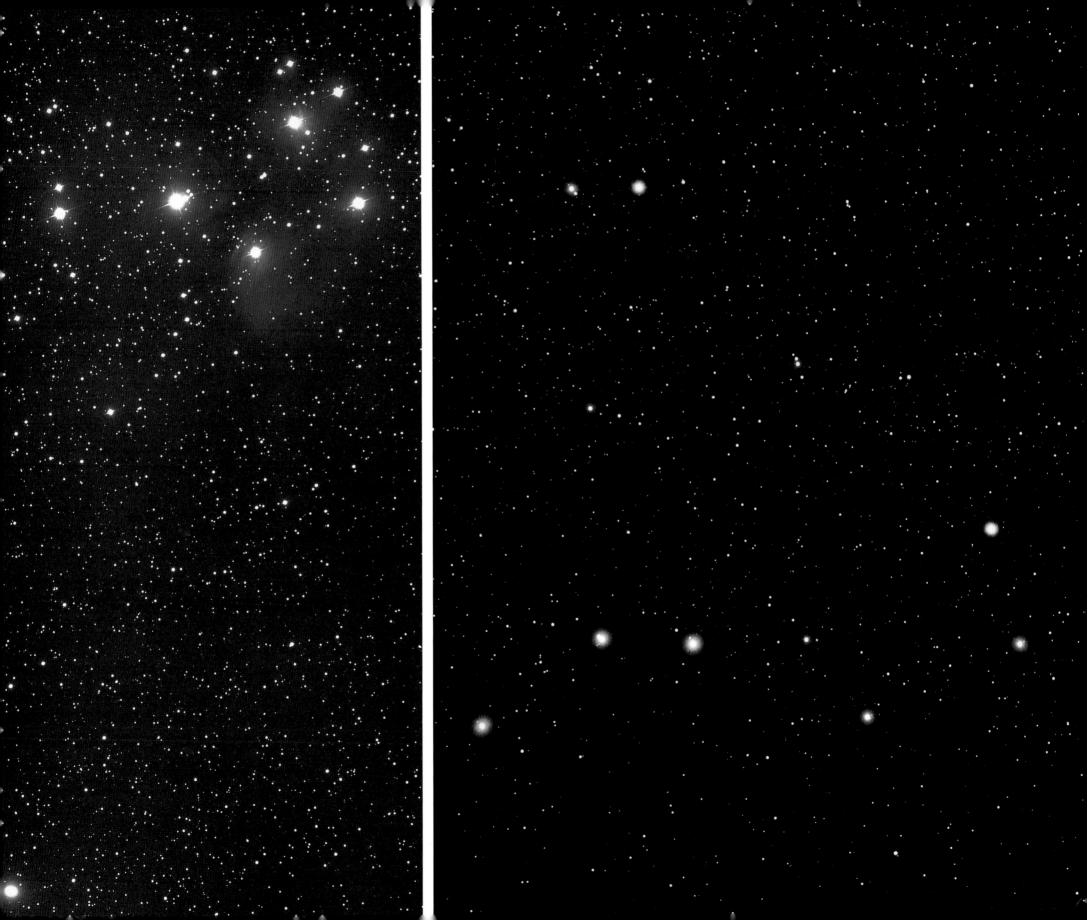

Cassiopeia

Named after Queen Cassiopeia of Greek mythology, the constellation Cassiopeia has a distinctive W-shape which makes it easy to identify in the sky. The star forming the central point of the W, known as Gamma Cassiopeiae or Chi, is a variable star, one whose brightness varies over time. This variability might be due to the occasional ejection of its outer layers. The white star forming the lowermost point of the W, on the right-hand side, is called Alpha Cassiopeiae, or Schedar. Situated 120 light years away, it is 190 times as luminous as the Sun and, like Chi, is variable.

right
North celestial pole

This photograph shows the apparent path traced by stars in the night sky as the Earth rotates beneath them. It was taken by leaving the camera pointing at the night sky, resting on a firm support, with the shutter open for several hours. The celestial pole, the point about which the sky appears to turn because of the rotation of the Earth, lies at the centre, and here we are looking out to the stars along the Earth's axis of rotation.

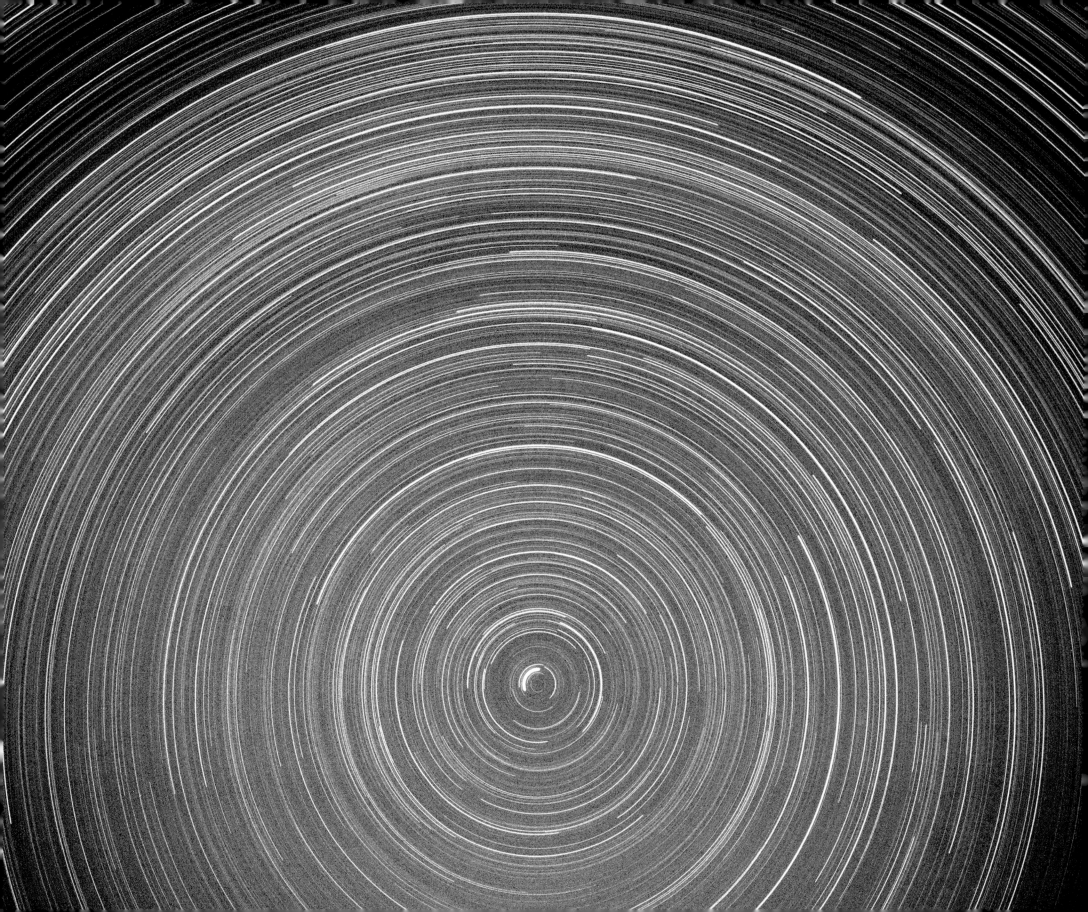

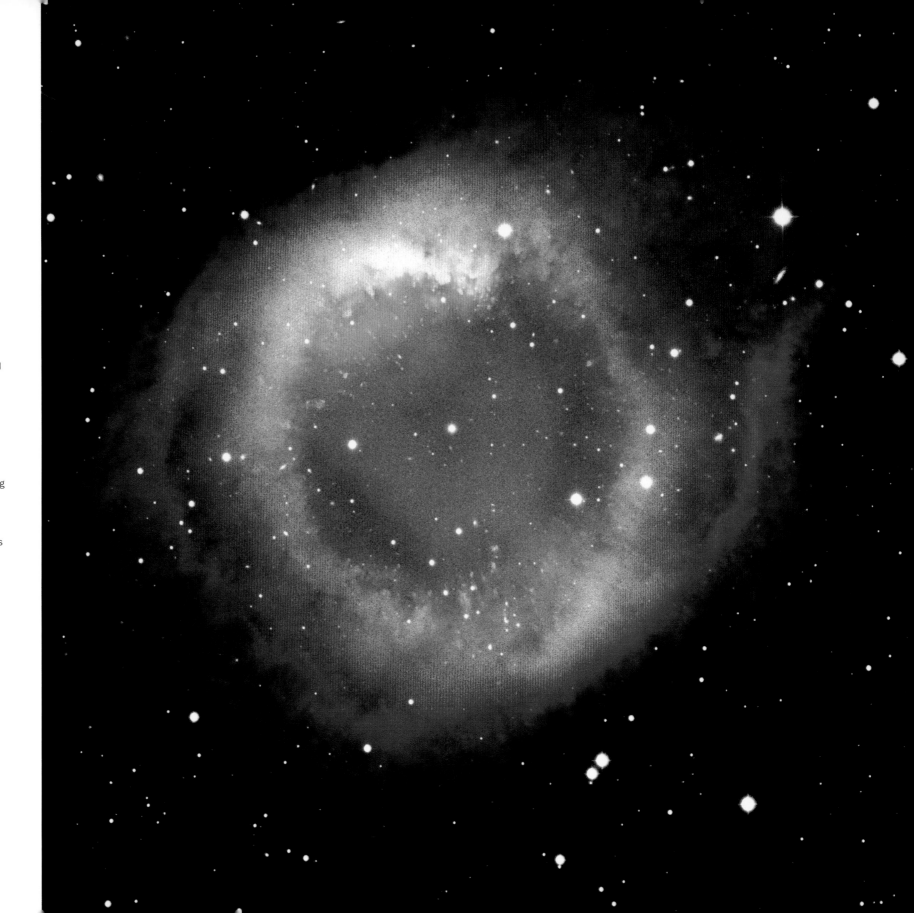

Helix Nebula (NGC 7293)
The Helix Nebula marks the death of a Sun-like star. It consists of ionized gases in an expanding shell of material ejected from its fading central star. Green indicates the presence of excited atoms of oxygen, while the red of the outer ring indicates hydrogen and nitrogen atoms ionized by the hot central star. Cometary knots, the pinkish blobs radiating out from the central area, give the nebula its alternative name, the Sunflower Nebula. This true-colour photograph was taken with the Anglo-Australian Telescope from New South Wales, Australia.

Cometary knots in the Helix Nebula (NGC 7293)
This picture shows part of the Helix Nebula in detail and reveals numerous bright-rimmed, comet-shaped objects called cometary knots. The gaseous head of each cometary knot is twice the size of the solar system and their tails reach 160 billion kilometres in length. Their bright rims are the result of ionization by the extremely hot central star. Astronomers suggest that they formed when hot gas thrown out from the central star collided with cool gas ejected 10,000 years earlier, causing the clouds of gas to collapse into denser droplets. The photograph was taken by the Hubble Space Telescope.

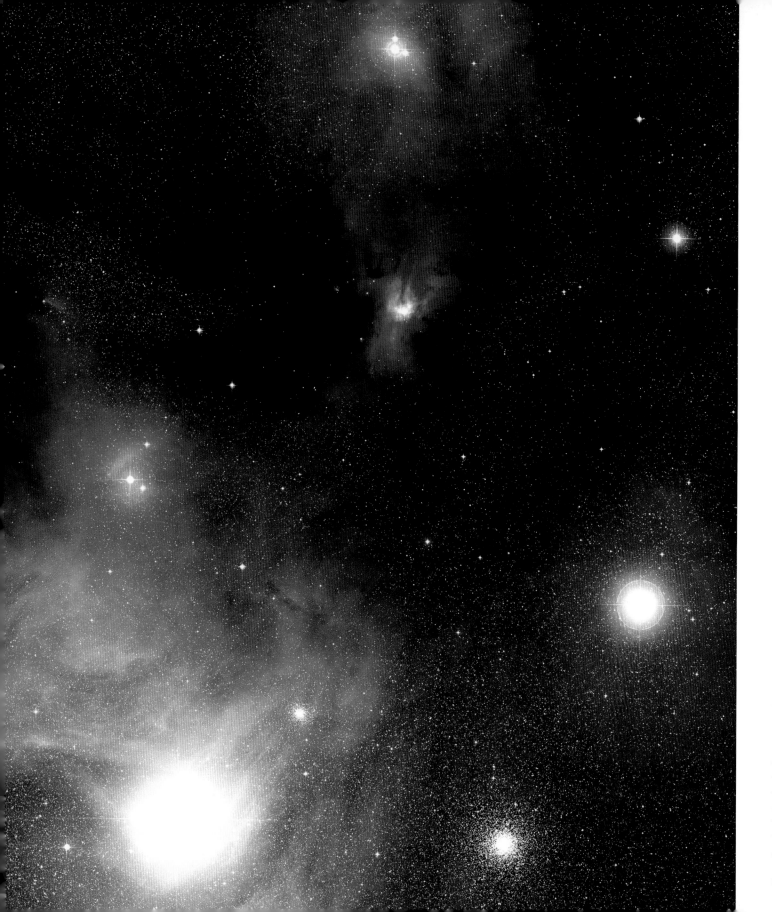

Antares and the Rho Ophiuchi Nebulae
The dusty region between the constellations of Ophiuchus and Scorpius contains a diverse collection of astronomical objects. The bluish glow in the upper part of this picture is a cool cloud of gas and dust, 540 light years away, which is reflecting the light of hot, young stars embedded in it. The dark clouds silhouetted against the bright background are unlit clouds of stellar building material. The dying supergiant star, Antares, dominates the lower part of the picture. Shedding material as it nears the end of its life, it is enveloped in a cloud of particles that reflect its own yellow starlight. A red emission nebula surrounds the star Sigma Scorpii and two globular clusters are also present, one lower centre right and the other within Antares's yellow haze.

right
Antares
Antares is a giant star, 520 light years away and 500 times the diameter of the Sun. If it were at the centre of the solar system it would totally engulf the Earth. Antares is only 500 million years old, but its great mass means that it has already used up the supply of hydrogen fuel in its core. As the hydrogen fusion reactions stopped, it became unstable, cooling and swelling to a gigantic size. New reactions in the core began producing heavier elements such as carbon, and compounds including silicates and titanium dioxide. Rising to the surface, they condensed into fine particles and drifted away, forming a huge nebula that reflects Antares's yellow colour. This photograph was taken from the UK Schmidt Telescope at the Anglo-Australian Observatory.

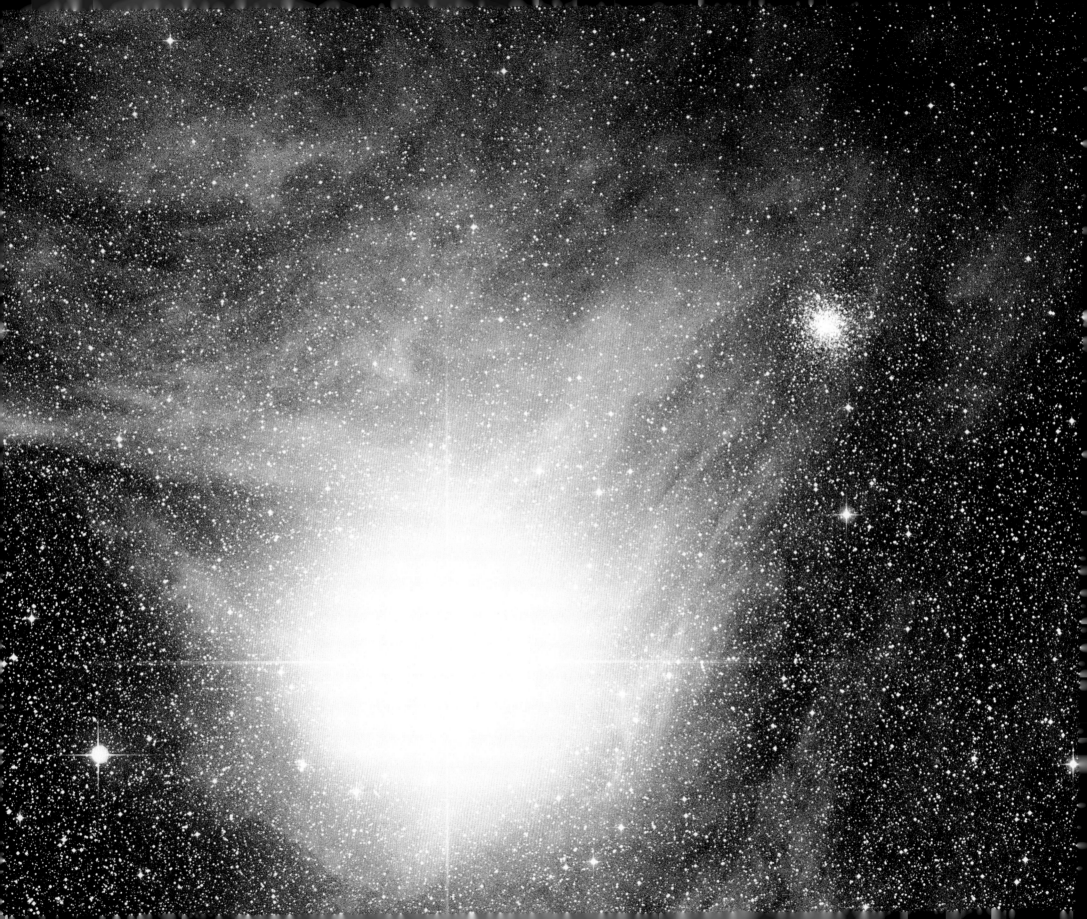

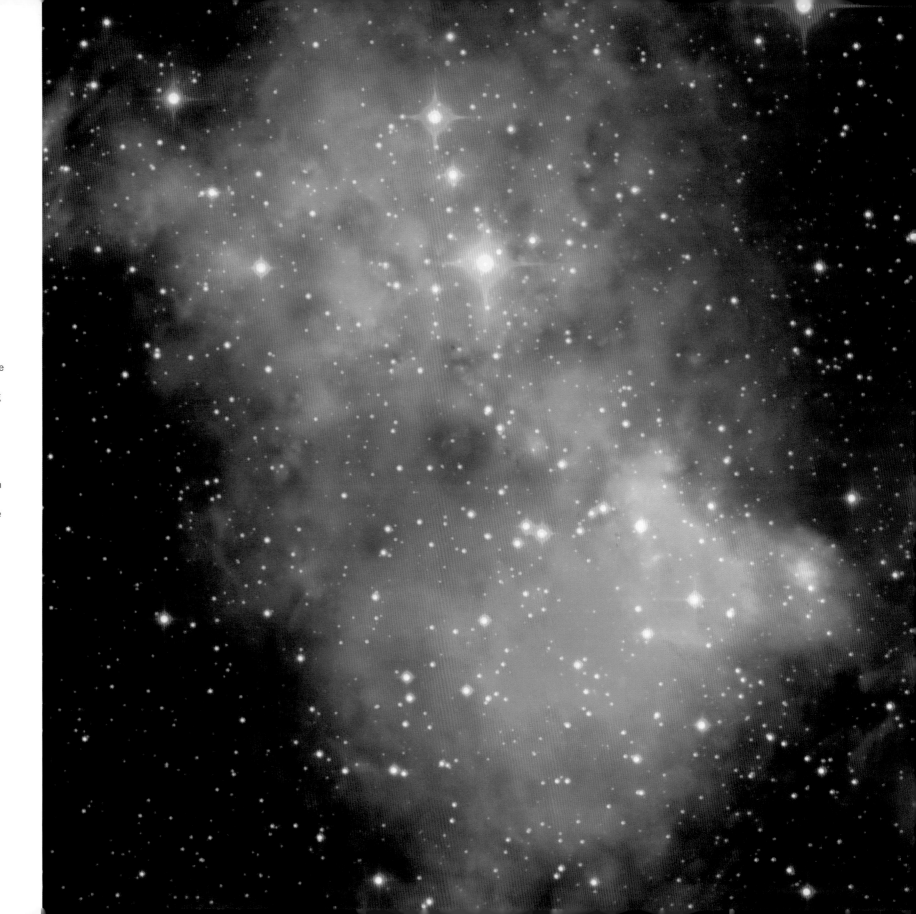

**Dumbbell Nebula
(M27, NGC 6853)**

The Dumbbell Nebula is one
of the nearest planetary nebulae
to the Earth, less than 1,000
light years away. This expanding
hollow sphere of gas, two light
years in diameter, was ejected
from the surface of a dying
Sun-like star. This stage in
a star's evolution lasts only
about 100,000 years, a fraction
of its total lifespan of several
billion years. This infrared image
has been coloured to indicate
the light emitted by different
elements: hydrogen is blue,
sulphur green and helium red.

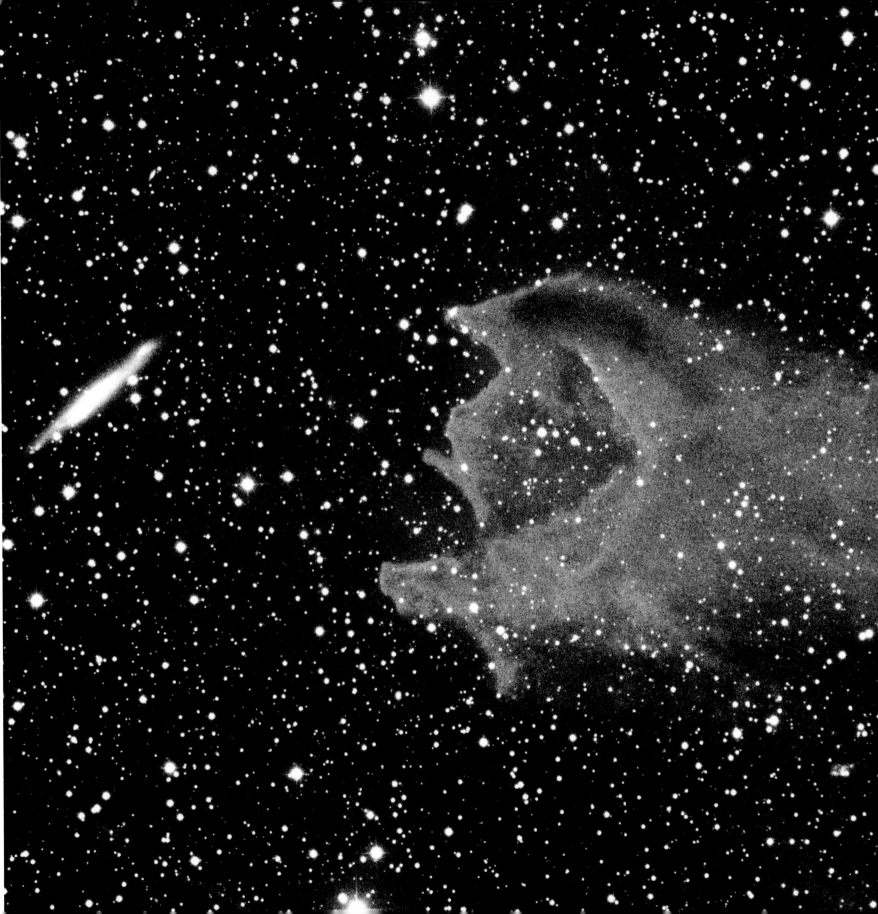

Cometary globule (CG 4)
A cometary globule is a dense cloud of gas and dust. This image shows CG 4 which is 1,300 light years away. Cometary globules are so called because of their superficial resemblance to comets, with a bright-rimmed head and long diffuse tail which can be up to 10 light years in length. Nearby young stars ionize hydrogen in the head of the dust cloud, making it glow red, and their radiation sweeps the dust into a long, tenuous tail. The blue colour is the result of light-scattering by tiny dust particles. This photograph was taken with the Anglo-Australian Telescope.

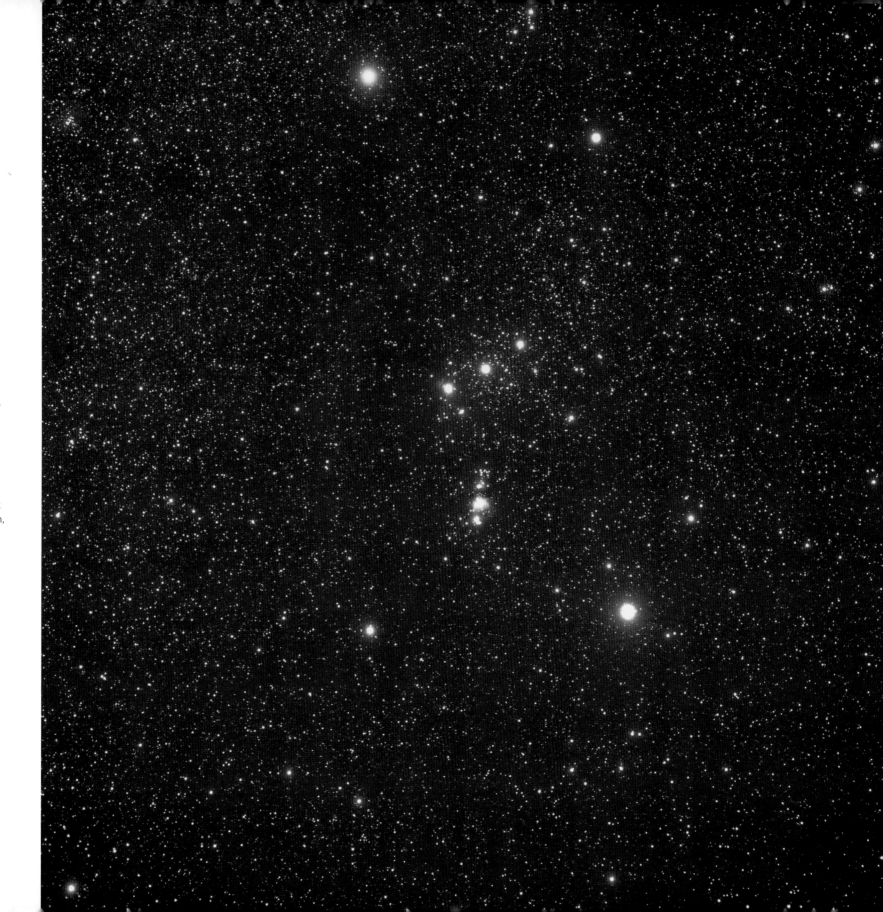

Orion the Hunter

Orion is one of the most easily recognized constellations in the night sky. The large quadrangle of four bright stars makes up the hunter's shoulders and feet, and the diagonal of three stars forms his belt. The 'sword' hanging from his belt contains the glowing red Orion Nebula. The two brightest stars in this constellation are Betelgeuse, at the top left corner, a red giant about 400 light years from Earth, and Rigel, at the bottom right corner, a hot blue supergiant about 1,400 light years away.

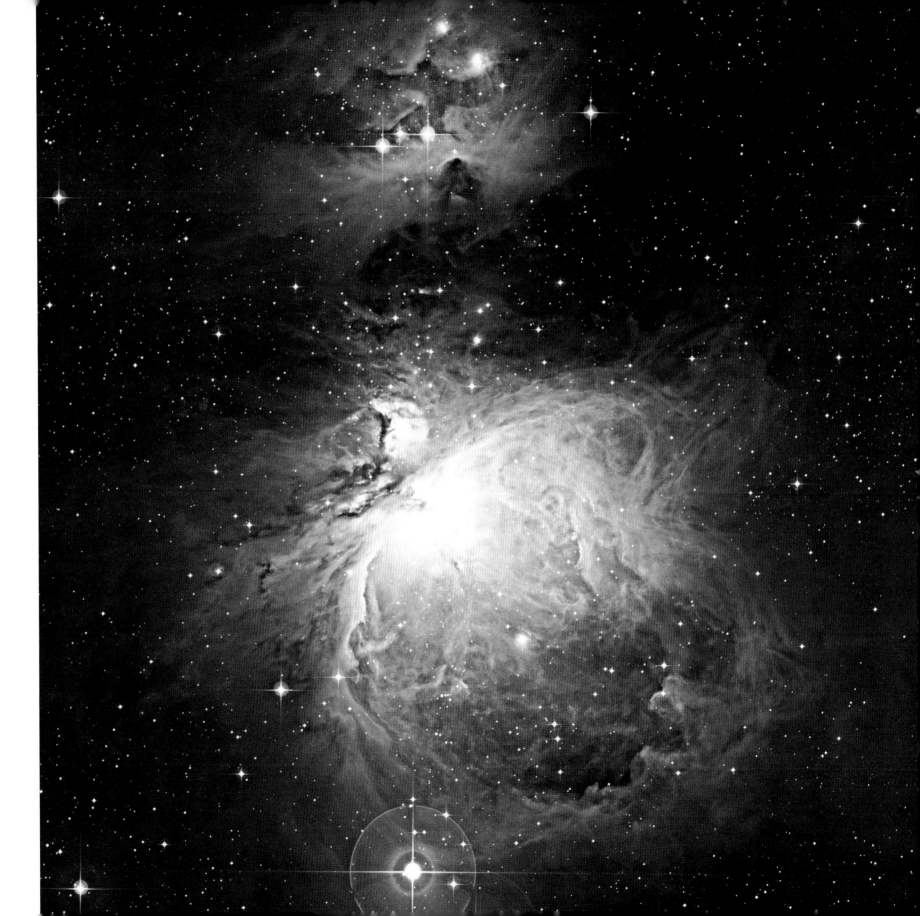

Orion Nebula (M42, NGC 1976)
This telescopic image shows the glowing red patch in the middle of Orion's sword. This is the famous Orion Nebula, the nearest star-forming region to Earth, 1,500 light years away. The nebula is visible to the unaided eye and is about 20 light years across. Stars are being born within this glowing cloud of dust and hydrogen-rich gas as we watch. In this image, strong ultraviolet radiation from a cluster of young stars hidden in the nebula makes it glow by ionizing the hydrogen and causing it to emit red light.

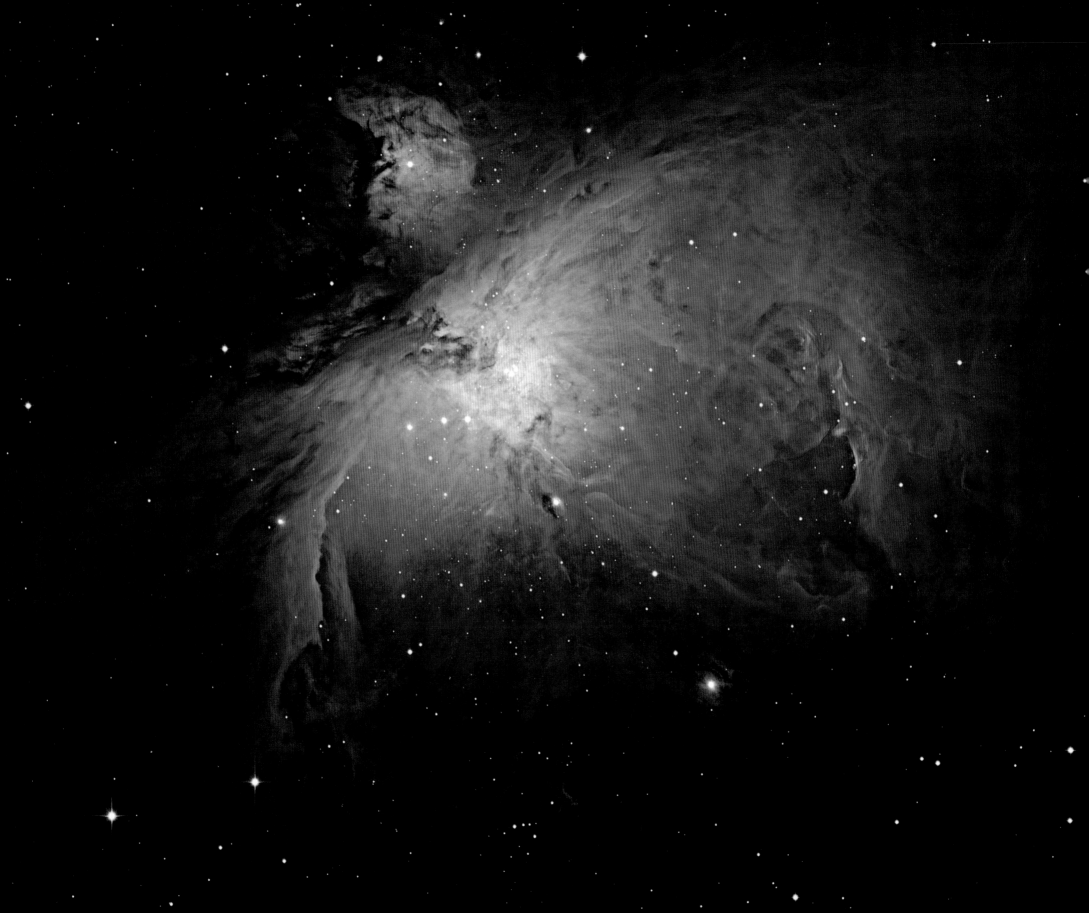

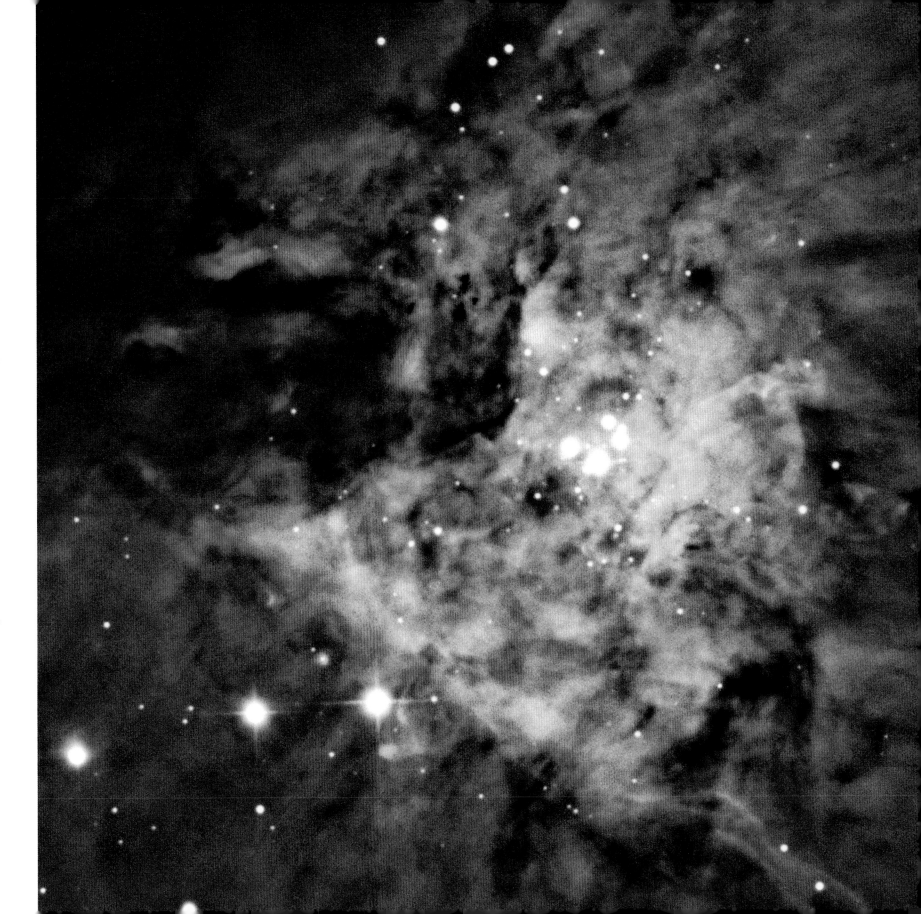

left

Part of the Orion Nebula (M42, NGC 1976)

The inner regions of the Orion Nebula are host to the brilliant young Trapezium stars. Their ultraviolet light excites the abundant hydrogen and oxygen causing them to emit their characteristic red and green light, which combines to give a yellow colour. The Orion Nebula was the first nebula ever to be photographed, in 1882, and its proximity makes it an ideal laboratory for studying the details of star birth. This short exposure picture was taken with the Anglo-Australian Telescope.

Trapezium region of the Orion Nebula (M42, NGC 1976)

The Trapezium stars are the brightest members of a substantial cluster of young stars, most of which are hidden by dust. Along our line of sight to the nebula, radiation from the Trapezium stars has blown away the dust and gas from which they formed. Beyond the stars the dust is much denser and it glows strongly as it is bombarded by intense ultraviolet light. This image comes from the Anglo-Australian Telescope.

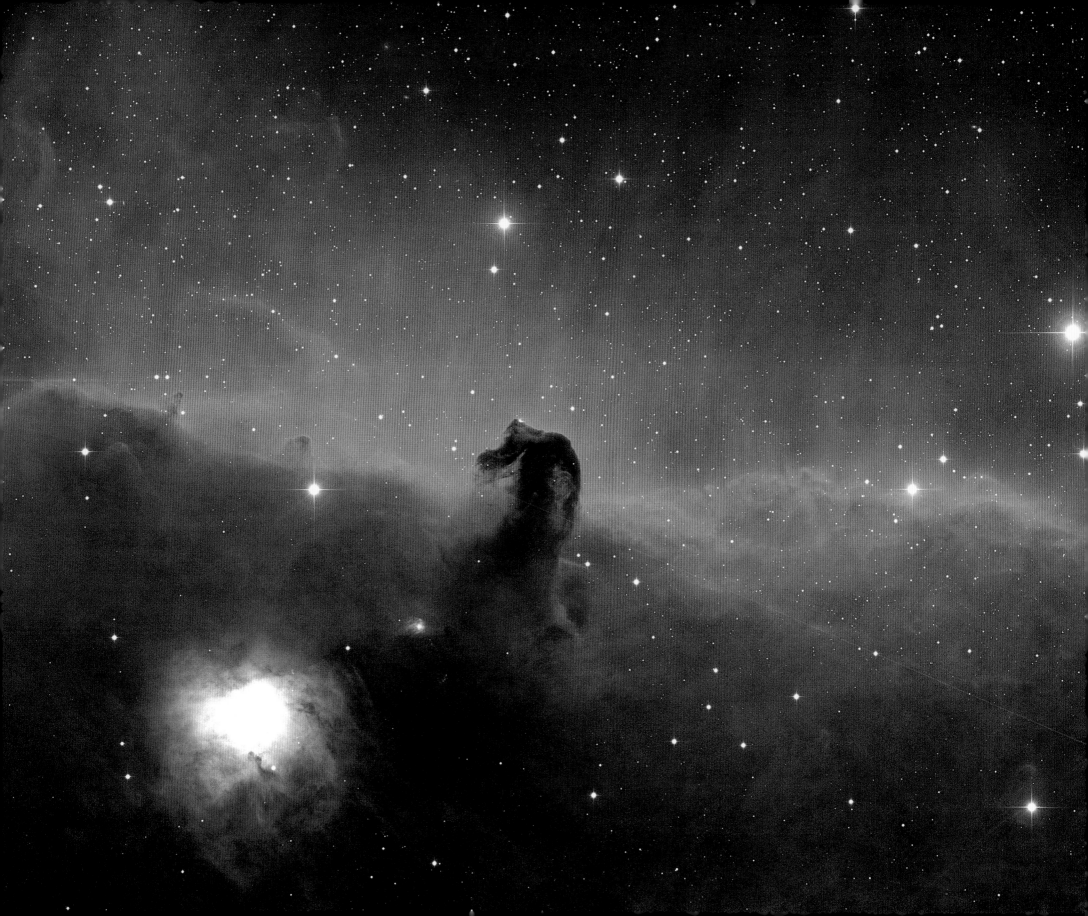

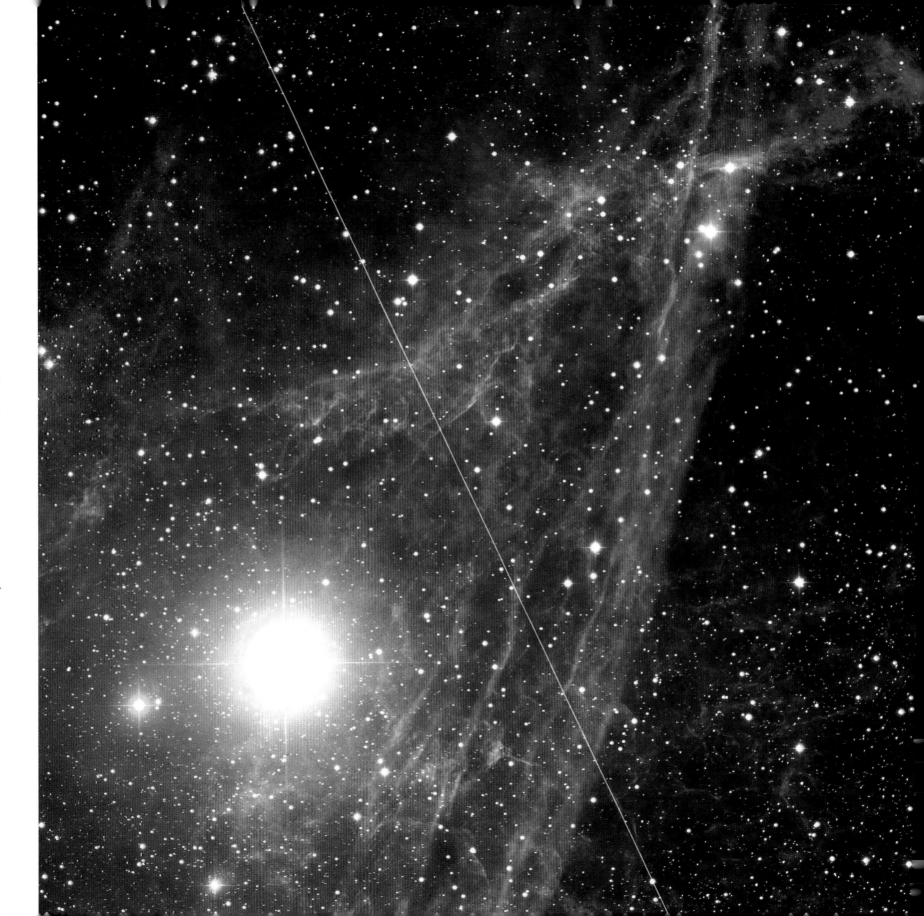

left

Horsehead Nebula

The horse's head is an opaque cloud of gas and dust in Orion, about 1,500 light years away, which is seen in silhouette against a brilliant red backdrop. The red strip is the glowing surface of an extensive dark cloud which is lit by the star Sigma Orionis (not seen). The whole view is part of a spectacular star-forming region that includes the Orion Nebula, four degrees to the south. Closer to the Horsehead a bright star has drifted into the dust and is seen by its reflected blue light. The horse's head is only visible on long exposure photographs, which emphasize the background brightness.

Vela Supernova Remnant

Twelve thousand years ago the life of a massive star ended in a cataclysmic supernova explosion, blasting most of its substance into space as a glowing shell of stellar material. The resulting shock front continues to expand and today appears as a luminous, wispy nebula 1,600 light years away. A piece of space junk crossing the field of view while the green-sensitive plate was being exposed resulted in the green line that can be seen on this photograph from the Anglo-Australian Telescope.

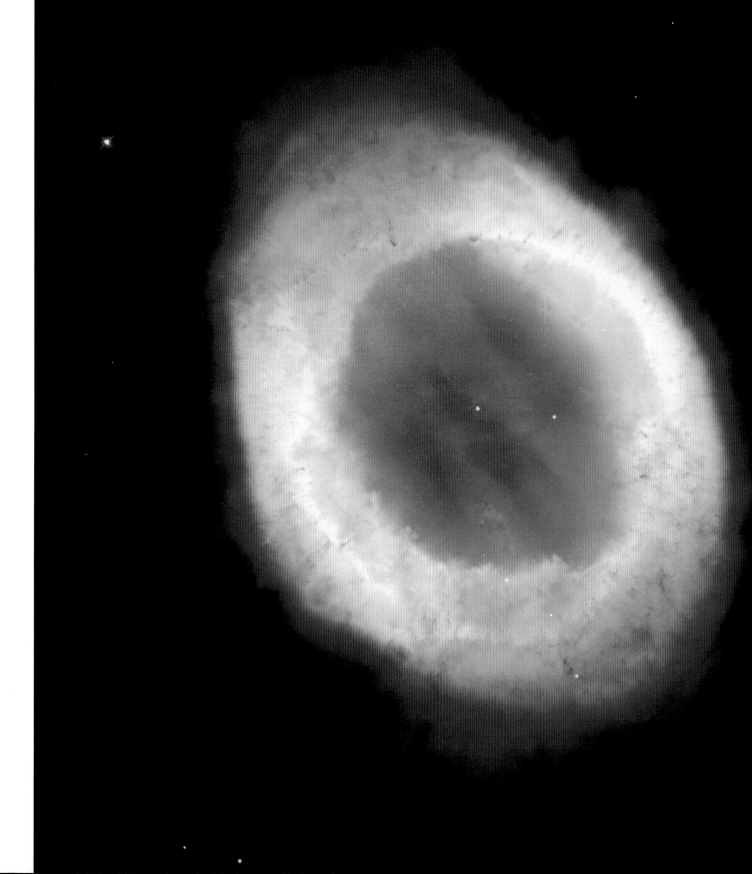

Ring Nebula (M57, NGC 6720)
This false-colour Hubble Space Telescope image is of the Ring Nebula, 2,000 light years away. The Ring is a planetary nebula, that is, a Sun-like star in the late stages of evolution. As they die, Sun-like stars swell to become red giants before ejecting their outer layers. What remains is a small, hot star that will become a white dwarf, within a shell of glowing gas expanding at about 20 kilometres per second.
The type of stellar outburst determines the nebula's shape; in the Ring Nebula it is barrel-like and less than a light year across. By chance we happen to see this structure almost end-on. Intense radiation from the central white dwarf causes the gas in the shell to glow.

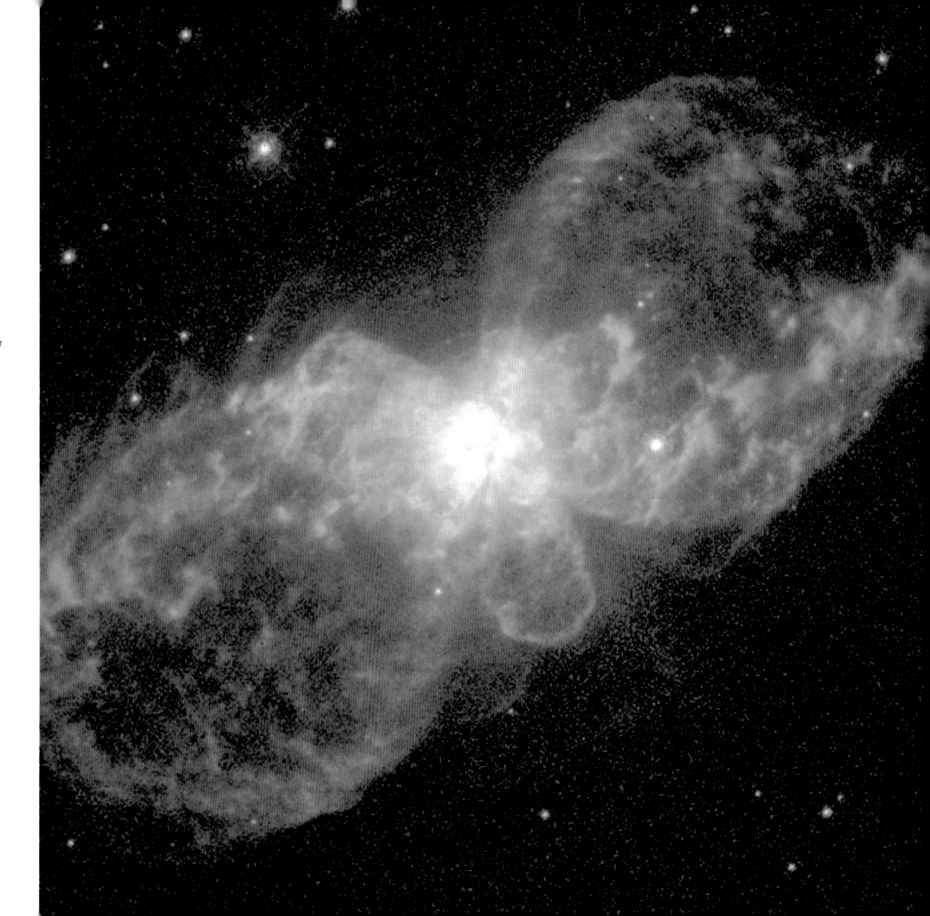

Butterfly Nebula (Hubble 5)
Hubble 5 is a 'butterfly' or bipolar planetary nebula 2,200 light years away, and was formed when an ageing red giant star threw off its outer layers. The new outburst was restricted by a ring of previously ejected stellar material, so instead of expanding into a sphere, the gas remains pinched in at the equator. This constrains the recent gas outburst into two lobes driven outwards by stellar winds from the extremely hot central star. This image was taken by the Hubble Space Telescope in 1997.

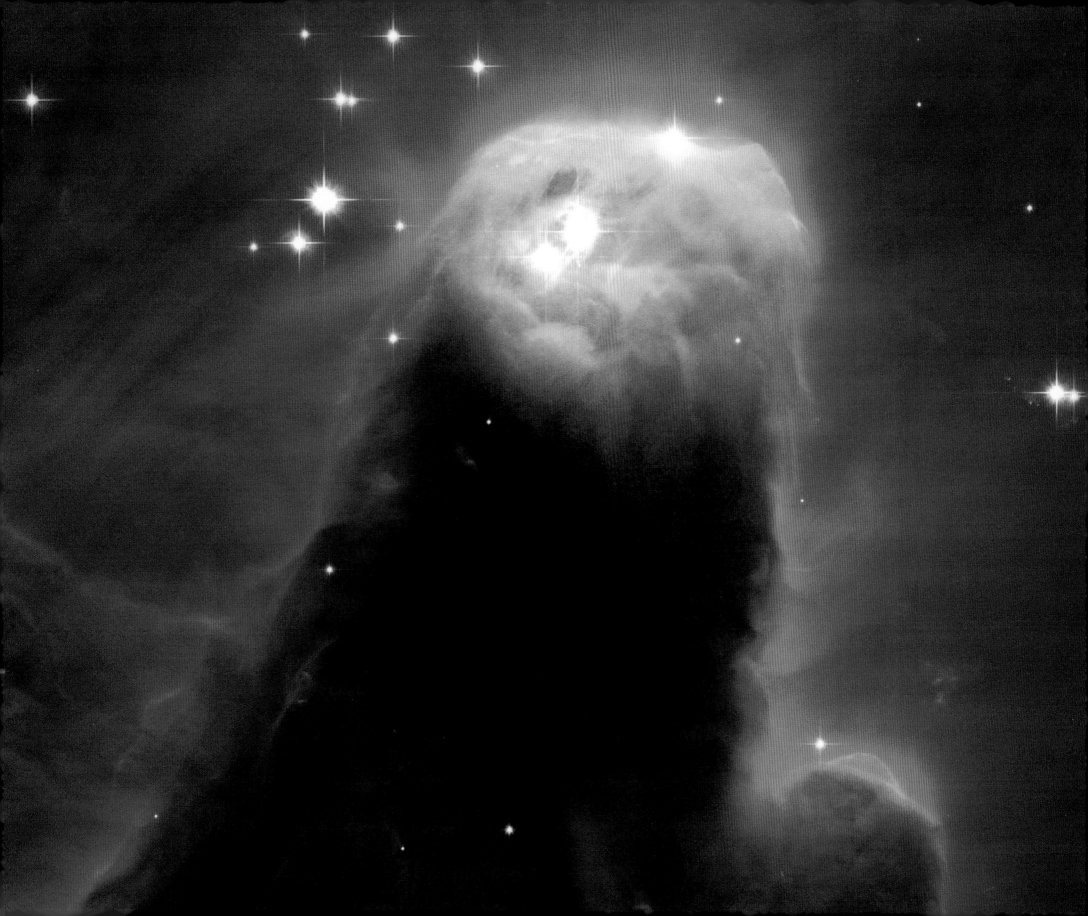

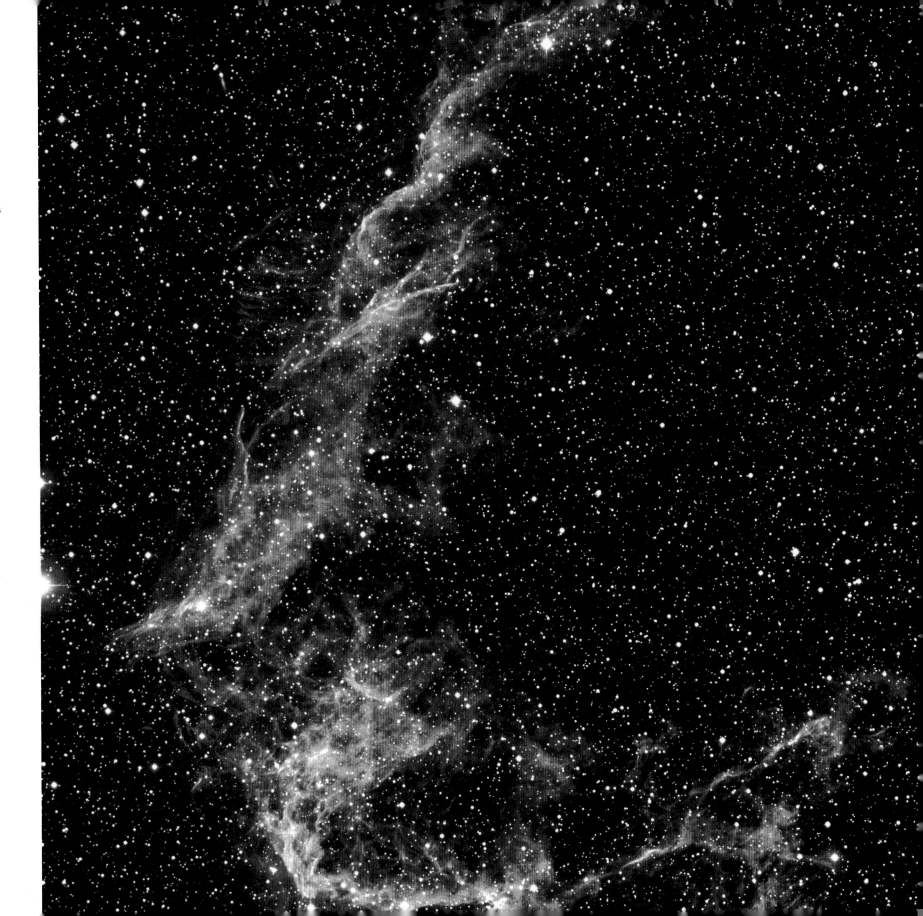

left

Cone Nebula (NGC 2264)
This is the tip of the Cone
Nebula, two and a half light years
long and silhouetted against
a bright red emission nebula.
This opaque pillar of gas and
dust is 2,500 light years away
and appears in a rich star-
forming region in the
constellation Monoceros.
It is mostly dark – it is only
visible because of the bright
background – but the tip of the
cone is illuminated by ultraviolet
radiation from nearby young
stars. The picture was taken
in 2002 by the new Advanced
Camera for Surveys on the
Hubble Space Telescope.

Veil Nebula
Thin, finely structured filaments
give the Veil Nebula
an evanescent beauty. It is part
of the Cygnus Loop, a large
supernova remnant that forms
an almost spherical shell
of glowing gas, 2,600 light years
away. The star responsible
exploded between 15,000
and 30,000 years ago, and the
resulting shock front has been
travelling out from the explosion
ever since. The shock excites
the interstellar material that
it encounters, making it glow.
The photograph comes from
the Isaac Newton Telescope on
La Palma in the Canary Islands.

321 And beyond

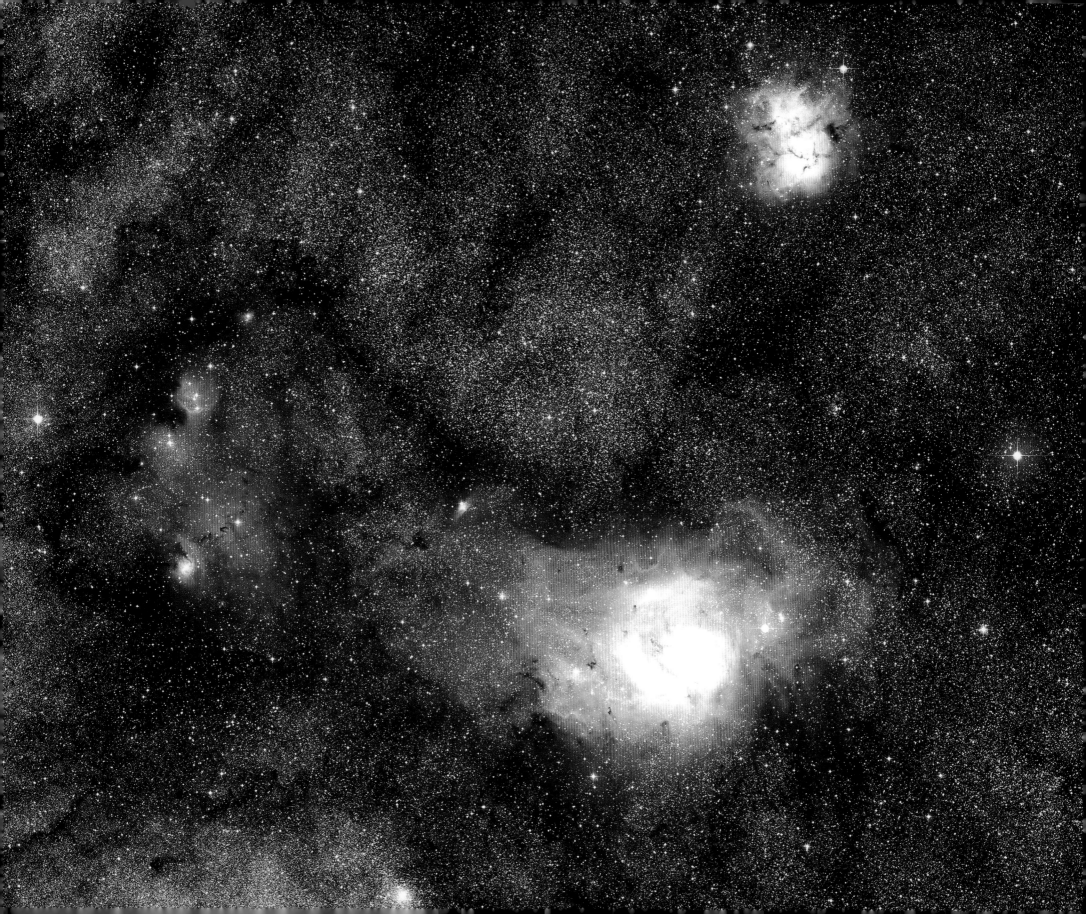

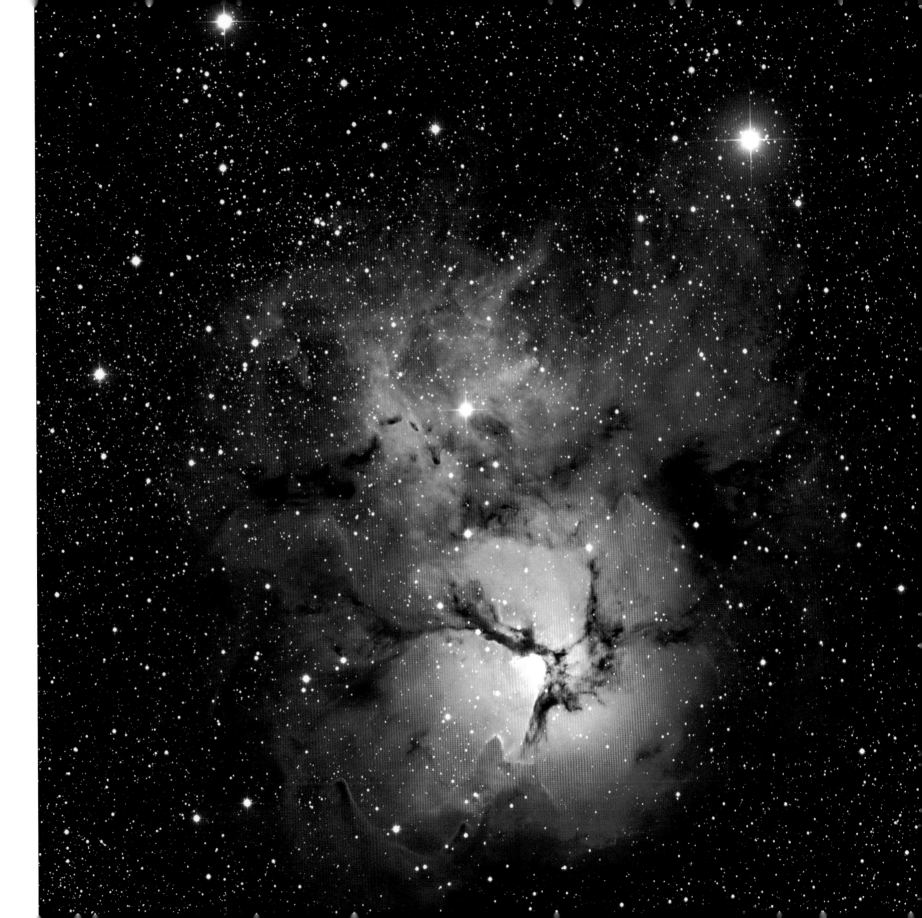

left

Lagoon Nebula (M8, NGC 6523) and Trifid Nebula (M20, NGC 6514)

Around 5,200 light years away, these red nebulae are hot, dense clouds of ionized hydrogen at about 10,000 kelvin. Such nebulae are usually found around massive hot stars, whose strong ultraviolet radiation ionizes the gas and causes it to glow. The larger of the two nebulae in this picture is the Lagoon Nebula, illuminated by the blue supergiant 9 Sagittarii, among others. The smaller (top) is the Trifid Nebula, with the multiple star HN 40 at its centre.

Trifid Nebula (M20, NGC 6514)

Measuring about 40 light years across, the Trifid Nebula contains enough gas and dust to make many thousands of stars like the Sun. In the constellation Sagittarius, it is a combined emission and radiation nebula. The hot, young stars that have already formed emit ultraviolet radiation, which causes hydrogen gas in the clouds to emit red light. Dusty regions scatter and reflect starlight, making them appear blue, while thicker dust blocks out the light entirely, appearing as the three dark tendrils which give the nebula its name. This photograph comes from the Anglo-Australian Telescope.

323 And beyond

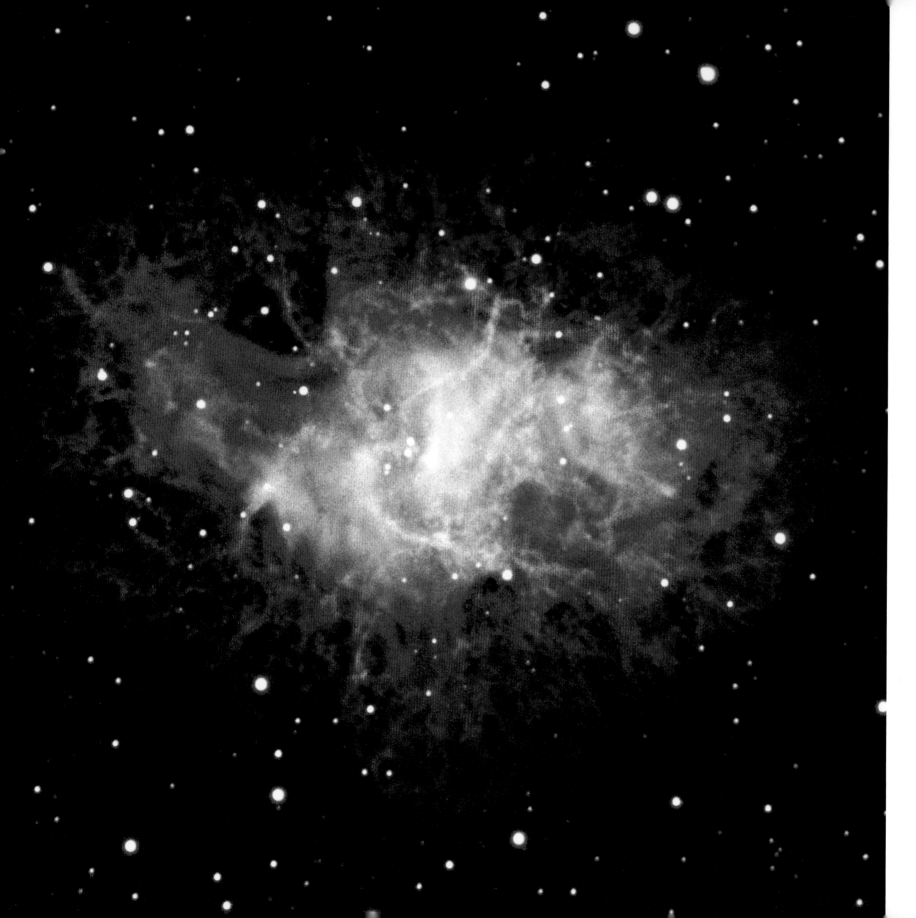

Crab Nebula (M1, NGC 1952)
In AD 1054, Chinese astronomers saw a supernova, the violent explosion of a star. Today, its remains form the Crab Nebula, 6,500 light years away in the constellation of Taurus. Red filaments of hydrogen expanding at 1,000 kilometres per second surround an inner, pale blue nebula. At the centre is a pulsar, an extremely dense, rapidly spinning neutron star formed as the star blew off its outer layers and the core collapsed in on itself. Energetic charged particles from the pulsar cause the nebula's core to emit the bluish synchrotron radiation. This photograph was made from monochrome plates taken by a 5-metre telescope at the Palomar Observatory, California in 1956.

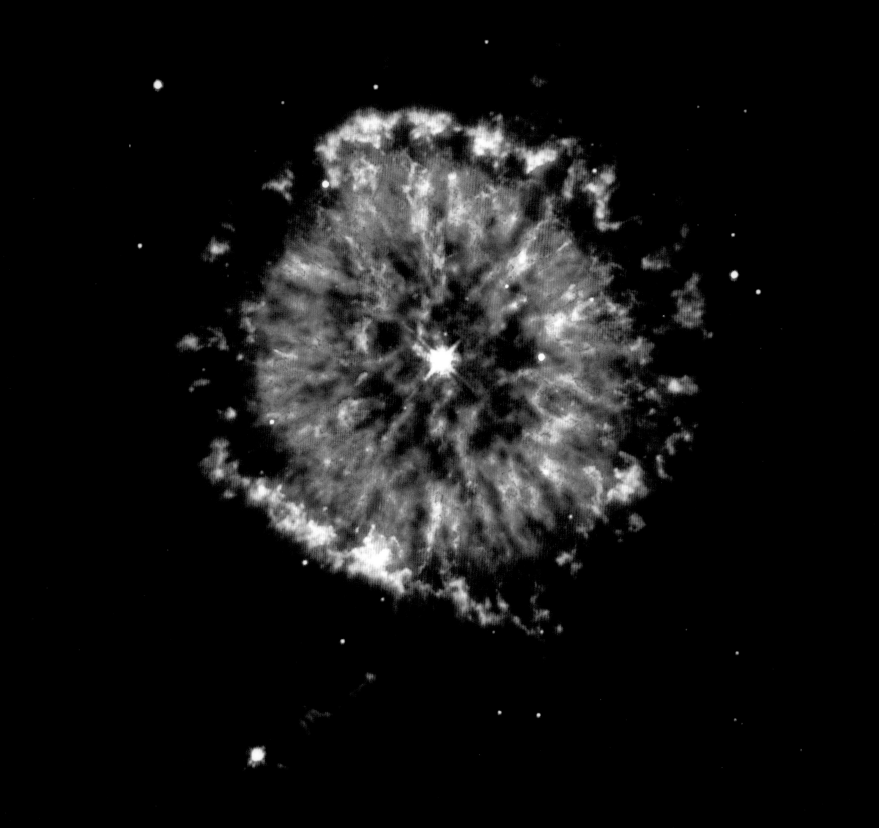

Planetary Nebula (NGC 6751)
This image shows the white
dwarf star at the centre of the
planetary nebula NGC 6751.
White dwarf stars are typically
the size of the Earth but with the
mass of the Sun and so dense
that one teaspoon-full would
weigh 100 tonnes. They form
when a Sun-like star has
exhausted its supply of hydrogen
fuel and ejects its outer layers
and collapses in on itself.
Bubbles and streamers
of ejected gas radiating out from
this example in the constellation
Aquila are ionized by the star's
intense radiation, forming
a glowing shell almost a light
year across. Although its source
of fuel has vanished, the white
dwarf is still hot at more than
100,000 kelvin. The hottest
gas in this photograph from
the Hubble Space Telescope
is coloured blue, the coolest red.

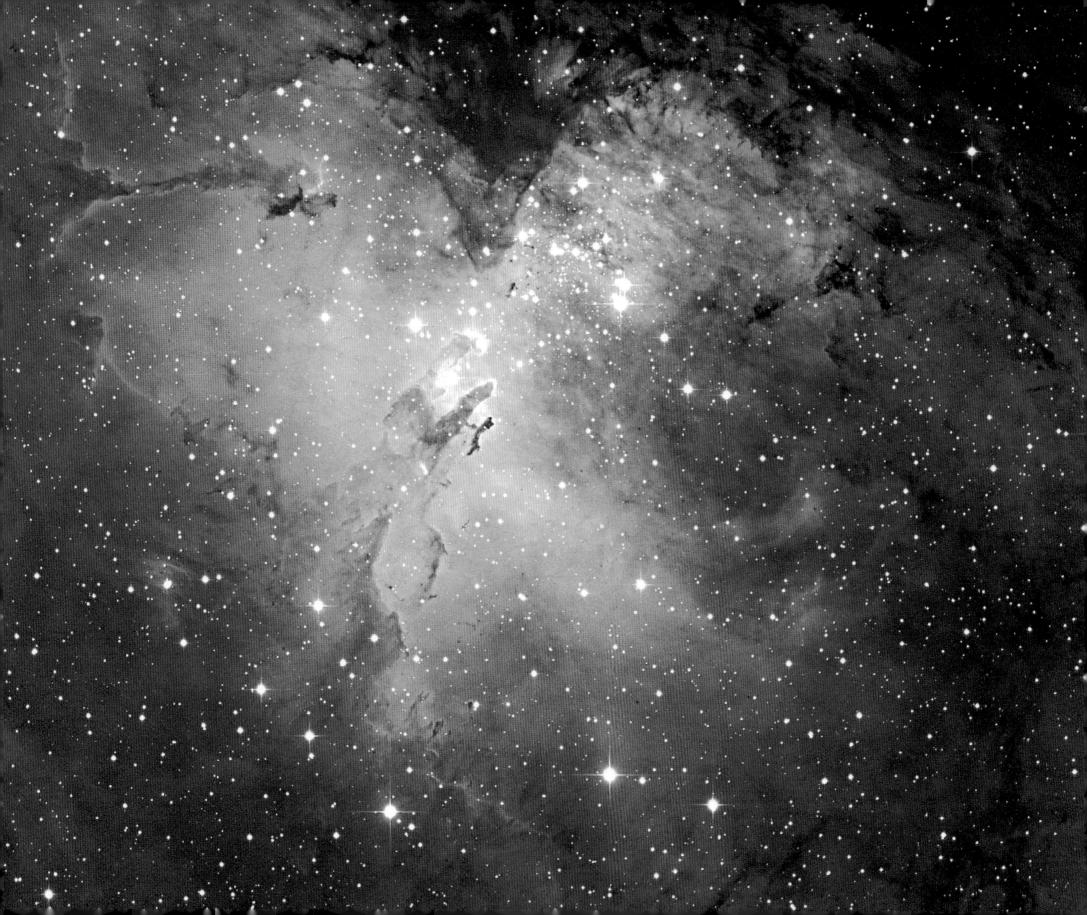

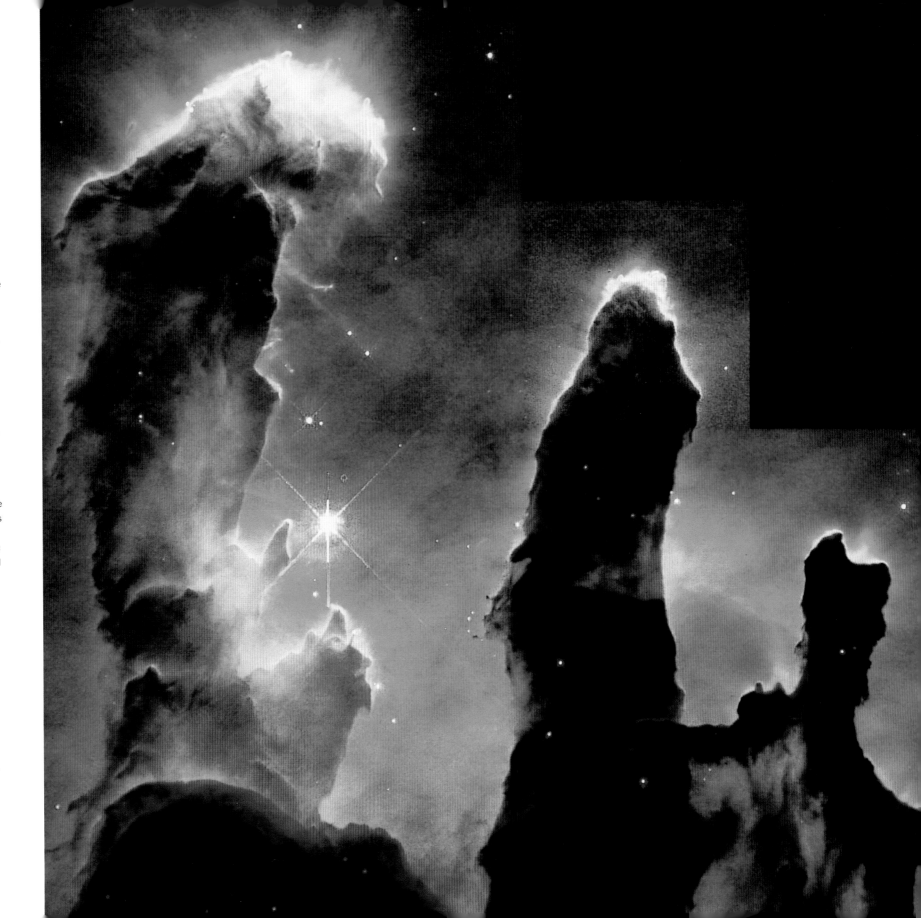

left

Eagle Nebula
(M16, NGC 6611)

This cloud of gas and dust lies
7,000 light years away and
is called the Eagle Nebula.
It is an active star-forming
region, and there is plenty
of evidence of young stars
in the loose cluster seen here.
These stars are hot, massive
and very luminous. Their intense
radiation is etching away the
dense dusty clouds from which
they so recently sprang.
The interstellar matter is patchy
and forms the dense, dusty
columns visible at the centre
of this picture, silhouetted
against the bright nebula.
This picture was made with
the Anglo-Australian Telescope.

Dust columns in the Eagle
Nebula (M16, NGC 6611)

The Hubble Space Telescope
captured this image of the Eagle
Nebula's characteristic columns
of gas and dust in 1995.
The columns contain embryonic
stars, formed as stellar material
in the densest part of the
nebula's cloud collapses in
on itself and coalesces.
Once enough material has
accumulated, drawn together
by the protostar's ever-
increasing gravitational pull,
nuclear reactions (hydrogen
fusion) are triggered and the
star begins to burn brightly.
The tops of the columns glow
in the ultraviolet radiation
emitted by newly born stars
in a nearby cluster. The colours
in this image are false.

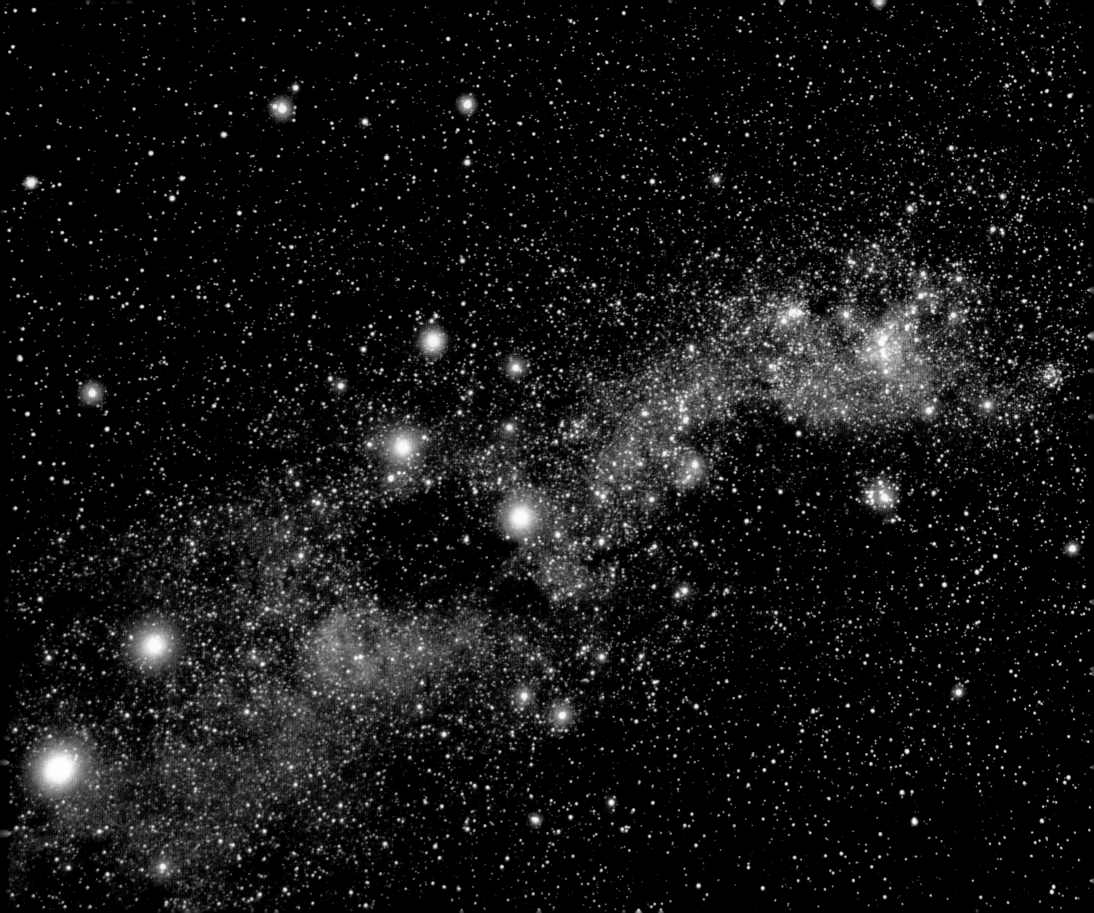

Southern Cross

The Southern Cross is the popular name for the southern hemisphere constellation Crux Australis, established as a separate constellation relatively recently, in 1679. It is visible here, left of centre; its brightest stars, Alpha, Beta, Delta and Gamma Crucis, form a kite shape with the yellow star forming the tip. The stars are many times brighter than the Sun and they are between 88 and 460 light years away. The two bright stars in the lower left corner are Alpha and Beta Centauri, also known as the Pointers, which point the way to the Southern Cross. The bright star in the lower right corner is Eta Carinae (of the constellation Carina), which forms the lower point of a cross-shaped pattern of stars known as the False Cross.

right
An open cluster of stars (NGC 3293)

Many stars are born and spend their lives in brilliant clusters like this one 8,500 light years away in the constellation Carina. Although the stars were born around the same time, the more massive, bright orange star is at a more advanced stage of stellar evolution than its companions, because it started out with a greater mass. The most massive stars use up their supplies of hydrogen fuel fastest, while smaller stars burn more slowly and survive longer. As stars burn up their fuel they swell enormously and become cooler and redder like this orange star here.

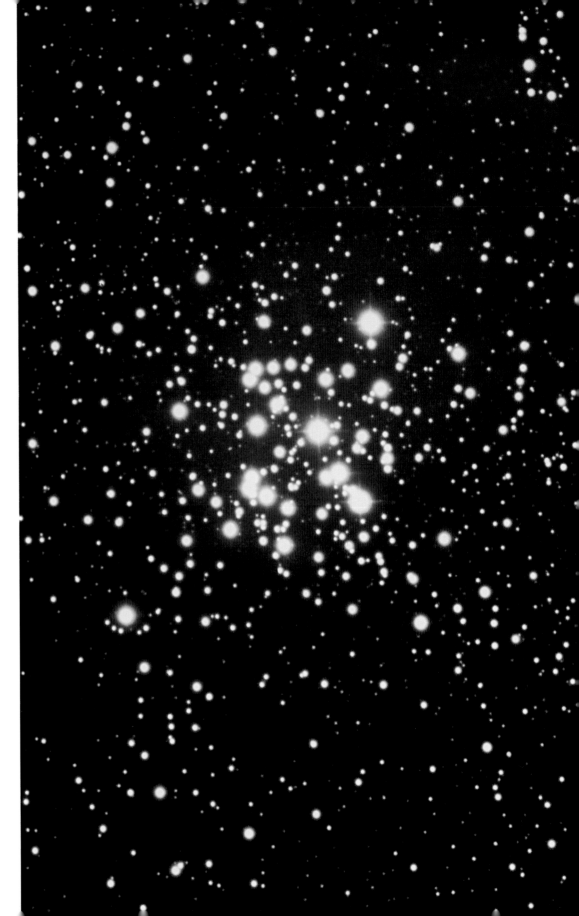

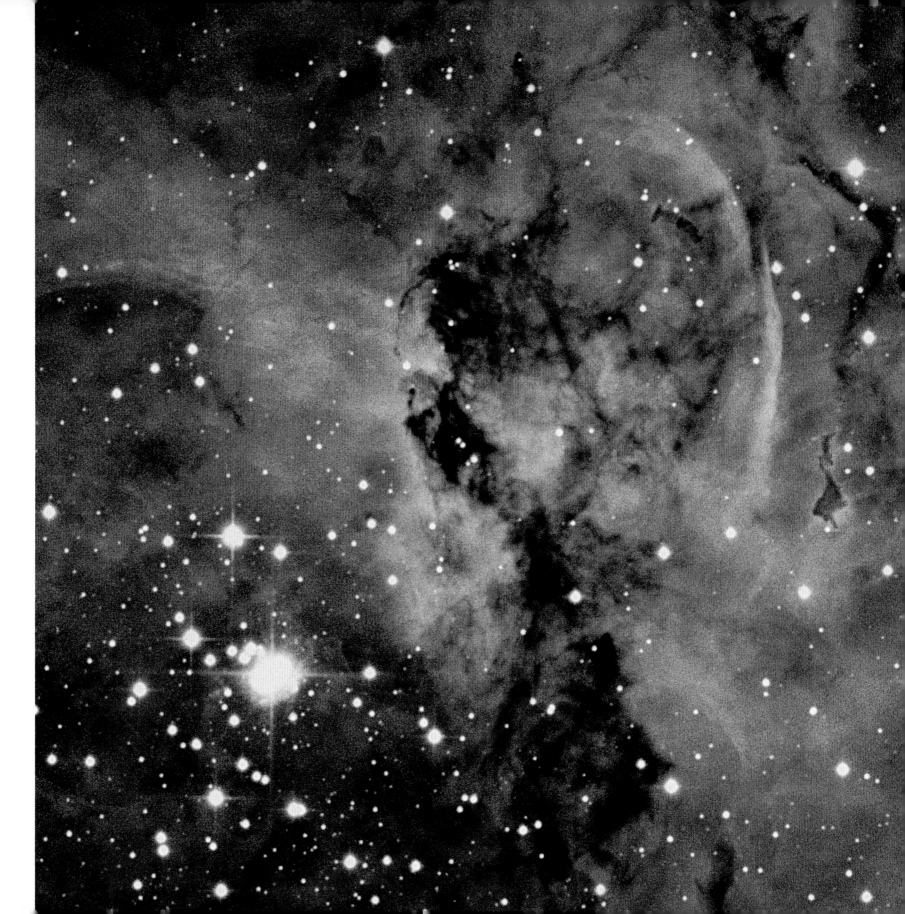

**Keyhole Nebula
and Eta Carinae**

The English astronomer
John Herschel (1792–1871),
observing from South Africa,
first described this complex
nebula in 1838. He observed
a bright circular shell, seen in the
upper part of the picture here,
extending downwards to form
a dark keyhole shape, its surface
glowing in the light of the
hypergiant star, Eta Carinae,
seen alongside. In 1843,
Eta became briefly the second
brightest star in the sky as it
threw off a layer of stellar
material, before fading rapidly,
shrouded in its own dust. It no
longer illuminates the nebula's
rim and the lower part of the
keyhole shape has vanished.

far right
**Star birth nebulae (NGC 3603
and NGC 3576)**

These star-forming regions
appear side by side in the sky,
but only because they lie in the
same sight line. NGC 3603 on
the left is about 20,000 light
years away, while the more
flamboyant loops of NGC 3576
(right) are only one third as far
away. Their reddish glow is the
result of ionization of hydrogen
by ultraviolet light from the hot
young stars within them.
The more distant NGC 3603
appears brick red because
much of its blue light is absorbed
by dust particles in the line
of sight. The closer nebula
appears pinkish because more
of the blue component remains
in the light that reaches us.

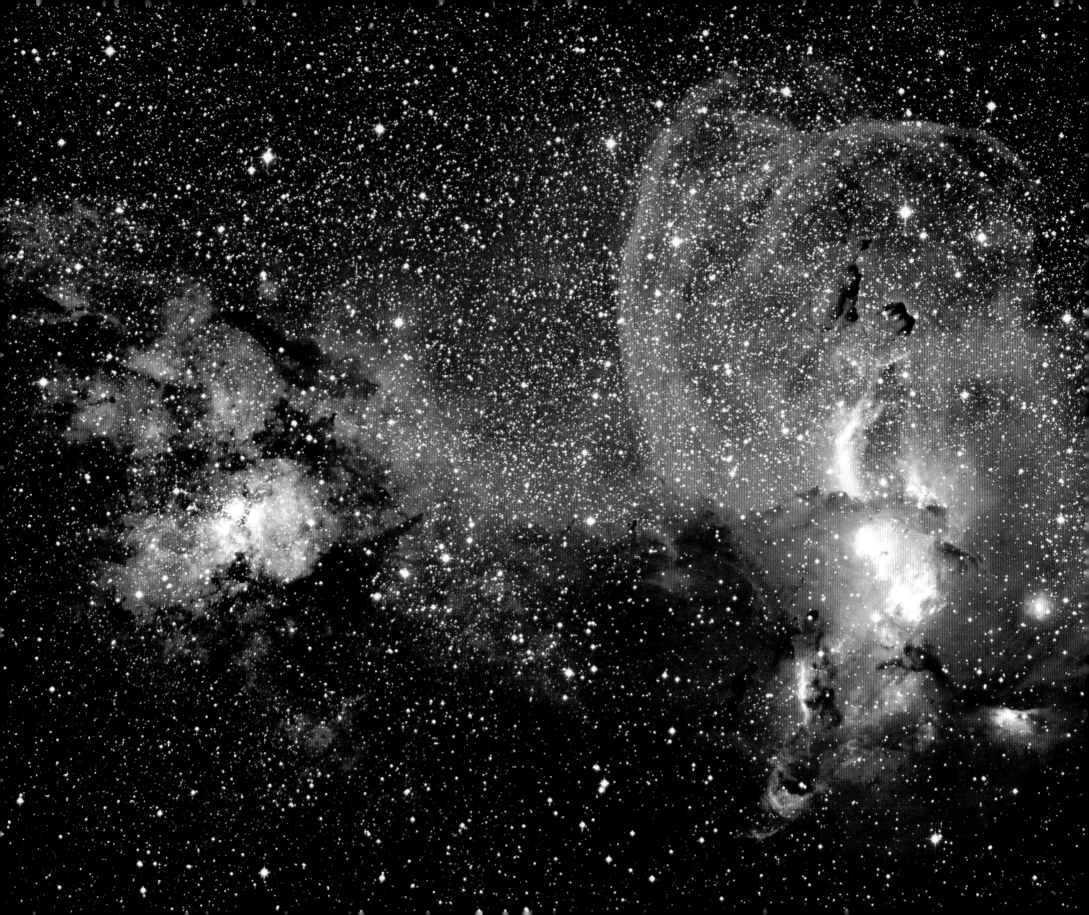

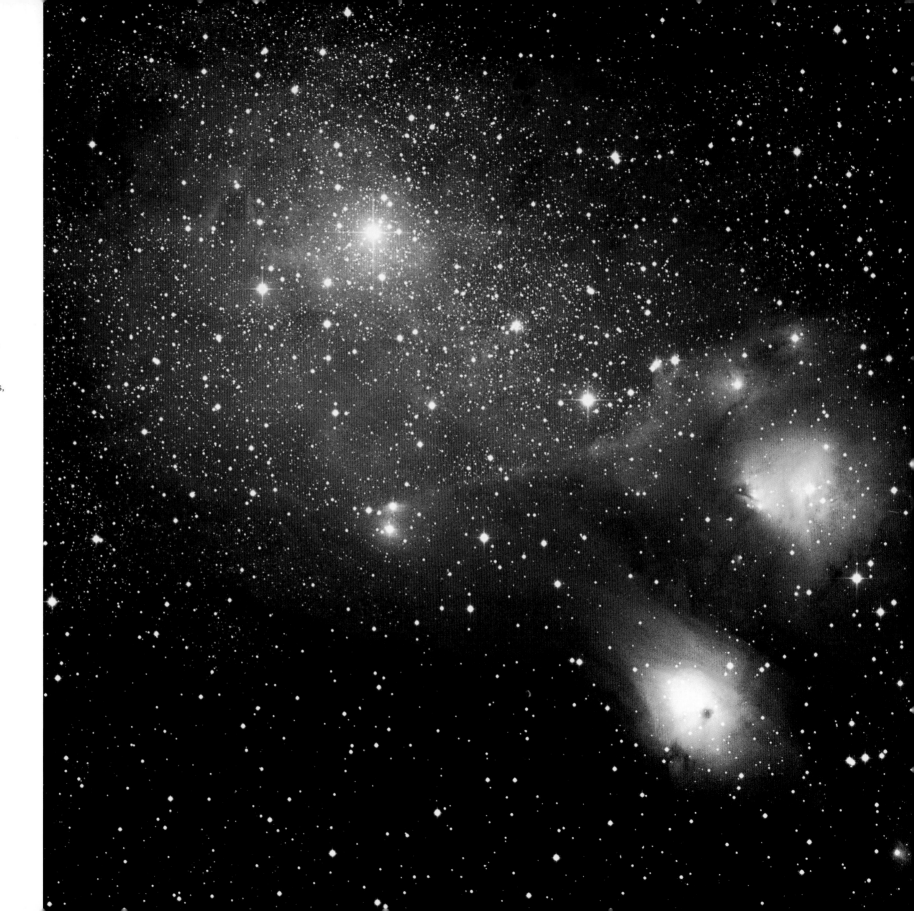

Nebulosity in Sagittarius
The centre of the Milky Way galaxy lies in the direction of the constellation Sagittarius, but our view of it is largely obscured by clouds of interstellar dust. The cloudiness, or nebulosity, of this region of the sky is illustrated in this photograph taken from the Anglo-Australian Observatory. Dust particles in the clouds scatter light from bright stars embedded in the dust, producing two blue reflection nebulae. Elsewhere, the red glow from excited hydrogen mixes with the scattered blue starlight, creating a magenta hue. These clouds are 10,000 light years away.

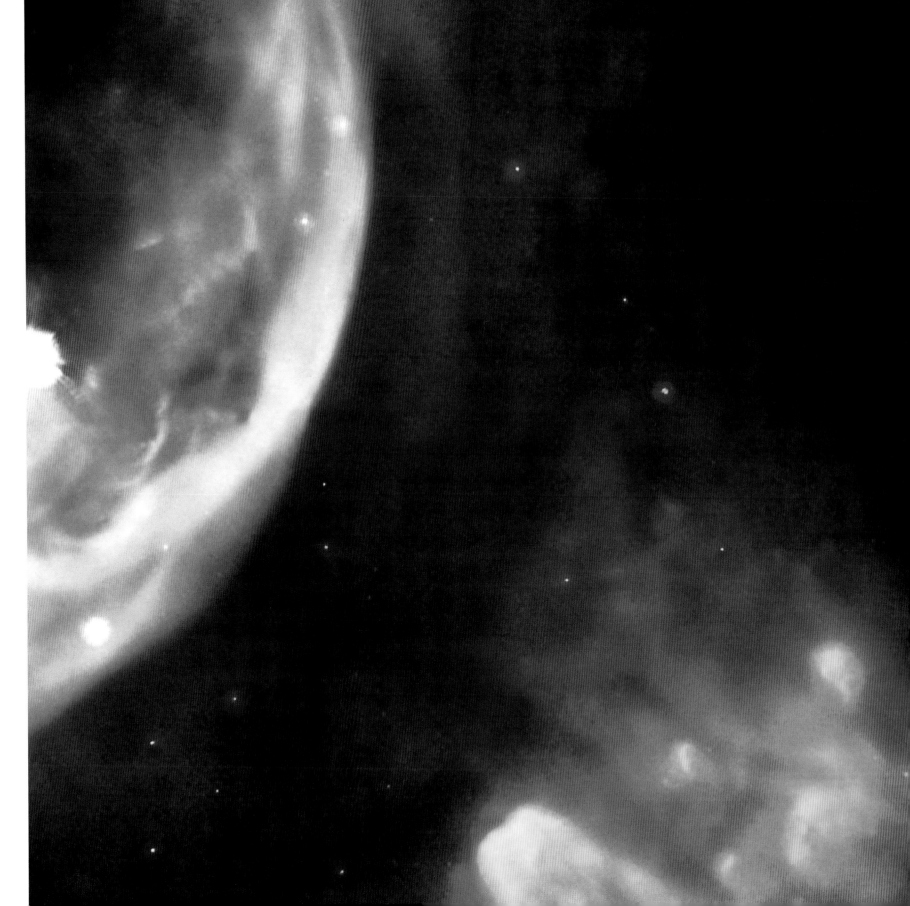

Bubble Nebula (NGC 7635)
Crossing the upper left corner
of this picture is the edge
of the Bubble Nebula, an almost
perfect hollow sphere of gas
and dust, 10 light years across.
It has been created by intense
stellar winds from an unusual
massive and very hot object
known as a Wolf-Rayet star.
These winds and ultraviolet
radiation from the star excite
the displaced interstellar
medium and make it glow.
The Bubble Nebula is 11,000
light years away in the
constellation Cassiopeia,
and this false-colour picture
was made with the Hubble
Space Telescope.

**Globular cluster 47 Tucanae
(NGC 104)**
47 Tucanae (or 47 Tuc for short)
is a magnificent sight, visible
to the naked eye from the
southern hemisphere. It is the
second brightest globular cluster
in the Milky Way, which has over
100 such clusters. These stately
cities, made up of millions
of stars, are three times older
than the Sun and were formed
long before our galaxy evolved
to its present state. The centre
of 47 Tuc is crowded with
1,000 stars per cubic light year,
and there is plenty of evidence
of stars interacting with each
other. The cluster is 150 light
years across and 15,000 light
years away, on the outskirts
of the galaxy. This is an Anglo-
Australian Telescope picture.

Globular cluster Omega Centauri (NGC 5139)
Omega Centauri is visible to the naked eye in the constellation Centaurus from both the northern and southern hemispheres. This globular cluster is named as though it were a single star but actually contains several million of them. The cluster is almost as old as the universe: it formed early in the Milky Way's history, around 12 billion years ago, and like most globular clusters is in the galaxy's halo. Although its stars are less densely packed than those of its southern rival 47 Tucanae, it is the brightest globular cluster in the sky today, despite its 17,000 light-year distance. This is an Anglo-Australian Telescope picture.

Stingray Nebula

This distinctively shaped cloud of glowing gas and dust is a small planetary nebula lying 18,000 light years away. It is the youngest known planetary nebula, since its central star only became capable of making the gas glow in the last 20 years. The shell of gas, the size of 130 solar systems, is expanding, propelled by a stream of particles rushing out from the central star (the stellar wind). Most nebulae disperse after a few tens of thousands of years, leaving their parent behind as a white dwarf. In cosmic terms, this stage in a star's evolution is very short as it represents a mere 100,000 years in a star's 10 billion year life. This 1997 image was taken by the Hubble Space Telescope.

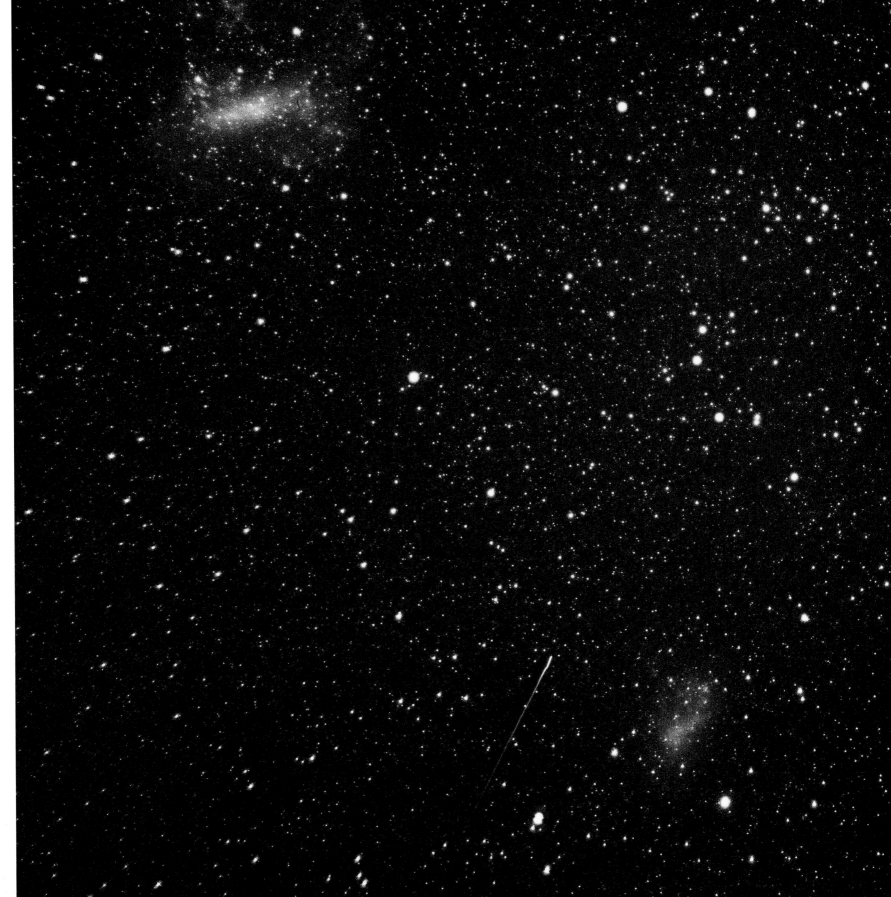

Magellanic Clouds
Visible to the naked eye from the southern hemisphere, the Large and Small Magellanic Clouds look like detached portions of the Milky Way. They are the nearest galaxies to the Milky Way, just 160,000 and 190,000 light years away respectively. These irregularly shaped collections of stars and gas orbit around our galaxy perpendicular to its disk and will eventually merge with it and lose their identity. This photograph was taken from the Anglo-Australian Observatory at Siding Spring in New South Wales, Australia, from where the Magellanic Clouds are often visible on clear dark nights.

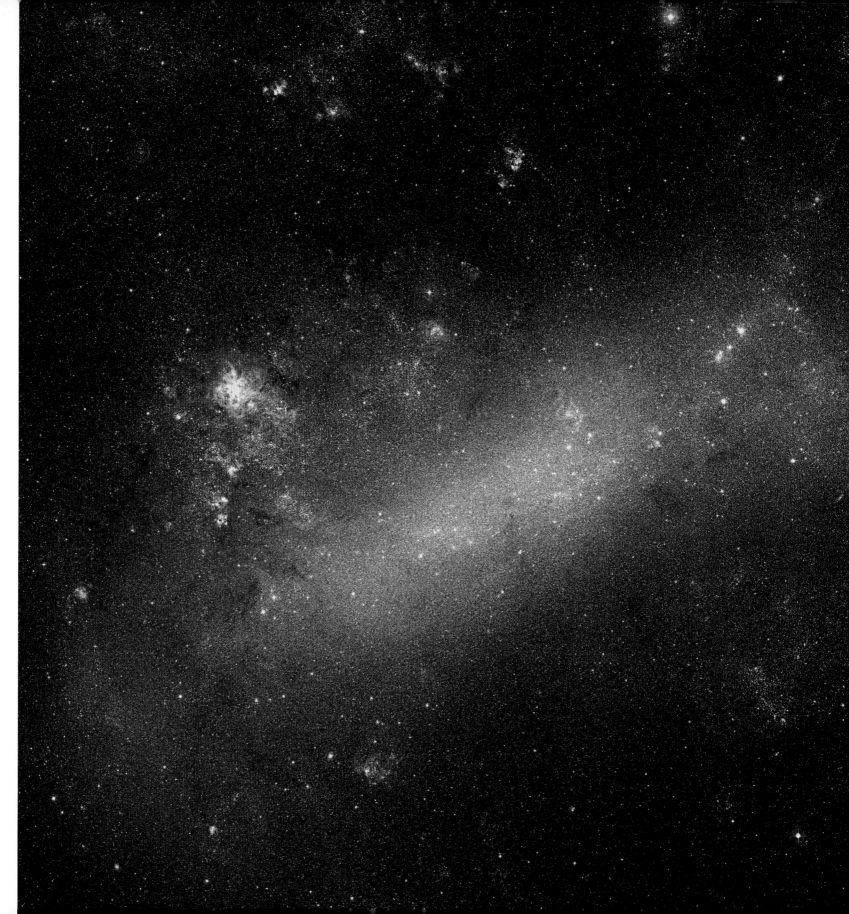

Large Magellanic Cloud
At a distance of 160,000 light years, the Large Magellanic Cloud is our nearest galactic neighbour. Made up of many star clusters, nebulae and dust clouds, this complex satellite of the Milky Way contains only a tenth as much mass, but is still a substantial galaxy. It also hosts one of the most massive star-forming regions known anywhere, the spectacular Tarantula Nebula (NGC 2070), at its eastern end. This photograph was made from UK Schmidt plates at the Anglo-Australian Observatory.

far right
Supernova 1987A
A supernova is the huge explosion in which massive stars end their lives. Supernova 1987A exploded in the Large Magellanic Cloud on 23 February 1987, and was the first supernova to be visible to the naked eye since 1604. It is the brightest star in this picture (bottom right), which was taken two weeks after the explosion. By then the supernova had turned from blue to deep yellow as it cooled. Although previously all supernovae were thought to originate from red supergiants, the star that exploded was blue. This photograph also shows the spidery tendrils of the enormous Tarantula Nebula (NGC 2070), the largest and brightest nebula in the Large Magellanic Cloud.

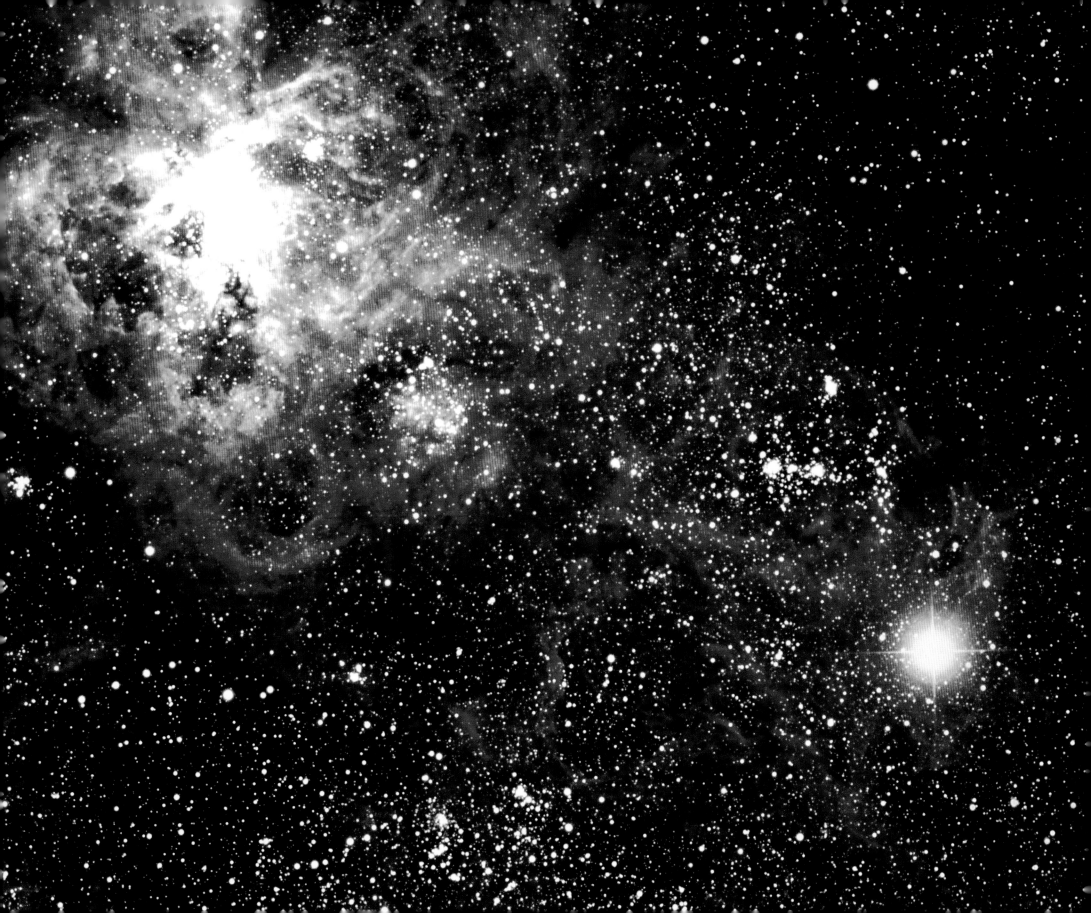

left

Supernova remnant and Pulsar (PSR 0504-69)

This coloured x-ray image shows the pulsar PSR 0504-69 (centre) and its associated supernova remnant (orange, above and left). The pulsar is the remains of a star that exploded as a supernova, while the remnant is the remaining stellar material that was ejected in the explosion. The spinning pulsar sweeps a beam of radio waves across the Earth, 20 times a second. This radio beam is thought to arise from the acceleration of charged particles above the pulsar's magnetic poles. The remnant emits x-rays as a result of its high energy particles interacting with the pulsar's strong, rotating magnetic field. This image was obtained using the Chandra X-ray Space Telescope.

Light echoes of Supernova 1987A

The brilliant flash of light from Supernova 1987A took about 170,000 years to arrive from the Large Magellanic Cloud and be seen from Earth. On its journey, the expanding shell of light from the exploding star encountered a number of dust clouds which acted as reflective surfaces close to the line of sight. Taking a slightly longer route, this reflected light (or light echoes) arrived a few years later than the light travelling directly from the explosion. The echoes appear as two concentric rings in this picture. Although the picture was made two years after the central exploding star had faded, it accurately reflects the colour of the supernova when it was at its brightest in May 1987. This image was made by subtracting two photographs from each other, hence the black stars and coloured photographic noise.

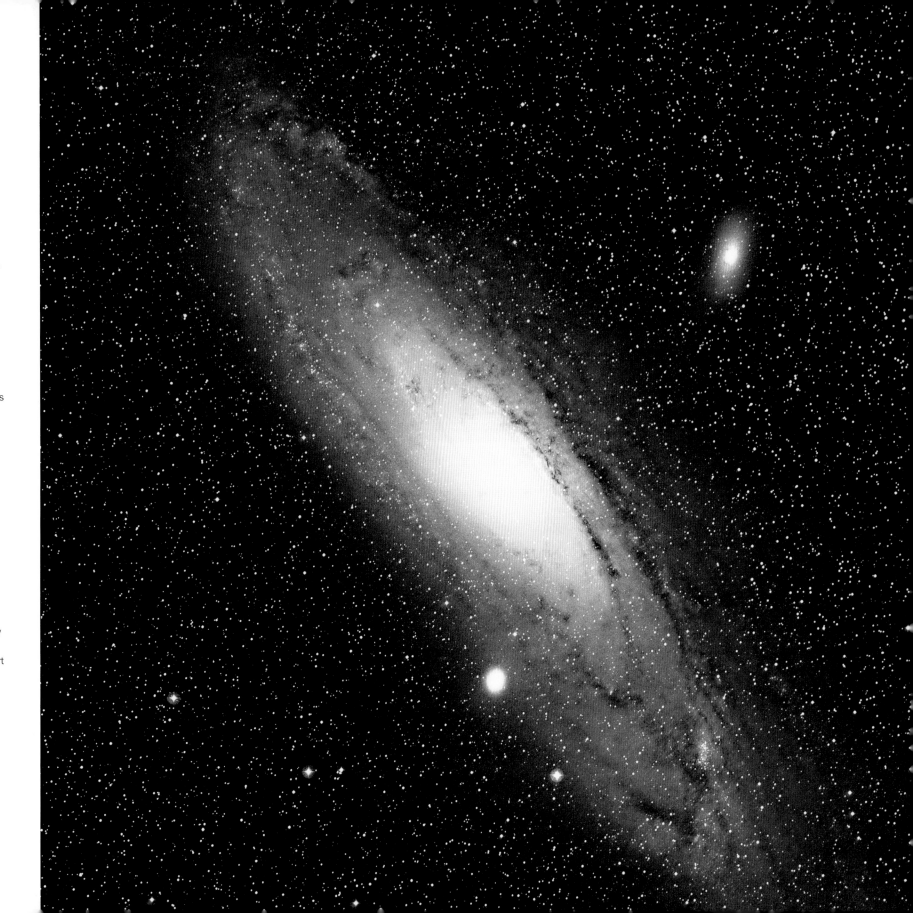

**Andromeda Galaxy
(M31, NGC 224)**
The Andromeda Galaxy
is 2.3 million light years away
and is one of the most distant
objects visible to the unaided
eye. It is also the nearest spiral
galaxy to the Milky Way, which
it resembles in size and form.
None of these facts were known
before the 1920s, when the
US astronomer Edwin Hubble
(1889–1953) identified many
fuzzy shapes in the sky as
distant galaxies like our own.
The Andromeda Galaxy
contains 100,000 million stars
and is one of a similarly
unimaginable number of galaxies
in the universe.

far right
**Nucleus of the Andromeda
Galaxy (M31, NGC 224)**
A vast multitude of stars orbits
around the nucleus of the
Andromeda Galaxy. Tangled
bands of dust are also visible
in this picture, silhouetted
against a bright starry
background. This is much like
our galaxy's nucleus might
appear to an outside observer.
The abnormally high speeds
of the stars very close to the tiny
inner nucleus itself suggest that
a black hole might lie at the heart
of the Andromeda Galaxy, as in
our own galaxy. This image was
produced using photographic
plates from the Isaac Newton
Telescope at the Roque de los
Muchachos Observatory on
La Palma in the Canary Islands.

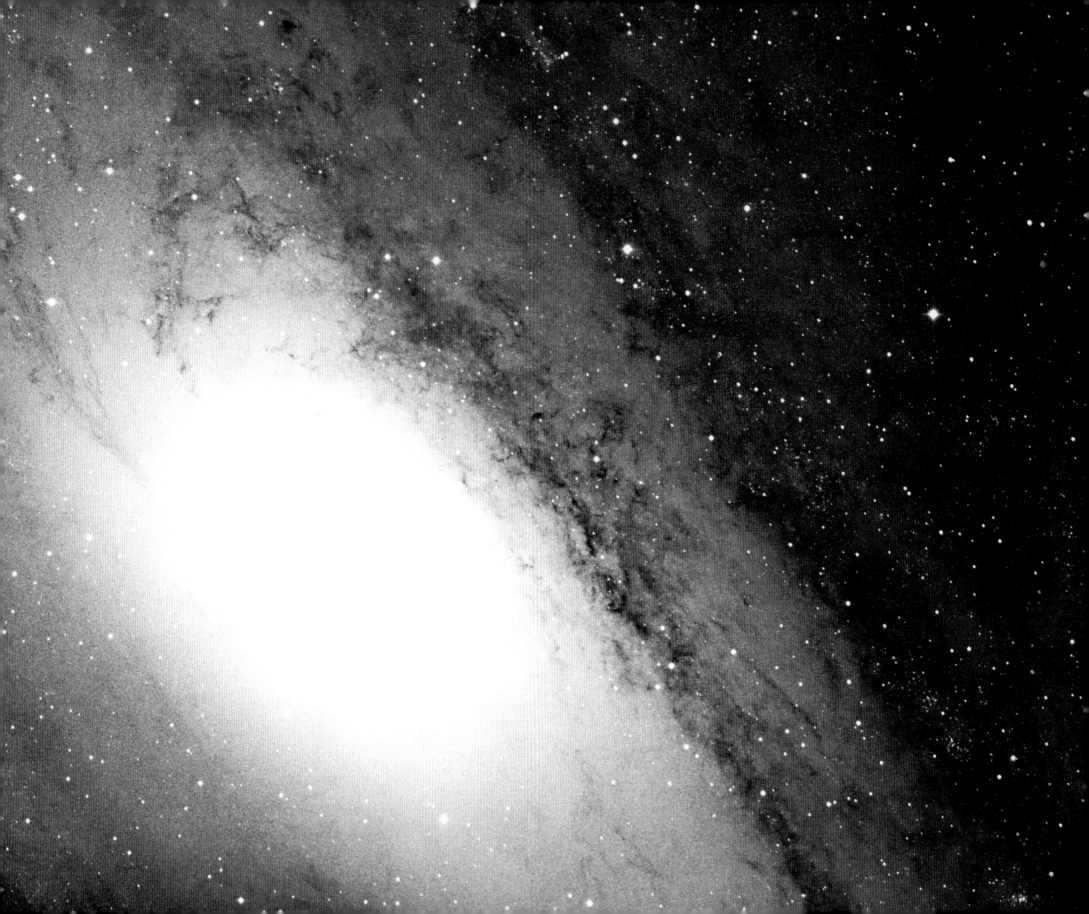

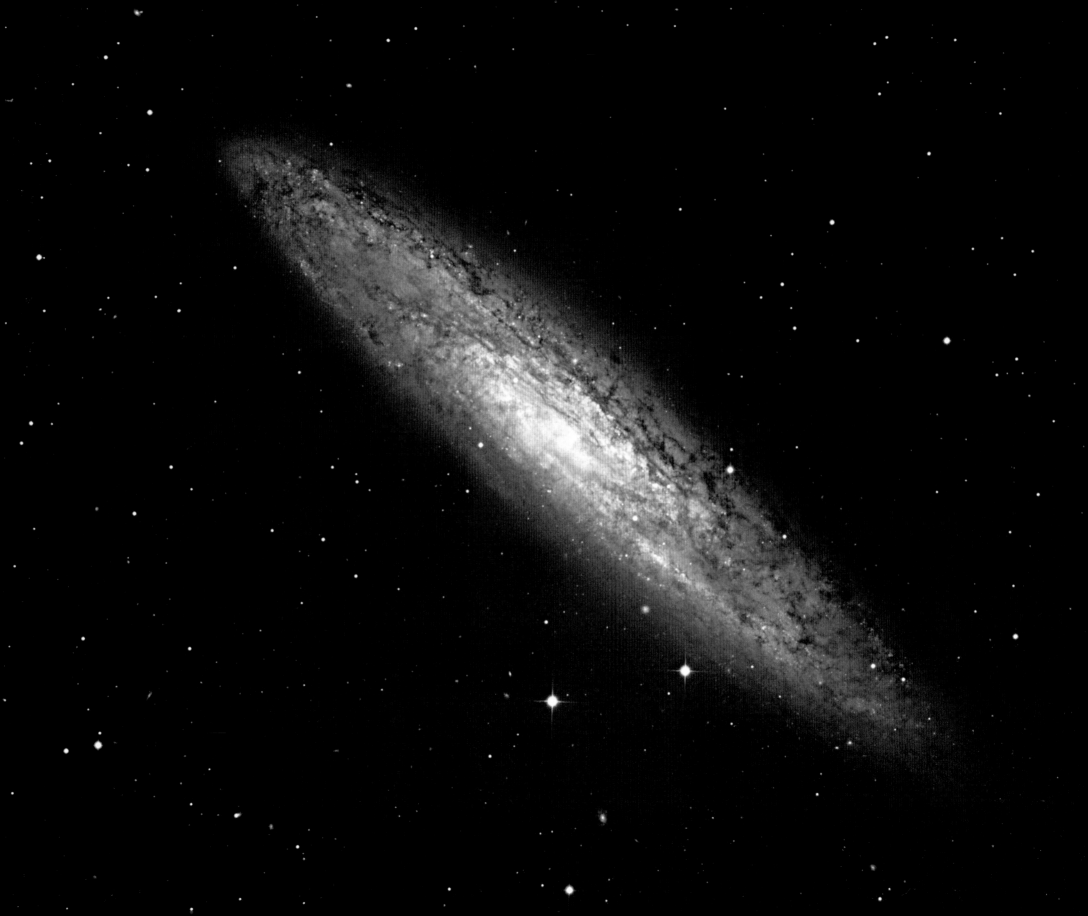

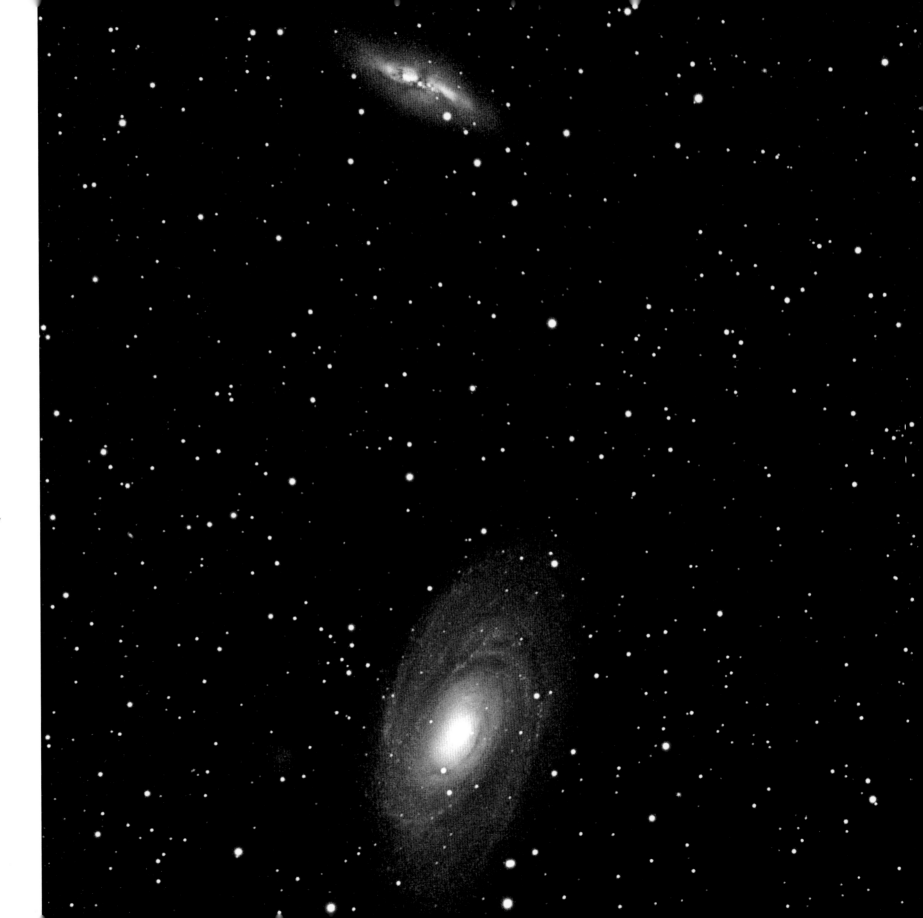

left

Starburst galaxy NGC 253

The spiral galaxy NGC 253 appears here in the southern constellation of Sculptor, and at only 10 million light years away is one of the Milky Way's nearest galactic neighbours. Though it is bright it is also very dusty (the dust is visible here as dark patches) and is producing new stars at a prodigious rate, hence its starburst designation. NGC 253 is seen almost edge-on so appears elongated in shape, and the abundant dust clouds make the spiral arms difficult to discern. This image was taken from the Anglo-Australian Observatory.

M81 (NGC 3031) and M82 (NGC 3034) in Ursa Major

This optical image shows two spiral galaxies in the constellation Ursa Major (the Great Bear), which are about 12 million light years away from Earth. Currently about 150,000 light years apart, these two galaxies are trapped in a gravitational waltz. There have been several close encounters and both galaxies still carry evident collision damage. M82 (top) is the most affected, its spiral shape seriously distorted with dust lanes askew, violent outflows and strong radio and x-ray emission. In M81 the effects are more subtle but just as widespread. Eventually, these galaxies will merge into one, but not before there are more cosmic fireworks.

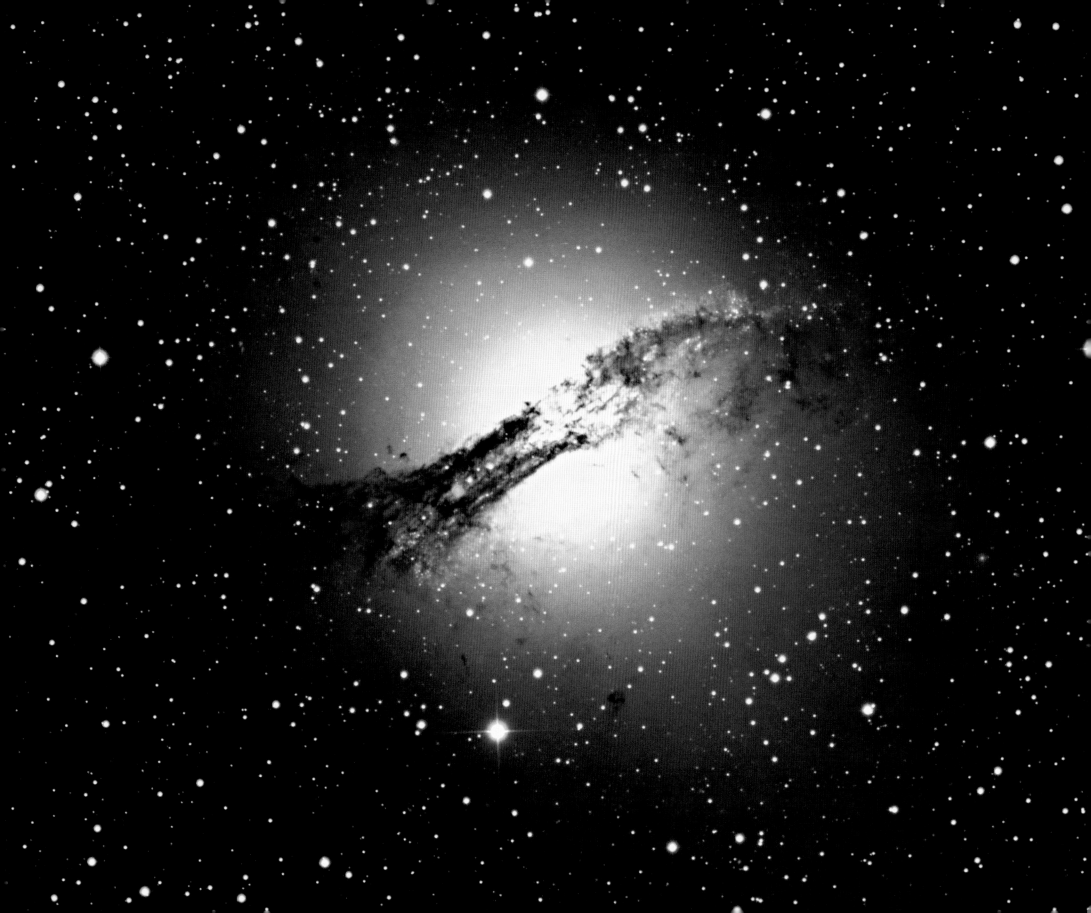

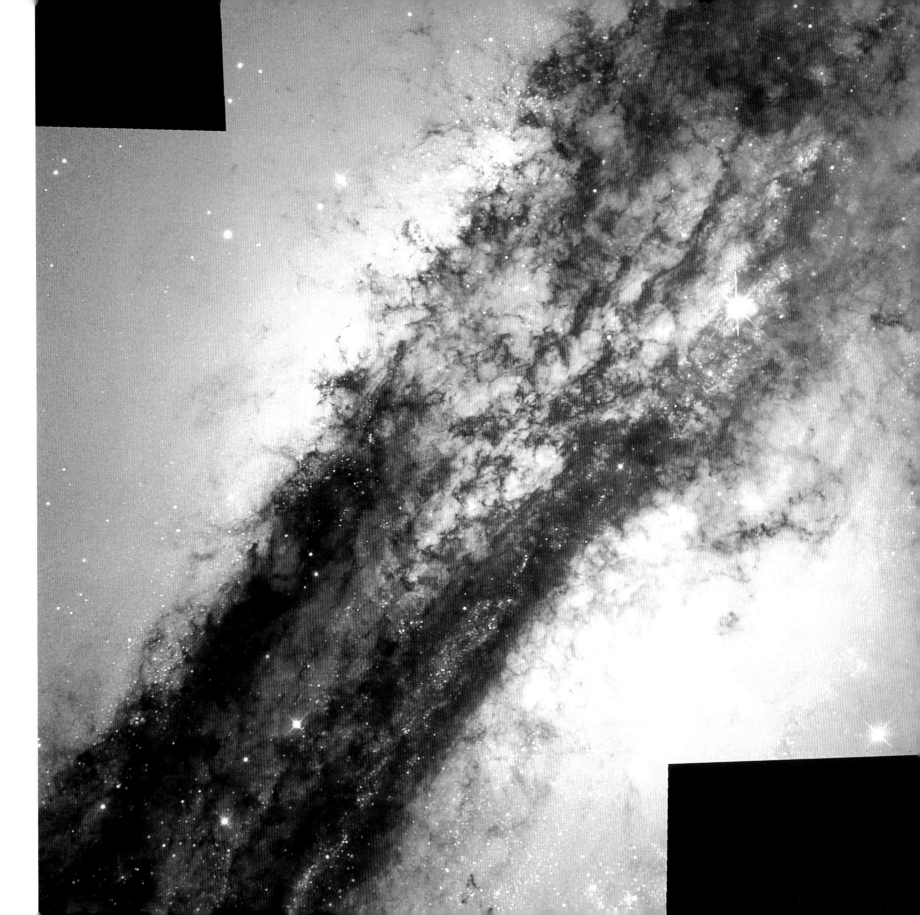

left

**Centaurus A Galaxy
(NGC 5128)**

Several thousand million stars, mostly old and yellow, make up the elliptical galaxy NGC 5128, which is 12 million light years away. Most elliptical galaxies have little gas and dust, but this galaxy is surrounded by a dense band of dust which blocks out the light from the stars behind. This is the remains of a dusty spiral galaxy that NGC 5128 absorbed about a billion years ago in a merger that made the galaxy one of the strongest sources of cosmic radio waves. It is also known as Centaurus A.

**Dust band, Centaurus A Galaxy
(NGC 5128)**

This Hubble Space Telescope image shows the dense band of dust which encircles NGC 5128, silhouetted against the bright nucleus. The dust is not totally opaque everywhere and so the light filters through from background stars. The light is both dimmed and reddened since dust in its path absorbs blue light from the stars. On the fringes of the dust, young blue stars are visible, their formation triggered by the merger of two galaxies.

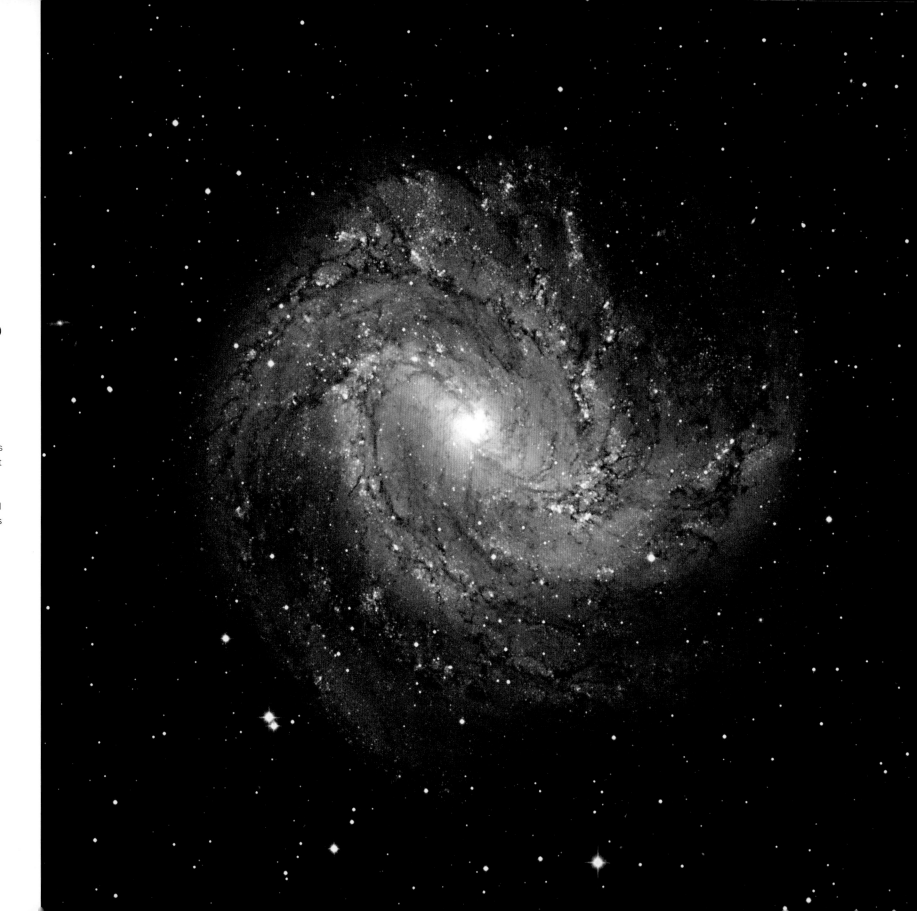

Spiral galaxy M83 (NGC 5236)
In this Anglo-Australian
Telescope photograph,
the spiral galaxy M83 probably
looks very much like our own
galaxy would from a position
20 million light years above
its plane. Like the Milky Way,
it is composed of billions of stars
and huge clouds of gas and dust
organized in a graceful spiral.
Older, yellow stars are
concentrated around the central
nucleus while younger blue stars
and clouds of red glowing
star-building material form
the trailing spiral arms.

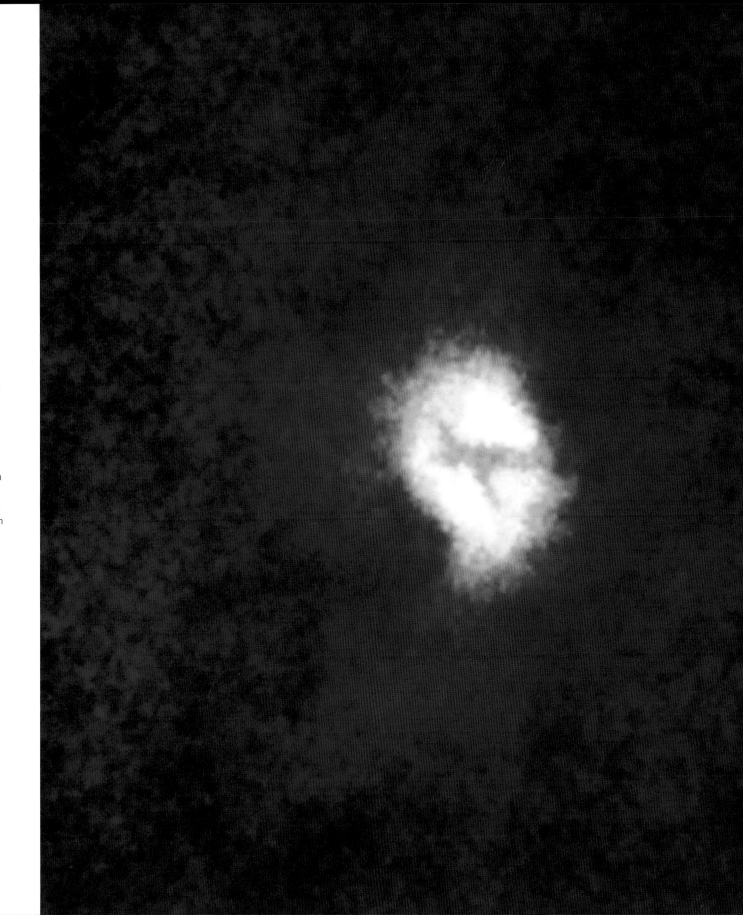

Core of the Whirlpool Galaxy (M51, NGC 5194)

Black holes cannot be seen directly because nothing, including light, escapes from their gravitational pull. The black hole's immense gravity pulls in dust, gas and stars, which are heated to enormously high temperatures as they spiral inwards. This trapped material forms a bright spinning accretion disk around the black hole, as seen here in the core of M51, which shoots out jets of radiation as the black hole accelerates it to nearly the speed of light. The cross-shaped cloud is opaque material silhouetted against the bright disk.

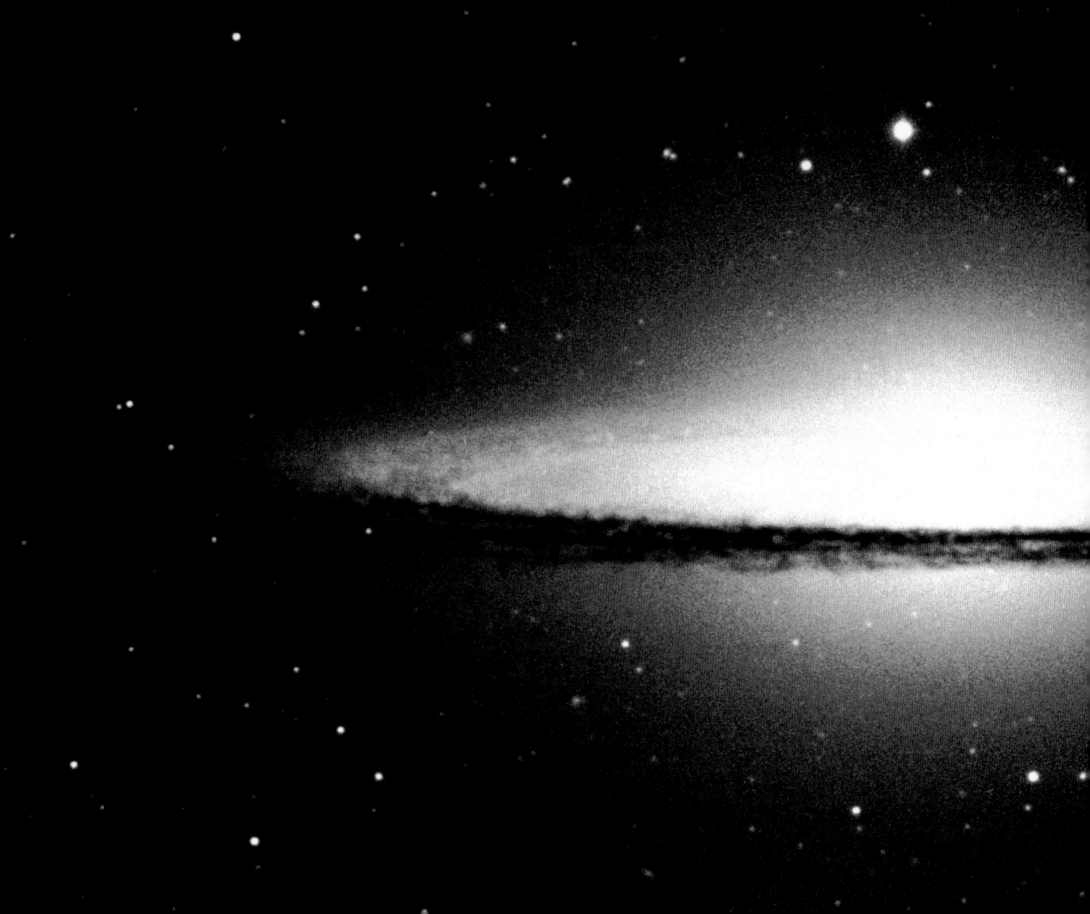

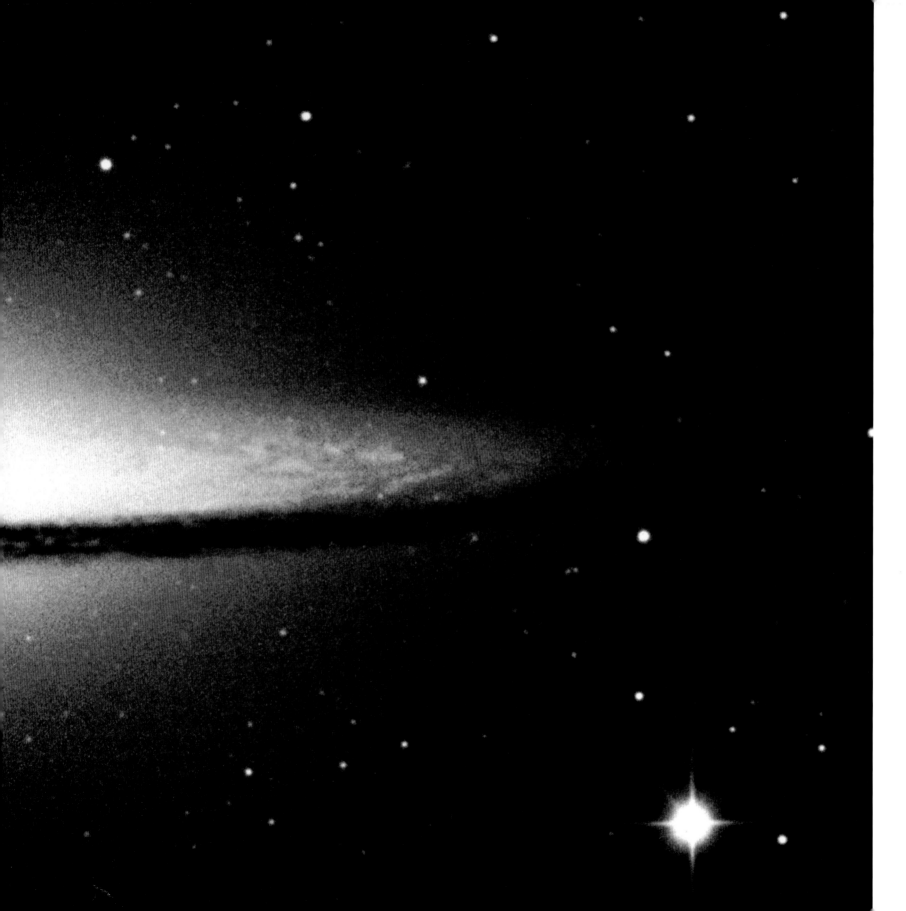

**Sombrero Galaxy
(M104, NGC 4594)**
Resembling a Mexican hat,
the Sombrero is a spiral galaxy
about 30 million light years away.
Its diffuse central bulge is made
up of billions of faint, old stars.
This is an unusually large and
bright example of the cloud of
stars around a nucleus, present
in most spiral galaxies including
the Milky Way. The edge-on view
of M104 shows its dusty outer
rim silhouetted against the
bright centre. This image
was produced by the Anglo-
Australian Observatory.

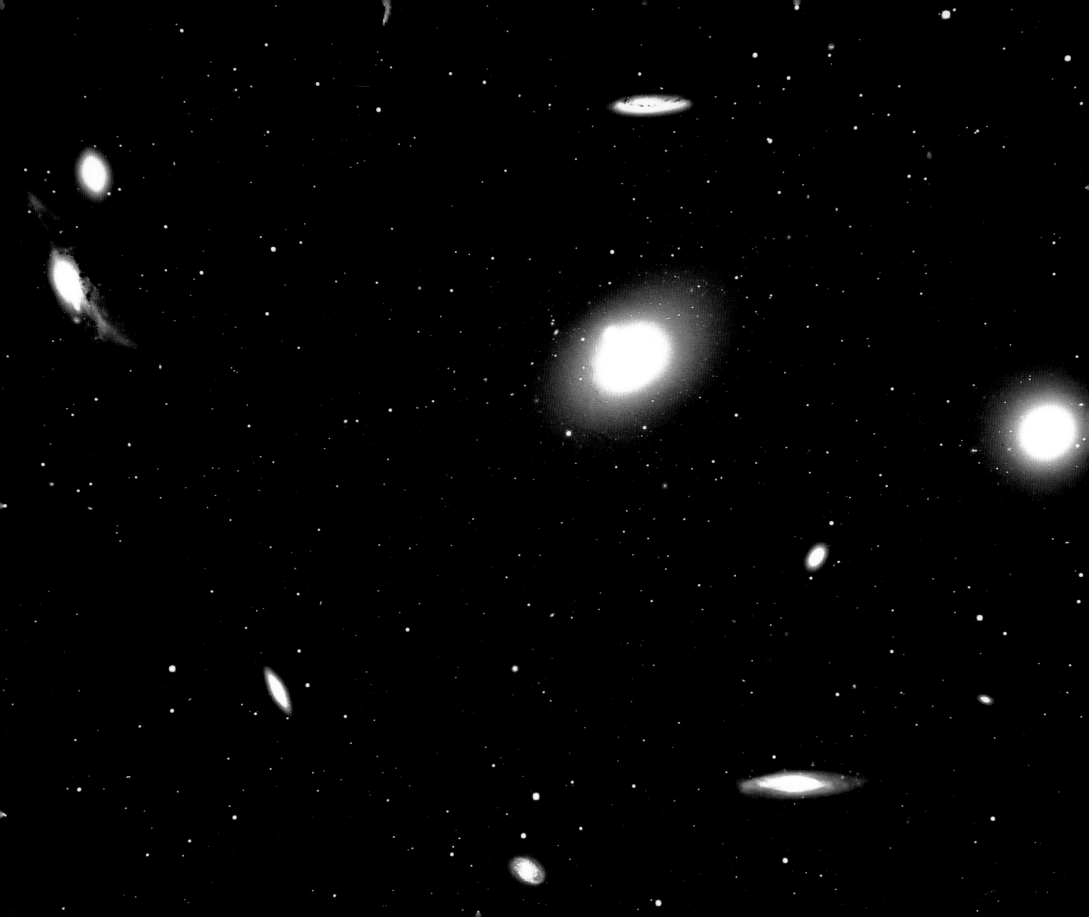

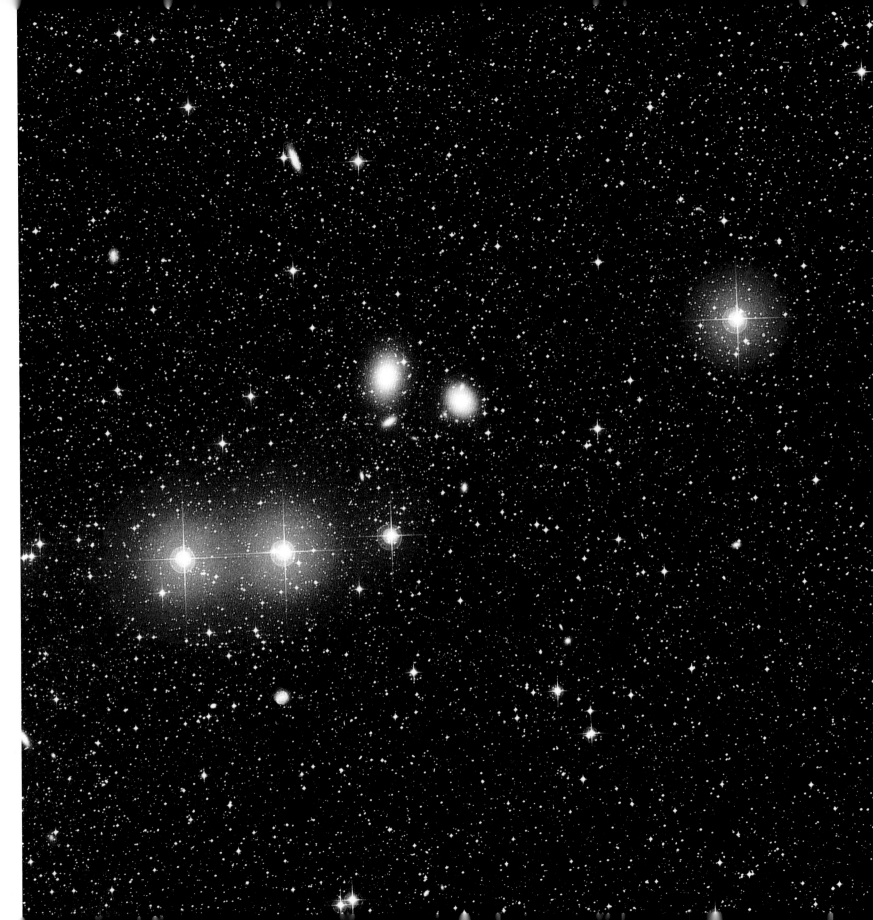

left

Virgo Cluster of galaxies

Matter is not spread evenly
throughout the universe. It tends
to clump together: stars form
clusters in galaxies, galaxies
form galaxy clusters, and galaxy
clusters form superclusters.
This optical photograph from
the 4-metre Mayall Telescope
at Kitt Peak National
Observatory in Arizona shows
part of our nearest galaxy
cluster, the Virgo Cluster.
This galaxy cluster is around
50 million light years away
and appears in the constellation
of Virgo. It contains over
2,000 galaxies in a region that
is 10 million light years wide.
This image includes some
of the brightest galaxies within
the cluster, including M86
(NGC 4406), the elliptical galaxy
just above and to the right
of the centre.

**NGC 5903 and NGC 5898
in Libra**

This image shows two bright
elliptical galaxies (centre, purple),
NGC 5903 on the left and NGC
5898 on the right. These were
amongst the many objects that
the English astronomer William
Herschel (1738–1822)
discovered and catalogued
during his systematic surveys
of the skies. These discoveries
later formed the basis for the
New General Catalogue, which
was published in 1888. These
elliptical galaxies appear in the
constellation of Libra and are
believed to be around 50 to 60
million light years away.

**Giant elliptical galaxy M87
(NGC 4486)**

Forty-one million light years
away, at the dynamic heart
of the Virgo cluster, lies the giant
elliptical galaxy M87. Many times
the mass of the Milky Way,
it appears yellow because
it is made up of mainly old, cool
stars and contains little gas and
dust which lend other galaxies
their red and blue colours.
During the course of its history,
this material has probably been
used up building stars,
suggesting that M87 is more
evolved than the Milky Way.
This image comes from the
Anglo-Australian Observatory.

**Nucleus of the giant elliptical
galaxy M87 (NGC 4486)**
This glowing white and turquoise
plasma jet is 5,000 light years
long. It emerges from an
accretion disk spiralling around
the supermassive black hole,
which lies at the heart of the
giant elliptical galaxy M87
(NGC 4486). The accretion disk
is made of stars, gas and dust
being pulled apart by the black
hole's powerful gravitational
field. As the plasma swirls
inwards at a temperature
of millions of kelvin, the disk
emits narrow jets of synchrotron
radiation from its poles. A similar
mechanism may explain the
galaxy's strong emission of radio
waves and x-rays. This false-
colour image was obtained using
the imaging apparatus called
a charge-coupled device.

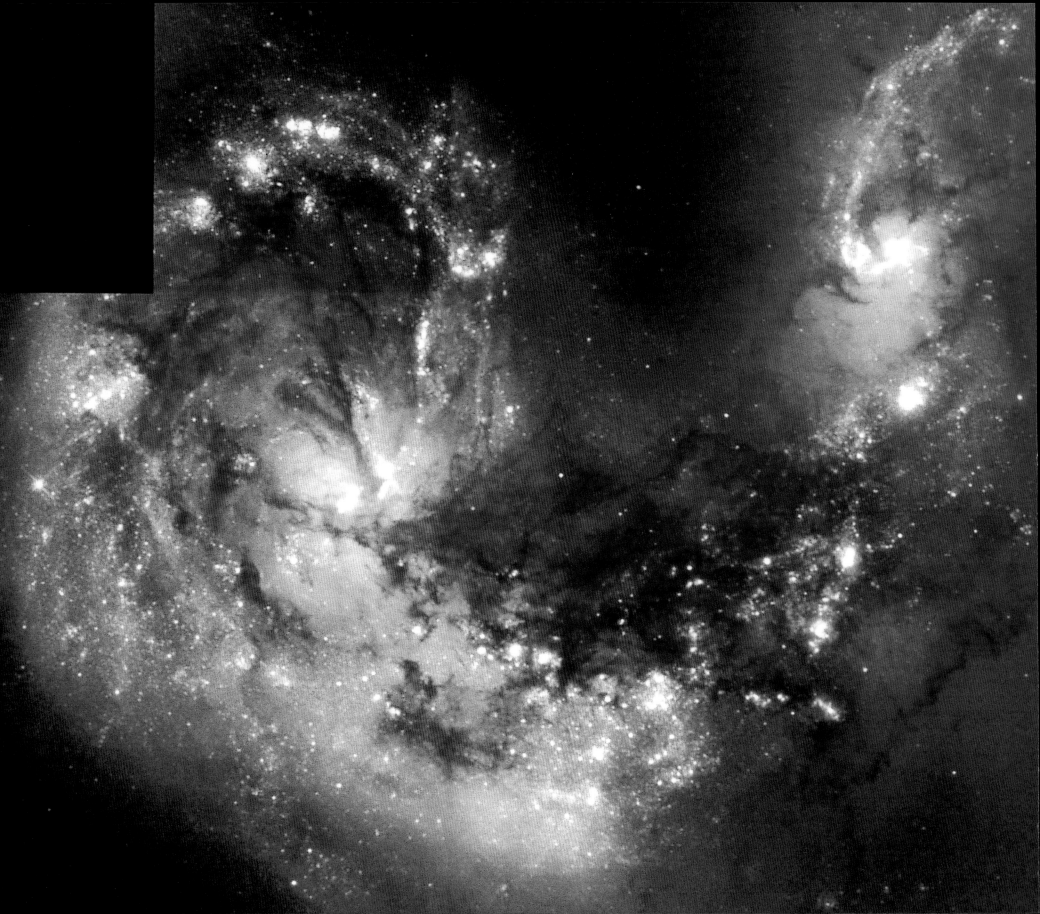

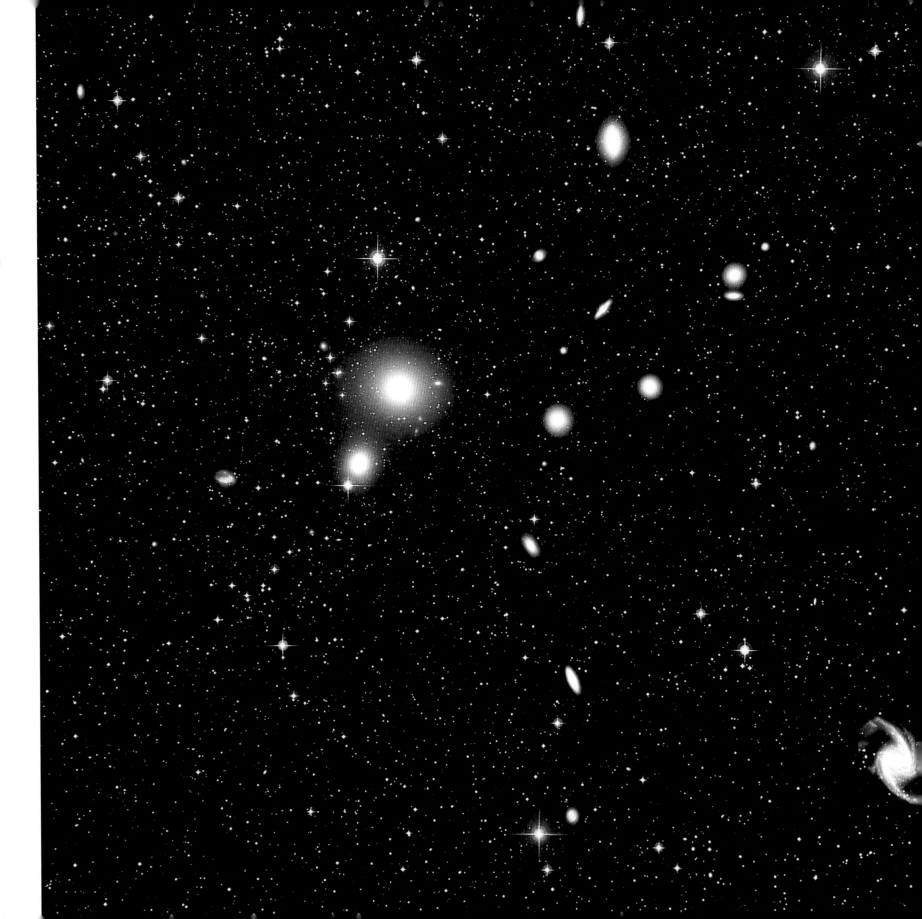

left
Antennae galaxies (NGC 4038 and NGC 4039)
The interaction that produced the antennae (not seen here) after which these two galaxies are named has almost destroyed them. The two original nuclei are visible as yellow blobs, but all other signs of order have vanished. About 63 million light years away, in the constellation Corvus, the interaction has triggered the creation of over a thousand bright young star clusters, which appear white and blue against the abundant clouds of dusty gas. This image was taken by the Hubble Space Telescope.

Fornax galaxy cluster
The cluster of galaxies in the constellation Fornax displays a variety of galaxy types. At the lower right, face-on, is a barred-spiral galaxy (NGC 1365), and near the centre are two bright elliptical galaxies (NGC 1399 and NGC 1404). Named after the small and inconspicuous constellation in which it appears, this cluster lies around 70 million light years away. This optical image was produced by digitally combining photographs taken with blue and red sensitive plates by the UK Schmidt Telescope.

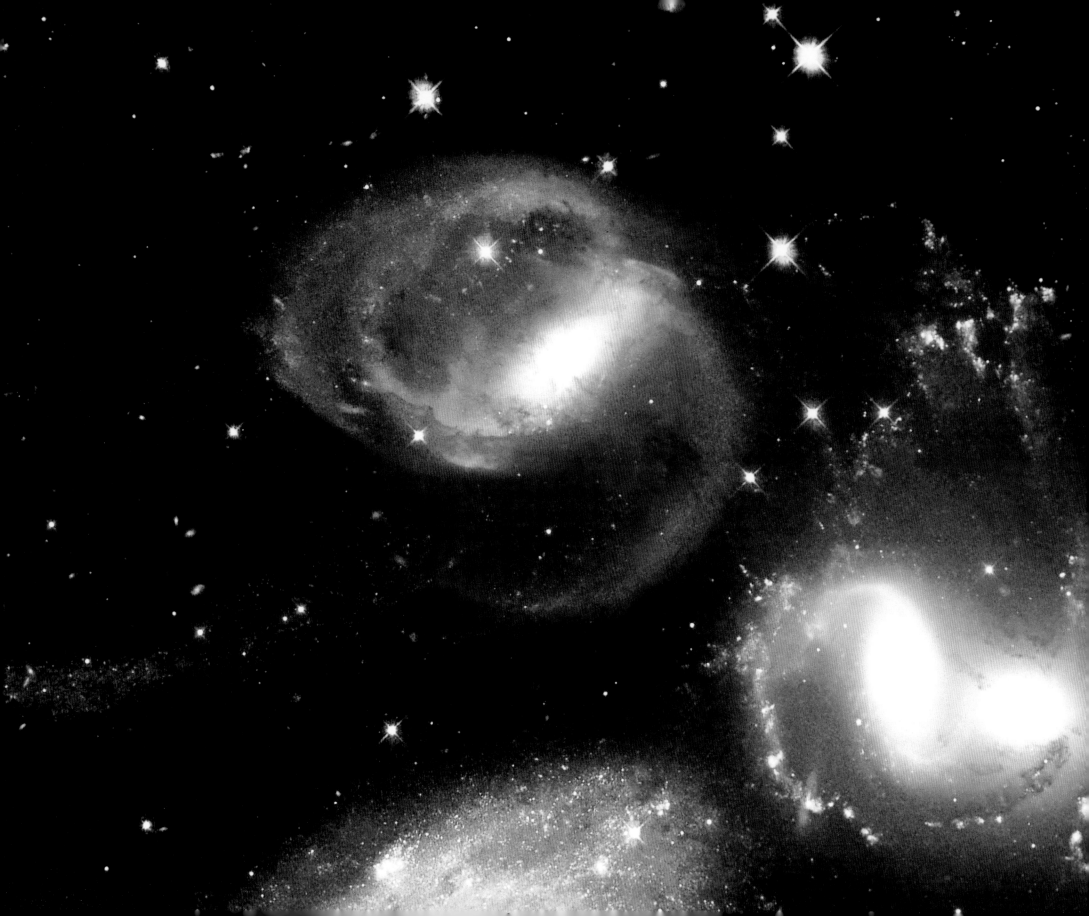

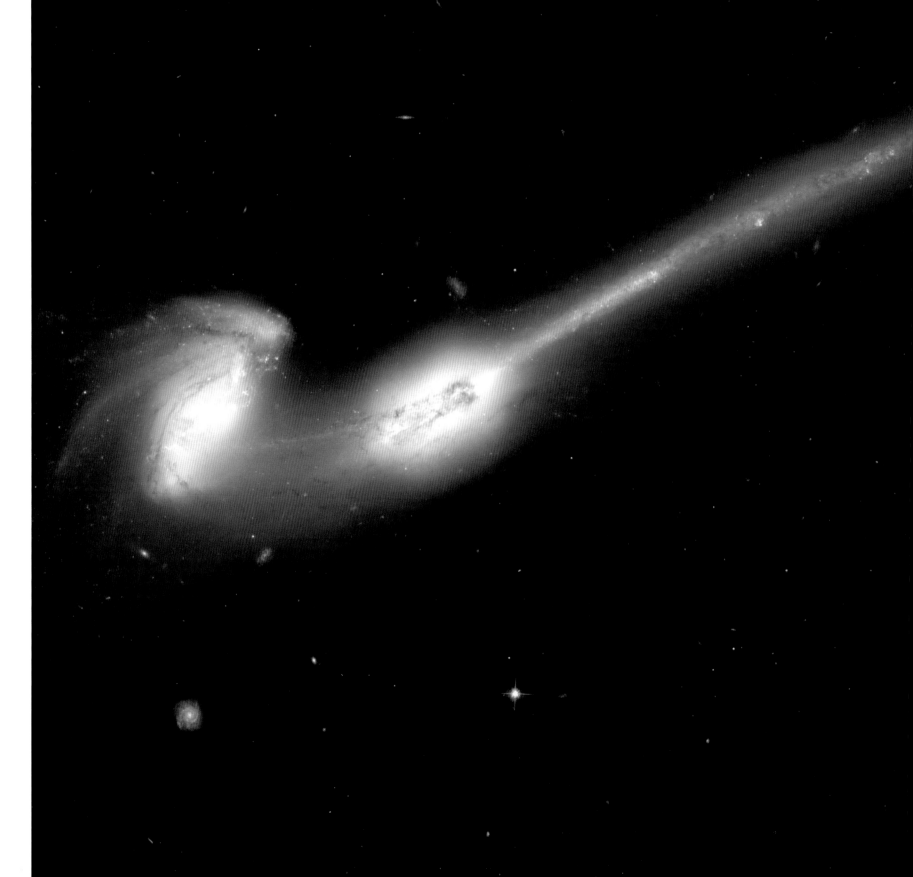

left

Stephan's Quintet

In 1877, when French
astronomer Edouard Jean Marie
Stephan (1837–1923)
discovered his Quintet in the
constellation Pegasus,
he thought he had found
an unusually compact group
of the then-mysterious nebulae.
They are now known to be
galaxies, and this image shows
three of the quintet. Redshift
measurements have shown that
one of the five galaxies is much
closer to Earth than the others,
which are about 250 million light
years away, and merely lies
in the same line of sight.
The remaining four are probably
physically associated and they
should perhaps be renamed
Stephan's Quartet.

**The Mice, colliding galaxies
(NGC 4676)**

Long tails of stars and hot gas
reach far out into space in this
view of two colliding spiral
galaxies, lying 300 million light
years away in the constellation
Coma Berenices. Gravitational
interaction has distorted their
nuclei and triggered the
formation of hot young blue
stars, in the process pulling out
a stream of stars. In 400 million
years' time the two nuclei will
merge completely to create
an elliptical galaxy, with material
from the tails forming globular
clusters and dwarf galaxies
around it. This image was taken
by the Hubble Space
Telescope's Advanced Camera
for Surveys in 2002.

Coma cluster
The Coma galaxy cluster is about
20 million light years in extent
and 350 million light years
distant. It contains over 3,000
galaxies but is dominated by two
bright elliptical galaxies at the
cluster's centre – NGC 4874
(lower right) and NGC 4889
(middle left). Like most rich
clusters Coma is dominated
by galaxies of this type, which
are thought to be the result
of many galactic mergers.
This image was taken using
blue-green, red and near
infrared filters.

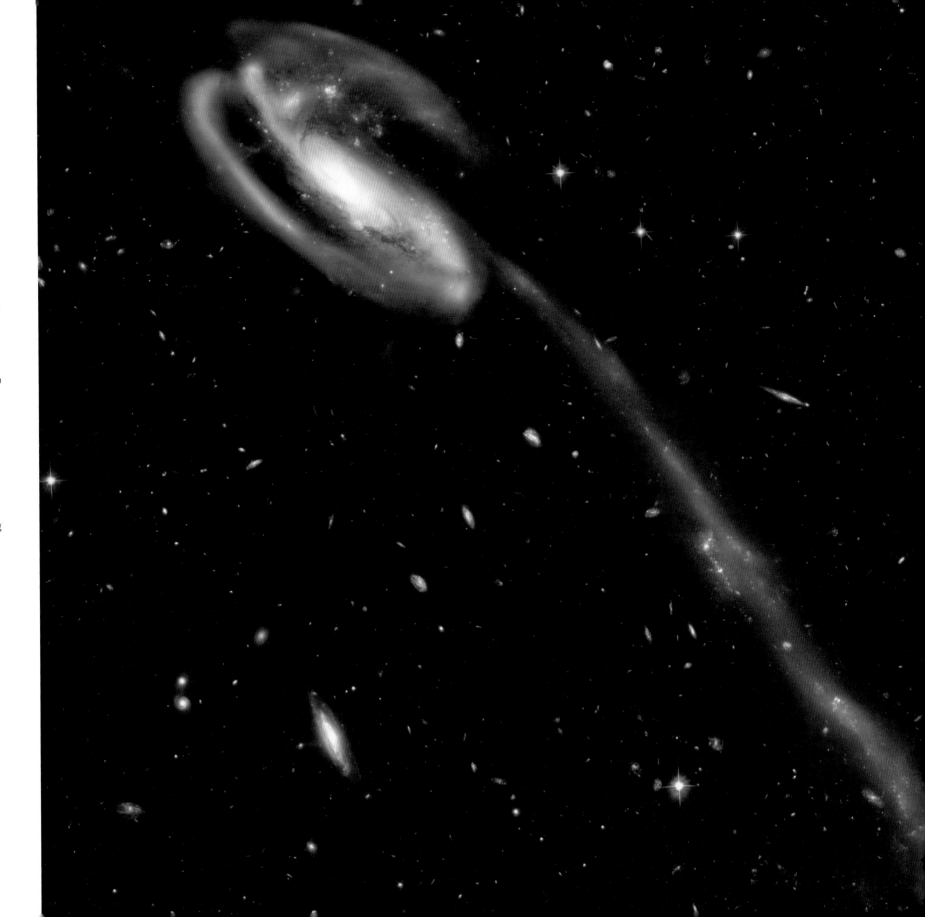

The Tadpole, colliding galaxies (UGC 10214)

Two galaxies are colliding 430 million light years away. The unusual shape of the large spiral galaxy is due to its collision with a small bluish galaxy, seen near the nucleus (upper left part). As with the Antennae galaxies, gravitational forces have created the long, tadpole-like tail of stars and interstellar material and triggered the formation of the huge blue star clusters, massive enough to become small, self-gravitating galaxies or globular clusters. This 2002 optical image of Galaxy UGC 10214 comes from the Hubble Space Telescope's Advanced Camera for Surveys.

Cartwheel Galaxy

The intriguing Cartwheel Galaxy is made up of a ring of young stars connected to a hub by starry spokes. It formed when a dwarf galaxy passed through the middle of a larger spiral galaxy causing it to send out a ripple of energy which triggered an expanding wave of star formation, now 170,000 light years in diameter.

The Cartwheel is part of a group of galaxies about 500 million light years away. This image was made using a charge-coupled device and comes from the Anglo-Australian Observatory.

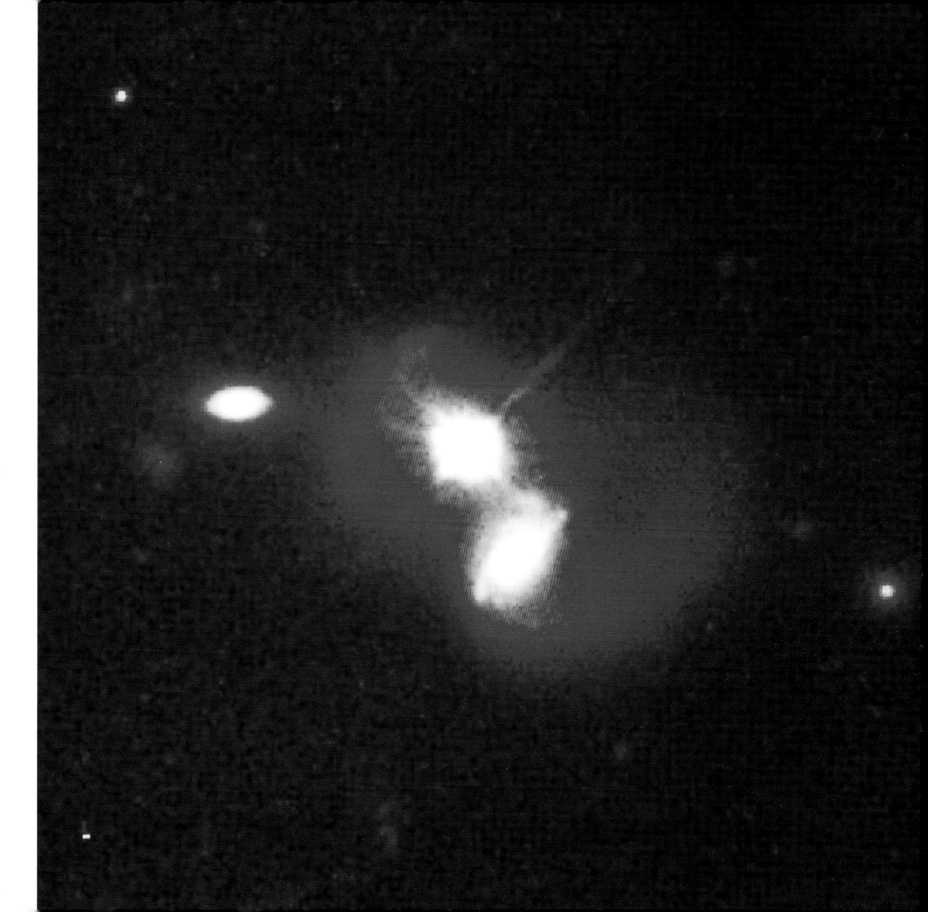

Quasar and companion galaxy
In this optical Hubble Space Telescope image the central bright quasar PG 1021+008 is interacting with a companion galaxy (lower right). Both are 1.6 billion light years away. The name quasar is a contraction of quasi-stellar, given because these objects look rather like stars. Quasars are enormously luminous objects, which allows us to see them across much greater distances than ordinary galaxies. They are believed to be the active nuclei of extremely distant, young galaxies. A disk of captured matter, an accretion disk, emits radiation as it falls towards a central black hole. In this example, the immense gravitational pull of the black hole is also distorting the companion galaxy as it swallows matter from it.

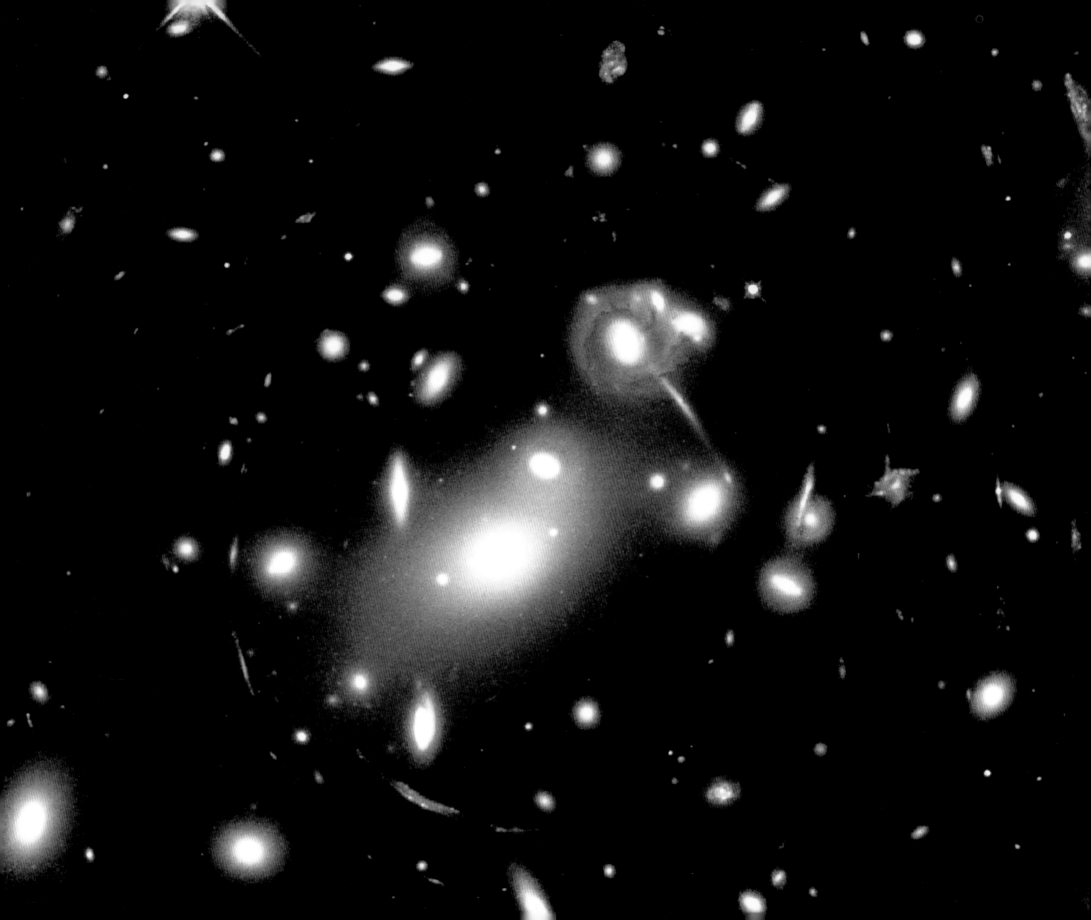

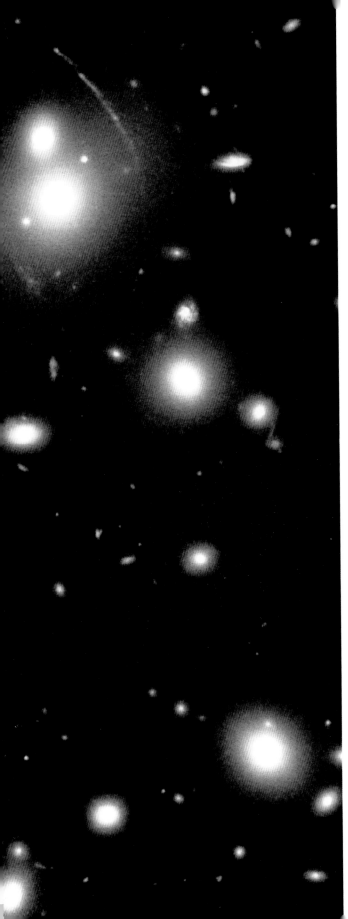

left

Galaxy cluster Abell 2218

This image of a galaxy cluster, two billion light years away, shows the effect known as gravitational lensing. Abell 2218 is so massive that its gravitational field bends the light from objects beyond. Because the cluster's field of gravity is irregular, the lens distorts the background galaxies into multiple bright arcs surrounding it. The galaxies or quasars whose light has been distorted lie five to ten times further away than Abell 2218, near the boundary of the observable universe. The image was taken by the Hubble Space Telescope in 2000.

Quasar radio map

At the top in red, quasar 1007+417 throws out a long plasma jet which ends in a large radio-emitting lobe. Characteristic of quasars, radio jets shoot out from the top and bottom of the great spiralling disk of matter that swirls around the central supermassive black hole. Like all very distant objects, this quasar's light is stretched by the expansion of the universe; the measured redshift suggests that it lies at a distance of four to six billion light years from Earth. This false-colour radio map comes from the Very Large Array Radio Telescope in New Mexico.

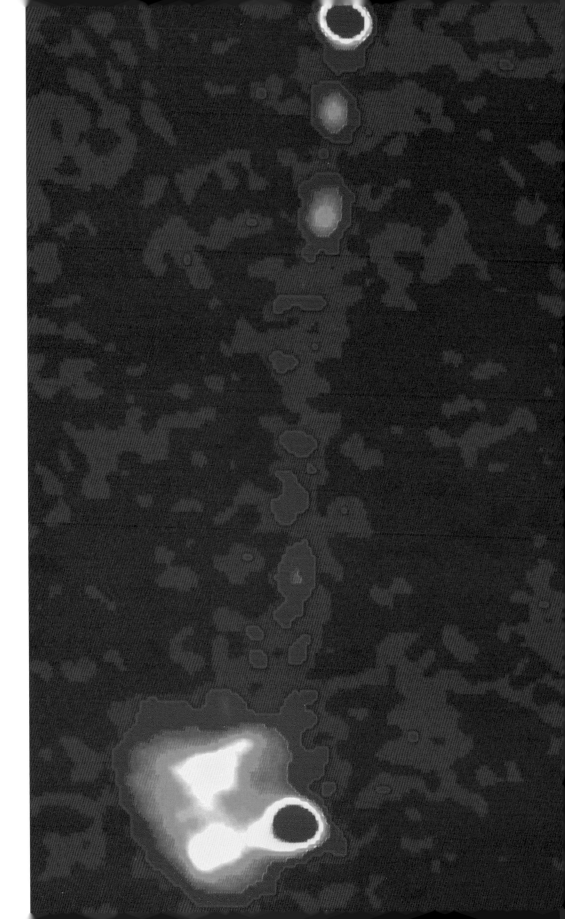

Einstein Cross

This pattern results from a phenomenon known as gravitational lensing. By chance, a galaxy 400 million light years away lies between Earth and a quasar that is eight billion light years away. The galaxy's gravity acts as an enormous but imperfect lens, directing the light from the point-like quasar into separate paths; this results in the four images that surround the image of the galaxy. Here gravitational lensing produces a symmetrical cross shape because the 'lensing' galaxy is almost directly in our sight line to the quasar.

The pattern is named after Albert Einstein (1879–1955), whose theory of relativity predicted this phenomenon. This image comes from the Hubble Space Telescope.

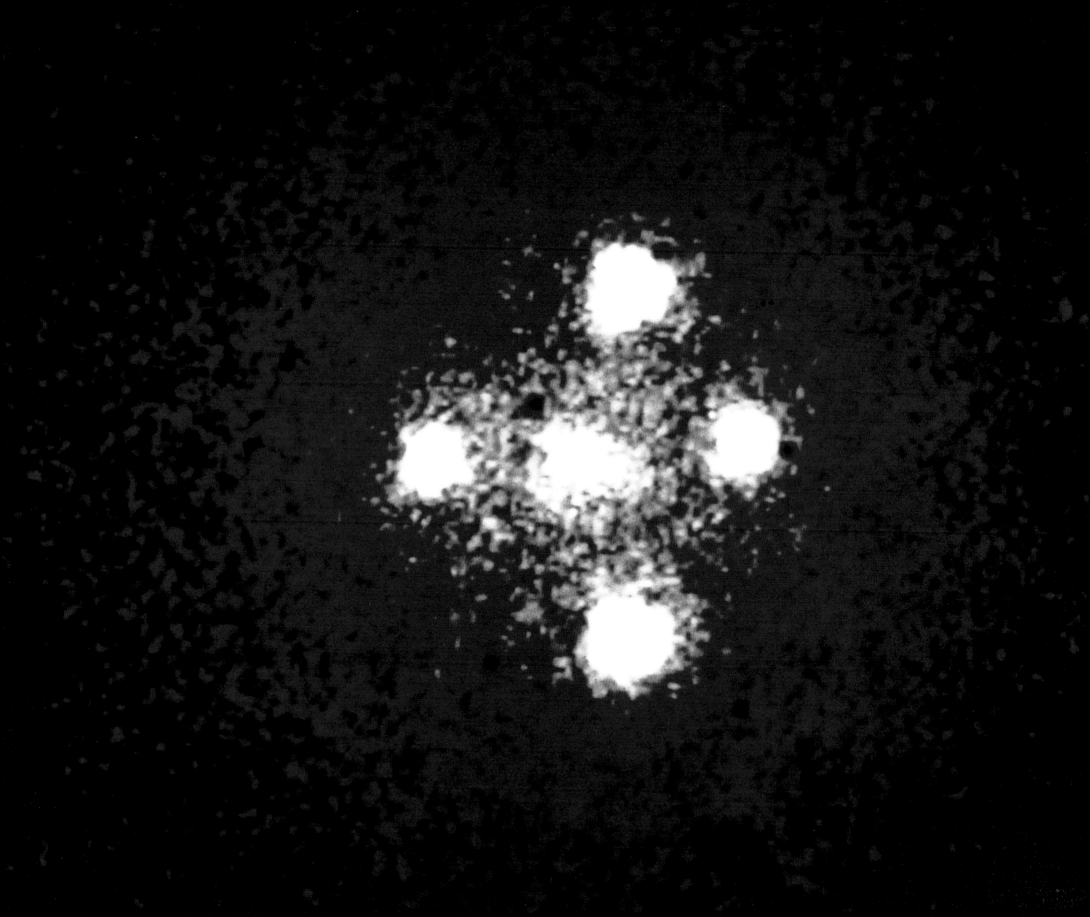

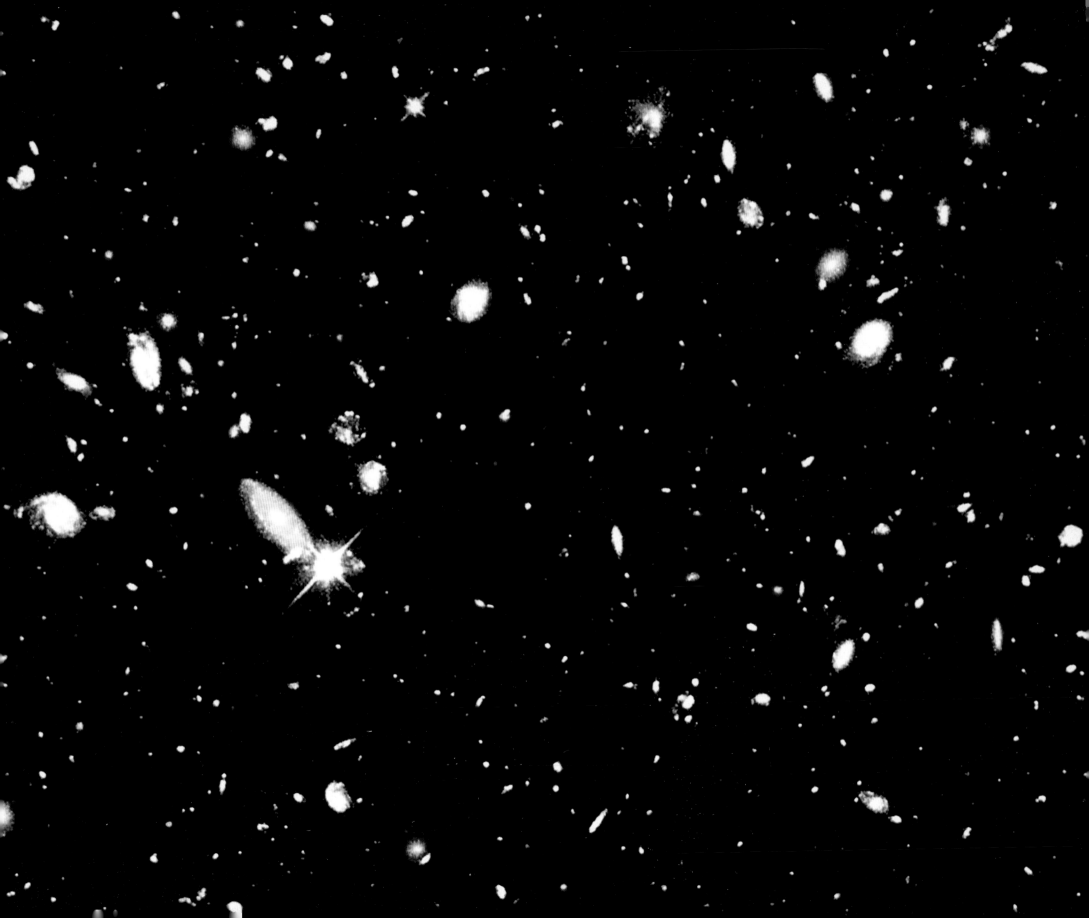

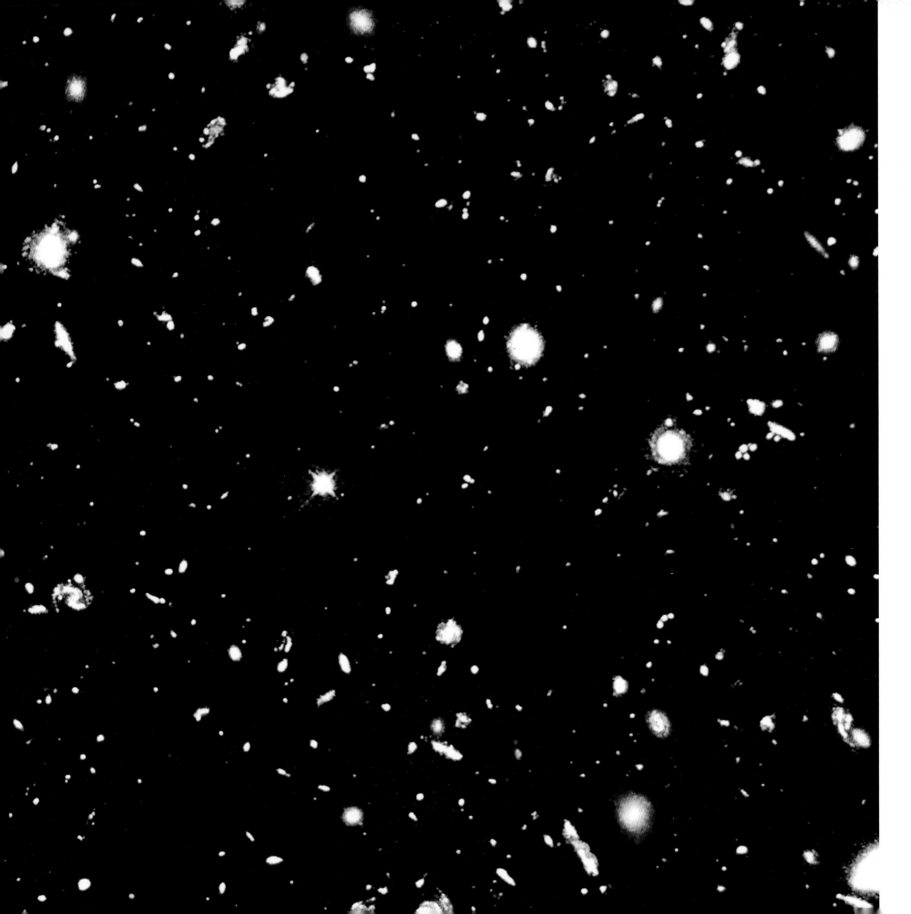

Hubble deep field

One of the most remarkable astronomical images ever made, this Hubble Space Telescope picture reaches deep into space and time. It shows thousands of galaxies in a tiny patch of sky in the constellation Ursa Major. The most distant objects here are small blue irregular clouds, which lie close to the edge of the observable universe. Their light began its journey through space over 10 billion light years ago, so we see the clouds as they were when the universe was only about a tenth of its present age. They are small and immature, lacking the structure and shape of most of today's familiar galaxies. The bigger and brighter galaxies in the picture are closer, and so we see them at a much later stage in their evolution. These represent essentially what the universe looks like today. Looking into space is equivalent to looking back in time, as the further away objects are, the longer it takes for their light to reach Earth. Light from objects further away than about 12 billion light years has not had time to reach Earth yet as the universe has not existed for long enough. The edge of the observable universe is defined by the travel time of light rather than any physical boundary.

Glossary

Accretion disk

A disk-shaped cloud of gas that forms around a dense object, such as a black hole or neutron star, from matter that is pulled in towards it.

Amino acid

Any of a group of organic compounds that consist of both a carboxyl group and an amino group attached to the same carbon atom. Amino acids are the building blocks of proteins and they are involved in a huge variety of biochemical reactions.

Amoeba

A single-celled creature which has a distinct nucleus and other organelles, with a thin cell membrane. Amoebae are characterized by foot-like appendages called pseudopodia which are used for feeding and locomotion, resulting in a constantly changing body shape. Amoebae are classified as belonging to the group Protozoa, which includes Radiolaria and Foraminifera.

Angiography/angiogram

See Arteriography.

Anglo-Australian Observatory (AAO)

An observatory which is jointly owned and operated by the UK and Australia. It is located at an altitude of 1,150 metres on Siding Spring Mountain near Coonabarabran, New South Wales, and its headquarters are in Epping, New South Wales. It has two main telescopes, a 3.9 metre reflector (the Anglo-Australian Telescope) and a 1.2 metre Schmidt Telescope (the UK Schmidt Telescope).

Anglo-Australian Telescope (AAT)

A 3.9 metre reflector telescope which opened in 1974 at the Anglo-Australian Observatory. See Anglo-Australian Observatory and Telescope.

Apollo programme

The Apollo programme began in 1961 and set out to take humans to the Moon. Manned Apollo missions ran from 1967 to 1972, and six Apollo missions had successful moon landings. The programme has generated a wealth of scientific data and returned some 400 kilograms of lunar rock samples to Earth. It also provided some of the most memorable television footage ever produced when the US astronaut Neil Armstrong (1930–) first walked on the Moon on 20 July 1969, during the Apollo 11 mission.

Arteriography

A form of x-ray photography which allows the imaging of blood vessels within the human body. Although soft tissue and body fluids are transparent to x-rays, chemical compounds that are opaque to x-rays can be injected into the bloodstream, making them visible to x-rays. Arteriography, which is also known as angiography, is commonly used to look for the blockages and constrictions in the arteries that are associated with heart disease. The images produced by arteriography are known as angiograms.

Asteroid

One of the many small rocky or metallic objects in the solar system, most of which orbit the Sun in a zone that lies between Mars and Jupiter, known as the asteroid belt. The smallest asteroids are about 10 metres across while the largest are about 1,000 kilometres across. Asteroids rotate about an axis, typically over six to 24 hours, and some even have satellites of their own. They are believed to have formed by accretion of smaller bodies during the early stages of the solar system's evolution, but were prevented from joining together to form a planet (like Mars, Earth, Venus and Mercury) by the gravitational pull of Jupiter which had already formed nearby. Almost all asteroids are fragments of larger bodies, broken apart by frequent collisions during their 4.6 billion year existence.

Astronomical unit (AU)

A unit of length. Originally defined in 1672 by the Italian-born French astronomer Giovanni Domenico Cassini (1625–1712) as the mean distance between the Earth and the Sun. One astronomical unit is equivalent to 150 million kilometres.

Atom

The smallest unit of a chemical element; the building block of all materials. Atoms consist of a central nucleus, made up of positively charged protons and (sometimes) electrically neutral neutrons. The positive charge of the nucleus is balanced by a surrounding cloud of negatively charged electrons. Atoms join together to form molecules. The diameter of an atom in a crystal structure is commonly a few tenths of a nanometre.

Aurora Borealis/Aurora Australis

Also known as the Northern (and Southern) Lights, aurorae appear in the Earth's polar regions as displays of coloured, moving light and are most clearly seen at night. They result from the interaction of charged particles in the solar wind with the Earth's atmosphere. The Earth's magnetic field channels charged particles emanating from the Sun towards the poles. There, collisions between the particles and the molecules that make up the Earth's atmosphere cause emissions of energy in the form of light.

Bacterium

A single-celled organism possessing genetic material and a cell membrane, but lacking a true nucleus and other organelles. Bacteria reproduce by division, typically every 20 minutes, and rapid growth of bacterial colonies inside the body can cause disease. However, the vast majority of the billions of bacteria present in the human body are not harmful, and many are beneficial. Bacteria also occupy a vast range of other environments and include some species that are tolerant of extreme conditions, such as the high temperatures of hot springs. See Cell.

Billion

1×10^9; one thousand million (1,000,000,000).

Binary star

A pair of stars locked in orbit around each other by their mutual gravitational attraction. Their orbits can take from minutes to hundreds of years to complete.

Black hole

An extremely dense object whose gravitational pull is so strong that even light cannot escape from it. Black holes therefore cannot be observed directly, but their presence is inferred from the behaviour of material nearby: material spirals rapidly around a black hole, trapped by its gravity before disappearing over the event horizon, beyond which nothing can escape. One of the ways in which they are believed to form is when a massive star collapses at the end of its life.

Bright-field microscopy

A form of optical microscopy in which the object is viewed using light transmitted directly through the object from below. This technique is commonly used to study living cells. See Light microscope.

Bubble chamber

A device used in high-energy physics for detecting and tracking small charged particles. Liquid is heated to above its boiling point in a sealed tank. The passage of small charged particles through the superheated liquid causes ionization of the molecules making up the liquid, which induces boiling (the conversion of the liquid to a gas). The formed bubbles can be photographed, recording tracks made by the particles. Bubble chambers were superseded by particle colliders during the 1970s.

Caldera

A large crater caused by volcanic activity. Many volcanoes have a caldera at their summit. In dormant volcanoes the caldera is often flooded to form a lake.

Capsid

The protein coat that surrounds and protects viruses.

Cell

The basic structural and functional unit of life. Only a few types of life, such as viruses, are not cellular. Most cells are microscopic, ranging in size from 0.01 to 0.1

millimetres in diameter. Cells can exist as independent life forms, as in bacteria and protozoa, or they can live in groups called colonies, as in some algae. They can also combine with many similar cells to form tissues, as they do in higher plants and animals. A single cell consists of a mass of protein which is differentiated into cytoplasm and nucleoplasm, the latter containing the genetic material. The cell is held together by a cell membrane and – in the case of plants, fungi, bacteria and algae – a tough outer cell wall. There are two main types of cell: the more primitive prokaryotic cells (bacteria are of this type) and the more complex eukaryotic cells (all other organisms are made up of this type). See Bacterium and Organelle.

Chandra X-ray Space Telescope

A NASA x-ray telescope in orbit around Earth, launched by the Space Shuttle Columbia in July 1999. It is designed to observe x-rays from high energy regions of the universe such as neutron stars, black holes and other remnants of exploded stars. It is operated from the Chandra X-ray Center at the Smithsonian Astrophysical Observatory in Cambridge, Massachusetts. See Telescope.

Charge-coupled device (CCD)

A device used for capturing images that consists of a silicon chip containing an array of light-sensitive diodes. The diodes become charged when light falls on them, the amount of charge being dependent on the amount of light each is exposed to. The charges, which form an analogue signal, are converted to digital form for storage and display on a computer. More sensitive to light than photographic emulsion, they are used widely by both amateur and professional astronomers to capture images.

Chloroplast

The organelle responsible for photosynthesis in plant cells. See Cell and Organelle.

Chromosome

A twisted thread of deoxyribonucleic acid (DNA) found in the nucleus of plant and animal cells. They bear the genes, which determine an individual organism's characteristics. These genes are each made up of a specific sequence of nucleotides (the molecules that make up DNA) at a particular site on a chromosome. Humans have 46 chromosomes in all cells apart from reproductive cells, which have half that number.

Comet

A small body of rock and ice in orbit around the Sun. Many comets have long, highly elliptical orbits which take them out to the farthest reaches of the solar system and take decades to complete. Each year about 25 comets can be seen from Earth through telescopes as their orbits take them past the Earth and Sun, but only a few of these are bright enough to see with the naked eye. There are about 900 known comets, three-quarters of which are long-period comets (with an orbital period of more than 200 years). They are named after their discoverers, who are often amateur astronomers. Comets are believed to be icy planetesimals, left over from the formation of the solar system's outer planets.

Computed tomography (CT scan)

Tomography is the term used for any method that produces images of single planes through body tissue. Computed tomography is an x-ray technique that rotates an x-ray source about the patient. Electronic sensors arranged in a tube around the patient detect the x-rays that pass through the body. Complex computer algorithms convert this data into a three-dimensional map of density variations within the body. CT scans, like MRI scans, allow doctors to 'see inside' a patient in three dimensions with millimetre precision. CT, also referred to as computerized axial tomography (CAT scan), was introduced in 1972. A more recent development in CT technology is the helical scanner, which consists of a continuous spiral of sensors. This provides much higher resolution than was possible with the conventional CT scanners.

Constellation

A group of stars that together form a recognizable shape, named after the real and mythological characters or inanimate objects they resemble. Common examples are Taurus (the Bull), Ursa Major (the Great Bear), Orion the Hunter, and Crux (the Southern Cross). The constellations provide a good basis for subdividing the celestial sphere, for the purpose of locating and identifying objects, since on human timescales they are effectively permanent features of the night sky. The stars in a constellation lie at very different distances and are not genuinely associated with each other; their association is merely an artefact of line of sight. The sky is divided into 88 areas based on a group of 48 figures listed by the Egyptian astronomer and geographer Ptolemy in the 2nd century AD, and further figures identified later on. The brightest stars in a constellation are identified with a Greek letter (or sometimes a number) and the genitive case of the constellation's name. For example, Alpha Centauri is the brightest star in the constellation Centaurus and Eta Carinae is the fifth brightest star in the constellation Carina. Nebulae are also often named after the constellation in which they appear: the Orion Nebula is a famous example.

Corona

The atmosphere of extremely hot (2 million kelvin), highly ionized gas that surrounds the Sun and extends millions of kilometres into space. It displays loops and jets of glowing plasma following the lines of the Sun's magnetic field. The overall shape of the corona is determined by the Sun's magnetic field.

Cortex

In general, an outer layer or rind. An example is the outermost layer of human hair, which is strengthened with the protein keratin.

Crystal

A solid structure in which atoms are arranged in a regular pattern. Many solids form crystals whose shapes reflect their atomic structure. For example, the cubic shape of crystals of table salt reflects a cubic packing system of the sodium and chlorine atoms within. Similarly, the flat shape of mica crystals is the result of a crystalline structure composed of loosely bound flat sheets of atoms. See Atom.

Cyclone

An area of low atmospheric pressure, around which winds rotate, anti-clockwise in the northern hemisphere and clockwise in the southern hemisphere. They are more commonly referred to as depressions or lows. See Tropical cyclone.

Cytoplasm

The transparent, thick fluid that fills the bulk of cells. Many important cellular reactions, such as protein synthesis, occur within the cytoplasm. See Cell.

Dark-field microscopy/illumination

A type of optical microscopy in which the lighting is arranged to produce an illuminated object set against a dark background. This technique is commonly used in high-resolution microscopy as it helps to pick out very fine details. See Light microscope.

Dark nebula

See Nebula.

Dentine

A bone-like material that is the main constituent of teeth. It is permeated with a network of tunnels which carry blood vessels and nerve fibres.

Earth

The third planet from the Sun, orbiting at a mean distance of 150 million kilometres. It is not quite spherical, being flattened at the poles. With a diameter of 12,756 kilometres, Earth is similar in size to Venus. Its atmosphere is composed of 78 per cent nitrogen, 21 per cent oxygen and 0.9 per cent argon, by volume, with carbon dioxide, hydrogen and other gases present in small quantities. The atmosphere and vast oceans on Earth make the planet appear predominantly blue from space and white clouds of condensed water vapour often obscure large areas of its surface. The average surface temperature is 15 degrees Celsius, ranging from minus 50 degrees in the Siberian winter to 40 degrees Celsius in the Saharan summer. Such equable temperatures allow liquid water to exist at the surface, and water covers 71 per cent of the Earth. The presence of water allowed the development of life, which has itself greatly modified the environment over its 3.5 billion year presence on Earth. The Earth's solid outer shell is called the lithosphere, which has the crust on top, and is divided into large plates whose movement results in volcanism, mountain-building and earthquakes (see Plate tectonics). Below the lithosphere is the more viscous asthenosphere, over which the plates ride, and below this the iron-nickel core. The Earth has one natural satellite, the Moon. See Planet.

Eclipse

An eclipse is the passing of one celestial body in front of another. For example, a solar eclipse occurs when the Moon passes directly between the Sun and the Earth, causing a shadow to pass over the Earth's surface.

Ejecta

The material, for example rocks, thrown up by an explosion such as that caused by a meteorite impact or a volcanic eruption.

Electromagnetic radiation

Energy that travels through space as waves (or particles) at the speed of light (2.9979×10^8 metres per second or 299 million metres per second). The light detected by our eyes is a small part of the wide range of radiation that makes up the electromagnetic spectrum. The type of radiation and its properties depend on its wavelength. Visible light lies in the middle of this spectrum of wavelengths. Infrared, micro waves and radio waves have longer wavelengths while ultraviolet, x-rays and gamma rays have shorter wavelengths. None of these are visible to humans, but a range of detectors exist to record their presence, allowing us to see them by converting the radiation into visible colours. Images formed at these otherwise invisible wavelengths are very informative and expand our knowledge of the universe far beyond what we could learn using the naked eye alone.

Electromagnetic spectrum

The range of wavelengths over which electromagnetic radiation extends. The spectrum is divided into: radio waves (wavelengths from several kilometres to about 30 centimetres); microwaves (30 centimetres to one millimetre); infrared (one millimetre to 700 nanometres); visible light (700 nanometres to about 380 nanometres); ultraviolet (380 nanometres to 60 nanometres); x-rays (60 nanometres to 100 femtometres); and gamma rays (wavelengths less than 100 femtometres).

Electron microscope

A microscope that employs a beam of electrons, in place of the beam of light that optical microscopes use, to magnify very small objects. The beam is focused by magnetic fields (generated by so-called 'electron lenses') instead of glass lenses, and the image is viewed on a fluorescent screen or TV monitor. The first electron microscopes were developed in the 1930s. See Scanning electron microscope, Transmission electron microscope and Scanning tunnelling electron microscope.

Element

A substance that cannot be subdivided by chemical methods. Elements differ in the number of neutrons and protons contained in the nucleus of their atoms: hydrogen has one proton, helium has two, lithium three, and so on. The further subdivision of atoms into smaller particles is the domain of sub-atomic physics rather than chemistry. There are 92 naturally occurring elements, which are classified in the periodic table.

Elliptical galaxy

A type of galaxy with a smooth circular or elliptical appearance, no spiral arms and little interstellar gas or dust. Elliptical galaxies consist mainly of old stars and contain abundant globular clusters. They range in size from a thousand light years in diameter (dwarf ellipticals) to more than 100,000 light years in diameter (giant ellipticals). See Galaxy.

Emission

The release of a photon (the smallest 'particle' of light) from an atom.

Emission Nebula

See Nebula.

Endoscopy

The imaging of the interior of the human body using a miniature television camera mounted on a movable rod-like device called an endoscope, which can be inserted into the body. This imaging technique enables the investigation of the body's interior with minimal surgical intervention.

European Space Agency (ESA)

A group of European countries for cooperation in space research and technology. The ESA headquarters is in Paris.

Excitation

The process in which an atom, nucleus, electron, ion or molecule absorbs energy that raises it to a higher quantum state than that of its lowest stable energy state or ground state. On returning to the ground state, the energy is released as radiation.

Excited atoms

See Excitation.

Femtometre (fm)

10^{-15} metres. See Metric system.

Fibrin

The fibrous protein made in the blood at the site of an injury. A tangled mass of fibrin forms the basis of blood clots.

Flagellum (plural flagella)

A long, fine, tail-like protrusion from some cells. Sperm cells are a familiar example of a cell with a flagellum. In this case, as in most, the flagellum is used for movement, allowing the sperm to swim.

Galaxy

The principle visible structures of the universe, galaxies are systems of stars, often with interstellar gas and dust, bound together by gravity. They range in size from a few hundred to 600,000 light years in diameter, the smaller ones with less than a million stars, the largest with a million million stars. Galaxies are classified according to their shape, and can be spiral (with arms), elliptical (without arms) or irregular. Within these broad categories, spiral and elliptical, they are further divided according to their shape and the presence or absence of gas and dust. See Local Group, Galaxy cluster and Galaxy supercluster.

Galaxy cluster

An aggregation of galaxies. Galaxies are not scattered evenly throughout the universe but are grouped in clusters and superclusters. Cosmologists suggest that these clusters form the fundamental units of even larger-scale chains or filaments which surround voids where galaxies are scarce. The Earth's galaxy, the Milky Way, belongs to a rather small cluster of 31 galaxies known as the Local Group, but some clusters, such as the Abell Cluster, can be very dense and contain thousands of galaxies. See Local Group.

Galaxy supercluster

A group of galaxy clusters. For example, the Virgo supercluster (sometimes known as the local supercluster) has the Virgo Cluster of galaxies at its centre and includes the Local Group near its edge. It has a flattened shape, is probably 100 million light years across and contains at least 100,000 galaxies. See Galaxy cluster and Local Group.

Galileo space probe

A NASA space probe, launched in October 1989, sent to orbit Jupiter. It encountered and photographed two asteroids en route, Gaspra in 1991 and Ida in 1993, before arriving at Jupiter in December 1995. The main

spacecraft orbited Jupiter for two years, surveying the planet's weather systems and satellites. It also sent a smaller probe down into Jupiter's hostile atmosphere, which managed to transmit data for 58 minutes before breaking down.

Gamma rays

Electromagnetic radiation with a wavelength of less than 100 femtometres. This is the most powerful radiation in the electromagnetic spectrum. See Electromagnetic spectrum.

Geostationary Operational Environmental Satellite (GOES)

A series of US weather satellites used to monitor conditions over the USA and eastern Pacific. The basic instrument used in a GOES is a radiometer, which senses infrared radiation emitted from clouds and the surface of the Earth. The GOES system is also used to coordinate search-and-rescue missions across the area of coverage.

Geostationary orbit

Objects placed in orbit at different altitudes above the Earth move at different speeds relative to the Earth's surface. A geostationary orbit is achieved at 36,000 kilometres above the Earth, where objects move at a rate that exactly matches the speed of the daily rotation of the Earth about its axis. This means that satellites can be positioned so they appear to hover over a fixed spot. Many weather and telecommunications satellites are in geostationary orbit.

Giotto space probe

A probe launched by the European Space Agency in July 1985 to intercept Halley's Comet. On 14 March 1986 it passed within 600 kilometres of the comet's nucleus, taking close-up images and analysing its gas and dust. Giotto survived this encounter and was redirected to study Comet Grigg-Skjellerup, which it passed at a distance of 200 kilometres in July 1992.

Globular cluster

A dense group of old yellow stars in the outer regions of a galaxy. All large galaxies have them, and they are most abundant around giant elliptical galaxies. Globular clusters contain tens to thousands of millions of stars and range from 100 to 300 light years across. Stars are most concentrated near the centre and less dense towards the edge. There are about 140 known globular clusters in the Milky Way, orbiting around it, and they formed early in the galaxy's history.

Halo

The galactic halo is a sphere of material around a galaxy, which includes globular clusters and highly ionized, high-temperature gas.

Hubble Space Telescope (HST)

Named after the US astronomer Edwin Powell Hubble (1889–1953), the Hubble Space Telescope has provided some of the clearest and most detailed views of our galaxy, and those beyond, since its launch in 1990. In orbit 600 kilometres above the Earth's surface it avoids the problem of clouds, smog, light pollution and other atmospheric distortions suffered by Earth-bound telescopes. It is also able to take images using wavelengths to which the Earth's atmosphere is opaque, such as x-rays. It was built by NASA and the ESA, and carries many different instruments including the Wide Field and Planetary Cameras and the Advanced Camera for Surveys.

Hurricane

The name given to a tropical cyclone in the North Atlantic and eastern Pacific. See Tropical cyclone.

Hydrogen

The lightest and most abundant element in the universe, making up some 73 per cent of its mass. A hydrogen atom consists of one proton and one electron. In the Earth's atmosphere it exists as a colourless, odourless gas in minute quantities, only 0.00005 per cent by volume. It is the main fuel of Sun-like stars and the dominant component of the atmosphere of gas giants and of interstellar gas clouds.

Hypergiant star

A star whose mass is more than 30 times that of the Sun. See Supergiant star.

Immunofluorescent microscopy

A means of imaging different kinds of cells in the human body that otherwise would appear similar under a microscope. Antibodies are 'tagged' with a compound which fluoresces (emits light) when exposed to ultraviolet light. The antibodies are capable of chemically identifying different tissues, which they attach themselves to. This enables microscopists to highlight the tissues they are interested in. See Light microscope.

Infrared radiation

Infrared radiation has longer wavelengths (one millimetre to 700 nanometres) than visible light and cannot be detected by the human eye. Infrared-sensitive detectors convert these wavelengths into visible wavelengths, and these images can have a number of uses. Warm objects emit infrared radiation, and infrared cameras are used to detect people trapped inside collapsed or burning buildings. Satellites such as the Landsat and SPOT families generate infrared images which often show land surface features more clearly than visible light images. See Electromagnetic radiation and Electromagnetic spectrum.

International Space Station

The largest international science project ever attempted, involving 16 countries in the construction of a 100 metre long space laboratory orbiting 400 kilometres above the Earth. The first section was launched by Russia in 1998 and subsequent sections have been added, the most recent in April 2002. Scientific work taking place on board includes experiments on the effects of microgravity on life forms, pharmaceutical synthesis, and materials science.

Ion

An atom that has lost or gained one or more electrons. See Atom and Ionization.

Ionization

The process by which an atom loses or gains electrons. This occurs at high temperatures, under bombardment by high energy particles or when the atoms are exposed to short-wavelength radiation such as ultraviolet and x-rays. See Atom.

Isaac Newton Telescope (INT)

A 2.5 metre reflector telescope at the Roque de los Muchachos Observatory on La Palma in the Canary Islands. It is jointly operated by the UK and the Netherlands and has been situated on La Palma since 1984. Between 1967 and 1979 the Isaac Newton Telescope was located at Herstmonceux in Sussex, UK. See Telescope.

Jupiter

In orbit at a mean distance of 770 million kilometres, Jupiter is the fifth planet from the Sun. It is the largest planet in the solar system, with a diameter of 142,984 kilometres and a mass two and a half times greater than all the other planets put together. Jupiter has a thick atmosphere, of about 90 per cent hydrogen and 10 per cent helium with traces of methane, ammonia, water and other gases. At the centre of the planet it is thought that there is a hot, solid core about ten times the mass of the Earth. This is surrounded by a dense layer of hydrogen and helium that behaves as a liquid metal under the immense pressures (3 million bars) here. Beyond this is a layer of normal molecular liquid hydrogen which grades into gaseous hydrogen towards the surface. At the surface Jupiter's atmosphere is very turbulent, fuelled by heat from within the planet, with distinctive coloured bands caused by convection and spots caused by storm systems. Jupiter has 16 known satellites, including the four discovered by Galileo Galilei (1564–1642) in 1610, the Galilean moons, and a very faint ring of particles. See Planet.

Kelvin

The SI unit of temperature. Degrees on the Kelvin temperature scale are of the same magnitude as degrees Celsius; the difference between the two is that the Kelvin scale starts at absolute zero, the lowest temperature possible, equivalent to minus 273 degrees Celsius. The freezing point of water (zero degrees Celsius) is thus 273 kelvin, while the boiling point of water (100 degrees Celsius) is 373 kelvin.

Keratin

A tough, fibrous, waxy protein that helps to strengthen and protect structures such as hair, fingernails and toenails, feathers, and the outermost layer of the skin.

Kilometres (km)

10^3 metres. See Metric system.

Kirlian photography

When a very high voltage is applied to an object, the discharge of electricity into its surroundings can be seen and photographed. The strength and distribution of the discharge depends on a number of factors, the most important of which is the presence of moisture on and around the object. Kirlian photography is named after the Russian researchers Semyan and Valentina Kirlian who described this process. Kirlian photographs of parts of the human body have been interpreted as images of the person's 'aura', although this is not widely accepted within the scientific community.

Kitt Peak National Observatory (KPNO)

An observatory located at an altitude of 2,120 metres in the Quinlan Mountains in Arizona, USA. It was founded in 1958 and is part of the National Optical Astronomy Observatories. Its largest telescope is the 4 metre Mayall Telescope, which opened in 1973.

Landsat

The longest running Earth observation programme. The first Landsat satellite was launched in 1972; the most recent, Landsat 7, was launched in 1999. Landsat was originally run entirely by NASA, although the US Geological Survey now plays a part in administering the programme.

Lava

The name given to molten rock or magma when it occurs on the Earth's surface, for example in a volcanic eruption.

Light microscope

An optical instrument, also known as an optical microscope, that uses glass lenses to magnify small objects down to about 500 nanometres. Invented by Hans and Zacharias Janssen in c.1590, the light microscope is used widely in biology and medicine to study living and fixed cells. A variety of lighting arrangements and other variations to the basic microscope exist for specific imaging purposes, including bright-field microscopy, dark-field microscopy, immunofluorescent microscopy and polarized light microscopy. Resolution is limited by the wavelength of light. See Bright-field microscopy, Dark-field microscopy, Immunofluorescent microscopy and Polarized light microscopy.

Light year (ly)

A measure of distance: the distance light travels in one Earth year, equal to 9.5 million million kilometres.

Limb

The rim of the visible disk of a planet, moon or star.

Local Group

The cluster of galaxies to which our galaxy, the Milky Way, belongs. The Local Group is about three million light years in diameter and has 31 confirmed members, including the Andromeda Galaxy (M31). Galaxies belonging to the next nearest group are about nine million light years away. See Galaxy cluster.

Lumen

The cavity in a tubular organ, such as blood vessels.

M numbers

See Messier Catalogue.

Macrophotograph

A photograph of an object visible to the naked eye. Macrophotography of small objects often employs special close-up lenses fitted to conventional cameras. The word macrophotograph combines the Greek elements *makros* (large), *photos* (light) and *graphein* (write).

Magellan space probe

A NASA space probe sent to Venus, which was launched from the Space Shuttle Atlantis in May 1989. From a highly elliptical near-polar orbit, reached in 1990, its onboard radar mapped the entire surface of the planet at an average resolution of 120 metres. A radar pulse sent down to the surface at an oblique angle was reflected back as a slightly modified signal, rough areas appearing radar-bright and smooth areas appearing radar-dark. Simultaneously, a second transmitter sent down a vertical radar pulse. This signal was also reflected by the surface, and time difference between transmission and detection of this reflected signal gave the height of surface features to an accuracy of 10 metres. Magellan radar data has been used to create surface elevations of the Venus landscape, as well as plan and aerial views. The colouring of these images has been provided by the few pictures obtained by landing probes such as the Russian Venera probes between 1970 and 1982, which managed to send back some pictures before succumbing to the extremely high temperatures and pressures on Venus. Their pictures

revealed the sky to be brilliant orange and the rocks to appear reddish-brown.

Magma

The term used to describe molten rock when it occurs beneath the Earth's surface. Volcanoes normally overlie a magma chamber which is the source of the gases, ash, pumice and lava they erupt.

Magnetic Resonance Imagery (MRI)

A medical imaging technique based on the measurements of the interaction between hydrogen atoms in the body with a very strong applied magnetic field. The patient is placed in a tunnel-shaped magnet within which the magnetic field can be varied and focused on different parts of the body. Unlike x-ray photography, which can only detect radio-opaque materials such as bone, magnetic resonance imagery allows doctors to visualize most of the body's tissues with millimetre resolution. Multiple scans allow three-dimensional images to be constructed.

Mariner space programme

A NASA project to explore the inner planets – Mercury, Venus and Mars. The first Mariner probe was launched in 1962, although it had to be destroyed after veering off course shortly after launch. A second attempt by Mariner 2 in 1962 succeeded in a flyby of Venus. Later missions, ending in 1975, provided almost all the information we have on Mercury and Venus, and paved the way for the Viking missions to Mars in 1975. Mariner 9 was the first probe to go into orbit around another planet, Mars, in 1971.

Mars

The fourth planet from the Sun, orbiting at a mean distance of 228 million kilometres. With a diameter of 6,794 kilometres, Mars is about half the size of Earth. It has a thin atmosphere composed of 95 per cent carbon dioxide, 2.7 per cent nitrogen, 1.6 per cent argon, 0.1 per cent oxygen and 0.1 per cent carbon monoxide with small traces of water vapour. Atmospheric pressure at the surface is very low, about 6 millibars, and the average surface temperature is minus 50 degrees Celsius, with a range of 0 to minus 125 degrees Celsius. There are two permanent water-ice caps at its poles, which are topped by a thin layer of carbon dioxide ice in winter. Mars's red colour is caused by the oxidation of iron in its iron-rich basaltic rocks. There are currently no active volcanoes on Mars but the presence of a number of huge dormant volcanoes indicates that the planet has been very volcanically active in the past. The surface is scarred by many impact craters and also bears evidence of the earlier presence of rivers and lakes, which have since dried up. Mars has two small satellites, Phobos and Deimos. See Planet.

Mars Global Surveyor (MGS)

A space probe launched by NASA in November 1996 to study the atmosphere of Mars and map its surface. It began mapping the planet in March 1998.

Mercury

Orbiting at a mean distance of 58 million kilometres from the Sun, Mercury is the innermost planet of the solar system. Grey in colour, it is 4,879 kilometres in diameter and has no permanent atmosphere. The average temperature at the surface is 170 degrees Celsius but in the absence of an atmosphere and being close to the Sun, Mercury has the widest temperature range of any planet in the solar system, soaring to 430 degrees Celsius during the day and falling to minus 183 degrees Celsius at night. Mercury's surface is scarred with impact craters, much like the Moon, although the craters are generally smaller and debris is not ejected as far from impact sites because of higher gravity. It has no natural satellites. See Planet.

Messier Catalogue

A list of celestial objects in the sky compiled by the French comet-hunter Charles Joseph Messier (1730–1817). The first list was published in 1771 and his final list with 103 objects was published in 1781. The catalogue included star clusters, nebulae and galaxies. Astronomers still refer to the objects from Messier's catalogue as Messier objects and identify them by their Messier or M numbers. The list has been extended beyond the original 103 by later observers. All Messier objects now have an NGC number as they also appeared in the New General Catalogue published in Britain a hundred years later.

Meteor

The brief streak of light produced by a small piece of interplanetary debris as it enters the Earth's atmosphere at high speed. Small debris particles burn up in the upper atmosphere between about 115 and 85 kilometres above the Earth's surface as they hurtle along at between 11 and 72 kilometres per hour. It is estimated that 100 million meteors, visible to the naked eye, enter the Earth's atmosphere in any one 24-hour period. Meteor showers occur when the Earth's orbit takes it through the trail of debris left by a comet.

Meteorite

A natural object from space that hits the surface of Earth or other planets. The planets of the solar system, and their satellites, are covered with craters caused by meteorite strikes. Most meteorites landing on Earth are believed to be fragments of asteroids, but some originate from the Moon and from Mars, perhaps thrown up into space by earlier meteorite strikes. Objects of 1 kilogram or more tend to survive entry into Earth's atmosphere and fall to the ground. More than 10,000

meteorites have been found, many on the surface of the Antarctic ice sheet where they show up well. There are fewer meteorite craters on Earth than on other planets due to plate tectonic movement and active surface erosion. Earth's atmosphere also means that many objects burn up before reaching the ground. Meteorites are the oldest known rocks, dating back to the beginning of the solar system 4.6 billion years ago.

Metre (m)

The basic SI unit of length: defined in 1983 as the distance travelled by light in a vacuum in 1/299 792 458 seconds. See Metric system.

Metric system

Devised in revolutionary France in 1799, the metric system is a decimal system of weights and measures. It was intended to replace existing illogical, confusing systems of weights and measures with one based on simple, uniform principles. The fundamental metric unit of distance is the metre, originally defined as one ten millionth of the distance over the Earth's surface between the equator and a pole. In 1983 the metre was redefined as the distance travelled by light in a vacuum in 1/299 792 458 seconds. From the metre is derived the kilogram, the weight of a cube of water ten centimetres on each side. Although a decimal system for time was proposed, it failed to catch on and the second remains the unit of time in the metric system. The metric system has been formalized as the Système International d'Unités, set up by the 11th General Conference on Weights and Measures in 1960. Metric units are more properly known as SI units. All scientific and most technical disciplines now use SI units, and the metric system has been adopted for general use by the majority of countries. For reference:

1 kilometre (km)	= 1,000 metres (m)
1 metre (m)	= 100 centimetres (cm)
	1,000 millimetres (mm)
1 millimetre (mm)	= 1,000 micrometres (μm)
	10^{-3}m (one thousandth of a metre)
1 micrometre (μm)	= 1,000 nanometres (nm)
	10^{-6}m (one millionth)
1 nanometre (nm)	= 1,000 picometres (pm)
	10^{-9}m (one billionth)
1 picometre (pm)	= 1,000 femtometres (fm)
	10^{-12}m (one trillionth)
1 femtometre (fm)	= 1,000 attometres (am)
	10^{-15}m

Imperial conversion:

1 inch = 2.54 centimetres; 1 foot = 30.48 centimetres; 1 yard = 0.91 metres; and 1 mile = 1.61 kilometres.

Micrograph

Originally, a photograph taken using a camera attachment fitted to a microscope. The term is now used for all images of objects smaller than the naked eye can

resolve. Images obtained using SEM are called scanning electron micrographs; images obtained using TEM are called transmission micrographs. See Scanning electron microscope and Transmission electron microscope.

Micrometre (μm)
10^{-6} metres. See Metric system.

Microscope
An instrument for magnifying small objects. See Light microscope and Electron microscope.

Microscopy
The act of observing objects through a microscope. See Light microscope and Electron microscope. Also Bright-field microscopy, Dark-field microscopy, Immunofluorescent microscopy and Polarized light microscopy.

Millimetre (mm)
10^{-3} metres. See Metric system.

Mitochondrian
The organelle responsible for respiration – the production of energy from food – in both plant and animal cells.

Molecule
A group of atoms which forms the fundamental unit of a chemical compound, or element. For instance, water molecules are composed of an oxygen atom bonded to two hydrogen atoms. Only a few elements – the noble gases – commonly occur as single atoms.

Moon
The only natural satellite of the Earth. With a diameter of 3,476 kilometres, it is the fifth largest satellite in the solar system. The Moon is gradually moving away from Earth and eventually it will be lost as it passes beyond the influence of the Earth's gravitational pull. There are several theories about the Moon's origin. One is that it formed from material ejected from the Earth's surface in a massive meteorite impact. Another is that it formed elsewhere in the solar system and was later captured by the Earth's gravitational pull, while another suggests that it formed by accretion at the same time as the Earth in the early years of the solar system. The Moon rotates once on its axis for every orbit around the Earth, and so the same side always faces the Earth. There is very little atmosphere or water on the Moon so the main erosive process is lunar cratering.

Myofibrils
The component fibres that make up muscle fibres in an individual muscle.

Nanometre (nm)
10^{-9} metres. See Metric system.

National Aeronautics and Space Administration (NASA)
The National Aeronautics and Space Administration is a US government agency founded in 1958 for civil aeronautical research and space exploration. The NASA headquarters is in Washington, DC.

Nebula
A cloud of gas and dust in space. There are three main types of nebula: reflection nebulae, which reflect light from nearby stars; dark nebulae, which appear dark but are visible when silhouetted against a bright background; and emission nebulae, which emit their own light because ultraviolet radiation from nearby stars excites or ionizes their constituent gases.

Neptune
Neptune is the eighth planet from the Sun in orbit at a mean distance of 4,497 million kilometres. At 49,528 kilometres in diameter, Neptune is smaller than Jupiter and Saturn but still about four times the diameter of the Earth. Its thick atmosphere consists of 85 per cent hydrogen and 15 per cent helium with traces of methane, ethane and other gases. Methane in Neptune's atmosphere makes the planet appear blue because it absorbs light at the red end of the spectrum, leaving the blue component to be reflected. At the centre is a small, hot, rocky core. At the top of the thick atmosphere there are dark and light bands and spots representing weather systems. Wispy, white clouds of methane ice appear above the main cloud tops. Neptune has eight known natural satellites and five rings. See Planet.

NGC numbers
See New General Catalogue.

Neutron star
A small star consisting entirely of neutrons, formed when a massive star undergoes a supernova explosion, and the core collapses under its own gravity. The star becomes so dense that the protons and electrons of its constituent atoms combine to form neutrons. Typically neutron stars are about 30 kilometres in diameter, but with a mass similar to that of the Sun. See Pulsar and Supernova.

New General Catalogue (NGC)
The shortened title for the *New General Catalogue of Nebulae and Clusters of Stars*, compiled by Johan Ludwig Emil Dreyer (1852–1926) and published in 1888. It was a revised, updated and enlarged version of John Frederick William Herschel's (1792–1871) *General Catalogue of Nebulae and Clusters of Stars* of 1864. The NGC contained 7,840 galaxies, nebulae and star clusters listed in order of right ascension. Additional objects were listed in two *Index Catalogues* and given the prefix IC. The objects in these catalogues are still known by their by NGC or IC numbers. Only a small proportion of NGC objects also have a Messier number since the *New General Catalogue* was far more comprehensive.

Nucleus (of atom)
The central part of an atom, containing neutrons and protons and most of the atom's mass.

Nucleus (of cell)
The organelle found in most plant and animal cells that contains genetic material organized into chromosomes, bound by a double outer membrane.

Optical microscope
See Light microscope.

Optical telescope
An optical telescope allows very distant objects to be seen by collecting and magnifying the light they emit or reflect in the visible part of the electromagnetic spectrum. There are two main types of optical telescope. The refracting telescope uses a converging lens to collect light, and the resulting image is magnified by the eye-piece. The reflecting telescope uses a concave mirror to collect and focus the light and a second, smaller mirror at 45 degrees to the main mirror to reflect the light into a magnifying eye-piece. This is the kind of telescope that most amateur astronomers would have in their garden. See Telescope.

Orbit
The path of one celestial body as it rotates around another in space. The Earth's orbit, for example, is the elliptical path it travels around the Sun each year.

Organelle
A discrete, minute structure within a cell which has a specialized function. The main cell organelles are mitochondria (respiration), chloroplasts (photosynthesis), ribosomes (protein synthesis), Golgi apparatus (storage and transport of secretory products), lysosomes (the supply of enzymes for use in the cell) and endoplasmic reticulum (protein and fat synthesis and transport).

Photosphere
The visible surface of a star, from which most of the star's energy is emitted as visible and infrared radiation.

Photosynthesis
The production of carbohydrates by plants using sunlight to provide the energy for a chemical reaction between carbon dioxide and water. In effect, energy from sunlight is stored in the chemical bonds of the carbohydrate molecules for later use. Photosynthesis takes place in the chloroplasts of a green plant leaf and produces oxygen as a by-product. Photosynthesis is the ultimate source of practically all of the oxygen in the Earth's atmosphere.

Phytoplankton
See Plankton.

Picometre (pm)
10^{-12} metres. See Metric system.

Planet
A body which does not give out light, and which orbits around the Sun or another star, excluding small bodies such as asteroids and comets. The nine planets of the solar system originated in a cloud of interstellar gas and dust around the protosun. Material gradually accreted to form larger bodies, each developing an increasing gravitational pull of its own as it grew from a disk of dust whirling around the Sun. The planets are thought to have already been formed 4.6 billion years ago, since the oldest rocks in the solar system are this age. The inner, terrestrial planets (in order of average distance from the Sun) are Mercury, Venus, Earth and Mars. They are relatively small and are composed of rock around a dense metallic core. The outer planets are the gas giants Jupiter, Saturn, Uranus and Neptune. They are composed of a rock and metal core surrounded by immense layers of solid, liquid and gaseous hydrogen. The outermost planet, Pluto, and its large satellite, Charon, are rocky and might in fact be large asteroids captured from the outer Kuiper Belt containing millions of icy planetesimals, or escaped satellites of a gas giant.

Planetary nebula
A cloud of glowing gas and dust around a mature star, formed when a red giant ejects its outer layers. The ejected gas glows red in the ultraviolet light from the hot central star. See White dwarf and Red giant.

Planetesimal
A body of rock, and/or ice, between 0.1 and 100 kilometres in diameter, with sufficient gravity to attract other material to it. Those in the solar system are thought to be left over from the formation of the planets, which grew by accretion of planetesimals. Most planetesimals lie on the outskirts of the solar system in the Kuiper Belt.

Plankton
Aquatic organisms that drift with water currents in a sea or lake. Some planktonic creatures have limited powers of locomotion, but others are able to propel themselves along. Plankton include both microscopic single-celled plants (phytoplankton, mostly algae) and animals (zooplankton, including protozoa and tiny crustaceans), as well as some larger animals such as jellyfish.

Plasma (in physics)
A special type of gas in which positive ions exist surrounded by a cloud of free electrons. Normally, electrons are firmly bound to atoms in a gas. Plasmas occur in nature in interstellar space and in the

atmosphere of stars, including the Sun
(the solar plasma).

Plate tectonics

The theory that the Earth's outer shell is divided into seven large rigid plates and several smaller ones which move relative to each other. The theory of plate tectonics was formulated in the 1960s and unified the theories of continental drift and of sea-floor spreading. Mountain-building, earthquakes and volcanic zones are generally confined to the boundaries of these plates and are the result of different kinds of interaction between adjacent plates.

Pluto

The ninth planet from the Sun, Pluto has a highly elliptical orbit. Its distance from the Sun varies between 4,425 million kilometres at its closest to 7,375 million kilometres at its farthest, with a mean distance of 5,900 million kilometres. It is the smallest planet of the solar system and with a diameter of 2,302 kilometres, it is smaller than Earth's Moon. Pluto has a very thin atmosphere, composed of methane and possibly some nitrogen and carbon monoxide. The temperature at the surface is estimated to be between minus 165 and minus 205 degrees Celsius. It is thought to have a relatively large rocky core surrounded by a layer of frozen water and a surface layer of methane. This small planet was once thought to be an escaped satellite of Neptune, but it is more likely to belong to the Kuiper Belt of asteroids which orbit the Sun in these outer reaches of the solar system. Pluto has one satellite, Charon, which has a diameter of 1,186 kilometres – relatively large for a satellite. Charon is locked in a synchronous orbit around Pluto. To an observer on the planet's surface, Charon would appear to hang motionless in the sky, always showing the same face, since both its orbital period and its axial rotation match the rotation period of Pluto. See Planet.

Polarized light microscopy

A type of optical microscopy which uses polarized light. Light waves oscillate about a plane as they travel. Normally, light from a bulb consists of waves oscillating about many planes. Passing this light through a polarizing filter restricts oscillations to a single plane. (Polarizing filters are used in sunglasses to cut down glare and reflections.) This property is useful to microscopists since many materials twist light by differing extents. A principal application of polarized light microscopy is in the study of rocks; under certain conditions different minerals show characteristic colours when viewed as very thin sections in polarized light, which helps geologists to identify them. See Light microscope.

Polymer

A substance consisting of long molecules containing many repetitions of a sequence of atoms. Examples include DNA, proteins and starch.

Prion

A very simple protein complex, without a cellular structure and lacking genetic material, that reproduces on the surface of cells. It is an abnormal form of a cell protein found in the brain of mammals. While harmless prions are common in humans, pathogenic prions are thought to be responsible for diseases such as Creutzfeldt-Jacob disease (CJD), Bovine Spongiform Encephalopathy (BSE) and scrapie.

Protein

Any of a large group of organic compounds consisting of one or more long chains of amino acids. They are found in all life forms. There are many different types of protein and they all perform different functions; important examples include enzymes, antibodies, keratin and fibrin.

Protostar

A star in the earliest stages of its formation, still in the process of condensing out of its parent cloud of gas and dust, before hydrogen fusion has begun. The dust falling into protostars makes them invisible at optical wavelengths, but they glow brightly at infrared wavelengths.

Protozoa

A group of single-celled micro-organisms, including both plant-like and animal-like forms. Examples include amoebae and *Vorticella*. The group Protozoa belongs to the kingdom Protoctista, which includes the single-celled organisms that cannot be assigned to the animal, plant or fungal kingdoms.

Pulsar

Pulsars are spinning neutron stars that sweep a beam of radio waves across the Earth every time they rotate, like the beam of light from a lighthouse. They are created in a supernova explosion from the collapse of the core of a supergiant star. They are small (20 to 30 kilometres across), incredibly dense, highly magnetized and spin rapidly. Their radio emissions are believed to result from the acceleration of charged particles above their magnetic poles.

Radar

A method of detecting distant objects, such as aircraft, which relies on their ability to reflect radio waves of centimetre wavelengths. Radar has also been employed to map the surface of inaccessible terrain, such as the surface of Venus (see Magellan). The word radar is derived from radio detection and ranging. A transmitter produces a beam of radio-frequency radiation. When the beam is interrupted by a solid object, part of the beam's energy is reflected back and detected. The time delay between the radiation leaving the transmitter and its reflection being detected enables the object's distance to be calculated.

Radiation pressure

The slight force that photons of electromagnetic radiation exert. This force is inconsequential for large objects, but it can have a significant effect on very small particles. For example, radiation pressure pushes clouds of dust particles that are in orbit around the Sun outwards and sweeps the dust in comet tails away from the comet's head.

Radio waves

Electromagnetic radiation with a wavelength of several kilometres to about 30 centimetres. Radio wavelengths are used for broadcasting and two-way communication. Many kinds of objects in space are naturally strong emitters of radio-frequency radiation, including black holes, neutron stars and pulsars. See Electromagnetic radiation and Electromagnetic spectrum.

Red giant

A relatively cool, large and bright star. Stars like the Sun generate energy through the nuclear fusion of their hydrogen atoms to create the heavier element, helium. As the star becomes older, the amount of helium present gradually increases until its mass enables the spontaneous fusion of helium, generating carbon. This new reaction causes an increase in the core temperature of the star, leading to its expansion into what is known as a red giant.

Redshift

If a source of light is travelling away from us, the wavelength of the light reaching us is lengthened (the Doppler effect). This change in wavelength is called redshift and is equivalent to a shift towards the red end of the spectrum; the faster an object is moving the greater the shift. The amount by which the wavelength is shifted, the redshift value, enables the calculation of distance to galaxies and quasars since the speed that an object is receding relates directly to its distance away (the theory states that the further away an object is the faster it is receding).

Reflection nebula

See Nebula.

Refraction

The bending of light as it passes from one transparent medium to another with a different optical density. For example, a pencil placed in a glass of water appears to bend at the junction between the optically dense water and the less optically dense air.

Satellite (artificial)
A man-made spacecraft in orbit. Satellites exist for many different purposes, such as relaying telecommunication signals, gathering information about conditions in the Earth's atmosphere for weather forecasting, or photographing the Earth's surface for environmental monitoring purposes. See Geostationary Operational Environmental Satellite.

Satellite (natural)
A relatively small natural body in orbit around a planet. For example, Earth has one natural satellite, the Moon, while Jupiter has 16.

Saturn
Orbiting the Sun at a mean distance of 1,427 million kilometres, Saturn is the sixth planet of the solar system. It is rather flattened in shape with a diameter of 120,540 kilometres at the equator and 108,730 around the poles. Saturn's thick atmosphere is composed of 96 per cent hydrogen and 4 per cent helium, with traces of methane, ammonia, ethane and other gases. At the centre is a hot, rocky core about twice the size of the Earth. This is surrounded by a layer of liquid metallic hydrogen and helium, followed by a layer of normal molecular liquid hydrogen which merges into gaseous hydrogen towards the surface. The atmosphere at the surface is turbulent, with bands of cloud and spiralling storm systems. Saturn has a bright and extensive ring system made of ice particles ranging from fine dust to boulders measuring 10 metres across. Together the rings have a full diameter of about 270,000 kilometres, but they are each only a few hundred metres thick. Saturn has in excess of 30 satellites, more than any other planet in the solar system. See Planet.

Scanning electron microscope (SEM)
A scanning electron microscope, like a transmission electron microscope, uses a beam of electrons to view an object rather than a beam of light as in optical microscopy. In a scanning electron microscope the electrons are reflected off the surface of the object, which is normally plated with a very thin layer of metal to increase its reflectivity. This produces a perspective image similar to everyday photographs of three-dimensional objects. Scanning electron microscopes first appeared in the 1940s, although they did not become common until the 1960s because of the complex electronics required to process the images. See Micrograph.

Scanning tunnelling electron microscope (STEM)
Developed in the 1980s, the STEM works by running a fine metal probe across the surface of the subject without touching it. An electrical field applied between the metal probe and the object draws electrons from the probe to the object. This flux of electrons, known as the tunnelling current, varies as the distance between the metal probe and the object changes. Measurements of changes in the tunnelling current as the object is scanned allow the construction of a detailed map of the surface of the object. This technique is extremely sensitive, allowing individual atoms to be visualized.

Shield volcano
A volcano in the shape of a flattened dome, built by eruptions of free-flowing, runny lava. This type of volcano is named after an Icelandic example thought by the Viking colonists to resemble their large round shields. (Steep-sided cone volcanoes consist of layers of much thicker lava which does not flow as far from the source of the eruption.)

SI units (Système International d'Unités)
The recommended set of units for scientific and technical measurement. See Metric system.

Skylab Space Station
Launched in May 1973, Skylab was the USA's first manned space station, designed to test the potential for long missions in space. The mission relied heavily on Apollo programme vehicles and technology. It was nearly a write-off after the space station was severely damaged during its launch. This resulted in extensive repair work by the crews who manned it; the spacewalks required exceeded the total previous time of extra-vehicular activity. In all, Skylab was inhabited by three different crews for a total of 171 days. The empty space station was brought back into the Earth's atmosphere in 1979.

Solar system
The Sun and all the planets in orbit around it. The solar system includes nine major planets and their 61 known satellites, plus countless asteroids, comets and smaller interplanetary debris. In order of average distance from the Sun, the nine planets are Mercury, Venus, Earth, Mars, Jupiter, Saturn, Uranus, Neptune and Pluto. The outer limit of the planetary system is marked by the outermost point in Pluto's orbit, that is 7.3 billion kilometres from the Sun. However, there are objects beyond this, including a band of icy planetesimals known as the Kuiper Belt which might extend as far as 150 billion kilometres from the Sun. If we take the edge of the solar system to be Pluto's orbit, then the solar system is 14.6 billion kilometres across, equivalent to about one six-hundredth of a light year.

Solar plasma
See Plasma.

Solar wind
The stream of atomic particles blown away from the Sun by the pressure from its radiation. It consists of elements such as helium and extends about 5 billion kilometres from the Sun, increasing in speed as it goes. The solar wind flows at 50 kilometres per second near the Sun, and by the time it reaches the Earth it is rushing past at several hundred kilometres per second. It is the interaction of the solar wind with particles in the upper atmosphere near the poles of planets in the solar system that causes aurora, known as the Northern (and Southern) Lights on Earth.

Space shuttle programme
The development of NASA's partially reusable Space Transportation System was announced by the US president Richard Nixon in 1972 and just nine years later the first space shuttle, Columbia, successfully lifted off from Kennedy Space Center. The spacecraft is launched by a rocket and can accommodate eight astronauts. Despite the mid-air explosion of the Challenger shuttle in 1986, which resulted in a temporary cessation of shuttle activity, the programme has been a great success with over a hundred flights in its first 20 years. As well as acting as a vehicle for placing satellites into orbit, the Shuttle programme has provided a platform for Earth observation and numerous scientific experiments.

Spiral galaxy
A type of galaxy that has bright arms of stars, gas and dust extending in a spiral shape from a central hub. The arms contain sites of active star formation while the hub features a concentration of old stars. Spiral galaxies range in diameter from 10,000 to over 300,000 light years. Earth's own galaxy, the Milky Way, is a spiral galaxy. See Galaxy.

SPOT
An Earth observation satellite programme begun by the French government in the mid-1970s and carried on in partnership with Belgium and Sweden. SPOT stands for Satellite Pour l'Observation de la Terre. The first SPOT satellite was launched in 1986, with a further four launched to date. SPOT colour images have a resolution of just 10–20 metres.

Stain
A substance used to make materials more clearly visible through a microscope. Coloured dyes are used for light microscopy, while transmission electron microscopy employs solutions of electron-dense compounds such as uranyl acetate and lead citrate – which act as stains by interfering with the transmission of electrons.

Star
A glowing sphere of gas that produces energy by the fusion of hydrogen to form helium at some stage in its life. The term includes stars like the Sun, which are currently burning hydrogen, and protostars which are not yet hot enough to burn hydrogen, as well as giant and supergiant stars which are burning other nuclear fuels since their hydrogen supplies have run out. It also includes white dwarfs and neutron stars, which consist of spent nuclear fuel. Nuclear reactions provide a star's heat and light, causing them to shine. Late in a star's evolution these reactions also produce heavier elements such as carbon and iron, which are distributed throughout the universe by planetary nebulae and supernova explosions.

Stellar wind
The same phenomenon as solar wind but for any star other than the Sun. See Solar wind.

Stereoscopic microscopy
A form of optical microscopy which allows depth perception and three-dimensional imaging. Stereo vision in humans and other animals with two forward-facing eyes works by combining images observed from slightly different angles. The brain interprets these images to generate information on the distance to objects – otherwise known as depth perception. Stereo microscopes take advantage of this ability to perceive depth by having two sets of optics, one for each eye. They are used in situations where depth perception is useful, for instance in microsurgery, or the manipulation of small objects. Similar stereo techniques, using paired cameras or sensors, are widely used in many imaging and remote sensing technologies.

Sub-atomic particle
Any particle smaller than an atom. Before 1897 it was thought that atoms were the smallest objects possible. The existence of three major constituents of atoms, electrons, protons and neutrons, was discovered between 1897 and 1932. Since then many smaller particles, including quarks, neutrinos, muons, tauons, photons, bosons and gluons, have been observed or postulated to exist.

Sun
The central body of the solar system and at 150 million kilometres away from Earth, our nearest star. The Sun has a surface temperature of 5,770 kelvin and a calculated core temperature of 15.6 million kelvin. It is made largely of hydrogen (71 per cent) with some helium (27 per cent) and heavier elements such as carbon (two per cent). It is estimated to be 4.6 billion years old, the same age as the whole solar system. Energy is produced at the Sun's core, by nuclear fusion of hydrogen to form helium. This energy takes 10 million years to travel to the Sun's outer surface, the photosphere, where it radiates out into space. It is the Sun's gravitational attraction that holds the planets of the solar system in orbit around it.

Supernova
A violent explosion in which stars, of more than eight

times the mass of the Sun, end their lives. During a star's evolution, the nuclear fusion of hydrogen to form helium results in the creation of increasingly heavier elements. Once the core consists entirely of iron and these heavier elements, nuclear reactions cease and the star collapses under its own gravity. The density of this stellar material becomes so high that electrons and protons combine to form neutrons, and a neutron star, or even a black hole, is born. Meanwhile, the formation of this immensely dense central body causes the star's surrounding layers to rebound and be ejected at high speed – the supernova explosion – producing a bright flash that may last for two to three months.

Supergiant
Supergiants are stars considerably more massive than the Earth's Sun (at least 6–10 times larger). In their early stages, these massive stars behave in a similar way to the Sun, creating energy through the fusion of hydrogen, albeit more rapidly. However, in the later stages once most of the hydrogen is exhausted, these stars have enough mass to enable the fusion of heavy elements. The very high energy production of supergiants makes them large in size and extremely bright. See Hypergiant.

Synchronous orbit
The situation in which a satellite in orbit around a planet takes the same time to complete an orbit as the planet takes to rotate once on its axis. The satellite thus appears to remain stationary above a point on the planet's surface. See Geostationary orbit.

Synchrotron radiation
The type of electromagnetic radiation emitted by a charged particle, such as an electron, when it moves through a magnetic field at almost the speed of light. Pulsars, supernova remnants and radio galaxies are all sources of synchrotron radiation.

Tectonic faulting
The fracturing of a planet's crust, and the movement of the ground on each side relative to the other, as a result of geological movement. See Plate tectonics.

Telescope
An instrument that collects radiation from a distant object in order to produce an image of it and/or to enable analysis of the radiation. See Optical telescope and X-ray telescope.

Transmission electron microscope (TEM)
Transmission electron microscopes were developed in the 1930s in response to the fundamental limitation of light microscopes, which cannot resolve an image of less than 0.2 micrometres. This limitation is the result of the relatively long wavelength of visible light. Electron microscopes use beams of short-wavelength electrons which are capable of resolving a specimen's much finer details. In a transmission electron microscope, the electrons are passed through the sample before being projected onto a fluorescent screen, creating an image. See Scanning electron microscope.

Tropical cyclone
A tropical cyclone is a low pressure area in an oceanic region of the tropics or subtropics, forming where sea surface temperatures are above 27 degrees Celsius. Tropical cyclones can develop wind speeds of up to 120 kilometres per hour, and the deep atmospheric circulation or convection over the ocean results in the development of towering thunder clouds. These clouds spiral around a cloud-free central eye (where air is descending due to low pressure near the ground) and form a wall around it – it is the passage of this eye-wall over land that causes the most damaging winds and heaviest rain on the ground below. See Cyclone, Hurricane and Typhoon.

Typhoon
The name given to a tropical cyclone in the western Pacific. See Tropical cyclone.

UGC numbers
See Uppsala General Catalogue of Galaxies.

UK Schmidt Telescope (UKST)
A 1.2 metre telescope located at Siding Spring in New South Wales, Australia. It opened in 1973. See Anglo-Australian Observatory.

Ultrasound
Sound energy (physical vibrations in air or other materials) at frequencies greater than 20,000 hertz (oscillations/second), beyond the range of the human ear. Ultrasound scanning, or ultrasonography, is a medical imaging technique that works by detecting echoes of ultrasound waves as they pass through the human body. Echoes are strongest from dense and smooth surfaces. The time taken for an echo to return gives an indication of the depth of the reflective surface that caused it. Ultrasound scans are frequently used to study the abdominal region, particularly the development of embryos in the womb, while very high frequency ultrasound can be used to study structures as delicate as the eye.

Ultraviolet radiation (UV)
Electromagnetic radiation with slightly shorter wavelengths than visible light (380 nanometres to 60 nanometres), between that of violet light and long x-rays. The Sun emits UV radiation, which causes the skin to darken or tan. Overexposure can cause skin damage. Many insects can see ultraviolet radiation.

Uppsala General Catalogue of Galaxies
A catalogue of galaxies drawn up in 1973 based on the blueprints obtained by the Palomar Observatory Sky Survey. It contains descriptions of the galaxies and their surrounding areas, their conventional classification and, for flattened galaxies, their angles.

Uranus
The seventh planet from the Sun, Uranus orbits the Sun at a mean distance of 2,870 million kilometres. It is similar in size to Neptune, with a diameter of 51,118 kilometres. It has a thick atmosphere of 83 per cent hydrogen, 15 per cent helium and 2 per cent methane. Uranus appears blue-green in colour because methane in the upper atmosphere absorbs the red component of light, leaving the blue and green components to be reflected. A small, rocky, hot core lies at the centre of the planet, blanketed by a thick atmosphere. The top of the atmosphere appears featureless in photographs but computer-enhanced images reveal faint bands and spots like the other gas giants. Uranus has 15 known satellites and 11 faint, narrow, elliptical rings composed of icy boulders measuring over a metre across. See Planet.

Vascular tissue
The tube-like structures used to transport water, minerals and sugars in all higher plants. In many cases, stiffened vascular tissues are used to support the plant.

Venus
Venus is the second planet from the Sun, orbiting at a mean distance of 108 million kilometres. With a diameter of 12,104 kilometres, Venus is similar in size and internal structure to the Earth; however, its greater proximity to the Sun ensured that it evolved very differently. Venus has a dense atmosphere of 96.5 per cent carbon dioxide and 3.5 per cent nitrogen, by volume, with traces of sulphur dioxide, water vapour, argon, hydrogen and carbon monoxide. Atmospheric pressure is about 92 times that on Earth at sea level (92 bars). The great abundance of carbon dioxide in Venus's atmosphere results in strong 'greenhouse' warming; the average surface temperature is 460 degrees Celsius. The surface is permanently obscured by a thick cloud layer of water and sulphuric acid droplets, but radar mapping has revealed that the surface is topographically varied, with highland and rolling plains, volcanoes and rift valleys. See Planet.

Very Large Array Telescope (VLA)
A radio telescope situated on the Plains of San Augustin, west of Socorro in New Mexico, USA. It was completed in 1980 and is operated by the US National Radio Astronomy Observatory. It has 27 movable dishes mounted along a Y-shaped railway track with three arms that are 19, 21 and 21 kilometres long respectively.

Viking space programme

Two NASA Viking probes were sent to Mars in 1975, arriving just under a year later. Both crafts included an orbiter which mapped the planet's surface and a lander which analysed the soil, photographed the surroundings and took weather readings. The landers supplied the first television pictures taken from the surface of another planet, but returned no positive evidence for the presence of life on Mars.

Virus

A non-cellular life form consisting of a core of genetic material RNA (ribonucleic acid) or DNA (deoxyribonucleic acid), surrounded by a protein coat or capsid. Viruses are incapable of replicating on their own; instead, they parasitize the cells of a host organism, redirecting the cell's metabolism to manufacture more virus particles. In many cases this occurs without destruction of the host cell, but viruses are also a principal cause of disease.

Voyager space programme

The two Voyager probes were launched by NASA in 1977. Their initial mission was to explore the gas giants, Jupiter and Saturn, and their moons, although Voyager 2 also flew past Neptune and Uranus. The two probes far exceeded their initial mission lifespans and have continued to send back useful data from the farthest reaches of the solar system; they are not expected to shut down until their nuclear power systems eventually weaken in around 2020. Voyager 1, which is departing the solar system at a rate of 17 kilometres per second, is the most distant human-made object in the universe.

White dwarf

A small, dense star – one end result of a star's evolution. All but the most massive stars evolve into a white dwarf once they have used up their store of hydrogen fuel. Once nuclear burning has stopped, the core collapses and the star's outer layers are ejected as a planetary nebula. The core contracts under its own gravity until it is about the size of Earth and extremely dense (a cubic metre of the star would weigh one hundred million kilograms). These stars then cool, gradually becoming fainter and redder.

Wolf-Rayet star (WR star)

A very luminous star in the latter stages of its evolution that has lost its hydrogen envelope and is burning helium. These stars have a mass greater than 10 times that of the Sun and surface temperatures of 20,000 to 40,000 kelvin. Strong stellar winds from these stars causes them to lose mass rapidly. They were discovered in 1867 by French astronomers Charles J E Wolf (1827–1918) and Georges A P Rayet (1839–1906).

X-ray

Electromagnetic radiation with a wavelength of 60 nanometres to 100 femtometres, shorter than UV radiation. See Electromagnetic radiation, Electromagnetic spectrum and X-ray photography.

X-ray diffraction/crystallography

Diffraction is a property of electromagnetic waves whereby they bend if passed through an aperture similar in size to their wavelength. X-ray diffraction is the bending of x-rays as they pass through an aperture. This property is applied in crystallography (the study of crystals) to determine the spacing of atoms in a crystal structure. X-rays are similar in wavelength to the distance between atoms in a crystal; thus they are diffracted when passed through a sample, and the degree of bending can be measured. This allows the atomic spacing in different directions through the crystal to be determined, and hence the crystal structure can be described.

X-ray photography

X-rays are a category of high-energy, short-wavelength electromagnetic radiation. Whereas low-energy electromagnetic radiation, such as visible light or ultraviolet, interacts with and is reflected by most materials, X-rays pass unhindered through many fluids and solids including skin and muscle. However, they are partly absorbed and reflected by dense material such as bone. This property allows the familiar x-ray imaging of the human skeleton. X-ray photography, or radiography as it is correctly known, is not limited to the human body, however. Insights into the internal structure of many objects are gained through the technique. One practical application is the detection of internal cracks inside metal structures, such as aircraft wings, that cannot be seen from the surface.

X-ray telescope

An instrument used to focus the x-rays emitted by distant objects into an image. X-rays are normally invisible, so this telescope not only enlarges the images but converts them to a visible format. See Telescope.

Zooplankton

See Plankton.

Phaidon Press Limited
Regent's Wharf
All Saints Street
London N1 9PA

Phaidon Press Inc.
180 Varick Street
New York, NY 10014

www.phaidon.com

First published 2002
© 2002 Phaidon Press Limited

ISBN 0 7148 4280 X

A CIP catalogue record for this book
is available from the British Library.

Editor:
Amanda Renshaw
Project Manager:
Victoria Clarke
Editorial Researcher:
Ian Lawson
Editorial Assistants:
Charlotte Garner, Emily Winter
Picture Researchers:
Adrienne Corner, Mari Knutsson
Designer:
Atelier Works
Production Manager:
Sarah McLaughlin

Printed in Italy

Acknowledgements
The editor would like to thank Chris Boot
whose own idea inspired the existence
of this book, and Ken Arnold, David Brodie,
Quentin Newark and John Stack for their
contribution and advice.

Photographic Acknowledgements
Michael Abbey/Science Photo Library (SPL):
44, 50, 55, 82–3, 102–3; Photographed by
Lúcia de Abreu and Ian Marshal (Godwin
Laboratory, Cambridge): 60; Aeroservice/SPL:
166; © Heather Angel: 73, 81, 96, 97, 112,
115, 116, 122–3, 124–5, 127, 128, 132, 133,
142; © Anglo-Australian Observatory,
photograph by S Lee, C Tinney and D Malin:
362; © Anglo-Australian Doherty Observatory,
photograph by David Malin: 301, 305, 306,
311, 314, 315, 316, 317, 323, 326, 329, 330,
331, 332, 334, 335, 337, 339, 341, 344, 346,
348, 350–1, 354; © Anglo-Australian
Observatory/Royal Observatory, Edinburgh,
photograph from UK Schmidt plates
by David Malin: 308, 308–9, 313, 322, 338;
Wolfgang Baumeister/SPL: 24;
Biophoto Associates/SPL: 139; © Werner
Bischof/Magnum Photos: 120;
Alan Boyde/Wellcome Photo Library: 66;
© Dee Breger, Lamont-Doherty Earth
Observatory: 31, 36–7, 43, 45, 58, 65, 70–1,
78, 87, 91; BSIP/SPL: 29; Dr Jeremy
Burgess/SPL: 35, 59, 117, 119;
Celestial Image Co./SPL: 353, 357;
Marie-Thérèse Cerceau, Laboratoire de
palynologie/CNRS/Museum national d'histoire
naturelle, Paris: 32–3; © CNES, 2002,
courtesy SPOT Image Corporation: 162; CNES,
1986 Distribution SPOT Image/SPL: 169, 174,
177; CNES, 1987 Distribution SPOT
Image/SPL: 167; CNES, 1988 Distribution
SPOT Image/SPL: 160; CNES, 1989
Distribution SPOT Image/SPL: 158, 175;
CNES, 1991 Distribution SPOT Image/SPL:
191, 199; CNES, 1992 Distribution SPOT
Image/SPL: 171, 180; CNES, 1995
Distribution SPOT Image/SPL: 176; CNES,
1999 Distribution SPOT Image/SPL: 181;
CNES, 2001 Distribution SPOT Image/SPL:
178; CNRI: 42; CNRI/SPL: 152, 155; © digital
image 1996 Corbis; original image courtesy of
NASA/Corbis: 168, 172, 179, 182, 184, 185,
186, 209, 210, 213, 214, 220; Custom
Medical Stock Photo/SPL: 86; © Peter
David/Natural Visions: 143; Deutsches
Museum, Munich: 144; Martin Dohrn/SPL:
104; Dopamine/CNRI: 129; Driscoll,
Youngquist & Baldeschwieler, Caltech/SPL:
18; Dr Johannes Durst/SPL: 250; © Earth
Satellite Corporation 1980: 203; © Earth
Satellite Corporation 1982: 202; © Earth
Satellite Corporation 1989: 200; Earth
Satellite Corporation/SPL: 163, 188, 196,
198, 205, 206, 207; © Harold & Esther
Edgerton Foundation, 2002, courtesy of Palm
Press, Inc.: 130; Electron Microscopy Unit,
Royal Holloway University of London: 21, 47,
63, 67, 68, 76; Eric F Erbe, USDA, ARS, Henry A
Wallace Beltsville Agricultural Research Center,
Electron Microscopy Unit, Beltsville, Maryland:

32; Eye of Science/SPL: 40, 72, 84, 99; Léon
Foucault/Société française de photographie,
Paris: 49; © Akira Fujii/DMI: 300, 302(l), 312;
David Furness/Wellcome Photo Library: 126;
Genesis/Lockheed Martin Space Systems
Company Astronautics Operations: 272;
Genesis/NASDA, Japan: 252; GJLP/CNRI:
131; Gusto/SPL: 141; Tony & Daphne
Hallas/SPL: 248, 345; Adam Hart-Davis/SPL:
110; Harvard College Observatory/SPL: 246;
Yoji Hirose/Galaxy Picture Library: 236, 303(r),
304, 328–9; Garion Hutchings/SPL: 137;
© IAC/RGO/Malin, photograph from Isaac
Newton Telescope plates by David Malin: 321,
343; Jules Janssen/Observatoire de Paris:
254–5; JPL/Galaxy Picture Library: 258, 269,
271, 282; Manfred Kage/OKAPIA/CNRI: 46,
79; Manfred Kage/SPL: 53, 98, 107, 136, 138;
James King-Holmes/Institute of Animal
Health/SPL: 39; Martin Knight/Wellcome
Photo Library: 56; © 2001 Dennis Kunkel
Microscopy, Inc., Kailua, Hawaii: 69, 82;
Maurice Loewy & Pierre Puiseux/Société
française de photographie, Paris: 238–9;
Dr Kari Lounatmaa/SPL: 25; Mike
McNamee/SPL: 111; © Malin/Caltech,
photograph by Bill Miller: 342;
© Malin/Pasachoff/Caltech, photograph
by David Malin: 324; © 1986 Max-Planck-
Institut für Aeronomie, Lindau/Harz, Germany:
247; Microfield Scientific Ltd/SPL: 34;
Principal Investigator Bernard H
Mollberg/NSSDC/NASA: 208; Professor Pietro
Motta/Department of Anatomy/University
'La Sapienza', Rome/SPL: 54; Courtesy NASA,
COsmic Background Explorer (COBE) Project:
298–9; NASA, H Ford (JHU), G Illingworth
(USCS/LO), M Clampin (STScI), G Hartig
(STScI), the ACS Science Team, and ESA: 320,
361; NASA/Galaxy Contact/Oxford Scientific
Films: 187, 193, 197, 215, 240, 245, 276–7,
292, 318, 368–9; NASA/Genesis: 165, 189,
190, 194, 195, 218, 225, 227, 230, 232, 234,
259(r), 264, 293; NASA/Goddard Space
Flight Center/SPL: 233; NASA/IPAC/Caltech:
145; NASA Johnson Space Center (41D-43-
027): 216; NASA Johnson Space Center
(ISS001-E-5107): 161; NASA Johnson Space
Center (STS087-707-092): 192; NASA
Johnson Space Center (STS087-717-088):
201; NASA/SPL: 105, 211, 212, 217, 219,
221, 224, 226, 235, 241, 243, 244, 253,
257, 259(l), 261, 262, 263, 265, 273, 275,
280, 281, 283, 284, 286, 287, 288, 290,
291, 340–1; National Optical Astronomy
Observatories/SPL: 251, 302–3, 310, 352;
© The Natural History Museum, London:
41, 64, 93, 106; Adolphe L Neyt/Société
française de photographie, Paris: 36;
NIBSC/SPL: 22, 30; Yorgos Nikas/Wellcome
Photo Library: 57; Photo Lennart
Nilsson/Albert Bonniers Förlag AB: 26, 88,
108–9, 121, 147; Susumu Nishinaga/SPL: 90;
Northwestern University/SPL: 17; NRAO/SPL:
365; NRSC Ltd & CNES/SPL: 183; Claude
Nuridsany & Marie Pérennou/SPL: 52, 61, 70,
74, 75, 113, 114, 118, 125; Dr Mitsuo
Ohtsuki/SPL: 15, 16; L'Oréal/Eurelios/SPL:
94–5; © Oxford Scientific Films: 80; Alfred

Pasieka/SPL: 20, 148; Dr David
Patterson/SPL: 62; PLI/SPL: 231; Pryor et al,
McDonald Observatory/SPL: 278; Dr David
Roberts/SPL: 140, 150, 153; Lewis M
Rutherfurd/Société française de photographie,
Paris: 238; St Bartholomew's Hospital/SPL:
135; John Sanford/SPL: 237; David
Scharf/SPL: 38; Dr Rudolph Schild/SPL: 355,
360; © Herbert Schwind/OKAPIA/Oxford
Scientific Films: 108; Science Photo Library:
14, 85, 146, 149, 151; Science Source/SPL:
18–9; Provided by the SeaWiFS Project,
NASA/Goddard Space Flight Center, and
ORBIMAGE: 222; Space Telescope Science
Institute/NASA/SPL: 279, 294–5, 319, 325,
327, 333, 336, 347, 349, 356, 358, 359, 363,
364–5, 367; Sinclair Stammers/SPL: 92;
Dr Linda Stannard, UCT/SPL: 23, 27;
STScI/Galaxy Picture Library: 307; Andrew
Syred/SPL: 48, 89; TRACE/Galaxy Picture
Library: 256; University of
Edinburgh/Wellcome Photo Library: 28; US
Geological Survey/EROS Data Center: 159,
164, 170, 173, 204; US Geological
Survey/SPL: 223, 266, 268, 270; Dr M I
Walker/Wellcome Photo Library: 77; Wellcome
Trust Medical Photographic Library: 154;
Wessex Regional Genetics Centre/Wellcome
Photo Library: 51; Maximilian Wolf/Fonds
Camille Flammarion/Société astronomique
de France: 249; © Fumio Yokozawa: 134–5.

Jacket: front cover (t) Solar Plasma: ESA/SPL
and (b) Knotweed pollen: David Scharf/SPL;
back cover (t) Heat-loving bacteria: Wolfgang
Baumeister/SPL and (b) Earth showing Europe
and North Africa: PLI/SPL.

The publishers have made every effort
to include the most precise information relating
to the magnification, size and distance of the
objects illustrated in this book. Due to the
nature of the material some of the
measurements are approximations.